YALE UNIVERSITY PRESS
PELICAN HISTORY OF ART
Founding Editor: Nikolaus Pevsner

PAINTING AND SCULPTURE IN EUROPE: 1880–1940
George Heard Hamilton

George Heard Hamilton has been a member of the history of art faculty at Yale University, and a curator of modern art at the Yale University Art Gallery. From 1966 to 1977 he was Director of the Sterling and Francine Clark Art Institute in Williamstown, Massachusetts, and Professor of Art at Williams College. He was Slade Professor of Fine Art at Cambridge in 1971-2, Kress Professor in Residence at the National Gallery of Art, Washington, D.C., in 1978-9, and in 1979 became a Fellow of the American Academy of Arts and Sciences. He is a trustee of the Museum of Modern Art in New York, a member of the International Association of Art Critics, and a past president of the College Art Association of America. He has also written the volume on Russian art and architecture in the *Pelican History of Art* series.

George Heard Hamilton

PAINTING AND SCULPTURE
IN EUROPE 1880-1940

Yale University Press · New Haven and London

First published 1967 by Penguin Books Ltd
Sixth edition with a revised bibliography by Richard Cork published by Yale University
Press 1993
20 19 18 17 16 15 14 13 12 11 10 9 8 7 6 5 4 3 2 1

Set in Monophoto Ehrhardt, and printed in Singapore by CS Graphics

Designed by Gerald Cinamon

ISBN 0-300-05648-6 (cloth)
 0-300-05649-4 (p/b)

Library of Congress catalog card number 71-128577

TO THE MEMORY OF ARCI BIANCHI
1910-1964

Era già l'ora che volge il disio
ai naviganti e intenerisce il core
lo dì c'han detto ai dolci amici addio.
Purgatorio *VIII, 1-3*

CONTENTS

FOREWORD

This history begins where the preceding volume in the series, Fritz Novotny's *Painting and Sculpture in Europe: 1780 to 1880*, comes to an end; that is to say, at the moment when changes in the theory and practice of Impressionism had become perceptible in the attitude and work of Degas, Monet, Renoir, and Cézanne. It ends in 1939-40, when the modern movement, formulated between 1900 and 1915, had been confirmed by the mature work of its leading masters in the years between the two World Wars. Exceptions have been made for certain artists, long-lived and of extraordinary powers – a Matisse, a Picasso, or a Lipchitz, for example – whose later work continued to exemplify or expand values established long before.

In a general work such as this it is tempting to stray from the customary historical progression in order to linger over less prominent artists or less critical movements so that one's text, and point of view, may not seem repetitious or conventional. But restrictions of space, for the author, and of time, for the reader, compelled me to resist it. I have, therefore, by omitting many admirable artists and interesting works of art, chosen to present this history in terms of the central tradition of European modernism. British art and artists have been discussed only when they have contributed to that history or when their work gains new dimensions when seen in relation to it.

To the collectors, scholars, and curators who have answered my inquiries about works in their care, whether by letter or in conversation, and who have generously permitted their reproduction, I can best express my gratitude by saying that without their help this volume would not have been at all. I am also deeply indebted to the following for their assistance at difficult points along the way: Professor Josef Albers; Mr Ronald Alley of the Tate Gallery; London; Mr and Mrs Walter Bareiss; Mr Douglas Cooper; Professor Jacques de Caso of the University of California at Berkeley; Mr and Mrs Marcel Duchamp; Mr Hugh Edwards of the Art Institute of Chicago; Mr and Mrs Naum Gabo; Mr Donald C. Gallup of the Yale University Library; Mr Henry G. Gardiner of the Philadelphia Museum of Art; Miss Camilla Gray; Mr Bernard Karpel, Librarian of the Museum of Modern Art, New York; Mr Johan H. Langaard, Director of the Munch-Museet, Oslo; Mr Julien Levy; Mr Stephen Tschudi Madsen; Mrs Lydia Winston Malbin; Professor Sibyl Moholy-Nagy of Pratt Institute, Brooklyn; Dr Aleksis Rannit of the Yale University Library; Mr Andrew Carnduff Ritchie, Director of the Yale University Art Gallery; Miss Caroline Rollins, of the Yale University Art Gallery; Miss Gertrude Rosenthal, Chief Curator of the Baltimore Museum of Art; Mr Arturo Schwarz; Mr Brooks Shepard, Jr, Librarian of the School of Music, Yale University; Mr John D. Skilton, Jr; Mr James Thrall Soby; Dr Louise Averill Svendsen of the Solomon R. Guggenheim Museum, New York; Mr Frederick A. Sweet of the Art Institute of Chicago; the late Mrs Kay Sage Tanguy; Professor Joshua C. Taylor of the University of Chicago; Mr Richard L. Tooke of the Museum of Modern Art, New York; Mr Peter A. Wick of the Fogg Museum of Art but then of the Museum of Fine Arts, Boston; and to my colleagues in the faculty of the history of art at Yale: Kurt Forster, Egbert Havercamp-Begemann, Robert L. Herbert, Edgar J. Munhall (now of the Frick Collection), and Charles Seymour, Jr. Mrs Aimée Brown Price's editorial skill smoothed many rough places in the final draft. The typing of the correspondence and of numerous versions of the manuscript was ac-

complished with unfailing skill, patience, and understanding by Mrs Patricia S. Beach and Mrs Lila Calhoun in New Haven, and by Mrs Rachel Norton in Williamstown, Mass.

I wish especially to thank the trustees of the John Simon Guggenheim Foundation for a fellowship in 1958-9 which made possible further studies in Europe. Lastly I owe heartfelt thanks to my wife and children, who so often waited while I worked. They join me in dedicating this book, alas too late, to a friend whose love of music, art, and letters immeasurably enriched our own.

G. H. H.
New Haven, Conn., 30 June 1966

In preparing this new edition in integrated format I have been greatly helped by those friends and scholars who have called to my attention certain errors of fact, but I hope that those who questioned my interpretation of modern art will not be disappointed to find that the argument remains substantially intact. Like Henry James, I believe that art is a human situation, and hence essentially private.

The Librarian and staff of the Sterling and Francine Clark Art Institute have provided prompt assistance on innumerable occasions, and Mrs Selma Sabin of the Institute has taken charge of the correspondence and typing for this edition.

For their exemplary patience, combined with tactful if persistent goading, I owe to the Editor and Assistant Editor of this series a debt of gratitude now many years overdue.

G. H. H.
Williamstown, Mass., 30 September 1970

The changes in the third edition consist principally of the elimination of errors, the regrettable notation of the deaths of many artists in recent years, and the suppression of the concluding chapter which had become too summary an account of developments since 1945.

In bringing the bibliography down to the present I have been helped during my residence in Washington by the staff of the library at the National Gallery of Art and the resources of the Library of Congress. I am most grateful to my research assistant for the Kress Professorship, Mary Jane Pagan, for her imaginative and prompt solution of many nagging problems.

I have always believed that the writing of history is also an exercise in criticism. Since this book was begun twenty years ago I have come to realize that it has been an experience in self-criticism as well; a record of one person's effort, from adolescence into later life, to understand the forms and meaning of the modern movement.

G.H.H.
Washington, D.C., 1 June 1979

For this reprinting certain errors have been corrected, and death dates added. In the bibliography more easily obtainable recent publications have been substituted for a number of older works, and there has also been some updating of the notes.

My gratitude to Judy Nairn, now the Joint Editor of this series, is greater than ever.

G. H. H.
Williamstown, Mass., 1 July 1982

In this new edition changes of ownership have been recorded wherever possible, and death dates added. For the first time, colour plates replace some of the black and white illustrations and the bibliography has been extensively enlarged and updated by Richard Cork to take account of the rapid growth of publications on the twentieth century in the last decade.

G.H.H.
Williamstown, Mass., 1 May 1993

PAINTING AND SCULPTURE
IN EUROPE 1880-1940

Note: Whenever the location of an object is indicated within parentheses, the reference is to the principal gallery or museum in the given city. For London, New York, and Paris, however, the institutions are to be understood as the Tate Gallery, the Museum of Modern Art, and the Musée National d'Art Moderne (Centre National d'Art et de Culture Georges Pompidou).

INTRODUCTION

In the half-century between 1886, the date of the last Impressionist exhibition, and the beginning of the Second World War, a change took place in the theory and practice of art which was as radical and momentous as any that had occurred in human history. It was based on the belief that works of art need not imitate or represent natural objects and events. Therefore artistic activity need not be concerned with representation but rather with the invention of objects variously expressive of human experience, objects whose structures as independent artistic entities cannot be evaluated in terms of their likeness, nor devalued because of their lack of likeness, to natural things.

The artistic systems of the nineteenth century, prolonged into and through Fauvism and Expressionism, were based upon the Renaissance conception of the work of art as being to some extent a description of the objective, natural world which conforms to certain familiar and demonstrable spatial perceptions, and in which each of us could find confirmation for the fact or experience recorded in the individual work of art. Van Gogh's *Doctor Gachet* [44] may be one of the most intensely introspective portraits in the western tradition, but it is still traditional because it is a portrait of a particular individual, and we accept it as an essentially accurate account of what we would have seen had we been in that person's presence. With Cubism and the succession of movements derived from its premises, no such relationship is necessary or inevitable. In relation to the actual world, the work of art is no longer a description or an illusion of that actuality, but rather is in and of itself its own reality, a real thing, subject to the laws of art rather than of

nature, imposing its own system of relations upon nature. Of all the new aesthetic principles, this has been the most difficult to explain and to accept. Habits of vision, of education, and even of speech oppose it. The accumulated artistic evidence of the past, as well as the continuing tradition of naturalistic description in the mass media of visual communication, are there to tempt us into trying yet once more to translate art into the terms of nature and of our own experience. Yet unless we resist we shall remain blind or insensitive to much that is provocative, strenuous, and profound in the art of our own time.

In earlier art the forms represented in painting or which existed in three dimensions as sculpture had been either simulated or actual elements within a natural environment, and as such had conformed to the limitations imposed upon natural forms by light, colour, and their apparent position in visual space. Modern art disregards these traditional uses and transforms them into new. Form may exist apart from colour; colour may ignore the localization implied by light; and volume, as in certain Constructivist sculpture, may be treated as a denial of mass. In any given instance, colour, light, or mass may become a function rather than a determinant of form, because the conception as well as the apprehension of form is held to be a mental quite as much as a perceptual activity. Forms are conceived and experienced in the mind. Perception is a means towards the knowledge of form, not an end in itself. As Picasso insisted: 'I paint forms as I think them, not as I see them.' The position was defined less epigrammatically by Albert Gleizes and Jean Metzinger in the first book devoted to

Cubist aesthetics: 'A realist will fashion the real in the image of his mind . . . Far be it from us to throw any doubts upon the experience of objects which impress our senses; but, rationally speaking, we can only experience certitude in respect to the images they produce in our minds.' Henceforth, the source and justification of the work of art must be sought in mental situations, rather than in the phenomenal world.

Although this revolution in ways of conceiving and perceiving the artistic object, for that is what it was, had been anticipated earlier, by Manet, for example, it was accomplished with difficulty, not by any one individual, but by many artists in several different countries during the early years of this century. By 1915 the principles of abstract or non-objective art had been formulated, and the first non-representational objects produced by Kandinsky in Munich, by Larionov and Malevich in Russia, by Kupka and Delaunay in Paris, and very soon after by Van Doesburg and Mondrian in Holland. After the First World War, as their work was consolidated by various groups and associations of artists, the abstract movement reached Great Britain and the United States. Even devolopments apparently in opposition to abstraction, such as Dada and Surrealism, with their use of actual objects, and the revival of exaggeratedly realistic techniques of representation, cannot be considered as simply having returned to the principles of artistic imitation, because what was presented was not the objective world of appearance but the world of dream imagery, of psychic experience. After 1945 abstract art emerged with new and startling vitality on an international scale in the movements known as Abstract Expressionism or Action Painting in America and Britain, and as *tachisme* or *art informel* on the Continent. Whatever the future may hold, and more representational modes have indeed reappeared since 1960, the theory and practice of abstract art may for ever have changed our conception

of the relation of art, a human activity, to nature, a non-human situation.

None the less the spectacular achievements of the earliest abstract artists should not obscure the presence of other masters – Picasso and Matisse, Brancusi or Henry Moore – whose work continued to owe allegiance, in whatever degree, to the phenomenal world, although for each of them the fundamental independence of the work of art has been more artistically important than any resemblances it might have to objects of nature. Nor should we forget that this new conception had been prepared by the activities of the immediately preceding generation. It is implicit, perhaps, as early as 1866, to mention only one instance, in Manet's disregard of conventional connotations of natural forms when, as Zola tells, he sat down before any object and painted it without intellectual or emotional (expressive) preconceptions. Gradually, in the later works of the Impressionists and Post-Impressionists, especially in Van Gogh's and Gauguin's, a painting became more a record of the artist's experience than an account of perceived natural facts, until it could be said to have originated in the mind rather than in observed nature.

From these premises two conclusions followed. Because the work of art no longer necessarily corresponded to objective natural facts, the perceptual characteristics of those facts, their natural shapes, dimensions, or coloration, could no longer be used as criteria for the evaluation of artistic qualities. With the disappearance of objective criteria based on natural ('normal' anatomy, for one), the work of art became more exclusively a manifestation of the artist's intimate, subjective experience, and in turn its evaluation depended upon the spectator's subjective response to its particular artistic order. He may reject the work of art if he wishes; but he does so on his own recognizance, because value judgements no longer have any relevance to generally accepted

systems of aesthetics or artistic evaluation. Traditional authority, whether of the state, the academy, or of the individual aesthetician, has only an empirical validity. Each new development requires a new aesthetic, or at least the revision of an earlier one, and the establishment of values is now the business of the artist. The critic, the teacher, the historian must follow where he leads. As a result the spectator can no longer expect, as he had since the Renaissance, to be entertained by images passively presented to his eye. Like ancient or medieval man, he has had to become actively engaged with the work of art, he has had to accommodate his most recalcitrant visual habits to new forms and new ways of seeing forms. He has had to recognize the ability of the artist to think new things about new problems, and both have often seen forms which at first appeared harsh or disagreeable but which continue to provide answers to the questions we ask about our imaginative life. As that life constantly changes, so the questions are always new, and we must be prepared for the novelty, for the originality of the answers. Difficulties arise when, as happens so often, we are faced with the answers before we have asked the questions.

For some time this subjective, intensely personal bias was the principal source of conflict between a public which still looked for recognizable images of persons, places, and things, and the artist who was providing images of hitherto unimagined events in the realms of shape, of colour, and of events occurring in newly invented spaces. This antagonism was most noticeable and most unfortunate for the artist who was condemned, as Guillaume Apollinaire said, to exist 'on the edge of life, on the outskirts of art', as art, about 1910, was usually understood. Even before 1900 he had been forced in certain instances into involuntary and tragic isolation, as we know from the biographical catastrophes of Van Gogh, Gauguin, and Munch. But the public also lost the very kind of art it most demanded. In the traditional forms of portraiture, mural painting for religious or governmental purposes, and genre painting the period we are about to study is all but barren. It is still too early to tell whether the increasing number of public commissions which have been awarded certain prominent artists in Europe and America since 1945 indicates that the conflict which condemned the artist to the hypocritically picturesque poverty of Bohemia and the public to the spiritual wasteland of Philistia will end in a new and different definition of the artist's position in modern society. The traditionally uneasy relationship of artist and patron has been irremediably weakened by the assertion and proof of the artist's independence of expression, and of the independent character of the work of art, as well as by the almost total failure of artistic quality wherever the state, as the sole agent of society, has dictated artistic form and content. Yet what seems to be emerging now, especially among younger members of the public, is an understanding of art as a fundamental, constitutive, and essential factor in society – as a good in and of itself – and of the artist as an acknowledged legislator of our spiritual, even of our political, condition.

In any age, and no less in our own, the true artist, like the true poet and priest, has always been aware of those conditions as they are revealed in the significant ideas of his time. To accuse him of insensitivity or ignorance of social concerns, as has so often happened when his formulations have seemed incomprehensibly private or have offended the received opinions of the day, is to disregard Kandinsky's dismay when he learned that the comfortable reality of everyday life had been shattered when Rutherford smashed the atom, or to ignore the Futurists' acceptance of the dynamics of modern urban existence, or Mondrian's and Malevich's desire to transmute individual suffering into lean geometrical symbols of universal public harmony.

The new world of forms which replaced that of the nineteenth century corresponds, just as did the medieval and Renaissance forms which supplanted those of the classical and medieval worlds, to a new conception of physical and philosophical reality, and to the artist's responsibility to discover forms properly expressive of these new ideas. The formative ideas of our age, whether political or economic, philosophical or psychological, are too complex to summarize, but it must be said that much twentieth-century art will remain without significance unless we are aware that the world it presents (not represents), like the new cosmology and the new psychology – the macrocosmic and microcosmic phases of contemporary being – is one of change, process, and becoming, one in which matter is not substance but energy, where reality is understood as a system of relations rather than of visual or tangible extensions, a world, as Kant suggested, whose fundamental truths may be closer to the character of human thought than to any systems of natural law lying for ever beyond the reach of our understanding or interference.

Thus to hint at the wider intellectual and imaginative implications of the new artistic objects is to suggest that any proper evaluation of their artistic structure must take account of their expressive content as well as of their perceptible forms. This aspect was from the first slighted in the new criticism created to account for the new structures. As long ago as 1876 Konrad Fiedler stated that 'the content of a work of visual art that can be grasped conceptually and expressed in verbal terms does not represent the artistic substance which owes its existence to the creative power of the artist'. And as recently as 1913 Clive Bell declared that 'the representative element in a work of art may or may not be harmful; always it is irrelevant'. These sharp distinctions between form and representation, between design and subject matter, were necessary in a period when works

of art could no longer be evaluated entirely in terms of the image represented, but in the course of the argument the distinctions became too categorical. Subject matter was considered so subordinate to texture, shape, line, and colour that with it content, understood as the ultimate meaning of the formal structure, was largely ignored or dismissed. Although even now, for instance, there has been little study of the content as distinct from the subject matter of Impressionism, the critical evaluation of more recent art is increasingly concerned with the implicit meanings which it contains. In this development the scope of strictly formalist criticism has undoubtedly been enlarged by Surrealism and by the doctrines of social realism. Our understanding of Munch and Van Gogh, for instance, would be incomplete without some recognition of the degree to which psychological and social realities affect the artist and his work. No longer may we, nor should we, take works of art at their face value, so to speak. In this present book we shall be concerned with the ways by which works of art reflect, in Kandinsky's phrase, the dark picture of the present time. But it would be misleading to think that important works of art merely give formal meaning to the important and obvious truths of an age. Too often such truths have been apparent only to the artist or the poet. Van Gogh was one of the few men of his time to be aware of the apocalyptic character of the later nineteenth century. The artist may be dealing with hidden rather than with dominant ideas, but he does not merely illustrate them. His works *are* those ideas, in the form of art.

The kind of art here referred to, and which is the subject of this book, is customarily described as modern. It can also, of course, be called contemporary because much of it has been produced within the lifetime of at least the older readers of this volume. Although the two adjectives have similar meanings and are on occasion interchangeable (the counterpart of

the Institute of Contemporary Arts in London is the Museum of Modern Art in New York), the first term is more often used to indicate a specific quality in a work of art which distinguishes it from other objects made at the same time, but less capable of evoking the particular character, the special feel, of our age. Present-day academic art, for instance, is always contemporary but never modern. It was this rather than the vapid conventions of the contemporary art he knew that Baudelaire had in mind when he wrote that the 'principal and essential problem' of criticism was 'to discover whether we possess a specific beauty, intrinsic to our new emotions'. The identification and analysis of that 'specific beauty', in the sense that it is equivalent to what we now describe as modern art, is the purpose of this text. To discuss all contemporary art would be a physical as well, probably, as an intellectual impossibility, but one can point to those objects which embody, or which have seemed to some contemporary spectator (a Huysmans finally discovering Cézanne, or a Fry trying to see Picasso plain) to embody something distinctly different from what he had known before or what he might find elsewhere at that time.

This tradition of the modern has now for a century been at odds with tradition in the conventional sense. To establish the authenticity of his objects, independent of life and nature, the modern artist has been obliged to reject all traditional authority whether of subject matter, of function, or of craftsmanship. But in rejecting traditions – more properly conventions – which were no longer useful for his purposes, he embraced a wealth of other and in their own terms quite traditional forms which enlarged the expressive potentials of modern art. These were the productions of the various archaic, non-European, and so-called primitive cultures which had previously been considered tentative, exotic, or inept by the standards of Graeco-Roman and Renaissance aesthetics. As Cézanne and Van Gogh were forerunners in basing their practice on the intensity of private sensation, so their friend and contemporary Paul Gauguin first saw the relevance of primitive and even untutored expression for modern experience. At first in Brittany and then in Polynesia, where he went with photographs of Egyptian and Cambodian sculpture then classed as primitive, he discovered unexpected forms which corresponded to his new feelings. Yet Polynesian art was perhaps less important for Gauguin than the revelation of African Negro sculpture was to be for Picasso and Matisse, and the subsequent recognition by many others of the powerful immediacy of formal expression in the work of many folk artists, of children, and even of the insane. But however important the primitive and naïve arts may have been as formal ingredients of much modern art, their significance for the artist was as much psychological as formal. The imitation of primitive forms profits an artist nothing unless it deepens and strengthens his work's expressive content.

Works of art have many meanings and some have more than others, but even if all their meanings may never be known to any one observer, his obligation is still to encounter each work from as many aspects of his own intellectual and emotional experience as he can. Because each work of art originates in the mind and feelings of a human being, it reaches its destination in the mind and feelings of another. A work of art, therefore, is a fact of consciousness quite as much as it is an object existing beside us in the physical world and an event in the chronology of the historical past. A history of art is therefore a history of consciousness, and a history of modern art is uniquely a history of self-consciousness within which we can at least try to reconcile the polarities of the actual and the abstract, of the rational order of Mondrian and the passionate intuitions of Picasso, of the traumatic biologies of Miró and the 'hand-painted dream postcards' of Dali.

LATER IMPRESSIONISM

The Impressionist aesthetic has never been easy to define, and the critical evaluation of the later work of the men who created the first demonstrably Impressionist art in the 1860s and 1870s has often been contradictory. Until quite recently Claude Monet's latest paintings looked too loose and patchy to be thought qualitatively equal, let alone superior, to his more detailed earlier work. Yet the last paintings of Cézanne were considered so much finer than the earlier that the term 'Post-Impressionist' was proposed by Roger Fry in 1910 to describe their denser structure and more complex colour.[1] The work of Gauguin, Van Gogh, and Seurat, as well as the later paintings of Cézanne, are now usually so described, but the word fails to define the kind of painting which Fry saw was no longer conventionally Impressionist. Nor is it useful as a chronological distinction. In the work of Degas and Pissarro through the 1880s, and in Renoir's well into the new century, there was a continuing process of change which must be accounted for, although each artist was committed, at least in theory, to working in the actual presence of his subject, whether outdoors or in. This change, which was perceptible in Impressionist practice soon after 1880, was mentioned by Renoir long after the event when he told his dealer, Ambroise Vollard: 'About 1885 a break occurred in my work. I had reached the end of Impressionism and had come to the conclusion that I knew neither how to paint nor to draw. In a word I was in a blind alley.'[2] The way out was to lead even that staunchest of Impressionists towards a new and symbolic content.

The manner which Renoir found for himself was the most conspicuous but not the only

indication that a movement which had once appeared so coherent no longer expressed the intentions of those responsible for its first public presentation in 1874. The presence or absence of the leading members of the original group in the last four Impressionist exhibitions is symptomatic of the differences which were driving them apart. The fifth, sixth, seventh, and eighth exhibitions were held in Paris in 1880, 1881, 1882, and 1886. Cézanne exhibited in none of them. Monet, the most powerful landscape painter, and Renoir, in technique the most Impressionist of the figure painters, exhibited only in 1882, the one year Degas abstained. By then Monet, and Renoir who had been accepted at the Salon, had found a wider public and more frequent sales. Of the original group only Degas and Pissarro continued to exhibit regularly. Two newcomers first appeared in the last two exhibitions: Odilon Redon, an older artist who was never strictly speaking an Impressionist, and Paul Gauguin, who would soon cease to be one. These men, who became the leaders of a new anti-Impressionist movement within a few years, had been invited by Degas, and their presence indicated his lack of sympathy with strict Impressionism quite as much as his curiosity about new developments. He himself, with the principal women painters, Berthe Morisot and the American Mary Cassatt, continued to refine the vision and technique they had brought to such perfection some years before. Until her death in 1895 Berthe Morisot departed little if at all from the manner she had formed for herself with Manet's encouragement, and so she belongs to the earlier history of the movement. Mary Cassatt, on the contrary, looked

more to Degas as her mentor and was to make an important contribution, through her coloured etchings, to the aesthetic of the nineties. Degas's own work, developing without perceptible changes of direction or startling discoveries, acquired in these years the expressive monumentality which is the most conspicuous stylistic aspect of what may be called Later Impressionism.

EDGAR DEGAS (1834-1917)

'No art', Degas confided to George Moore, 'was ever less spontaneous than mine. What I do is the result of reflection and study of the great masters; of inspiration, spontaneity, temperament – temperament is the word – I know nothing.'[3] In so few words Degas revealed not only much about his working method but also something of the psychological conditions which separated him from his contemporaries. In denying that his art was the product of enthusiasm he emphasized his dependence on contemporary subject matter, his care for exact visual appearances, and his reliance on conclusions reached by the mind from sensations provoked by phenomena. These are the presuppositions, so characteristic of the positivist temper of mid-nineteenth-century aesthetics, which underlie the Impressionism of Monet's and Renoir's Argenteuil scenes of the late sixties, and of Degas's early racecourse pictures. But Degas had always refused to believe that form was nothing in and of itself, nothing more than the continuous transformation of retinal experience. His lifelong study of the masters of the European tradition, especially of the North Italian painters of the Renaissance and early sixteenth century, convinced him that space is not so much an attribute of form as the arena in which form is most completely experienced. In studying three-dimensional forms, usually seen along a receding diagonal, and in adjusting them to the two-dimensional square or rectan-

gular surface, Degas set himself the traditionally difficult problems of western painting, but he solved them in new and unexpected ways which owed much to his interest in photography and the Japanese print.[4]

The results of his reflection and study, of his search for a more monumental expression than Impressionism afforded, one supported by older and even alien traditions, were seen in his principal contribution to the eighth and last Impressionist exhibition in 1886, a series of ten pastel paintings of the female nude. Pastel in itself was a sign of change. As his sight failed, as it became more difficult for him 'to see around the spot which was always in front of his eyes', he grew impatient with oil, and after 1875 used pastel even for his finished works. But his interest in it, if prompted at first by the relief it afforded his eyes, led him to experiment until little was left of the familiar technique. He steamed the pencils until they were soft, or soaked them in different fluids until they could be worked with the brush. He tried many combinations of media, overlaying the surface with gouache, water-colour, ink, and even oil, alternating with layers of pastel until the unaided eye can no longer detect the sequence in which the pigments have been applied or the substances of which they are composed.

The new paintings of 1886 had no individual titles, merely numbers within the *Suite de nuds* [*sic*] *de femmes se baignant, se lavant, se séchant, se peignant, ou se faisant peigner.*[5] The French phrases are so matter-of-fact as to discourage translation, but they define the primary visual fact that these are studies of the naked subject. The distinction between nakedness and nudity is clear and defensible in English but less apparent in French, where one word must do for both conditions, the one an actual physical situation, the other an ideal or absolute state. The distinction must not be pressed too far, but it has its usefulness for us who have grown unaccustomed to seeing the naturalistic nude

in art if we are to understand the critical reaction to Degas's pastels upon their first appearance. From his treatment of these forms arose the popular conception of Degas as a misogynist who so disliked women that in these paintings, which must be considered among his greatest works, he observed her as a 'human animal, a cat licking itself'. Degas's attitude, as we know from his letters and the testimony of his closest friends, was neither so simple nor so ungallant. If in art his attitude towards women was unusually uncommitted, his own words suggest that his detachment was as much artistic as psychological. 'The nude', he told George Moore, 'has always been represented in poses which presuppose an audience, but these

1. Edgar Degas: The Tub, 1886.
Farmington, Conn., Hill-Stead Museum

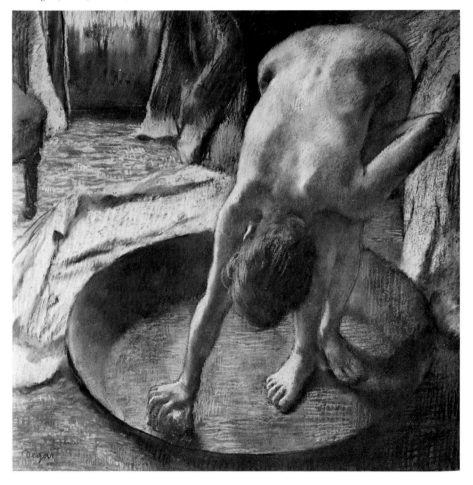

women of mine are honest, simple folk, un-concerned by any other interest than those involved in their physical condition. Here is another, she is washing her feet. It is as if you looked through a keyhole.'

This 'keyhole aesthetic' can be seen in a pastel of a woman stooping to sponge up water from a shallow tin tub [1]. The oblique point of view, not only inward and downward but somewhat from the left of centre, as if the spectator had momentarily turned to look at the scene and in another moment will have walked away, is typical of Degas's interest in observing his subjects from unexpected posi-tions. Somewhat earlier he had noted the possibility of painting portraits 'seen from below', after having made them 'seen from above'. And later he wrote to a friend: 'In vain I repeat to myself every morning, tell myself again that one must draw from the bottom upwards, begin with the feet, that the form is far better drawn upwards than downwards; mechanically I begin with the head.'[6]

Degas insisted that drawing 'was not the form, but the sensation one has of it'.[7] Thus he placed the source of pictorial form within the ex-perience of the object rather than in the object itself. But between the apprehension of form and its registration in a drawing there had always to be an interval. To a younger painter he remarked: 'It's all very well to copy what you see, but it's much better to draw what you see only in your mind. During such transforma-tion the imagination collaborates with the memory. You reproduce only what strikes you, which is what is necessary. Then, your memory and your imagination are freed from the tyranny imposed by nature. That is why pictures made this way, by a man with a culti-vated memory familiar with the masters as well as his craft, are almost always remarkable works.'[8] If the pastels of 1886 communicate a grandeur larger than the subject would seem to require, it is because in Degas's cultivated

mind the nudes have been imaginatively trans-formed by his memories of those greatest of all bathers of the Renaissance, Michelangelo's soldiers hastening from their bath to the battle of Cascina.[9]

The most trivial action served Degas's pur-pose. This is particularly true of his sculpture, where he pursued the springs of motion to their source, paradoxically by obliging the living model to remain motionless for long periods of time in poses requiring the most difficult muscular extension. His sculpture, which we know only from the seventy-three works cast after his death from wax and clay fragments found in his studio, was not the pastime of an idle hour subtracted from his true profession.[10] His first horses may have served in the con-struction of his early paintings, but by 1880 he had gained sufficient confidence to exhibit at the fifth Impressionist exhibition his first and only fair-sized sculpture, the radically realistic *Fourteen-year-old Dancer*, whose impertinent expression was matched by the artist's impu-dent combination of real cloth, real hair, real ribbons, and wax. This was the only piece of sculpture exhibited in his lifetime, but as his eyesight failed he turned more and more to modelling. In his cold, dark, and dirty studio he worked over his figures in clay or plasticine, repeating, as he had in his drawings, the same theme again and again. The *Dancer looking at the Sole of her Right Foot* [2] occurs in four versions, and is the pose a tired and unwilling model described in the most circumstantial account we have of Degas's working methods. There we learn that at the end of the morning's session his passion for truth kept the exhausted girl on the stand while he carefully measured her with a compass, often inflicting long scratches on her naked body.[11]

Degas's sculpture is Impressionist to the degree, but only to the degree that his paintings are. The same search for the momentary posture, for the realization of the suddenly seen is

2. Edgar Degas:
Dancer looking at the Sole of her Right Foot,
after 1896.
New York, Metropolitan Museum of Art

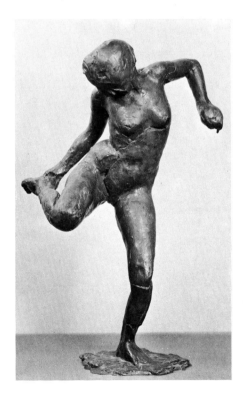

expressed with the utmost formal coherence, because, as he said, 'nothing in art should seem accidental, not even movement'.[12] Nor are they merely variations of pictorial problems. The *Dancer* exists so thoroughly in three dimensions that any one view is only partial and the whole can never be understood until the spectator moves around it. Renoir insisted that Degas was the greatest sculptor of the nineteenth century, and however extravagant this statement may sound in the face of Rodin's claim to the title, there can be no question that the modelled surfaces of Degas's bronzes are second only to Rodin's within the naturalist convention. Degas's sculpture in a sense is also more 'modern'. Disdaining the heroic and symbolic themes that obsessed Rodin, he pursued in unliterary and unidealized subjects, his horses, dancers, and nudes, a relentless investigation of the artistic process. When Vollard suggested having one of his figures cast in bronze he was indignant: 'Bronze is all right for those who work for eternity. My pleasure consists in beginning again and again.' Because his sculpture became known only after his death, it was without influence on his contemporaries or successors, but it has since become apparent that its formal power was an integral part of the sculptural tradition to which both Rodin and Maillol belong.

To twentieth-century eyes the beauty of Degas's forms in any media lies in just that revelation of permanence within transient actuality, of the artistic hieroglyph that is more significant than the comparable form in nature. We tend to read his creations as abstract patterns and constructions. Hence, he seems one of those prophetic masters of the late nineteenth century who, more than any save Cézanne and Seurat, anticipated abstract art. In this we do Degas some injustice. For him, as for Cézanne and Renoir, there could be no question of abandoning the model, of deserting that nature which he loved so much. But although he chose

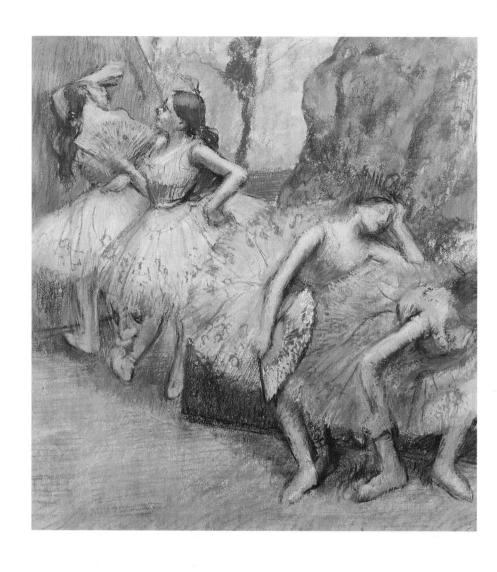

3. Edgar Degas: Dancers in the Wings, 1890–5. *The St Louis Art Museum*

his subjects with a naturalist bias, from 'nature just as it is', in interpreting them he retained something of the psychic distance that Ingres imposed between himself and actuality, so that by the close of his working life he had achieved a monumental synthesis more promising for the future than any naturalistic analysis had been. That synthesis dominated his last pastels, painted between 1890 and 1905, when he was almost blind. In these majestic recapitulations of his favourite nudes and dancers, the line is broader, more direct, more powerful, the interplay of arms and legs more intricate and more abstract [3]. As details became less and less visible he stressed the contours in order to contain the form. Often he found his lines by tracing an earlier drawing and then retracing the copy, a process which led to the elimination of all but the essential structure of the figure. Although the line is groping and peremptory, one may feel, as Paul Signac noted in 1898, that Degas sought 'consolation in colour'.[13] The fragile schemes of the earlier pastels were consumed in fires of emerald, purple, and orange, supported and contradicted by adjacent and complementary tones. His colours were, indeed, his last and greatest gift to modern art. Even as blindness descended, his palette passed to the Fauves.

AUGUSTE RENOIR (1841-1919)

Renoir, more than any of his contemporaries, persuades us that the Impressionist aesthetic was predominantly hedonist. His love of life and of people, and his devotion to woman as the most beautiful of all created beings, informed his art from first to last, and for the expression of these feelings he had, even by 1880, developed a pictorial technique exquisitely adjusted to the representation of sumptuous materials and delicate flesh. With Claude Monet he had worked towards the Impressionist dissolution of form through the vibration of light, but he had added his own taste for brilliantly prismatic colours and had suffused the surface of his canvases with the luminous tones he admired in his favourite eighteenth-century masters, Boucher and Fragonard.

The public image of Renoir is based primarily on his paintings of the 1870s. When his name is invoked they crowd our visual memory, those indescribably fresh and richly human figures in paintings as 'amiable, joyous, and lovely' as Renoir himself wished them to be. But we might say of Renoir what he had said of Degas, that, had he died earlier, in his case at forty, we should remember him as 'an excellent painter, no more'. It was after forty, after 1881, that Renoir became more than the most ingratiating of the Impressionists, that he became an artist in the line of descent of European figure painting, perhaps even the last of that line. He achieved this position by his interpretation of that traditional touchstone of monumental art, the nude. Like Degas but with a world of difference, formal, technical, and psychological, Renoir found there the source of his most profound artistic expression.

In 1880 he still had far to go before his earlier descriptive studies of the model would become the classic statements of his later years. He went, in fact, as far as Italy, where the revelation of the Renaissance coincided with his growing conviction that there was more to the art of painting than the record of casual impressions. He had certainly not ignored the masters in his youth. The Praxitelean prototype for the *Bather with a Griffon* of 1869 (São Paulo) is apparent at a glance. But by 1881 he was deliberately searching for some way to control the flux of sensation. In the autumn of that year he went to Italy, to Venice, where he was surprised to find Carpaccio's colours so fresh and gay. When he reached Rome he was prepared for the Raphael of the Stanze and the Farnesina. At Naples and Pompeii the frescoes introduced him to an earlier classicism. Some months later, in a letter

from L'Estaque, where he was visiting Cézanne, he mentioned how he thought he was succeeding, as an Impressionist, in accommodating the 'grandeur and simplicity of the old masters' to the practice of working in full sunlight.[14]

The results of his travels and meditations appeared in a large canvas of bathing nudes, his first work on such a scale since the thoroughly Impressionist *Canoers' Luncheon* of 1881 (Washington, The Phillips Collection). The large *Bathers* [4] occupied Renoir at intervals between 1884 and 1887, when it was exhibited at Georges Petit's gallery in Paris. It came as a surprise to a public which had only just begun to accept Renoir as a painter of modern life in its most gracious aspects. Of that there was little left; one saw only three female nudes beside a stream with two smaller figures in the

right background. The whole was so flat, dull, and brightly pale that it might almost have been a fresco on plaster, which, indeed, was partly Renoir's intention, since he wanted the matt effect he had seen in Italy, of 'fresco in oil' as he said. To this end he abandoned his prismatic palette for a close range of pale pinks and yellows overlaid with a violet cast. Only in the landscape to the far right and in the water were there traces of his earlier iridescence.

But more than the colour came as a surprise. Renoir had suddenly recovered the definition of form, so discredited in his earlier work, by a limiting edge or contour. The outlines of the figures describe clear and continuous volumes, each distinct from the other, especially where one shape overlaps another. The subject was enigmatic, for what were those who agreed that

4. Auguste Renoir:
Bathers (Les Grandes Baigneuses), 1884–7.
Philadelphia Museum of Art

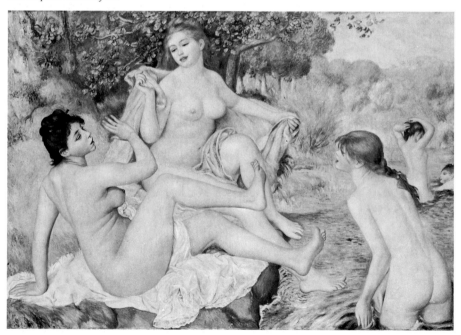

modern painting should deal with contemporary life to make of figures contrived to demonstrate artistic principles rather than an actual event? The composition had artistic rather than naturalistic precedents; Renoir had found his principal figures on a seventeenth-century lead bas-relief at Versailles by Girardon. He changed the dimensions and reduced the number of figures, but he adopted the action of the girl splashing water on her companions, and merely rearranged the seated nudes in the foreground. To be sure, he invented the third figure, after several false starts, and he brought all three into a tighter relationship. But the past hangs heavy over the whole design, and the contrived posture of the nude on the left is due to his failure to resolve his borrowings. There are reminiscences, too, of Italian art. The close-knit structure of the principal figures interlocked along the legs and connected each to each by wrist and ankle is unthinkable without Raphael's designs for the Farnesina. Only the girl in the far right distance with her hands to her hair seems entirely contemporary.

This uneasy compromise between the past and the present may partially explain the unfavourable reception this deliberate work encountered when it was first exhibited, and the lukewarm response it elicits today. Now that we know the heights to which Renoir was to rise in the years to come, we may admit that the synthesis was faulty. But the picture was not a failure. Although Renoir himself gradually diminished the linear emphasis in his later works so that by 1895 there was little trace left of this 'dry' or 'Ingriste' manner, the conception of such a painting and the discipline it demanded were to have consequences for the future. As the only monumental painting of the nude by an Impressionist master between Manet's *Olympia* of 1863 and Cézanne's several *Bathers* at the turn of the century, it not only called attention to the artistic and intellectual vacuum created by the Impressionists'

repudiation of traditional subjects and so helped prepare the Symbolists' appreciation of Moreau and Puvis de Chavannes but also suggested what the requirements of such themes would be in the future, a problem taken up in turn by Cézanne, Maillol, Matisse, and Picasso.

The *Bathers* was the central event in Renoir's rejection of pure Impressionism, but it had been anticipated by other, even if only partially, 'dry' works, and was followed by still more. Of the former the *Umbrellas* of 1884 (London, National Gallery) came early in the process; begun in 1881-2, the woman and child to the right are executed in the earlier prismatic manner, the other figures and the umbrellas, more tightly drawn and more sober in colour, were completed in 1885-6. A later and more compact painting of *The Daughters of Catulle Mendès at the Piano* of 1888 (U.S.A., Private Collection) is almost his last elaborately linear painting. The colour is perhaps a touch too warm, with the reds which became so prevalent in his late work already dominant, but the manner is appropriate to a subject which has so many edges in the violin, the bow, the piano. Soon after this his preference for variegated colour again came to the fore, and in his *Young Girls at the Piano* of 1892, purchased that year by the state (Paris, Louvre), he reestablished the balance between colour and contour which he maintained for the rest of his life. Only in the hastiest of his sketches, and when the inexorable arthritis stiffened his hands until the brush could only be controlled from the wrist and arm, need we look for a decline from the highest standards of execution. Even then it is an open question whether Renoir intended us to treasure the least of his works.

That there is an effect of drawing at all in his later works is the more remarkable when we consider his usual manner of working. There are a few preliminary drawings for his later paintings, but according to contemporary witnesses

he preferred to make a number of small oil sketches of the composition, or even of parts of it, until the principal arrangement was settled. Then, turning to the white canvas, he at once and without preliminary outlines began working in colour. At first formless, the colours gradually grew into the shapes of the final picture, the forms stabilizing themselves, as it were, out of coloured cloud.[15] Such a system could have been perilous, and indeed it was not invariably successful, but Renoir's ability to control the growth of his coloured forms was strengthened by his decade of self-discipline as a draughtsman.

If Renoir remains for us the painter of radiant pictures, he was not a particularly happy person. Even before his lengthy illness he had been remarked as of a nervous, introspective nature. The painter of the most serenely smiling works of modern art was rarely seen to smile. 'Who can fathom that most variable of men?' Pissarro asked, and in 1890 Téodor de Wyzewa described his earlier work as 'the most perfect expression of our somewhat morbid [maladif] sentiments'.[16] Maladif suggests the psychological tone of Berthe Morisot and her Daughter [5], so transfused with 'that restless and irresolute feminine melancholy' which de Wyzewa thought he saw in everything Renoir painted. The oddly cold yet intimate exchange of affection and reserve between mother and daughter has been made visible by the unexpected juxtaposition, at once awkward and intimate, of the frontal and profile positions. It has been said that Renoir never painted a sad picture, but certainly he rarely painted any so melancholy.

After the turn of the century Renoir found for the nude, which he considered one of the 'indispensable forms' of art, a full and classic expression in a long series of seated bathers. The example of 1916 [6] is one of the last and finest, even though there are elements which must be attributed to his crippled condition. The subsidiary figures in the right background as well

as the slightly brushed foliage show that summary execution which damaged his reputation when a flood of insignificant sketches came upon the market after his death. But such evidence of physical disability is obliterated by the light-shot flesh and the powerful conception of the principal figure. The whole is treated as a series of slowly curving and crossing volumes. There are unexpected distortions, notably the length of the left arm and the relation of the head and neck to the shoulders, but they are required by the design, by the adaptation of those many curves to the rectangular picture space. To the powerful generalization of this huge, Michelangelesque body (large in scale, but not in actual size), the head contributes its own share of passive physical acceptance of natural process. This is truly the type of figure that does not 'think', in Renoir's terms. In this way he accomplished his final synthesis of Impressionism and his own kind of classicism. The artificial action that disturbed the unity of the Bathers has been eliminated by the simple expedient of avoiding all suggestion of action, completed or to come.

Such nudes are classic as well as classical, not because of any iconographical reference to Antiquity but because Renoir was able to maintain for more than twenty years (c. 1896-1919) that equilibrium between natural appearance and an ideal conception which occurs in all truly classical art. He was also tempted by classical themes in the stricter sense of antique subjects. In 1895 he made many studies for a series of paintings of Oedipus, a theme one would have thought unsympathetic to his undramatic tastes.[17] More than a decade later, in 1908, he painted a Judgement of Paris, and six years later a second, more elaborate version. The first, or rather a drawing for or after it, was the primary source for one of his principal pieces of sculpture, a high relief of the same subject [7]. His first attempts at sculpture, a small relief portrait of his youngest son Claude (Coco) in profile, of

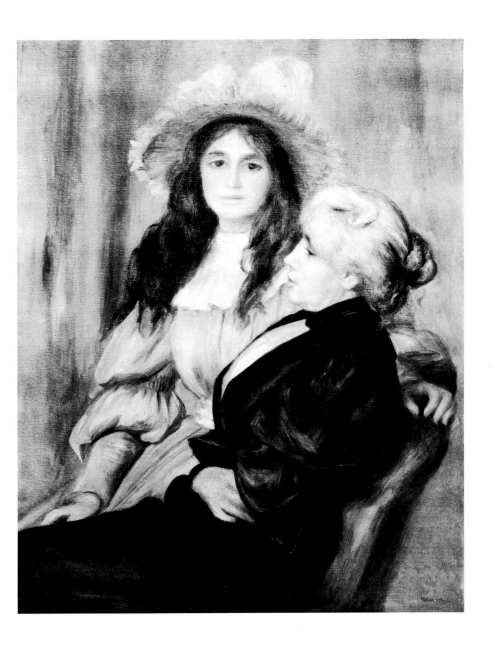

5. Auguste Renoir: Berthe Morisot (Mme Eugène Manet) and her Daughter Julie, 1894.
Paris, the family of Mme Ernest Rouart

6. Auguste Renoir: Seated Nude, 1916. *Art Institute of Chicago*

7 (*opposite*). Auguste Renoir: The Judgement of Paris, 1916. *Cleveland Museum of Art*

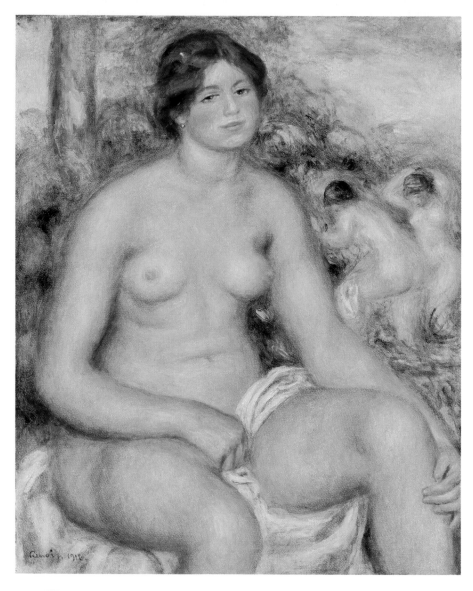

YALE UNIVERSITY PRESS - 19/4/94
HAMILTON & WATERHOUSE - H6

1907, and a small head of the boy of the next year, were modelled when his hands were already partially paralysed. The history of his subsequent sculpture, created after a paralytic stroke in 1910, is the victory of artistic will over devastating physical handicaps, but it also raises a difficult issue for criticism. Because the later sculpture was executed by others, can it be considered original work by Renoir, and if so, what value has it as sculpture?

It is well to remember that, although these objects were never actually touched by Renoir's hands, they have no relation to anyone else's work. Renoir had long wanted to make sculpture, and when urged by Vollard, he agreed to try. The collaboration between the painter and his ablest assistant, the young sculptor Richard Guino, who had studied with Maillol, resulted in several important pieces which, although executed by Guino, are entirely within Renoir's aesthetic.[18] The first full figure, the *Standing Venus* in the small version of 1913 or the larger *Venus Victrix* of 1914-16, and the relief of the *Judgement of Paris* after the painting of 1908 are the most typical and the most sculpturally convincing. Guino worked from drawings and under the painter's constant supervision. Although his hands were useless, Renoir indicated the necessary adjustments by pointing with a stick to the parts to be altered. The slow, easy rhythms and the heavy, fruit-like forms are the three-dimensional expression of Renoir's ideal

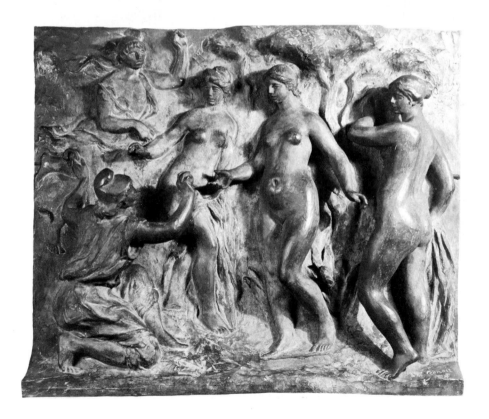

of human beauty. Nor should these pieces of sculpture be considered mere curiosities. The *Venus* and the allegorical figures of *Fire* and *Water* of 1916-17 (also known as the *Blacksmith* and *Washerwoman*) maintained the older European tradition of the figure as the most eloquent and dignified vehicle of artistic expression to a point well past the emergence of abstract art.

Although his physical miseries multiplied and the war brought anxiety and grief when his elder sons were wounded and Mme Renoir died, he ignored adversity and continued painting until his death late in 1919. Long before then he had been recognized as one of the great masters of French art. In 1892 an exhibition of 110 items at Durand-Ruel's had established his reputation, and in the autumn of 1904 a retrospective showing of thirty-five paintings at the second Salon d'Automne proved that his work had meaning for the younger painters, even if he could not reciprocate their enthusiasm. When he visited the Louvre on his last visit to Paris in the summer of 1919, to find his portrait of Mme Charpentier hanging at last among the old masters he so much admired, the frail artist in his wheelchair was received, as he said, 'like a pope'.

CLAUDE MONET (1840-1926)

Although Monet has long been considered the archetypal Impressionist, he was possibly the first to express publicly his dissatisfaction with the 'cult'. As early as 1880 he confessed that he rarely saw his colleagues in the group since it had become 'a banal school with its doors open to the first hack who comes along'.[19] His impatience might have been attributed to his growing success, for he was shrewd and had found that if he let the dealers compete for his work, they were more eager to promote exhibitions and sales. He was also the first Impressionist to gain a reputation abroad. Durand-Ruel's travelling exhibitions in the United States in 1886 and 1887 were not commercially profitable, but among the paintings sold Monet's were in the majority.[20] In Paris his position as one of France's principal artists was confirmed in 1889 by a joint Rodin-Monet exhibition at the galleries of Georges Petit. From then until the First World War his reputation was secure, although it declined with the rise of Fauvism and Cubism and was almost eclipsed when he died in 1926. The reasons for these shifts in critical opinion, and for the present restoration of Monet to a commanding position among the masters of modern art, may be sought in the character of his later work and its relation to contemporary abstract painting.[21]

It must first be said that the changes in his critical fortunes were not caused by any loss of invention or slackening of discipline. Monet, one of the most conscientious artists, was continually, even increasingly, dissatisfied with his own achievements. Because his sensibility, as he said, 'had become more acute with age', and the coloured visions which we see in his canvases were but dim reflections of what he saw in his mind's eye, he was often discouraged by the failure of his marvellously deft hand to realize his vision of the natural world. That shop-worn phrase, 'the mind's eye', may in fact conceal the secret of Monet's intentions and discontent.

His success in the 1890s was largely based upon his series of ten to twenty or more paintings of the same subject seen at different times of the day and year, under differing atmospheric and climatic conditions.[22] The duplication of views of the same landscape motif was not new or unusual with Monet, and may be traced to the popularity of Hokusai's series of woodcuts, the *Thirty-six Views of Mount Fuji*. But his earlier, random views of villages along the Seine had not been conceived or exhibited as a group under a single title. The first works to be seen as a series were the fifteen paintings of *Haystacks* in 1891, and the six views of a row of poplar trees beside the River Epte in 1892. As a

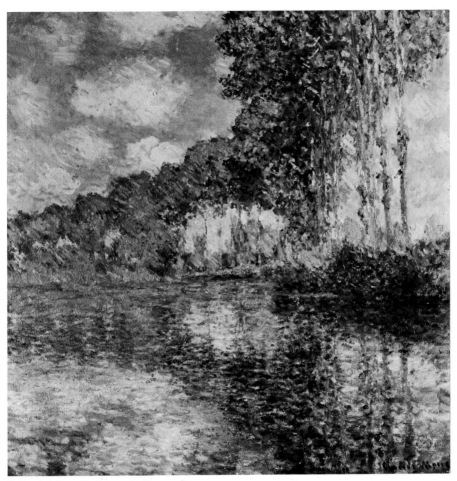

8. Claude Monet: Poplars on the Epte, c. 1891.
Edinburgh, National Gallery of Scotland

whole they exhibit the tendencies of Monet's art at this time and prepare the direction which it was to take for the rest of his life. The most conspicuous element was the treatment of the surface as a two-dimensional pattern. The earlier snapshot view of town or country with a strongly accented perspective, often developed along an acute, Japanese diagonal, was replaced by superimposed bands of meadow, water, shore, distant hills, and sky punctuated by conical haystacks or swept by the linear arabesques of trees. In the Edinburgh example [8] the square canvas, in itself a new shape, is decoratively divided by the shoreline and by the symmetrical unfolding of the trees and their reflections in a sweeping double curve. The loss

of depth is balanced by the lateral expansion of the canvas at either side, a tendency which became increasingly panoramic.

In colour there is a similar change from the bright local hues in strong contrasts which had prevailed until the 1870s to more delicate harmonies of pink and gold, light blue and lavender, shot with their complementaries. It is colour released from its source in the object, colour dissolved in the atmosphere, sustained by the light that transfers it to the eye and canvas. Eventually, in the *Cathedrals of Rouen* of 1895 and in the London and Venice views of 1904 and 1912, Monet, quite as much as Whistler, painted the impalpable atmosphere rather than the substantial objects within it.

This synthesis of elements carefully selected and controlled was no less dependent upon prolonged scrutiny of natural facts. Although as he grew older Monet finished many paintings in the studio, each canvas still celebrated an actual event, in the sense that Monet had been there, then. Did he not buy that row of poplars lest they be cut down by a timber merchant before he could finish painting them? Nor for all the power and freedom of execution was less effort involved. Because he was more than ever absorbed in the analysis of specific light effects, he could work on each canvas for only a brief spell, perhaps thirty minutes at most under favourable conditions. He grew desperate when the light changed and he had failed to capture the effect he saw.[23]

The climax of his new manner was revealed in the twenty views of the west façade of Rouen Cathedral exhibited at Durand-Ruel's in 1895 [9, 10]. They had been eagerly awaited ever since it became known that he had been working on the series for three years and had twice postponed the exhibition. The critical reaction on the whole was gratifying. Most of the pictures were sold, and the exhibition was admired by such keen observers as Pissarro, Degas, and Cézanne. But for all that, the *Cathedrals* became

the principal target for those who believed that the collapse of Impressionism was the result of Monet's lapse into 'formlessness'.[24] The series does indeed raise certain problems that have not yet been satisfactorily resolved. The subject in itself was odd, given Monet's lack of faith, but he may not have been entirely insensitive to the enthusiasm for medieval architecture and archaeology that accompanied the religious revival of the 1890s. Nevertheless, such a non-romantic, anti-picturesque treatment of a monument so charged with literary and historical associations was puzzling. There was also a conflict between the accurate, almost photographic constant in Monet's repeated views, and the extravagantly subjective analysis of atmospheric effects. Never before had an object so saturated with public values been so exhaustively presented in private ones. Nor had the Impressionist technique yet been brought to such refinement. In his prolonged painting sessions, seated in a cramped room in a shop opposite the façade, Monet precipitated his vision in innumerable and infinitesimal strokes, building a pictorial surface so rich and dense that it suggested an actual material texture, as of a masonry or plaster wall.

Most contemporary critics failed to see that the proper content of the *Cathedrals* was the subjective experience of nature through a succession of separate 'instantaneities', a word Monet had already used to describe the effect he desired. But we circumscribe his intentions unduly if we place this 'instantaneousness' solely in retinal experience. Monet has too long been dismissed as 'only an eye'; he must be thought of as having a mind in the special sense in which mind has come to be understood in the twentieth century. We are so constructed that there can be no seeing without feeling, and as

9. Claude Monet: Rouen Cathedral, 1894. *Paris, Musée d'Orsay*

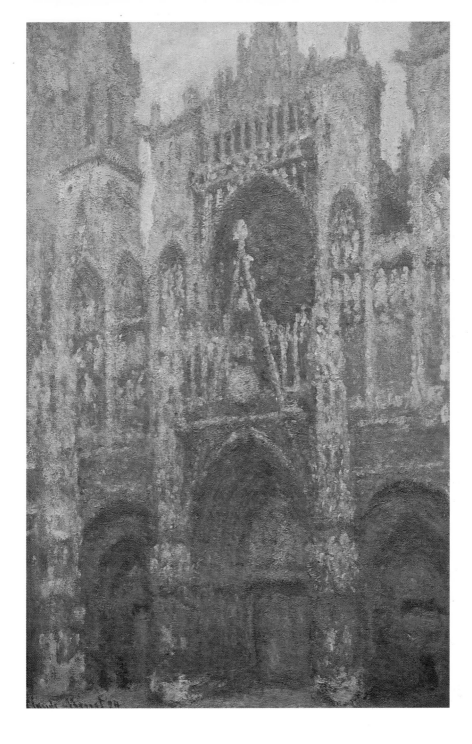

we now understand the physio-psychological structure of perception, there can be no feeling without thought. This thought may lie near or even below, perhaps deep below, the threshold of rational consciousness, but it remains none the less a thought, which is to say the total physio-psychological reaction of the organism to the event. Therefore the *Cathedrals* must be considered the revelation of a physiologically complicated and psychologically continuous experience which can only be known by the spectator when he sees (or imaginatively re-views) the series as a whole. To isolate one painting from the group is to disturb if not to destroy the complex, for the form (which is multiple in space) and the content (which is durational in time) cannot be known apart from the group as a whole. Each painting, in any series, is only one item in a continuous psycho-logical adventure. When the shapes, the archi-tectural structure, of the cathedral of Rouen, or of the Houses of Parliament, were dissolved in the coloured atmosphere there emerged a new concept of form as process in time. Because Monet's intention was not to fix what remains but to seize what passes, he discovered his con-tinuities within change rather than in per-manence, in becoming rather than in being. His pictures, far from representing a retreat into a too personal and therefore incommunicable attitude of art for art's sake, were, save for Cézanne's landscapes and still lifes painted at the same time, the most adventurous excursions until then into a new kind of space where the flux of coloured particles suggested simul-taneously the atomic hypothesis of nature and the indivisible continuity of consciousness.[25]

These ideas were more fully realized in the works that occupied Monet's attention for the last quarter of a century of his long life, his 'water landscapes' of the lily pools in his beloved garden at Giverny. In the series shown in 1900 and 1909 the canvases were of the usual dimen-sions, but the view was downward and closer to

the surface of the water, until the horizon and the surrounding edges of the pools disappeared. The effect may be partially explained by his failing eyesight. Cataracts progressively affected his vision until, it is said, he could identify his colours only from the labels on the tubes. How-ever that may be, Monet refused to succumb to physical handicaps. The broad style of his later work, like Renoir's, triumphs over rather than compensates for disabilities.

Gradually the canvases grew in size, laterally, until they surrounded the artist in his studio. At this juncture Georges Clemenceau urged Monet to complete a huge frieze of water-lilies for two oval rooms to be constructed by the state on the ground floor of the Orangerie in Paris. Standing today in the midst of these rooms the observer feels that he has entered upon some new existence, surrounded by moving waters in which are hints of undulating and mysterious plants, while the sky is known only as an indistinct shimmer from lighted clouds above. Historically, this is the last and possibly the finest pictorial example of the decorative style that developed in the 1890s as Art Nouveau. Philosophically, it is the climax and conclusion of Monet's search for a spatial and temporal continuity which would give 'the illusion of an endless whole'.

The full-sized studies for these murals lay rolled and forgotten at Giverny until they were brought to light in 1950. The apparent dissocia-tion of colour and brush stroke from the object, in loose skeins of paint revealing so precisely the action of hand and brush as the blind artist struggled to fix his half-seen, half-remembered visions, resembled the techniques of contempo-rary Abstract Expressionist or Action Painting

10. Claude Monet: Rouen Cathedral, Morning Sun, 1893. *Paris, Musée d'Orsay*

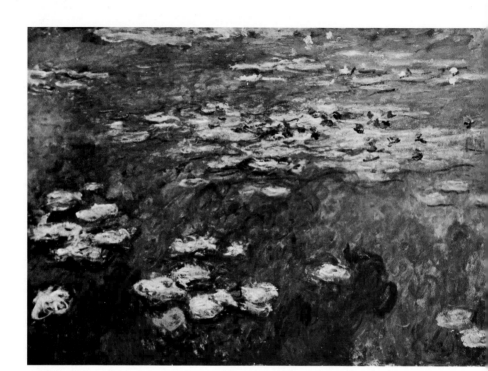

11. Claude Monet: Water Lilies, c. 1920.
Pittsburgh, Museum of Art, Carnegie Institute

[11]. But however close Monet's method may seem to current practice, he was not knowingly creating an abstract design. His aim, as the last surviving member of the original Impressionist group, was still the presentation of his immediate experience of nature, even if the results of his observations had become more reflective than descriptive. In an important if not entirely verbatim interview with Monet when the second series of *Water Lilies* was exhibited in 1909, Roger Marx, who knew the artist well, formulated the more complex character of the later paintings.[26] 'My only virtue', he had Monet say, 'resides in my submission to instinct. Because I have rediscovered the powers of intuition and allowed them to predominate, I have been able to identify myself with the created world and absorb myself in it.' For Monet the water-lily garden held his idea of infinity; it was a microcosm where one beheld the 'instability of the universe transforming itself under our eyes'.

Such thoughts led Monet to speak of music and of Claude Debussy, with whose works his own shared, he thought, certain points of contact in the 'harmonies and concords of colours which are sufficient in themselves and which succeed in touching us, as a musical

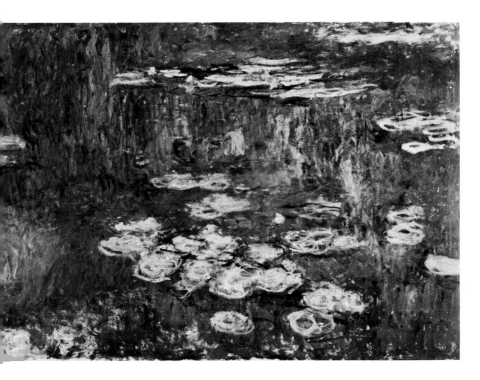

phrase or chord touches us, in the depths of our being, without the aid of a more precise or clearly enunciated idea'. The indeterminate and the vague were proper means of expression; through them 'sensation is prolonged [because] they formulate the symbol of continuity'. Even Debussy's statement of 1893 that he wanted music freed from 'a more or less exact reproduction of nature', so that it could express 'the mysterious correspondences between Nature and the Imagination', may owe as much to Monet as it does to Baudelaire.[27]

This revelation of the continuity of consciousness, in Debussy's unfolding harmony and in Monet's serial painting, is the truly Symbolist rather than literally Impressionist aspect of their work, and perhaps their most important contribution to music and art. When the argument over form or formlessness has abated, we shall see that their studies of interior states of being and their discovery of the means whereby they may be expressed have been determining, if long unrecognized, factors in the development of modern art.

PAUL CÉZANNE (1839–1906)

Although during his lifetime Cézanne was the least conspicuous and the most misunderstood of the major Impressionists, around his art there has risen in the seventy-five years since his death a body of criticism often as puzzling as the chronology of his life and works. Of none of his contemporaries do we have so few answers to the first questions we should ask: where, when, and under what circumstances were the works created? To put them in order and to see in them what their author intended is a task

made doubly difficult by the apparent unevent-fulness of his life, by his infrequent and cryptic statements, and by the reports of conversations coloured by his interlocutors' prejudices. Of the thirteen hundred paintings executed be-tween 1880 and 1906, when Cézanne was most distinctively himself, there are few signed and none dated, and many, upon which we must depend for our understanding of his work, were in his own eyes partial or total failures.[28]

The obscurity of Cézanne's biography is the result both of his temperament and of historical conditions. Deeply hurt by the unfavourable criticism of his work at the first and third Impressionist exhibitions in 1874 and 1877, he withdrew to his family home at Aix-en-Provence, where, but for extended visits to Paris and painting excursions in the Île-de-France, he remained. We can see now that his art required the solitude and long hours empty of all but artistic reflection which a small town provided, but against that great gain must be set a small loss. Had the public, the critics, and even some of his friends known him better, had he been able to exchange opinions with others, his discovery of himself might have been less delayed and less painful. The general appreciation of Cézanne had to wait until the retrospective exhibitions of 1895 and 1898 at Ambroise Vollard's gallery, when his reputation became the responsibility of a succession of younger generations who plundered his art for what they wanted to see. At first it was the 'decorative' aspect that was admired by the Symbolists and Nabis; after the memorial exhibition at the Salon d'Automne in 1907 the Cubists laid claim to the structural effects. Later Cézanne was hailed as a pioneer of abstract art because of the apparent subordination of subject matter to design in his later work. Each view is tenable but partial, and none entirely accords with what may have been his purpose. By 1920 his relation to Impressionism could be ignored, and the image of Cézanne as the master who destroyed its formlessness and laid the foundations for the new, abstract, and constructivist art of the twentieth century was complete.[29]

Such was not actually Cézanne's achievement, and to read his works thus is to sacrifice their meaning for a subsequent and different ideal. Just as until lately it has been difficult to accept Monet as a great painter of the twentieth century, so we must reconsider Cézanne as one of the nineteenth. He was born in 1839, slightly earlier than Monet and Renoir, and if he was unusually slow in finding his direction, at least by 1880 he had exhausted the uses of objective Impressionism. Like Renoir, he had come to feel that a faithful account of what is momentarily seen was of less importance than the examina-tion of his 'sensations', of his own visual experience, and of the relation of that experience to the object in nature. His task became the transformation of that relation into a pictorial harmony which should not only be true to the fact in nature and to his experience of it but should also be presented in a pictorial statement as complete as any to be found in the works of the old masters. Such terms as these, even if verbally too abstract as a description of his paintings and analytically too simple as a reduc-tion of his intentions, are justified by his own elliptical remarks. 'I think of art', he is reported to have said, 'as personal apperception. I place this perception in sensation, and I require that the intelligence organize it into a work of art.'[30]

Cézanne's first critics thought him un-schooled or maladroit, but his earliest drawings are proof that later distortions were due to artistic necessity. That necessity can only partly be explained by the demands of pictorial design. If we assume that they are the result of a continual adjustment among the truths of what is known, what is seen, and what is felt, we shall be in a better position to estimate the originality of an art as remote from the less

sensuous constructions of Cubism as it is from the naturalistic immediacy of earlier Impressionism. And if we remember that the motif as registered by his extraordinarily acute vision was always measured in his mind's eye against his lofty ideal of art embodied in the masters of the European Baroque, in Poussin, Rubens, and Puget, we can appreciate the difficulty and solemnity of his task.

The virtues of his mature style are found in the *Gulf of Marseilles seen from L'Estaque* [12], a village on the Mediterranean coast near Marseilles. The apparently straightforward division of the canvas into horizontal zones of foreground, sea, mountains, and sky is the basic scheme upon which Cézanne developed his concordances between the sharp geometry of the houses and the softer masses of the hills, between the middle plane of the sea and the distant sky, both painted in his particular blue, with the higher bluish hills between. The 'organizing intelligence' is manifest in the counterplay of verticals and horizontals in the foreground, whereby buildings and landscape are so tightly locked that any given plane of house, tree, or ground may simultaneously cling to the flat, two-dimensional pattern and yet tilt sideways into three-dimensional space. This ability to maintain a tension between the actual and the illusionary dimensions was early remarked as characteristic of his work. In the technical sense it is produced by his conviction

12. Paul Cézanne:
The Gulf of Marseilles seen from L'Estaque, 1883-5.
New York, Metropolitan Museum of Art

that no distinction can be made between drawing, line, plane, and colour. As he wrote to Émile Bernard just two years before his death, and for once with unaccustomed clarity: 'Drawing and colour are not distinct. As one paints, one draws. The more harmonious the colour, the more accurate the drawing. When colour is richest, form is most complete. The secret of drawing and modelling lies in contrasts and relations of tones.'[31] In practice Cézanne sought this fusion of the pictorial elements by small touches of paint which, if correct in hue and value, would create both the distance and the angle of each plane. The difficulty of achieving such accuracy multiplied rather than diminished with experience. Because he could distinguish the closest gradations of colour in an apple or a landscape the task of finding the exact hue on his palette to project the 'sensation' of a shape seen at a given distance required endless observation. The length of time Cézanne spent on each painting was noticed by his contemporaries. Unlike the earlier Impressionists, whose works, at least in theory, were begun and ended on the spot, he returned to the motif to work on the same canvas again and again. If interrupted he might work on another of quite a different subject before returning to the first. While he pondered his still lifes in the studio, the fruits shrivelled and the flowers died, until he was driven to use artificial ones. Such continuous yet intermittent observation and analysis of sensations account, quite as much as his theoretical statements, for the character of his painting.

Cézanne's later works have often been described as 'timeless' in the sense, one assumes, of 'monumental, of enduring beyond considerations of momentary value', as the dictionary puts it. Monumental in the qualitative sense they are. Never before or since have the humblest objects of ordinary use, bottles, kitchen knives, and fruit, appeared with such unassailable dignity. But 'timeless' is an inappropriate adjective for any art even remotely related to Impressionism. In contrast with the snapshot vision of the early Impressionists, Cézanne's canvases are cumulative records of successive instantaneities. Each picture is not an account of the motif as an element enduring ideally outside ourselves and so beyond temporal experience: it is built up by deposits of successive and discrete observations which can still be seen in the multiplied contours of objects, in the substitution of a constant, suffused, and embracing light for the atmospheric glimmers of Impressionism, and in the shifting perspectives in the landscapes and still lifes. These orthogonal discrepancies, which were first thought the result of defective vision or lack of technical address, and later were considered proof that this overwhelming feeling for form obliged him to distort the 'natural' appearance of details for the sake of the total design, are rather evidence of the time Cézanne spent in the act of painting, and of the several slightly differing positions from which each object was studied. If this hypothesis holds, and there seems to be sufficient documentary and visual proof to support it, the spatial relations in Cézanne's later works are inevitably, at first glance, far from clear. Such a glance will never enable us to comprehend the intricate interrelationships of forms seen from shifting points in space at various times. In this introduction of change and process, through multiple sightings deposited upon its surface, the picture became a record of the continuous present, of the experience of space in the mode of time, and, in turn, an experience that requires time to unravel.[32]

If, with these ideas in mind, we turn to one of the finest of his later paintings, the *Still Life with a Plaster Cupid* [13], we shall be less disturbed by the two-dimensional dislocations of the perspective and more aware of the changing, implicitly three-dimensional relations of objects to each other and to the spaces in which

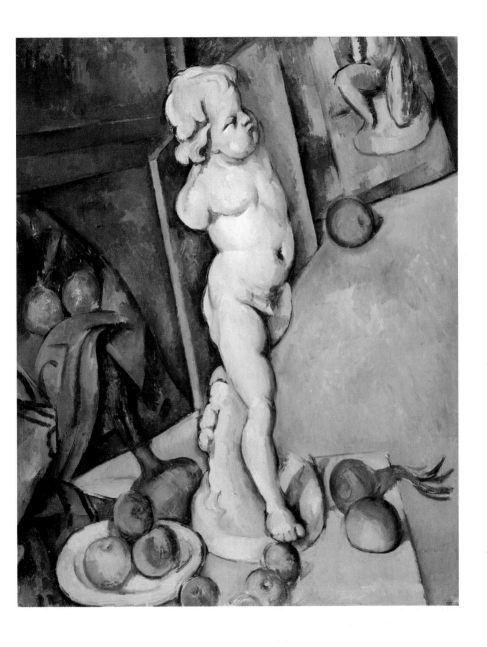

13. Paul Cézanne: Still Life with a Plaster Cupid, *c*. 1895. *University of London, Courtauld Institute Galleries*

they are seen. The plaster figure serves as a vertical axis from which the principal areas of the surface diverge along the lower left to upper right diagonal, while as it twists, counterclockwise, upon itself it generates multiple spatial experiences. Cézanne achieved this by constantly shifting the position of the figure from a directly frontal view to one seen slightly from above. By this means the major portions of the body and the base exist in differing relations to the upper and lower parts of the painting. The legs and base are the culminating function of the still life on the table. The eye then passes upward and into the space of the room, through the torso to the canvas behind it, the latter relationship suggesting that the figure is represented in the canvas rather than being on the table. Cézanne has here revealed a profound visual truth: objects in space may be known separately, but when seen together they participate in each other's existence. Even the floor shares in these excursions. From the bottom to the top of the picture it does not stretch in a continuous inclined plane but is drawn around the table, then pulled towards the canvas on the floor behind the figure before it reaches the wall. At that point it presses so firmly back into space that Cézanne fixed it with a large green apple, undiminished by distance, to bring our eyes abruptly forward to the surface, whence this whole adventure started.

This brilliantly sustained sequence of relations between surface and depth, between a small fragment of feeling like the three apples on the plate and the wider order within which it exists – the space of the picture, of the room, of the painter's world – is the principal subject of Cézanne's work from about 1886 until late in the nineties. These were years of comparative quiet following his marriage, his father's death, and his inheritance of considerable property. The paintings of these years have a fullness and serenity, an ease of design and execution that could scarcely have been postulated on the

evidence of his earliest tormented and romantic work, or the competent but unexciting Impressionist exercises of the seventies. They include the most familiar of all his paintings, the spacious views of Mont-Ste-Victoire (Courtauld Collection, London; Metropolitan Museum of Art, New York); the heaped still lifes in Paris and Washington; the solemn, seated figures of the *Woman in Blue* (Paris), of the *Man Smoking* (Mannheim and Moscow), and the *Card Players* (Paris; Moscow; Metropolitan Museum of Art, New York). This development culminated in the several large paintings of nude female figures. The canvases in London, Philadelphia, and the Barnes Foundation, Merion are the climax of decades of investigating the problems of composing nude figures in a landscape setting. In these paintings, from the first ones devised in emulation but also in despite of Manet's *Déjeuner sur l'herbe*, Cézanne assumed the anti-Impressionist task, as had Renoir, of creating in the manner of the old masters a large composition of nude figures without using allegorical or mythological themes. The iconographical difficulties are worth remarking. Although the painting of modern life precluded traditional subjects, scenes of contemporary figures bathing would have been implausible for the female nude and too commonplace for the male.

Cézanne's knowledge of the nude was tentative and in a sense vicarious. He had drawn it in life class at school and in his first years in Paris, but in the provincial and puritanical environment of Aix he was reluctant to employ models. Consequently, the nudes in his later works are based on earlier studies, photographs, memories, and even sketches of soldiers bathing in the river near by.[33] The impossibility of transporting large canvases to the site was an additional handicap. The last and possibly the finest of the *Bathers* [14] combines studies of nature in the central landscape with arbitrary figures whose distortions seem dictated less by

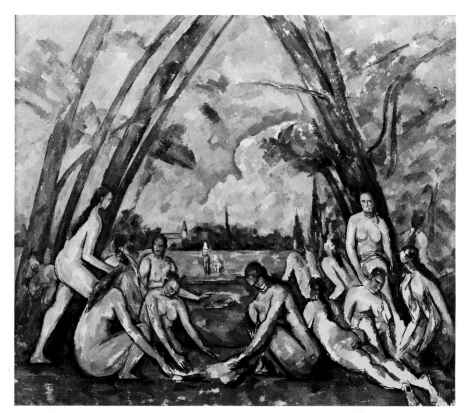

14. Paul Cézanne: The Bathers, 1898–1905.
Philadelphia Museum of Art

his insistence on the painter's 'true path – the concrete study of nature', than on the embracing architecture of the design. The two groups to the left and right look much simpler than they are because the majestic arch of trees towards which they are attracted holds them firmly in place, and in space. Memory and its transformations can be seen in the standing bather at the far left. Her pose, with one foot raised to show the muscles of thigh and calf, is a convention, but as she becomes identified with the thrust of the tree-trunk behind she is both less and more than a studio incident. Whatever she loses in naturalness, the design gains. Another curious aspect of this painting is the seated figure to the right of her whose head is missing. Here again the demands of composition take precedence over anatomical logic. Where, we might ask, could her head be put? Towards the far right, where the canvas is noticeably unfinished, the planes of colour are less securely anchored within their contours and sometimes seem to shift and move in space. We can believe that we are looking into one of those situations where Cézanne found the control of his planes agonizingly difficult, and also at the

kind of pictorial structure that stirred the imaginations of the Cubists when works like these were seen in quantity in 1907. An even more influential source for Cubism may have been the exhibition of Cézanne's water-colours at Bernheim-Jeune's the same year. In the later ones particularly, where the areas of white paper correspond to the bare canvas in his unfinished paintings, the construction is more spare, and we see how Cézanne's eye found the fundamental rhythms and spatial relations before his hand defined them as tree-trunk and foliage.

In the final decade of his life Cézanne's art underwent a remarkable change. The cool and weighty formal arrangements began to disintegrate as colour became more intense, the surface more agitated, and for the first time since the 1860s the character of the subject itself counted for something. As the artist aged his sympathies were attracted by elderly people, as isolated and unsuccessful as himself. The several portraits of his gardener Vallier, and above all the *Woman with a Rosary* (London, National Gallery), are poignant images of old age. Although in the latter painting the prevailing colour scheme of dark grey, brown, and blue is sombre, the interior modelling is enlivened with such vivid hues that one understands how the Fauves no less than the Cubists looked to Cézanne as a progenitor. The influence of this painting can be traced through the sequence of exhibitions where it first appeared; it was seen in the memorial exhibition at the Salon d'Automne in 1907, in the first Post-Impressionist exhibition at the Grafton Galleries in London in 1910-11, and in the Armory Show in New York in 1913.

To the end of his life Cézanne maintained his unfaltering devotion to his art; under the most adverse climatic conditions he went to the motif, impelled by a consuming sense of his own inadequacy, of his failure to achieve that ultimate revelation of 'art as a harmony parallel to nature'.[34] His exacerbated nerves, his peremptory manners, his mounting suspicion of almost everyone who came near him, were remarked on by younger artists whose accounts have formed our image of Cézanne as a disagreeable old man. But there is enough evidence to the contrary to indicate that he was grateful for the admiration of a new generation. His irritation and sense of failure may have been aggravated by the diabetes from which he is said to have suffered. Despite such handicaps his last paintings are unexpectedly brilliant and inventive. Because he pushed forward all areas of a canvas simultaneously, each picture presents the state of his sensations and the degree of their realization at the moment he stopped working. The late landscapes are like visible charts of his jangled nerves. Intense objectivity of vision, so passionately desired and so long sought, has been transformed into acutely subjective expression. As with Monet, in the end the dialectic of Impressionism was reversed. The revelation of the outer world became the disclosure of the most intimate, private sensibility. Yet Cézanne's words were distorted and his works misread to prove an argument at odds with his beliefs. The jagged edges and sudden collisions of coloured planes in the last landscapes are not demonstrations, as the Cubists thought, of his famous exhortation to 'treat nature in terms of its geometrical shapes, of the sphere, the cylinder, and the cone'.[35] On the contrary, a landscape like the *Mont-Ste-Victoire* [15] corresponds to Maurice Denis's definition of a Symbolist painting, deduced from his conversations with Cézanne: 'Every work of art is a transposition, an impassioned equivalent . . . of the perceived sensation, or more usually of a psychological fact.'[36]

The last period of Cézanne's activity is sometimes described as 'baroque', but the word does not fit, if by it we mean anything other than that his ultimate manner is unexpectedly rich in colour and dramatic expression. It is baroque

as a late phase but not otherwise, for there is little specifically seventeenth-century in its formal order, light, or space. Even his familiar remark that he wanted 'to do Poussin over again after nature' is not apt, because the perceptual basis of Cézanne's painting is contrary to the conceptual principles of Poussin's.[37] Nor does it help if we describe the whole of his work after 1885 as a 'classical' reformulation of the formlessness of Impressionism. This only burdens classicism with one meaning more, and casts an unfavourable light upon Impressionism. It would be closer to the truth to say that the late works of Cézanne, like those of

Renoir, Monet, and Degas, and despite his protestations that he was only the precursor of the new art and had not yet 'realized' his sensations, are the final triumphs of Impressionism from the hands of a master who grew beyond its earlier empirical observations to conceptions intense, exalted, and profound.[38]

GEORGES SEURAT (1859-91) AND NEO-IMPRESSIONISM

'Colour, which is controlled by fixed laws, can be taught like music.' Charles Blanc's statement, first published in 1867 in his popular

15. Paul Cézanne: Mont-Ste-Victoire, 1904.
Philadelphia Museum of Art

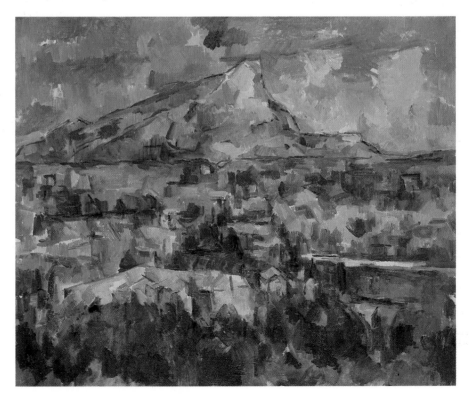

Grammaire des arts du dessin, epitomizes the Neo-Impressionist attitude towards the expressive possibilities of art and indicates its programme. Since the natural world was considered a system of determinable elements, it was thought that form could be reduced to a series of interchangeable parts, or relations, which could be manipulated to produce a predetermined result. Just as there are mathematical and physical relations among musical tones, so there are physical relations among colours which can be demonstrated in the laboratory and repeated in the studio. But what cannot be reduced to a system, so far as we know, are the psychological potentials of physical materials and their relations as perceived by the beholder. In his desire to control

the physical properties of colour and space, Georges Seurat was a man of his time, just as in his choice of subject he explored the Impressionist themes of landscape and café life already treated by Monet and Degas. But through his 'truly pictorial and artistic search for the symbol (without worrying about the word), in the interpretation of the subject and not in the subject itself',[39] he so extended the expressive content of his Impressionist motifs that the term 'Neo-Impressionist', coined by his contemporaries, seems both necessary and appropriate. His *Sunday Afternoon on the Island of the Grande Jatte* [16] projects a new set of symbolic images even as it accepts, absorbs, and discredits the Impressionist position. One wonders how many in 1886, when the painting

16. Georges Seurat: A Sunday Afternoon
on the Island of the Grande Jatte, 1884-6.
Art Institute of Chicago

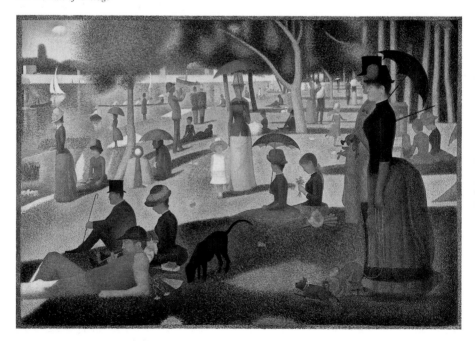

was seen twice, in May at the last Impressionist exhibition and in August at the second Salon of the Indépendants, were aware of this paradoxical situation. Even a critic so sympathetic to modern art as Octave Mirbeau, the friend of Monet and Rodin, only grudgingly acknowledged the talent in 'this immense and detestable painting', which seemed to him 'an Egyptian fantasy, a mixture of eccentricity and honest errors'.[40]

Its 'Egyptian' look, which was noticed by other reviewers, is perhaps the 'quality which more than any other set it apart from earlier Impressionism. The clue to this is found in Seurat's remark to Gustave Kahn that he wanted 'to show the moderns moving about on friezes in the same way [as in the Panathenaic frieze], stripped to their essentials, to place them in paintings arranged in harmonies of colours – through the direction of hues – in harmonies of lines – through their orientation – line and colour fitted to each other'.[41] In these words, which Seurat later amplified and codified in a famous letter to a journalist who had asked about his theories, we can hear echoes of his conversations with Charles Henry, a mathematician deeply interested in the reconciliation of science with aesthetics, as well as reflections of his reading in recent scientific texts on the 'laws' or properties of colour and design.[42] His problem was to find the proper forms and technique for expressing the 'processional' aspect of modern life while retaining the Impressionist revelation of light and atmosphere. To his taste the Impressionists had been too casual and too careless. Because his logical and reflective mind demanded the reduction of instinct to order, of impulse to calculation, he 'stripped to their essentials' not only subjects from modern life but also the Impressionist method of presenting them. His studies of light and colour were more thorough than any the Impressionists had ever made, and his analysis of line unprecedented in their aesthetic. They

had read Chevreul but had not followed to its ultimate conclusions his 'law of the simultaneous contrast of colours', whereby adjacent objects not only exchange reflections of their own colours but create in each other reactions complementary to their own. In a yellow object set beside a red one a practised eye will see a trace of green, the complementary of red. Even such a simplification of Chevreul's law suggests the complexities which Seurat faced. With more knowledge than the Impressionists, and a more disciplined eye, he had to find all the hues in the spectrum as well as a way to brighten or darken a given hue in relation to the simultaneous contrasts produced by the colours around it. If he did not always achieve the exact equivalent of the physical properties of each colour, this merely proves he was an artist, not an apparatus. But given his extraordinarily subtle eye for colour, he also required a technique which would guarantee absolute control over every hue and its variants, and obviate any distortion of the painted surface through uneven drying and cracking such as he had observed in Delacroix's work. This he found in dots of colour set down with the tip of the brush, a method he described as Divisionism, because of the actual separation of colours, rather than Pointillism, which called more attention to the technique than to the results.

His first exhibited work, which was favourably noticed at the Salon of 1883, was a black-and-white drawing of the painter Aman-Jean (New York, Metropolitan Museum), executed in black conté crayon on rough laid paper. Because the soft crayon did not everywhere penetrate the pitted surface, the effect of the white paper shining through the lustrous blacks gives an unexpected vibrancy to the values and establishes the forms in a delicately lighted space. In his black-and-white drawings Seurat displayed his impeccable sense of style, for which the word 'classic' is neither an inappropriate nor an overwhelming designation.

Only he could take those most unclassic elements, the awkward costumes of the 1880s, and, by revealing their essential shapes, endow them with unity and serenity without losing the quality that makes them unmistakably of the period.

The first of his seven major paintings was *Une Baignade à Asnières* (National Gallery, London), which was shown at the first Salon des Indépendants in 1884. The technique, still basically Impressionist, was less disconcerting than the schematic design with its contrasts and analogies among the seated and reclining figures. In numerous preliminary studies executed out of doors at Asnières, downstream from Paris, Seurat painted as a typical Impressionist. He used small sketches (*croquetons* he called them), quickly brushed on wooden panels the size of his paint-box, to refer to the actual colours perceived in nature, when he constructed his large pictures in the studio. The method was traditional, but so accurate were his notations of colour that he could work, we are told, in his gaslit studio after dark.

In the *Grande Jatte* the procedure was much the same, the results more spectacular. Not only is the picture larger than the *Baignade*, with many more figures, but the relation of figures to setting is more intricate. Seurat once described painting as 'the art of hollowing out a surface', and in this more than in any other work he created an effect of deep, continuous space, controlled by a linear geometry he had learned from the Italian masters.[43] Within this space, which had already been settled in all its details, he placed his figures in a pattern only apparently random. It consists of groups of two and three persons alternately standing and seated, and arranged along several diagonals intersecting in the two central groups with parasols.[44] Again there is the visual recall of one figure by another; the woman fishing farthest to the left is echoed by the last figure in the distance. Although the latter is almost invisible, once we

have found her we experience that sense of a pervasive structural unity which only the greatest masters of form in space, a Piero, a Raphael, or a Poussin, can communicate. A more modern feeling is aroused by the inexplicable contradictions in the perspective. The figures recede from near right to far left along a diagonal contrary to the apparent space, but each figure is also seen as if the spectator were directly in front of it, a method Seurat must have found in Japanese prints. On the other hand, and although we seem to be looking into space, we see figures overlapping each other in the flat planes of Egyptian reliefs.

The *Grande Jatte* has a hushed effect, like the murals of Puvis de Chavannes (see below, p. 80) and its author was simultaneously denounced as a 'false Puvis' and acclaimed as a 'modernizing' one. So complex a composition, so redolent of the present yet fraught with the magic of the past, was considered by his contemporaries, by the young painters and poets of the later 1880s, as Symbolist as any work by Puvis (Moréas's 'Manifesto' appeared while it was still at the Indépendants), since through a process of 'subjective deformation' of objective nature a feeling was conveyed for which the pictorial form was the plastic equivalent. As in the earlier *Baignade*, although with more monumentality, Seurat conferred the quality of timelessness upon the time-bound subject matter of Impressionism. His theme, the pleasures of a Sunday afternoon, is comparable to Monet's *Picnic* of 1866 and Renoir's *Moulin de la Galette* of 1876, but his invention endows the subject with an unexpected dignity which many then thought, and some still do, at variance with the circumstances.

The *Grande Jatte* was Seurat's last reckoning with outdoor colour and daylight in a monumental figural composition. *The Models (Les Poseuses)* of 1888 (Merion, Barnes Foundation) can be read as an allegory on the relation between art and life, between modern painting

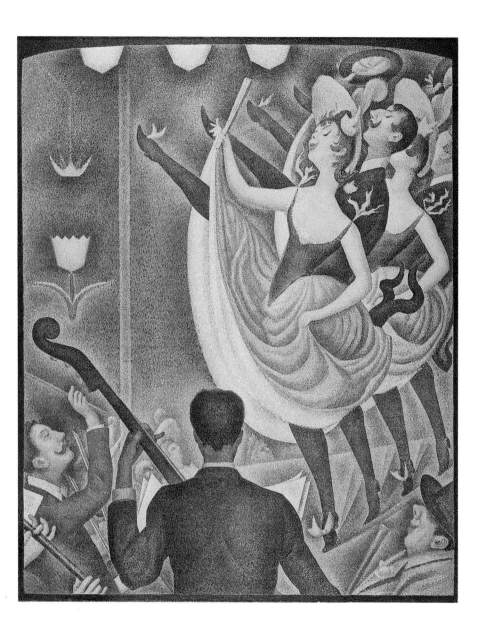

17. Georges Seurat: The Can-Can (Le Chahut), 1889–90. *Otterlo, Rijksmuseum Kröller-Müller*

and the ideal standards which Seurat had learned from his teacher, Henri Lehmann, himself a pupil of Seurat's idol Ingres. It is also a statement of the changes which occur in light and colour when objects are brought indoors, for against the wall behind the three nude models posing in the cool light of the studio can be seen a portion of the right half of the *Grande Jatte*. *La Parade* or *The Sideshow* of 1887–8 (New York, Metropolitan Museum) is a night scene, the darkness illuminated by stylized rows of gas-jets. Here the deep space of the *Grande Jatte* and *The Models* is treated as a series of flat rectangular planes, so close to the surface that the effect is like Japanese screens sliding one behind another. The proportions by which the composition is divided into groups of three, four, and five figures, and the frame intersected by the screen-like architecture, can be traced to the mathematical and aesthetic theories of Charles Henry.

Seurat was also interested in the psychological properties of line, and with Henry believed that horizontal and vertical lines express repose and tension respectively, ascending lines gaiety and joy, descending lines melancholy and sorrow. In his last three major works he explored the expressive potentials of more animated curves and arabesques. *The Can-Can (Le Chahut)* of 1889–90 [17], at first glance even more Egyptian in the overlapping legs and skirts, is virtually a treatise on the ecstatic effect of lines rising sharply from the horizontal. From lower left to upper right the movement is a continuous and accelerated 'lift', underscored by the strong diagonal of the bass-viol and stopped at the left margin by the decorative forms of the gaslights. The portrait of his mistress powdering herself, *La Poudreuse*, of 1889–90 (Courtauld Institute Galleries, University of London) is the foil to *The Can-Can*, the rhythmical curves creating an effect of privacy and calm quite unlike the other's brassy clatter. Seurat's last, unfinished canvas, *The Circus* (Paris, Louvre), was seen at the Indépendants in March 1891, only a few days before he died. In it the discursive social documentation of the *Grand Jatte* was condensed into a metaphor of pleasure and excitement.[45]

These seven large canvases were painted in Paris in the winter months; the summers Seurat spent on the Channel coast, where, in the skies and lighthouses, the quays and shoreside structures of the little coastal ports, he found an actual geometry of form to be studied under the brilliant but diffused light. His evocation of the trance-like atmosphere of these somnolent harbours is a major contribution to modern landscape painting [18].

No consideration of Seurat would be complete without mention of the more introspective, melancholy, almost sombre character of his black-and-white drawings, in which he expressed moods rarely encountered in his paintings. This is not just a matter of the monochromatic tones, or the strange stillness he imposed upon his often active subjects. By prolonging the Impressionist moment until we seem to hear time passing by, he expressed the poignancy of transience. His untimely death at thirty-one cut short an art that was growing ever more complex in content and in form.

Seurat's death deprived those who had followed him into the 'elegant and modern city of Neo-Impressionism' (the phrase is Guillaume Apollinaire's) not only of their leader but of the one major talent among them, the only one who could surmount the restrictions his methods imposed. The method had already proved a disappointment to Camille Pissarro (1830–1903), who had insisted on including his young friends Seurat and Signac in the last Impressionist exhibition. Between 1885 and 1888 Pissarro painted landscapes with unrelenting attention to the dots of divided colour, and among them are some which are inferior to Seurat's only because they

18. Georges Seurat;
Port-en-Bessin, the Bridge and the Quay, 1888.
Minneapolis Institute of Arts

are less firm. But he soon tired of the effort Divisionism demanded, as well as of the rigid limitations he felt it placed on his imagination, and by 1889 returned to the earlier and far from disorderly technique with which he created his late masterpieces, the views of Rouen and Paris painted between 1896 and his death in 1903.

Seurat's younger colleague and faithful disciple, Paul Signac (1863-1935), came very close to the master in his early landscapes.[46] The motif of his *Gasometers at Clichy* (Melbourne), discovered in the raw outer edges of the urban environment, is symptomatic of the radical social and political convictions of many of the Neo-Impressionists.[47] The industrial, proletarian scene had been treated by Seurat in his drawings and in the factories seen in the far background of *Une Baignade,* and it was to be extensively worked by Maximilien Luce (1858-1941). The construction of Signac's few figural scenes is unsteady, but the odd portrait of the critic Félix Fénéon (1890, New York, Private Collection), sub-titled *Against the Enamel of a Background Rhythmic with Beats and Angles,* is worth remembering as a deliberate attempt to demonstrate Charles Henry's number theories. Although Fénéon had been the first to use the

word 'Neo-Impressionism' as early as 1886 and 1887 in his criticism of Seurat,[48] it was Signac who provided a comprehensive rationale of the movement in his treatise, *D'Eugène Delacroix au Néo-impressionnisme* (1899), but its date marks it more as a memorial than as living doctrine. In later years Signac, an indefatigable yachtsman, sailed into all the harbours of Europe and returned with canvases painted in large blocks of vivid colour, like Turner (whom he admired) systematized. It is no coincidence that the glowing hues of his *Port of Marseilles* [19] have something of the vitality of Fauve colour; it was painted in 1905, the year of the first Fauve demonstration at the Salon d'Automne (see below, p. 159), and exhibited

the following spring at the Indépendants. As vice-president from 1890 and later president of the Société des Artistes Indépendants, Signac maintained until his death the generous policies of that institution long after its usefulness as an arena for avant-garde production had declined.

Of Seurat's other French disciples Henri-Edmond Cross (1856–1910) was the most gifted. His lyrical and less formal application of large dots of bright colour in his landscapes of Provence, painted after 1900, had a passing but important influence on the early Fauve paintings of Matisse, Derain, and Braque. A number of Belgian painters became familiar with Seurat's work when it was exhibited in Brussels by Les

19. Paul Signac: View of the Port of Marseilles, 1905. *New York, Metropolitan Museum of Art*

XX, a group of twenty progressive artists whose annual exhibitions between 1884 and 1893 brought to Belgium the work of the most significant contemporary Europeans.[49] The ablest of the Belgians was Théo van Rysselberghe (1862-1926). In his large picture of 1903, *A Reading* [20], where Maeterlinck, Fénéon, and others are seen listening to Vielé-Griffin reading his poetry, he handsomely accommodated the divisionist technique to the informal group portrait of artists and writers inaugurated by Fantin-Latour in the 1860s. The photograph of Whistler's *Carlyle* on the wall to the left is an indication of the cosmopolitan tastes of the Belgians. The architect Henry van de Velde (1863-1957) was briefly a divisionist painter

before he became an energetic propagandist for Art Nouveau. In the latter capacity he created for the German critic and art historian Julius Meier-Graefe a frame for Seurat's *Can-Can*, and furniture for the room in the critic's Paris apartment where it hung.

JAMES MCNEILL WHISTLER (1834-1903) AND IMPRESSIONISM IN ENGLAND

In England the practice as well as the criticism of Impressionism in its purest or French aspects was from the first inhibited by the strength of the British landscape tradition as well as deflected by the radical aestheticism of James McNeill Whistler (1834-1903), the

20. Théo van Rysselberghe: A Reading, 1903.
Ghent, Museum voor Schone Kunsten

American artist whose work belongs to the history of both British and American painting. But for those factors, British critics and their public might have taken sooner and more kindly to contemporary French painting, for there were several ties which could have made for mutual sympathy and interest.[50] Monet and Pissarro had both spent the winter of 1870-1 in and near London, where they learned to appreciate the pictorial virtues of the British climate and the work of its most profound interpreter, Turner, however much they might later deprecate his influence on their own work. And the fact that Alfred Sisley (1839-99), one of the most consistent of the French Impressionists, was the son of English parents may indicate that there was nothing congenitally alien to the English temperament in the discoveries of the French. Also there was for the artists themselves, towards the turn of the century, a source for primary information about modern French art immediately at hand. Lucien Pissarro (1863-1944), the eldest son of Camille, visited England in 1883-4 and settled there in 1890, attracted by the developments in modern book production which followed upon the activities of William Morris. At first he was busier with his books than with his painting and produced many fine volumes at his Eragny Press, named in honour of his father's home in France. After 1900, when he moved from Epping to London, he came to know many of the younger artists and encouraged their efforts to learn more about events in France. Lucien Pissarro's own painting was faithful to his father's, but being himself of the generation of Seurat and Signac it was rather towards Neo-Impressionism that his influence led his English friends. Hence, given the inevitable time-lag between two national traditions, in this instance extended by decades of British indifference to modern French painting, it is not surprising to find that the most progressive of the new generation after 1900 - the younger

friends of Lucien Pissarro and of Walter Sickert, who had once been a younger friend of Whistler - were more interested in problems of pictorial design than of atmospheric tone. Evidence of a strictly divisionist palette and brush stroke are infrequent, but in the landscapes and interiors of certain artists working after 1900 there is more awareness of Seurat's linear structure than of Monet's refracted lights.

Meanwhile for thirty years the critics and public had on the whole resisted the visual allure of contemporary French art. Durand-Ruel's exhibitions in the early 1870s elicited a pitifully meagre response, and his later exhibitions, including the magnificent one of 1905 at the Grafton Galleries of 315 paintings dominated by works by Degas, Monet, and Renoir, were received with more curiosity than understanding. For this situation Whistler may perhaps be partly responsible. For all that he knew the coming men in Paris as well if not better than any other English or American painter of his generation, he was not the ideal interpreter of French art in London, preoccupied as he was in gaining a hearing first of all for his own. Whistler had left the United States for good in 1855, settling first in Paris, where he was soon a familiar of the men whose naturalist point of view shaped the progressive painting of the 1860s. His *Symphony in White, No. 1: The White Girl* (Washington, National Gallery), shared the dishonours of the Salon des Refusés of 1863 with Manet's *Déjeuner sur l'Herbe*, and with Manet and Baudelaire he was among those who paid their *Homage to Delacroix* in Fantin-Latour's painting at the Salon of 1864. Had Whistler remained in France his art might have been strengthened by Manet's naturalist vision, but the *White Girl*'s melancholy pallor is symptomatic of her author's English, and momentarily Pre-Raphaelite, interests. In 1859 Whistler moved to London, and although he was much in Paris, especially during the last decades of the century, his art became in-

separably part of the modern movement in England. Like Manet, he defied the conventions of academic portraiture with *The Artist's Mother* (Paris) and *Thomas Carlyle* (Glasgow), which he so annoyingly insisted were primarily *Arrangements in Grey and Black*. Although the portraits were first exhibited without their controversial titles, his emphasis upon colour and line at the expense of subject matter was revolutionary in 1872, and when the portraits were seen in Paris in 1883 and 1884 their elegant restraint and muted tonal values were not lost on the youngest Impressionist generation. Whistler's shallow spaces, simplified profiles, and careful proportions reappeared in Seurat's *Models* of 1887–8 and in the flattened patterns of Vuillard's and Bonnard's earlier work.

In his landscapes Whistler turned from Monet's and Pissarro's sun-swept meadows along the Seine to another and very different river, the Thames at dusk when its ugly industrialized shores fade into the deepening blue of twilight pierced by the golden light of distant lamps. To the French painters' patient pursuit of the exact hue with which to transcribe the flickering nuance of light objectively seen and recorded, Whistler preferred a general tone, a drift of shadow to express a mood more than to describe a place. It is some measure of his originality that his *Nocturne: Blue and Gold – Old Battersea Bridge* (London), for all its indebtedness to Japanese design, preceded by twenty-two years Monet's study of the façade of Rouen Cathedral drenched in mist.

Whistler was the first of the British and American Impressionist painters, but his Impressionism was profoundly subjective rather than descriptive. 'Nature', he told the fashionable London audience which attended his *Ten O'Clock* lecture in 1885, 'contains the elements, in colour and form, of all pictures, as the keyboard contains the notes of all music. But the artist is born to pick and choose, and group with science, these elements, that the result may be beautiful – as the musician gathers his notes, and forms his chords, until he brings forth from chaos glorious harmony.' The musical analogy was apt and remains important. In stressing the presence of non-figurative factors in his design, through the several categories of his *Symphonies, Nocturnes,* and *Notes* (still another musical metaphor), Whistler compelled his reluctant public to consider the elements of art rather than the objects those elements may happen to resemble. Ruskin could dismiss the *Nocturne in Black and Gold: The Falling Rocket* [21] as 'a pot of paint flung in the public's face'; a later public cannot but see it as a decisive event leading to the definition of a painting as an arrangement of coloured surfaces before it is anything else, even a falling rocket.

In the decorative arts Whistler's preoccupation with the means rather than with the content of expression was less subject to the law of

21. James McNeill Whistler: Falling Rocket, *c.* 1874. *Detroit Institute of Arts*

diminishing returns, for his painting became slight and repetitious as he grew older. It may even be that his most important achievement was his conception of the integrated environment as we understand it today. For himself and his friends Whistler devised colour schemes for interior decoration that were aggressively austere for the time. By 1866 his own dining-room was blue with darker blue dado and doors, the drawing-room pale yellow and white, the studio grey and black, as it appears in the portraits of his mother and Carlyle. His clean and empty spaces, quite as much as the better publicized interiors of Voysey and Mackintosh, foretold the principles of interior design developed in Germany, Austria, and the Netherlands after 1900. As late as 1905 Marcel Proust

could write that in his 'intentionally empty room' there was only one reproduction of a work of art, 'an admirable photograph of the *Carlyle*'.[51] But that was the year of the first Fauve demonstration in Paris, and in the excitement of the new colours of the twentieth century Whistler's gentler harmonies were long overlooked.

The strength of the British landscape tradition and the difficulty of accommodating it to the more analytic vision of the French can be noticed in the career of Philip Wilson Steer (1860-1942), the most eminent English landscape painter of his time. He studied in Paris in 1882-4, but since he knew no French it is often assumed that he had few contacts with his young French contemporaries. Certainly he

22. Philip Wilson Steer:
Girls running: Walberswick Pier, 1894.
London, Tate Gallery

was not over-impressed with the memorial exhibition for Manet which he visited in 1884. But there were occasions until the early 1890s when he demonstrated an original and intuitive understanding of French painting. There are suggestions of Monet in a few of his landscapes, of Seurat in a view of sailing-boats, and of Degas in some figure compositions, but most interesting of all, there is a feeling for the quickened perceptions of modern life, somewhat like Whistler's, yet all his own, in paintings like the *Girls running: Walberswick Pier* of 1894 [22], treated with a brilliant palette and speckled brushwork. At such moments Steer was thoroughly a modern master, but very soon he turned away to treat the inland landscape in the tradition of Constable and Turner, whose *Liber Studiorum*, so we are told, he carried with him when searching for a motif. The landscapes of his middle years, after 1900, are broadly composed and richly brushed, but they do not enlarge our understanding of a mode of painting already consecrated by Rubens and the great English masters.

More continuous and more effective contacts with French painting were established by Whistler's young friend, Walter Richard Sickert (1860-1942), who worked with him briefly in 1882-3. Sickert's Whistlerian works are few and not very important, but he learned from the master, whose teachings he repudiated only in 1910, much about the craft of print-making and the elements of pictorial style. In 1883 he accompanied Whistler's *Portrait of the Artist's Mother* to Paris, where it was to be exhibited at the Salon, and took with him Whistler's letter of introduction to Degas. For the next few years Sickert was close to Degas, who showed him how to surprise his subject in an unguarded moment and to find in the activities of the lower classes more vigorous subjects than any Whistler usually treated. Sickert's paintings and etchings of the interiors of the music halls of London belong with the *café-concerts* of Degas

and Toulouse-Lautrec in the iconography of later-nineteenth-century popular entertainment, but his records of their dingy interiors, momentarily made glamorous by artificial light, and of the good-natured vulgarity of performers and audience alike have a fragrance, one might almost say an odour, all their own. Sickert was also a landscape painter whose views of Dieppe and Venice, mostly painted between 1895 and 1905, are in the Impressionist tradition of the informal townscape. He differs from the French Impressionists in his more prominent line, especially in the drawing of architectural elements, and in his palette, which is predominantly sober, even sombre, in its harmonies of pink and grey against greens often taken very close to black. The darkness of his colours and his frequently dense impasto give his best works a physical substance very different from the clear and diaphanous texture of French paint.

How successfully Sickert accepted the technical and compositional methods of French painting and subordinated them to a peculiarly English vision can be seen in *The Mantelpiece* of about 1907 [23]. It is contemporary with the work of the Fauves (see below, pp. 158 ff.), but it is much more traditional. Sickert's antecedents here are Whistler and Degas, whom he follows in the diagonal position of the mirror and the pattern of the objects seen on the wall within it, while his true contemporaries are Vuillard and Bonnard (see below, pp. 108 ff.) whose interiors, especially those with mirrors, he would have seen on one of his many visits to Paris. There are hints of what he himself described as 'ready-made life', in *The Mantelpiece* and the many nudes, with or without their companions, in shuttered upper rooms of dreary boarding-houses where the filtered light lends a kind of poetry to what the spectator knows is a squalor unredeemed by any but the poet's vision. In later landscapes, after 1920, there were times, as in *The Mill Pond, Auberville*

23. Walter Sickert: The Mantelpiece, c. 1907.
Southampton, Art Gallery

(Cambridge), when his way of seeing nature as structured space and radiant colour seems as close to the vision of the French Impressionists as Steer's tumbled meadows and scudding clouds were to Constable's.

AUGUSTE RODIN (1840–1917)

To the development of the new, anti-naturalist, and Symbolist art the French sculptor Auguste Rodin made important contributions, despite the fact that by training and inclination he was as committed as any of his Impressionist contemporaries to the study of nature. The contrast between Degas's *Fourteen-year-old Dancer* of 1879 and Rodin's *Age of Bronze* of 1876,

which were seen almost simultaneously in Paris, is instructive. Both works were condemned for the very realism their critics expected and admired, provided it was tempered by some trace of idealism. What seems odd today is that the public by and large failed to look beneath the brilliant descriptive modelling of each work, and so could not distinguish between the radical psychological realism of Degas's figure and the symbolical content of Rodin's. The sculpture of Degas, as we have seen, remained an unknown aspect of his work after its single public appearance at the Impressionist exhibition of 1881. Rodin, on the contrary, became a figure of international significance, the most admired, prolific, and influential sculptor since Bernini. But just because his sculpture, in multiple plaster, bronze, and marble versions, was so familiar and accessible, the world grew weary of it. After his death in 1917 his work lost favour as fast as Monet's. By 1930 even discerning critics had turned from him, declaring that he had chosen 'the path of intellectual suicide', and that the famous *Gates of Hell* seemed to fall into the category of 'the conscious classics of 1900'. There is some justice in these remarks, for there is much in Rodin's elaborate allegories which may never again seem urgent, but there is more, much more, in his art than just 'the superlative character of his craftsmanship'.[52]

Certain tendencies in modern aesthetics have retarded our recognition even of that craftsmanship. The enthusiasm after 1900 for direct carving called attention to Rodin's marbles, which were always executed by professional carvers and only finished at the last, if even then, by the master. The duplication of many works in bronze, with or without his sanction, vitiates one's interest in them as original sculpture. On the other hand, Rodin was a superb modeller, perhaps the greatest in the history of European sculpture. Because the slightest touch of his fingers on the clay could be preserved, even in

reproductions several times removed from the original, we are aware of his supreme control of his surfaces, his unerring instinct for the right amount of pressure or exaggeration that would communicate, through reflections of light from his constructed volumes, the character he sought. As he said, 'to model shadow is to bring out the thought'.[53] Yet it is a mistake to consider Rodin only an Impressionist in bronze. He was not interested in merely transmuting into metal the look of certain substances in nature. For him, as for Monet, Cézanne, and Debussy, whose pictorial and musical techniques had at first been devised as visible and audible equivalents of objective appearance, sculpture was an instrument for his personal interpretation of nature. As he later remarked: 'Painting, sculpture, literature, and music are closer to each other than we generally believe. They express all the feelings of the human soul in the face of nature.'[54] In his later portrait busts we can see how he drew on his own sensitivity for the presentation of another's. The head of the young American attorney and early enthusiast for modern art, Arthur Jerome Eddy, of 1898 [24], like all great portraiture, is not just a satisfactory likeness: it is also an account of a condition, a searching, almost confessional statement of the spiritual unrest at the end of the century. But at the same time that we become aware of the sensitive personality of the sitter, we know that it is presented through the medium of clay, perpetuated in bronze. Modelling, Rodin said, 'is the reflection of life', but his power as a modeller lay in his ability to see beyond 'the surface and the system of surfaces' to the essential structure, to the form that supports the face and features, and to the spiritual structure that defines the personality.[55] This visual and expressive complexity was more simply stated by the Symbolist critic André Fontainas when he mentioned the 'multiple and essential appearances' in the *Balzac* of 1898.[56] It was first monumentally

24. Auguste Rodin: Arthur Jerome Eddy, 1898. *Paris, Musée Rodin*

presented in the striding *St John the Baptist Preaching* of 1880, which exemplifies Rodin's conviction that 'in reality, time does not stop', and that 'movement is the transition from one attitude to another'.

Rodin's early years were difficult, not only because his talent exceeded the perception of his critics but also because he had been refused admission to the all-powerful École des Beaux-Arts and had had to make do at the 'Petite École' of the decorative arts, where drawing from the nude was not offered. His earliest employment was as a designer and modeller of decorative sculpture. Not until 1877 did he become known in Paris, with his *Age of Bronze*, the life-sized nude male figure which he had to

defend, when it was first exhibited, from the absurd accusation that it had been cast from life. Although his works were at first unfavourably received, his talents were recognized by the government in 1880, when he received a commission to design a monumental bronze door for a new museum of decorative art. The museum was never built and the doorway never finished, but the huge *Gates of Hell*, as they are called from the Dantesque origin of the iconography, became the source for many of Rodin's later works [25].[57] Into this vast design, which eventually included 186 figures, he poured his energies for the next twenty years. Except for the *Burghers of Calais* (1884–6) and other commissioned works like the *Balzac*, most of his individual figures and groups came from or were absorbed into the *Gates*. The first design was clearly Ghibertian, with a series of rectangular panels on each door. This was then modified until each leaf presented a continuous sequence of the damned rising and falling in a movement reminiscent of that which sweeps through Michelangelo's *Last Judgement*. Figures in many sizes project in many degrees of relief from a turbulent background of rock and cloud. If Ghiberti's panels were ever justly criticized as more pictorial than sculptural, Rodin's almost pass the frontiers of painting; the effects of dissolving and emergent movement are prophetic of the cinema. Over the whole, in the centre of a deep lintel where a dimly seen skeleton suggests the Gothic source of this modern *Dance of Death*, sits the most familiar of Rodin's male figures, the poet Dante, now known when detached from the whole and enlarged to heroic size as *The Thinker*. At the top three male nudes form the group of *Shades*. These identical figures, wearily and with

infinite regret preparing to enter Hell, are variations of his earlier Michelangelesque *Adam*. The shadowy imagery of symbolic creatures, already half withdrawn from life, has taken the place of the specific expression of mingled shame and desire in the first man.

A comparable process works upon the Dantesque themes. Of the characters in the *Inferno* only the groups of Ugolino and of Paolo and Francesca are identifiable. For the anonymous others Hell is less a place of eternal physical pain than a condition of intolerable psychic distress, the result of irreconcilable conflict between men and women, women and women, men and men, in which the body is more the vehicle than the source of agony. The Baudelairean tone of this imagery conveyed by yearning, shuddering forms is obvious; Rodin much admired the *Fleurs du mal*. For Rainer Maria Rilke, who was once Rodin's secretary, this was an art 'to help a time whose misfortune was that all its conflicts lay in the invisible'.[58] Certainly the feeling of dream and nightmare, for which the plunging forms constantly changing in direction, velocity, and size are equivalent visual symbols, is inescapable. One may invoke the name of Freud, whose contemporary discovery and analysis of the ambiguity of psychic imagery and its multiple meanings may be compared with Rodin's continuous physical and ideational transformation of the human body.[59]

Despite his talents, the vastness of his sculptural ambitions, and the range of his imaginative involvement in human life, Rodin was not strictly a monumental sculptor, for he had difficulty in imposing formal unity upon many separate elements. The *Gates* remained unfinished, because he could never decide when to stop. Always just beyond the present effort were other images begging to be brought to sight. Even in works conceived as compact groups, like the *Burghers of Calais*, the unity is less formal than psychological, an accumulation

25. Auguste Rodin: The Gates of Hell, 1880–1917. *Paris, Musée Rodin*

26. Auguste Rodin: Torso of Adèle, *c.* 1882.
Private Collection

of expressive parts. Rodin, indeed, was singularly obsessed with the fragment as an object in its own right.[60] His admiration of antique art (he collected such remains as he could afford) sharpened his eye for the expressive character of even the most mutilated whole and encouraged him to isolate it as an independent object. In Michelangelo's unfinished marbles he found his popular and often abused device of contrasting a highly finished, fragmentary form with the roughened or even natural stone from which it emerges. By concentrating on the torso, the head, or on detached limbs, he converted ancient accidents into a modern aesthetic that influenced sculpture for years to come. The way the torso of *Adèle*, of about 1882 [26], floats freely in space is characteristic of Rodin's indifference to architectural and spatial considerations, for which he was to be blamed by

a younger generation. Yet within such a torso the emphatic geometry of breasts and limbs may have been what a younger sculptor saw when, early in the new century, Constantin Brancusi acknowledged Rodin's stature even as he rejected his influence.

For modern eyes the work that best summarizes Rodin's achievement is the calamitous *Balzac* [27]. We admire it because it seems the simplest in form, the most penetrating in its psychological insight, and the most directly expressive of all his works. In 1891 he accepted a commission from the Société des Gens de Lettres to design a monument which had been

27. Auguste Rodin: Balzac, 1892–8.
Paris, intersection of the Boulevards Raspail and Montparnasse

under consideration since Balzac's death in 1850. After seven years of research and sculptural revisions, he presented the final version in plaster at the Salon of 1898. During that time his conception of the monument changed from a portrait based on surviving likenesses of the writer to a colossal synthesis of Balzac as an individual and as an almost superhuman creative force. Here if ever in the history of nineteenth-century sculpture was what, in the phrase of Novalis, quoted on the occasion, could be called an 'aesthetic imperative'.[61] The *Balzac* could have, and should have, put an end for ever to that tradition of public sculpture Rodin despised, of the countless frock-coated statesmen accompanied by 'tables, chairs, machines, balloons, and telegraph instruments' which lacked 'interior truth'. Now that such commercial sculpture, as he called it, has found its proper aesthetic oblivion, we can see that the *Balzac* was the first conspicuous sculptural portrait in modern times in which creative expression took precedence over verisimilitude. In Rodin's final concept the writer appears as a gigantic figure (he was actually rather a short man), dominated by creative inspiration. His weight rests massively on one leg, his hands are concealed beneath the voluminous gown swathing his heavy body. The elemental block, so 'shapeless' at the base, is crowned by a powerful head with deeply undercut features.

To the public at the Salon of 1898, and especially to the members of the Société des Gens de Lettres (who rejected it), the statue was crude, incomprehensible, a travesty of a great author. The summary details submerged in a few broad oppositions of dark and light seemed all the more offensive because Rodin was also exhibiting the large marble version of *The Kiss* of 1886, his most popular treatment of sexual attraction. The contrast between the sensual modelling of the marble and the inchoate surface of the plaster was too violent to be easily accepted by those unprepared for the transformation of an iconic image into a creative symbol. The critical tempest which raged in the international press for several months was the most severe storm to engulf any major artist since the treatment Manet had received at the Salon des Refusés in 1863. But this time there was an important difference. Although the unfavourable comments exceeded the favourable by far, in number and intensity, the weight of informed opinion was on Rodin's side. The ignorant might recoil before this 'ignoble and insane nightmare' and scoff at the 'toad in a sack', but their opposition eventually collapsed in the face of those who understood Rodin's intention and the difficulty of his achievement. In defining what they felt and saw in this work, which the sculptor himself described as of a kind 'yet unknown', many indirectly expressed their realization that this was indeed a new kind of sculpture. It was frequently compared to Egyptian art, a comparison we would not understand unless we remembered that the abrupt definition of the mass by a few broad planes was so entirely unlike the easy transitions of academic sculpture that it seemed more like the simplified forms of Egyptian art. Even more interesting are the frequent references to primitive sculpture, to 'a monolithic form . . . a caryatid wrenched from some prehistoric monument', or even to a natural object such as a volcanic rock washed by the sea.[62] The true originality of the work was reflected in the fact that there were no proper words with which to confine it. In his search for an expressive synthesis, Rodin, like Cézanne, had become the 'primitive of a new art'.

He had also, although less unexpectedly than would now appear, created the first authentically 'ugly' work of modern art. All his life he had found sources of expression in unprepossessing as well as in conventionally attractive objects. The title of his first significant piece of

sculpture, the *Man with a broken Nose* (1864), suggests strength rather than charm, and the *Helmet Maker's beautiful Wife* (1890) is a distressingly literal depiction of physical deterioration. But in the *Balzac* the source of ugliness had been shifted from the theme to the treatment. The jagged profiles, the gross modelling of the head, the inexplicable lack of transition between the violent and summary planes, the coarse texture of the plaster surface, are the sources of its power, but even now they may repel at first sight. In technique as in interpretation Rodin made no compromise with taste. In time, of course, taste caught up with him, and the figure, which had been returned to the artist at the conclusion of the Salon, was finally cast in bronze and erected in Paris in 1939 by private subscription. The

Société des Gens de Lettres made do with a dumpy seated figure by Rodin's friend, Alexandre Falguière (1831-1900).[63]

At the International Exposition of 1900 Rodin, like Courbet in 1855 and Manet in 1867, showed his works in a pavilion constructed at his own expense. The exhibition, at which the unfinished *Gates of Hell* were seen for the first time by the public, contained all his principal works, and established his position as the most eminent living sculptor. Thereafter he undertook no major monuments, but turned to drawing as his principal means of expression. He broke with the academic convention of drawing statically posed nude figures by insisting that his models, of whom he sometimes used several at once, move at will about the studio. After studying their movements he

28. Auguste Rodin: Study of a Nude.
New Haven, Conn., Yale University Art Gallery

trapped the most intricate postures transitional between one action and the next in a few free lines. A broad wash of one or two tints gives substance to the contours, but as it overlaps or withdraws within them, it reinforces the feeling of continuous movement [28]. These later drawings were rarely if ever preparatory to his sculpture, which towards the end consisted almost exclusively of portraits. They were, as Rodin told Bourdelle in 1903, 'the result of my sculpture', and should be seen as the culmination of his lifelong study of form in movement.

Rodin's influence has been truly incalculable. The scope and intensity of his imagination, matched in his lifetime only by Wagner's, which was similarly directed towards a symbolic interpretation of human experience, overwhelmed most of those who came within his range but who used his technique to treat problems of lesser moment. Perhaps the proof of his greatness is to be seen in the work of such men as Maillol, Brancusi, Lipchitz, and others, who had to reject his method and his programme in order to assert their independence. Through the loyal opposition, so to speak, Rodin's inexhaustible energies reach to the present.

An exception may be made for certain works by Antoine Bourdelle (1861-1929), Rodin's pupil and his marble carver for fifteen years. At first he promised to develop further Rodin's treatment of the surface in themes as dramatic as his *Mask of Beethoven* [29], a study of 1901 for a symbolic monument which obsessed him for many years. But after his first Salon success of 1910 with *Hercules the Archer,* a strained essay in the archaic Greek mode, he turned from realism, so basic to Rodin's art, to neo-classical mannerisms, mostly remarkable for their sophisticated details. His shallow, flattened, very linear reliefs for the Théâtre des Champs-Élysées in Paris (finished in 1912) were comparable to Bakst's settings and Nijinsky's choreography for Debussy's ballet, *L'Après-midi d'un faune,* produced also in 1912.

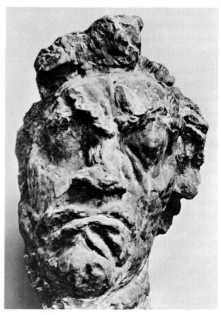

29. Antoine Bourdelle: Beethoven, a Tragic Mask, 1901. *New York, Private Collection*

His works were popular and for twenty years influenced much public sculpture throughout Europe and the Americas. But if his substitution of rhetorical gesture for structural design was easily imitated, his importance for his own generation lay in his vision of a sculpture more closely related to architecture. His best work was always serious and occasionally majestic. The colossal *Vierge d'offrande* at Niederbruck in Alsace is still remembered, and from the monument to General Alvear in Buenos Aires (1917), a dramatic equestrian figure supported by four virtues, the head of *Eloquence*, known in reductions and variants, is the simplest and most sculpturally convincing of his later work. His studio has been preserved in Paris, where a new gallery has been built to house his largest plaster models so that his work can be judged as a whole.

MEDARDO ROSSO (1858-1928)

Between 1890 and 1910 the Italian sculptor Medardo Rosso enjoyed a European reputation second only to Rodin's, but he sank into obscurity before 1914, the year in which his works were finally sponsored by his own government at the Venice Biennale. Since his art had usually been thought of as the epitome of sculptural Impressionism, which it was and was not, it shared the varying fortunes of pictorial Impressionism between the two Wars. The recent revival of interest in the nature of materials and their expressive qualities has brought Rosso's work to a more just and tolerant attention. His historical importance is now a support and not merely a justification for the extraordinarily original character of his sculpture.

Rosso was almost self-taught. After only a few months at the Academy in Milan in 1883, he was expelled when he petitioned for more liberal instruction in anatomy and the nude. The following year he appeared in Paris, where he worked in Dalou's studio and met Rodin. From the first he attracted attention with the genre scenes, heads, and portraits which he exhibited at the Salon and at the Exposition Universelle of 1889. Clemenceau admired his work; Zola acquired a statuette; Henri Rouart, the friend of Degas, commissioned his own portrait; and Rodin offered to exchange works with him. It was even whispered that Rodin was disturbed by Rosso's popularity and not entirely immune to his influence.

The Italian had arrived in Paris at an opportune moment. The public did not yet understand the progressive experimentations of the major Impressionists but was ready to accept Impressionist techniques provided the subjects so treated were familiar and comprehensible. Rosso's themes were among the commonplaces of anecdotal art, but his method of treating them, and his theories of sculpture, were more daring than any Rodin had attempted. He was

pre-eminently a modeller, and his first bronzes, despite their sentimental aspects, displayed his ability to capture with a flick of his fingers the effect of light falling upon, penetrating, and dissolving the solid substances of nature. His *Bersagliere with his Girl* of 1882 differs little from a contemporary commercial figurine except that it is startlingly pictorial. Its subject is really the light streaming from an imagined street lamp above the figures. As it falls it shatters and absorbs all individual details until little is left of the figures but the main masses as they might be instantaneously seen among the shadows. The eye must reconstruct the action of a man stealing a kiss from a girl through the absence and accents of light struck off the roughened surfaces.

Rosso carried this disintegration of form even farther in his *Impression in an Omnibus* of 1884, a group of five half-length figures emerging from an undefined mass of clay. These were portraits of five men and women he saw daily on the bus to his studio and whom he persuaded to pose. The work, unfortunately destroyed in Rosso's lifetime, should be studied in his own photographs, where we can see that his intention was to create in solid sculptural materials a fugitive impression of actuality.[64] Later in Paris he stated that for him painting and sculpture were not separate arts, that art itself was indivisible, and that the means were less important than the evocation of nature and humanity. Such a conception embodies the familiar Baudelairean doctrine of the unity and interchangeability of sensuous, and hence artistic, experience, a doctrine singularly inappropriate, one might think, for sculptural expression, because its strict application would require, as Rosso hoped, the suppression of just those elements, tangible materials and palpable space, that distinguish sculpture from other arts. Rosso insisted that material should be subordinated to expression: 'The sculptor must, by a *résumé* of the impressions he has

received, communicate everything which has struck his own sensibility, so that those who look at his work will experience completely the emotion he felt when he studied nature.' And he believed that sculpture was not even essentially three-dimensional: 'One does not walk around a statue any more than one walks around a painting, because one doesn't walk around a form to acquire an impression of it. Nothing in space is material.'[65]

This curiously unsculptural aesthetic can now be understood as Rosso's way of rejecting the Italian tradition, which he felt as a handicap to contemporary expression. Instead of the three-dimensional plasticity of ancient or Renaissance sculpture with its burden of idealistic and idealized subject matter, Rosso emphasized the sculptor's right to consult his own experience of the immediate present with all the freshness of vision that Impressionist theory and practice had released in painting. His

Conversation in a Garden of 1893 [30] carried farther than the *Impression in an Omnibus* this research into the sculptural optics of the passing moment, but now within a more complex psychological situation. Here the sculptor himself is conversing with two seated women, who seem to turn away from him. The situation is not only contemporary, it is also entirely transient. In a moment the figures will have changed places, the conversation will have taken another turn, and this 'impression' of the experience will be the only record of the event. There was no precedent in the history of ancient or modern sculpture for so restricted, so exclusively visual, and, one might even think, so trivial a sculptural motif. But just at the point when, or should we say where, the images are about to dissolve into the material, the material, perhaps against the sculptor's will, recovers its importance as the substance of the work without which neither form, face, nor 'impression'

could exist. The dominance of the material is half the fascination of Rosso's *Madame X* of 1896 [31], where wax is the perfect substance for the elusive expression. It is with such a work as this that Rosso takes his place among the early masters of modern art. His insistence on the validity of ordinary experience, however fleeting, was another and eventually successful attack upon the debilitated formalism of fashionable academic sculpture. His discovery that even the most commonplace event may be rich in psychological overtones which can be expressed through the coming and going of light became an inspiration for the Italian Futurists and an important element in their conception of the dynamism implicit in modern life. The finest Futurist sculptor, Umberto Boccioni, indicated his debt to Rosso when in 1912 in his manifesto of Futurist sculpture he described him as 'the only great modern sculptor who has attempted to open up a larger field to sculpture, rendering plastically the influences of an ambiance and the atmospheric ties which bind it to the subject'. If the line of descent from Rosso's *Impression in an Omnibus* to Carlo Carrà's painting *What the Tram Car Told Me* (1911) is direct, one may also think that Boccioni's *States of Mind* (1911) owes much to Rosso's revelation of the psychological as well as of the physical circumstances within which objects are observed and events occur.

In quantity Rosso's work was inconsequential beside Rodin's, but in the revelation of the essential character of contemporary experience without recourse to conventional symbolism it was more modern. Although there were relatively few individual objects, it gradually became known through numerous replicas in plaster, bronze, and wax. Through the generosity of the sculptor's son many of these have been preserved, with his drawings, in the Museo Medardo Rosso at Barzio in Italy.

30 (*opposite*). Medardo Rosso: Conversation in a Garden, 1893.
Rome, Galleria Nazionale d'Arte Contemporanea

31. Medardo Rosso: Madame X, 1896.
Venice, Cà Pesaro, Museo d'Arte Moderna

SYMBOLIST ART

The progressive painting of the later 1880s and 1890s was not so much Post- as Anti-Impressionist in technique and expression, although the word Impressionist was used as late as 1889 by members of the younger generation to indicate their adherence to the new tendencies. In the title of their exhibition at the Exposition Universelle that year in Paris, Gauguin and his friends from Pont-Aven described themselves as the 'Groupe Impressionniste et Synthétiste'. In 1891, the year Gauguin's followers, the Nabis, first exhibited together as 'Symbolistes et Impressionnistes', the critic Georges-Albert Aurier published the first considerable appraisal of Gauguin under the title 'Le Symbolisme en peinture – Paul Gauguin'.[1] Through the association of these three words, Impressionist, Synthetist, and Symbolist, we can trace the web of meanings that the new art embodied.

Gauguin called himself an Impressionist in 1889, but he rejected the other terms because neither adequately characterized his art. It is true that by 1885 Symbolism had been preempted for the new literature which was publicly proclaimed as such the next year by the poet Jean Moréas in his 'Symbolist Manifesto' of 1886.[2] The term was relevant for the new painting as well, because the intentions of poets and painters, for a few years at least, were similar. Synthetism had a more limited but specifically artistic application: it was used to mark the break between the analytical methods of the Impressionists and the new synthesis of vision and expression.[3]

There were other, extra-artistic reasons as well why a new word was needed. Impressionism, like Academic Idealism and Naturalism, and Neo-Classicism before that, had become identified with contemporary political, moral, and intellectual problems. The poets and painters of 1885, disgusted by the inability of society to solve these problems, repudiated the standards of a rationalist and materialist era in favour of a new set of values for which the highest spiritual significance was claimed. They found their belief that art was the vehicle for those values confirmed by the great Romantics before them: in Balzac's statement that 'the mission of art is not to copy nature but to express it', and in Delacroix's that 'in his soul man has innate feelings which actual objects will never satisfy, and the imagination of the painter or poet can give form and life to these feelings'.[4] Charles Baudelaire, youngest of the Romantic poets and eldest critic of modern art, believed that there was more in the work of art, literally and figuratively, than meets the eye, and in his sonnet *Correspondances* (first published in 1857) stressed the similarities between experiences of nature and interior states of mind. Such ideas convinced Gauguin and his disciples that an object or situation was little in itself; it was only a sign of something else, and its meaning, its symbolic value, lay not in how it was seen but in what it was felt to be. These symbolic values, however, were not to be expressed in the threadbare conventions of academic art. The difference between the older allegorical painting and the new Symbolism was tersely put by Gauguin when he wrote that Puvis de Chavannes 'explained his idea, but he does not paint it'.[5]

The work of art was considered the equivalent of the emotion provoked by an experience, the visual elements of which had been transformed rather than merely represented. It was not only a synthesis of feeling and form, of fact

and idea but also more than fact and even, apparently, more than form, since the emotion or idea to be expressed might escape complete transformation into art. In the Symbolists' insistence on the 'idea' present in every true work of art (Aurier proposed that the new painting be known as 'Idéiste') we hear echoes of Hegel and Schopenhauer, who believed in the eventual primacy of music over the other arts because only through music could ultimate reality be known. The belief that art is an approach to such reality and that life is meaningful in so far as it can be translated into artistic terms gave a new direction to the familiar theory of 'art for art's sake'. Art was now considered not only different from life, pursuing its own ends with its own means, but even superior to life in the sense that 'real' life is created by art.[6] The artistic consequences of such ideas have been immense. Although Symbolism eventually expired of its own supra-artistic aspirations, the Symbolists, by freeing painting from what Gauguin called 'the shackles of probability', created the philosophical as well as practical premises for much twentieth-century art.

This reaction against the conventions of Naturalism was part of a broader anti-scientific movement, in philosophy as well as in art. As early as 1865 Hippolyte Taine, who had already developed his determinist theory of literary history, admitted that art as well as science was a means to knowledge.[7] By 1889 the philosopher Henri Bergson had come to believe that intuitive experience was the only source for the knowledge of reality, and that art was a direct revelation of such experience.[8] From the debate over the nature and purpose of art two important principles emerged. In the first place it became apparent that the more one rejected the work of art as a description of phenomenal appearance observed and recorded by the conscious mind, the more one came to use it as an instrument for exploring, and eventually for exploiting, the unconscious

creative processes. Awareness of such processes was not new, and for our purpose we need look no farther into the past than to so revealing a remark as Delacroix's: 'There is an old leaven, a black depth that demands satisfaction. If I am not writhing like a snake in the hands of a Pythoness, I am nothing.'[9] So thoroughly did the Symbolists believe that art is ultimately based upon emotional experience rather than upon visual analysis that Maurice Denis could write to Édouard Vuillard in 1898 that 'any emotion can become a subject for a painting'.[10] In his comments on Moréas's manifesto the poet and critic Gustave Kahn, who has been called the 'Baudelaire of the Symbolist movement', declared that introspection knew no limits: 'Thus we carry the analysis of the Self to the extreme.'[11] The dream life proved a fertile source for such subjectivity. In 1881 the young poet Jules Laforgue wrote of 'a poetry that would be psychology in the form of a dream, with flowers, air, odours. Inextricable symphonies with a melodic phrase (a subject), the design of which would reappear from time to time.'[12] Such an aesthetic programme with its memories and mixture of Baudelaire, Rimbaud, and Mallarmé, of Schopenhauer and Wagner, was soon realized by Gauguin and Redon. But the conception of art as dream reminds us that the significance of dream imagery with its sources in both the rational and irrational would soon be studied by Freud. Is it no more than coincidental that Freud spent the winter of 1886-7 in Paris studying the causes of hysteria in Dr Charcot's celebrated clinic, and that his *Interpretation of Dreams* (1900) might be a handbook for the pathology of Symbolist art, a psycho-analytical confirmation of the belief that in its origin and development the work of art is a system of multiple meanings?

Freud's revelation of the laws of psychic experience was related to a further consequence of the Symbolist programme, the search for the

laws of art itself which led to the study of objects then called primitive or produced by so-called primitive peoples.[13] The hope that through such study a more profound reality might be discovered, or recovered after its long disappearance, is related to Mallarmé's definition of poetry as 'the expression, through human language, reduced to its essential rhythm, of the mysterious meaning of aspects of existence'.[14] So pervasive was this search for the origins of expression, and for forms of expression unsullied by cultural inhibitions, that the work of Cézanne, whose sensibilities were those of a nineteenth-century individual refined to the highest degree, was described as 'primitive' as early as 1890.[15]

From this search for the fundamentals of expression and the exploration of individual feeling came the larger part of later nineteenth-century art which still stirs our imagination. If the years around 1886 now seem the watershed between analytical Impressionism and the synthetic and Symbolist art of Seurat, Gauguin, and Van Gogh, they also provide a convenient line of demarcation between some older painters who used conventional forms for symbolic purposes, and those of the next generation who were already finding new symbols for new feelings.

GUSTAVE MOREAU (1826–98)

In contemporary French criticism of Symbolist art four names were constantly evoked as predecessors of the new painting. These men, Gustave Moreau, Pierre Puvis de Chavannes, Odilon Redon, and Eugène Carrière, have been dealt with differently by later critics. Of them all, only Redon can be said today to excite any general admiration. Puvis de Chavannes receives a respectful but unenthusiastic assent, Moreau until quite lately had been ignored by all but the Surrealists, and Carrière has been almost forgotten.[16] Like their fates, their arts were various, and related less to each other's

than to their common suspicion of the positivist and naturalist philosophy within which they had all come to maturity. Puvis de Chavannes had thought of engineering as a profession until his health failed. Redon was once an architectural student and was always deeply interested in natural history. Carrière was so concerned with the relation between art and evolution that late in life he delivered a lecture on 'L'Homme visionnaire de la réalité' in no less a place than the Hall of Anatomy in the Paris Museum of Natural History. Moreau had been the least contaminated by such theories, since he had early withdrawn into the silence of his studio, but his hermit's existence, like his art, was a protest against the doctrines of optimism and progress. From these facts it is clear that these men did not turn from naturalism on impulse. They believed that art had other ends than the description of the material world.

Because Gustave Moreau lived so secluded a life, shut up in his studio on the slopes of Montmartre, and never exhibited after 1886, when sixty-five water-colour illustrations for La Fontaine's *Fables* were seen at Durand-Ruel's, his art was known more by hearsay than by example. Huysmans in his novel *À Rebours* (1884) brought him to the attention of those interested in modern art when he described Moreau's gifts as a water-colourist in terms which are still applicable: '. . . never before had the art of water-colour succeeded in reaching such a brilliancy of tint; never had the poverty of chemical pigments been able thus to set down on paper such coruscating splendours of precious stones, such glowing hues as of painted windows illuminated by the noonday sun, glories so amazing, so dazzling, of rich garments and glowing flesh tints.'[17] But all this was at the service of an almost pathologically morbid perception, of a nervous system 'altogether modern in its morbid sensibility', in Huysmans's phrase. To his contemporaries Moreau seemed modern only in his sensibility. His preferred subjects

were remote and mythological, and the content which he revealed in his indolent images of Pasiphaë or Narcissus had little to do with the robust excitements of the ancient texts.

Today we may be more puzzled than captivated by this bejewelled and intricate art. It is interesting to learn that in 1892 Moreau was unexpectedly appointed professor of painting

32. Gustave Moreau:
Hercules and the Hydra of Lerna, 1876.
Art Institute of Chicago

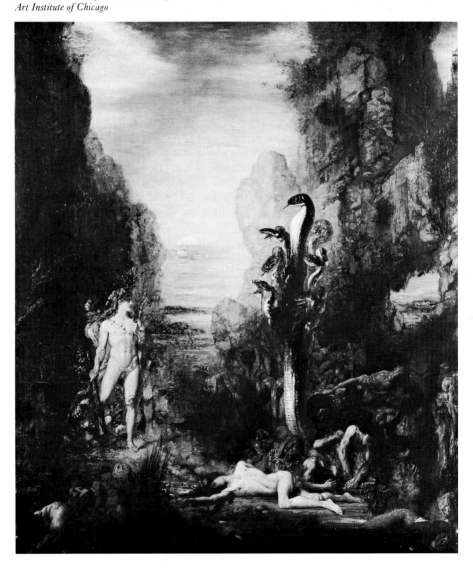

at the École des Beaux-Arts and that the recluse proved a sympathetic master, especially to Matisse, Rouault, and Georges Desvallières, who continued into the twentieth century the tradition of his smouldering colours. But in his own work there is a lack of resolution between the forms and their content, between the universal themes of death, frustration, and unconsummated desire, and the niggling, miniaturist's technique. We might even dismiss him with Degas's cynical remark: 'He would have us believe that the gods wear watch chains,' did it not do injustice to a considerable if curiously restricted talent.

Moreau knew his greatest success at the Salon of 1876 with his *Salome* that so excited Huysmans, and his *Hercules and the Hydra of Lerna* [32]. In the latter the contrast between the noble nude bodies of Hercules and of the latest victim sprawled at the monster's feet, with the broken and putrescent cadavers strewn among the rocks, recalls the horrors of Géricault's *Raft of the Medusa* sixty years before and indicates Moreau's descent from the Romantics through Chassériau, his teacher. But perhaps Moreau was more successful than his master, who had looked for a compromise between the idealism of Ingres and the passion of Delacroix; for there is much in his picture that points to the future as well as to the recent past. Moreau had said that he believed neither in what he touched nor in what he saw: 'I believe only in what I do not see and solely in what I feel.'[18] This is what the Surrealists discovered when they visited the deserted rooms in the immense house and studio which Moreau built and bequeathed to the nation as his own memorial. His landscapes quite as much as his figures could never have been seen or touched, in the sense that an Impressionist landscape communicates an almost palpable sensation of atmosphere and light. These are solely the spaces of the imagination. Behind his Hercules and beyond the looming rocks extends a vast watery plain. Unknown,

untravelled, waiting for the hero, it sleeps beneath a sun already setting through a murky twilight. Such a landscape has no counterpart on earth; it is a landscape of the mind within the dimensions of a dream.

The Surrealists' discovery of Moreau now seems inevitable as well as appropriate. Less expected has been the recent enthusiasm for his fragmentary sketches and watercolour studies, which have been offered as prophetic forerunners of Tachisme and Abstract Expressionism.[19] He must have thought them important because he had many of them framed and hung in his studio, but the fact that twentieth-century eyes, more sensitive to formal than to representational values, can discover no natural or figural references in them does not mean that they are totally abstract. What they do reveal is a Symbolist awareness of the expressive overtones of colour which was all too often stifled by Moreau's obsessive interest in descriptive linear detail.

PIERRE PUVIS DE CHAVANNES (1824–98)

In 1887, the year after the Moreau exhibition, Durand-Ruel arranged the first retrospective showing of the work of Puvis de Chavannes.[20] By then Puvis was a respected painter, best known for his first series of murals in the Panthéon in Paris (1874–8), and for those in the museums of Lyon, his birthplace, and Amiens, and for one large easel painting, the *Poor Fisherman* of 1881 (Paris). The latter captured the imagination of the younger painters and continued to do so until well past 1900. Even without the verbal testimony of their admiration it would be enough to consult such works as Gauguin's *Vision after the Sermon* [36] or Van Gogh's views of the boats on the beach at Saintes-Maries to know that its simplified and enigmatic design proved compelling. As in all Puvis's best work, the ostensibly uncomplicated and conventionally allegorical subjects seemed

to embody more than their traditional meanings.

Although Puvis thought himself the champion of tradition and spent much of his life painting large murals for public buildings, he must be counted one of the progenitors of Symbolist art. As early as 1885 August Strindberg, the Swedish playwright and painter, found that in Paris 'one name was pronounced by all with admiration, that of Puvis de Chavannes'.[21] And long after, in 1936, Émile Bernard described him as the 'true creator of Symbolism and Synthetism, because he showed the way to all the novelties in poetry and decorative art'.[22] Of these two aspects, Puvis's poetry, his choice and interpretation of his subjects, is the least accessible to us. The decline of classical learning and the bankruptcy of the values for which the familiar signs were current exchange have deprived his themes of much of their meaning. But if we overcome our reluctance to examine his work we shall find in it artistic powers of a high order.

Puvis's desire to preserve the plane of the wall in his murals (which were executed in oil on canvas and not in true fresco, although often mistaken for such, so close to stone and plaster were his colour schemes) obliged him to suppress an illusionistic third dimension. His emphasis on the plane led him to the most daring distortions, in both perspective and the figure. These distortions in turn would have been incomprehensible had they not been accompanied by a drastic elimination of every extraneous detail and the reduction of every form to its simplest and broadest contours. Even movement across the two-dimensional surface was reduced to a minimum. If Moreau's figures were trapped in a 'passionate silence', Puvis's were just as passionately still. The consequent simplification of form, light, and space was in accord with the new demand that a work of art be just such a synthesis of vision and design. Puvis's own words confirm this point of view: 'I have wanted to be more and more sober, and more and more simple. I have condensed, sum-

marized, compressed. I have tried to say as much as possible in a few words.'[23] All these aspects of his art are present in *The Shepherd's Song* of 1891 [33]. That this is a later study of a

33. Pierre Puvis de Chavannes:
The Shepherd's Song, 1891.
New York, Metropolitan Museum of Art

portion of an elaborate mural composition, the *Vision antique* of 1886 in the Palais des Beaux-Arts in Lyon, suggests that Puvis himself was as much interested in the formal relation of line, shape, and colour as in the literal poetics of subject matter. His habit of reworking his themes, of shifting a figure from one group to another, was adopted by Gauguin. His cool, chalky colours, predominantly pale blue, pink, and yellow, reappeared fifteen years later in Picasso's early Paris pictures.

Puvis de Chavannes also tried to break the hold which the official Salon exerted over the young and unknown. In 1890 he founded, with Rodin, Carrière, and Meissonier, the Société Nationale des Beaux-Arts, whose annual exhibitions until 1910 were held on the Champ de Mars. At this distance the new Salon seems scarcely more liberal and little less tiresome

than the old, but in its time it had its novelties. Here in the nineties were Sisley with his landscapes so long rejected elsewhere, a few younger Impressionists and Symbolists like Maufra, Cross, and Anquetin, Sargent and Whistler, Charles Conder, the Swiss painter Ferdinand Hodler, and the Swedish and German Impressionists Anders Zorn and Max Liebermann.

ODILON REDON (1840–1916)

In the work of Odilon Redon the antagonism between naturalism and an older romantic nostalgia for ideal beauty was resolved by the discovery of new symbols and a new pictorial method, both based upon an intentional solicitation of ideas arising in the unconscious mind. Redon, a native of Bordeaux, had thought of becoming an architect, and to that end studied structure and design until he failed the examinations. He believed that his architectural studies had provided him with certain basic techniques, such as the knowledge of forms in lighted space, but one may think that he learned quite as much about space and light from Corot, and of darkness from Rembrandt. The masters of line were also dear to him: Holbein and Dürer at first, later Pisanello and Leonardo, whose *sfumato* effects he absorbed into his mature style. At the same time that he shared the enthusiasm of the 1860s for Baudelaire and Delacroix, whose works in the museum at Bordeaux he had copied, he was bewitched, and the word is rightly used, by the new scientific discoveries, especially in Darwinian biology. Encouraged by an older scientist, Armand Clavaud, later curator of the botanical garden at Bordeaux, he studied anatomy, osteology, and microscopic life with such understanding that Pasteur, to whom he sent a copy of his first set of lithographs, *Dans le Rêve* (1879), remarked that his monsters were 'fit to live'. Redon was pleased, for he always insisted that his strangest inventions were based on a close study of living creatures.

Thus he was able 'to make improbable beings live, like human beings, according to the laws of probability by putting, in so far as possible, the logic of the visible at the service of the invisible'.[24] His method differed from those of Moreau and Puvis de Chavannes, who explored the dream world with their eyes wide open. Whereas they preferred to illustrate familiar tales, and there are no *invented* symbols as such in their work, Redon was more interested in setting beside the words a 'pictorial metaphor' (the phrase was Rémy de Gourmont's and Redon liked it). His desire, as he said, was to submit 'the torments of the imagination' to the laws of art, in order to lead the spectator's imagination to the 'frontiers of thought'. His several series of lithographs are, indeed, 'metaphorical' accompaniments to the works of such writers as Poe, Baudelaire, Flaubert, and the author of the *Apocalypse*, with whom he shared an interest in 'the ambiguous world of the undetermined'.

With only a few exceptions, Redon's lithographs are in black and white. For him black was 'the most essential, the prince of colours' (Mallarmé called his blacks 'as royal as purple'), and from the emergence of his own style about 1870 until the early 1890s he worked almost exclusively in black and white, executing several hundred charcoal drawings in which the imagery was no less imaginative than in his lithographs, and the technical skill with which he manipulated the granular and refractory medium rivalled, when it did not surpass, Seurat's.

The premises of Redon's art, as well as some of its implicit promises which were fulfilled in the twentieth century by the Surrealists, are seen in a print from the early series of 1882, *À Edgar Poe* [34]. The ambiguous title 'À l'horizon, l'ange des certitudes, et, dans le ciel sombre, un regard interrogateur' is scarcely clarified by the fragmentary apparition of the angel, who emerges as if a shutter were abruptly

34. Odilon Redon:
'À l'horizon, l'ange des certitudes, et, dans le ciel
sombre, un regard interrogateur',
from *À Edgar Poe*, 1882. *Art Institute of Chicago*

The severed head of *Orpheus* [35] is less realistic, less macabre, a reflection on the significance rather than on the fact of the poet's gruesome death. His later work became not only more brilliant but also joyous as his circumstances improved and a long series of private griefs and vexations came to an end. Many paintings and drawings of religious subjects may be tokens of his sympathy with the Catholic Revival, which numbered several of his friends as converts, but his religious convictions were always most personal and private. Among the later pastels and oils are many studies of flowers, at times as truthful as any botanist could wish, at others as magically inventive as in the *Etruscan Vase* (New York, Metropolitan Museum), where the flowers are painted in the style and colours of the terracotta vase itself. Because he examined nature with such tireless devotion, it is appropriate to discuss his colours in terms of the substances he loved so much. If Moreau's

35. Odilon Redon:
Orpheus, after 1903. *Cleveland Museum of Art*

raised on the edge of a vast sea. In the sky, whose 'dark clarity' is undisturbed by a phosphorescent cloud, the 'interrogatory glance' appears as a moon-like object fitted with an expressionless eye. The images are disparate, the shapes unrelated, yet the whole is held together by the 'torment of the imagination'. Its meaning can never be reduced to terms, for it is as much an image within an image as is the reference in the angel's face to that most mystifying of earlier reveries, Dürer's *Melencolia I*.[25]

In 1895 Redon told Émile Bernard that he was tired of charcoal and wanted to work in colour. Henceforth his remarkable feeling for exquisitely varied colour relationships, so long kept in abeyance by his obsession with the black of his 'sad art', was realized in hundreds of paintings in oil and pastel. His enthusiasm for hallucinatory images of death and terror abated.

remind us of jewels and Puvis's of stones, Redon's are like the flowers themselves. No one else, not even Degas, extracted from pastels such saffron and heliotrope, such anemone reds and blues, so much amber and gold and coral set against cerulean blue and pearl.

It is easier to understand Redon's appeal for the Symbolists than it is to account for the long years which elapsed before his art was appreciated as the extraordinary evocation of the subconscious world of dreams which it is. His first exhibition of drawings was not held until 1881, when he was over forty, and was not a success. For that reason he turned to lithography, for although his prints were published in very small editions, there were enough collectors with a taste for the fanciful to make them pay, especially after Huysmans had included Redon with Moreau among his favourite modern artists. Redon's sympathetic understanding of the younger generation led him to join in founding the Société des Artistes Indépendants in 1884, and he served as its first vice-president. As so often happened with French artists of the nineteenth century, he was soon better known abroad than at home. In 1886 he was invited, with Monet and Renoir, to the third exhibition in Brussels of Les XX. After 1890 he became known and beloved by the younger Symbolist painters, especially by Bonnard, Vuillard, Denis, and Sérusier among the Nabis. His participation in their large group exhibition at Durand-Ruel's in 1899, and the prominent position assigned him by Maurice Denis in his painting *Hommage à Cézanne* (1900, Paris), is proof of the contribution he made to the development of more decorative and abstract tendencies in early twentieth-century painting. In 1904, at the second Salon d'Automne, the year before the first appearance of the Fauves, he shared the honours of a retrospective exhibition with Monet and Renoir, and in 1913 an entire alcove at the Armory Show was devoted to his work.

Despite such interest and approval by the avant-garde, Redon's art has never been widely liked or understood. With any expression which is so fundamentally private there will always be many for whom access is difficult. Even those who are predisposed towards this world of psychic imagery may be disturbed by an inadequate mastery of that element of design by which Redon himself set so much store, the linear arabesque. Late in life he confessed that, although he had studied skeletal structures, his knowledge of anatomy was weak and that, if he were to begin again, he would pay more attention to the human body, dissecting and modelling it. One may think that a more conventional draughtsmanship might have compromised the mystery, but too often the mystery itself is jeopardized by a failure of the hand to master the form in the inner eye. This is not the voluntary simplification of Puvis, subtracting everything inessential, but an involuntary failure to add that final thrust of charcoal or crayon which would reveal the imaginative being. Nevertheless, Redon was one of the first to free the exploration of the dream world from the restrictions of literature by giving the artist licence to construct his own irrational logic, and he presented that logic in images which still repay attention.

PAUL GAUGUIN (1848-1903)

The lasting achievement of Paul Gauguin and of his friend and contemporary, Vincent van Gogh, was to have created the most masterly visualizations of the Symbolist aesthetic. Their work, so fundamentally new and so crucial for the development of Expressionism, has sometimes been eclipsed by the sordid tragedies of their lives, which were joined for a few disastrous months in 1888. To find a just balance between each man's art and the life which by turns sustained and crippled it is a difficult task. Of the two Gauguin was the more worldly, the

more ambitious, and the more innately gifted. Arrogant and selfish he may have been, but there was more truth than bravado in his words to his wife, written from Tahiti in loneliness and despair: 'I am a great artist and I know it. It is because I am that I have endured such suffering.'[26] He came late to painting, resigning from a profitable position on the stock exchange only in 1883, when he was thirty-five. He soon mastered Impressionism under Pissarro's instruction, but by 1885 was dissatisfied with a method suitable only for the description of what he saw before him. By then he knew that he would have to reject the Impressionist aesthetic, which he always thought had been 'shackled by the need of probability', if he were ever to achieve 'the translation of thought into a medium other than literature', the expression of 'phenomena which appear to us as supernatural, and of which, however, we have the sensation'.[27] His problem thenceforth was to find themes with which to symbolize such sensations, and a technique appropriate for their presentation.

From his first visit to Brittany in 1886 and his trip to Panama and Martinique the following year he brought back paintings which already differed from Impressionism in their brighter colours and exotic subjects. But he was also looking at works other than Impressionist for the secrets of expressive power. Like the Pre-Raphaelites, he saw in the art of the Quattrocento a quality which he felt had been lost. The spaces of Fra Angelico and the rhythms of Botticelli, which he knew from photographs, can be traced in his work for years to come. The colour patterns and strong contours of Japanese prints also impressed him, and he laid tribute on other arts, on medieval tapestries, folk art, the clumsy stone sculpture of Breton churches, and arts even farther afield. Gauguin boasted of his 'savage blood'; through his mother he was descended from Spanish grandees who had settled in Peru, and as a child he had lived in Lima for

four years. 'Primitive' arts appealed to him, not only those then erroneously considered primitive, such as Egyptian and Cambodian sculpture, but the prehistoric arts of Central and South America, which were seen for the first time in any quantity at the Exposition of 1889. In all these he found what he needed, an attitude towards design in which expressive need took precedence over natural fact. Eventually his search led him to conclude that the sources of art lie deep within human consciousness and that painting should return to its original purpose, the examination of the 'interior life of human beings'.[28] In words which give the lie to the belief that he was inarticulate he stated his conception of the basically emotional character of the artistic process: 'Where does the execution of a picture start, where does it end? At the moment when intense feelings are fused in the depths of one's being, when they erupt, and [the whole] thought flows forth like lava from a volcano. Is not that the work then, suddenly created, brutally if you wish, but great and superhuman in appearance. Cold and rational calculations have nothing to do with this eruption, for who knows when, in the depths of his being, the work was begun, perhaps unconsciously?'[29]

The inability of the Naturalists and Impressionists to represent experiences which cannot be explained by sense perceptions was surmounted by Gauguin in his first completely Symbolist painting, the *Vision after the Sermon*, finished in October 1888 [36]. The outward and inner events, the priest and peasants and their recollection of the sermon they have just heard (on Jacob wrestling with the angel), are separated by discrepancies of scale, perspective, and colour. In the foreground the devotional mood is presented by the coifs, folded hands, and figures kneeling at the left. Between them and the biblical apparition a tree divides the picture diagonally into its physical and psychic halves. Japanese influence accounts for the flattened

36. Paul Gauguin:
The Vision after the Sermon – Jacob Wrestling
with the Angel, 1888.
Edinburgh, National Gallery of Scotland

forms with dark contours, the areas of pure colour, the absence of shadows, and the wrestling figures, which are actually after a drawing by Hokusai. The unnaturalistic colour, especially the dominant red ground, indicates Gauguin's attempt to reach a synthesis by 'complication of the idea through simplification of the form', that 'synthesis of a single form and single colour in which only the essential counts'.[30]

To name the elements in the picture, however, is not to identify the impulses which brought them together. During the summer of 1888 at Pont-Aven in Brittany Gauguin worked with a much younger artist, Émile Bernard. For some two years Bernard and Louis Anquetin had been painting in a patterned, heavily contoured manner which they called *cloisonnisme* because the dark outlines between the colours resembled the metal divisions in *cloisonné* enamel. When he arrived at Pont-Aven Bernard painted his *Market in Brittany – Breton Women in the Meadow* (St Germain-en-Laye, Collection Mlle Bernadette Denis) as a demonstration of his theories. Although Bernard's painting impressed Gauguin (he took it with him to Arles that autumn, where Van Gogh copied it in water-colour), it seems now a contrived and inexpressive work.[31] Its weakness can probably

be traced to Bernard's belief that painting is primarily decorative rather than interpretative. But the flat, empty faces and the pattern of coifs that are common to both works prove how much Gauguin took from his young friend. Because his appearance at Pont-Aven coincided with a turning-point in Gauguin's thinking, Bernard's historical importance as a catalyst must be recognized. His peculiar draughtsmanship still lingers in the major paintings of Breton subjects which Gauguin executed during the summer and autumn of 1889, namely *La Belle Angèle* (Paris), *The Yellow Christ* (Buffalo), and *The Calvary* (Brussels).

Gauguin had offered the *Vision* to the village church at Nizon near Pont-Aven, but the bewildered curé's refusal to accept it is more understandable than the opinion still current that Gauguin's paintings are devoid of religious meaning, and that his intransigent anti-clericalism, then and later, deprives his work of any spiritual content. Religious he may not have been in any orthodox sense, but his religious paintings are anything but irreligious. The Brittany pictures, and later those depicting the myths of Polynesia, even his strange combinations of Tahitian figures and Christian rites, embody more than his respect for the simple piety of the unlearned: they exemplify his recognition of a metaphysical mystery for which devotion, rite, and image are outward and visible signs.

Gauguin's signs, however, are not always easy to read. Like Redon's, they were intended to awaken in the spectator sensations analogous to the artist's. The large wood relief of 1889-90, *Be in Love and You Will Be Happy* [37], was, in his own opinion, his 'best and strangest work' until then. It reminds us that he was not only a painter, but with a versatility he shared with Degas whom he so admired, he was sculptor, engraver, and ceramist as well. In this carving – one of his finest – he has left behind the diluted decorative effects of Bernard for complex formal, psychic, and sexual connotations. He described the subject as the artist himself, 'like a monster, seizing the hand of a woman who resists him, and telling her, "Be in love and you will be happy"'. The fox, he added, 'is the Indian symbol of perversity'.[32] The effect is like a nightmare of unsatisfied desire, possibly a symbolic statement of his own domestic misery, of the separation from his wife and children which became permanent when he had to leave them with her family in Copenhagen in 1885. The frequent changes of scale in the figures, the fact that only parts of some appear, a torso here, a hand or head there, reinforces the impression that we are peering deep into a dream where figures and faces emerge into half-consciousness and then withdraw. The principal figure is crudely carved, the outlines simplified, the planes flattened and brought forward to the surface. All the faces seem more African or Asian than European. The relief undoubtedly incorporates memories of Martinique, as well as of the 'primitive arts' he had seen at the Exposition of 1889, and substantiates his words to his wife that in him there were two natures, 'the Indian and the man of sensitivity'.[33]

After he had had six years as a professional artist his money was gone, his collection of Impressionist paintings sold or in his wife's possession, and no one would purchase his work. To attract customers he organized, with Bernard and other young artists who had worked with him at Pont-Aven and in Paris, an exhibition on the grounds of the Exposition of 1889, in the Café des Arts, since known by the name of its proprietor, Volpini. This exhibition of the 'Groupe Impressionniste et Synthétiste' was the first public demonstration of Symbolist art. In addition to seventeen works by Gauguin and twenty-three by Bernard, there were paintings by Schuffenecker, Anquetin, and Charles Laval, who had gone to Martinique with Gauguin. Gauguin's first prints, an album of zincographs, could be seen on request.

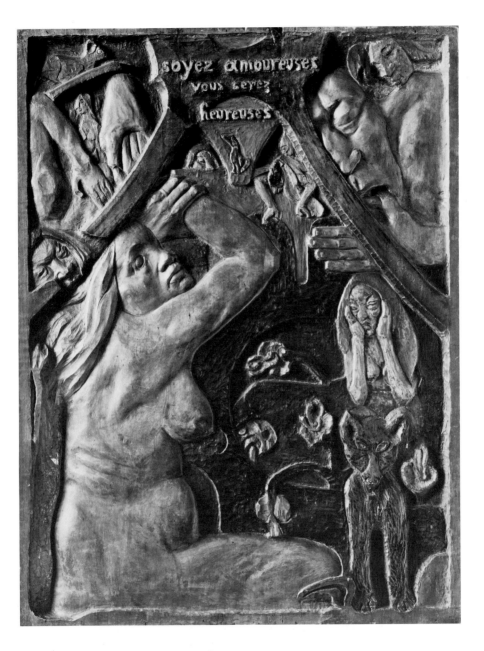

soyez amoureuses
vous serez
heureuses

37. Paul Gauguin: Be in Love and You Will Be Happy, 1889-90. *Boston, Museum of Fine Arts*

Unfortunately this first and only inclusive manifestation by the group which became known as the School of Pont-Aven attracted little attention, and Gauguin's finances deteriorated to such an extent that he decided to find a more sympathetic and less expensive place to live, far from France and Paris. After long and difficult negotiations with the Colonial Office he departed for Tahiti on 4 April 1891. To secure funds he had held an auction of his own work on 23 February.[34] The sale was only a moderate success, but among the purchasers was Degas, who bought *La Belle Angèle*. The criticism published for the occasion was quite as important, because it established the relation between Gauguin's ideas and those of his friends

among the literary Symbolists, particularly Moréas, Julien Leclercq, Charles Morice, and Mallarmé. The most important article was Aurier's 'Le Symbolisme en peinture – Paul Gauguin', which appeared in the March issue of the *Mercure de France*, the most substantial Symbolist journal. Although the terms in which Aurier tried to define the new style were too general and too personal to gain currency, they captured something of the meaning Gauguin's painting had for the sensitive contemporary observer. After evoking Baudelaire and his doctrine of the mysterious correspondences between nature and feeling, Aurier concluded that a work of art should be 'Idéiste' (a 'barbarous neologism', as he admitted), 'because its

38. Paul Gauguin:
Aha oe Feii? – What! Are You Jealous?, 1891–2.
Moscow, Pushkin Museum

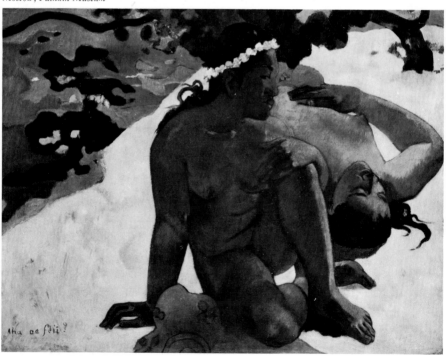

sole ideal is the expression of the Idea; Symbolist, because it expresses this Idea through forms; Synthetist, because it presents these forms, these signs, in such a way that they can be generally understood; Subjective, because the object is never considered merely as an object, but as the sign of an idea suggested by the subject; and Decorative, because truly decorative painting as conceived by the Egyptians and probably by the Greeks and the primitives, is simultaneously subjective and synthetic, symbolic and *idéiste*'.

Gauguin has for so long been identified with the romantic image of the civilized man fleeing the moral restraints of western society to live like a noble savage (or in his case, as an ignoble beachcomber), that his Tahitian paintings have been preferred to his earlier work. Although they are more spectacular in colour, size, and subject than the Brittany pictures, they are not thereby more novel. If Gauguin had never seen Tahiti, the essential elements of his style would not have been different. Tahiti supplied him with new themes, but he interpreted them in the tradition of French art. The *Hina Te Fatou - The Moon and the Earth* - of 1893 (New York, Museum of Modern Art), which once belonged to Degas, is unthinkable without Ingres's *La Source*. The recumbent nude in *Nevermore* of 1897 (Courtauld Institute Galleries, University of London) is a variation of Manet's *Olympia*, which Gauguin had copied in water-colour. The tropically sensual forms and colours of *Aha oe Feii? - What! Are You Jealous?* [38] cannot conceal the traditional pictorial architecture of the first figure's body. Surprisingly, it was to reappear a decade later in Maillol's most 'classic' sculpture, his *Mediterranean* of *c.* 1901 [77]. Even the religious paintings, like the tender *Ia Orana Maria - I Greet Thee, Mary* - of 1891 (New York, Metropolitan Museum), painted during his first year in Tahiti, continues the sequence of Breton subjects, now translated into Tahitian with the attendants' gestures taken

from a photograph of a Cambodian relief.[35] The combination of elements is typical of Gauguin's fundamentally European, as well as eclectic, taste. Even in the purely Tahitian subjects, like the majestic *Te aa no Areois - Queen of the Areois* (New York, William S. Paley), his vision of the simplicity and beauty of primitive life was expressed in terms of Egyptian sculpture, which he considered one of the supreme accomplishments of western culture. It is hard now to understand why these paintings were so unfavourably received when they were shown at Durand-Ruel's in November 1893, three months after Gauguin had returned to Paris, discouraged by his failure to make a living in Tahiti. But the public had looked so long on the tarnished colours of academic painting, or been so dazzled by the vivid hues of Impressionism, that it was insensitive to the subtlety of his close weaving of related tones, his pinks with purple, his yellows beside orange and coral, against contrasts and complementaries.

The eighteen months he spent in France added little to his art or to his reputation, which were of so little account that at another auction of his recent work on 18 February 1895 he had to buy back no less than forty-seven of the seventy-four paintings and drawings, among them the masterpieces of the first Tahitian period. For the occasion he had asked Strindberg for an introduction to the catalogue. Strindberg's letter of refusal was so candid that Gauguin published it with his own reply. Both documents contain important and now familiar statements which will bear re-reading.[36] Strindberg's letter included a reference to Puvis de Chavannes, whose work he preferred to Gauguin's. The latter let the remark stand, for there was little he could say, his own art being more indebted to Puvis for its final formulation than to any other contemporary artist. Memories of *The Poor Fisherman* and of *The Young Women beside the Sea* (Paris, Louvre) are threaded through the masterpieces of the Tahitian

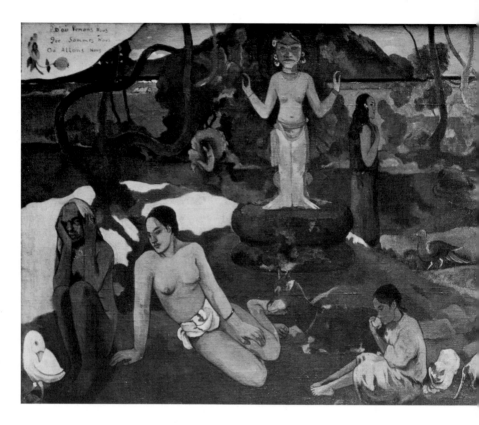

39. Paul Gauguin: Whence Come We?
What Are We? Where Are We Going?, 1897.
Boston, Museum of Fine Arts

period. The relation between Puvis, foremost of the older allegorical painters, and Gauguin, first of the new, is important. A few years later Gauguin explained to Charles Morice the differences between Puvis's art and his own: 'Puvis explains his idea, yes, but he does not paint it. He is Greek, whereas I am a savage, a wolf in the woods without a collar. Puvis will call a picture *Purity* and to explain it will paint a young virgin with a lily in her hand – an obvious symbol, which is understood by everyone. Gauguin, with the title *Purity*, paints a landscape with a limpid stream; no taint of civilized man, perhaps a figure.'[37]

With these distinctions in mind, between allegory as the explication of a thought existing

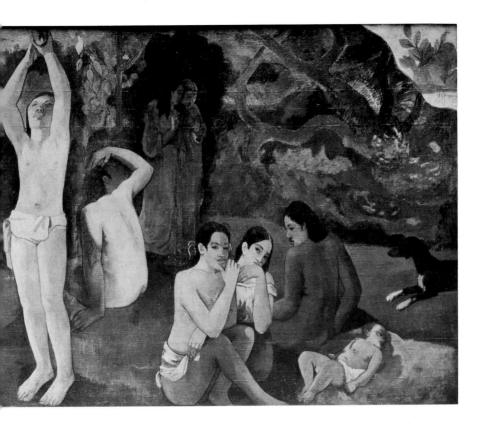

before the pictorial form has been conceived, and symbols as forms equivalent to but not identical with the thought to be expressed, we can approach Gauguin's largest and most truly Symbolist painting with less bewilderment than greeted it at Ambroise Vollard's gallery late in 1898. On that occasion André Fontainas, himself a Symbolist poet, published a sympathetic review of the exhibition, the first to be held since Gauguin's second departure in 1895, but he declared he could make nothing of *Whence Come We? What Are We? Where Are We Going?* [39]. Fontainas deplored 'the dream figures, dry, colourless, rigid, presented without precision, the forms badly produced by an imagination maladroitly metaphysical for

which meaning is difficult and expression arbitrary'.[38]

Fontainas was not the last to think Gauguin's metaphysics 'maladroit', but at least he was unaware of the artist's own account of the origin and significance of this work, which he had begun in a state of profound despair, just before his attempted suicide, and which he intended as a testament of his artistic convictions. Gauguin's justification of his right to construct his own sequence of symbolic images is contained in three important letters.[39] The last account is the most summary: 'Day-to-day existence. The man of instinct wonders what all this means.' But he added, 'explanatory attributes – known symbols, would congeal the

canvas into a melancholy reality, and the problem would no longer be a poem'. In the first letter, written soon after the picture was finished, he spelt the figures, from right to left, as the passage between birth and death. But that they signified more than so hackneyed a text could convey is suggested by his statement: 'I have finished a philosophical work on this theme [of the title] comparable to the Gospels.' His second letter, a lengthy reply to Fontainas written in March 1899, contains his most memorable statement about the Symbolist work of art. After calling attention to the musical elements in modern painting ('Colour, which is vibration, just as music is, reaches what is most general and therefore vaguest in nature: its interior force'), he evoked the synaesthetic sources of his own art: 'Here in my hut, in complete silence, I dream of violent harmonies in the natural scents which intoxicate me. A delight distilled from some indescribably sacred horror which I glimpse of far off things. The fragrance of an antique joy which I am breathing in the present. Animal shapes of a statuesque rigidity: indescribably antique, august, and religious in the rhythm of their gesture, in their singular immobility. In the dreaming eyes is the overcast surface of an unfathomable enigma. And comes the night when all things are at rest. My eyes close in order to see without comprehending the dream in the infinite space stretching before me, and I have the sensation of the melancholy progress of my hopes.'

Gauguin offered several readings in all for these 'images within images'. Their number is immaterial, but we can at least see that the symbols were intended to provoke questions which we cannot and perhaps should not try to answer. One concerns the relative value of civilization and primitive life. Gauguin told Morice that 'two sinister figures in the right background are recording near the tree of silence their note of anguish caused by this very science'. But more fundamental than any interpretation, which would only be relevant to the surface of life, is the deeper psychic experience, that 'indescribably sacred horror' that Gauguin experienced in the act of dreaming.

In his letter of 1901 to Morice, Gauguin remarked of the 'big canvas' that 'so far as the execution is concerned [it] is very imperfect; it was done in a month without any preparation and preliminary study'. The picture is, indeed, hastily brushed on coarse sacking in thin layers of paint, with dark purples, blues, and greens as background for the dull yellow figures. In his last years Gauguin was often hard put to find paints and canvas, and many of his late works show these same colours laid thinly on cheap cloth. In rejecting the traditional standards of the schools he had always preferred a broad, even brutal craft, and from adversity he extracted new effects. This ability to see and accept the nature of materials is one of his strongest claims on the attention of artists today. He advised Daniel de Monfreid to mix a little sand with his clay so that he could not too skilfully model a nostril with a twist of the finger. And there is a hint of the Surrealists' ability to exploit double images in his statement that he discovered in the graining of a wooden plank the image of the severed head of the king for his *Arii Matamoe – The End of the Royal Line* (Paris, private collection). In his ceramics, of which he made a considerable number before 1891, he incorporated the accidents of the kiln. But nowhere was matter 'more enriched by the artist's hand', as he put it, than in his graphic work. Almost alone he accomplished a renewal of wood engraving, which had become exhausted in the technical brilliance of commercial illustration. By printing his roughly gouged blocks, probably by hand and without a press, on different coloured papers and in several colours, usually dark red, brown, purple, and yellow, he achieved a variety of unusual, even 'primitive' effects, in which the character of the wood grain was preserved.[40] His first group of

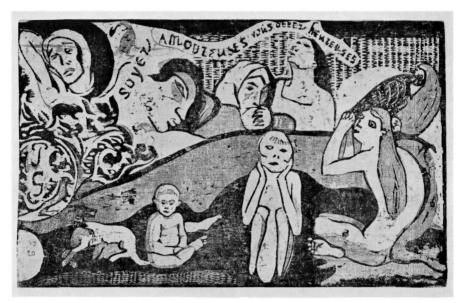

40. Paul Gauguin: Be in Love and You Will Be Happy, *c.* 1893-5.
Art Institute of Chicago

ten woodcuts, all of Tahitian subjects, was made in 1893-5 in Paris. The engraving, *Be in Love and You Will Be Happy* [40], is a later and much changed variant of the earlier relief. The wood was coarse and fibrous, the cutting more abrupt and 'Synthetist' than anything he had done for several years. The distortions are so violent, especially in the figures to the lower right, that it is clear how much the Fauves of 1905 owed to him.

When Gauguin's poverty, illness, and loneliness were ended by his death in 1903 in the remote Marquesas, whither he had followed his dream of a simpler and less corrupt existence than he had found in Tahiti, there were only a few who were aware that a great artist had been lost to France. Among them Charles Morice, who had collaborated in the publication of Gauguin's first Tahitian manuscript, *Noa-Noa*,[41] revived his memory for the twentieth-century public with his memorial articles.

These encouraged the sponsors of the newly founded Salon d'Automne to arrange a comprehensive retrospective exhibition in 1906. The coincidence of this with the first demonstrations of the Fauves at the same Salon in 1905 and 1906 established the influence of Gauguin upon the younger masters of decorative design, chief among them Matisse. His influence upon German and North European Expressionism after 1890 was even more conspicuous. Nevertheless, the understanding of his art has been handicapped by those aspects of his work which his contemporaries most admired, the decorative and literary. An age which was soon to believe that the quality of a work of art can be deduced from its formal properties alone, and that representational elements are at best superfluous, granted Gauguin his place with the Post-Impressionists, but some steps below Seurat and Cézanne. To describe his work as decorative is to imply that its formal and

expressive elements are vitiated by surface charm. In the least of them this is so, and an inferior Gauguin is more frequent than an inferior Cézanne. But in his rejection of naturalism, in his examination of the unconscious creative process, and in his exploitation of that process in his materials, Gauguin anticipated much recent art. At his best his paintings have a tragic grandeur which, as Octave Mirbeau wrote, was most accessible to those who had known 'sorrow and the irony of sorrow which is the threshold of mystery'.[42]

VINCENT VAN GOGH (1853-90)

Van Gogh's life is even more difficult to disentangle from his works than Gauguin's; for were his paintings worthless, his history would still command attention. It was a dramatic and tragic adventure which he both lived and described. His autobiography in the form of some 755 letters to his devoted brother Theo and a few friends is one of the most relentless documentations of the search for the self in literary history. In his paintings and drawings Van Gogh also illustrated that life, literally and figuratively. Each of his pictures was a stage in his search, each 'a cry of anguish', as he said, so that to understand his art it is not enough to judge it in purely artistic terms. From 1881, when he decided to be entirely an artist, his art was indistinguishable for him from that reality which he hoped his life would become.

He had tried to discover himself, his own reality, in others' lives and in other ways of living, and each attempt had been a more hopeless failure. He had been born in a small Dutch village, the son of a protestant pastor, three of whose brothers were art dealers. This heritage was important, because his life was spent in the service alternately of art and of religion until he discovered his own synthesis of their claims. In 1869 he went to work for the French dealers, Goupil and Co., in their branches in The Hague, London, and Paris. He was dismissed in 1876 as incompetent. By then he had learned to loathe the insincerity with which art dealers, to his mind, preferred the popular article to the true work of art; but his own conception of artistic value was queerly muddled. From the lessons he had heard from his father's pulpit and his own conception of Christian charity, he believed the best art was that which best expressed the sufferings of the poor. In London, in 1873-5, he became familiar with English illustrative engraving, and admired the anecdotal paintings of Herkomer, Fildes, and Holl. He found in their studies of the poor and homeless the same humanitarian sympathies he admired in the novels of Dickens and George Eliot. By the time he settled at The Hague in December 1881 he had collected several thousand engravings cut out of English, French, Dutch, and Belgian illustrated papers. Such material, we might think, would have been the worst source for any contribution to progressive art, and it is true that Van Gogh only gradually mastered his taste for sentimental subject matter. As late as 1882 he confessed to his brother that he had just begun to realize that Daumier was more than merely a clever caricaturist. But among the painters of sentiment there were some from whom he learned much about picture-making: from Rembrandt, whose greatest successor in Dutch painting he became, and from Millet, whose noble design contributed much to his own conception of the heroic aspects of peasant life. His early admirations are also important, in so far as they warn us not to dismiss any of his works as mere technical exercises. Each had its own purpose as a statement of his beliefs and state of mind at the time. As he wrote of one of his landscapes of the Rhône, it was a 'crude effort, and yet I am trying to get at something utterly heartbroken and therefore utterly heartbreaking'.[43] The problems of Van Gogh's art are thus different in kind as well as in degree

from those of his French contemporaries. Its function was intentionally less artistic than social, and less social than personal. It answered his need for communication between himself and others, in the course of which he hoped to find the love that was always withheld and for lack of which he died. Since he justified his art by the truth of his feelings, his art is totally self-expressive. When it achieves, as it does at times, a more than personal power and beauty, it is expressive to such a degree that it became almost immediately, although too late to save him, one of the principal sources for the broader currents of European Expressionism.

Feeling alone is not enough; its privacy inhibits communication. Van Gogh's problem was to find and then to master a manner with which he could, as he wrote Theo in 1881, give form to his feelings, to 'the things that fill my head and my heart [and] must be expressed in drawings and paintings'.[44] He had always drawn, even as a child, and in 1880, when he realized that his missionary work among the Belgian miners in the Borinage was a failure, he began drawing again, making studies of working people in everyday dress and comparing them with the figures in popular handbooks. The wonder is not that for so long his drawings were, as he knew, crude and ill-proportioned, but that so soon and so surely his characteristic style appeared in the tight, angular contours and richly worked surfaces, even in the ungrateful charcoal he used so much at first.

Although Van Gogh sought and occasionally received instruction, he was unteachable and ultimately self-taught. The bitter quarrels which ran through his life may be explained as the result of his inability to accept any discipline, and his successes are the more triumphant proof that at times he could submit to the most difficult of all disciplines, that of the self. Since he could not abide the opinions of others, he had to discover most of the secrets of his craft for himself. An example of his early

method is the pen drawing of a wintry Dutch landscape [41]. The attention to peculiarities of structure in each tree is symptomatic of his insistence on the closest fidelity to nature. The peculiar pull of the perspective is the result of his self-directed research. At The Hague in 1882 he had devised an 'instrument for studying proportion and perspective', such as Dürer had described and 'the old Dutch masters used'. It was no more than a rectangular frame across which strings could be stretched in a pattern of squares, or, as in the sketch Van Gogh drew for his brother, in a schematic indication of perspective by means of strings stretched from the centre of each side and diagonally from the corners.[45] If the pattern so formed is ruled across the drawing reproduced, the horizontal and vertical median lines and one diagonal will intersect upon the two smallest trees in the distance. The effect of this device, if not its actual use, may be seen much later in certain landscapes of Provence, where one's eye is irresistibly drawn to the mathematical centre of the scene. His instrument, however, was not a crutch but an aid to his vision; for upon the scheme it revealed he built up each separate form with the pen, modulating the width and direction of each stroke to create the rounded tree-trunks, the lithe young branches, and the dry, trodden grass.

This drawing was made at Nuenen, where Van Gogh lived with his family for two years after leaving The Hague. He had spent almost fifteen months in the capital, studying first with the popular painter Anton Mauve (1838–88), a relative by marriage. But Mauve grew impatient with his odd behaviour, and they quarrelled. Nevertheless, Van Gogh kept an affectionate respect for the older man, and there is much of Mauve's subtlety of colour in his own work, as well as a similar preoccupation with the simplest aspects of Dutch landscape and peasant life. In that life he found the formal sources and expressive character for

41. Vincent van Gogh: Pollarded Birches with Shepherd and Peasant Woman, 1884. *Amsterdam, Rijksmuseum Vincent van Gogh*

his first masterpiece, *The Potato Eaters* [42], painted at Nuenen in May 1885. The works of the Nuenen period (1883-5) seem dark when compared with the vivid palette he discovered in Paris and Provence, but they are not more dark than much contemporary Dutch painting, and they are already irradiated by Van Gogh's peculiar intensity. The theme of the peasants' meal has obvious overtones of Millet and the ethic of Barbizon. The quick, nervous brushing of the highlights on heads and hands is close to Hals, and the effect of light prevailing against darkness, and in the contest illuminating the inner as much as the outer man, is a debt he owed to Rembrandt. The execution of this work proved long and troublesome. Van Gogh admitted that it had become a 'tissue of rough, coarse aspect', he was dissatisfied with the lack of relation between the heads and bodies, and in the end he painted two versions.[46] But the coarseness was an inextricable part of the fabric, since his intention was not to portray the peasants in their Sunday best, as did the popular masters of the picturesque, but in their 'roughness', in order 'to emphasize that those people, eating potatoes in the lamplight, have dug the earth with those very hands they put in the dish, and so it speaks of *manual labour*, and how they have honestly earned their food'. His painting was soon to increase in skill, but nothing he did was ever a more convincing expression of his power. Our eyes, habituated to contrived faults, are no longer disturbed by the crudities and disproportions.

Since Van Gogh could live with no one, least of all with his family, he left Nuenen late in

42. Vincent van Gogh: The Potato Eaters, 1885.
Amsterdam, Rijksmuseum Vincent van Gogh

1885 for Antwerp, where he worked in the academy and in a free drawing school, and where for the first time he seems to have had direct contact with Impressionism and Japanese prints. But he had little or no money, and by the middle of February 1886, facing a physical and nervous breakdown, he left for Paris to join Theo, now an assistant manager for Boussod and Valadon. His two years in Paris transformed him from an awkward imitator of nineteenth-century Dutch realism into a master of modern design, but at too rapid a pace for his peace of mind. He saw the full richness of Impressionist painting at last and accepted its brilliant palette. For a while he worked in Cormon's studio, where he met Toulouse-Lautrec and Émile Bernard. Seurat he knew slightly, and he briefly adopted some aspects of Divisionism.

But more important than his conversations with Bernard about a new method of painting in flat areas of unbroken colour was his friend-ship with Gauguin, who confirmed his belief, already half-formulated at Nuenen, that 'colour expresses something in itself'. The discovery that colour has inherent expressive properties apart from its descriptive usefulness became for Vincent, as he called himself in France, the password to that 'new art of colour, of design' which he believed was imminent. Although Gauguin and his friends from Pont-Aven were seeking for this new art to save themselves, Vincent hoped that it would enable him to save others, that through the radiance of his coloured light he could create images that would have the power to stay the desperate and con-sole the lonely.

Paris soon proved too distracting for this serious, humourless Dutchman. Irritable, impatient, and totally self-centred, he argued himself into quarrels and drank to regain self-confidence. With his health seriously impaired, he set out in February 1888 for Arles, hoping to find a milder climate and less costly living. His manners and appearance so repelled all but a few of the reserved and suspicious inhabitants of Arles that he was soon as lonely as ever and drugged himself with tobacco, alcohol, and work. During the summer of 1888, in his first enthusiasm for the landscape and light of Provence, he painted some of his most serene and coherent masterpieces. His intense colour,

Impressionist in its brilliance but Synthetist in the broad planes bounded by firm, Japanese contours, appears at its best in the portrait of the *Postman Roulin* (Boston), his own *House at Arles* (Amsterdam, Van Gogh Museum), and in the two versions of his bedroom (Amsterdam and Chicago). In the paintings of that small room, furnished with such care and pride – for it was, he thought, his home at last – we have perhaps the only tranquil image he was ever to paint. By then the irresistible pressures were close upon him. They permeate the baleful *Night Café* [43], in which the symbolic values he now attributed to colour and design were explicitly revealed. In a letter to Theo he explained how

43. Vincent van Gogh: The Night Café, 1888.
New Haven, Conn., Yale University Art Gallery

44. Vincent van Gogh: Dr Gachet, 1890. *Private Collection*

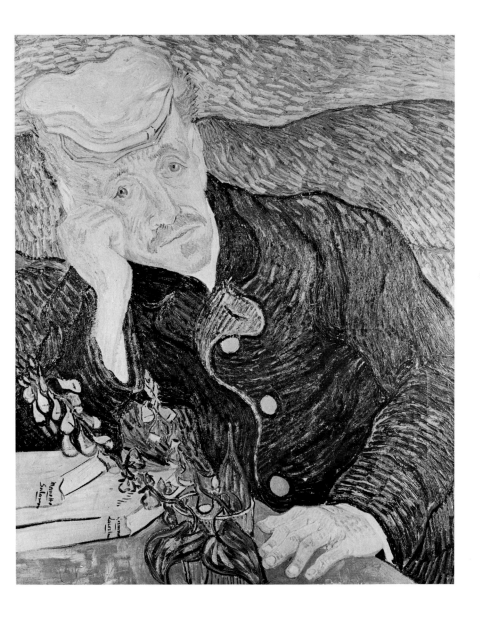

he had painted the picture, 'one of the ugliest I have done', in disharmonies of red, green, and yellow, 'colour not locally true from the point of view of the stereoscopic realist, but colour to suggest any emotion of an ardent temperament'. By means of red and green he had 'tried to express the terrible passions of humanity [and] the idea that the café is a place where one can ruin oneself, run mad, or commit a crime'.[47] In its very execution the painting is a demonstration of passion, so thickly are the impastos built up, so violent the discrepancies between the original visual experience and the pictorial interpretation.

The harsh and tragic expressiveness of the *Night Café* is a clue to Vincent's inner turmoil at the time. In such circumstances, the arrival of Gauguin in October could only lead to catastrophe. To the shrewd Parisian stockbroker turned painter Vincent's insistence on the moral values of art seemed childish, but Gauguin's sophisticated aesthetics were just as antipathetic to Van Gogh. At first their discussions had seemed 'electric', but in the end they became unendurable. On 24 December Van Gogh lost control of himself, ineffectively attacked Gauguin, and mutilated his own left ear.[48] When he recovered his senses he understood that he was subject to attacks of insanity, and in May 1889 he voluntarily entered the asylum at Saint-Rémy. There he remained for a year, with periods of agonizing inertia alternating with lucid intervals in which he painted as intensely as ever. By May 1890 he felt sufficiently recovered to return north, and after a brief visit to Theo, his wife, and infant son in Paris, he settled at Auvers-sur-Oise to be near Dr Paul Gachet, an eccentric physician who was interested in art and psychiatry and who had known Cézanne and Pissarro twenty years before. Independence, which was only loneliness, proved intolerable. On 27 July, while painting a landscape beside a road near Auvers, he shot himself, and died two days later.

Van Gogh's madness has inevitably confused the evaluation of his work. It is true that he was at times insane, although the precise nature of his illness has never been satisfactorily diagnosed, and it is equally indisputable that the paintings executed after his first attack are more distorted in drawing, more vehement in brushwork, one might even say more expressive.[49] But they are not thereby the works of a madman. Van Gogh painted only when his mind was clear, and the specific character of his later work can be postulated on the promise of the earlier. In his last canvases the colour is finer, more subtle, and the contrasts of complementaries less insistent. Both line and colour are more responsive to his demands, as in the blue and yellow harmonies built upon linear arabesques in his portrait of Dr Gachet [44] with the 'heartbroken expression of our times'. It was no madman who could write of such works, as Vincent did in the letter Theo found in his clothes as he lay dying, that they would 'retain their calm even in the catastrophe'.[50]

With Van Gogh, as with Gauguin and to some degree with Cézanne, the progression from descriptive realism to an art in which feeling was symbolized by colour and design, was achieved by immense suffering, which imparts to such painting its tragic seriousness. In all his work this is nowhere more poignant than in his still lifes, where the humblest garden plants are the instruments of poetic communication. And nowhere is this achieved with more intensity than in the canvases of the *Sunflowers* [45]. The symbolism of these compositions in which yellow, that most unmanageable of

45. Vincent van Gogh: Sunflowers, 1889. *Amsterdam, Rijksmuseum Vincent van Gogh*

colours because it admits so few gradations of value, is manipulated in various hues and intensities, was summarized by Van Gogh in the word 'gratitude', to which may be added the mystical significance he attributed to the sun and to sunlight as cosmic manifestations of life.

The several *Sunflowers* were to decorate Gauguin's room in Arles, but later they were added to the portrait of the postman's wife, the *Woman rocking a Cradle* [46], so that the latter, framed on either side by the flowers, would make a 'sort of decoration; for instance, for the end of a ship's cabin'.[51] The portrait was to be a picture 'such as a sailor at sea who could not paint would imagine to himself when he thinks of his wife ashore'. Van Gogh's words indicate how he had passed from the close observation of nature to the construction of images based on interior vision. In 1889, when his convalescence forced him to work indoors and without a model, he was dependent, like the sailor, on his imagination. Even before that he had written: 'I have a terrible lucidity at moments, these days when nature is so beautiful. I am not conscious of myself any more, and the picture comes to me as in a dream.'[52] To his reliance upon memory there was added another factor, the intentionally 'primitive' aspect of the figure, for as he wrote to Theo: 'When you see it you will agree with me that it is nothing but a chromo-lithograph from the cheap shops, and again that it has not even the merit of being photographically correct in its proportions or in anything else.' For his purposes Van Gogh had destroyed the authority of the schools. Like Gauguin and Bernard in Brittany, he went to the sources of popular visual experience, to the prints sold in the shops, for designs which would have instantaneous meaning for people untutored in the ways of Paris. He thought of his colours, too, as recapturing something of the rude vigour of the popular prints. The clash of red and green in the *Woman rocking* is sharpest in the foreground in the opposition between the green skirt and the red chair and floor, more sensitive in the papered wall behind, where the pattern of flowers against a circular repeat is rendered with 'primitive' attention to detail.[53]

Until the last year of Van Gogh's life his works were infrequently exhibited, although Theo had sent a few examples to the Indépendants in 1888 and 1889. Then in 1890 he was invited to exhibit with Les XX in Brussels, where the only painting he ever sold, his *Red Vineyards at Arles* (Moscow), was seen by the Belgian painter Anna Boch (1848–1935), who subsequently acquired it.[54] In January Albert Aurier's article, 'Les Isolés – Vincent van Gogh', appeared in the *Mercure de France*. This, the first and only critical review published on Van Gogh in his lifetime, was reprinted in *L'Art moderne* (Brussels) and contributed to the interest and antagonism his work aroused. To the Indépendants in Paris that spring he sent ten paintings, so that the range of his talent could be seen at last, too late. But his prodigious influence on twentieth-century painting derives from the exhibitions held after 1900. The first retrospective at Bernheim-Jeune's in Paris in 1901 was an important factor in the development of Fauvism, corroborated by another at the Indépendants in 1905. The exhibitions at Amsterdam (1905) and at the Sonderbund in Cologne (1912) and Berlin (1914) confirmed his position for the painters of Germany and Northern Europe. His influence reached the English-speaking world in 1910 at the Post-Impressionist exhibition in London, and in 1913 at the Armory Show in New York. Our knowledge of his life and works is largely due to the devotion first of Theo's widow, Johanna van Gogh-Bonger, and later of their son, Ir V. W. van Gogh of Laren, who published his letters and lent from their great collection to innumerable exhibitions throughout the world.

46. Vincent van Gogh: Woman rocking a Cradle (Mme Roulin), 1889.
Otterlo, Rijksmuseum Kröller-Müller

groupe aura à entendre la lecture d'un rapport relatif à ces difficultés qui pourraient se renouveler, paraît-il, en ce qui concerne les expositions des Gobelins et de Beauvais.

<center>°₀°</center>

Entre sceptiques :
Pourquoi appelle-t-on l'amour une affection ?
— Probablement parce que c'est une maladie !

<center>•*•</center>

Mlle Lili, âgée de trois ans, interroge son frère, le petit Jacques, gentleman de sept ans.
— Qué c'est ça sur la table ?
— Des poireaux.
— Qué c'est ça des poireaux ?
Jacques réfléchit quelques instants, puis avec conviction :
— Des poireaux, dit-il, c'est des manches d'oignons!

RÊVERIE. — Croquis d'Émile Bernard.

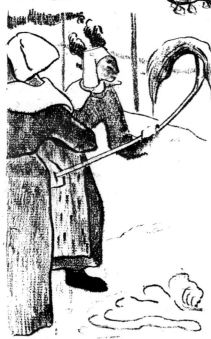

LES FANEUSES. — Croquis de Paul Gauguin.

M. Durand à un jeune homme qui, respectueusement, lui demanda la main de sa fille :
— Vous l'aimez donc beaucoup ?
— Énormément.
— Je ne vois pas d'inconvénients à ce mariage... Mais, au moins, avez-vous tâté ma fille ?
— Oh! oui, un peu partout... Et elle se laisse si bien faire !

<div align="right">MASCARILLE.</div>

<center>————◇◆◇◆◇————</center>

ÉTUDES SUR M. BEYLE (1)

(FRÉDÉRIC STENDALH.)

Dans notre époque, la littérature a bien évidemment trois faces ; et loin d'être un symptôme de décadence, cette triplicité, expression forgée par M. Cousin en haine du mot *trinité*, me semble un effet assez naturel de l'abondance des talens littéraires : elle est l'éloge du dix-neuvième siècle qui n'offre pas une seule et même forme, comme le dix-septième et le dix-huitième siècle, les quels ont plus ou moins obéi à la tyrannie d'un homme ou d'un système.

Ces trois formes, faces ou systèmes, comme il vous plaira de les appeler, sont dans la nature et correspondent à des sympathies générales qui devaient se déclarer dans un temps où les Lettres ont vu, par la diffusion des lumières, s'agrandir le

(1) Aujourd'hui que les œuvres de Stendalh sont devenues, pour beaucoup un passionnant sujet d'études, de recherches et de polémiques, aujourd'hui que toute une école de romanciers le revendique comme précurseur et que, de tous côtés, l'on recherche, et l'on publie ses œuvres inédites et jusqu'à ses notes, ses projets et ses plans (travail de MM. Paul Adam et Moïse Renault actuellement en préparation), il nous a semblé intéressant de réimprimer, pour nos lecteurs, cette curieuse étude sur la *Chartreuse de Parme*, écrite par Balzac pour le numéro du 25 septembre 1840 de la *Revue Parisienne*, aujourd'hui presque introuvable. N. D. L. R.

47. Émile Bernard: Peasant Girl keeping Ducks, and Paul Gauguin: The Gleaners.
Drawings reproduced in *Le Moderniste*, 3 August 1889

THE SCHOOL OF PONT-AVEN
AND THE NABIS

Until Gauguin departed for Tahiti in April 1891, his art and his example had been dominant factors in the development of painters who in age and experience were to him as students and disciples. Only Toulouse-Lautrec, whose art was based on a life-long admiration for Degas, stood apart from those who found in Gauguin's painting a way leading from their manifold enthusiasm for the art of the past and present towards a coherent style. They, too, admired medieval sculpture and stained glass, folk images, Japanese prints, and the arts of remote and primitive peoples. Yet if most of them lacked Gauguin's capacity for transcending his sources, their work has its place in history because it provides a link between the greater Symbolists of the nineteenth century and the Expressionists of the twentieth. And in some respects it is the pictorial counterpart in France of that international attempt to create a comprehensive decorative style known as Art Nouveau (see below, pp. 131 ff.).

Two men who were very young in 1888, Émile Bernard (1868-1941) and Maurice Denis (1870-1943), became the leading propagandists for the groups known as the School of Pont-Aven and the Nabis. There was never a 'school' at Pont-Aven in the literal sense, but so profound was the effect of Gauguin's ideas upon some of the young painters working with him in Brittany that the name has been attached to their efforts. Bernard always insisted that it was he who introduced Gauguin to the *cloisonniste* and Synthetist manner in the summer of 1888. As we have seen, Gauguin did admire Bernard's work to such an extent that his *Vision after the Sermon* is different in degree, if not entirely in kind, from his earlier painting. But it is not fair to insist, as do some protagonists for Bernard, that without his *Yellow Christ* of 1886 (Paris, Collection Bernard-Fort) we would not have had Gauguin's of 1889. The first is a simplification, to be sure, but it derives from late medieval and Renaissance religious painting. The second is a projection of a new artistic experience based primarily on the discovery of Breton folk sculpture and only secondarily on Bernard's elliptical style of drawing. The qualitative difference between the two men's work can be seen by comparing their drawings of two Breton subjects, published in the summer of 1889 [47]. In Gauguin's the line is crisp and economical, a synthesis of form and of the feeling the form inspired; in Bernard's it is slack and passive, as if he had seen only the picturesque appearance, not the structure, of his form.[55]

Bernard's later polemical publications did more to weaken his claims to originality than the facts warrant. He was gifted, but perhaps too facile in several arts ever to master one. He was also philosophically minded and well-educated. His desire to produce beautiful objects in various materials is a reflection of the widespread development of the decorative arts and crafts after 1880. By putting his theories into practice in the design of stained glass, embroidered tapestries, and wood-carvings, Bernard drew Gauguin's attention to the expressive possibilities of utilitarian design. The coarse pastiche of Italianate manner and academic subjects in his later painting makes one regret that he did not continue as a decorative artist.

Bernard, however, has a place in history for his early, enthusiastic promotion of the modern movement. He arranged the first retrospective exhibition of Van Gogh's paintings at the gallery of Le Barc de Boutteville in November 1890, only four months after the artist's death. And when he returned to France in 1901 after eight years' teaching in Cairo, he continued in his own periodical, *La Rénovation esthétique*, to redefine the Symbolist doctrines of his youth. In 1904 he visited Cézanne at Aix and recorded

an important interview with the ageing artist. The letters he received and published from Cézanne and other painters contain important statements on artistic theory and practice.[56]

The only group manifestation of the artists who had worked with Gauguin at Pont-Aven or came under his influence was the Café Volpini exhibition of 1889. In addition to Gauguin and Bernard the principal contributors were Louis Anquetin (1861-1932), who soon abandoned his cloisonnist style for the study of Rubens; Émile Schuffenecker (1851-1934), Gauguin's long-suffering confidant, whose style then and later was a mannered Impressionism close to Gauguin's painting before 1888; Charles Laval (1862-94), who had accompanied Gauguin to Martinique; and finally Daniel de Monfreid (1856-1929), later Gauguin's loyal friend and correspondent. The list is not impressive, nor are the names of those who visited Gauguin for varying lengths of time in Brittany between 1888 and 1890 much more so. The brief promise of Armand Séguin (1869-1903), Charles Filiger (1863-1928), and Meyer de Haan (d. 1894) soon petered out, and Maurice Maufra (1861-1918) devised an intensified Impressionism of limited charm.

Only Paul Sérusier (1863-1927) emerges as a figure of some significance, for it was he who communicated Gauguin's ideas to the group of young artists who called themselves Nabis. When Sérusier stopped at the Pension Gloanec in Pont-Aven in the summer of 1888, he frequented the academic painters, who thought Gauguin and his friends the worst riff-raff. But from a distance he grew curious about their theories and technique. Encouraged by Bernard, Sérusier introduced himself to Gauguin, and in September, just before returning to his job as *massier* or proctor at the Académie Julian, he passed a morning painting under Gauguin's direction. The master's advice had historic consequences when Sérusier

imparted it to his friends in Paris, and through Maurice Denis's theoretical writings it became an important factor in the theory of Expressionism and later of abstract art. We are indebted to Denis for his account of the actual circumstances: 'Upon his return in October 1888 from Pont-Aven Sérusier revealed Gauguin's name to us, and showed us, not without some mystery, the cover of a cigar box upon which one could make out a shapeless landscape, synthetically formulated in violet, vermilion, Veronese green, and other pure colours, just as they come from the tube, and almost unmixed with white. "How do you see that tree?" Gauguin had asked in the Bois d'Amour. "Is it quite green? Then put on green, the finest green on your palette; – and that shadow, is it a bit blue? Don't be afraid to paint it as blue as possible." '[57] Sérusier's small landscape, which was treasured as the *Talisman* [48], is

48. Paul Sérusier:
Landscape of the Bois d'Amour (The Talisman), 1888. *Paris, Musée d'Orsay*

no longer very startling, but in the eyes of his friends the areas of unmodelled yellow, blue, and red, creating a surface pattern distinct from and in tension with the natural objects, revealed the expressive powers inherent in the formal elements of pictorial design. Sérusier himself continued to paint until the nineties in Gauguin's manner, but as he had little control over drawing and design his work became progressively weaker, until it was almost a parody of Gauguin's. His brief treatise, *A B C de la peinture* (1921), is a curious and very personal summary of Synthetist and Nabi doctrines on the interrelations between nature, art, and mathematics.

Gauguin's theory of the correspondence between natural form and artistic feeling, and Sérusier's experimental demonstrations, were enthusiastically received by the young artists at the Académie Julian. In that very autumn of 1888 Sérusier and Denis, Édouard Vuillard, Pierre Bonnard, Paul Ransom, K.-X. Roussel, and the sculptor Georges Lacombe began to meet, regularly and semi-secretly, to discuss the new ideas. They were soon joined by others, among them the Dutch painter Jan Verkade and the Hungarian artist Rippl-Ronai. Their monthly dinners, costumes, and ceremonial (suggestive of contemporary Rosicrucian rituals) and their designation of themselves as Nabis (the Hebrew word for prophets) were related to the widespread interest in theosophy and eastern religions. But the name Nabi also indicates that their works for a time had several elements in common, which was apparent to everyone when they exhibited together semi-annually at Le Barc de Boutteville's gallery during the 1890s. Until the emergence of Cézanne at the end of the decade and the eruption of the Fauves in 1905, theirs was the most progressive art in Paris.

At first their flat colour patterns were still more simplified, more 'medieval' than Gauguin's; for although Gauguin had found in certain aspects of late medieval art stylistic elements suitable for the expression of modern experience, the Nabis were trying to fit contemporary life into the styles of the past. This was particularly so with Denis. A sincere Christian, he dreamed from an early age of restoring religious art to its previous glory, and much of his work, in fact the majority of it after 1900, consisted of religious subjects and paintings for religious institutions.[58] As such, it belongs to the history of modern religious art and iconography. But through his long life he deviated very little from the principles of design he had worked out by the mid nineties. His was not a strong talent; his greatest charm is perhaps the mildness with which he presented the characters of fairy tales and figures from the Gospels in very pale colours and with a relaxed, almost inert, line. As a boy he had admired Puvis de Chavannes, and later, like the Pre-Raphaelites and Gauguin himself, he discovered Fra Angelico and Quattrocento art. There is something of Puvis's linear simplicity in his *Mary with the Christ Child and St John* of 1898 [49], just as there are suggestions of Angelico's measured emptiness in the space behind the figures (with Nazareth looking much like Florence seen from Fiesole). The flat pattern is Nabi, the tender feeling is entirely Denis's. Such a work exemplifies the theories announced by Denis in his famous 'Définition du Néo-traditionnisme', published in August 1890, when he was just twenty years old.[59] In the first paragraph he declared, without qualification, that 'a picture – before being a war-horse, a nude woman, or some sort of anecdote – is essentially a surface covered with colours arranged in a certain order'. For years afterwards Denis insisted that his statement was not to be taken as a demand for a non-representational art. Certainly he did not have that in mind, for in the remainder of his extended and somewhat bombastic essay he argues that the modern artist should return to the

simplicity of painting and sculpture before Raphael in order to communicate the expressive power of nature seen directly and sincerely. His objections to the contrary, what he wrote helped to open the way to abstract art. He insisted so often on the expressive properties of disturbed and disappointed by the vulgarity of modern middle-class life. As sons of prosperous members of that society, they were undergoing the familiar reaction to the parental environment. Fearful of the future, they hoped to find security in the splendour of a vanished

49. Maurice Denis: Mary with the Christ Child and St John, 1898. *Copenhagen, Ny Carlsberg Glyptotek*

pictorial design regardless of the subject, that such a statement as the following must have stirred the imaginations of painters a few years later, had they chanced to read it: 'Is not that work of art, conceived without regard for any contingent imitation, the most expressive?'[60]

Denis's emphasis on the values of the past appealed to several of the Nabis who were age. It is therefore ironic that the only members of the group whose work is remembered today for its intrinsic rather than its historical significance are those who fixed their whole attention on that bourgeois world in all the immediacy of ordinary present experience. Although as theorists Édouard Vuillard (1868–1940) and Pierre Bonnard (1867–1947) con-

tributed less than Sérusier, Denis, or Bernard, their works exhibit the most delicate sensations, carefully pondered and realized with exquisite tact. They had grown weary of academic training and had been working together for some months at the Académie Julian when they witnessed Sérusier's revelation of the new colour theory. For the next few years they investigated its potentials in the flattest of patterns, doubtless inspired by the large exhibition of Japanese prints at the École des Beaux-Arts in 1890. In their own prints, especially the coloured lithographs commissioned by Vollard, properties of Japanese colour and design were adapted to subjects drawn from bourgeois Parisian life.[61] The print-like effect of Vuillard's earlier and more Nabi manner is seen at its best in *Under the Trees* [50], one of ten decorative panels of children playing in the parks of Paris which Alexandre Natanson commissioned for his dining-room overlooking the Bois de Boulogne. The interlace of horizontal and vertical elements creates a flat 'surface covered with colours arranged in a certain order' and emphasizes the elements the Nabis admired in Gauguin and Puvis de Chavannes. The blurred edges, muted colour, and indistinct details prepare us for those investigations of the psychological ambiance of daily life which Vuillard and Bonnard made so much their own.

Regardless of the size of his canvases, Vuillard was pre-eminently the painter of experience on a small scale, of the corner of a room closed in by walls and furniture, of figures reading in the lamplight after supper, of everyday commonplaces transmuted into poetry by means of visual ambiguities not unrelated to the verbal experiments of his friend Mallarmé. In his work after 1895 Vuillard suggested the three dimensions by changes in the patterns of textiles and wallpapers. When at first one sees only a confusion of fabrics, one recalls that his mother was a dressmaker and that Vuillard grew up in rooms full of patterned stuffs. Even the slightest of his

50. Édouard Vuillard: Under the Trees, 1894.
Cleveland Museum of Art

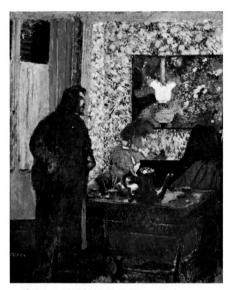

51. Édouard Vuillard: Missia Natanson
at the Piano with her Brother, Cipa Godebski,
1897. *Karlsruhe, Kunsthalle*

interiors are remarkable as depictions of individuals *within* their environment, surrounded and explained by the spaces they have created for themselves [51]. It is interesting to know that he often took impromptu photographs of his family and friends, catching them off guard and perpetuating a spontaneous pose or gesture on canvas.[62]

Vuillard's technique is related to Impressionism in the small brush stroke, reflected lights, and broken surface, but after his early Nabi use of flat patterns, he developed a controlled and repetitive touch, not uninfluenced by Neo-Impressionism. He also evolved his own technique of distemper on canvas or board. In this medium, in which glue rather than oil binds the pigments, the colour is matt and clear, and even earth colours do not darken. When he worked in oils he kept the flattened harmonies of distemper. After 1900 Vuillard became better known, and he received commissions for portraits from people higher in the social scale than those for whom he had painted during the nineties. His pictures became larger, the touch looser and more rapid, the expression less introspective. But if his later work was less adventurous in design and interpretation, in a way more impersonally 'impressionist', it was an important documentation of upper-middle-class French society during the first half of this century.

Where Vuillard was at his best in his smaller works, and many of his pictures are very small indeed, Bonnard conferred upon the painting of domestic experience monumental size and scale. His earlier Nabi work was as assured as Vuillard's, with a dash of humour which the latter never had. Among his coloured lithographs the poster for *La Revue blanche* of 1894 [52] is an entertaining and stylish image of the woman of Paris, comparable to Lautrec's but less raffish, and fully as skilful in the integration of figures and text. Bonnard made important contributions to the revival of the illustrated book and interpreted with incomparable insight one of the subtlest texts of the period. His illustrations for Vollard's edition of Verlaine's *Parallèlement* (1900) perfectly complement the poetry.

In the twentieth century Bonnard's painting developed with unexpected splendour. In canvases of considerable size, worked over for long periods, he distilled his preoccupation with domestic life in loosely woven veils of iridescent colour. More than episode or event, it is the secret life of inanimate objects that Bonnard depicts. This revelation of situations felt but unseen is his most individual, indeed his most thoroughly Symbolist, achievement, the result of his way of constructing space from several points of view, so that we seem to enter his pictures from the positions of the objects rather than of ourselves. Often we do not even see the human figures at first, and only later realize that they, like the chairs and table, have

52. Pierre Bonnard: Poster for *La Revue blanche*, 1894. *New Haven, Conn., Yale University Art Gallery*

53. Pierre Bonnard: Dining Room in the Country,
1913. *Minneapolis Institute of Arts*

been observing us all the while [53]. This sense
of detachment from the immediate moment,
which lends his paintings the effect of time
suspended in a continuous, vibrant present,
may be due to Bonnard's personal and quite
deliberate isolation from the ordinary dis-
tractions of life. His remarks in 1943 indicate
how thoroughly he had parted from Impres-
sionism, despite apparent similarities of colour
and theme: 'Through attraction or primary
conception the painter achieves universality. . . .
If this attraction, this primary conception
fades away, the painter becomes dominated
solely by the motif, the object before him. . . .
The presence of the object, the motif, is very

disturbing to the painter at the time he is
painting. Since the starting-point of a picture
is an idea, if the object is there at the moment
he is working, the artist is always in danger of
allowing himself to be distracted by the effects
of direct and immediate vision, and to lose the
primary idea on the way.'[63] Until his death in
1947 Bonnard preserved, into the midst of the
twentieth century, the Symbolist contention
that for every emotion, for every human thought,
there existed a plastic and decorative equivalent,
a corresponding beauty.

So persuasive is the feeling of being intro-
duced into the domestic scene, of listening to
confidences whispered by a close friend, that

Vuillard and Bonnard have been called 'Intimists'. Their communication of living spaces charged with psychological overtones may be related to their work for the theatre. Among other occasions, in 1893 Vuillard, Bonnard, Roussel, and Ranson designed and painted the scenery for Lugné-Poë's production of Ibsen's *Rosmersholm*, the first in France, at his new Théâtre de l'Œuvre, and in 1896 Bonnard and Sérusier worked on the production of Jarry's *Ubu Roi*. The way so many of the figures in their paintings turn their backs to the spectator resembles the naturalistic style of acting encouraged by Lugné-Poë.

The talents of the other Nabis were of a lesser order, although each added his own contribution to what can now be recognized as a communal style. Ker-Xavier Roussel (1877-1944) may be remembered more for his coloured prints of the nineties than for his later semi-Impressionist paintings on bucolic, pagan themes. Paul Ranson (1864-1909) offered his studio as the original meeting-place for the group and gave each of the members a distinct and picturesque name: Denis was 'Le Nabi aux belles Icônes' and Bonnard 'Le Nabi très japonard'. His designs for tapestries and embroideries, often executed by his wife, the only woman member, added to the development of Art Nouveau in France. In 1908 he founded a school in Paris, where instruction in Nabi principles was continued by Denis and Sérusier for many years after his death. The Dutch artist Jan Verkade (1868-1946; after his conversion, Dom Willibrord Verkade) adapted Nabi ideas to mural painting, which he practised within the Benedictine order, principally at Beuron in Germany. His book, *Le Tourment de Dieu* (1923, first German edition 1920), is an important source for the history of the movement. The Hungarian painter József Rippl-Ronai (1861-1927), who was frequently in Paris during the 1890s, knew the Nabis and used their flat patterns and bright colours for a time. After his return to Budapest,

his work became more conventional in the international mode of academic Impressionism. The Swiss-French artist Félix Vallotton (1865-1925) was never an actual Nabi, but he was known to them all and his own art was deeply influenced by their theories of design, even if its tone was more matter-of-fact. During the nineties he worked as a wood-engraver and provided a long series of entertaining portrait vignettes for the *Revue blanche* which show his gifts for catching the essentials of personality in a simplified scheme of black and white. His later hard and realistic nudes and still-life paintings were, like Bernard's, an attempt to revive the past within the present.

HENRI DE TOULOUSE-LAUTREC (1864-1901)

The tragedy of Lautrec's life, if of less moment historically and symbolically than Gauguin's or Van Gogh's, is no less poignant and no less inseparable from his art. Lautrec was of ancient, aristocratic lineage, and in the ordinary course of events might have become a sportsman with a taste for drawing. But he was frail from birth, and his legs, after being broken accidentally in adolescence, did not develop normally. As a result he was grotesquely dwarfed, with a man's torso on a boy's legs. He was a precocious draughtsman, and during his long convalescence turned seriously to drawing and painting. In 1881 he entered the studio of the academic portraitist Léon Bonnat, passing the next year to the atelier of Fernand Cormon. Despite such conservative training, his first paintings were unsparingly direct studies of the model. Soon he discovered the elements of Impressionist vision and colour and learned something of the new attitudes towards art and design from the more adventurous younger painters, notably Émile Bernard.

It is difficult not to think that Lautrec's deformity prompted him to set himself apart

from the society into which he had been born and to seek his friends among those who, for other reasons, were also outcasts. Such he found in Montmartre, newly notorious as the centre of Parisian night life. There in the restaurants and dance halls Lautrec found the tolerance and understanding he extended to others, unmixed by the pity he disdained. But it is also possible to think that his taste would have led him to the entertainment world soon enough. Of living painters he most revered Degas, and his own work may be seen as a continuation, in a less formal and more illustrative vein, of Degas's dancers and entertainers of the *cafés-chantants*. In the works of the older artist, and in the Japanese print, Lautrec found the intimate, sideways glance along an oblique diagonal which captures the figure in its most characteristic gesture, the brusque, theatrical lighting, often directed like footlights from below, and the unexpected posture of the figure in movement. However, there are fundamental differences between Degas and his disciple. Lautrec had none of Degas's distrust of human beings. Whereas the figures in the latter's work, except for his portraits, are usually anonymous, Lautrec in the brief decade of his artistic maturity created a world of recognizable and captivating characters. The dancers, singers, and *diseuses* of the nineties, May Belfort with her little cat, Jane Avril, La Goulue, Chocolat and Footit, and the inimitable Yvette Guilbert of the pert nose and black gloves, attained through Lautrec's painting and prints an immortality matched by no other group of entertainers, unless it be the stars of the early cinema.[64] Lautrec's theatre and cabaret scenes often portray the entertainers at their most amusing moments, but behind the comedy there are hints of melancholy, disillusionment, even despair. This is perhaps the most remarkable aspect of his famous scenes of women in the *maisons closes*. He whose life was to be so short was peculiarly responsive to those whose future

was at best uncertain. His imaginative identification with his people saves him from the impersonality and cruelty of caricature, and prevents us from dismissing his pictures as an expense of spirit in a waste of shame. Himself a living caricature, he saw others without censure or sentimentality.

The formal structure of Lautrec's art exhibits a further stage in the understanding and exploitation of oriental design. The earliest Impressionists had prized Japanese prints for their literal rendering of contemporary manners; the middle generation, Degas and Monet in the seventies, had ransacked them for unexpected, casual glimpses of space. Then Gauguin and Van Gogh saw the new colours and stronger patterns with which to renew their own art. Lautrec and others after 1885, when a far wider range of prints could be seen in large exhibitions in Paris, paid more attention to the expression of movement within the two-dimensional linear pattern. The influence and simultaneously the transcendence, first of Japanese perspective, and secondly of oriental linearism, can be studied in *At the Moulin Rouge* of 1892, Lautrec's *annus mirabilis*, when his artistic individuality emerged in his scenes of the notorious restaurant [54]. If we start with the man in the top hat at the end of the table we are not far from the realism of Degas in his café scenes of the early eighties. But Lautrec has exaggerated the perspective by raising the angle of vision and has stressed the individuality of each figure (except for the woman with her back turned, they are all identifiable, including the artist himself passing across the background with his tall, stooped cousin and constant companion, Dr Tapié de Celeyran). Apparently he was dissatisfied with the painting in its original form and changed its proportions by adding strips at the bottom and right, thereby transforming a placid group of friends into a composition fraught with strange and even sinister overtones. The lengthened perspective of the

balustrade in the foreground and the strange green-and-white face of the woman at the right, seen so suddenly in close-up, heighten the psychological tensions.

Although the effect of *At the Moulin Rouge* is primarily due to the startling perspective, the additions to the original canvas also increased the contrast between the straight lines of the balustrade, the curves in the bent-wood chairs, and the outline of the woman's black sleeve at the right. This linearism, with its power to set his forms in motion across even shallower spaces, dominates the posters with which Lautrec significantly affected the development of a peculiarly modern pictorial idiom.

With the introduction of large-scale colour lithography in the 1880s, figural subjects tended more and more to usurp the printed text of the posters of all sorts which had become a common sight on the walls and hoardings of European cities. Technical considerations as well as the requirement of legibility at a distance fostered designs of bold colours in flattened planes defined by emphatic linear contours. The

54. Henri de Toulouse-Lautrec:
At the Moulin Rouge, 1892. *Art Institute of Chicago*

artistic as well as commercial criteria for a successful poster were thus analogous to the aesthetic preferences of the Nabis, and both in turn owed much to the Japanese print. Others before Lautrec had demonstrated the artistic possibilities of the poster, among them the prolific Jules Chéret (1836-1933), whose frivolous and somewhat fussy posters were admired by Seurat, and Eugène Grasset (1841-1917), whose work from the middle 1880s showed more understanding of the possibilities of two-dimensional design. But no artist, and certainly none with so limited a production – Lautrec produced only thirty-two posters in ten years – so quickly or so completely proved that a fine poster was no less a work of art than any other form of graphic expression. His first, of La Goulue dancing at the Moulin Rouge, shows his adaptation of the colours and printing technique of the Japanese wood block.[65] In rapid succession in the next two years came his most famous posters: *La Reine de joie* of 1892, showing Jane Avril at the Divan Japonais, of Jane Avril again dancing at the Jardin de Paris, in which the neck of the bass viol is prolonged in a sinuous curve as a frame for the whole design, and the bold black-and-red silhouettes of Aristide Bruant of 1893. Of these *La Reine de joie* [55], an advertisement for a novel about upper-class corruption by Victor Joze, printed in yellow, red, green, and black, is a telling comment on manners as well as proof of Lautrec's ability to create space and movement by pattern and line alone. Lautrec, like Degas, was captivated by forms in movement, but where Degas sought the attitude which suggested action accomplished as well as that about to begin, Lautrec was more interested in the continuity of movement. He extended and

contracted his silhouettes to represent shapes transforming themselves within the space of an uninterrupted motion. In a lithograph of Loie Fuller, the American dancer who captivated Europe with her manipulation of 'butterfly' veils of chiffon swirling rapidly under changing coloured lights, Lautrec simplified the moving form to such a point that he seems about to announce the organic abstractions of Arp and Miró.[66]

In Lautrec's later years graphic work took precedence over his paintings, which were often studies for lithographs. His favourite pictorial medium, oil on cardboard, allowed him to work as rapidly as possible; the painting, whatever its size, acquired the improvisatory character of a sketch. His collected albums included two series of Yvette Guilbert (1894 and 1898) which did much to establish the singer's reputation; a series of actors and actresses in their stage roles (1894); and the twelve plates of *Elles* in 1896. In the latter, perhaps the subtlest of his studies of women, he recovered through a renewed analysis of Degas something of the three-dimensional vision which had been dissipated in the posters. In 1899 his health failed, and he was confined for some months in a clinic at Neuilly. The published rumours that he had lost his mind after a decade of debauchery were refuted by his circus scenes in coloured crayons, drawn from memory during his seclusion. The occasionally violent distortions were caused by expressive necessity rather than by any loss of manual control.

Lautrec was recognized for the artist that he was in his lifetime. From 1889 to 1897 he exhibited almost annually in the Indépendants, and in Brussels with Les XX and its successor La Libre Esthétique. His posters were seen in London in 1895 and 1896, and the Goupil Gallery held an exhibition of his work in 1897. Upon his death in 1901, at the age of thirty-seven, his father ceded his parental rights in

55. Henri de Toulouse-Lautrec:
La Reine de joie, 1892.
New Haven, Conn., Yale University Art Gallery

his estate to Maurice Joyant, Lautrec's friend and Theo van Gogh's successor at Boussod and Valadon. Joyant's efforts to secure official recognition for the artist were rewarded when the Toulouse-Lautrec museum was opened in 1922 in the ancient episcopal palace at Albi, the artist's birthplace. Here were deposited the collections Joyant had received from the family, together with his own additions.

If Lautrec in the end seems less than a major artist, in the sense that there are few of his works with which history could not dispense, at his best he was an extraordinarily skilful illustrator of a very special sensibility. His talent may be more accurately measured by comparing him not with the major Impressionists but with other contemporary draughtsmen. In their lifetimes both Jean-Louis Forain (1852-1931) and the Swiss artist long resident in Paris, Théophile Steinlen (1859-1923), enjoyed greater popular and almost equal critical favour, but despite their ability to visualize an anecdotal situation, they are remembered more for their sharp social criticism than for their artistic skill. The chief source of Forain's earlier illustrative style was wittily summarized by Degas when he remarked that Forain 'paints with his hand in my pocket'. He also leaned heavily on Daumier for his later courtroom scenes and on Rembrandt for his religious paintings and etchings, which are not without a sardonic and quite modern bitterness.[67] Steinlen's work was more eclectic. Except for a few posters in the Art Nouveau style of the nineties, and his doleful treatment of the Parisian poor, which may have impressed the young Picasso, it lacks stylistic coherence.

JAMES ENSOR (1860-1949)

The assimilation of Van Gogh's work to the French school, the result of his close association with French painters during the last four years of his life, and the pitiful denouement of his tragedy in the towns of Arles and Auvers, placed the history of French painting and of European Symbolist and Expressionist art in a false perspective. Had Van Gogh remained in Holland and created works of the quality he produced in France (psychological and technical impossibilities, to be sure), it is probable that the anti-rational factors in his work would sooner have been recognized, and his position as the eldest of a group of isolated but original masters earlier clarified. His vast fame, developing soon after 1900, has made it difficult for historians west of the Rhine to estimate the achievements of certain artists whose activity in the final decades of the nineteenth century was of the utmost significance for the development of Symbolist painting in Germany and northern Europe and to a lesser extent in their own small countries. The works of each, of the Belgian James Ensor, of the Norwegian Edvard Munch, and of the Swiss Ferdinand Hodler, at first met with the antipathy that so often greets the appearance of progressive tendencies in a conservative milieu. By the middle of their lives, however, each had overcome mistrust, and in the end became something of a national institution. Indeed, by hoarding their work their homelands have made it difficult to see abroad. The cause and effect in each case are symptomatic of the provincial cultures in which these artists had to make their way, and which they never renounced. Munch, who spent the most productive years of his maturity in Germany, returned permanently to Norway at forty-six. The lives of the others were even more restricted. Ensor rarely travelled farther than from Ostend to Brussels, and Hodler scarcely left Geneva. Nevertheless their accomplishments were important at the time, and have been influential far beyond the frontiers of their own countries.

The contrast between Ensor's life in his parents' souvenir shop at Ostend and his phantasmagorical imagination seems implausible

until we remember that among the staples of the shop were the sea-shells, toys, and carnival masks that appear in his paintings. Of these, the mask became his most profound disguise. It is both a threat and a protection. Behind the façade of its assumed personality one may indulge in the most discreditable activities. With a mask, each of us may smile and smile, and be a villain. With his 'suffering, scandalized, insolent, cruel, and malicious masks', as he described them,[68] Ensor created an art which is still as disconcerting as when he first challenged the artistic traditions of Brussels in his youth.

Although so much of Ensor's life, like Vuillard's, was spent in the crowded rooms of a lower-middle-class flat, he was neither untutored nor uncultured. If his mother's Flemish origins were humble, his father, an expatriate Englishman, was well-educated. As a young man Ensor studied for three years in Brussels, where he moved in one of the most intellectual circles, that of the family of Ernest Rousseau, the rector of the university. They and their friends were among his earliest patrons; they encouraged his fancy and supported him when the expression of that fancy was condemned. In his earliest works – landscapes, genre scenes, and opulent still lifes – an appreciation of the discoveries of Courbet and Manet was soon replaced by an Impressionism so competent that his much-criticized *Woman eating Oysters* of 1882 (Antwerp) would not have discredited a Paris painter a decade earlier. When his entries were rejected at the Brussels Salon in 1883, he joined the group of twenty artists led by Octave Maus who called themselves Les XX.

Had Ensor adopted Neo-Impressionism, like the younger artists who were captivated by Seurat's *Grande Jatte* when it was seen in Brussels in 1887, his reputation might have been made much sooner, and, like theirs, soon lost. But he was on the point of parting for ever

56. James Ensor: Entry of Christ into Brussels, 1888.
Malibu, Calif., J. Paul Getty Museum of Art

from the traditions of French painting. Only two years later his most original indictment of modern society and of contemporary art, whether Belgian or more progressively Parisian, was spurned by his friends of Les XX. The enormous canvas of *The Entry of Christ into Brussels* of 1888 [56] is an imaginative account of the furious demonstrations that might greet the Saviour on a new Palm Sunday. In depicting the event as a socialist holiday, Ensor expressed his disgust with what Mallarmé had called the 'ordinary enemy, the people', with truly Flemish profusion of detail. The Christ, a tiny figure in the centre mounted on the ass, is dwarfed by a mob of citizens, soldiers, and delegations of workers waving banners with irrelevant slogans (including a misspelt sign for 'Colman's Mustart'). Towards the front, where the individual faces become more distinguishable, they harden into masks, among them the prominent death's head in the foreground next to the younger worker whose profile is one of the most brilliant examples of the controlled violence of Ensor's paint.

The fundamental themes of Ensor's iconography had been stated. Life is a far from comic carnival in which, behind our masks, as hideous as ourselves, we perpetrate by thought and deed all manner of evil. The grimace of the mask is as humourless as the grin of the death's head, that final and most hideous mask which we wear within us. These themes are joined in the *Masks confronting Death* of 1888 (New York), in which Death, the only unmasked figure, is a pitiable spectacle, shrunken and foolish in his mummer's costume. If the assembled masks remind us of the lewd spectators in early Flemish paintings of Christ Tormented, we realize that beyond the nineteenth century Ensor looked to the masters of imaginative fancy in the past, to the clumsy humours of Breughel as well as to Bosch's vision of a society at the mercy of its passions. The masks in *Intrigue* of 1890 [57], as the title

indicates, re-enact at Carnival a bit of local scandal, in this case apparently with reference to an unfortunate experience Ensor's sister had had with a Chinese art dealer. The denunciation of social hypocrisy is more direct and leads eventually to some of his most scarifying attacks on the social order, as in the set of etchings of the seven cardinal sins executed in 1892 and 1904, where his technique is intentionally barbarous. Monstrously degenerate figures, helpless victims of their passions, are as uninhibited as Alfred Jarry's characters in his drama *Ubu Roi*.

Ensor's symbolism has been discussed with little reference to his technique, for, as with all figural Expressionism, the end to be expressed takes precedence over the means. In any basically conceptual or classic art, the formal order can precede the investiture of that order with specific details. We may believe that the plan of a painting by Poussin or even by Cézanne could exist before the recognizable elements of subject matter were introduced, and much of the pleasure they afford us derives from our visual search for that plan. In all Expressionist art, even of the most abstract varieties, what is to be expressed determines to a much greater degree the character of the formal elements, and especially the technique. The formal elements, in fact, have no independence apart from the content they are devised to project. The criticism, to say nothing of the enjoyment, of such art will largely depend upon the spectator's interest in its subject matter and expressed content, since there are fewer opportunities for purely pictorial pleasures. In *The Entry of Christ* there is, for the lover of formal values, distressingly little form. The crowded canvas offers no release for the eye from the pressure of faces surging forward, of banners and inscriptions incessantly demanding attention (or for the imaginative ear from the raucous sounds of the brass bands). The whole is as restless and as vivid as any

57. James Ensor: Intrigue, 1890.
Antwerp, Koninklijk Museum voor Schone Kunsten

actual parade, and as devoid of any apparent unifying principle. But Ensor's intention was not so much to please as to persuade. As a social critic he takes his place with other masters of caricature who may be charged with similar faults by the aesthetic purist. With Hogarth and Rowlandson he joined, possibly through ancestral sympathies, the masters of English caricature and social criticism, to whom he owed as much as to his great Flemish predecessors, whose taste for the erotic and scatological he shared with his slightly older Belgian contemporary, Félicien Rops. But having said so much in defence of Ensor's contempt for classic order, it must be added that in comparison with Rops and the English illustrators, he is often more artistically satisfying. His colour alone would earn him a place among the masters. However English influences reached him, the late Turner certainly confirmed his love for the iridescent colours of the sea which almost

washed his doorstep in Ostend. After 1900 his anger diminished and his most embittered pictures were often merely bland revisions of much earlier ones.

We cannot wonder that Ensor was so little appreciated at first. The import of his symbolism, his ability, as a contemporary critic noted, 'to express the inexpressible of forms seen in a coma',[69] would be understood only a full generation later, by the Dadas and the Surrealists. Later than that the paintings of Jean Dubuffet and the principles of *art brut* justified the subtleties of his outrageously primitive drawing. Yet he was never entirely neglected. His art reached Paris in considerable quantity before the end of the century. The special issue of *La Plume* in 1899, commemorating an extensive exhibition presented by the same journal the year before, included tributes by Verhaeren, Maeterlinck, Meunier, and others. Exhibitions at Antwerp (1921), Hanover

(1927), Brussels (1929), and Paris (1932 and 1939) made him well known on the Continent. After his death in 1949 two prints by Paul Klee were found among the debris of his studio. Since it is unlikely that Ensor would have acquired them himself, given his contempt for any art other than his own, they must witness the admiration felt for the older fantasist by his most illustrious successor among the modern masters of the imagination.

EDVARD MUNCH (1863-1944)

Oskar Kokoschka's statement that Munch, even as a young man, did not close his eyes to 'the modern Inferno' and so was able to 'diagnose the panic and universal anxiety' suggests why the Norwegian painter was so influential in the development of modern Expressionism.[70] From this point of view he may be compared with Van Gogh. Despite differences in origin and artistic training, and although success came relatively soon to Munch and his long life was crowned with honours, neither man could conform to the prevailing social code, and each had to find his own pictorial symbols for psychic maladjustment. The Netherlander's passion was externalized in radiant and tragically powerful symbols, in the *Sunflowers* and the last *Cornfields*. Munch's torment found release in intensely subjective images, often morbid and disturbing but always illuminating the newly discovered interior consciousness of human beings. It is perhaps also worth noting that each painter reached the climax of his career towards his fortieth year. Van Gogh's life was abruptly terminated at the age of thirty-seven; when Munch was the same age, around 1900, he created the works still considered his most personal and powerful.

The depression which lies so heavily over much of Munch's early paintings may be traced to the illness, death, and religious obsession which filled his childhood and youth. Before he was fourteen his mother and eldest sister had died of consumption. His father, a military physician, was extravagantly pious. Later, as a young painter largely self-taught, Munch became a member of 'Christiania's Bohemia', so-called from the controversial novel of sexual freedom by Hans Jaeger, the leader of the literary avant-garde in Norway. The writers and artists who composed the group were concerned with contemporary political, social, and ethical questions, those problems which Ibsen had treated with more detachment in his plays, among which *A Doll's House* (1879) and *Ghosts* (1881) were phrased in naturalistic conventions comparable to the pictorial realism, distantly related to Courbet, of Munch's earliest independent work. In 1889 Munch won a government scholarship to study in Paris. His few months in Léon Bonnat's studio were of little account compared with the revelation of contemporary French painting, reinforced by other visits during the nineties. He accepted the influence of Impressionism and of Seurat, Van Gogh, and Gauguin, in that order and with increasing understanding. In Gauguin he found the flowing contours which marked his art until the end of his life. Redon, too, deeply impressed him. Traces of the linear arabesques and nightmare gloom of Redon's lithographs occur later in his own prints. This discovery of the expressive properties of artistic form led Munch to create his own decorative and symbolic naturalism. It is advisedly described as naturalism since, unlike the fantastic and exotic subjects of Redon and Gauguin, Munch's themes were almost always derived from his immediate experiences.

In Paris Munch also came to understand himself and the kind of art he wanted to create. He noted in his journal in 1889, when he was twenty-six: 'No longer shall I paint interiors, and people reading, and women knitting. I shall paint living people who breathe and feel

and suffer and love – I shall paint a number of pictures of this kind. People will understand the sacredness of it, and will take off their hats as though they were in church.'[71] In these three sentences he rejected the emotionally neutral subjects of Impressionism, and stated his determination to paint pictures expressive of states of mind and his vision of a group of

58. Edvard Munch: In Hell, 1904–5. *Oslo, Kommunes Kunstsamlinger, Munch-Museet*

pictures having a continuous, cumulative effect. The latter idea he developed as an extended *Frieze of Life*. As such it was never completed; the components were never definitely established, and although as many as twenty-two separate paintings were shown together at the Berlin Sezession in 1905, it remained a collection of disparate canvases differing in size, scale, and technique. Only the theme held the parts together, the theme of suffering through love towards death, suffering more mental than physical, realized by gesture more than by action, by facial expression more than by event.[72] The individual episodes in sum comprise the fullest statement any artist has left of the *fin-de-siècle* mood of disillusionment with man's material and social development. Science, which earlier had promised so much, had uncovered through psychiatry the subconscious instincts. Unable to escape from them and from the intuitive decisions they impose, man had become the victim of his own biology. Illness, alcoholism, the agonies of loneliness in adolescence, maturity, and old age, the peremptory demands of love, which is only the compulsion of desire, and its issue in disenchantment, jealousy, and despair, these are the stages through which life, in Munch's terms, must pass. The tensions between instinct and society, as he presented them, can never be resolved. If the end is madness, to which he himself nearly came, one's only recourse may be to look these terrors in the face, as he did in his remarkable self-portraits, especially that known as *In Hell* [58], where the naked soul peers out of the naked body.

This iconography of 'modern psychic life', as Munch later described it,[73] was, of course, impossible to represent within the limitations of a realistic technique, wherein it would have appeared ludicrously melodramatic. Munch's discovery in Paris of the expressive elements of colour, line, and figural distortion were basic to his programme, and by 1893 he created the quintessential picture of his career, *The Scream* [59]. The fusion of naturalism and symbolism, of the external face of the event and of the inner horror experienced by the foreground figure, was achieved through the contrast of curved and straight lines and of lurid reds and yellows with the ghostly distortions of the other figures. The complex emotional situation was suggested in the epigraph he wrote for the picture when it was reproduced in the *Revue blanche* two years later: 'I stopped and leaned against the balustrade, almost dead with fatigue. Above the blue-black fjord hung the clouds, red as blood and tongues of fire. My friends had left me, and alone, trembling with anguish, I became aware of the vast, infinite cry of nature.'[74] From this it appears that the figure is Munch himself, who hears the dreadful sound in nature and screams as he hears it. Only a few years later, and in a very different setting, the cry of nature was to sound mysteriously in the third act of Chekhov's *Cherry Orchard* (1904), where also only one person would hear it.

The literary bias of Munch's art is evident and cannot be ignored. Just as he once described Ibsen's *Rosmersholm* as 'the greatest winter landscape of Norwegian art', so his ability to create a pictorial paraphrase for a verbal experience was one of his principal gifts, and reminds us that his associations were quite as intimate with writers as with artists. When he was a youth in Norway the greatest of them, Ibsen, was living in Germany and Italy, but he knew Hans Jaeger, and later in Berlin Strindberg and the Polish poet and novelist Stanislas Przybyszewski, among others. The line of literary development from Ibsen's naturalistic social dramas and Jaeger's Zolaesque treatment of sexual experience through Ibsen's later symbolist plays, culminating in the statement of the artist's plight in *When We Dead Awaken* (1899), corresponds to Munch's increasingly introspective treatment of his own subjects.[75] Before his breakdown in 1908 he had passed

59. Edvard Munch: The Scream, 1893. *Oslo, Kommunes Kunstsamlinger, Munch-Museet*

60. Edvard Munch: Ashes, 1894. *Oslo, Nasjonalgalleriet*

beyond Ibsen's symbolism, with which his own *Scream* may be compared, to more pessimistic themes of frustration and despair resembling the situations in Strindberg's plays where the characters seem similarly moved by forces over which they have no conscious control. It may be worth noting that the first (destroyed) version of Munch's *Puberty*, in which a nude girl is depicted at the moment when she first realizes her latent sexuality, preceded by five years one of the most controversial literary statements of troubled adolescence, Frank Wedekind's drama, *The Awakening of Spring* (1891).

During the 1890s, the climactic decade of his art, Munch continued to explore the nature of psychic obsession. In *Ashes* [60], the man and woman are set in no very clear spatial relation to each other, but are called together by their separate torment, the face of the lover dissolved in the flowing contours of his figure, the woman angular and lost. This theme, with its implications of hysteria induced by sexual frustration, was reworked several times, as a print as well as in oil, and over a span of some years. In his search for graphic and pictorial equivalents for complex psychological confrontations, Munch reached beyond the conventional uses of his media to explore the promptings of creative intuition. In his lithographs, particularly, we watch the image emerging from apparently random configurations of lines. In oil also he suppressed, to some extent, the control of the conscious mind, letting the hand work as the spirit prompted. In this he anticipated the explorations of unconscious creative processes developed by Kandinsky a few years later.

Munch was a powerful and prolific graphic artist. His first etchings were made in 1894, his first lithographs and woodcuts the next year. Here again Paris played a crucial role. Through Auguste Clot, the master printer for Vuillard, Bonnard, and other French painters interested in the revival of the graphic arts, Munch learned the technique of colour lithography. It was also in Paris that he saw Gauguin's woodcuts and learned how to exploit the nature of the material. For many of his woodcuts he adopted Gauguin's method of cutting the lines into the block so that they appear white when printed. In his most famous print, *The Kiss* of 1897–8, he over-printed, in the Japanese manner and with Oriental economy, the interlocked figures of the lovers upon the grain of the wood itself. His methods as well as his emotionally charged images soon became the most important contemporary influence in the development of German Expressionist prints.

By 1900 Munch had made his best-known statements, technically, formally, and iconographically. His art had become widely appreciated, beginning in Germany, where he had lived almost continuously since 1892 and where his reputation was made when his first exhibition in Berlin proved so disturbing that it had to be closed after a week. Although his earlier paintings now seem strong only in comparison with the academic Impressionism which was Berlin's closest acquaintance with progressive art, the controversy prompted a number of younger artists to resign from the Verein Berliner Künstler which had arranged the exhibition. In 1896 they founded the Berliner Sezession, one of the first of the radical organizations which emerged during the 1890s in Germany and Austria.

Despite his growing success abroad, and even at home, where by 1900 he was recognized as a leading Norwegian artist, the disorder of his own life became intolerable. After the untidy collapse of a protracted love affair and a series of public brawls, he suffered what he described as a complete nervous collapse and retired to a Danish nursing home during the winter of 1908–9. While there, and not unlike Vincent at Saint-Rémy, he took stock of himself and his art. His *Self Portrait in a Blue Suit* (Bergen), painted in the nursing home, is as remarkable for the impassively objective self-analysis as for

the studiously spaced brushwork and the brilliant colour, proof that he was familiar with the work of the young painters of the Brücke to whom he had already given so much. On his recovery he returned to Norway for the remainder of his long life. Thenceforward he was no less prolific and enjoyed increasing prestige, confirmed in 1916, when his murals for the Aula or Great Hall of the University of Oslo were installed.[76]

Unfamiliarity with these murals, and indeed with most of his later work, has encouraged the assumption that the quality of his vast production between 1909 and his death in 1944 was less than that of the earlier work. Now that a new municipal museum has been built in Oslo to contain the works he bequeathed the city, that opinion may be subject to revision. But it would seem that if his line is often as nervous as ever and the colour brighter as he emerged from the sombre tonalities of the 1890s, yet the brushwork is occasionally slack and there are empty stretches where observation takes the place of feeling. Such technical changes cor-

respond to a new direction in his art. Instead of the revelation of private despair, he was looking around him, in the world, for more optimistic and universal symbols. Although he thought of the University murals as a continuation of the *Frieze of Life,* all private tensions were eliminated in the inspired simplicity of his *History* and *Alma Mater.* The latter, a kind of Scandinavian *Caritas,* is a robust maternal figure nursing a child in a widespread Norwegian landscape of fjord and birch-grove. *History* is his conception of the primordial process of education [61]. Beneath a great oak tree, towering over a majestic Norwegian landscape, a blind old man tells of events long past to a boy eagerly listening. The Homeric overtones of Munch's design, which he wanted 'to be at one and the same time peculiarly Norwegian and universal', are appropriate to the neo-classical architecture of the hall.

The murals remain the most impressive expression of the second part of his artistic life; for although there were new subjects in his later work, landscapes as well as scenes of workers

61. Edvard Munch: History (*left*) and The Sun, 1910–15. *University of Oslo*

and children, some modelled sculpture, and numerous searching self-portraits, there were fewer fresh insights into the human situation. Often older themes, even those from the *Frieze of Life*, were reworked with surprising detachment and serenity. The release of his intolerable tensions under Dr Jacobsen's care in Copenhagen had made it possible for him to live, but more difficult to invent.

FERDINAND HODLER (1853–1918)

Like Ensor and Munch, the older Swiss painter, Ferdinand Hodler, had accepted mid-century naturalism and even Impressionism in his earliest works, but soon found that he would have to transcend their expressive limitations if he were ever to realize his feeling of spiritual isolation in a hostile and materialistic environment. For such was Geneva, where he settled in 1871. He had been born in Bern, and his childhood had been marked by painful poverty and, like Munch's, by illness and misunderstanding. He studied landscape and figure painting with Barthélemy Menn, a gifted artist who was a friend and follower of Corot and the Barbizon masters; but more important was his discovery in late medieval painting, and especially in Holbein, of simplified but fully three-dimensional forms set against flat backgrounds. By such contrasts between acutely realistic details and a highly abstract design, Hodler could communicate his feeling for the conflict between commonplace actuality and the mystical order which alone gives that actuality significance. It was thus no wonder that the first painting of his maturity in which realism and decorative abstraction were maintained in a skilful and mysterious equilibrium should have been remarked by the French Symbolists when it was shown at the Salon in 1891. This was his *Night* (Bern), in which seminude sleepers strewn singly or in pairs upon a steeply sloping ground are watched by a shrouded form which may symbolize death as much as slumber.

In Paris, where Hodler spent some months in 1891, he was drawn to the Rosicrucians, whose belief in the communion of spiritual and physical presences was close to his own. He exhibited at the Salon de la Rose-Croix at Durand-Ruel's the next year, and his association with this group, which included a few feeble followers of Gauguin and the Nabis,[77] partly accounts for the content as well as the form of his important canvas of 1893-4, *The Chosen One* [62], in which six angels hover around a naked boy, actually the artist's son. This remains his most integrated pictorial statement, strong in the personal attachment he felt for his child. In earlier combinations of figures and landscape there had been awkward contrasts between realistic and stylized elements, but here the human and supernatural beings are as simplified as the landscape behind them. Only the faces of the angels are realistically modelled, but the repetition of the same face imposes a decorative and stylistic continuity. This repetition of slightly varied but identical elements of form, line, or colour, a kind of pictorial Leitmotiv, was the basis of Hodler's theory of 'parallelism', by which he sought to intensify the expressive content of his work. Such recurrent forms account for the often persuasive effect of his large mural compositions. Among them the *Retreat from Marignano* (1896-1900, Zürich, Landesmuseum) and the *Departure of the Volunteers in 1813* (1908, University of Jena) retain their decorative qualities. But in his grandiose philosophical compositions the theatrical gestures outstrip the mystical content, so that the effect often seems more superficially choreographic than expressively dramatic. Nevertheless, Hodler's bravura style proved immensely exciting to publics other than those in Switzerland, where his work was slow to secure more than a grudging recognition.

62. Ferdinand Hodler: The Chosen One, 1893-4.
Bern, Kunstmuseum

For a few years around 1900 Hodler was so closely identified with the avant-garde in Germany and Austria that his work is almost synonymous with the 'Sezession Style'. His success in Paris, where he continued to exhibit important works throughout the 1890s, was surpassed in Germany when *Night* was awarded a gold medal in Munich in 1897. He appeared at the Berlin Sezession in 1898, and at the Viennese in 1900 and 1901. There the enthusiasm was so great that by special invitation a group of thirty-one paintings became the principal attraction at the Sezession's international exhibition of 1904.[78] This occasion, when Hodler was one of a group that included Munch, Gallén-Kallela, Cuno Amiet, and Jan Thorn-Prikker, may be considered the climax of Symbolist painting. In the year that followed Gauguin's death and preceded the first Fauve manifestation these men were the acknowledged leaders of modern art in Norway, Finland, Switzerland, and Germany.

To other than Central European eyes Hodler's work often looks too expansive for its purpose, and more decorative than spiritually convincing now that his message seems vitiated by the pantheistic languors of the *fin-de-siècle*.[79] His huge canvases are filled with so few figures and incidents that we weary of the empty surfaces almost unenlivened by felicities of brushwork. An exception may be made for his portraits and for his late landscapes of the mountains and of Lake Geneva. In spare lines and a few vivid colours, comparable to the best

Fauve work, he set forth his mystique of the Alpine landscape. In his insistence that formal elements are in themselves expressive, he not only accomplished for Swiss painting the transition from Impressionism to Symbolism but also encouraged others to participate in the experiments which led to abstract art.

The Alpine landscape was also a source of inspiration for the Italian painter Giovanni Segantini (1858-99). With the brilliant, pure colours and staccato brushwork of French Neo-Impressionism, he expressed in his peasant scenes from the high upland pastures his mystical and pantheistic feeling for nature as the source and scene of man's destiny.

ART NOUVEAU AND JUGENDSTIL

The French and German terms in the title of this section belong to the history of the decorative arts and do not properly refer to the major pictorial and sculptural events. Nevertheless, in much important work of the 1890s there were elements which contribute to the developments in the decorative arts in the decades just before and after 1900. For these reasons, and despite the fact that only passing mention can be made of the principal achievements in the decorative arts, the relation of their theory and practice to painting and even sculpture during the period 1895-1910 must be noted, especially in the final phase of Symbolist painting outside France. Although the new decorative movement collapsed and vanished after 1910, its fundamental concept of the expressive properties of form, line, and colour was an important contribution to the discovery and formulation of abstract and non-objective art.

The complex history of Art Nouveau, Jugendstil, or 'Modern Style', as it was variously called in England and on the Continent, has not yet been fully unravelled, but it is clear that there were at least five major centres of activity: Glasgow, Brussels, Paris, Munich, and Vienna.

Artists working in each city were inevitably affected by national traditions (German Jugendstil had a pronounced Biedermeier flavour, and much French Art Nouveau was based on eighteenth-century Rococo design), but to some degree they were all influenced by the ideas of Ruskin and Morris and by the productions of the English Arts and Crafts Movement of the late 1880s. They shared a common desire to discover a new decorative style, one with architectural potentials, which would re-establish the mutual responsibility of the designer and craftsman to the consumer through the production of artistically valid objects, devoid of the servile historicism and eclecticism which had corrupted both machine-work and handicraft. From this it followed that such a system of design must be original rather than imitative, and 'natural' rather than 'artificial'. Ruskin had insisted on the appropriateness of natural forms, realistically rendered, for industrial design. Morris used the same forms, often the commonest garden flowers, but with a degree of stylization more suitable for the two-dimensional surfaces of his fabrics and wallpapers. The designers of the nineties were just as committed to the study of nature, but for reasons which may have been related to the new ideas of physical and psychological continuity they examined aspects of nature in movement, in long-stemmed flowers and aquatic plants stretched and distorted by the continuous pressure of wind and water. Dank and listless blossoms also expressed to perfection the *fin-de-siècle* mood of despondency, introspection, and ennui. Preliminary suggestions of this type of design had appeared in the work of Van Gogh, especially in his densely interwoven drawings of plants and grasses, in the tropical tendrils looping through Gauguin's Tahitian pictures, and in Munch's linear treatment of landscape and figures. Even Lautrec had devised for the shifting play of Loie Fuller's scarves an anagram of expressive intensity

remarkably like Munch's swelling and contracting lines.

The mention of Munch in relation to contemporary appearances of this stylistic element in French painting is relevant, for the term Art Nouveau comes from the name of the shop which Samuel Bing, an art dealer from Hamburg, opened in Paris late in 1895. He dealt in furniture, fabrics, and Japanese prints, and was anxious to present the latest European designs to the Parisian public. To that end he commissioned Henry van de Velde, the Belgian Neo-Impressionist painter turned designer, to create four rooms for his shop, and there in 1896 Munch held his first one-man exhibition in Paris. The curvilinear structure of so much of his work of the 1890s corresponds to the dominant role played by similar undulating and abruptly reversed curves in French and Belgian Art Nouveau production. The most famous as well as the first complete Art Nouveau interior, the house in Brussels for Dr Van Tassel by the Belgian architect Victor Horta (1861-1947), is exactly contemporary with Munch's *Scream* (1893).[80] Horta's curving surfaces, enriched with linear patterns of the greatest complexity, and his interlaced wrought-iron ornaments sometimes have a distinction matched only by the best Rococo, but they were easily imitated and so quickly vulgarized that a limp and somehow disagreeably insinuating line became accepted as the principal characteristic of Art Nouveau design. But even the most energetic 'whip-lash' curve was not the exclusive hallmark of the style. In the work of certain English and Scottish artists, straight lines and rectangles were prominent elements in the same search for an unacademic and antihistorical design. Through the final flowering of the English Arts and Crafts Movement, especially in the work of the Scottish architect Charles Rennie Mackintosh (1868-1929) and his associates in Glasgow, and in the black-and-white drawings of Aubrey Beardsley (see below,

pp. 147-8), Great Britain intervened decisively in the development of contemporary art on the Continent.

In the mural frieze for a tearoom in Glasgow, Mackintosh swathed his tall female figures, still vaguely Pre-Raphaelite, in an apparently random but actually carefully controlled interlace of branches on which bloom Beardsley's roses, now heraldically enlarged. The abrupt reversed curves of the twining stems, as well as their sudden swelling and shrinking, is reminiscent of similar figures and foliage in drawings by the Dutch artist Jan Toorop [63] which were known to Mackintosh and the Glasgow group at this time. Since Toorop (1858-1928) had been born and brought up in Java, the eccentric flat patterns and drawn-out proportions of his skeletal figures may owe much to Javanese jointed paper puppets, but the general air of sickly melancholy which infects his scenes is of a piece with the moods presented by Munch and Beardsley. Such drawings occupied a special and very brief place in Toorop's *œuvre*. His life was long, but spent in the examination of several different stylistic possibilities. The intensity of his Art Nouveau work he never recaptured.

Through the educational activities of Henry van de Velde, who wrote and spoke widely about the new English and Scottish developments, this crisper and more rectilinear design became known throughout central Europe. Van de Velde's example was important because his furniture, which was closer to that of Mackintosh and other English designers than to the curvilinear and French fashions, was extensively exhibited around 1900. His theories were still more influential, both as a justification for the new design and as a possible programme for future developments. He was later to take perhaps too much credit to himself for the development of Art Nouveau, but the argument running through his critical and theoretical writings shortly before and for some years after

63. Jan Toorup: 'O Grave! Where is Thy Victory?', 1892.
Amsterdam, Rijksmuseum

1900 proved convincing. His insistence on 'one single principle: that of the rational conception of every form' led him to discard from his own work the last vestiges of even stylized natural ornament, in search of 'one sovereign ornament, realized in the play of proportion and volume, suffused with a rhythm that animates and transports'. Such ideas, which logically could lead only to abstract art, became widely known during his service as director of the School of Arts and Crafts at Weimar (1901–14), and were fulfilled by his successor, Walter Gropius, when in 1919 he combined the academy and the school to form the Bauhaus (see below, p. 331). The

aesthetic basis for Gropius's interest in designs appropriate for mass production had been defined by Van de Velde as early as 1910 in a poetic essay, 'Amo', in which he declaimed his admiration for machinery and for the forms produced by machines.[81]

In Germany the new mode was christened *Jugendstil* upon the appearance in 1896 of *Jugend*, a satirical weekly published in Munich which popularized the style by ridiculing its more extravagant aspects. In the Bavarian capital the artistic atmosphere was more liberal than elsewhere, so that, despite public resistance, the new symbolic art was more firmly estab-

lished by the end of the century than was Impressionism in Berlin. Even in academic circles the most popular teacher, Franz von Stuck (1863-1928), with whom Jawlensky, Kandinsky, and Klee studied at various times, was more interested in the expressive qualities of symbolic subjects than in Impressionism. The climate was, in fact, so little sympathetic to naturalist values that such prominent German painters as Lovis Corinth and Max Slevogt left early in the century for Berlin.

As early as 1891 a retrospective exhibition of Hans von Marées had called attention to the expressive properties of his form. The following year the Munich Sezession was founded, the first of the German and Austrian artists' groups organized to present their more liberal points of view through public exhibitions. Although this was the oldest of the Sezessions and one of the first to lag behind the modern movement, none the less it encouraged the more radical formations which followed. The presence in Munich of certain masters of Jugendstil design, especially August Endell (1871-1925) and Hermann Obrist (1863-1927), was also significant.[82] Nor should Adolf Hölzel (1853-1934) be overlooked. His criticism, most

of it published in the widely read *Kunst für Alle*, was sympathetic to Post-Impressionist and Symbolist painting. In 1902 he gave a warm reception to the first works by Van Gogh to be seen in Munich. Under his direction the landscape painting of the nearby Neu-Dachau group may have differed little from the idealistic tendencies of Worpswede in the north, but his own investigations into the properties of colour led him close to, if not completely into, total abstraction. Although he made many experiments with form and colour in studio exercises and in relation to decorative design, his most non-representational works cannot quite be considered examples of an independent abstract art; for it is not easy to determine whether a given composition is an exercise in 'absolute' art, as Hölzel phrased it, or a free interpretation of natural elements. Such a work as the *Composition* by the decorative painter Hans Schmithals (b. 1878), painted in Munich about 1900 [64], shows the difficulties of deciding where abstraction begins and representation ends. If each part is examined separately the whole may seem composed of free, curvilinear arabesques. On the other hand, it may just as convincingly be seen as a stylized interpretation of floral forms.

64. Hans Schmithals: Composition, *c.* 1900.
Munich, Historisches Stadtmuseum

The intricate interlace, none the less, is an energetic example of Munich Jugendstil design, comparable to Endell's famous plaster relief on the façade of the Atelier Elvira (a photographer's studio that was destroyed in 1944), which was by far the best-known example of Jugendstil in Germany.

In Austria the term Secession Style referred to the latest developments in painting and the decorative arts as they were presented in annual exhibitions by the Vienna Sezession, founded in 1897. The mass of its new building, designed in 1897-8 by Josef Maria Olbrich (1867-1908), basically a cube surmounted by an openwork metal dome, indicated that this easterly extension of the new style was affected by the rectilinear work of the Scottish school in the West. The work of the first president and most notable artist associated with the Vienna Sezession, Gustav Klimt (1863-1918), now seems as much a result of the movement as at the time it was one of its causes. Until 1892 he had been a member of an artist-decorator's firm. With his brother and others he provided murals, usually of historical or allegorical scenes with the realistic historical paraphernalia typical of Hans Makart, for museums and theatres in Vienna and elsewhere. After his brother's death he abandoned this profitable enterprise and for several years painted very little until 1897, when a tendency, hitherto suppressed, for flatter and more simplified compositions and contours became dominant. His murals for the University of Vienna representing Philosophy, Medicine, and Jurisprudence (1900-3, destroyed in 1944) caused the most violent controversy over modern art the city had ever known. Instead of a conventional array of familiar historical figures, Klimt created masses of huddled naked forms, symbolizing philosophically varieties of human affection and despair, and medically the wretched conditions flesh is heir to. A huge female mask, faintly glimmering in the starlight, seemed to say that philosophical truth is never more than partially revealed. In the foreground of *Medicine* the goddess Hygeia, robed with Minoan splendour, guarded her healing but poisonous-looking cup. The academic faculties of philosophy and medicine protested so violently that, by government decree, the murals were returned to the painter. But we may now think that by evoking a mood of almost Schopenhaurian gloom Klimt had painted a true picture of the spiritual conditions of the day.

In the following years Klimt's work became flatter, the line more sinuous and rhythmic, the colours less naturalistic. In his Beethoven frieze, executed in tempera, gold leaf, and stucco as a background for the Max Klinger exhibition at the Sezession in 1902, the influence of British and Dutch Art Nouveau can be detected in linear rhythms reminiscent of Mackintosh and Toorop, and in the erotic tone borrowed from Beardsley's *Salome*. The influences are easily traced: Mackintosh's work, in its own way affected by Toorop's, had been seen in some quantity at the Sezession in 1900. Klimt might have succumbed to such different suggestions, but instead he fused them into an ornate style of his own which reached its climax in murals for the dining-room of the Palais Stoclet at Brussels, designed by Josef Hoffmann (1870-1956) in 1905.[83] Klimt's life-long interest in decorative design and his willingness to experiment with unusual effects are seen in his choice of mosaic as his medium (the murals were executed by members of the Wiener Werkstätte, the arts and crafts studios fostered by the Sezession). Even in a water-colour study for the section known as *The Kiss* [65], his concern for the material required the precise separation of the different elements. But the balance between a realistic treatment of heads and hands against flat clothing and backgrounds, which he may have learned from Hodler and which had appeared in his portraits for some years, was upset; only part of the woman's face and one of her hands can be deciphered against the

65. Gustav Klimt: The Kiss, 1909.
Strasbourg, Musée des Beaux Arts

Impressionism to a geometry of design transitional between Monet and Seurat on the one hand, and Mondrian on the other. This aspect of his work remained, however, without issue or influence. Rather it was his example, his impressive demand for artistic freedom of expression in the face of governmental and social opposition in Vienna, that encouraged such younger Austrian Expressionists as Kokoschka and Schiele.

SYMBOLIST ART IN RUSSIA:
THE SLAVIC REVIVAL AND MIR ISKUSSTVA

In Russia, a comparable search for more subtle and anti-academic expression in painting and the decorative arts, although in relation to indigenous Russian historical experience, was also affected by the aesthetic and stylistic character of European Symbolism. In Moscow after 1850 the revival of interest in the Slavic past, an aspect of the Pan-Slavic political movement, was supported by the industrialist and connoisseur Savva Mamontov.[84] In the winter at his house in Moscow and in the summer on his estate at Abramtsevo he gathered around him a number of painters, sculptors, and designers. From their discussions came a new interest in earlier Russian art, long neglected since Peter the Great had turned towards Europe, and from their studies came the design and production of arts and crafts according to the principles of medieval technique and manufacture. Many of their efforts, like the little chapel at Abramtsevo (1880-2) by Apollinary Vasnetsov (1856-1933), the first archaeologically accurate reconstruction of medieval Russian architecture, or the production of Alexander Ostrovsky's drama *Snegurochka* (*The Snow Maiden*) in 1885 for Mamontov's private theatre, with sixteenth-century sets by Viktor

elaborately patterned robes and the spirals of the wall plane. Abstract design rules almost the whole, and in certain sections, as in the arrangement of many small squares within a larger one near the bottom of the man's garment, Klimt's interest in geometrical design carries him far towards non-objective art. It is instructive to think that such work as this is contemporary with Kandinsky's discovery of abstract art in Munich and precedes the preoccupation with the square by Malevich and by the artists of De Stijl and of the Bauhaus. His understanding of the vitality of ornamental elements released from representation makes Klimt's work once again of interest to spectators who otherwise might weary of his bloodless eroticism. In his landscapes he submitted the subjects and techniques of both Impressionism and Neo-

Vasnetsov (1848-1927), belong to the history of nineteenth-century revivalism, but in the decorative work produced by Mamontov's craftsmen there could be seen the same feeling for the relation of tools to materials and of forms to their functions that had entered the aesthetic of Art Nouveau and Jugendstil by way of the English Arts and Crafts movement. In the slightly later productions from Talashkino, a colony near Smolensk established by Princess Maria Tenisheva, the emphasis on functional design, strongly impregnated with Jugendstil linearism, was more evident. In both places the craftsmen opposed the well-designed and individually-produced object to the run-of-the-mill mechanically manufactured item, which was no better in Russia than elsewhere, and so asserted the supremacy of artistic over purely utilitarian standards.

In painting the emphasis on expressive properties of colour and composition at the expense of illusionistic and illustrational values, which may be followed in the gradual decline of historical realism from the archaeological accuracy of the Vasnetsov brothers to the idealistic representations of Russian saints by Mikhail Nesterov (1862-1942), came to a brilliant and pathetically brief climax in the work of Mikhail Vrubel (1856-1911), a painter who might have been ranked with the leading Symbolist masters of the 1890s, with Gauguin, Munch, and Hodler, had not public indifference and his own emotional instability wrecked his career. The first measure of his talent was seen in his restoration of the murals in the old church of St Cyril at Kiev, where his study of the mosaics of St Mark's in Venice shows in his understanding of Byzantine colour and design. Even then he was not satisfied with merely studying the past, and wrote that he was driven by 'the mania of being absolutely obliged to say something new'. This concern with novelty, we might even say this desire to be 'modern', appears in his interpretations of Lermontov's poem, *The Demon*. The theme of an androgynous, Lucifer-like creature, of more than mortal beauty but

66. Mikhail Ivanovich Vrubel: The Demon, 1890. *Moscow, Tretyakov Gallery*

doomed never to know mortal joy, haunted Vrubel to the end of his creative life. In visualizing it he passed from quite naturalistic description to the evocation of a jewelled and brooding presence, its peacock wings broken beneath it, and upon its face an expression of unfathomable despair [66]. So obsessive seems his treatment of this theme that it is probably correct to read into his interpretations his sensitivity to the general artistic crisis which Symbolist art embodied, the disgust with realism and the determination to replace it with artistic symbols, as well as his own neuroses.

For Mamontov Vrubel designed objects to be produced at Abramtsevo, and for the house in Moscow murals and decorative sculpture. A resemblance to Cézanne has sometimes been detected in his schematic treatment of planes in the backgrounds of his paintings and in his later drawings,[85] but it must be accidental, since there is little likelihood that he could have seen much of the French master's work at first hand. Nor can the deeply undercut folds of the draperies in his sculpture be considered proto-Cubist. Although such devices call attention to the general tendency of Symbolist art to pass from representation to abstraction, their significance in Vrubel's work is that they prepared the ground for the wider acceptance of French modernism which followed in Russia, especially in Moscow, soon after 1905, that fateful year which began with the January Revolution in St Petersburg, which saw the catastrophic end of the Russo-Japanese War, and in which Vrubel's reason finally failed.

Despite its points of contact with Symbolist neurasthenia and the spiritual alienation of the fin-de-siècle, Vrubel's art is categorically Russian in its spirituality and Oriental coloration, and is thus inseparable from the Slavophile interests of the Mamontov circle in Moscow. In St Petersburg, traditionally Russia's 'window opening on Europe', a different mood prevailed. The dreary routine of academic realism and idealism, dominant in the Petersburg academy, which was still Russia's leading art school, and the prevailing conventionality and eclecticism of official taste, dominated by the German sympathies of the court, were challenged by the activities of a group of young men in an informal association which they called Mir Iskusstva (The World of Art). In their upper-class education and their sense of themselves as subversive missionaries in a world of dreary routine they resembled their contemporaries in Paris, the Nabis, for they too believed in the importance of art for life, even of life for art, that last and characteristic phase of the aesthetic of art for art's sake.

One of the leaders and the principal spokesman for the group, Alexander Benois (1870-1960), was of French and German descent and knew Europe well. Another, Sergei Diaghilev (1872-1929), a member of the provincial nobility, had come to the capital to study law, but was taking music lessons with Rimsky-Korsakov. A third, Léon Bakst (1868-1924), had left the Academy disgusted by its unimaginative instruction. Together they dreamed of invigorating Russian art, although in the end it was more a matter of improving Russian taste, by establishing closer contacts with the West through exhibitions and the publication of a review. To follow their interests and activities through the pages of their magazine, Mir Iskusstva (1899-1904), is to see how closely they identified themselves with the later stages of Impressionist and Symbolist art elsewhere. In the second issue, Diaghilev's article on 'The Bases of Artistic Values' was illustrated with works by Puvis de Chavannes, Moreau, Beardsley, and Burne-Jones. Elsewhere there were articles on Rodin, Whistler, and Beardsley, reproductions of the decorative productions of the Glasgow School and the Wiener Werkstätte, and news of important exhibitions in Paris, Berlin, and Vienna. In the last issues their enthusiasms coincided with the most advanced

contemporary taste, and they reproduced paintings by the Neo-Impressionists, by Gauguin, the Nabis, and Cézanne. On the other hand, the Russian painters presented by *Mir Iskusstva* were by and large of little consequence for the development of later Russian art. The paintings of Viktor Borrisov-Mussatov (1870-1905) are still interesting for their more intimately nostalgic note. His women dreaming in deserted country parks, dressed in the costumes of the 1850s and seen, like Turgenev's characters, through the veils of memory, reappeared almost simultaneously in a more vigorous context in the early work of Kandinsky. But his and several other painters' repetitive reveries of ancient Moscow and old St Petersburg were only superficially decorative, without relation to the radical revision of pictorial structure which would so shortly appear, even in Russia itself. How complex and contradictory the situation was can be seen in the amount of space allotted in *Mir Iskusstva* to the productions of Abramtsevo and Talashkino as well as to earlier and authentic Russian antiquities. Yet from these attempts to state the premises of a new art in terms of the revival of the past came the tardy but by far the most effective Russian contribution to the total history of Symbolist expression, the early ballets of Sergei Diaghilev, in which traditional Russian themes were embodied in dissonant music and clashes of bold colour.

His first ballet, *Le Pavillon d'Armide*, presented in St Petersburg in 1907 with setting and costumes by Benois, was a tribute to the Rococo elegances of St Petersburg so beloved by the members of Mir Iskusstva. St Petersburg again, seen as a child's memory of a winter carnival in the early nineteenth century, was the subject for Stravinsky's and Benois's *Petrouchka* (1911). By then Diaghilev had taken his company to Paris, where he scored his greatest successes with Borodin's Polovtsian dances from *Prince Igor* (1909) and Stravinsky's *Firebird* (1910). The sets and costumes for these ballets, by

Alexander Golovin (1863-1930), Bakst, and Nicholas Roerich (1874-1917), dazzled western eyes with their brilliant evocation of the Russian past, medieval folklore, and finally, when the curtain rose on the barren landscapes of Stravinsky's *Rite of Spring* (1913), of 'pagan Russia'.

When Benois, Diaghilev, and Bakst transferred their interests and activities to Paris, Mir Iskusstva declined, and the later exhibitions of the group were of little consequence for contemporary Russian art. By 1912 the modern movement had begun in earnest, and Larionov's 'primitivism' and Malevich's 'Cubo-Futurism' shattered the dreams of the past (see pp. 306 ff.). Between their programmatic abstractions and the decorative Symbolism of Mir Iskusstva a curious connexion may be traced in the work of the Lithuanian composer Mikolojus Čiurlionis (1875-1911), who turned to painting in 1905, discouraged by his inability to project through music his vision of a philosophical reality beyond experimental time and space.[86] To that end he painted a series of musical 'abstractions' (*Sonata of the Sea*, *Pyramid Sonata*, etc.), each in four 'movements' with the titles of musical *tempi*, in which cosmic energies are suggested by natural forms and forces so simplified as to be scarcely recognizable. Attempts have been made to establish Čiurlionis as the first abstract artist, on the grounds that his non-representational images of 1907-8 preceded those of Kandinsky, Kupka, and Delaunay. The dates are not in doubt, but the degree of abstraction is. Just as with other contemporary artists, Schmithals and Hölzel among them, and even Kandinsky himself, it is difficult if not impossible to decide whether a given form is an abstraction from nature, a decorative pattern devoid of expressive content as such, or a non-objective form intended to convey a non-naturalistic and transcendental meaning. Čiurlionis's *Composition* of 1906 [67] is in one sense an abstract design, but in another it is an arrange-

67. M. K. Čiurlionis: Composition, 1906.
Kaunas, Lithuania, Museum of Vytautas the Great

ment of sailing-boats and architectural elements (perhaps columns?), seen against the sun. The most abstract forms are the irregularly disposed and intersecting bands, one of which is compulsively filled with the small circles which sometimes occur in the work of the mentally deranged (the artist did, indeed, die insane), but their meaning in relation to the landscape is formally unconvincing. Čiurlionis was self-taught, and his work was compromised by his inexperience as a draughtsman and painter. A retrospective exhibition by Mir Iskusstva in 1912 brought him to the attention of the Russian public, but the time for that sort of unsteady decorative abstraction had passed.

SYMBOLIST ART IN SPAIN:
THE EARLY WORK OF PABLO PICASSO

Fin-de-siècle disillusion was enthusiastically investigated by members of the youngest generation of artists in Barcelona, Spain's most modern industrialized city and the capital of the separatist province of Catalonia. The ethnic pride of the Catalans and their poor opinion of the conventional culture of Madrid coincided with the economic prosperity of Barcelona in the 1880s and 90s and accounted for the adventurous character of its art and architecture at the turn of the century. Here the Catalan architect Antoni Gaudí i Cornet (1852–1926) made his fantastic contributions to the architecture of Art Nouveau. Here three of the most influential painters of the twentieth century, Picasso, Miró, and Dali, first realized their vocations. However much they would change in the course of their careers, and however closely their careers would be identified with other national traditions, in Europe and even in the United States, they cannot be understood without the background of Barcelona's cosmopolitan culture at the turn of the century, none more so than Picasso, whose first mature works must be reckoned among the last achievements of late Symbolist art.

Pablo Ruiz y Picasso was born in Málaga in 1881 and lived there and in Galicia until 1895, when his father, Don José Ruiz, a painter of

sentimental 'drawing-room pictures', was appointed to the faculty of the Barcelona academy. At fifteen Picasso had mastered the conventions, technical and expressive, of academic painting. The proof can be seen in such large, and not entirely unimpressive, canvases as *First Communion* (1895-6) and *Science and Charity* (1897) (both in the Museo Picasso, Barcelona).

In 1899 Picasso joined a group of young artists, poets, and journalists who met at the café Els Quatre Gats (The Four Cats), the centre of Barcelona's political and artistic avant-garde. A remarkable aspect of the discussions at the café, which has been described as 'a Gothic tavern for those in love with the North', was the interest shown in Northern European as well as strictly French culture.[87] By the mid 1890s Impressionism was no longer a novelty, and even the delicate Intimism of the Nabis though attractive seemed less emotionally rewarding than contemporary work in England and elsewhere. Burne-Jones and Whistler were much admired; Rossetti, Beardsley, and the English illustrators were reproduced and discussed in the progressive journals. Picasso was from the first a lively, caricatural draughtsman, but by 1898, in the menu cards he designed for Els Quatre Gats, he was using flat spaces, strong contours, and early nineteenth-century period costumes, much like those in the work of the popular English illustrator Randolph Caldecott, whom Gauguin also admired. If the formal elements of Picasso's earliest work were related to the sinuous linearism and flat, two-dimensional space-patterns common to later Symbolist painting and to the decorative patterns of Art Nouveau, its expressive tone was saturated with the intellectual interests of his companions, enthralled by the philosophy of Schopenhauer and Nietzsche, the dramas of Ibsen, Hauptmann, Strindberg, and Maeterlinck, and the music of Wagner. All these artists presented their ideas through the ex-

periences of isolated, frustrated, or doomed individuals. From them, as much as from the English and French painters and illustrators, Picasso derived his mood of sadness and separation, deepening into the melancholy and spiritual alienation of the Blue Period of 1901-4.

By then Picasso had paid his first visit to Paris (October-December 1900), where he was immediately drawn to Toulouse-Lautrec and Forain, whose more caustic and objective attitudes towards society appeared in his own art, especially in a series of strongly coloured pastels of café figures. He also admired Carrière (significantly a painter whose works were almost entirely monochromatic), and discovered the compassionate rendering of the socially dispossessed in Daumier, for whom a large retrospective was held when Picasso was next in Paris in 1901, and in the graphic work of Théophile Steinlen. Since the latter's talent was on the whole routine, and except for a few posters in the 1890s rarely rose above the level of competent illustration, Picasso was more

68. Pablo Picasso: The Blind Man's Meal, 1903.
New York, Metropolitan Museum of Art

taken by his themes than his technique. By 1902 the café subject had acquired monumental shape and outline, as in the *Two Women at a Bar* (Hiroshima Museum of Art). In his paintings of a mother and child, a sort of secular Madonna, there was an almost mystical sense of detachment from the actual world, and in his solitary outcasts (*The Blind Guitarist* of 1903 in Chicago), a sensitive identification with suffering. The *Frugal Repast*, an etching of 1904, is the best known, but the *Blind Man's Meal* may be more poignant because of its formal power [68]. The simplified contours and modelling may owe something to his friend and compatriot Isidro Nonell y Monturiol (1873-1911), whom Picasso knew in Barcelona and whose studio in Paris he shared for a time. Nonell had treated the theme of the physically and mentally handicapped in his drawings of the *Crétins* of Bohí in 1896, with similarly encompassing outlines and broadly modelled forms. In his work around 1900 there is the same atmosphere of physical and moral fatigue that we find in Picasso's. He also used monochromatic schemes, usually a dark blue-green. But Nonell's work does not explain Picasso's; in the crucial instance of a drawing and a painting resembling Picasso's *Two Women at a Bar*, Nonell's work may be later. Older influences are also present. After 1904, when Picasso settled permanently in France, his art became so closely identified with the School of Paris that its Spanish sources were often ignored. In the *Blind Man*, in which he gave the full measure of his individuality, the Spanish character is strong. The names of Zurbarán and Velázquez could be invoked for the dish, the pitcher, and the crust of bread. The intensely introspective mood, and the attenuated, Mannerist anatomy may owe something to El Greco, whose work, just coming again into public view in the 1890s, Picasso had copied during the few months he spent at the academy in Madrid in 1897. Even more than these formal parallels,

the innate human dignity with which poverty and physical misfortune are presented may be counted one of Picasso's most Spanish traits.

If the subjects and mood of the Blue Period can be interpreted in terms of Picasso's poverty and loneliness in Paris, aggravated by the intellectual discontent engendered by the cultural climate of Barcelona around 1900, the most conspicuous formal element in these paintings, the prevailingly blue colour scheme, is less easily explained. The theories that he was too poor to purchase other colours, or that he painted only at night, are too simple. The Romantic fondness for blue as the most spiritual colour, which the young artists of Barcelona learned through a translation of Novalis's *Blue Flower*, with later literary associations from Mallarmé and Verlaine relating it to the concept of decadence, cannot be ignored. There was also the bluish-green tonality of Burne-Jones's later work and of Whistler's *Nocturnes*, which were much admired in Barcelona. To these may be added a notable 'blue' picture that was much remarked when Picasso first arrived in Paris, Puvis de Chavannes's *Vigil of St Genevieve*, which had been placed in the Panthéon only three years before. Not only the almost monochromatic blue of the mural but the uncomplicated outline of the figure, the simplified interior modelling, and the geometrical setting, not to mention the saint's wasted features, occur in Picasso's Blue Period pictures. Puvis's prestige was at its height in 1904, when the Salon d'Automne included a retrospective exhibition of forty-three paintings. A year later his influence could still be seen in the lumpy modelling of the seated nude figure in Picasso's *Acrobat on a Ball* (Moscow), to be compared with the father in Puvis's *Childhood of St Genevieve* in the Panthéon.

The largest work of the Blue Period, *La Vie* of 1903 [69], painted in Barcelona after poverty had forced Picasso to leave Paris for the last time, was his summation of his experi-

69. Pablo Picasso: Life (La Vie), 1903. *Cleveland Museum of Art*

ences during these first years. This ambitious statement of the mystery and misery of existence has its analogies with Hodler's *Night* of 1890, Gauguin's *Whence Come We . . .* of 1897 [39], and with Munch's several versions of the *Dance of Life*. The straitened figure of the woman on the right owes something to *St Genevieve*, although her feet resemble those of Gauguin's Tahitians. The limpid modelling of the nudes is common to Symbolist art and may be compared with Minne's *Kneeling Youth* [74]. And there is something Pre-Raphaelite about the tone of the whole, not unlike the distant and pallid atmosphere in Burne-Jones's work.

On the wall behind the principal figures two drawings are Picasso's tribute to the masters who were then emerging as major influences in French and European painting, to Gauguin, whose heavy contours are apparent in the two huddled nudes, and to Van Gogh, whose more clamorous subjectivity is recalled by the crouching figure below, an echo of his lithograph of *Sorrow* of 1882. In so large and carefully considered a work as this, it is important to point to the elements drawn from other artists if we are to understand Picasso's artistic personality, which time and again has been more refreshed by the contemplation and analysis of works of art than of what is customarily described as 'life' or 'nature'. In his major works there is often a conflict continually renewed between the demands of life and art. The fact that art is usually victorious is a clue to the character and meaning of his work, one that can guide us through the riddles of his incessantly contradictory 'periods' and 'styles'. With *La Vie*, the first of his monumental figure compositions, Picasso summarized and prepared to set aside the introspective pathos of later Symbolist painting. It perfectly exemplifies the phrase 'la tristesse stérile' with which Gauguin's friend and critic, the Symbolist poet Charles Morice, characterized the paintings he saw at

one of the artist's first Paris exhibitions.[88] But within a year the sadness had almost disappeared, and from the self-conscious 'sterility' of his beginnings Picasso passed to the threshold of his most fertile inventions.

In his work of 1905, during the so-called 'Pink' or 'Circus' period, lighter, more variegated colours expressed a change of mood as the melancholy isolation of the blue figures yielded to the tender representation of acrobats and their families. The change can partly be credited to an improvement in the artist's material circumstances and the increasing confidence which success assured. The circus themes can be related to a long tradition, beginning with Daumier and continued by Toulouse-Lautrec, in which the clown was seen as a pathetic victim of society's indifference to his true character, his joys and sorrows concealed by the obligatory mask and costume. Picasso's figures are not so sentimental. Wistful they were at first, but in the largest picture executed up to this time, the *Family of Saltimbanques* of 1905 [70], the six persons have no dramatic connexion with each other, and the space that separates the woman on the right from her companions cannot be psychologically bridged. The picture is important because its effect is the sum of its artistic parts, not of any anecdotal relationships among the figures. Henceforward, and with only rare exceptions such as those induced by the political crises to which Picasso felt himself committed, the content of his work has been identical with its formal structure.[89]

This tendency became more pronounced in 1906 in the studies of nude boys and horses related to an unfinished composition, *The Watering Place*. In the best-known example, the *Boy leading a Horse* (New York, William S. Paley), the artist omitted the halter; the relation between the forms as forms was more important to him than the event. The nude figure emptied of dramatic action was a step

70. Pablo Picasso: Family of Saltimbanques, 1905. *Washington, National Gallery of Art*

towards consideration of the pictorial surface as an artistic structure having less and less relation to events outside itself. A further stage was reached in the massive nude female figures, singly or in pairs, of 1906. By then, however, he was about to extinguish the last vestiges of Symbolist sentiment in the painting that announced the beginnings of Cubism, the *Demoiselles d'Avignon* [131]. (See below, pp. 235–7.)

ENGLISH SYMBOLISTS: BURNE-JONES, BEARDSLEY, AUGUSTUS JOHN

In England during the last two decades of the nineteenth century, while the public, and the painters too, were debating or ignoring the merits of French Impressionism, certain artists were making substantial contributions to that very movement which was to replace Impressionism before ever the latter had been established as a factor in British art. The foremost of these was Sir Edward Burne-Jones (1833–98), whose usual reputation as a late and diminished follower of the Pre-Raphaelites has obscured the esteem in which he had come to be held abroad. Pre-Raphaelite paintings, it is true, had been shown in Paris at the Exposition Internationale of 1855 and had been seen occasionally thereafter, but they had made little impression until Burne-Jones's *King Cophetua and the Beggar Maid* (London) appeared at the Exposition of 1889, where it was admired by Gauguin.[90] Its elaborate and forlorn charm appealed to Puvis de Chavannes, so like in some ways his own melancholy mood, so unlike his quiet emptiness in its richly textured and modelled surfaces, and in 1892 he invited Burne-Jones to exhibit at his new Salon. Burne-Jones sent twelve works that year, including three scenes from his uncompleted *Perseus* cycle (Stuttgart, Staatsgalerie), and *The Depths of the Sea*, the only painting he ever sent to the

71. Sir Edward Burne-Jones: The Depths of the Sea, 1887. *Cambridge, Mass., Fogg Art Museum, Harvard University*

Royal Academy. It would be idle to pretend that this weirdly unpleasant work, even in the water-colour reduction [71], which had looked 'like a dream well enough' in the studio, had any great influence on contemporary painting, but it is impossible to ignore the atmosphere which it still communicates, or the manner in which it brought down, if not up, to date the morbid, unworldly imaginings which had emerged as the obverse side of the Impressionists' vision of a sunlit, empirical world from which all fancy had fled. More than that, the peculiar morbidity of Burne-Jones's figural style was in harmony with the disillusionment, the *fin-de-siècle* world-weariness so prevalent throughout Europe. As early as 1882 Zola had noted 'la caractère moderne du pessimiste', and Téodor de Wyzewa stated that for him a work of art to be 'really new, that is, in keeping with the latest inventions, had to be a bit sickish'.[91] In 1878, when Ruskin so publicly preferred Burne-Jones's work to Whistler's, a writer in the *Magazine of Art* (London) observed that 'these archaic affectations are more modern, more entirely of the nineteenth century, than is a factory or a positivist'. And in 1885 the English critic Claude Phillips, in discussing Burne-Jones with Moreau and Puvis de Chavannes, noticed 'the element of peculiar melancholy' which he thought 'pre-eminently modern and . . . an inseparable character of all the higher art of the century'.[92] Phillips had no way of knowing that Gauguin, who was still an Impressionist in 1885, was to be one of the principal practitioners of that 'higher art', but he might have been interested, had he ever known it, that Gauguin acknowledged, even if he could not admire, the artistic integrity of Burne-Jones, when he saw his work in Paris in the early 1890s, and even the young Picasso became aware of it in Barcelona towards the close of that decade.

There was a similar flavour of Pre-Raphaelitism in the early drawings of Aubrey Beardsley

(1872–98), but any lingering trace of romantic medievalism was quickly transformed into an unmistakably contemporary expression by this extraordinarily gifted and doomed young man. Beardsley's drawings, so impeccably executed with a fine steel pen in dense black ink that it is sometimes difficult to believe that they were actually 'hand-made', are the supreme accomplishment of the English 'Decadence' with which they are inseparably related through their frequent appearance in such periodicals as *The Yellow Book* and *The Savoy*. With his air of languid aestheticism Beardsley might have stepped from the pages of Huysmans's *À Rebours*, whose hero cherished most his water-colours of *Salome* by Gustave Moreau. With his own illustrations, published in 1894, for Oscar Wilde's drama about the perverse young

72. Aubrey Beardsley:
The Eyes of Herod,
1893. *Cambridge, Mass., Fogg Art Museum, Harvard University*

woman, Beardsley achieved notoriety and lasting fame. Although the drawings sometimes have little enough to do with the text, they are remarkable accomplishments, not only for so young a man – Beardsley was only twenty-one when they appeared – but for the precocious originality that could integrate influences from so many sources into an intensely individual statement [72]. A Beardsley drawing cannot be mistaken for the work of anyone else, but just as unmistakable are the references to the flat, juxtaposed shapes of Japanese prints, the contours of Greek vase painting, Celtic interlace, Rococo curves, and Whistler's spangled peacock patterns. From the Pre-Raphaelites he took the heavy, pouting features, diminished as the heads of his figures shrank in proportion to their bodies, and the baleful facial expressions in which earlier Victorian pangs of conscience were distorted by guilt and lust. From these various elements he contrived a style that was the perfect embodiment of his subject, the power of evil to corrupt the body and degrade the soul. *Salome* was Beardsley's finest achievement and his most completely Art Nouveau work, but later drawings, like the sprightly Rococo 'embroideries' for *The Rape of the Lock* (1896), should not be overlooked. By the end of his short life Beardsley's international reputation was equal to Whistler's, and it was more up to date. He had set the tone for contemporary black-and-white illustration, both in technique and content, and his death, like Burne-Jones's, was noted as a major loss by the leading Jugendstil journals in Germany, Austria, and Russia.

The English intervention in the development of Symbolist art on the continent was effective but short-lived, and scarcely less lasting at home as an element in the formation of a modern point of view, that is to say one that could be distinguished from the pallid stylization of literary subjects which continued as an aspect of academic painting. Yet traces of something

73. Augustus John: The Way down to the Sea, 1909–11. *Exeter, New Hampshire, The Lamont Art Gallery of the Phillips Exeter Academy*

stronger can be seen as late as 1909 in Augustus John's large canvas, *The Way down to the Sea* [73]. John (1878–1961) dazzled his contemporaries for half a century and more by his singular facility as a draughtsman and portraitist, although he brought to the latter little that was new in the way of psychological understanding or even of design, and his drawings all too often betray his dependence on the masters of the past. But in *The Way down to the Sea*, for all the reminiscences of Burne-Jones in the simplified and repetitive movement of the draperies and of Puvis de Chavannes in the meagre and flattened landscape, there are also traces of the designer John might have become. The sideways arch of the composition bears comparison with Picasso's only slightly earlier *Family of Saltimbanques* [70], and the expressive content has something of the same psychological detachment from active life, even if it is shallower and entirely more decorative.

SYMBOLIST SCULPTURE

In contrast to the protean variety and intensity of Rodin's art, the work of those few sculptors who can properly be called Symbolist appears of little consequence. However, it is well to remember that Rodin belonged to an older generation, for whom the ideals of material and social welfare had seemed vital factors in human experience. This Rodin himself expressed in studies for his unfinished *Tower of Labour* (1890–7). But by 1900 disillusionment with progress was so prevalent among the younger artists that there were few who could accept the immense vitality of his *Balzac* as an appropriate symbol of the spiritual conditions of the day. For those, like Brancusi, who saw it as the foundation stone of modern sculpture, its importance was more formal than expressive.

The spiritual *malaise* of the 1890s was not easily treated in sculpture, if indeed it ever could be adequately expressed in three-dimensional forms, but it was attempted with some success by the Belgian Georges Minne (1866–1941). He came of old Flemish stock and had studied architecture, his father's profession, in Ghent before beginning to paint and model. He spent a year at the academy in Brussels and then went to Paris to work on his own. After Rodin patronizingly dismissed him with a word of encouragement, he returned to Belgium, where he spent the remainder of his life except for the years of the First World War, when, with other prominent Belgians, he lived in Wales. In 1899 he settled with his large family at Laethem-Saint-Martin near Ghent, where he was joined by a number of artists whose activities made the small village famous as an artists' colony.

In his early drawings and woodcut illustrations for the works of the Belgian Symbolist writers Minne revealed the sources of his inspiration in Gothic art and in the medieval revival of the Pre-Raphaelites. Both influences are strong in one of his elaborately finished drawings, *The Outcasts (Les Réprouvés)* of 1898, in which the fingers of the desperate couple are twisted in the manner of Grünewald, who was then just becoming known to the Symbolist generation.[93] The poetry of Georges Rodenbach and the plays of Maurice Maeterlinck inspired him to find sculptural metaphors for the tentative gestures, interrupted phrases, and mysterious silences with which they had expressed their conception of man's inexplicable destiny. The image which most completely embodied these feelings was first modelled in 1896 as a *Kneeling Youth*, a motif which Minne reworked with minor variations for many years, including the

74. Georges Minne: Kneeling Youth, 1898. *New York, Museum of Modern Art*

two versions of the *Relic Bearer* of 1897 and 1929. It is most familiar in the piece of 1898 [74], in which the attenuated proportions, the softly modelled flesh, and the unstable posture are sculptural symbols for the withdrawn, unworldly mood. Five marble examples of this figure were set on the rim of a large simple basin for a fountain commissioned in 1906 by Karl Ernst Osthaus for his museum at Hagen (subsequently transferred to Essen; bronze replicas in Ghent and Brussels). The idea of repeating the same figure may have come from Rodin, whose identical versions of the *Adam* of 1880 became the *Three Shades* surmounting the *Gates of Hell*. Because Minne's figures cannot all be seen at once from the same position, so that each appears not quite like its fellows, the spectator becomes absorbed, as it were, in turning the same thought over in different ways. The atmosphere of silent resignation may even remind one of that most famous of all Symbolist fountains, in the forest of Maeterlinck's *Pelléas et Mélisande*, where the inarticulate lovers become aware of their impending fate.

Although one would never surmise from his sculpture that Minne was concerned with scientific or social issues, he was deeply interested in machinery, especially in steam engines, and received a commission for a monument, in the end never completed, to the socialist journalist Jean Volders. When the narcissistic mood of the 1890s was no longer viable, he looked to the strong, simple realism of Constantin Meunier, which he had at first rejected. After the war he did little more than rework his grieving nude figures, and returned in his drawings, often large in size, to his earlier theme of mother and child.

To the novelty and difficulty of accommodating philosophical and allegorical subjects to the formalistic aesthetic of the early twentieth century can be laid the first success and the probable final failure of two notable Scandinavian sculptors. The Norwegian Gustav Vigeland (1869–1943) acquired his technical proficiency at the academy in Oslo before studying in Paris and Italy (1892–5), where he mastered a technique so exhaustively realistic that his stumbling naked *Beggars* of 1899 (Oslo), rather than Rodin's *Age of Bronze*, might be thought to have been cast from life. This realism was curbed by the study in 1900 of medieval sculpture in France and England in preparation for the restoration of the cathedral at Trondheim. In the same year he first sketched a colossal basin upheld by straining nude male figures, the central motif for the monumental fountain in Oslo that occupied him for the rest of his life. The model for the square pool around the basin with twenty *Tree Groups* at the corners and sixty relief panels along the sides was first shown in 1906. These pieces, with others for the avenue and bridge approaching the fountain, were cast by 1914 but not installed until 1944; hence they were little known until recently and had no influence on sculptural developments elsewhere.

Vigeland's allegories are not easy to decipher, and are best summarized as a statement of the doubt, disillusion, and physical decline that beset humanity on its passage through this world. Nor was his mastery of form impeccable. There are clumsy and unconvincing passages, but at times, as in the figure of Death sitting in a tree [75], he found a sculptural counterpart for a poetic, almost pictorial metaphor. Seen beside the wide waters of the basin, the *Tree Groups* have their peculiar symbolic appropriateness.

Vigeland's self-confidence may have been his misfortune. He induced the city of Oslo to support his work for the better part of his lifetime, but he could brook no criticism. Over the years in arrogant isolation he added to the bronze fountain thirty-six figural groups, larger than life and greatly varied in posture, age, and

75. Gustav Vigeland:
Death in a Tree, from the Frogner Fountain,
c. 1908. Oslo, Frogner Park

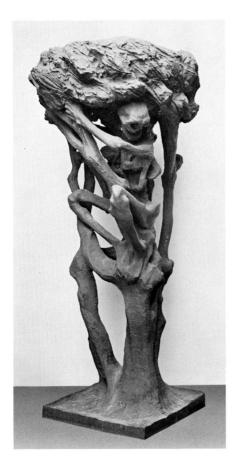

type, from infants to the elderly and the dead. They are arranged to the west of the basin in rows on circular steps surmounted by an immense column of 121 writhing figures. The plaster models were transferred to granite by artisans who preserved in that obdurate material his disagreeably soft and fleshy modelling. The megalomaniac scope of Vigeland's achievement, however unsympathetic to contemporary taste and tangential to the history of modern sculpture, is a memorable episode in the history of Symbolism. Were its quality only better, the fountain in the Frogner Park might, for its size, allegorical intricacy, and for the artist's life-long dedication to his ideal, be described as sculptural Wagnerism.

Although Vigeland's abrupt switch from bronze to granite was not accompanied by any convincing understanding of the formal consequences of a change in material, it may have been prompted by the growing use of harder stones by other Scandinavian sculptors.[94] In 1909-10 the Dane Kai Nielsen (1882-1924) carved a terminal granite portrait of Bindesbøll in situ in a square in Copenhagen, and in 1913 the Swede Carl Milles (1875-1955) finished his granite Sea God, the first of an uncompleted series of marine figures for the quays of Stockholm. Milles was almost entirely self-taught, but he had been to Paris, where his earliest groups were small genre scenes, like episodes from Steinlen modelled with the restrained naturalism of Dalou. A sojourn in Munich, where he studied the Aegina pediments, and two years' residence in Italy enlarged his knowledge of ancient, medieval, and Renaissance art. He made his reputation with a series of monumental fountains on ancient or indigenously Swedish subjects. The Folke Filbyter Fountain of 1927 at Linköping, and the Poseidon and Orpheus Fountains [76] of 1930 and 1936 at Göteborg and Stockholm were the most successful. The latter, in fact, was the crowning

sculptural achievement of twentieth-century Swedish neo-classicism, a movement particularly influential in the decorative arts.

Milles's sophisticated, often incongruous mixture of humour, monumentality, and archaic detail is still interesting, but the relation of form to content now seems frequently self-conscious and literary. As in much of Bourdelle's work, gesture and action exceed the expressive requirements of the subjects. Still, in the elongated proportions of the *Orpheus* and his companions there is a last recall of the more subjective and spontaneous poignance of Minne and the artists of the nineties.

Like many eclectic masters, Milles was a gifted teacher, able to communicate to others the beauty he had found in the great artistic traditions. In 1931 he joined the Cranbrook Academy at Bloomfield Hills, Michigan, established by the Finnish architect Eliel Saarinen as a centre for instruction in architecture and the arts and crafts. During his long residence in the United States Milles created fountains for Chicago, St Louis, Kansas City, New York, and towards the end of his life a many-peopled *Fountain of Faith* for Falls Church, Virginia. However old-fashioned his allegories, he never failed to integrate his light-footed figures with the play of moving water. By his bequest his house with its gardens on Lidingö Island, high above the waters of Stockholm harbour, became a museum. There one can measure his attempt to create a contemporary classical style against his own collection of antique sculptures.

The Yugoslavian sculptor Ivan Meštrović (1883-1962) treated a multitude of subjects in several classicistic manners, at times archaic, at others with a wild Hellenistic flair. He also enjoyed an international reputation. His monuments can be found in America as well as Europe, and late in life he settled in the United States to teach at the Universities of Syracuse and Notre Dame (Indiana). But so much storm

76. Carl Milles: Orpheus Fountain, 1930-6. *Stockholm*

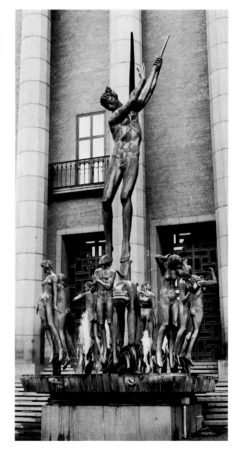

and fury yielded little in the way of original sculptural form, once the novelty of his technique had worn off. Like Milles, and the host of sculptors who followed where they led, he failed to realize that artistic symbols are only meaningful when they acquire expressive artistic form. No subject by itself, however exalted, guarantees artistic truth.

ARISTIDE MAILLOL (1861–1944)

From the circle of Gauguin and his followers there emerged an artist who passed through and beyond their interests in painting and the crafts to become the greatest French sculptor of the earlier twentieth century. Aristide Maillol was never formally a Nabi, but the members of the group were his close friends, and he shared their admiration for the master who had led them from Impressionism to Symbolism. Because he had been born in the Mediterranean fishing village of Banyuls near the Spanish frontier, it is customary to infer that he inherited the breadth and simplicity of his style from a people and a landscape which had once been Greek and Roman. His gravity, his patience, and his lifelong dedication to that most exemplary of classical motifs, the nude human body, do suggest that race and an historic environment contributed to the character of his art, but there were artistic sources for it as well. Although Maillol's sculpture has an aspect of timeless monumentality, it is no less closely tied in time to the theories and practices of late nineteenth-century French Symbolism.

Maillol arrived in Paris in 1887 to study at the École des Beaux-Arts, but by 1890 even his peasant patience was exhausted by the irrelevant teaching of Cabanel and Gérôme. Through his discovery of Gauguin, of his pottery and wood-carvings as well as of the paintings, and of Émile Bernard, he became interested in the crafts. His first tapestries were so successful

that in 1894 he was invited to exhibit in Brussels at La Libre Esthétique, the annual exhibition of contemporary decorative arts founded by Octave Maus in succession to Les XX. There Gauguin himself admired Maillol's work. His tapestries and the few paintings of the early 1890s are thoroughly Nabi. The flat patterns, clear colours, and slightly melancholy expression resembled Bernard's and Denis's work of those years. However, the large, slowly moving figures, which reappeared in his sanguine drawings throughout his life, owed more to Gauguin's nudes of 1887 from Martinique.

In 1896, when his eyesight was endangered by the strain of weaving, Maillol began to make statuettes in wood and terracotta with the same rounded forms which had been conspicuous in his painting. Vollard, urged by Vuillard, had a few cast in bronze, and in 1902 arranged a small one-man exhibition which made Maillol's reputation. Rodin is said to have remarked of the small seated *Leda*, startled by the approach of the swan, that he knew nothing so 'absolutely beautiful, absolutely pure, absolutely a masterpiece . . . in all modern sculpture'.[95] Rodin's enthusiasm, as generous as it was intelligent, was the more unexpected since this newcomer (one can scarcely call him a young sculptor, since he was already forty) proposed to replace Rodin's dramatic and agitated figures with the greatest simplicity of gesture and pose. As Maillol himself said later: 'There is something to be learned from Rodin . . . yet I felt I must return to more stable and self-contained forms. Stripped of all psychological details, forms yield themselves up more readily to the sculptor's intentions.'[96] But Rodin was pleased even so: such work, he said, 'makes no attempt to arouse our curiosity' (surely one of the reactions one still experiences before such sculpture).

In 1905 Maillol enjoyed his first popular success at the Salon d'Automne with his

77. Aristide Maillol: Seated Nude (Mediterranean), *c.* 1901.
Winterthur, Switzerland, Sammlung Oskar Reinhart

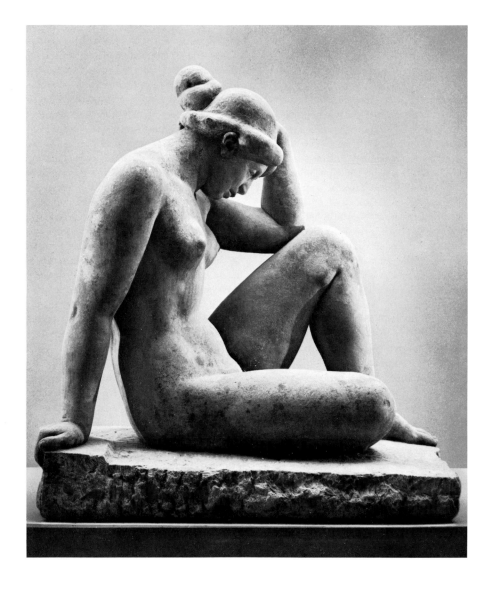

Mediterranean, then known only as *Femme accroupie* [77]. André Gide, turned critic for the day, admired it, but wrote that it 'signified nothing', and that one would have to look far into the past for 'such complete disregard of any consideration extraneous to the simple manifestation of beauty'.[97] Gide was stating the new aesthetic belief that form is expressive in and of itself. The sculptor's friend, Maurice Denis, invoked the watchword of their youth when he described Maillol's work as 'synthetist' because it ideally 'condenses, resumes, in a small number of clear and concise forms the infinitely varied relations which we perceive in nature. It reduces to the essential our most individual sensations, it simplifies what is complicated'.[98]

Maillol had found just such a synthesis in Gauguin, less in his sculpture, which he thought too elaborate and even ill-proportioned, than in the paintings. The relation between the *Mediterranean* and Gauguin's *Aha oe Feii?* [38], which Maillol could have seen in Paris, is clear, not only in the posture and the simplified modelling of the limbs, but in the expression. Both works project an atmosphere of close communion between human beings and the earth which nourishes them. Maillol's figure is as much a metaphor of the cultural geography invoked by the title he later gave her as Gauguin's Tahitians are inseparable from the nature which surrounds and supports them. Even the nakedness of these figures is symbolic, for it identifies them, so to speak, as entirely natural. Maillol's sculpture has other references, to art as well as to life. The slumbrous pose with arm linking head and thigh is an adaptation of Michelangelo's *Night,* which he much admired; the clear distinction between the different parts of the body, particularly at the waist, recalls the Egyptian sculpture which he and Gauguin had studied in the Louvre. Egyptian, too, was his rejection of Rodin's and Rosso's impressionistic

modelling for a continuous, smooth surface, whether in plaster, stone, or bronze, to concentrate and hold the light.

The confrontation of Maillol's figure with Gauguin's and Michelangelo's should indicate that this and later works are not just 'ponderous lumps of drastically simplified anatomical architecture', as they have at times been called,[99] that they are not mindless, even though their thoughts may be imperceptible. For Maillol they were 'poems of life', because the ideas he wanted to embody, the great abstractions of experience, of fruitfulness, beauty, endurance, and repose, were incommunicable for him in any other language than that of three-dimensional form. The comparative failure of his conventionally symbolic and allegorical sculpture, executed on commission, reinforces the conviction that his individual figures were intended to convey meanings which, although elusive and always non-verbal, were symbolic in a private sense that Gauguin and the Nabis would have understood. In his war memorials, his gently stooping or solemn flat-footed women did not express the particular accent of grief or resignation such public effigies require. Even the celebrated relief of the fallen warrior at Banyuls is a clever but cool archaic stylization, a mannerism Maillol usually avoided, and the side reliefs are clumsy. The monument to Debussy (Saint-Germain-en-Laye, 1935) has an affected grace suggestive of fashionable Salon sculpture, and the monument to Cézanne, begun in 1912 but not set up in the Tuileries Gardens until 1929, a reclining nude proffering a laurel branch to genius, seems an odd tribute to a master who had had such difficulties with the undressed figure.

Maillol was at his best when he was most private, as in the noble *Torso* of the early 1930s [78]. As Gide would have said, it means nothing outside itself, but in itself it is a statement of life as vital and intense as actual flesh. Its subtly

78. Aristide Maillol: Torso, *c.* 1933.
New Haven, Conn., Yale University Art Gallery

Maillol's early interest in decorative crafts-manship reappeared in his woodcut illustra-tions for certain classic and modern authors. His important patron, the German connoisseur Harry Count Kessler, had proposed an illus-trated edition of Virgil's *Eclogues* which was begun in 1912 but not published until 1926. Maillol not only drew the illustrations but cut them himself. His first experiments in en-graving in the 1890s had been inspired by Gauguin's disclosure of the artistic properties of the material, but Maillol refined his technique and conception in his own way until a single line enclosed the mass of the figure. His engravings were never merely pen drawings transposed to wood, as happened so often in even the better work of the nineteenth century, but were always visibly cut from the block. Other series of illustrations, which included lithographs as well as woodcuts, for Ovid (1935), Longus (1937–8), and Verlaine (1939) were important events in the history of the modern illustrated book. The theme was almost always Maillol's favourite, the delights of love; the expression characteristically and classically sensual and serene.

Maillol's gift for generalization led him far from portraiture, and the few portraits he executed are not, indeed, among his better work. A younger sculptor, Charles Despiau (1874–1946), developed a successful com-promise between the breadth of Maillol's manner and the circumstantial detail which portraiture needs. Although he worked for Rodin as a stone-carver (1907–14) he was essentially a modeller, and it is the touch of his fingers that enlivens a long sequence of portrait busts with just enough personality to set one apart from the others without disturbing a remarkably uniform sculptural expression. In his larger nude figures, however, he achieved neither Rodin's expressive nor Maillol's struc-tural unity.

adjusted geometry reminds us of those earlier instances of a renewed classicism, of Renoir's late nudes in oil and bronze to which Maillol owed so much [6, 7],[100] and of the calm which fell upon certain of Rodin's last works. One can also look to the contemporary abstract sculpture of Brancusi and Arp after 1920. Neither claimed Maillol as a master, but either would be un-thinkable without him.

EXPRESSIONISM

As a mode of symbolic communication art has always been expressive, because each work of art, whether conspicuously or indirectly, is a visual and tangible expression of values which the artist and the society in which he lives have held to be important. Since about 1910, however, the terms Expressionism and Expressionist have been used to denote a particular kind of painting and sculpture in which the values expressed were derived in the first instance from the artist's instinctive response to the basic materials and procedures of his artistic activity. The relation of this response to contemporary spiritual and intellectual conditions, the relevance, so to speak, of private to public values, is still of consequence, even if the dominant stylistic and technical aspects of a given work appear to be overwhelmingly subjective and individualistic.

The presuppositions of twentieth-century Expressionism were suggested as long ago as 1861 by Mallarmé when he remarked that an artist should be less concerned with the object to be depicted than with 'the effect it produces'. Fifty years elapsed before the final implications of this statement were revealed in the earliest examples of totally abstract or non-objective art, but during the last third of the nineteenth century the validity of objective representation was progressively undermined by the demands of the artist's and spectator's experience. By 1900 the more perceptive critics were at least aware that Cézanne's apples were more significant as analogues of a new mode of vision than as descriptions of botanical events.

We have traced the beginnings of this development through Later Impressionist and Symbolist art. In Van Gogh's and Gauguin's last paintings, and in Redon's pastels, colour, line, and texture became more and more important factors in the content, as well as in the construction, of the picture. This change from the conception of a work of art as a representational image of some natural or human fact to the belief that it must be primarily a statement, an expression, of personal experience, can be followed in Van Gogh's letters, where the problem of finding the proper means of 'expression' dominates his account of his intentions and activities. After the first hesitant attempts to express his compassionate concern with peasants and miners, comes his confession that he does not know whether he will be able 'to paint the postman as I feel him to be'. In the end he understands that 'instead of trying to record what I see, I use colour arbitrarily to express my feelings forcibly'.

Although the expression of such intensely personal emotion may not inevitably have required the suppression or elimination of objective representation, the fact that within twenty years of Van Gogh's death and seven of Gauguin's the forcible expression of feeling had led Kandinsky to banish almost all vestiges of the natural world from his *Improvisations* (which have been described as 'abstract expressionist' painting) means that the history of Expressionism includes the earliest formulations of totally abstract art. This was only one of the results of the exploration of subjective experience. Expressionism signifies emphasis upon or distortion of any or every element in a painting or sculpture, whether representational aspects are retained or not. In the work of the

artists to whom the word was first applied, the Fauves in France and the painters of Die Brücke in Dresden whose work matured almost simultaneously between 1905 and 1910, and in the early work of the German and Russian painters in Munich whose collective efforts led to the formation of the Blaue Reiter group in 1911, the traditional images of Late Impressionist figure painting, still life, and landscape were submitted to progressively emphatic exaggerations. Nevertheless, the expressive purposes of the French and German artists were as different as the ultimate appearances of their works. The French, with Matisse as their leader, were primarily committed to investigating formal problems of pictorial design. On the other hand, a sense of the artist's responsibility as a critic of society encouraged the young German painters of Die Brücke to express their concern with the psychological situation of modern man. In Munich the transcendental aesthetics of Kandinsky and Franz Marc led them and their followers towards and even beyond the threshold of abstract art. In their study of the expressive properties of pictorial form many of these artists discovered the direct and uninhibited work of untrained or folk painters, the so-called 'naïve' masters. In the following pages we shall follow the progress of Expressionism in France and Germany before 1914 and examine the art of the most accomplished of the naïve painters, Henri Rousseau, le Douanier. The work of other prominent European Expressionists active after the First World War will be considered in a later section.

THE FAUVES (1900-10): MATISSE, DERAIN, AND VLAMINCK

When the French critic Louis Vauxcelles used the word *fauve* (wild beast) to describe certain painters who exhibited together at the Salon d'Automne in 1905 and 1906, he unwittingly baptized the first incontestably modern movement of the twentieth century.[1] His remark was prompted less by the personalities or activities of the painters themselves – for on the whole they were circumspect individuals – than by the dismay so many spectators felt before their boldly coloured and distorted compositions. Yet the first Fauve demonstration was neither so unexpected nor so inexplicable as it appeared to be at the time. The principal Fauves, Henri Matisse, André Derain, and Maurice Vlaminck, had only pursued the implications of Symbolist theory to their conclusions. Almost from the first they had used the brighter, anti-naturalistic colours of the Symbolists, knowing less perhaps of Gauguin himself than of his ideas, which had reached them through the Nabis, especially through the earlier work of Vuillard and Bonnard before they renounced flat Nabi patterns for their characteristically attenuated Impressionism. Matisse, with his friends and followers Albert Marquet, Charles Camoin, and Henri Manguin, had also learned much about the expressive power of pure colour from Gustave Moreau at the École des Beaux-Arts. One of their fellow-students, although not professedly a Fauve, was Georges Rouault, Moreau's favourite pupil, who developed his teacher's colouristic splendours in his own way. From the masters of the immediate past they absorbed an even more useful lesson: that in the search for a new art, for new means of expression and new expressive ends, they must dare all, distrusting authority and relying only on themselves and the truth of their own experience.

This attitude, so thoroughly subjective and so fundamental for much modern art, was succinctly stated by Raoul Dufy, one of the first of the Fauves. Looking at his brushes and colours one day, he asked himself: 'How, with these, can I render, not what I see, but what is, what exists for me, my reality?'[2] The thought occurred to him after he had seen Matisse's large canvas, *Luxe, Calme, et Volupté* (Paris,

private collection) at the Indépendants in the spring of 1905. The painting, which was immediately acquired by Signac and not seen again in public until 1950, is now of more historical than artistic interest, for Matisse soon surpassed it.[3] But in its contrived and flimsy arrangement of clothed and nude female figures on a beach the younger painters saw, in Dufy's words, 'a miracle of the creative imagination at play in colour and line'. Actually the work was a synthesis of Neo-Impressionist blocks of colour, Gauguinesque figure drawing, and a composition as abrupt as Puvis de Chavannes's *Poor Fisherman* (newly returned to prominence in a retrospective exhibition at the Salon d'Automne of 1904). Now that Van Gogh and Gauguin were dead and Cézanne inaccessible at Aix, this work seemed the clue to a new kind of painting, until Matisse's contribution to the Salon d'Automne in October.

The Salon d'Automne, so-called because it was held in October or November to avoid conflict with others which took place in the spring or summer, had been founded in 1903 by a group of painters and poets, among them Renoir, Carrière, Huysmans, Rouault, Verhaeren, and Vuillard, led by the architect Frantz Jourdain, to oppose the meaningless banality of the official and semi-official Salons, now that the exhibitions on the Champ de Mars had become indistinguishable from those on the Champs Élysées. Nor was the Salon des Indépendants much better, since there each artist risked having his work swamped by the tide of incompetence which could not be refused admission to the jury-less exhibition. Although the works presented at the first two Salons d'Automne were unexceptionable, the small memorial exhibition for Paul Gauguin in 1903 and the larger retrospective for Cézanne in 1904 established it as a centre for progressive art.

Matisse and his friend Marquet had exhibited there from the start, although their work was little noticed. In 1904 Manguin, Jean Puy, and Othon Friesz contributed, and in 1905 they were joined by Derain, Vlaminck, and Kees van Dongen. Georges Braque, whose work did not become Fauve until 1906, exhibited only in 1907; Dufy only in 1906 and 1907. So there was gradually assembled a group of young artists – in 1905 they ranged in age from twenty-three to thirty-one – whose leader, recognized as such for the incomparable boldness of his work, was the slightly older Henri Matisse (1869-1954). He was then thirty-six, and had been painting professionally for almost ten years. After an early success at the Champ de Mars with the *Luncheon Table* (Paris, Collection Stavros Niarchos), a personal but still Impressionist treatment of a traditionally Impressionist subject, he had been seeking a more direct synthesis of colour and design. By 1899 his range of vivid complementaries, principally green and red against orange and purple, had achieved a resonance which has been described as 'pre-Fauve', but for a few years after 1900 dark tones again invaded his canvases. The full possibilities of colour unmodulated by value were revealed to him in the summer of 1904 when he worked at St Tropez on the Mediterranean with Signac and Cross. By then those Neo-Impressionist masters were painting simplified landscapes with large blocks of colour. The divisionist subtleties of Seurat were a thing of the past, but it is only just to note that in water-colour both Signac and Cross worked with a freedom and spontaneity often absent from their oils. Although Signac's influence on Matisse was limited to one year and concentrated in one major painting, this revival of interest in divisionist technique coincides with a resurgence of Neo-Impressionism. Signac's essay, *D'Eugène Delacroix au Néo-Impressionnisme*, had been published in 1899 and was still being read in the studios. There were exhibitions of Maximilien Luce in 1904 and of Cross in 1905 at the Salon d'Automne, and in the

latter year at the Indépendants a large retrospective exhibition of Seurat shared honours with Van Gogh's. This activity did not pass unnoticed by the younger men. In the work of most of the Fauves, and especially in Derain's and Braque's, a mosaic surface characterizes their early Fauve painting. As regards Dufy, and with major modifications, it can be considered the principal component of his later style.

Neo-Impressionism, however, was not the only or even the principal source of Fauvism. The taste for colour and a flattened picture surface had been fostered by Gauguin, whose works were seen in 1903 and again in a large retrospective at the Indépendants in 1906. Before then, in the summer of 1904, Maillol had taken Matisse and Derain to see Daniel de Monfreid's large and little-known collection of Gauguin's work at his house in southern France when the two painters were at Collioure. If their works executed during those crucial months before the Salon d'Automne of 1905 are not remarkably Gauguinesque in theme or treatment, nevertheless they prove their understanding of Gauguin's colour and modelling. The sight of his canvases must have persuaded them to reject chiaroscuro. But almost at the same time Derain, who had accepted 'the new conception of light consisting in this: the negation of shadows', decided to eradicate the lingering traces of Neo-Impressionism. In a letter to Vlaminck he wrote that 'it only injures things that owe their expression to deliberate disharmonies'.[4]

Derain's friend Maurice Vlaminck (1876–1958) was the third important Fauve. An almost entirely self-taught artist who sandwiched painting between stints as a professional bicyclist and itinerant violinist, he had been living at Chatou near Paris, where he and Derain met in 1899 or 1900. The contrast between the two young painters of the 'School of Chatou' was startling. Derain, well educated and perhaps too familiar with the history of art, was a man of wide culture. Vlaminck professed to despise acquired learning, loathed academies, and boasted that he had never set foot in the Louvre. In his case a little learning might have been a less dangerous thing and saved him later from routine. But as early as 1900 Vlaminck proved the fundamental power of his untrained and arrogantly undisciplined abilities in such remarkable works as the *Man with a Pipe – Le Père Bouju* (Paris). The colour was already strong and personal, and the facial distortions precociously violent for this date. He first felt the full brilliance of modern colour at Bernheim-Jeune's Van Gogh retrospective the next year. With characteristic effrontery he declared that he loved Van Gogh better than his own father and adopted the Dutchman's high palette and directional brush stroke. But whereas Van Gogh was a most subtle colourist, Vlaminck's sensitivity was less complicated. His best landscapes, painted between 1901 and 1910, were based upon a scheme of red, white, and blue, that most disagreeable combination of primaries, sometimes squeezed directly from the tube and set against Van Gogh's yellows and oranges. In *Tugboat at Chatou* [79] the boats are drawn in continuous horizontal stripes of red, white, and blue; the buildings and foliage on both banks of the river are bright yellow, orange, and green. The effect was intentionally strong and after half a century has lost none of its power. But in the long run Vlaminck paid too much attention to his own feelings (his stated purpose was to express 'not an artistic but a human truth'), and too little to artistic order. After a brief investigation of the appearance but not the structure of Cubism, he developed his idiomatic treatment of village and farm scenes, intensifying the perspective and manipulating the paint in such a way that the landscape seems to have been observed by someone passing at high speed and as quickly set down [80]. Since Vlaminck was passionately fond of speed, turning to racing cars when his

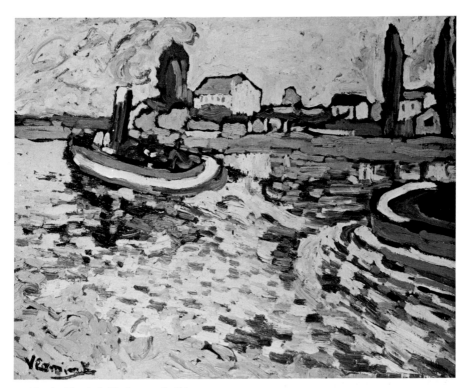

79. Maurice Vlaminck: Tugboat on the Seine,
Chatou, 1906.
Washington, National Gallery of Art

career as a bicyclist ended, the result is perhaps true to his experience and would still be interesting had he not repeated it, with diminishing vigour, until the end of his long life. For all that, he is worth attention. His best early pictures are as Fauve as anyone's, and his later paintings hold a modest place in the history of European Expressionism. His truculent novels and memoirs, as well as his art, are piquant episodes in the history of Fauvism.

Of the paintings exhibited in 1905 one which still conveys a measure of shock is Matisse's *Woman with the Hat* [81]. We must not be distracted by our nostalgia for the feminine fashions of 1905, nor imagine that the first effect

was lessened by the conventional pose in which Matisse had placed his wife. Such matters are immaterial when we confront the vivid and apparently chaotic colours and brushwork. Here are the 'deliberate disharmonies', in Derain's words, of red, green, orange, purple, and blue. Such modelling as there is, and then only in the face, is created inversely by green, the complementary of flesh tones. There is no drawing as such; contours are little more than ragged edges between planes of colour, and the whole is brushed, especially in the background and towards the sides, with a crudity scarcely seen before, save in certain works of Ensor's (in places the canvas is actually left

80 (*below*). Maurice Vlaminck:
Winter Landscape, *c.* 1935.
Private collection, U.S.A.

81. (*opposite*) Henri Matisse:
Woman with the Hat (Madame Matisse), 1905.
San Francisco, Museum of Modern Art

bare). Such remarks, however, are valid only if the portrait is compared with the conventional production of 1905. The longer we study the painting the more we discover that what at first seemed merely wilful was actually intentional. Each major hue has its primary position and its secondary accents. Beneath the violence there is a plan; there are progressions and recalls of colour that betray the artist's instinctual sensitivity. Despite all the refinements and developments which his art underwent in the next fifty years, Matisse never surpassed, in intensity and immediacy of expression, the *Woman with the Hat.*

Cézanne's influence has so often been thought the result of the Cubists' discovery of the structural character of his art that it requires some effort to remember that, until the large retrospective of 1907, he was considered primarily a decorative painter whose elegantly coloured and artfully contrived surfaces were not incompatible with Gauguin's or even the Nabis' premises. In such terms we can more easily understand the point of view expressed by Maurice Denis in his painting *Homage to Cézanne* (Paris), exhibited at the Indépendants in 1900, which shows the Nabis (Sérusier, Vuillard, Bonnard, and Denis) standing with Redon before a still life by Cézanne. It places Cézanne squarely within the Nabi movement and suggests that what they and those who were soon to be known as the Fauves saw in his work was not the underlying structure of planes defining space and mass but the surface pattern created by the colours in which the planes were embodied. If further proof were needed of this point of view, it can be found in a lithograph after Cézanne's painting of foliage, which Matisse contributed to Bernheim-Jeune's Cézanne album of 1914.[5] The tilted, angular planes of the original were flattened and re-created as an elaborate linear arabesque. There we can see for ourselves what Matisse saw in the small Cézanne of three *Bathers* that he bought from Vollard in 1899. Eyes trained by the Cubist aesthetic will search, with some difficulty, for evidence of Cézanne's concern with volumes in space; Matisse saw the rhythmic exchanges between the three figures and the shimmer of red-brown and yellow foliage against the blues and greens of the landscape. Through his eyes we can understand what he owed to Cézanne, and how, when he presented this relatively insignificant canvas to the city of Paris in 1936, he could write: 'It has sustained me spiritually in the critical moments of my career as an artist; I have drawn from it my faith and my perseverance.'[6]

The insistence upon integrity of feeling, in turn dependent upon the exploitation of instinct and intuition, which was simply put by Vlaminck and more philosophically expressed by Matisse in his famous statement of artistic principle published in 1908 (see below, p. 168), was reinforced not only by Gauguin's and Van Gogh's search for instinctual emotion in 'primitive' peoples and examples of folk art but by a more general awareness of non-European cultures. The exhibitions in Paris of Mohammedan art in 1903 and of late medieval French painting in 1904, the latter under the rubric of 'French Primitives', opened new sources of artistic experience. To this may be added the discovery of African sculpture by the artists themselves. Vlaminck seems to have been attracted by its expressive properties before 1905 and to have called Derain's attention to it soon after. By 1906 Matisse had bought a small wooden head, which he showed to Picasso. The study of Negro sculpture was of more consequence for the genesis of Cubism, but the taste for primitive art, for itself and as a confirmation of Gauguin's and Van Gogh's search for the ultimate sources of feeling, was not lost on the Fauves, particularly on Derain, whose figure paintings of this period sometimes show an extreme simplification derived from African and Polynesian sources. Further, there is a hint that the scandal of the Fauve demonstration at the Salon d'Automne in 1905 was perhaps not entirely unexpected. In his introduction to the catalogue Élie Faure urged the visitors to be tolerant: 'To put ourselves in contact with the young generation of artists we must be free to hear and willing to understand an absolutely new language. Listen to them, these primitives.'[7]

From the works which André Derain (1880–1954) sent to the Salons of 1905 and 1906 it is more difficult to select one which would so well summarize his achievement at that time. The landscapes of Collioure, where he worked with

Matisse in 1905, are treated in a relaxed divisionist manner. The broad blocks of colour are set off against the white ground, and the scenes, which are not essentially different from those of Impressionist landscapes, are often viewed from a height. There is one group of pictures, however, which may well rank as his outstanding contribution to Fauvism, and among the finest he ever painted. These are the views of London and the Thames done late in 1905 and in the spring of 1906, in emulation of Monet's London scenes, painted at the turn of the century, which had been seen in Paris in 1904.[8] The subjects are the same, but all the rest is different. Both artists painted the Houses of Parliament in different lights, but where Monet concentrated on a sequence of atmospheric effects on buildings and bridges seen from a few fixed positions, Derain moved up and down the Thames, painting the Pool of London as well as

sections of the river banks [82]. The powerful linear construction, the broad patches of strong colour, the unexpected points of view, and the unmistakable atmosphere of London, a city Derain enjoyed, were put together with an intensity and unity that he never surpassed. If Matisse was always a *fauve*, Derain was certainly never finer than when he was one. Only a short time later he rejected his brilliant palette for the muted tones with which he created his own transcriptions of Cézanne's landscapes and figures. In the large *Bagpiper* of 1910-11 [83] he reached his parting from the ways of modern art. The view is as spacious as any in a late Cézanne, the architectural shapes as up to date as the simplified forms in Braque's early Cubist landscapes of 1908-9, but the illogically romantic figure and the Poussinesque tree show that he was beginning to look less at his contemporaries than at the old masters in order to find

82. André Derain: The Pool of London, 1906.
London, Tate Gallery

83. André Derain: The Bagpiper, 1910-11.
Minneapolis Institute of Arts

that equilibrium of form and design which he felt had been lost to modern art. His learning supplied him with models all the way from the French and Italian primitives to Caravaggio and Rubens, and to his credit there are many handsome still lifes and landscapes, and a few elaborate figure compositions which incorporate his search for solid volumes. But because he himself called for a return to tradition, his work after 1920 must be measured against the masters he admired. Then his references to Rubens and Poussin seem obvious or irrelevant. In the theatre, however, he found an opportunity to use his authentic talents. His sets and costumes for the Ballets Russes and other companies, beginning with his designs for Diaghilev's *Boutique fantasque* (1919), are memorable contributions to modern theatrical art.[9]

For a time after 1920 Derain was internationally renowned, but when his increasing conservatism led him farther towards pastiches,

he was displaced from the centre of the progressive effort. Recently attempts have been made to reconsider his later work in the light of his intentions rather than of his accomplishments, but it is still difficult not to think that those intentions, however sincere and well argued, were peripheral to modern experience.

The tragedy of André Derain, if such it was, lay in the discrepancy between his early promise and his later ambitions. No such grandiose future was predicted for the other Fauves, nor did they test themselves against the monumental painting of the past. As minor masters they excelled in what they set out to do. Albert Marquet (1875-1947) and Matisse had met in Moreau's studio, and by 1900 were painting, as Marquet himself said, in the Fauve manner. Indeed, certain of Marquet's early studio nudes are only surpassed in boldness of colour and design by his friend's. Marquet, however, chose neither to lead nor to follow Matisse in the search for total pictorial intensity. He remained all his life a painter of exquisite landscape tonalities, a master of grey who looked backwards to Impressionism for his subject matter. In *Winter on the Seine* [84] his characteristically firm linear structure, Fauve in its spare synthesis, supports the delicately graded tones of grey, green, and white.

Raoul Dufy (1877-1953) was a master of life's minor pleasures, and his painting fulfils Matisse's desire that his own art should be mentally soothing, like 'a comfortable arm-chair for a tired businessman'. Before he left Le Havre for Paris, Dufy had practised a mild and simplified Impressionism based on the works of Boudin which he had studied in the local museum. In Paris he joined his friend Othon Friesz in 1900 in the studio of Léon Bonnat, and met other young men soon to become the Fauves. We have seen how he was converted in 1905 to a new art of intense colour and fragmentary drawing by the sight of a Matisse, but his most Fauve canvases were created in 1906

84. Albert Marquet: Winter on the Seine, *c.* 1910. *Oslo, Nasjonalgalleriet*

85. Raoul Dufy: Avenue of the Bois de Boulogne, *c.* 1930. *Present location unknown*

when he painted at Trouville with Marquet. The Fauve aesthetic soon proved too strenuous for him. After an apprenticeship to Cézanne, which was briefer than most, he turned to themes from the most leisured existence, from the racecourse, the regatta, and the Riviera [85]. One might deprecate such trivial subjects had not Dufy endowed them with his own joy in living and presented them with just the right nuance of colour and twist of line to bring out their character. Like many minor masters he found a formula which, once established, he never fundamentally changed, but it is so amusing, and its variations are so clever, that it rarely grows tiresome. From Fauvism he kept a taste for colours which were bright but never garish and which he applied to canvas or paper – for he was equally a water-colourist – in broad

86. Kees van Dongen: The Violinist, *c.* 1926. *Liège, Musée des Beaux-Arts*

patches. Upon them his objects, dissociated from their local colours, were drawn in stenographic outlines unequalled for their wit and affectionate irony. Like Renoir, whose *Moulin de la Galette* he copied in old age when he, too, was paralysed by arthritis, it may be said that Dufy never painted a sad picture.

Of the other Fauves there is not so much to be told. Kees van Dongen (1877–1968), Dutch by birth but long resident in Paris, expressed his wild humour and extravagant mockery in Lautrec-like themes from the circus and cabaret. His technical as well as expressive contribution to Fauvism was long overlooked. Before he left Holland in 1897 he was painting with strong contrasts of dark and light colours, blue-black and brick-red. He was also the only Fauve to enjoy years of success as a painter of fashionable if slightly eccentric portraits [86]. Jean Puy (1876–1961), Henri Manguin (1874–1949), Charles Camoin (1879–1965), Louis Valtat (1869–1952), and Othon Friesz (1879–1949) occasionally painted strongly Fauve pictures, but did not sustain the intensity of their work of 1905–7. Sooner or later they found an honourable if uninteresting compromise with a more naturalistic vision.

Fauvism, it now appears, was more an episode than a school. The painters had come together through ties of friendship and a mutual conviction that art required a more vigorous attack, but when the friendships faded there was little left in common. The Cubists at least shared a technique, the Futurists a plan of action, and the Dadas a *Weltanschauung*, but the case for Fauvism rested on each man's instinctual reaction to visual stimuli, and that cannot be exchanged with another's. The Fauve position was best put by Matisse in his famous 'Notes d'un peintre', published in 1908.[10] The instinctual basis of his art, an art which originated in sensation preceding reflection, was stated with disarming candour: 'What

I am after, above all, is expression . . . [and] I am unable to distinguish between the feeling I have for life and my way of expressing it . . . Composition is the art of arranging in a decorative manner the various elements at the painter's disposal for the expression of his feelings.'

Matisse's equation of expression (expressive form) with feeling can be considered in relation to certain trends in contemporary philosophy and aesthetics. His 'expression of feeling' resembles the doctrine of intuition as it had been expounded by Bergson as early as 1889, and again in 1900 by Benedetto Croce. The latter's definition of intuition is not so very different from the French philosopher's: 'Intuitive knowledge is expressive knowledge . . . Intuition is distinguished as form from what is felt and suffered, from the flux and wave of sensation, or from psychic matter. And this form, this taking possession, is expression. To intuit is to express, and nothing else (nothing more, but nothing less) than to express.'[11]

It may be objected that Matisse was no philosopher and that his statements refer only to his own experience as an artist, but what great artist has ever been unaware of the philosophical positions of his time? And for Matisse there is some shred of proof, because we know that in the early years of the century he held philosophical discussions with the English critic and archaeologist Matthew Stewart Prichard. Since there is evidence that their talk dealt with Bergson (and certainly there is a hint of Bergsonian 'duration' in Matisse's remark that 'indication of motion has meaning for us only if we do not isolate any one sensation of movement from the preceding and the following one'), they may also have touched on the parallel theories of intuition put forward by Croce.

Matisse confessed that a few years earlier he had been content 'to put down the passing sensations of a moment', but had come to realize that so immediate and primitive a form

of expression could not completely or permanently define his feelings. He wanted 'to reach that state of condensation of sensations which constitutes a picture. Perhaps I might be satisfied momentarily with a work finished at one sitting but I would soon get bored looking at it; therefore, I prefer working on it so that later I may recognize it as a work of my mind.' Those last words are a clue to the greatness of Matisse, and to the fact that his pictures outlast our first enthusiasm. Each one, although rooted in emotion, has been refined by the conscious mind until it has passed the double standards imposed by taste and will. Photographic sequences of several of his works taken while in progress are proof of his exacting and intentional decisions. More than once we would have cried halt, so perfect seems the order already achieved, but Matisse went farther, erasing, eliminating, and at the last adding something totally new, a colour or line, a pattern or arabesque, which he found the composition required. The final result conforms to his own definition: 'If in the picture there is order and clarity, it means that this same order and clarity existed in the mind of the painter and that the painter was conscious of their necessity.'

The appeal to order and clarity might have seemed strange to those who remembered the 'horrors' of 1905, but Matisse had already begun to transform the instinctual immediacy of the earlier Fauve manner into an art of harmonic balance between feeling and will. The change is clearly seen in the large figure compositions of these years in which he succeeded in expressing the 'nearly religious feeling' that he had towards life, especially in the two versions of Le Luxe. The title itself suggests this greater concentration, for all that is left is the first word of the Baudelairean quotation which had inspired his Luxe, Calme, et Volupté. Of the two paintings the earlier (Paris) has some of the ragged edges of 1905, few contours, and bright, modulated

colour with Impressionist reflections. In the later, *Le Luxe II* [87], the pale tans, turquoises, and pinks have been reduced to a few tones applied in almost completely flat planes; the contours are emphasized and express far more than meets the eye. Merely to count the lines in either the standing or the crouching figure is to wonder how Matisse could express so much volume with so few strokes, with that 'hypnotic and broken draughtsmanship' which, as a contemporary artist wrote, is 'the only line that can record without betrayal the meanderings of his sensibility'.[12] It recalls the artist's advice to his pupils: 'One must always search for the desire of the line, where it wishes to enter or where to die away.'[13] Even the ambiguous disappearance of the right arm of the crouching figure into the left leg of her companion is purposeful: 'Limbs may cross, may mingle,' Matisse wrote, 'but still in the eyes of the beholder they will remain attached to the right body. All confusion will have disappeared.'

With *Le Luxe II* Matisse completed and closed the Fauve revolution. Perspective and modelling had been routed; such space as there was had been reduced to a minimum, and light was a function of flat colour, rather than a reflection from a lighted surface. Between colour and line there was now a balance which Matisse's mastery maintained for the remaining half-century of his creative life. Colour, line, and plane were no longer representative of objects so much as communicative of the underlying mood of the work, in this case the sense of luxurious grace and relaxation suggested by the title. Nevertheless, *Le Luxe II* was a revolutionary statement in its time, and, like every revolutionary, had its ancestors, its precedents. In one sense Matisse's picture was basically traditional. Within its dream-like figures we

87. Henri Matisse: Le Luxe II, 1907–8.
Copenhagen, Statens Museum for Kunst

can see reflections of Gauguin, even of Puvis de Chavannes. The radical Matisse was the truest traditionalist in that he made the great past live again, not through imitation but by validating its own experiments as he pushed ahead.

The first version of *Le Luxe* was shown at the Salon d'Automne of 1907; the second was not exhibited in Paris, but its appearances abroad indicate the extent of Matisse's reputation as 'the king of the wild beasts' in the years before 1914. It was seen at the second Post-Impressionist exhibition in London in 1912, and a few months before that at the Sonderbund Exhibition in Cologne, where it was selected by Walter Pach and Arthur B. Davies for the Armory Show in New York in 1913. Its international travels were matched by the scope of Matisse's patronage. Although French collectors were few and far between for many years, his works were eagerly sought as early as 1906 by the American critic Leo Stein, his sister Gertrude, and their brother and his wife, Mr and Mrs Michael Stein. Between 1905 and 1907 the Stein family bought most of his best works. After that, the Russian merchant Sergei I. Shchukin acquired no less than thirty-seven works, including the mural decorations, *Dance* and *Music* of 1910, which he commissioned for his Moscow residence. Another enthusiastic Russian collector, Ivan A. Morozov, owned a number of important works, including a triptych of Moroccan figures of 1911–12. After the October Revolution the Shchukin and Morozov collections were brought together, with others, as the Museum of Modern Western Art in Moscow. Meanwhile most of the Leo and Michael Stein paintings were dispersed, a number from the latter finding their way to Scandinavian collections and museums.

As his fame abroad increased, his position at home declined. With the dissipation of Fauve energies Matisse was no longer the leader of the younger generation whose attention had been caught by the memorial exhibitions of Cézanne's

work in 1907. There now occurred a curious retrograde sequence of influences. Whereas the Nabis and Fauves had preferred Cézanne's last paintings, seeing in the brilliant proto-Fauvist planes of colour justification for the decorative qualities of their own work, the younger men were more interested in the landscapes and still lifes of the 1880s and 1890s. The less vivid colours left the structure more exposed and encouraged them to look at the design. The consequence of this for the development of Cubism belongs to a later chapter; its significance for Matisse must be noted here.

Matisse was never a Cubist, but there is a period in his work for several years after 1910 when a darker palette, a radically synoptic drawing, and a system of constructing space by overlapping and interpenetrating planes prove that he, too, was looking for a more constructive, less purely sensational basis for his art. This development can be followed in the five busts of *Jeannette*, done in 1910-13. That these more dramatic experiments occurred in sculpture, in actual rather than simulated volumes, proves the importance of sculpture in Matisse's total *œuvre*, even if the sixty-eight recorded examples are outnumbered by his vast pictorial production. His own sculpture frequently appears in his paintings and, significantly, in his 'Notes d'un peintre' of 1908 the problems of representing movement are discussed in sculptural rather than in pictorial terms.

In his first works of sculpture, such as *The Slave* of 1900-3, Matisse was still a disciple of Rodin, taking over the stance of the *Walking Man* as well as Rodin's modelled surfaces. Rodin's influence is perceptible in the first two heads of *Jeannette*. In the third the ovoid shape of throat, head, and hair are emphasized, and in the fourth [88] there is an aggressive attack on the surface and an insistence on physical ugliness reminiscent of the *Woman with the Hat*. But in the fifth [89] the problems of inner

88. Henri Matisse: Jeannette IV, 1910-11.
Private Collection

89. Henri Matisse: Jeannette V, 1910-13.
Toronto, Art Gallery of Ontario

structure have displaced both modelling and conventional aesthetic considerations. The hair and back of the head have been removed, and the planes of the left side of the face exaggerated, while the right is treated as a series of flat and rounded forms having little relation to life. The effect may at first seem capricious. It becomes one of sculptural clarity the longer one studies the bust.

The climax of this 'constructive' period occurred in the large paintings of 1916-17, in the *Moroccans* and the *Piano Lesson* (both in New York), the large studio interiors (Detroit; Phillips Gallery, Washington), and perhaps most memorably in the huge *Bathers by a River* [90] and the sculptured *Backs*. These are Matisse's answers to the structural problems raised by Cézanne and the Cubists. In the *Bathers* the theme is Cézanne's. His, too, is the counterpoint among figures, nature, and the pictorial architecture of space, the same indifference to the emotional potentials of the subject. There are references to Cubism in the stiff figures which, apparently secured to the vertical planes of the background, shift their positions both laterally and in depth. But the majestic visual effect, accomplished with a very restricted colour scheme of dull greys, greens, and black with accents of blue, is entirely Matisse's. To paraphrase Mallarmé, no contemporary work, Cubist or not, contained so much mystery in so much austerity. There are hints, also, of the later Matisse, of the taut, linear emptiness of the Barnes murals (1931-3, see below, p. 446), although his painting by and large was to be filled with colour, light, and detail for years to come.[14]

Comparable in size and scale to the *Bathers* are the four bronze versions of *The Back*. The first, Rodinesque treatment of a theme previously painted by Courbet, and by Cézanne, whose early version of Courbet's painting seems to have been Matisse's point of departure, was

90 (*below*). Henri Matisse: Bathers by a River, 1916–17. *Art Institute of Chicago*

91 (*opposite*). Henri Matisse: The Back IV, *c*. 1929. *London, Tate Gallery*

probably modelled in 1909. There were two more between 1914 and 1917, and a fourth *c*. 1929.[15] The first was seen in plaster at the second Post-Impressionist exhibition in London in 1912, and at the Armory Show in New York in 1913, but it was afterwards forgotten, and the others were unknown until 1949–50, when they were exhibited in Lucerne and Paris. No more illuminating demonstration exists, not even the famous reductive drawings of swans for his illustrations to Mallarmé, of the process whereby Matisse passed from an analytical vision to the abrupt syntheses of his maturity.[16] In the second stage the sense of the living model still survives, of a figure standing in a space filled with light and air, although the modelling is as violently syncopated as in the last bust of *Jeannette*. In the final version [91] the few simplified masses appear colossal. Although the relief is of the same dimensions as the others, the scale is more than life-size and surpasses

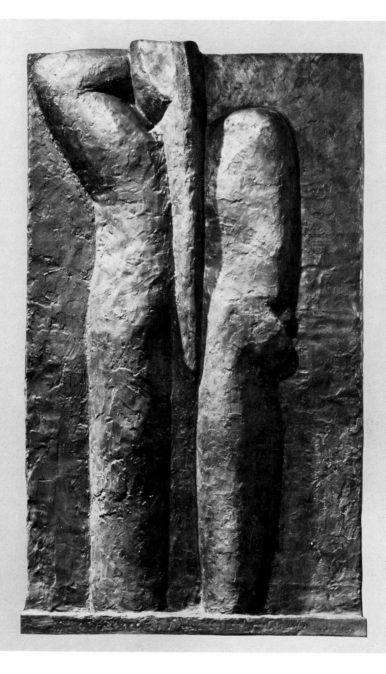

even as it subsumes any concern with an individual model. Nor is there any space apart from the forms themselves; figure and space are one.

GEORGES ROUAULT (1871–1958)

At the Salon d'Automne of 1905 Rouault's paintings were included in the general critical condemnation of the Fauves for their violent colour and radical distortions of line and composition. But this was actually all he had in common with Matisse and Derain, with Valtat and Jean Puy, whose portraits and landscapes were expressively bland in comparison with his *Prostitutes* and his water-colour of shabby *Strolling Players, Actors, Clowns* which no less discriminating a critic than Charles Morice considered a 'painful delineation of utter moral decay'.[17] The typical Fauve subject, in the Impressionist tradition, was devoid of social comment. Rouault's figures, even if ostensibly descended from the social caricatures of Daumier, Forain, and Toulouse-Lautrec, already represented their creator's intensely religious attitude towards the tragedy of life. Rouault had no interest in the decorative aspects of the Fauve programme, however it might be enlarged and enriched by an exquisite sensibility for colour and design. For him these were merely means whereby he could express what Matisse described, in more narrowly aesthetic terms, as 'the nearly religious feeling I have towards life'. For Rouault art and life were meaningful only *sub specie aeternitatis*, and since he found for his religious experience, which was totally Christian, significant artistic forms, his art became the most truly religious expression in modern French painting.

He had been a favourite pupil of Gustave Moreau at the École des Beaux-Arts, and upon the master's death became curator of the Musée Gustave Moreau established by the artist's bequest. Although he rejected his master's preoccupation with allegorical and mytho-logical subjects, he must have agreed with Moreau's definition of art as 'a furious tracking down of the inner feeling solely by means of plastic expression'.[18] Soon after 1890 he abandoned elaborate compositions on traditional religious themes (the *Child Jesus among the Doctors* of 1894 at Colmar, or the *Dead Christ mourned by the Holy Women* of 1895 at Grenoble) for an abrupt manner reminiscent of the late Goya and of the mature Rembrandt. The change of style must be considered more a psychological than a formal necessity. Rouault denied that he wanted to continue the social irony of Degas or Lautrec, with whose last works his broken line and spattered surfaces have certain affinities, by saying that he had undergone a 'moral crisis of the most violent sort. I experienced things that cannot be expressed by words. And I began to paint with an outrageous lyricism which disconcerted everyone'.[19] His dark, burning colours owed something to Moreau, less perhaps to the metallic glitter of the older painter's finished works than to the brilliant gouache and water-colour sketches with which he had tested the expressive powers of colour almost deprived of imagery. Significantly, gouache and water-colour were Rouault's preferred media for many years. Also, at the age of fourteen he had served an apprenticeship in two stained-glass workshops, where he had wondered at the depth and purity of colour in ancient glass. The heavy black boundaries enclosing the coloured areas in his paintings after 1910 have been traced to his memories of medieval glass, a comparison which Rouault never refuted.[20] At first his colours were very dark, the figures appearing in deep purples, blues, and reds from the surrounding gloom. In his oils, many of which he worked upon for a decade or more, the colours were applied in layer upon layer of translucent pigment. The effect of depth created by these coloured strata took the place of perspective in the figural compositions, which

became increasingly two-dimensional, the subject often reduced to a single head seen frontally and varied only by a slight inclination of the neck. In the series of sacred and circus images with which he closed his long career, the lighter hues suggest that anger and despair had subsided as he emerged from 'his night of tragic predicaments' (the phrase is again Morice's).

Rouault's 'outrageous lyricism' coincided with his friendship with the polemical Catholic writer Léon Bloy, whom he met in 1904 and who similarly was disgusted by the shocking disparity in modern society between faith and works. Rouault's art became the pictorial counterpart of Bloy's desire, 'at this dreadful close of the century, when everything seems lost, to thrust at God the insistent cry of dereliction and anxiety for the orphaned multitude which the Father in his celestial heights seems to be abandoning and which no longer has the strength even to die bravely'.[21] Like Bloy, although without his approval, Rouault found the truths of religious experience in the most unlikely places, above all in the outcasts of society condemned to a degrading existence by the hypocrisy and injustice of the ruling classes. Rouault's first critics were startled by the ugliness of his prostitutes and clowns, but they failed to see that the absence of conventional beauty revealed the social truth that these miserable people were the results, not the cause, of man's inhumanity to man [92].

With the appearance of specifically religious symbols, such as the brutalized head of Christ of 1905 (New York, Collection Walter P. Chrysler, Jr), the reciprocal factors in Rouault's equation for the human condition were complete. In the clown who silently suffers beneath the mockery of his make-up Rouault recognized himself, in fact 'ourselves ... almost all of us'.[22] But the clown as the 'fool of Christ' can be a symbol of the divine acceptance of human fate. Rouault revealed this identity of God and man by interchanging the features of his figures, as

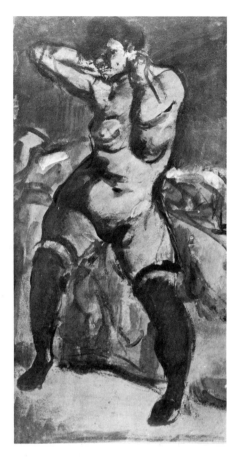

92. Georges Rouault:
Circus Woman (La Saltimbanque), 1906.
Grenoble, Musée de Peinture et Sculpture

in his self-portraits as a clown, and by repeating the posture and gesture of Christ scourged in the clown and worker [93].

In addition to his criticism of society for its humiliation of man's spirit through the corruption of his flesh, whether that flesh be abused in the prostitute, abased in the clown, or made gross through power corrupted in the king and judge, Rouault stated his belief in the possibility of the Christian regeneration of mankind by placing the events and parables of the New Testament in the blighted industrial environs of Paris. In paintings of *The Christ of the Suburbs* factory chimneys tower like broken crosses over a figure moving mysteriously in its own radiance through the ranks of the poor. At times, too, Rouault's compassion took an ironic turn. Among his illustrations for *Les Réincarnations du Père Ubu*, Ambroise Vollard's sequel to Jarry's comedy, there are amusing caricatures of different bourgeois types, although here, as always in his work, he condemned each class, profession, or occupation as a whole rather than the individuals trapped within it.

Rouault saw himself not so much a social critic as the pitying companion of the poor in spirit, 'the silent friend of those who labour in the barren field, the ivy of eternal misery climbing the leprous wall behind which rebellious humanity hides its virtues and its vice'.[23] This aspect of his thought dominates the fifty-seven large plates of *Miserere et Guerre*, originally planned as illustrations for two texts by André Suarès, whence the clumsy title. The drawings, originally done in 1914–18, were photographed on copper plates which the artist then attacked with a variety of tools and acids until he re-created in black and white the lustrous depth and substance of his oils. Seen in sequence, the plates unfold his favourite theme of Christ and clown, hieratic icon and contemporary man, conjoined in a vision of our failure to heed the commandments of divine love.

In the art of the twentieth century, and in French painting in particular, Rouault occupied a singular and solitary position. In his synthesis of line and colour with a prophetic social or ethical ideal, he was an Expressionist in the line of descent from Van Gogh and Gauguin, but he was also an Expressionist in the Germanic and wider European sense. We may regret that his concentration upon a few motifs limited his art, especially in comparison with the stylistic and thematic variety of Picasso or Matisse, for in the long run he did not avoid a certain monotony and routine. At his best his images may be the most truly 'sacramental' in modern religious painting, to be seen in the context of the Catholic revival of Bloy, Charles Péguy, and Jacques Maritain, who, with his wife, was one of the artist's lifelong friends. Therefore it seems all the more wasteful that his art was so long ignored by the Church in which he was a communicant throughout his life. Only in 1939 was one of his stained-glass windows selected by Canon Devémy, who with Father Couturier chose the artists to create works for the church of Notre-Dame-de-Toute-Grâce at Assy (Haute-Savoie). In 1946–50 four additional windows were made from his designs, but this was a slight token of the buildings which might have been filled with his glass.[24]

Rouault's career was intimately associated with Ambroise Vollard, the dealer who had arranged Cézanne's first one-man exhibition in 1895 and who became the principal agent for the Post-Impressionists. In 1913 Vollard acquired Rouault's entire stock of paintings under a contract which kept the artist hard at work for almost thirty years finishing his canvases, and making prints and drawings for the lavishly illustrated books which Vollard published. After the latter's death in an automobile accident in July 1939 Rouault sued to recover

93. Georges Rouault: Three Clowns, 1917–*c*. 1935. *Private Collection*

his unsold and uncompleted works.[25] The decree which awarded them to him was considered an important confirmation of an artist's right to his property so long as he considered it still unfinished, but it was difficult to appreciate Rouault's rigorous standard of quality which condemned 315 of those works to the flames as unworthy of his gifts.

MODERN GERMAN ART

After an examination of French art, modern German painting and sculpture may seem to lack any consistent direction. The logical progression of French art is absent, and in its place there are apparently only flashes of genius in the midst of unregulated idiosyncrasies. The judicious observer, however, will take account of certain geographical, political, and social conditions that account for the spasmodic character of the historical sequence, and he will not lose sight of the profoundly individualistic accomplishments of many German artists. The wonder is less that so little can be reduced to a historical and critical order than that so much is of lasting artistic value.

Since the end of the sixteenth century Germany has had no coherent or continuous artistic tradition. Its Renaissance had come late, and then been ended by the Thirty Years War; its eighteenth century had been overwhelmed by French influence. The political division of the country into a multitude of separate states, large and small, fostered the development of separate cultural centres. Unlike France, where for three centuries the provinces had looked to Paris, in Germany the cities, jealous of their historical independence, acknowledged no one capital which would have drawn the energies of artists from every part of the country. Berlin did not emerge as the dominant political centre until the middle of the nineteenth century, and as the modern cultural capital it has never entirely overshadowed Dresden, Munich, and some of the newer industrial cities of the Rhineland.[26]

Yet this political fragmentation was not entirely disadvantageous for the artist. The more distant his city or town from Berlin, the less oppressive the restrictions of authoritarian taste. Whereas in France, England, and the United States there have been few important developments in modern art outside Paris, London, and New York, in Germany the exhibition and acquisition of works of art by dealers, museum curators, and enthusiastic private collectors created the conditions for an experience of art unmatched in any other country before 1914. Such critical support, often in conflict with a middle-class philistinism no whit less obtuse and arrogant than in other countries, encouraged the radical artists' organizations, the Sezessions and artists' unions, to provide the opportunities for exhibition and discussion so essential for the formulation of a modern aesthetic.[27] But in spite of such activity Germany, like England and the United States, had to hurry to catch up with the twentieth century. In imperial circles Impressionism was considered discreditable as late as 1908, when Wilhelm II forced Hugo von Tschudi to resign as director of the National Gallery in Berlin because he had acquired too many modern French pictures. Tschudi's appointment to the Bavarian state gallery in Munich proved that there was a more liberal artistic atmosphere elsewhere.

If in the face of such diversity it is idle to postulate a single formative principle, it is nevertheless possible to detect two aspects of a continuing debate over the significance of artistic form. The first and older proposition, based on the German art of the Middle Ages and Renaissance, holds that the work of art, before it can be recognized as a system of formal relations, must be experienced as a kind of communication, and that its value in large part derives from the character and quality of the

experience to be communicated. At its worst or least sensitive this attitude justifies the frequent and tedious treatment of the anecdotal, the erotic, and the macabre in German art; at its best it helps to explain the mystical intensity of Grünewald or the serene humanism of Dürer. The belief that the significance of the work of art is primarily formal is more recent. It can be followed through the materialistic historical theory of Gottfried Semper (1803–79) and the psychological investigations of Theodor Lipps (1851–1914), until it was articulated as a theory of 'pure visibility' by Konrad Fiedler (1841–95). From his observation of the activity of his friends the painter Hans von Marées (1837–87) and the sculptor Adolf von Hildebrand (1847–1921),[28] Fiedler concluded that art is based on the autonomous development of perceptual experience rather than on idealistic presuppositions, and that '. . . interest in art begins only at the moment when interest in literary content vanishes. The content of a work of visual art that can be grasped conceptually and expressed in verbal terms does not represent the artistic substance which owes its existence to the creative power of the artist'.[29] Fiedler's essay, *Über die Beurteilung von Werken der bildenden Kunst (On Judging Works of Visual Art)*, was little noted when it appeared in 1876, but it has since been recognized as a primary contribution to the aesthetics of Impressionism and of later, twentieth-century formalism. Hildebrand's short treatise of 1893, *Das Problem der Form in der bildenden Kunst (The Problem of Form in the Plastic Arts)*, in which an argument somewhat similar to Fiedler's was applied to the origin of sculptural form, was more widely read and hastened the liberation of modern sculpture from anecdote and idealism. The originality of these ideas can be seen when the works of Marées and Hildebrand in which they originated, so monumental in form yet almost devoid of narrative content, are compared with the melodramatic compositions of the popular

mythological and historical painters of the turn of the century.

The distinction between these two points of view should not imply that there can be any division or separation of the elements in an actual work of art. Form and content are inseparable, for one cannot be created without the other. It is possible, however, to think that one aspect may momentarily take precedence in the artist's conception and in the spectator's experience of a given work. Perhaps the difference can be tested by contrasting two typically Expressionist works, Käthe Kollwitz's *Mourning* [101] and Ludwig Meidner's *Self Portrait* [113]. In the former the experience of grief is communicated by the disposition of a few large forms which are seen as forms before they are identified in the posture of tragedy. In the latter the shocking disclosure of what appears to be an abnormal personality is revealed by the image a moment before its formal properties can be defined. Only then do we observe how it has been effected by distortions of line and value and by the irascible track of the brush across the canvas.

The emergence and eventual dominance of a formalistic aesthetic during the first third of the twentieth century resulted in a temporary decline of interest in the expressive values of subject matter which were dismissed as literary and therefore anti-artistic. But the once popular masters of anecdote and historical illustration cannot be entirely ignored. In addition to their interest for the social historian, they can still arouse our curiosity about the relation of form to subject and content, and then we understand why they were once admired by the masters we now esteem. *Salome with the Head of John the Baptist* [94] by Lovis Corinth (1858–1925) is an example of the true and tried mixture of the erotic, the macabre, and the bizarre. In the version reproduced, a study for the more carefully finished picture which was shown at the second exhibition of the Berlin

Sezession in 1900, Corinth's choice of an informal, unexpected point of view and his interpretation of Salome as a type of contemporary degeneracy are to be noted. The painter found happier and more impressive occasions for developing his gifts in his portraits, which are frequently of considerable psychological penetration. In 1911 he suffered a stroke which paralysed his right hand, but he taught himself to paint with his left hand with such success that his last landscapes, especially the views of the Walchensee painted after 1918 [95], have

earned him a place with the younger Expressionists. The dates, however, indicate that he can be counted as a companion but not as a pioneer in the development of specifically twentieth-century Expressionism.

The slightly older Max Liebermann (1847–1935) became the leading exponent of an Impressionist point of view, although that term has not quite the same implications for German that it has for French painting. When Liebermann visited Paris in 1872, one of the first Germans to do so after the Franco-Prussian

War, he was more attracted by Millet than by Manet and the young Impressionists. His interest in expressive subject matter soon led him from Barbizon to Holland, where he spent many summers, and where he found the picturesque themes for his first characteristic pictures. These scenes of peasants and of elderly pensioners, so like in some ways the contemporary but less accomplished work of Vincent van Gogh, were treated with a dexterous brush in the manner of Frans Hals, his favourite among the older Dutch masters. If at times, in his earlier work especially, Liebermann observed his subjects with the unsentimentality of a Courbet, he never achieved the total emotional detachment of a Manet or a Degas. The combination of the new objectivity with a traditional German interest in subject matter can be seen in his paintings of the zoological gardens [96]. The flat spots of sunlight filtered through the trees, the tilted perspective, and the figures summarily brushed in in the background are analogous to Renoir's figural Impressionism of the later 1870s, but the connotations of the

94 (*left*). Lovis Corinth: Salome, 1899.
Cambridge, Mass., Busch-Reisinger Museum,
Harvard University

95 (*above*). Lovis Corinth: Walchensee Landscape, 1921.
Saarbrücken, Saarland Museum

96. Max Liebermann: The Parrot Keeper, 1902.
Essen, Museum Folkwang

German art. His collection of French Impressionists (unfortunately dispersed after his death in 1935) was one of the most distinguished in Berlin. As a founder and later president of the Berlin Sezession he helped to promote a more sympathetic understanding of the modern movement. But having come late to Impressionism, Liebermann and his followers could not accommodate themselves to more advanced tendencies. Little more than a decade after its formation, the Sezession appeared outmoded to Emil Nolde and the painters of Die Brücke, who were shortening the gap between Paris and Berlin.

Although Liebermann and Corinth were remarkably gifted, they cannot be judged except in terms of the naturalist traditions of nineteenth-century German painting. After 1900 an artist who rejected that tradition had to find for himself the forms with which to express the experience which was uniquely his. The conditions of his art have been outwardly a search of the past and present for situations uncompromised by academic conventions, and inwardly a search of himself to discover the meaning of what he has felt. That search, with its attendant discoveries, is the history of modern art in Germany, for which the adjective 'Expressionist', first loosely applied by German critics to the French Fauves and then by extension to the progressive art of other countries, by 1912 had come to signify peculiarly German qualities.[30] German Expressionism was first announced by a few gifted but isolated individuals, then organized and directed by the two groups of artists who founded the Brücke in Dresden in 1905 and the Blaue Reiter in Munich in 1911. Before turning to those characteristically twentieth-century activities, we must examine the work of five men and women who effected the transition from nineteenth-century Naturalism through turn-of-the-century Symbolism to the Expressionism of modern times.

subject are more exotic and thus more obtrusive than orthodox Impressionism would permit. Nor is his colour as unconventional as the French painters': it is more tonal, more contained within a pre-determined and muted harmony, with browns and greys offsetting the brighter hues. Max Slevogt (1868–1932) similarly used a dashing Impressionist brush stroke in his genre scenes and portraits, conspicuously in his several studies of the singer d'Andrade as Don Giovanni which stem from Courbet's and Manet's figures from the theatre a generation or so earlier.

In other matters Liebermann was an important intermediary between the new painting in France and the older, narrative tradition of

WILHELM LEHMBRUCK (1881-1919)

The usefulness of a distinction between a formal and an expressive aesthetic, as well as the danger of applying it too rigidly, appear when we confront two leading German sculptors of the early twentieth century, Wilhelm Lehmbruck and Ernst Barlach. The formal volumes of Lehmbruck are brimming with unspecified but perceptible emotion; the specific characterizations in Barlach's work are subordinated to massive formal generalizations. More than that, we may postulate a classic, Mediterranean source for Lehmbruck's nudes, just as we must trace the anguished content of Barlach's figures to Late Gothic art.

The cultural orientation of the Rhineland, where Lehmbruck, a miner's son, was born near Duisburg, has traditionally been towards France and Italy. In Düsseldorf, where he lived from 1895, he studied at the academy and mastered the contemporary modes, passing from the sentimental naturalism of the Salon nude through a realism reminiscent of Meunier to the Baroque drama of Michelangelo and Rodin. His nude Man of 1909 is scarcely distinguishable from Rodin's Adam of 1880. In 1910 he settled in Paris, where he saw not only the full pathos and power of Rodin but also the calm, formal harmonies of Maillol. Henceforward he accepted the influence of both masters and resolved them in a personal manner. The quieting effect of Maillol's cubic masses appeared immediately in the Standing Nude of 1910 and the familiar Torso of the same year derived from it. The remote, almost Praxitelean rhythms of the body were saved from neo-classical emptiness by the sensitive texture and by the pathetic accent of the slightly bent head and closed eyes. One may think of the subdued glow of Renoir's late flesh painting as one's eyes wander over these delicately modulated surfaces, executed in the half-light in which Lehmbruck liked to work.

A tendency to emphasize the abstract geometry of anatomical volumes was reinforced by his second trip to Italy in 1912. In an etching of an Egyptian figure in the Vatican, the spheres and ovoids of head, head-dress, and breasts anticipated the stylized torsos of 1913-14. In a contrary movement, the sentiment of the earlier figures was accentuated by elongating the body to a quite unnaturalistic degree, as in the Kneeling Woman of 1911 [97], and the Standing Youth of 1913. Comparisons have been made between these and certain medieval figures, including the kneeling angel on the façade of Orvieto Cathedral. German Expressionism contained many medieval elements, but it is probable that the source for these distortions can be found in Rodin's drawn-out figures on the Gates of Hell. An indication of Lehmbruck's regard for the master is seen in his Fighting Warrior (1914-15), a standing version of Rodin's Prodigal Son.

With the War Lehmbruck's elegiac concept of the male nude acquired a truly tragic expression. The Fallen of 1915-16, a nearly prostrate nude warrior clutching the hilt of a broken sword, is a sparse sequence of opposed and parallel tubular limbs. Even more moving is the Seated Youth of 1918, first entitled The Friend [98]. The powerful energies of Rodin's Thinker have been drained of passion, until all that is left are thin forms barren of modelling. It is understandable that Lehmbruck's native Duisburg should have erected this figure after his own death by suicide in 1918 as the principal memorial for a new military cemetery.

Although Lehmbruck began and ended his mature production with marble figures, the Standing Figure of 1910 and the geometrical Female Torso of 1918, he was more a modeller than a carver, and he had many of his works cast in artificial stone to preserve the textures of the original clay. The chalky grey surfaces of his casts now seem inseparable from his sculptural expression. He was also an etcher

97. Wilhelm Lehmbruck: Kneeling Woman, 1911. *Buffalo, N.Y., Albright-Knox Art Gallery*

and lithographer, producing some seventy-five plates. In most of them the human figure appears in attitudes related to his sculpture, the broad volumes defined by delicate, repeated contours. His insistence that 'there is no monumental architectonic sculpture without contour or silhouette, and silhouette is nothing other than surface'[31] may account for our feeling that his figures have sometimes not quite emerged into three dimensions but are still enclosed in their defining contours, just as their limbs seem bound by their meditations.

98. Wilhelm Lehmbruck: Seated Youth, 1918. *Duisburg, Wilhelm-Lehmbruck Museum*

ERNST BARLACH (1870-1938)

Barlach was eleven years older than Lehmbruck, but because he came to his mature style only after 1906 and because his more Germanic point of view is closely related to the Expressionist movement as it developed before 1914, he may be said to belong to the same generation. His art, however, is very different, and he himself had little use for what he considered Lehmbruck's too linear idealizations. Where the latter, working almost solely with the nude body, created open and attenuated structures, Barlach confined his heavily draped figures within bulky contours. The formal distinctions have technical as well as psychological sources. Lehmbruck worked with clay over a spindly armature; Barlach preferred to carve heavy, close-grained woods.

The expressive content of his work from the very first communicated his mystical interpretation of life as man's lonely search for himself, for others, and for his lost God, a search beset by invisible presences which emerge, as visible artistic forms, from 'an unknown darkness' within the artist's consciousness. But these forms were not easily realized. Until he was thirty-five he was undecided between sculpture and the decorative arts; among his early works are ceramic figures and ornaments still permeated with the languors of Jugendstil. But in 1906, during a two-months' visit to Southern Russia, he found the subjects he needed, the anonymous Russian peasants whose unpremeditated faith and inexhaustible patience provided him with visual symbols of great simplicity, symbols, as he later wrote, of 'the human condition in its nakedness between Heaven and Earth'. Barlach tired of hearing of the 'Russian' origin of his mature style, but his interest in Russian peasant life did lead him to study medieval German sculpture, especially wood carving, in which there was a freer play of emotion than in monumental stone.

In 1910 he withdrew to the town of Güstrow east of Lübeck, where he spent the remainder of his life. In the simplicity of that life, and in his humble subjects, he found his technical as well as spiritual relationship to medieval German wood-carvers. Although his models were usually developed in plaster and many were subsequently cast in bronze, his major sculpture preserved the broad planes and sharp edges characteristic of the carver's technique, whatever might be the material. His best works are figures, singly or in pairs, symbolizing a wide range of emotion from resignation and despair through curiosity and wild humour to ecstasy, folly, and madness [99]. Whether in wood or plaster, the forms are

99. Ernst Barlach: The Solitary One, 1911.
Hamburg, Kunsthalle

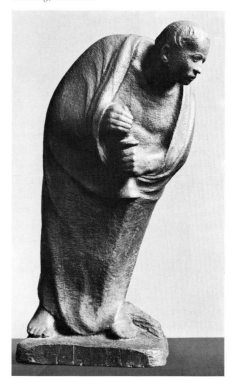

sometimes so tightly compact that their emotional charge seems about to explode. Barlach's intention was illustrative but rarely anecdotal. Usually he let a single figure tell his tale through its posture and gesture. He was also a playwright whose position is assured in German Expressionist literature. In his dramas, notably in *Der tote Tag* (*The Dead Day*, 1912) and *Der Findling* (*The Foundling*, 1922), he set forth the tragic perplexity of human life in a mixture of realistic prose and symbolic situations amplified by the lithographs and woodcuts which accompanied them. In the lithographs for *Der tote Tag* the bulky forms of the murderous mother and her son have the lunging weight of his sculpture. There is even a similarity between the light-flecked crayon scribbles and his wooden surfaces marked by the adze.

Under the Weimar Republic Barlach executed a number of war memorials. The first and finest, for the cathedral of Güstrow, was his most spiritual expression of the tragedy, a hovering bronze angel that seems asleep in death. Like his other memorials at Kiel, Magdeburg, and Bremen, it was dismantled by the Nazis when his art was condemned as 'degenerate', but it has been restored to Güstrow, and a second cast hangs in the Antoniterkirche in Cologne.[32] His studio at Güstrow, with many studies and finished works, is now a permanent memorial. The extensive collection of the late Hermann Reemtsma, who courageously supported the artist in his later years, has been installed by his bequest in the Barlach-Haus near Hamburg.

KÄTHE KOLLWITZ (1867–1945)

The quality of Käthe Kollwitz's graphic work is dependent upon its content. Her prints are less interesting as formal contributions to the modern movement than as profoundly compassionate comments on the troubles of our times. A member of a family with strong social and moral convictions, Käthe Schmidt early accepted the ethical principles of social democracy and of the feminist movement, although she kept aloof from strictly political activity. Upon her marriage in 1891 to Dr Karl Kollwitz, a physician who practised a form of socialized medicine, she settled in a working-class district in Berlin which was her home for the rest of her life. To her, as the doctor's wife, the people brought their troubles, but whatever comfort she could give increased her own knowledge of human misery.

As a student in a drawing school in Berlin she had preferred etching to painting, influenced by the dramatic prints of Max Klinger. Her first etchings, like his, were carefully descriptive and, in their use of space and chiaroscuro, even conventional. The development of her art is the story of the progressive elimination of the inessential and the discovery of her proper subjects, the few elemental themes which symbolize the tragic aspects of human life. Her earlier manner brought her public attention when the series of the *Weavers' Revolt* (1897–8) and the *Peasants' War* (1902–8) were exhibited. Each was correctly interpreted as a protest against the working conditions of the day, although cast in a historical frame. In the second series the broad sweep of figures moving across the plate subsided in moments of intense concentration, when the mother searches the battlefield by lantern-light for her dead son, or when the peasant woman sharpens her scythe.

With the development of her expressive powers came a corresponding study of technical processes. The later etchings were executed in multiple and mixed techniques, including intaglio. After 1910 lithography gradually replaced etching as her favourite medium. Her production was all but suspended in 1933 by the Nazis, when she was forced to resign from the Prussian Academy, to which she had been

100. Käthe Kollwitz: Death greeted as a Friend, from *Death*, 1934-5. *Berlin, Deutsche Akademie der Künste*

elected in 1919 as its first woman member. But she brought her career to a triumphant conclusion with her last and most poignant sequence, the eight lithographs of *Death* (1934–5). In the sixth of this series, *Death greeted as a Friend* [100], she forecast, although still with horror, her acceptance of the idea of death which haunted her all her life. The image of a man embracing, with mingled rapture and terror, his fearsome friend is executed with broad crayon strokes recalling the flat planes of Barlach's sculpture, which she knew and admired.[33] Her own sculpture was on the whole more tentative than her graphic work, although the relief *Mourning* [101] has something of Barlach's ability to convey emotion through a few very simple planes.

The intensity of her work, which underlies even her tenderest studies of mothers and children, is its truly Expressionist aspect. An entry in her diary, written mid-way in her career, is illuminating. In 1912 her young son Peter was 'devouring' Wedekind's drama *The Awakening of Spring*, which moved her to re-read his other plays. 'When I read them now,' she wrote to her older son, 'I once more recover the sensation I used to get from them, namely that life in its violence, burdensomeness, and inexorability is almost unbearable. The naked quality of his writings, the brutal nakedness, passionate magnifications, the crudeness – I used to try for the same thing in my work, but with a different slant.'[34]

In an age of abstraction, Käthe Kollwitz's work is hard to see, so to speak. As with other artists of social protest or criticism – Goya, Daumier, or George Grosz – the observer may want to resist its emotional demands. Many of her finest prints deal with subjects we would gladly ignore: inflation, unemployment, illness, starvation, civil strife, political imprisonment, and death, whether sudden or slow, early or late. The morbid and introspective character of her work is seen in her

101. Käthe Kollwitz: Mourning, 1938.
Hamburg, Kunsthalle

preoccupation with death and her own self portrait. But she was aware that hers was not 'a pure art', and was content that it 'should have purposes outside itself'. 'I should like', she added, 'to exert influences in these times [1922], when human beings are so perplexed and in need of help.'[35] For this reason her reputation will rest upon the images in which, as a woman and mother, she distilled her boundless compassion for that humanity which she interpreted as pitifully oppressed, miserably terrified by its meaningless fate, and helpless to help itself except through love.

PAULA MODERSOHN-BECKER (1876–1907)

In her search for expressive form, another woman painter followed a direction quite contrary to that taken by Käthe Kollwitz. Whereas the content of the latter's graphic work became more concentrated and intense, in Paula Modersohn-Becker's painting it was

dissolved in symbolic colour and pattern, after she had accepted certain principles of contemporary French art, to which Käthe Kollwitz remained immune. Had she lived longer and been better known, Paula Modersohn-Becker might have become an important agent for the transmission of French ideas to German painting, but by the time the younger men in Dresden and Berlin saw her work, they were more interested in its German than its French aspects.

Paula Becker had studied at Bremen and Hamburg before she visited the artists' colony of Worpswede, near Bremen, in 1897. Established a decade before by the landscape painter Fritz Mackensen (1866-1953), who had been attracted by the agreeable if melancholy scenery of moors, woodland, and canals, Worpswede, like similar settlements in Scandinavia and Germany – Neu-Dachau near Munich was another – was symptomatic of the desire of many late-nineteenth-century artists to encounter the spiritual realities which were believed to be more stable and more fundamental in such small rural environments. Such *Heimatkunst*, as it came to be called, can be considered, in part at least, as a reaction against the expressive attenuations of the Jugendstil and other end-of-the-century refinements. Mackensen's example encouraged others, among them Heinrich Vogeler (1872–1942), whose decorative Jugendstil designs momentarily interested Paula Becker, and the painter Otto Modersohn (1865-1943), whom she married in 1901. On the whole the Worpswede painters interpreted landscape and peasant life with something of the sentimental idealization of the Barbizon artists, although the overtones were more introspective than ethical.[36]

Paula Becker herself was aware of horizons wider than those of Worpswede. She had studied drawing in London when only sixteen, and travelled in Norway and Switzerland. She knew the Berlin museums and admired Rembrandt and the early German masters.

Although she studied with Mackensen for part of each year until 1900 and lived at Worpswede after her marriage, her four visits to Paris between 1900 and 1907 were more decisive for her art. On her first visit she seems to have been preoccupied with Millet and later academic painters of Breton peasant life. But a feeling for pattern, almost Nabi in its definiteness, began to appear in her work, and her awareness of basic problems in the relation of form to content was intensified by her experiences in Paris. In 1902 she wrote in her journal that she believed 'one should not think so much about Nature in relation to painting, at least not during the conception of the picture. The colour sketches should be made just as one has perceived something in Nature. But the principal thing is my personal feeling (*Empfindung*)'.[37] On later visits, after seeing the work of Van Gogh, Gauguin, and Cézanne, she absorbed

102. Paula Modersohn-Becker:
The Old Woman by the Poorhouse Duckpond,
c. 1906. *Bremen, Roseliushaus*

something from each master. Van Gogh is the dominant influence in her *Old Woman by the Poorhouse Duckpond* of *c*. 1906 [102]. The emphatic, two-dimensional drawing, the repeated pattern in the skirt, and the position of the hands recall Vincent's *Woman rocking a Cradle* [46]. But the stress is German, as in the curious juxtaposition of the goblet-like bush with the woman's head. Towards the close of her brief career, in a few still lifes, like the *Apples and Bananas* (Hamburg), she reached a personal synthesis of Gauguin's linear patterns and Cézanne's three-dimensional forms.

Her nude self portraits, painted in flat colours with large staring eyes like the Fayoum faces she had seen in the Louvre, show the German fondness for introspection. Of all her works the well-known portrait of Rainer Maria Rilke, whom she had known intimately at Worpswede and whose wife, the sculptress Clara Westhoff, introduced her to Paris, places her most firmly in the Expressionist tradition (Bremen, Roseliushaus).[38] It may not be the best likeness of the poet, but its direct and primitive force links her with other contemporary painters, including the more influential Emil Nolde.

EMIL NOLDE (1867-1953)

Nolde, like Käthe Kollwitz, was born deep in the nineteenth century, but there are fewer traces of the past in his work than in that of any of his contemporaries. Although he came late to artistic maturity and his powers were not fully revealed until he was nearly forty, from then until the close of his long life, he was a powerful if solitary force in modern German art, and a continuing influence upon those painters who maintained the figurative tradition within German Expressionism. Nolde knew and respected the work of Cézanne and the French Symbolists as well as Van Gogh, Ensor, and Munch. He insisted on self-expression like Van Gogh; he shared Gauguin's interest in primitive peoples and their art. But he was able to surmount these formidable competitors and in certain ways to press beyond their achievements. His individuality appears in his desire to create a kind of painting which should be purely German. Indeed, his art, more than that of the other and younger Expressionists, often seems to embody a mystique of blood and soil.

Nolde was born on a farm in Schleswig-Holstein and published his identification with his North German origin in 1901, when he dropped his family name of Hansen for that of the village of Nolde near his birthplace. Although he was well travelled and after 1902 spent most of his winters in Berlin, he preferred the lonely shores and moorlands of North Germany. In the summer, and occasionally for longer periods, he lived and painted almost as a hermit on the island of Alsen or near the remote villages of Rottebüll and Seebüll, where he lived from 1926 until his death.

More important for his art than the winter of 1899-1900, which he spent in Paris, were the few months the previous summer when he worked at the artists' colony of Neu-Dachau near Munich with Adolf Hölzel. Before that he had seen Hodler's paintings, which deeply impressed him. Hölzel's theories of the expressive potentials of colour and Hodler's symbolism introduced Nolde to the principal thematic materials of his mature work, in which he was to search through colour (and in his graphic work through contrasts of black and white) for the essential, archetypal sources of existence and feeling. Even before his studies in Munich there had been hints of these interests in his curious 'postcard' drawings of the Alps as gigantic old men's heads. When two of these were published in *Jugend*, they attracted so much interest that Nolde had them printed as postcards and sold 100,000, so it is said, in ten days. These men in the mountains, who

might have assured his success as a commercial artist, were elementary perhaps, rather than elemental, in the tradition of nineteenth-century *trompe l'œil* humour and fantasy. Nolde soon eliminated the humour to plunge deeper into the sources of consciousness, but he never rejected the fantastic, which often reappears, often in a wildly savage vein.

A deeply religious man, and like many in his time frequently racked by doubt, Nolde discovered in his own and other faiths the sources of his most powerful pictures. It may be that he first became interested in primitive art through his relations with the Brücke artists in Dresden in 1906-7. By 1910 he was sketching artefacts in Berlin, and the following year began an introduction to a book on primitive art, unfortunately never completed.[39] His long journey in 1913-14 across Russia to Korea, China, and the South Seas with an expedition organized by the German Colonial Office widened his knowledge of oriental and primitive peoples but scarcely affected his art. Like Gauguin's, its elements had been established before actual contact with Oceania. Unlike the Brücke painters, who accepted the superficial mannerisms of African and Polynesian carvings or merely introduced exotic subjects into their paintings, Nolde's primitivism was psychological rather than aesthetic or anthropological. Through brutally simplified drawing, broad, flat patterns, and ecstatic themes, through magical juxtapositions of intense colours and exploitation of the physical properties of materials, he created complements, not illustrations, of primitive experience.

His most enduring work may be his many religious paintings of Old and New Testament subjects. The earliest of these have long been the best known: the *Last Supper* (Halle) and *Pentecost* (Bern) of 1909, and the *Christ among the Children* (New York) of 1910. They have the tight composition in a very shallow space and the mask-like faces which replaced the brusque Late Impressionist technique and subjects of his very first work. They prove the important influence on Nolde, as on most German Expressionists, of Grünewald's Isenheim altar at Colmar, which he did not see until 1927, but knew through reproductions, which hung in every artist's studio.[40]

The demonic ecstasy which courses through the triptych of *Maria Aegyptica* of 1912 (Hamburg) is a more 'primitive' statement, but the culmination of his religious painting was the nine-part polyptych of the *Life of Christ* (1911-12) from which the *Doubting Thomas* [103] demonstrates the mystical content and Expressionist technique of his mature style. The range of frontal heads crowded into the top of the vertical canvas and painted in violent, unnatural primary blues, greens, and yellows suggests a row of masks. Nolde's study of primitive art underlies this, but it is worth noting that he used the mask, not to conceal the disreputable aspects of personality, as did Ensor, but to reveal the dominant traits of individuals taken as types of humanity. The intentionally awkward heads and arms of Christ and St Thomas prove that his draughtsmanship could be as savage as his colours. The thematic heart of the picture is found in the saint's astonished examination of Christ's wounds. Here the mystical element of the miraculous appearance is played out in a stillness almost deafening against the clash of red, green, and blue in the broad draperies. Before a work so intense, even so grotesque in its simplicity, we can believe that Nolde, after starting to work in despair and doubt, found his faith, as he said, in the act of painting. Such images were notable contributions to modern religious art, and one could wish for them a warmer ecclesiastical welcome than they received. The *Life of Christ*, which had been shown at the Folkwang Museum at Hagen, was to have gone to an international exhibition in Brussels in 1912, but had to be withdrawn when the clergy objected.

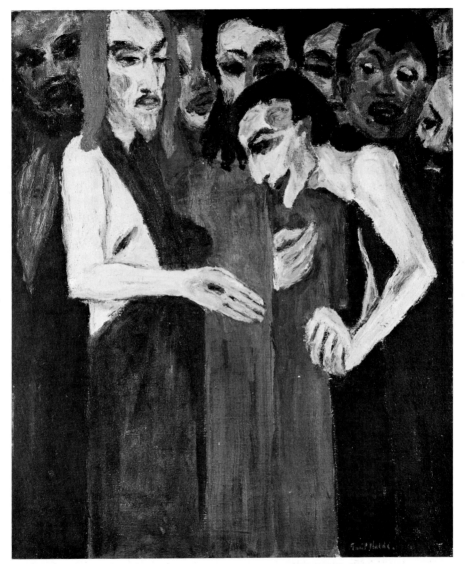

103. Emil Nolde: Doubting Thomas, 1912. *Seebüll, Germany, Ada und Emil Nolde Stiftung*

The majority of his paintings were land-scapes, often showing the play of elemental forces in land, water, and sky, figural subjects, portraits, and, in a less hectic mood, studies of gardens and flowers. In his ability, especially in water-colour, to communicate the essence as

104. Emil Nolde: Red and White Amaryllis.
Hamburg, Kunsthalle

105. Emil Nolde: Dancer, 1913.
Seebüll, Germany, Ada und Emil Nolde Stiftung

well as the appearance of flowers, Nolde has no equal among modern painters [104]. His colours often seem impregnated with the hues of summer, the oranges and scarlets of zinnias, the yellows of marigolds, and the disturbing mixed hues of magenta and lavender asters.

Nolde was a prolific graphic artist, producing slightly more than five hundred prints. Under the influence of Gauguin and Munch he exploited the material and technique of the woodcut in bold alternations of light and dark. He was also a masterly etcher and lithographer. In a coloured lithograph of 1913 [105], the savage intensity of a 'primitive' subject was interpreted even more directly and economically than in his paintings of the time.

Nolde's prints came to the attention of the

Brücke artists, who in 1906 invited him to join their group. He was pleased by their interest, but after eighteen months he resigned. He could not bend his individuality to their communal effort and apparently disliked their outspoken criticisms of each other's work. In Berlin he participated in the Sezession until, after three annual rejections, he protested publicly to Liebermann and was expelled. In 1927 his sixtieth birthday was celebrated with a large retrospective exhibition in Dresden, but only a decade later plans for his seventieth had to be abandoned. Although his art was German in its sources as well as in its expression, and he was not uninfluenced by ideas of national and even racial superiority, he was classified as a 'degenerate' artist by the Nazis and forbidden to paint. During the Second World War, however, he continued in secret to execute 'unpainted pictures', small water-colours from which in the years after 1945 he painted larger oils. These, with many works from every period of his life, are now to be seen in the Ada and Emil Nolde Foundation at Seebüll.

DIE BRÜCKE (THE BRIDGE): 1905–14

Although the talents as well as the points of view of the older German Expressionists had been various, the art of each had been based upon a traditionally humanist and idealist attitude towards subject matter. The peasants of Paula Modersohn-Becker and Barlach had been more typical than individual, with few details to situate them in time or place. Nolde's figures were still more timeless, and Lehmbruck's pathos was dressed in almost Hellenic serenity. Käthe Kollwitz's industrial workers suffered more as members of a class than as individuals. Of almost all the men and women created by these artists it might be said that their sufferings arose from situations beyond their control, as Käthe Kollwitz's people were victims of unemployment, famine, and war.

Only in Barlach's occasionally exacerbated figures was the specifically Expressionist quality of personal emotional disturbance present, that quality which Wilhelm Worringer defined in 1910 as the 'heavily oppressed inner life of Northern humanity'.[41]

In the work of other artists who were young in 1905, the contemporaries of the Frenchmen who became the Fauves and Cubists, there is a change in content as well as in subject matter. The subjects are more contemporary; the content expresses the city-dweller's restlessness, superficially as a reflection of the brilliance and agitation of the city, more profoundly as anxiety which may become deep psychic distress. The sources of this attitude lie far back in the nineteenth century, in the realization of the appalling emptiness of a world in which God, as Nietzsche had declared, was dead; in less clandestine but no less tormented sexuality; and in the pressures of mass society in which the individual discovers and maintains his integrity only with difficulty.[42] The artistic response to these spiritual events is the often frantic search for self-expression as a means to self-knowledge. The result of the search affects the subject as well as the content; for the former becomes the pretext for the psychological rather than descriptive statement of particular experience. In Germany this characteristically twentieth-century iconology first appeared in the work of a group of young artists in Dresden around 1905 who wanted to realize the kind of artists' community of which Van Gogh and Gauguin had dreamed. Their association did not last long, but it was remarkable for the intensity of their convictions, for their intellectual and technical cooperation, and for the insight with which, as critics of society, they exposed its moral decline. To them as much as to any artists was due the fact that the term 'Expressionist', which was used as early as 1911 to describe all modern painting, soon came to mean specifically German art.

'The Artists' Group of the Bridge' ('Künstler-Gruppe Brücke') was formed in Dresden in 1905 by four architectural students, Ernst Ludwig Kirchner, Fritz Bleyl, Erich Heckel, and Karl Schmidt, who added the name of his birthplace, Rottluff, to his own. Kirchner, the eldest, had always wanted to be a painter, and submitted to architectural training only from necessity. His enthusiasm for painting increased when he spent two years in Munich (1903–4) under Hermann Obrist, a leading designer of the Jugendstil. He had also, in 1898, discovered early German painting and prints on a visit to Nuremberg. His friends shared his enthusiasm for the German past, for the three painters, Van Gogh, Gauguin, and Munch, whose influence was then paramount, and for primitive art, especially the wood-carvings from Oceania and the German colonies in Africa preserved in the ethnographic department of the Zwinger in Dresden. Kirchner recognized their artistic qualities as early as 1904, and Heckel soon afterwards.[43] In 1905 Kirchner composed the manifesto of the group and cut the text himself in wood so that it could be published as a broadside. The statement was general and idealistic, calling on youth to help create 'freedom of life and of movement against the long-established older forces'. The final words were the most trenchant: 'Everyone who with directness and authenticity conveys that which drives him to creation, belongs to us.' In Nolde's prints which were exhibited in Dresden in 1906 the Brücke artists felt the immediate communication of creative energy, and in a letter inviting him to join them Schmidt-Rottluff amplified their intentions: '. . . one of the aims of the Brücke is to attract all the revolutionary and surging elements – that is what the name signifies.'[44] Through its communal activity and its annual and travelling exhibitions the group was to be a link between the present and the creative future. The members had no use for the resigned pathos of

Lehmbruck and Käthe Kollwitz, or for Barlach's medievalism. They would embrace the present with enthusiastic disillusion.

The activities of the Brücke included a series of exhibitions in Dresden and elsewhere. The first two, in 1906–7, were held in the showroom of a suburban lampshade factory, but later in 1907 and annually until 1910 they occurred in prominent Dresden galleries. Numerous travelling exhibitions circulated in Germany, Scandinavia, and Switzerland. These events were supported by a group of associate members who, in return for their financial contributions each year, received a portfolio of woodcuts or lithographs by one of the Brücke artists.[45] By 1911 all the members had moved to Berlin, attracted by the more vigorous intellectual atmosphere of the capital, where they participated as a group in the exhibitions of the Neue Sezession, and in large exhibitions of their own in Berlin and Hamburg (1911–12).

From time to time the active membership was increased. Although Fritz Bleyl withdrew in 1909, two recruits played important parts: Max Pechstein, who joined in 1906, and Otto Müller, who became a member in 1911. The Swiss and Finnish painters Cuno Amiet (1868–1961) and Axel (Akseli) Gallén-Kallela (1865–1931), Kees van Dongen, and the Czech Bohumil Kubista (1884–1931) were invited to join because the original members admired their work, but at best they can only be considered corresponding members, and their own work shows no trace of Brücke influence. Only Amiet, through whom they may have come to know more of Hodler, considered himself enough an active member to submit his resignation to Kirchner when the group was dissolved in 1913. By that time their individual styles had diverged, and they could no longer maintain their group activities or even share the same artistic sympathies. When Kirchner began the historical record of their activities, the others took exception to his statements of

fact and resigned.[46] Thenceforth they went their separate ways, and although they survived the First World War and were active for many years after, they had made their contributions, individually and as a group. They had created Germany's first modern movement with works, morbid and displeasing as at times they may be, that are often of authentic and indisputable force.

Of the Brücke artists Ernst Ludwig Kirchner (1880–1938) was the most gifted and the most professionally trained. In his earliest woodcuts the melancholy linearism of Jugendstil design was prominent, but by 1907 he had simplified and condensed his style to the degree represented by *Adam and Eve* [106]. His debt to Van Gogh and Gauguin appears in the simplified drawing and bold design of blue, red, orange,

106. Ernst Ludwig Kirchner: Adam and Eve, 1911. *Private Collection*

and green. Heavy black lines round the forms recall the pattern of the early German prints which he had admired in Nuremberg. In his interpretation of his subject Kirchner's painting summarizes the similarities and differences between the Brücke artists and the Fauves, with whom they are often compared. The bright colours and abrupt draughtsmanship may sometimes seem alike, but the fact that both the French and German anti-Impressionist demonstrations occurred in 1905 tells nothing about the differences between them. In the first place the French painters were ahead of the Germans, who only in 1907 reached the point Matisse had passed in 1905. In fact, the words of the Brücke artists were in advance of their deeds, and their achievement was neither technically nor expressively comparable to Fauvism until their Dresden exhibition of 1910. More than that, the expressive content of the Fauves and the Brücke painters is very different. One need only compare Kirchner's figures with Matisse's in *Le Luxe II* [87] to see that the French painter was concerned primarily with form, the German with content. Kirchner's figures look naked, and hence introduce questions as to the place and propriety of undressed figures in modern life. Matisse's are serenely and ideally nude. Even Matisse's most violently Expressionist paintings – for example the *Woman with a Green Stripe* (Copenhagen), or the *Gypsy* (Antibes) – have no such social or psychological connotations.[47]

Although Kirchner said that he was the first to appreciate the artistic qualities of primitive art, his work shows few direct traces of it. His sculpture is traditional in that it treats the human figure according to European canons, even at times in modern European dress. But we may feel that he accepted certain suggestions from primitive and folk art in the articulation of the limbs, the intentionally rough-hewn textures, and the crude colouring. In other respects the content of such a piece of sculpture

as the wooden *Dancer*, painted yellow and black (Amsterdam, Stedelijk Museum), communicates a not entirely 'primitive' experience. The intimation of modern sexuality in such sculpture and painting was still more explicit in Kirchner's paintings of 1911-13 of figures moving in city streets [107]. Their prototype was an earlier Dresden street scene of 1907 (New York) in a manner almost too close to Munch. Through French Cubism, Kirchner found his own idiom of tense, attenuated contours, broken by spiky faces and feet, evoking life along the Kurfürstendamm before the First World War. The overtones of sexual attraction and repulsion prepare us for George Grosz's brutal treatment of a similar iconography soon afterwards (see below, pp. 475 ff.).

When he was discharged from military service after a severe physical and nervous breakdown, Kirchner retired to Switzerland, where he spent the remainder of his life. The political

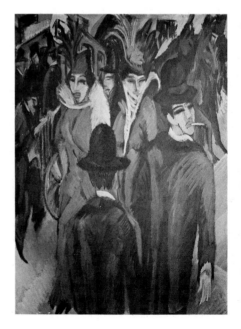

events in Germany after 1933 and the condemnation of his own art in 1937 so disturbed his precarious mental condition that in 1938 he committed suicide. During his last years his painting had grown brighter in colour and less subjective in mood, the themes often drawn from Alpine landscape and the joys of mountain life, but its more immediate attractiveness was sometimes paid for by a loss of power.

Kirchner was a prolific graphic artist whose prints were a major contribution to Expressionist art. The brilliant manipulation of full-face and profile heads, a device he learned from Picasso, in the woodcut of *Dr Bauer* shows that as late as 1934 his instinct for psychological expression was as sure as ever. Kirchner was also a gifted writer and a tireless propagandist for his own work under the pen name of L. de Marsalle.[48]

Of the other Brücke artists there is not quite so much to be said, if only because they worked within narrower stylistic limits. Erich Heckel (1883–1970), who practised architecture for a short time, never achieved as personal a style as Kirchner's. His *Convalescent Woman*, a triptych of 1913 [108], shows his concern with illness (Kirchner, too, had painted the sick), and the gentleness of much of his work. It is also a testimony to the admiration the Brücke artists felt for Van Gogh, Gauguin, and primitive art. The panels at either end, reminiscent of the decorative character of Gauguin's late painting, include a primitivistically carved statuette (sometimes mistaken for an additional figure), and a bowl of sunflowers.

Heckel's prints are a better measure of his talents than his paintings, in which his technique is often hesitant. The *Sleeping Negress*, a woodcut of 1908 [109], in subject as well as technique offers an early, almost precocious proof of the Brücke artists' primitivism. The white-on-black design, the heavy outlines, the

107 (*left*). Ernst Ludwig Kirchner: Berlin Street Scene, 1913.
Frankfurt, Städelsches Kunstinstitut, on loan from a private collection in Frankfurt

108 (*above*). Erich Heckel: Convalescent Woman, 1913.
Cambridge, Mass., Busch-Reisinger Museum, Harvard University

109. Erich Heckel: Sleeping Negress, 1908.
New Haven, Conn., Yale University Art Gallery

trace of tool upon material emphatically develop suggestions from Munch and Gauguin, but the intentional 'ugliness' is characteristically Expressionist. Later, a more delicate handling and a more introspective interpretation appeared in Heckel's graphic work.

The artistic personalities of Karl Schmidt-Rottluff (1884–1976) and Max Pechstein (1881–1953) are distinct and forceful, far more assertive than Heckel's, and both artists achieved public recognition much sooner, but in retrospect their work seems expressively and technically more limited. In both the direct influence of primitive art is obvious by 1911, and in Pechstein's it was intensified by his trip to the South Seas in 1914. But Pechstein's un-

deniable talents were diluted by his sophisticated acquaintance with French painting. A lithograph of 1912 representing nude figures dancing and bathing by a woodland pool is a paraphrase of Matisse's *Bonheur de Vivre* of 1905–6. His *Red Turban* of 1911 [110] shows how skilfully he could combine the most elementary factors of French art, a Matisse nude and a still life after Cézanne, with an exotic model. Probably for this reason he of all the Brücke painters was the first to be accepted as an Expressionist by the German public, and as the leading German Expressionist by critics elsewhere.

While Pechstein grew diffuse, Schmidt-Rottluff concentrated on a simplified, monu-

mental design in which crudely drawn and tilted planes, sometimes influenced by French Cubism, were combined with elements from Oceanic sculpture. Only rarely, as in his religious woodcuts executed at the end of the War, did his manner serve a powerful meaning. The print of the Christ who did not come, one of nine religious subjects published in 1919, is a horrifying but moving image cut at a time of profound public and private distress [111].

Otto Müller (1874–1930) was already a mature painter when one of his works at the Neue Sezession of 1910 attracted the Brücke artists' attention and they invited him to join them. His abbreviated, synthetic drawing was not unlike Kirchner's Cubist manner of 1911–13, and his favourite subjects, nude bathers and gypsies, were sympathetic on the score of their 'primitive' and exotic character. His colouring, however, is pale and dry in comparison with his friends'.

Christian Rohlfs (1849–1938) was never a member of the Brücke or of any group, but his work after 1905 runs parallel in some respects to that of the Dresden painters. He was so much older than they that he was slower to extricate himself from nineteenth-century naturalism, but after 1906 he came to know the modern masters when he was invited by Osthaus to teach in the Folkwang school at Hagen. His views of the church at Soest [112], where he spent several summers and where he knew Nolde in 1906, are among his most expressive works and precede the visionary architectural paintings of Feininger by several years (see below, p. 334). But unlike other German artists Rohlfs never found a truly distinctive style. His work is best regarded as a series of personal and occasionally very sensitive experiments in various manners.

There were many more Expressionist artists than can be discussed in this text, although few who successfully carried on into the post-war world with the intensity and originality they

110. Max Pechstein: The Red Turban, 1911. *Pittsburgh, Museum of Art, Carnegie Institute*

111. Karl Schmidt-Rottluff: Head of Christ, 1918. *New Haven, Conn., Yale University Art Gallery*

112. Christian Rohlfs: Church at Soest, 1918. *Mannheim, Städtische Kunsthalle*

113. Ludwig Meidner: Self Portrait, 1912. *Darmstadt, Hessisches Landesmuseum*

displayed before 1920. Indeed, the dangers of too absolute a submission to the dictates of spontaneous feeling can be seen in the rapid exhaustion of such a talent as Ludwig Meidner's (1884–1966). After studying in Berlin he spent a year in Paris (1906–7), where he knew Modigliani and other members of the avant-garde. During the decade after his return to Germany he painted his remarkable self portraits in which he seemed to lay bare the depths of a tormented, even diseased, personality [113]. Beyond this, pictorial self-analysis within a representational mode could not go, and there, in fact, Meidner stopped. After 1922 he abandoned such extremities of pathos for more conventional subjects and technique. His con-

tribution to Expressionism was small, but once seen it is not easily forgotten.

Between the Wars the prestige of the School of Paris as well as lingering anti-German feeling obscured the achievements of the German Expressionists for the public in Western Europe and the United States. Only after 1937, when their humiliation under Hitler became known through the exhibition of Entartete Kunst (Degenerate Art) in Munich, was much attention paid them (see below, p. 486). The Nazis' sale of a number of their works at auction in Lucerne in 1939, when important paintings were acquired by European and American museums, also contributed to their gradual recognition. The diminishing supply of

early-twentieth-century French art has been cited as a cause for their recent popularity, but if it ever was a factor it must be discounted by the interest their work provokes as it becomes better known. No one can study it without learning to respect its seriousness and occasionally tragic power.

KANDINSKY IN MUNICH: 1896-1914

Vasily Kandinsky (1866-1944) was thirty years old in 1896 when he declined a professorship in law at the University of Dorpat (Tartu) and left Russia for Munich to become a painter. Behind him were years of the study and practice of law and political economy. These, with his interest in ethnology, the natural sciences, and music, had developed his capacity for abstract thinking without stifling his sensitivity to art and music. From his earliest years he had been aware of the expressive powers of pure colour and pure sound, and his mature artistic achievement was to be based on mutual exchanges between visual and auditory properties, including the inaudible 'inner sound of things'. From childhood he remembered the excitement of seeing colours freshly squeezed from the tube, from adolescence the beauty of multi-coloured Moscow at sunset, ringing with bells. In 1889, while on an ethnological survey in the northern province of Vologda, he encountered other aspects of Russian colour and design in the traditional folk arts. So intense to him were the painted interiors of the peasants' houses that he felt as if he had stepped inside a picture, an effect he later hoped the spectator would experience in his own art. Other events he considered of prime importance were the discovery of the 'reciprocal resonance' of colour and light in Rembrandt's paintings in the Hermitage, the revelation of colour in music at a performance of Wagner's *Lohengrin*, and the effects of colour disengaged from subject matter when, at an exhibition of French Impressionist painting in Moscow, he at first failed to recognize the subject of one of Monet's *Haystacks*. It was to be fifteen years and more before he understood that the description of objects was irrelevant for his purposes, but his eventual discovery of non-representational art was implicit in the experiences of his Russian past.[49]

In Munich Kandinsky studied with Anton Azbé (1859-1905) and Franz von Stuck (1863-1928), until in 1901, with a number of now-forgotten artists, he formed a group called the Phalanx in the hope of attacking the academy and the then conservative Sezession. The most important contributions of the Phalanx were not the paintings by the members but their exhibitions of modern art, which brought to Munich works by Monet (1903) and the Neo-Impressionists (1904). In Kandinsky's painting until 1906-7 Signac's brick-like colour spots were developed as a surface pattern of extended strokes or as random clusters of large dots. He was also influenced by the prevailing Jugendstil and adapted its flat patterns, broad colour areas, and rhythmic lines to subjects from Russian and German medieval legends and fairy tales reminiscent of the symbolic atmosphere of Maeterlinck's plays, which he then admired[50] [114]. His analysis a few years later of Maeterlinck's use of words reveals his own search for synaesthetic reverberations of colours and sounds: 'The word is an inner sound. It springs partly, perhaps principally, from the object denoted. But if the object is not seen, but only its name heard, the mind of the hearer receives an abstract impression only of the object dematerialized, and a corresponding vibration is immediately set up in the "heart". Thus a green, yellow, or red tree in a meadow are accidental realizations of the concept tree which we formed upon hearing the word.'[51]

In the spring of 1906 Kandinsky and Gabriele Münter (1877-1962), who had been one of his pupils in the Phalanx school, settled at Sèvres,

where they remained a year. Gabriele Münter later said that they did not meet many of the leading younger painters in Paris,[52] but since Kandinsky exhibited at the Salon d'Automne from 1905 to 1910 and with the Fauves at the Indépendants in 1907, it would seem hardly possible that he should not have been familiar with their work. The more intense colour, abbreviated drawing and perspective, and gradual elimination of romantic subject matter from his landscape paintings of 1908 and 1909 bring them close to Fauve painting of a few years earlier. To this contact with the Fauves we may attribute his admiration for Matisse, which was stated more than once in his letters from Munich to the Russian periodical *Apollon*.

114. Vasily Kandinsky:
Night, 1906–7.
Munich, Städtische Galerie im Lenbachhaus,
Gabriele-Münter-Stiftung

When they returned to Germany Kandinsky and Gabriele Münter settled at Murnau, a village south of Munich near the Bavarian Alps. Here they were joined by Alexei von Jawlensky and Marianne von Werefkin, who had also left Russia for Western Europe. From their dissatisfaction with the conditions for exhibiting pictures in Munich came another organization, the Neue Künstlervereinigung-München (New Artists' Association – Munich), founded in January 1909 with Kandinsky as principal officer. Among the other members were the German painters Adolf Erbslöh and Alexander Kanoldt, the Austrian Alfred Kubin, and, briefly, Carl Hofer. In his contributions to the first exhibition of the NKV, as it was usually called, held in the Moderne Galerie Thannhauser in December 1909, Kandinsky carried further his simplification of form and intensification of colour in his characteristic resonance of brilliant greens and blues against red, yellow,

and violet, recalling the prismatic palette of the ancient icons he had admired in Russia.

The first exhibition had been limited to the members of the association. The second, in September 1910, was much larger, and included artists from East and West. From Russia Kandinsky invited David and Vladimir Burliuk, the latter subsequently a member of the Blaue Reiter group, and from Paris, among others, Braque, Derain, Van Dongen, Le Fauconnier, Picasso, Rouault, and Vlaminck. It was the largest and most inclusive exhibition of the new European painting which had yet been held. The international character of the group was remarked upon at the time, although the critics pointed out that it was scarcely

115. Vasily Kandinsky: Study for Improvisation 2 (Funeral March), 1909.
Munich, Städtische Galerie im Lenbachhaus, Gabriele-Münter-Stiftung

representative of art in Munich, since there was not a native 'Münchner' among them.

Until 1910 Kandinsky was working towards a more powerful design and the release of colour from its subservience to the object. Even in a black-and-white reproduction of a painting of this period the pattern of values is more assertive than the subject matter, in this case four figures and a horseman in a landscape which looks more like scenery for a play or ballet, whence perhaps the 'symbolic' subtitle, *Funeral March* [115]. The colours are so saturated that they seem to detach themselves from the forms, creating a design which exists apart from their descriptive function. To the degree that Kandinsky in the years 1909-10 learned how to endow colour with an independent existence he was moving towards total abstraction, but one must not assume that, if the forms in a given painting are not readily recognizable, it is therefore non-representa-

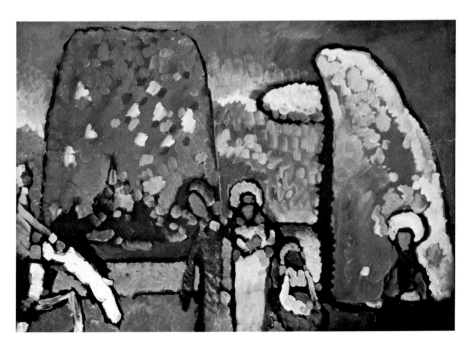

tional. Only very gradually and with some misgivings were all traces of the natural world eliminated. In his treatise *Über das Geistige in der Kunst (Concerning the Spiritual in Art)*, written in 1910 but not published until 1912, he warned against attempting total abstraction, because he feared that without the necessary 'spiritual qualities' such work would end in nerveless decoration.[53]

Kandinsky himself dated his understanding of the possibilities of non-representational design from an evening in Munich (apparently in 1910) when, upon returning to his studio at twilight, he failed to recognize one of his own paintings. It was standing the wrong way up and in the bluish dusk he saw only a picture 'of extraordinary beauty, glowing with an inner radiance'.[54] The discovery that coloured forms have inherent expressive properties regardless of their relation or lack of relation to objects in the phenomenal world was of the greatest importance to him, for it confirmed his belief that the artist's task is to present the reality of spiritual rather than sensational experience. Kandinsky's metaphysical hypothesis, presented in *Concerning the Spiritual in Art*, 'Über die Formfrage' (1912), and in other essays, is not always easy to follow, but at least we must accept his statements that in his own art he was trying to project his mystical apprehension of the spiritual values of life. Later popularization of the dialectic of abstract art led to the belief that non-representational forms can be devised which are devoid of meaning or content outside themselves. For Kandinsky all forms had meaning, no form was without meaning, although individual interpretations of forms might vary. Even in defining the expressive qualities of colour he recognized that no empirical evidence could prove that the values he assigned them would be relevant for every observer. In the main, however, Kandinsky's formal analysis follows a comprehensible pattern. In addition to the conventional divisions of colours into warm and cool, light and dark, he defined the qualities of the principal hues. Blue is 'the typical heavenly colour; the ultimate feeling it creates is one of rest'. It is 'horizontal', whereas yellow, which admits of so little gradation, is acute, aggressive, and vertical, even 'manic'. Green, composed of blue and yellow, is calm. The directions cancel each other out, so that 'absolute green is the most restful colour, lacking any undertone of joy, grief, or passion'. Form, which Kandinsky thought more fundamental than colour, since there can be no colour which does not take some form, has similar reverberations: 'a triangle (without consideration of its being acute or obtuse or equilateral) is such an entity, with its particular spiritual perfume. In relation to other forms this perfume may be somewhat modified but it remains in intrinsic quality the same, as the scent of the rose cannot be mistaken for that of the violet.'

Although vestiges of the phenomenal world did not disappear entirely from Kandinsky's painting until after 1920, if even then, the stages in his discovery of abstract art can be studied in the three principal types of paintings he executed between 1910 and 1914.[55] Of these the six *Impressions*, painted in 1911, are his last link with the immediate past. These large works, which he described as 'direct impressions of nature, expressed in purely pictorial form', often look very abstract, but such subtitles as *Fountain*, *Concert*, or *Policeman* are clues with which to unravel the coloured webs. Meanwhile, in 1909, he had painted the first of his forty-odd *Improvisations*. These were 'largely unconscious, spontaneous expressions of inner character, non-material in nature' and they remain among his most personal inventions. Of these, *Improvisation No. 30 (Cannons)* is the best known [116]. It was exhibited in London in 1913 and drew from Roger Fry one of the first descriptions in English of non-representational painting, concluding with the per-

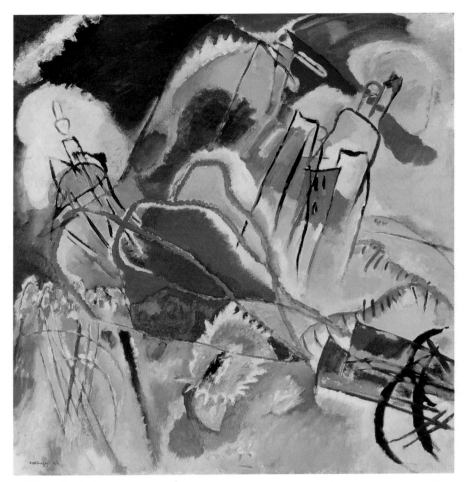

116. Vasily Kandinsky:
Improvisation No. 30 (Cannons), 1913.
Art Institute of Chicago

ceptive remark that '. . . one finds that after a time the improvisations become more definite, more logical, and closely knit in structure, more surprisingly beautiful in their colour oppositions, more exact in their equilibrium. *They are pure visual music,* but I cannot any longer doubt the possibility of emotional expression by such abstract visual signs'.[56]

When Arthur Jerome Eddy of Chicago, who had acquired the painting, wrote to ask Kandinsky about the significance of the 'cannons', the artist replied in words which were widely circulated when Eddy published them in his *Cubists and Post-Impressionism* (1914), the first extended study in English of the new painting. Kandinsky wrote: 'The designation *Cannons,*

selected by me *for my own use,* is not to be conceived as indicating the "contents" of the picture. These contents are indeed what the spectator *lives,* or *feels* while under the effect of the *form and colour combinations* of the picture . . . The presence of the cannons in the picture could probably be explained by the constant war talk that had been going on throughout the year. But I did not intend to give a representation of war; to do so would have required different pictorial means; besides, such tasks did not interest me – at least not just now. This entire description is chiefly an analysis of the picture which I have painted rather subconsciously in a state of strong inner tension. So intensively did I feel the necessity of some of the forms that I remember having given loud-voiced directions to myself, as for instance, "But the corners must be heavy!" '

The significance of these remarks for modern art and aesthetic theory lies in Kandinsky's explicit statement that artistic creation is not exclusively a conscious process but requires the cooperation of subconscious, or as we should probably say now, preconscious, experience. Conversely, the apprehension of the work of art by the spectator requires more than his identification of the forms with objects already known in nature. And when such objects appear in a painting without the artist's conscious will or intention, as did the 'cannons', the spectator must himself sufficiently relax the controls of discursive consciousness to allow free play to subconscious feeling. Kandinsky's epochal exertions can now be seen as the nexus between the aesthetic and psychological theories of Fiedler, Lipps, and the *gestalt* psychologists, and the artistic investigations of subconscious and automatic creative processes by the Dadas and Surrealists after 1916. In *Black Lines No. 189* of 1913 [117], the design is an apparently free but actually quite strict disposition of red, blue, green, and yellow shapes behind and between clusters of black lines. The technique

is as deceptively casual as the composition. The erratic lines, in single scratches or groups, and the careless brush strokes might be mistaken for doodling, so completely has Kandinsky accepted the promptings of intuition. But close attention reveals that this art is only seemingly accidental; each stroke, each line, has its own place and no other. Kandinsky was not interested in, nor did he countenance, artistic licence. Because each form or colour had its own meaning, which could be affected by the slightest alteration of shape or hue (a blue triangle is not the same as a yellow one, although something of the quality of the shape persists despite the change of colour), the fitting of such meanings together was of crucial importance if the content was to be properly expressed. The content, which requires expression because of its 'internal necessity', is of the greatest spiritual or psychological importance. Kandinsky's favourite word *geistig* contains traces of intellectual and mental aspects as well as what in English is more narrowly described as spiritual. Nor should we forget that Kandinsky was always aware of the religious implications of his thought. He had grown up within the Russian Orthodox Church, and during his years in Munich was deeply interested in theosophy and in the anthroposophical speculations of Rudolf Steiner (1861–1925).

The material world for Kandinsky had been reduced to nothingness by scientific progress. The news of Rutherford's bombardment of the atom filled him with dismay when he realized that the world of apparent substances no longer had any real existence. Henceforward, spiritual realities were alone valid, and his task was to reveal them. The content of his later work, no matter how impossible it may be ever to seize and reduce it to a verbal formula, is always of ethical as well as aesthetic significance. We may think that Kandinsky's description of his methods resembles the Freudian analysis of the

creative act as the resolution of subjective psychic tension. It probably does, but beyond that we must never forget that Kandinsky ascribed to his art an objective spiritual purpose. To examine his colours and shapes as ends in themselves would be to ignore what they were intended to do to us.

Consequently, Kandinsky could not indulge in the extremes of automatic inspiration. The works on which he spent the most time, thought, and energy are his *Compositions,* of which the first seven were painted between 1910 and 1913. These he described in 1912 as 'expressions of a slowly formed inner feeling, tested and worked over repeatedly and almost pedantically . . . Reason, consciousness, purpose play an overwhelming part. But of calculation nothing appears: only feeling.' Close study reveals that

117. Vasily Kandinsky: Black Lines No. 189, 1913. *New York, Guggenheim Museum*

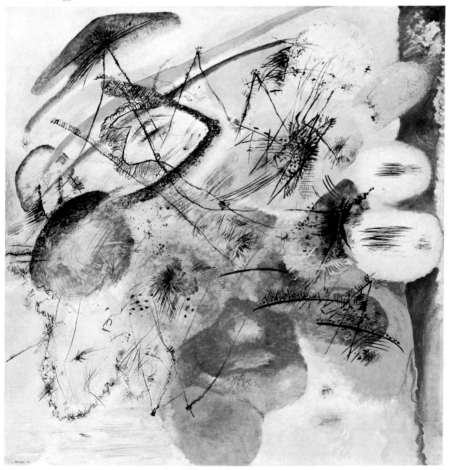

they were, indeed, consciously constructed from spontaneous configurations of colour and line, which were then fitted into a predetermined design. The first two (1910) continued the fairy-tale subjects of earlier years, although the figures are more simplified and less easily identified. The vestiges of landscape in the third and fourth (1911) are not unlike similar features in the contemporary *Improvisations*. In the last three (1911–13), representational elements have been suppressed, the scale is larger, the compositions are more complex yet unified by sweeping spatial rhythms, and the colours more intricately knit in constantly changing patterns. The preliminary drawings and watercolours, a carefully worked fragment for the central section, and an elaborately finished colour sketch for the last of this pre-war series, *Composition VII* of 1913 [118], prove the care

with which Kandinsky directed the promptings of intuition and instinctive response into channels ordained for them, although in the crowded but apparently informal design the elements seem to adhere more by free association than by plan.[57] 'Nothing of calculation appears; only feeling.'

As remarkable as Kandinsky's swift advance from merely 'abstracted' designs still reminiscent of natural forms to the supposedly spontaneous configurations of 1913-14 was his discovery of an entirely new kind of pictorial space. The forms in his pictures, the coloured shapes, have no familiar equivalents in the world of appearance, and therefore need not be placed in conventional perspective arrangements. Space, as with the Cubists, has become the function of the forms themselves. They occupy as much as they need, and between one shape

118. Vasily Kandinsky: Composition VII, No. 186, 1913. *Moscow, Tretyakov Gallery*

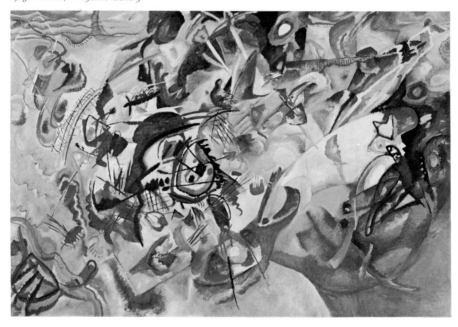

and another there is not emptiness but coloured form. Because the coloured elements are of different sizes and shapes and their meetings and intersections occur only according to their several necessities, the space of the picture as a whole, if we can think of it as such, appears infused with temporal as well as spatial dimensions. It continuously expands and contracts and can never be apprehended as a static unity; there is no single fixed position from which the observer can establish the relations of each form to all the others. This halting verbal description is useful only if it suggests that Kandinsky's space is remarkably like the space of dreams, of preconsciousness. For the first time in western art the ceaseless flux of psychic experience may have been represented, and Kandinsky may have found, whether he was aware of it or not, an image for consciousness at a psychic level below that at which images are formed. But the similarities between *Composition VII* and much later action painting, in which spontaneous, non-figural images are accidentally generated, should not lead us to forget that the effects which Kandinsky achieved were intentional, deliberate, and prepared.

In *Concerning the Spiritual in Art* Kandinsky wrote that 'the final, abstract expression of every art is number', but in the last *Improvisations* and *Compositions* painted before the First World War he dealt with irregular fractions and irrational roots. Not until after his return to Western Europe from Russia in 1921 did his painting become strict and geometrical. Its explication properly belongs with the story of neo-classical ideas of order after 1918 and will be considered there (see below, pp. 337-40).

Kandinsky's increasing search for freedom of artistic expression, for others as well as for himself, was misunderstood not only by the public and by the critics who thought him 'mad' but even by his associates in the N K V. When the members of the jury for their third exhibition, to be held in December 1911, rejected his *Last Judgement* because it exceeded the statutory dimensions, Kandinsky understood that the pretext concealed a fundamental difference of opinion and resigned from the organization. Gabriele Münter, Franz Marc, and Alfred Kubin left with him and planned the Blaue Reiter exhibition a few days later. Jawlensky and Marianne von Werefkin, hoping to keep the organization together, remained, but their works were so outnumbered by the conservative paintings of Kanoldt, Bechtejeff, and others that the N K V abandoned its plans for further exhibitions and little was heard of it again.[58]

Gabriele Münter's art until 1914 was very close at times to Jawlensky's and Kandinsky's, although she never ventured into non-objective painting. After separating from Kandinsky in 1916 she continued to paint at Murnau and exhibited extensively in Germany before and after the Second World War. In 1957 she established the Münter-Kandinsky-Stiftung (Foundation) in Munich with the gift of a hundred and forty-three oils by Kandinsky in addition to a number of his water-colours, drawings, and prints, and a representative selection of her own works.[59]

The most accomplished artist of the N K V after Kandinsky was Alexei von Jawlensky (1864-1941), an aristocrat and guardsman whose passion for painting led him to resign his commission and devote his life to art. In St Petersburg in the studio of Ilya Repin (1844-1918), the leading Russian historical painter of the late nineteenth century, he met Marianne von Werefkin (Marianna Vladimirovna Werefkina, 1860-1938), who shared his disgust with realism as a source of spiritual expression. Together they left Russia for Munich in 1896 in search of a more sympathetic environment. Marianne von Werefkin's enthusiasm for French Symbolist poetry and painting, her belief in the necessity for a new art more im-

mediately expressive of individual personality, and her encouragement of her companions were important contributions to the development of the new ideas in Munich, more important than her own paintings and drawings, which she herself considered secondary to the work of her friends.[60] Jawlensky was a founder member of the NKV in 1909 and served as its vice-chairman. By then he had become the first of the Munich artists to establish contact with the advanced French painters. He had travelled in Brittany and Provence, and had spent some months in Paris, where he saw paintings by Van Gogh and Gauguin and worked with Matisse. Through Diaghilev's interest he was included in the Russian exhibition at the Salon d'Automne in 1905. He exhibited again in 1906, and his works were seen that year in St Petersburg in the Blue Rose exhibition of Russian Symbolist painters.

On his return to Munich by way of Geneva he visited Hodler. His experience of Post-Impressionist and Fauve colour and linear distortion, and of Hodler's transcendental aesthetics, strengthened his feeling for colour and his fundamentally mystical conception of art. The strong hues, circumscribed by heavy blue lines, of his early still lifes (1905-9) would seem purely Fauve, did not the interpretation of subject matter count for more than in contemporary French painting. Jawlensky's figures, notably the series of *Heads* begun in 1910, are a convincing synthesis of Russian and French elements. His bold colour and rigorously simplified linear structure can be seen in the portrait of the Russian dancer Alexander Sacharoff, also a member of the NKV, whose exaggerated eyes recall those in ancient icons [119]. Like Kandinsky he was convinced that colours and sounds are interrelated and interchangeable. Colours 'rang like music in his eyes', and he described his landscape *Variations*, small pictures painted from the window of his

119. Alexei von Jawlensky:
Portrait of Alexander Sacharoff, 1913.
Wiesbaden, Städtisches Museum

room in Switzerland during the War, as 'songs without words'.

Although Jawlensky did not join the Blaue Reiter, he shared their dissatisfaction with the NKV and exhibited with the former group in Herwarth Walden's Sturm Gallery in Berlin. After the War he settled at Wiesbaden, where he worked on a long series of nearly abstract heads in oil, water-colour, and lithography in which the features were gradually reduced to a few curves and lines resembling a Latin cross. With Kandinsky, Klee, and Feininger he founded in 1924 the Blaue Vier (Blue Four). Although their exhibitions travelled widely for a time in Europe and the United States, this diminished successor to the Blaue Reiter added little to the reputation of its members.[61] In later life Jawlensky became so crippled with arthritis that he was obliged to abandon painting some years before his death.

FRANZ MARC AND DER BLAUE REITER
(THE BLUE RIDER): 1910–16

Upon their resignation from the NKV early in December 1911, Kandinsky, Gabriele Münter, and Franz Marc (1880–1916) organized their own exhibition, which opened on 18 December in the same gallery where the remaining artists of the NKV were installed. Although only forty-three works by fourteen painters were shown,[62] the group effort, fortified by the enigmatic title 'First Exhibition by the Editorial Board of the Blue Rider', represented a more advanced position in modern art. The title came from the almanac which Kandinsky and Marc had been planning for some time and which appeared in May 1912 with an abstract drawing by Kandinsky of a mounted horseman in blue and black on the cover. The theme of the horseman had been present in Kandinsky's art from the first; Marc's favourite colour was blue, and his cherished subject among the animals he loved was the horse.[63] The first exhibition lasted only until early January 1912, but it was followed in March by a second consisting of 315 examples of contemporary graphic art by thirty-one German, French, and Russian artists. The Brücke painters were seen for the first time in Munich; Arp and Klee were included. It was an important international survey and continued the NKV's generous policy of inviting foreign artists. Although these were actually the only Blaue Reiter exhibitions in Munich, the reputation of the group soon spread abroad. The first exhibition was taken to Berlin in March to inaugurate Herwarth Walden's new Sturm gallery (see below, p. 474), and it was also seen at Cologne, Frankfurt, and Hagen. The principal painters, Kandinsky, Klee, Macke, and Marc, were included in the Sonderbund exhibition in Cologne in June, and, with Campendonk, they formed an impressive group at Walden's 'First German Salon d'Automne' in Berlin in September 1913. The deaths of Marc and Macke at the front no less than the changed conditions in Germany after the War put an end to the group activities. From then onwards the surviving individuals, especially Kandinsky and Klee, must be followed separately.

The Blaue Reiter was an informal association of gifted individuals who believed in freedom for experiment and expression, and wanted proper opportunities to exhibit their work. It had no programme like the Brücke's for work in common, nor any thought of social reform. The position of the leaders can best be studied in the Blaue Reiter almanac, which was dominated by Kandinsky's interest in the reciprocal relations between music and painting, and by his and Marc's enthusiasm for the arts of primitive people and children. Among the contributions were Kandinsky's important 'Über die Formfrage', which continued the argument of *Concerning the Spiritual in Art*, his synaesthetic drama *Der gelbe Klang (The Yellow Sound)*, and essays on 'Anarchy in Music' by Thomas von Hartmann and on the relation of music to text by Arnold Schoenberg. There were facsimiles of musical compositions by Schoenberg, Alban Berg, and Anton von Webern, and shorter essays on aspects of contemporary art by Marc, Macke, and others. Reproductions of paintings and drawings by members of the group, principally the two editors, by Macke, Campendonk, Kubin, and Klee, and by the North German Expressionists were outnumbered three to one by illustrations of primitive, folk, and children's art. In addition to objects from Africa and the South Seas, examples of medieval German sculpture and woodcuts ('primitive' in the stylistic sense), Egyptian paper puppets, Japanese woodcuts and drawings, and Russian popular prints and sculpture, there were no less than seventeen examples of Bavarian *hinterglas* painting (devotional images

painted on the reverse of panes of glass) and other votive paintings which Kandinsky and Marc prized. Nine drawings by children constitute one of the first instances of the publication of such work for artistic reasons.[64] There were also seven reproductions of paintings by Henri Rousseau, most of them acquired by Kandinsky in Paris. This concentration on various kinds of 'primitive' art indicates a shift of interest on the part of the Munich group from the slightly older European masters admired in Germany. Of the Post-Impressionists there were only five reproductions after Cézanne, Gauguin, and Van Gogh, and nothing by Hodler, Munch, Ensor, or even Nolde. The emphasis fell on the psychological immediacy of unsophisticated expression, supposedly to be found in the direct statements of persons artistically untrained or belonging to less complex societies. The study of primitive expression eventually led Paul Klee to use the graphic techniques of children and psychotics, but before that Franz Marc wrote in the almanac that the new movement was 'trying to get back by another road to the mysterious and abstract images of inner life, which is governed by laws different from those science discloses in nature'. And in his mature work he postulated the visual expression of sub-human or non-human emotion.

In his essay entitled 'Masks', August Macke's definition of the spiritual necessities of the new art illuminated Marc's expressive purposes: 'To create form is to live. Are not children, who conceive directly and from their secret feelings, more creative than those who imitate Greek art? Are not animals artists, who have their own form, strong as the form of thunder? ... Man externalizes his life in forms. Every art form is the externalization of his inner life. The external appearance of a form in art is its inwardness.' And of folk art, and primitive art in general, as well as of the major Post-Impressionists, he concluded: 'Their works are the experience of their inner life. They are the form of their artistic imagination in the materials of painting.'[65]

In Marc Kandinsky had a comrade not only as eager as he to discover the mystical and spiritual properties of form but also one whose intellectual and artistic gifts would have made him a formidable contributor to the later development of non-objective art had he not perished at Verdun. Munich-born and the son of a painter, Marc entered the academy at twenty. The basis for the spiritual content of his later works may have been laid by his theological and philosophical studies at school, and by his visit in 1906 to Mount Athos. His earliest work was academic and realist in style and content, studio nudes and landscapes lightened by the revelation of Impressionist colour that he saw in Paris in 1903. Soon his passionate interest in animals led to serious study of their anatomy. A second trip to Paris in 1907 brought him closer to modern painting, including the work of Van Gogh. At the second exhibition of the NKV in 1910 he saw the recent developments in French Cubism, which led him from the conventional simplifications of his bronze *Leopard* of 1908 (Halle) to the dynamic, twisting *Tiger*, an oil of 1912 (Munich, Städtische Galerie im Lenbachhaus, Bernhard Koehler-Stiftung). At this time he met Kandinsky and joined the NKV. Kandinsky's theories probably encouraged Marc to abandon local colour in the boldly unnaturalistic *Red Horses* (Rome, Paul E. Geier Collection) and the *Blue Horses* (Minneapolis, Walker Art Center) of 1911. Marc's colour symbolism, as he explained to Macke in December 1910, was more biological and more passionate than Kandinsky's: 'Blue is the *male* principle, severe and spiritual. Yellow is the *female* principle, gentle, cheerful, and sensual. Red is *matter*, brutal and heavy, the colour that has to come into conflict with, and succumb to, the other two.' Mixtures of the primaries produced

reactions more emotional than intellectual: 'If you mix red and yellow to obtain orange you endow the passive and female yellow with a termagant-like, sensual power.'[66] The meditated and monochromatic Cubism of Picasso and Braque was less interesting to him than the brightly coloured works of Le Fauconnier and Delaunay, in which content retained something of its traditionally expressive connotations.[67] Both French painters had exhibited with the NKV in 1910, and their works were much admired in Germany before 1914. When Marc visited them in Paris in 1912, he found that Delaunay had gone beyond his belief in the 'Synchromatic movement [simultaneity] of light [as] the only reality' and was trying to represent 'the absolute rhythms of nature' by means of colour harmonies. In October Marc sent Kandinsky information which must have interested the older painter. Delaunay, he wrote, was 'feeling his way towards really constructive paintings, entirely non-representational, one might say, purely musical fugues'. If to these sources of inspiration we add the dynamic movement of the Futurists, whose principles Marc admired, although he had reservations about the quality of their work, the formal elements were at hand for the symbolic and abstract pictures he painted in the last months of his career.

His problem, given his belief that animals were more spiritual as well as more beautiful than human beings, was to express their condition without falling into sentimentality or merely naturalistic description. The difficulties at the first level of this search for symbolic form are suggested by his imaginative queries in 1911-12 concerning the possibility, even the necessity, of looking at the world through other eyes than our own: 'Is there a more mysterious idea for an artist than the conception of how nature is mirrored in the eyes of an animal? How does a horse see the world, or an eagle, a doe, or a dog? How wretched and soulless is our convention of placing animals in a landscape which belongs to our eyes, instead of submerging ourselves in the soul of the animal in order to imagine how it sees.'[68] In his first characteristic animal paintings he exchanged local colour for symbolic colour and descriptive form for more emphatic rhythmic harmonies, as in the *Red Horses*. But these were still external, consciously human constructions and represent the state of his development at the time of the Blaue Reiter exhibitions. Through the following year (1912-13) he moved much farther towards his subjective and introspective goal. In the *Deer in the Wood, No. I* [120] the animals and

120. Franz Marc: Deer in the Wood, No. I, 1913. *Washington, Phillips Collection*

the forest floor are fragmented and painted in the crystalline colours of Delaunay's Orphic Cubism. The plants and trees, and the suggestion of climate, of sun and wind moving through space, are treated schematically, as if seen through the eyes of the deer themselves. Other works of this time show Marc's preoccupation with the emotional tensions of animal existence. *Fear of Rabbits* (1912) expresses the anguish of the tiny huddled animal as a monstrously large dog passes overhead. In *Primeval Animals*

(Urtiere) of 1913 he seems to have been thinking beyond human history to the psychological conditions of original creation. The masterpiece of this period is the *Animal Destinies (Tierschicksale)* of 1913 (Basel), in which the terrified creatures cowering in the forest are attacked by revolving and intersecting rays of light, quite within the Futurist system of representing light as streams of dynamic energy but communicating in this instance the animals' helplessness at the supreme moment of their fate. Marc inscribed his belief in the unity of all life, human and animal, on the back of this canvas in the words 'Und alles Sein ist flammend Leid' ('and all being is flaming suffering').

Early in 1914 Marc's work became more abstract, even approaching non-objectivity, if we can interpret such a picture as the un-finished *Fighting Forms* (Munich) as having no phenomenal subject [121]. Its content seems to be the impact of two violently moving forms, an expanding red one to the left, a concentrated dark blue to the right. Towards the outer edges the forms dissolve in rainbow hues interwoven with crackling lines like a last faint echo of the Jugendstil. In such a work Marc penetrated beyond the description of his beloved animals to the sources of psychic energy common to human and non-human consciousness, transforming the appearance of animal energies as physical exertion into abstract lines and planes expressive of more universal spiritual forces in order to disclose 'the inner truth of things'.

As intelligent if less didactic than Kandinsky, with a more embracing love of created beings,

121. Franz Marc: Fighting Forms, 1914.
Munich, Bayerische Staatsgemäldesammlungen

and certainly with as fine a sense of colour, Marc was on the threshold of his career when the War took him. Even the dreadful conflict was for him less a present tragedy than a spiritual experience, an enormous cleansing, as he described it, of the European soul. His letters from the trenches with his hundred-odd 'Aphorisms' contain the mature statement of his philosophical conception of art. In his insistence on the 'inner necessity' of spiritual experience, and the reality of the world as a dynamic process, he was close to the German Romantic poets and painters he so admired.[69]

Although August Macke (1887-1914) was encouraged by Marc and Kandinsky, whom he had met in 1910, to exhibit with the Blaue Reiter, he was too captivated by nature and human beings to follow his older friends so far towards non-objective painting. Yet it was he, perhaps as much as Jawlensky, who understood the significance of the newer developments in Paris, and his synthesis of French means and German ends, as well as his enthusiasm for the sensuous vitality of bright colour, affected both Marc and Paul Klee. Macke was born in the Rhineland and studied at Düsseldorf, until he escaped from academic routine to the more liberal School of Arts and Crafts. Through Louise Dumont, the manageress and a leading actress of the state theatre, he came to design scenery. His rejection of the conventions of theatrical perspective in favour of simply painted hangings had little effect on theatrical history, but it helped to prepare his eyes for the spectacle of French colour when he visited Paris for the first time in 1907 and discovered Impressionism. On subsequent visits in 1908, 1909, and 1912, when he visited Delaunay with Marc, he became aware successively of Post-Impressionism, Fauvism, and Cubism, whose elements appeared almost immediately in his painting. With modifications depending upon the strength of his attachment at the time, an equation for his work can be devised in which

the constant of Impressionist subject matter is interpreted through Cézanne's multiple space, with the linear simplifications of Fauvism and with increasing attention to the Cubist analysis and reconstitution of objects in facets of transparent colour. He was also deeply impressed by Matisse, whose exhibition he saw in Munich in 1910, and by Delaunay, whose grids of line and colour he incorporated into the best of his own work of 1913-14.

Merely to list the sources Macke so eagerly accepted might suggest that he never outgrew his youthful and eclectic enthusiasms, but that would be to take no account of his own discoveries. His affectionate and lyrical attitude towards his favourite subjects – figures in a park, children playing by a spring, or elegantly dressed women looking in shop windows – is like an echo of earlier, if much loftier Rhenish art. Even his colour, bright but never strenuous, may be compared with late medieval painting in Cologne. It is almost as if Stefan Lochner's saints had been secularized and brought up to date. His mood is in striking contrast to the North German Expressionists', especially Kirchner's, whose city scenes were painted at the same time. Where Kirchner is strident, Macke continues the themes so placidly treated by Renoir in the 1870s. In his *Zoo* of 1912 [122], which may be compared with similar subjects by Liebermann [96], influences from the Blaue Reiter (Marc's animals), Cubism, and even Futurism (the shifting planes of colour simultaneously creating light and space) are bound together by the beauty of nature and living beings. 'Man', Macke wrote in the Blaue Reiter almanac, 'stands in the cross-fire of impressions from things in Nature. He responds to everything even as he produces works of art.'

In April 1914 Macke went to Tunis with Klee and Louis Moilliet, a Swiss painter associated with the Munich group. In his watercolours, especially the architectural views of Kairouan, Macke filled the Orphic Cubist grid

122. August Macke: Zoological Garden, I, 1912.
Munich, Städtische Galerie im Lenbachhaus, Bernhard Koehler-Stiftung

123 (*opposite*). Heinrich Campendonk: The Woodcarver, 1924.
New Haven, Conn., Yale University Art Gallery

with washes of pure colour. They are perhaps his most personal achievement, and are of historical interest for their effect on Klee, who soon after created his individual interpretations of the Delaunay-Macke formula. Macke's career, like Marc's, was cut short on the battle-field, but, brief as it was, he managed to create more than a thousand oils and water-colours in addition to numerous drawings.

In the work of Heinrich Campendonk (1889–1957) certain aspects of Blaue Reiter theory and practice were projected into the post-war period in more decorative, less philosophic terms. Campendonk was only twenty-two when Marc invited him to settle at Sindelsdorf in Upper Bavaria and join the Blaue Reiter. Most of his works before 1914 were repainted later,

but from the few that survive we can see that his mature style was based upon his enthusiasm for Orphic Cubism as interpreted by Macke, and for Bavarian *hinterglas* painting. By using the conventions of folk art, the stiff frontal drawing of figures with exaggerated heads and eyes, and by making more important figures larger than others, Campendonk created a kind of neo-primitive painting [123]. But he is too learned, too aware of French Cubist devices to be truly 'the German Henri Rousseau', as he has been called. At times he resembles Chagall, whose early peasant scenes were known in Germany after his exhibition at the Sturm gallery in 1914 (see below, p. 437). None the less he remained his own master, less cosmopolitan than the Russian, more attached to the mood as well as

to the themes and the methods of Bavarian folk art.

After 1922 Campendonk taught at Essen, Krefeld, and Düsseldorf, and, following his dismissal by the Nazis in 1933, in Amsterdam until his death. The dry stylizations of his later work, especially in his stained glass for churches in Germany and Holland, and after 1945 again in the Rhineland, remind us that he had intended to be a textile designer and had studied with Thorn-Prikker at the Arts and Crafts School in Krefeld. The geometrical elements within his figural patterns may be related to Kandinsky's work in Paris after 1933. Through his many woodcuts executed between 1912 and 1932, in which one can trace his continuing interest in the animal symbolism of Franz Marc, he postponed the inevitable extinction of the Blaue Reiter point of view.

Alfred Kubin (1877-1959) was a founding member of the NKV but left it with Kandinsky, Gabriele Münter, and Marc in 1911 to organize the Blaue Reiter exhibitions. His art, however, developed quite independently of the contemporary movement towards abstraction. He was a most imaginative illustrator, working almost exclusively in black and white, and in his weird images he maintained a mood of *fin-de-siècle* decadence half-way through the twentieth century. Kubin was born in Bohemia of Austrian civil servant and military stock, but his brief service in the army ended in one of the traumatic crises which marked his childhood and adolescence. In 1898 he decided to become

an artist and entered the Munich academy, where he was overwhelmed by Max Klinger's fantastic and morbid art, especially his etchings, from which his own early style stems. The influence of other illustrators recurs in his drawings: Goya's macabre mutilations, Rops's erotic mixture of sex and death, Blake's and Beardsley's visions of the monstrous and evil. These disparate elements come together in a twilight haunted space that owes much to Redon, whom Kubin admired and visited in Paris in 1905. From Redon's velvety lithographs Kubin derived the disagreeably soft modelling of his early ink and wash drawings. In these the ultimate horror is produced by Kubin's matter-of-fact attitude towards the fantastic.

After 1908 Kubin found a more personal calligraphic style in pen and ink, disarmingly

124. Alfred Kubin: A Lively Discussion, *c.* 1912. *Linz, Oberösterreichisches Landesmuseum*

but calculatedly casual, even childish at times [124], but one with which he created his pessimistic drawings and lithographs of social decay and probed deep into the dream-world of whose 'majesty and beauty' he made an intensive historical and psycho-analytical study. In 1906 he retired to a country house at Zwickledt in Upper Austria, where, but for occasional travels in Europe, he lived almost a hermit's life for more than fifty years, with a large library and print collection.

Kubin's works are important for later Surrealist imagery, and for the passing encouragement they gave Paul Klee whose drawings for *Candide* (1911) have a spidery quality close to the older artist's. His sardonic point of view made him an admirable illustrator for Dostoievsky, Poe, E. T. A. Hoffmann, and other authors of the fantastic. It is even possible that he may have influenced Kafka. In some respects his own novel of the dream world, *Die andere Seite (The Other Side)*, published in 1909, resembles Kafka's *The Castle* (published in 1924), just as his dreadful insects are like visual counterparts of the hero's predicament in Kafka's *Metamorphosis* (1916).[70] Like Kafka's work, Kubin's is symptomatic of much twentieth-century distress. His nightmare world of delirium, madness, and sadistic delight came true as history twice in his lifetime, to his deep dismay.

HENRI ROUSSEAU, 'LE DOUANIER', AND THE NAÏVE PAINTERS

The discovery and criticism of the work of Henri Rousseau (1844–1910) and of other so-called naïve or primitive painters is an integral, if often perplexing, aspect of Expressionism and of the aesthetics of modern art. Kandinsky himself wrote that Rousseau was the author of the 'new, greater reality', which he postulated as the complementary pole of the 'new and greater abstraction', and in the Blaue Reiter almanac he reproduced seven of Rousseau's

paintings in his own article on the question of form. In such works Kandinsky saw the same inner harmony and inner resonance he admired in the art of children and which he was trying to reveal in his own painting as the 'greater absolute'.[71] In simpler terms, Kandinsky associated the work of the self-taught Rousseau with that of the historically primitive peoples and of the European folk artists as a comparable revelation of intuitive experience untainted by conventional expression and technique. Consequently, the self-taught artists have been misleadingly characterized as 'primitive' on the assumption that their virtues, unlike those of other painters, are the result of technical inexperience and ignorance of traditional culture. Nor can they even correctly be described as folk artists, Sunday painters, or amateurs. Unlike the true folk artist, whose anonymous work is inseparable from the culture of a rural or peasant community, the modern naïve artist is usually a city-dweller working in only comparative isolation from the sophisticated currents of the day. The content rather than the technique of his work more often expresses a sense of separateness from his fellows. And although it is true that many of these artists have had to earn their living in other ways (Rousseau for some fifteen years was a minor customs clerk, whence his honorific title of 'le Douanier'), neither he nor others like him thought themselves anything else than dedicated painters whose true profession was art. Nevertheless, the definition and correct appraisal of the work of the professionally untrained raises problems for criticism; for in no other activity do we value so highly the work of those who, at least in theory, are unprepared to accomplish what they set out to do. On the other hand, the contemporary naïve artist, unlike his educated colleagues, may not really be adventurous in technique or expression. He has usually tried to master the realistic techniques already discredited by the avant-garde, and in his choice

of subject remains attached to themes already unfashionable, if not out of date. Although Rousseau was an exact contemporary of the Impressionists and his public career extends from the emergence of the Symbolists to the excitements of the Fauves, his landscapes are closer in design and tone to Corot than to Monet, his portraits restate the conventions of studio photography, and his figural compositions were conceived in emulation of the now forgotten favourites of the Salon. Rousseau never thought of himself as a radical artist; he wanted to be accepted at the official Salon, and in pursuit of that ambition he would probably have suppressed, had he known how, the crudities we now admire. This is the nub of the critical dilemma. Should the work of the naïve artist be valued because of, or in spite of, the lack of technical address which is often the despair of the artist himself; for the naïve painter is so by circumstances, not by choice. The question is less easily answered because Henri Rousseau, the first of such artists to achieve wide recognition, possessed formidable powers of expression and execution.[72]

Rousseau's artistic naïvety was matched by his innocence. Modestly but firmly he claimed for himself a position among the leading masters of the day, once remarking to Picasso that they were the greatest painters of their time, 'you in the Egyptian style, I in the modern'. Distressingly gullible, he was the butt of the cruellest practical jokes, but such was his self-confidence that he turned each into another proof of his abilities. The bizarre comedy of his misadventures reached a climax in 1909 when, at the age of sixty-five, he was implicated in a scheme to defraud the Bank of France. His age, his obvious innocence, and, in the judge's eyes, his total artistic incompetence, earned him a suspended sentence. By then, towards the end of his life, his faith in his art had been justified. The principal painters of Paris, among them Picasso, Delaunay, Marie Laurencin, and Léger,

sought him out, and the banquet held in Picasso's studio in 1908 was a disorderly but sincere testimony of their admiration.[73]

Rousseau was fortunate in that his decision to devote his life to painting coincided with the establishment of the Salon des Indépendants. It is unlikely that his works would ever have been cordially received at the official Salon; so it was providential that through the free, juryless exhibition he could be sure that each year something would be seen. Annually from 1886 until his death, with the exception of 1899 and 1900, he showed from three to ten paintings, among them such masterpieces as *War* in 1894 (Paris), and the *Sleeping Gypsy* in 1897 (New York). The majority, however, were landscapes and portraits. The atmospheric sub-titles for his views of Paris and its suburbs *(Sunset, After a Shower)* indicate his awareness of Impressionist atmospheric refinements, but there

125. Henri Rousseau, le Douanier: Portrait of Pierre Loti, 1891-2 (later repainted). *Zürich, Kunsthaus*

is nothing Impressionist in his colour or brushwork. The finished paintings are more linear and tightly handled than his preliminary sketches. Rousseau, like most self-taught artists, seems to have been afraid of losing control of his work if he let the contours relax. Consequently, his perspectives are conventional if slightly askew with each object, even trees and clouds, separately and clearly defined. But the subtle colours, the sensitive harmonies of greys and greens, are unexpected, and set Rousseau's landscapes apart from the work of all other naïve artists.

It is in his portraits and figure compositions that Rousseau emerges as the artist we believe him to be. The so-called *Portrait of Pierre Loti* [125], painted late in life, is an impressive demonstration of his method.[74] The intensity with which the individual forms were first observed and then painstakingly set down accounts for the careful distinction between the separate parts of the image and its environment. Indeed, each form is seen more in terms of its contour than of its interior mass. The dislocations in the drawing and position of the red cap, the ear, and the hand are typical of the naïve artist's conviction that there is an absolute relation between the actual form in space and its rendering on a flat surface. Since a more conventional perspective would fail to reveal the full size as well as bulk of these forms, they are distorted to emphasize these 'real' qualities. Apollinaire's account of how Rousseau painted his portrait becomes entirely credible.[75] According to the poet, Rousseau took careful measurements of his eyes, mouth, nose, head, hands, and body, and then transferred them to the canvas. The result is an almost geometrical division of the surface, upon which each visual element is locked into the overall design, especially to be observed in Loti's portrait in the embroidered foliage at the upper right, where every leaf is seen broadside to the canvas, and in the parallel stripes of the buildings and

126. Henri Rousseau, le Douanier: Merry Jesters, *c.* 1906. *Philadelphia Museum of Art*

the cat to the left. Within the face the firm contours and strong contrasts of light and shade create a form which is seen as simultaneously flat and as if carved from some intractable material. Whether or not we wish to accept this as a recognizable likeness of Loti, it remains one of the most visually compelling human images in modern art. The position of the hand alone reveals how much this combination of the human and the iconic must have meant to Léger when he came to know the Douanier in Paris shortly before 1910.

Although he shared with other naïve artists their obsession for exact and particular detail, Rousseau surpassed them all in his control of his compositions. Despite his attention to every spot on his surfaces, he knew how to subordinate each part to the rhythm of the whole. In the *Merry Jesters* [126] the various leaves on the trees and plants are grouped by kinds to create a pattern both balanced and bold, one which is also an extension of the humorous postures of the friendly animals peering at us from the foreground. In *Surprised! (Storm in the Forest)* of 1891 (London, National Gallery), which is possibly the earliest of his exotic subjects, the intricate interweaving of verticals and diagonals expressive of violence and terror never falters. The screen of driving rain which is represented by short slanting lines hints that the artist's 'innocence' did not prevent him from admiring Japanese prints.

The quality of Rousseau's jungle pictures and his allusions to service in a military band in Mexico during the French intervention of 1861–7 might indicate that the paintings were based on recollections of Mexican landscape, but there is no evidence that he ever left France.[76] Nor do the details of his jungles prove that he experienced tropical flora and fauna more closely than in the zoological and botanical gardens in Paris. Through his imaginative transformation of the commonplace into the unreal the most ordinary house plants were magnified into towering jungle trees. Similarly, the creatures inhabiting these forests, the hunters and dark-skinned natives, the monkeys and water buffaloes, were reproduced from photographs, or from dolls and toys.[77] Apollinaire wrote that Rousseau, while painting such scenes, felt their imaginative reality so intensely that he had to throw open the windows to escape from his self-created spells. Through his presentation of psychic experience in vividly visualized details Rousseau found another means of escape from the constricting shackles of nineteenth-century naturalism, one which the Surrealists would soon adopt for the exploitation of unconscious sensation.

In the variety of his themes, which range from still life to elaborate invented allegories, in the power of his design and vision, Rousseau has no peer among the other naïve artists who have come to public attention. They may pursue some aspect of experience with diligence and conviction, but technical as well as imaginative limitations confine them to their specialities. Only Séraphine Louis (1864–1934), a servant at Senlis whose work was almost accidentally discovered by Wilhelm Uhde, Rousseau's first biographer, is even a rival. Her principal invention, a magic plant or tree whose leaves are adorned with angels' eyes glittering and winking from intricately worked surfaces, does not lack splendour of colour and scale, but it becomes monotonous. Because the problem of figural representation is usually an obstacle for the naïve painter, such compositions are comparatively rare, although the classical scenes of André Bauchant (1873–1958) and the circus and other figures of Camille Bombois (b. 1883) are impressive. The naïve painters are usually at their best in landscapes and city scenes, for which photographs and postcards are often a substantial help. Louis Vivin (1861–1936) can be mentioned here for his meticulous brick-by-brick rendering of the monuments of Paris in

127. Louis Vivin:
Basilica of the Sacred Heart, Montmartre, c. 1935.
Private Collection

muted greyish tonalities whose overall harmonies unify the awkward and arbitrary perspectives [127].

Enthusiasm for these unassuming and hardworking painters ran high during the 1930s, probably in part as a reaction against the dominance of non-objective art and in conjunction with the Surrealists' insistence on the magical properties of the image.[78] Since then the excitement has somewhat abated, and Rousseau remains the only naïve painter who is consistently numbered among the masters of modern art. His genius emphasizes the need to distinguish between genuine if unprofessional ability and the ruck of amateur 'Sunday painting', which should properly be considered a therapeutic avocation. Nevertheless, the continuing interest in naïve painters is a significant aspect of contemporary aesthetics. At their best, which means when they are most honest and unselfconscious, they justify the modern artist's rejection of false or unusable cultural values, especially the lip-service paid to traditional techniques, wherever such values are still perpetuated by a school or a society. Through their unpremeditated and immediate acceptance of the psychological truths of visual and conceptual experience they help us to penetrate the mysteries which surround more complicated creative processes.

POST-IMPRESSIONIST AND FAUVE INFLUENCES IN BRITISH PAINTING

The history of the modern movement in British twentieth-century painting properly begins with the first effective encounters between English artists and the work of the French Post-Impressionists and Fauve painters. And as in France, where the emergence and critical definition of a new artistic current can be related to the successive exhibitions in Paris of the work of Gauguin, Cézanne, and Van Gogh just before and after 1900, culminating in the retrospective exhibitions at the Salon d'Automne from 1903, so a number of events in London marked the first collisions between the traditional and the new. At the beginning these events were brought about by the inability of the younger artists to exhibit their work under favourable conditions. By 1906 the New English Art Club, which had been founded in 1885 in protest against the hostile attitude of the Royal Academy towards even the most diluted British Impressionism, had come to seem no less academic in its attitude towards younger painters. Thereupon a number of artists and critics, encouraged by Frank Rutter, one of the first English critics enthusiastic for the new art, organized the Allied Artists' Association on the pattern of the Salon des Indépendants in Paris to provide an opportunity for any artist to exhibit his work without benefit of jury. The first exhibition in 1908, and the others which followed up to 1914 at the Albert Hall, were inevitably huge in quantity and miscellaneous in quality, but lively in their overall effect. There on occasion could be seen works by the leading new European masters, who otherwise would have had difficulty in finding gallery space in London. For instance, the early sculpture of Brancusi and the prints and paintings by Kandinsky were first shown there.

The full range and quality of the new art were not seen to any extent until November 1910, when Roger Fry opened his controversial exhibition at the Grafton Galleries of 'Manet and the Post-Impressionists' (an earlier and representative exhibition of modern French painting organized by Robert Dell had been held the previous June in Brighton, but had precipitated less excitement than occurred a few months later in London). The exhibition, which ran until 15 January 1911, immediately became one of those epochal events, comparable to the first Impressionist exhibitions in Paris and the Armory Show of 1913 in New York, which arouse the bitterest antagonism at the time, but which swiftly change the direction of an entire generation's artistic experience. Indeed, so intense was the interest which could be felt beneath the public protest that Fry and his supporters were encouraged to arrange a 'Second Post-Impressionist Exhibition' at the same gallery in October 1912. The first exhibition had been dominated by Gauguin, Van Gogh, and Cézanne, and it was to distinguish their works from those of the Impressionists – who were not included, but had been seen in quantity in Durand-Ruel's exhibition at the same gallery only five years before – that Fry invented the term 'Post-Impressionist'. Cézanne occupied the leading position in the second exhibition, but he was surrounded, not by Post-Impressionists in the strict sense, but by such younger painters as Matisse, Picasso, Braque, Vlaminck, Derain, and others who could be considered Fauves and Cubists. There were also Russian and English sections arranged by Boris Anrep and Clive Bell respectively.

The public of 1910 and 1912 was incensed, perhaps not surprisingly, given its unfamiliarity with such art, but its antagonism was aggravated by even the more responsible critics, who stooped to invective and vituperation to express their disgust with the new art. Through all the excitement Roger Fry's passionate conviction that modern art must inevitably be a matter of

form rather than of representation, and of 'significant form' at that, gained ground with a number of young painters whose work, despite serious qualifications, can with some reason be considered the British counterpart, if not the equivalent, of French Post-Impressionism. If their talents were far less impressive than those of their French predecessors and contemporaries, their imagination less lofty, and their vision less incisive and much less intense, they none the less, through their rejection of sentimental subjects and their reliance upon colour and design for the expressive content of their paintings, accomplished a similar although less

radical revision of Impressionism in favour of statements of contemporary experience. In several cases, such as Sickert's, they were better acquainted than the majority of their generation with recent developments abroad. Robert Bevan (1865-1925), the oldest among them, had painted in Brittany in 1894-5 where he had known Gauguin, whose linear patterns occasionally reappeared in his later work. He also admired Pissarro and the Neo-Impressionists, whose divisionist brush strokes recur in his painting about 1910, especially in the views of cab ranks and horse sales which are among his best and most thoroughly British works.

128. Charles Ginner: The Shell Filling Factory, 1918-19. *Ottawa, National Gallery of Canada*

In the activities of three still younger men the contacts between British painting and French Post-Impressionism were even closer. Charles Ginner (1878–1952) had been born in France, the son of a British physician practising at Cannes. By 1904 he was painting in Paris, and in 1905 he entered the École des Beaux-Arts. When he came to London in 1910, ostensibly to assist in hanging the exhibition of the Allied Artists' Association that year, he was already familiar with Van Gogh, whose brush stroke he adapted for his own purposes, and with the French masters, whose work he interpreted to his English friends. Although Ginner was perhaps the most knowledgeable of the younger painters, his own work was in some respects the most tentative. His figure drawing was

often clumsy and tight, and his brush stroke so scrupulous that the effect, in his London interiors and later in his landscapes, is often reminiscent of naïve or primitive painting. Such stiffness could be an advantage on the rare occasion when a larger size was required, as in his canvas for the Canadian War Commission, *The Shell Filling Factory* [128], now in Ottawa. Upon a visually chaotic situation Ginner imposed a crisp linear pattern derived from the rails, girders, and shell cases, and by stressing the similarity of costume and gesture in the groups of women workers he discovered a formal serenity not seen on such a large scale in painting since Seurat's *Grande Jatte* [16].

Harold Gilman (1876–1919), like almost all the gifted young painters of his generation, had

129. Harold Gilman : Canal Bridge, Flekkefjord, *c*. 1913. *London, Tate Gallery*

studied at the Slade and had been abroad, travelling in Spain, Norway [129], and the United States, but at the first Post-Impressionist exhibition he found himself facing up to modern French art for the first time. The next year Ginner took him to Paris to unravel the problems it had raised for him, and there his early enthusiasm for Gauguin was tempered by Cézanne, and by Van Gogh, whose intense colours and strong contours he never forgot. His best-known work, the portrait of his landlady *Mrs Mounter* (Liverpool; preliminary study in the Tate), where the head is constructed in planes of green, pink, and orange, bounded by the vivid orange kerchief within its dark-lined border, is a remarkable achievement, French in theory, so to speak, but English in the gravity and depth of feeling. It is unfortunate that after this he had only a few more years to live.

Another painter whose promise in the years just before the First World War was cut short by an early death was Spencer Frederick Gore (1878-1914), who had known Gilman at the Slade. In 1904 he was in Dieppe with Sickert and the following year in Paris, where he saw the Gauguin retrospective at the Salon d'Automne. The news he brought Sickert of events in London helped to persuade the older man to return to England, and their relationship continued, with Sickert, as he later confessed, learning much from Gore. At the Post-Impressionist exhibition Gore was more taken by Matisse than by Cézanne. On the other hand, he shared Sickert's enthusiasm for the theatre, especially the acrobats and ballet dancers at the Alhambra. His knowledge of Impressionism, gained from Lucien Pissarro, helped to lighten his palette, a process which continued after the Post-Impressionist exhibition. Understanding of Cézanne came a few years later in landscapes like *The Icknield Way* of 1912 (Art Gallery of New South Wales) which seem to forecast what would have been an increasing tendency to-

wards linear and spatial abstraction, analogous to, but more deeply rooted in, landscape vision than in contemporary French Cubism. Gore's life was too short and his interest in successive developments of modern painting too manifold for his work to present now more than a series of brilliant fragments.

These artists were friends of Sickert, and from their informal gatherings in one of his studios at 19 Fitzroy Street, where on Saturday afternoons they met to talk and to show their work to such as might be interested in buying it, came their more formal association as the Camden Town Group, organized in 1911 with sixteen members and Gore as president. Their three exhibitions, the first two in June and December 1911 at the Carfax Gallery and the last in December 1912 in Brighton, alternating with Fry's Post-Impressionist exhibitions, were a lively affirmation of their confidence in measuring themselves against the most controversial continental work. Late in 1913 the Camden Town Group was enlarged and renamed the London Group. Its first exhibition in March 1914 was the beginning of a long and important existence as an exhibition society. Among the new members were men like Bomberg, Epstein, and C. R. W. Nevinson, whose more aggressive attack on problems of pictorial form led within a few months to a direct confrontation with Cubism and Futurism (see below, pp. 294-5).[79]

When Duncan Grant (1885-1978) joined Sickert's Camden Town Group in 1911 he was already aware of the new French painting which he had seen at the first Post-Impressionist exhibition. A close friend of Roger Fry he became, after 1920, the principal painter of the Bloomsbury Group, to whom he had been introduced by his cousins the Stracheys. His art exemplified many of the Bloomsbury virtues – taste, a commitment to one's own times, and an awareness of currents of advanced art abroad. But it was often vitiated by the very

reticence which at the time made Grant seem to his friends the best exemplar of British modernism. He understood, for instance, the decorative premises of Matisse's painting as early as anyone, but his own decorative compositions often were just that. Where Matisse pushed beyond charm to profoundly expressive and convincing distortions, Grant stopped short at a point which then seemed more pleasing but now appears less powerful, save in a few portraits, notably that of *Vanessa Bell* (Tate Gallery). His designs for Fry's Omega Workshops may prove to be his most enduring contribution, in so far as a modest gift is best applied to more modest purposes.

Although Sir Matthew Smith (1879-1959) was working mostly in France before 1914 and so grew up apart from the Camden Town Group, his discovery of his own style offers similar but even more eloquent testimony to the degree to which this generation of British painters recognized, one might even say required, the example of the French Post-Impressionists and Fauves. Smith, however, was fortunate in being blessed not only with a stronger talent but also with a longer life, so that he could, far more than Gore or Gilman, make of French influences something entirely his own. After two unsatisfactory years at the Slade he went to France, painting first in

130. Matthew Smith: Pale Pink Roses, 1929.
Private Collection

Brittany and then in Paris, where for a few weeks in 1910 he was a member of Matisse's school. So brief an experience with Matisse would not have been enough to make him a Fauve, although his long periods of residence in France undoubtedly made him of all his generation the most familiar with contemporary French painting. Even so, his art has been often and too easily categorized as British Fauvism, and it is indeed true that he resembles such painters as Matisse and Dufy, less in the variety and pungency of their design than in their sometimes monotonous concentration on a similarly restricted repertory of hedonistic themes – the nude luxuriously relaxed, or abundant still lifes of flowers or fruit. Smith's practice, too, was Fauve and Expressionist in his reliance upon colour rather than drawing for the expression of form in space. In the two versions of *Fitzroy Street Nude* of 1915-16 the colours were not yet freed from the drawing, the figure being treated with bold strokes of green against a vivid yellow ground, the room with its accessories as a flat pattern of bright pink, red, green, and blue areas contained by emphatic coloured lines. In his later still lifes [130] drawing and colour were integrated in a surging design which showed how well Smith had learned his lessons, especially all that Matisse had translated into French from Van Gogh.

CUBISM

The character of the new painting which emerged in Paris during the decline of Fauvism, and which was so misleadingly baptized as Cubist before its character or even its technique had been fully revealed, is still not easy to reduce to words. But an attempt must be made, because Cubism embodied for the first time in Western art the principle that a work of art, in conception as well as in appearance, in essence as well as in substance, need not be restricted to the phenomenal appearance of the object for which it stands. That is to say, artistic reality can be something other than the kind of visual image that convention and habit have fixed as the true representation of an actual object in physical space. The development of this new mode of vision and of pictorial design has been carefully documented, so that the important historical events can be noted as they occur. Here we may observe that Cubism, although the source for much of the practice and theory of abstract art, is not a system for constructing totally abstract or non-objective works of art. In the truly Cubist picture, references to the natural world can always be found. However altered such references may be, however abstracted from nature, even their most ghostly presence enables the spectator to examine the pictorial or sculptural form in terms of its source in nature or human life. A work in which such a source is absent or invisible is not Cubist; it must be considered non-objective, and its elucidation requires a different aesthetic. Because some connexion between nature and the Cubist subject must be present, although it may vary in extent or intensity, Cubism can be approached through its treatment of one of the continuing problems of pictorial art since the Renaissance, the relation of an object to the space in which it is seen, and the presentation of that dimensional relation on a flat surface.

GEORGES BRAQUE AND PABLO PICASSO: 1906-20

The inventors of Cubism, Georges Braque (1882-1963) and Pablo Picasso (1881-1973), always considered the examination of form inseparable from the creation of 'the space it engenders'. That phrase, from the first treatise on Cubism by the painters Albert Gleizes and Jean Metzinger (see below, p. 260), was endorsed by Braque many years later when he said that the dominant idea of Cubism in its formative years had been 'the materialization of the new space'.[1] That space first appeared, in a surprisingly monumental manner, in Picasso's *Demoiselles d'Avignon* [131], which was at first known only to the artist's friends and then hidden for many years in a private collection.[2] Since its public appearance in 1937 it has been recognized as a watershed between the old pictorial world and the new; for quite as many elements in it looked to and even beyond the European past as others prepared the immediate future. The picture is ugly and difficult, but its difficulties prove how rapidly Picasso was moving in the winter of 1906-7 from the melancholy idylls of the Blue and Circus Periods towards a revolutionary investigation of form and space. Only a few studies of stocky, flat-footed women preceded this radical re-interpretation of the studio nude with its

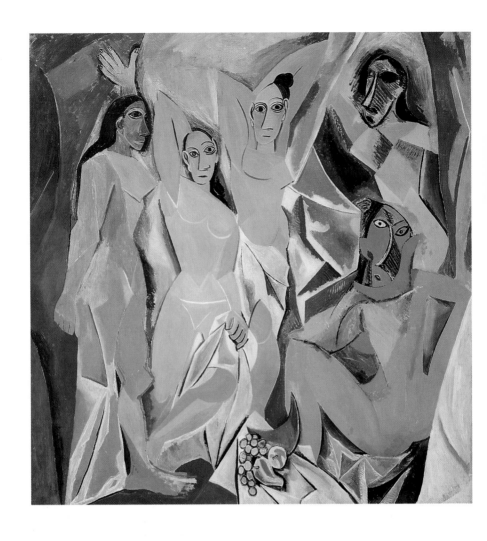

131. Pablo Picasso: Les Demoiselles d'Avignon, 1907. *New York, Museum of Modern Art*

references to Cézanne's many *Bathers* (especially in the two central figures with raised right arms and the one on the right with her legs apart). In the foreground the still life of fruit on a crumpled drapery, left over from the original design, in which a sailor and a man holding a skull were seen in a brothel, is clearly a tribute to the master of Aix. The figures, however, derive from, and develop towards, other ends. In the woman in profile on the left, whose eye is drawn full-face, the conventions of Egyptian sculpture are combined with the heavy drawing in Gauguin's later work. The staring, black-rimmed eyes and schematic features of the central women come from the pre-Roman Iberian sculptures in the Louvre, which were well known to Picasso. On the right the monstrously distorted faces, with noses treated as concave, strongly shaded planes, resemble African carvings from the French Congo and the Ivory Coast which Picasso admired and collected.[3] The broad surfaces of Negro sculpture, meeting at sharp angles, affected his treatment of these figures, whose breasts and limbs are drawn in angular planes which in some places are almost detached from their bodies. This tendency of the separate surfaces to slip from their natural positions and slide towards and even into each other, and the angular treatment of the reddish curtain on the left and the blue walls beside and between the figures, create the specifically Cubist aspect of the painting, that rejection of conventional perspective which henceforth was to distinguish Cubism from all previous compositional systems based on Renaissance perspective. In other words, in this painting there is no free, originally unoccupied space in which the women have been discovered. Such space as there is has been generated, so to speak, by their bodies and by the intervals between them, and even then it is broken into jagged facets, as if it were a substance as dense as flesh itself. Space, like the light that exists only as a function of the pink and yellowish bodies, is a function

of the forms rather than an environment for them.

The content of this work is as unexpected as its appearance. Although the historian can trace its ancestry past Cézanne to the great nude compositions of the European tradition, to Poussin, Titian, and Raphael, he cannot account for the violent restlessness which pervades this picture, nor for its startling disregard of any conventional canon of beauty. We must remember that its author, a Spaniard, was heir to the harsh realities of Spanish painting, and that restlessness was the hallmark of his career.

If Picasso, despite his lifelong residence in France and his identification with the School of Paris, cannot be considered a French painter, Georges Braque, the co-discoverer of Cubism, cannot be thought of as anything else. When, in one of the crucial confrontations of modern art, Braque was introduced to Picasso in the autumn of 1907 by the young and enthusiastic dealer Daniel-Henry Kahnweiler, and saw the *Demoiselles d'Avignon* in Picasso's studio he was unpleasantly surprised. Its formal crudity and violent expressive content offended his sense of clarity and order. At this time Braque was attracted to Fauvism and subscribed to its programme of subjectively distorted line and colour in his contributions to the Salon d'Automne in 1906 and 1907, but he had momentarily mistaken the character of his own perceptions. His serene and cool intelligence could not sustain the fervour that Fauvism required. He soon saw that other aspects of nature were more important for him, and found his reasons for their pictorial emphasis in Cézanne. The memorial exhibition of Cézanne's oils at the Salon d'Automne and of his watercolours at Bernheim-Jeune's in the autumn of 1907, and the publication that October of Cézanne's letters to Bernard, made the constructive, spatial elements in his work all the more apparent in contrast to the expressive exaggerations of Fauvism. In the landscapes

Braque painted at L'Estaque and La Roche-Guyon in the summers of 1908 and 1909 (significantly two of Cézanne's favourite sites), the geometrical simplifications of architecture and trees, and the sober grey, brown, and green colour schemes were based on Cézanne's example. A similar development was occurring at the same time in Picasso's painting, in the simple shapes and darker colours of his landscapes from La Rue-des-Bois, and in the landscapes painted in the summer of 1909 at Horta de Ebro (now Horta de San Juan) in northern Spain, where the geometrical tendency became dominant. Thus, in the months before they began working together, each understood and accepted the perspectival ambiguity implicit in Cézanne's coloured planes, which they saw as acting simultaneously in two different positions: one an illusion, a coloured equivalent for the position of the natural object in depth, the other actual, as an area of colour on the surface of the picture. But because their planes, even more than Cézanne's, are lighted from different directions according to the requirements of the design rather than of natural fact, they create spaces which could not be seen in actuality. At times exterior planes even seem to reverse themselves to suggest interior volumes rather than masses seen from without.[4]

It was at this juncture that this new kind of painting, which could have been accurately if awkwardly described as Post-Cézannian, became known as Cubist. In November 1908 Kahnweiler arranged an exhibition for Braque of work done the previous year after the painter withdrew his entries from the Salon d'Automne, where all but two had been rejected. Matisse, who was on the jury, is supposed to have said that the paintings were composed of 'petits cubes'. Matisse denied this, but Louis Vauxcelles, who had coined the term 'Fauve' three years before, described Braque's paintings as reduced 'à des cubes' in his review of the exhibition, and he wrote of Braque's 'bizarreries cubiques' when the painter exhibited two pictures at the Salon des Indépendants the next March. If one of these was the *Harbour in Normandy* [132], it may have been the first thoroughly Cubist painting to be seen in public, since in it Braque had worked from memory rather than from the motif, considering 'the relationships between things' more important than the things themselves. Freed from the demands of verisimilitude, he stressed those relationships as an intricate pattern of shallow, tilted planes held in place by the contrasting verticals and diagonals of masts and spars. It is tempting to think that he invoked Cézanne with the two cylindrical lighthouses as well as by the changing points of view and the coloured intersecting planes.

Cubism, like Post-Impressionism, is an inadequate and confusing term. By 1908-9 what was unusual about Braque's and Picasso's painting was not an effect of solidity and weight conveyed by geometrical masses, but just the opposite, the opening out of masses as transparent volumes and the dispersal rather than the concentration of these volumes across the represented space. There was, indeed, a brief moment in 1908 when Picasso was thinking more of mass than of volume. There are analogies between the large, rounded forms in his figure paintings that year and Cézanne's injunction to 'treat nature in terms of the sphere, the cylinder, and the cone'. But even in these examples the frayed edges of the shaded planes foretell the Cubist tendency to let the planes dissolve into each other. Picasso's determination to pursue Cézanne's ideas farther may be seen in drawings and paintings executed in 1908 and 1909. In landscapes, still lifes, and figure studies, especially heads and demi-figures, he, far more than Braque, reduced forms to 'little cubes' and then by shifting their axes broke the angular connexions and released new, non-naturalistic, pictorial rhythms. In the *Still Life*

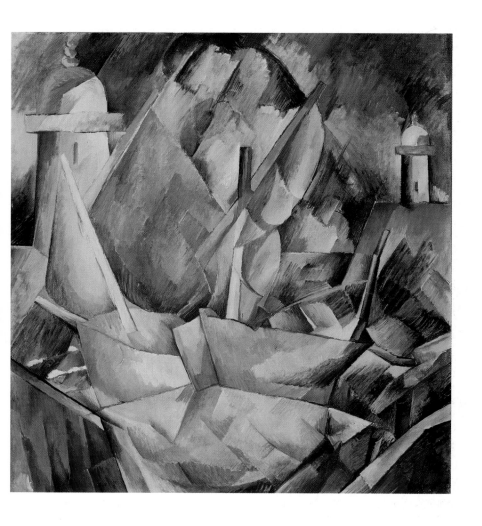

132. Georges Braque: Harbour in Normandy, 1909. *Art Institute of Chicago*

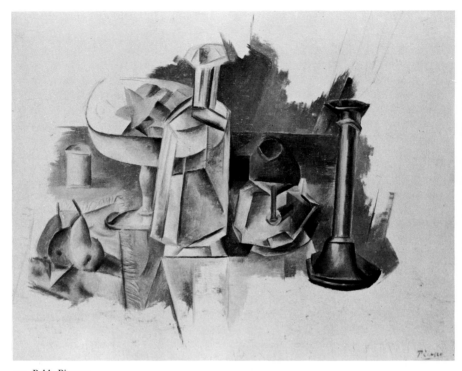

133. Pablo Picasso:
Still Life with Carafe and Candlestick, 1909.
Private Collection

with Carafe and Candlestick of 1909 [133], he was still as preoccupied with Cézanne as in the Horta de San Juan landscapes. The group of pears on the left recalls an earlier stage of his analysis of Cézanne's fruit; the shapes are as simple, the outlines as firm, but he had discovered how the objects, seen from several directions simultaneously, may exchange their masses and appear more numerous than they are. In this geometry one and one do make three. The objects, except the candlestick, which is comparatively intact, exist as volumes only by virtue of the clusters of sharp planes into which they have been shattered.

No other principle of early Cubist painting is more important than the one they demon-strate: that form is not a finite and fixed characteristic of an object. An object is seen in terms of planes which indicate but do not define its external and internal boundaries. Simultaneously, these limits are not absolute for any object in itself, but are always affected by its relation to other forms which may be seen beside or even through it. If we grant this much, then we must agree that the artist may, if he wishes, consult an object from several different positions in space and report the results of his observations. Although this principle must be used with caution, not invoked as a rule, multiple spatial observations recur in early Cubism and account for much of its dynamic quality. Since such observations

can only be pursued in time, the record deposited upon the canvas is one of temporal experience and imparts a restless, unstable character to the Cubist object. At moments it may seem to dissolve into the space it projects around itself; at other times it seems to be striving to materialize, to become a visual presence from a complex of shifting, interpenetrating, lighted planes.[5] In the difference of emphasis between these two modes we can situate the distinction, introduced into the criticism of Cubist painting some thirty-five years ago, between an 'analytical' phase from 1908 to about 1911, and a 'synthetic' one shortly thereafter.[6] Although too sharp a distinction need not be drawn between earlier and later Cubist paintings (between those of 1910-11 and those of two or three years later), it is true that after Braque and Picasso had discovered how to record their experiences of the visual and tactile effects produced by objects extending into space, they constructed new forms and new kinds of composition in which whatever naturalistic references were retained were 'synthesized' from planes, colours, and shapes having no necessary or preliminary connexion with the world of appearances. Even if Picasso may never have deliberately worked in this way, Braque certainly did, and Gris, as we shall see, developed it both as a technique and a style.

In the course of his study of the dynamic quality of Cézanne's planes, Picasso turned to sculpture. The total form of his life-size bronze *Woman's Head* of *c.* 1909 [134] is indicated by the limits of planes which have broken loose from the natural shape of the object. A comparison of this, Picasso's first thoroughly Cubist sculpture, with Matisse's *Jeannette V* of 1910-13 [89] will show their authors' preoccupation with the problem of mass in space. Matisse's work is formally more radical, but in an Expressionist rather than Cubist sense.

Towards the end of the next year, 1910, the dissection of the object had been pushed much

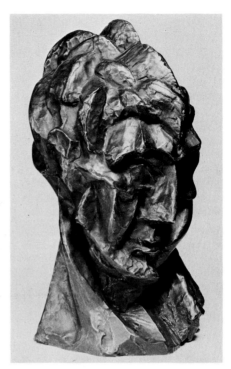

134. Pablo Picasso: Woman's Head, *c.* 1909. *Buffalo, N.Y., Albright-Knox Art Gallery*

farther. The small but awesome *Female Nude* [135] is scarcely recognizable as such, so thoroughly have the rounded surfaces of the natural body been reduced to flat polygonal planes which have then been rearranged in many ways, overlapping, interpenetrating, showing through and behind each other. The result justifies Guillaume Apollinaire's assertion that the Cubist painters created 'new structures out of elements borrowed not from visual reality, but entirely created by the artist and endowed by him with a powerful reality'.[7] If this is so, then the title should be taken as a hint, not a description. We misunderstand Picasso and restrict our own perceptions if we insist on restoring each plane to the position

135. Pablo Picasso: Female Nude, 1910.
Philadelphia Museum of Art

we suppose it had in nature, if we try to re-design the form for ourselves as a visibly female nude. This is a new configuration, of a kind never seen before in human history. It retains its artistic magic, its pictorial power, only if we accept it as the equivalent, not the duplicate, of a natural object. The entirely artistic quality of the painting, its unnaturalness so to speak, is further enhanced by the sombre brown–grey–black colour scheme, an intentional impoverishment of the palette of the Impressionists whose spaced but spotty brush strokes Picasso parodied in the background plane.

A further stage in the pictorial reconstruction of the fragmented object had already been reached by Braque in his *Violin and Palette* [136], painted during the winter of 1909–10. Braque later explained that the fragmentation of objects in such a work had been 'a means of getting closer to objects within the limits painting would allow. Through fragmentation I was able to establish space and movement in space, and I was unable to introduce objects until after I had created space'.[8] It is impossible for us now to follow his method step by step, but when we see that the violin is composed of curved and square planes meeting to form round or cubical volumes, we can understand Braque's words to mean that the violin has come into being, visually, in the spatial dimensions created by the planes into which it had been separated. The relation of such a method of visual analysis and pictorial synthesis to our conventional standards of artistic reality was wittily indicated by Braque at the top of the canvas, where a palette hangs from a matter-of-fact nail that casts a shadow. Because the source of light for this shadow is but one of several in the picture, and the violin and sheets of music below it are illuminated from different directions, the spectator is faced with a perplexing ambiguity. If he accepts one system as artistically valid, the other is discredited.

It is worth noting that Braque's picture is a more complete and total unity than Picasso's still life of the year before, in which the 'unfinished' effect called attention to the central group of objects (the canvas was actually in large part left bare in imitation of Cézanne's

136. Georges Braque: Violin and Palette, 1909–10. *New York, Guggenheim Museum*

137. Georges Braque: The Portuguese, 1911. *Basel, Kunstmuseum*

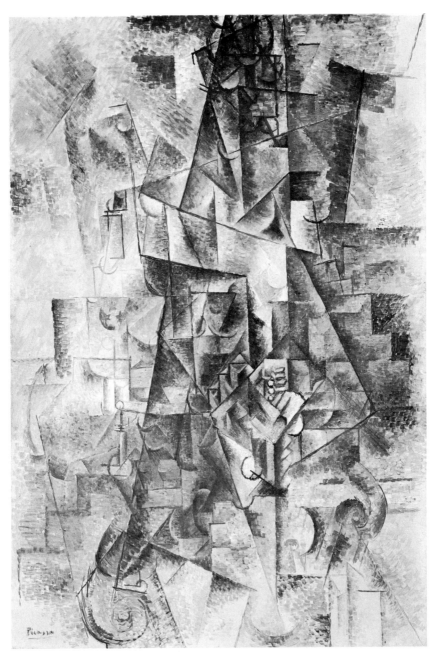

138. Pablo Picasso: The Accordionist (Pierrot), 1911. *New York, Guggenheim Museum*

uncompleted works). Braque, on the contrary, carried the interplay of forms in his invented space to the very edge of the canvas. The effect is less intense but more decorative than Picasso's, a characteristic distinction which can be made between the two artists' works for the remainder of their long careers.

Until the autumn of 1909 Braque's and Picasso's investigations had run parallel, but in the course of that winter and more intensively in 1910 and 1911 they converged in a re-markable identity of conception and execution. It has become commonplace to remark that their works of this period are difficult to dis-tinguish, and that each painter at times has mistaken the other's for his own. The situation is not so novel as it might appear. On earlier occasions artists working together to formulate a new pictorial mode had made simultaneous and identical discoveries. Monet and Renoir had painted together along the Seine in 1868 much as Braque and Picasso worked together at Céret, Sorgues, and Avignon during the sum-mers of 1911–14.

The climax of the converging styles may be studied in two works from 1911, Braque's *The Portuguese* [137] and Picasso's *The Accordionist* [138]. The starting-point for each in the actual or remembered image of a human figure with a musical instrument (Braque's plays a guitar) can be perceived without much difficulty if one assumes that the edges of the planes denote the outer extension of volumes in space. Since the volumes are suggested rather than described, they must be 'thought' by the spectator as well as 'seen'. This reversal of the usual relation between percept and concept is implicit in Cubism. Picasso later remarked: 'I paint forms as I think them, not as I see them.'[9] And the earliest historians of Cubism insisted that the spectator must reconstruct the appearance of objects for himself from information provided by the painter. As Braque said, the relationship between things is more important than the things themselves. Yet in each painting the original position of the objects in space is indi-cated by slight realistic details, the cord and tassel in Braque's, the curved chair-arms in Picasso's. From such incidents the spectator can weave his way through the web of lighted, intersecting, and interpenetrating planes spread out in a space so shallow that the objects seem to project outwards from the surface of the picture. The spatial ambiguity of a plane, which may begin as part of one shape only to end in another, contributes to the instability of images constantly shifting between natural and pictorial reality. Both paintings, like others of this period, are executed in a sober, almost mono-chromatic colour scheme of grey and brown lightly touched with ochre, black, and green. This reduction of the palette to a few earth colours was part of the Cubists' search for the reality of the object, its real rather than apparent existence in space, and a necessary reaction from the self-expressive brilliance of Fauvism as well as from the Impressionist dissolution of substance in a shimmer of appearance. Never-theless, something of the discipline of Neo-Impressionism, so strong an influence on the Fauves, lingers in the regularly spaced brush strokes which fill the planes.

These paintings, and others of 1911, form a series of austere images in which the natural objects mentioned in the titles are sometimes so hard to find that the term 'hermetic' has been used to suggest the apparent disregard of the spectator's comfort and the privacy of artistic expression which Braque and Picasso had adopted. Indeed, they seem to have been aware that in their search for the reality of the space engendered by the object they had sacrificed so many aspects of familiar appearance that the time had come to insist again upon the relation of the work of art to the world of things. Braque was the first to introduce commercial lettering into his paintings; the word 'BAL' and the number '10,40' in *The Portuguese* are

the earliest instances of his desire to contrast the simple presence of ordinary things with the conceptualized aspects of the principal figure. He explained that his purpose was 'to get as close as possible to reality . . . They (the letters) were forms which could not be distorted in any way, being themselves flat, these letters were not in space, and thus, by contrast, their presence in the picture made it possible to distinguish between objects situated in space and those which were not.'[10] But simultaneously the relation between natural and artistic reality, first suggested by the *trompe l'œil* nail in the *Violin and Palette* of 1910, became more complex with the introduction of shapes which could be considered 'real' as well as represented.

By 1912 Braque was mixing such non-artistic materials as sand, sawdust, and metal filings with his pigments. This gave the painted surface a tangible as well as visual texture and emphasized the fact that the painted image was an actual form on that surface. He refined this process when he added imitation wood-graining by running a decorator's comb across the tacky paint. He had once been apprenticed to a *peintre-décorateur* and knew the tricks of imitating wood and marble in paint. Picasso pushed the imitation of such banal aspects of the environment a stage farther when, in May 1912, he created the first collage (from the French verb *coller*, to paste or glue). This was a small oval *Still Life with Chair Caning* (Paris, Musée Picasso) with a piece of oilcloth pasted to the lower part of the canvas. Because the cloth was a lithographic imitation of actual caning, Cubist conceptual reality reached another intellectual dimension now that the painted forms were more artistically 'real' than the imitation ones.[11] Braque followed in September with the first of his *papiers collés* or compositions of pasted papers, a *Fruit Dish and Glass* (private collection, France), in which three pieces of wood-grained wallpaper were combined with a charcoal drawing.

The skill and authority with which both artists manipulated their discoveries can be seen in *papiers collés* executed only a few months later, where an 'analytical' fragmentation of objects was succeeded by their 'synthetic' construction from forms not originally derived from them. The process is illustrated in Picasso's *Guitar and Wineglass* [139], where the

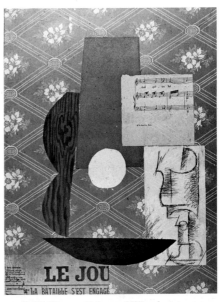

139. Pablo Picasso: Guitar and Wineglass, 1913. *San Antonio, Texas, McNay Art Institute*

guitar is composed of elements that are not very guitar-like. Furthermore, actuality is doubly strained by the fact that the body of the guitar is not represented at all; it is seen as a void between the curved fragments of wallpaper and the drawing of a wineglass dissected into its essential forms. In Braque's '*Le Courrier*' [140] the visual situation is more complicated; not one but several objects – a carafe, a wineglass, a packet of cigarettes, a newspaper, and a playing card – are seen on a wooden table, but

as forms flattened, interpenetrating, and presented simultaneously in pieces of paper, including imitation wood again, and charcoal drawing. The design that holds them together is an entity in itself; rectangular and circular shapes are placed against the top of a square table turned so that it becomes a non-naturalistic lozenge somewhat like a decorative trophy.

The different artistic personalities of Braque and Picasso can again be distinguished. Braque's feeling for a fundamental and pervasive compositional harmony has transmuted his repertory of humble objects into a design of rare elegance. Picasso, intensely observing actual things, could ignore decorative considerations in order to communicate his immediate ex-

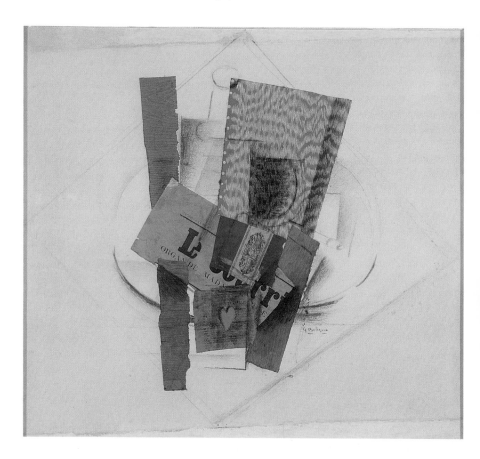

140 (*above*). Georges Braque: 'Le Courrier', 1913.
Philadelphia Museum of Art

141 (*right*). Pablo Picasso: The Three Musicians, 1921.
Philadelphia Museum of Art

perience of them. At this point he preferred ordinary commercial paints, including shiny enamels, to traditional artists' pigments. Like the actual materials in his collages they were more 'real', more directly sensuous.

Picasso has implied that he never created a pure abstraction, a work of art having no reference whatever to any object outside itself.[12]

We must accept his word, even if at times we cannot see the source of his forms. But he, as much as any other painter of this century, was responsible for the invention of the completely abstract, non-representational work of art. Although the radical originality of Cubism was its new conception and demonstration of the relation between pictorial and visual values,

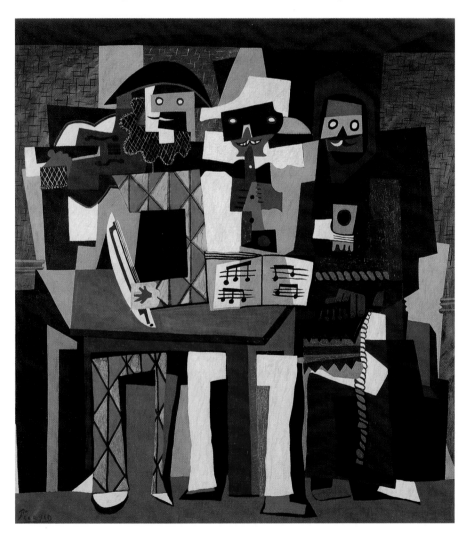

and in the purest Cubist work the natural object is always to some degree present, the existence of a purely abstract composition was implicit in the conceptual premises of Cubism, and it appeared as a perceptual possibility at the climax of Analytical Cubism. In the *Accordionist* the major divisions of the figure, in the form of superimposed and interpenetrating triangles and rectangles, are so prominent that they insist on being read as a design in themselves. We shall see what Mondrian was to make of this, but for Picasso these emerging, more regular planes offered new possibilities for formal inventions based on nature. Soon the entire pictorial surface became an arrangement of flattened forms looking as if they had been cut and pasted to the canvas. The most monumental examples of this Synthetic Cubism that succeeded the analytical phase are the two versions of the *Three Musicians* of 1921 (New York and Philadelphia) [141], in which many degrees of depth are represented by overlapping planes. But they are more than exercises in two-dimensional design; the contrast of the strong and brilliant colours of carnival costumes against the dark background creates a mysterious effect, as if the apparent subject, masked musicians, concealed a threat.

When the First World War began the co-discoverers of Cubism were separated, for ever, as it turned out. Braque was called up and served until 1916, when he was severely wounded. After 1920 he continued to refine his earlier Cubism in paintings that will be examined later. As a Spanish national Picasso was exempt from service and continued to work throughout the War. In 1917 he designed the curtain, sets, and costumes for Diaghilev's production of the ballet *Parade* (by Cocteau, Satie, and Massine). This included ten-foot Cubist constructions worn by the two 'managers'.[13] It is a pity that these, the largest of Picasso's Cubist works of sculpture, could not have been preserved, but like many of his early constructions in wood and pasted paper they were perishable and disappeared. Although rare and little seen, his smaller constructions were important three-dimensional explorations of the spatial hypotheses of Cubist painting, and

142. Pablo Picasso: Wineglass and Die, 1914.
Paris, Musée Picasso

among the earliest examples of sculpture constructed from extraneous and non-artistic materials. The *Wineglass and Die* of 1914 [142] is like a materialization of Cubist *papiers collés*, but the odds and ends of lumber constantly refer the pictorial image to the utterly commonplace. Picasso's discovery of the secret life that humble objects acquire when diverted from their ordinary purposes contributed to the development of both Dada and the 'junk culture' of the 1960s.

JUAN GRIS (1887–1927)

Of other Cubist painters the closest stylistically to Braque and Picasso was another Spaniard,

Juan Gris. Upon his arrival in Paris in 1906 he settled in a ramshackle tenement in the rue Ravignan, known as the Bateau-Lavoir, where he met Picasso, Apollinaire, Max Jacob, and other literary associates of the Cubists. He earned his living for a time as an illustrator for humorous weeklies, but almost from the first, as his paintings prove, Cubism for him was more interesting as a logical and intellectual system of composition than as a continuously experimental method. The distinction is clear in the epigram he pronounced in a lecture 'On the Possibilities of Painting', delivered to the students of philosophy at the Sorbonne in 1924: 'One of my friends [Georges Braque] has written: "Nails are not made from nails but from iron." I apologize for contradicting him, but I believe exactly the opposite. Nails are made from nails, for if the idea of the possibility of a nail did not exist in advance, there would be a serious risk that the material might be used to make a hammer or curling tongs.'[14] Further on he suggested the difference (and provided the terms later used in criticism) between Analytical and Synthetic Cubism by insisting that a painting must be a synthesis of abstract elements which materialize as pictorial forms related to the natural world. He had made the point more clearly in 1921, when he wrote: 'I work with the elements of the intellect, with the imagination. I try to make concrete that which is abstract. . . . Mine is an art of synthesis, of deduction, . . . Cézanne turns a bottle into a cylinder, but I begin with a cylinder and create an individual of a special type: I make a bottle – a particular bottle – out of a cylinder. That is why I compose with abstractions (colours) and make my adjustments when these colours have assumed the form of objects.'[15]

By 1912 he was using modular measurements and the traditional proportion of the golden section in his first Cubist still lifes, which, perhaps for that reason, now look a little dry and contrived.[16] A more fluent example of his

'deductive' method is *The Chessboard* of 1915 [143]. The wood graining and wallpaper might lead us to think it a collage, but the whole is painted, as if in imitation of pasted papers. The elements are as flat as paper, and the edge of the

143. Juan Gris: The Chessboard, 1915.
Art Institute of Chicago

dark-green area in the lower right centre looks as if it had been torn. But his intention was very different from Braque's or Picasso's. Clearly he did not reduce real objects to thin slices of raw materials but first selected his rectangular and polygonal shapes, each totally abstract in itself. By their position, colour, and simulated texture they hint at the actual objects for which, as symbolic abstractions, they stand.

Such a work exemplifies Apollinaire's contention that the origin of every work of art is in the mind. In Gris's chessboard, which moves towards its visual 'realization' on no less than three different planes (it is formed from the basic plane of the wood-graining and from flat, half-transparent planes lying one upon another),

144. Juan Gris: Guitar, Water Bottle, and Fruit Dish, 1922. *Private Collection, Spain*

we can see the process at work whereby the bottle became a cylinder. The origin of the chessboard, in so far as this particular painting is concerned, is conceptual rather than perceptual; the artist's mind has imposed its own categories of space and time upon phenomena presented to the senses. For Gris the things encountered in actual life were only clues to remind us that the pictorial reality of his pictures was more significant than any object in nature. 'No glass manufacturer', he wrote in 1921 to Amédée Ozenfant, 'would be able to make any bottle or water-jug which I have painted, because they have not, nor can they have, any equivalent in the world of the intellect.'[17]

It is also worth noting that in his collages the materials retain their original identities. For Braque and Picasso pasted papers were more interesting for their colour and texture than for themselves. With Gris a bit of newspaper continues to represent a newspaper within the picture, just as marbled papers are used for marble table-tops and wood-grained papers for panelled walls.

In the paintings executed between 1915 and 1920 Gris discovered his characteristic colour schemes of green, maroon, blue, and cream spiced with Spanish accents of yellow and red. In time his search for more condensed notations of form led to simplified and rather spare compositions dominated by curves and straight lines. In the *Guitar, Water Bottle, and Fruit Dish* of 1922 [144], a sequence of complicated natural forms is reduced to a few lines and planes. So economical are the means that one line may do the work of two, as in the lower edge of the guitar, which is the same as the curved edge of the table. Gris's later paintings have been often and perhaps unfairly overlooked in favour of his more rigorously analytical work of 1913-17. It is true that the colours are sometimes merely pretty and the drawing soft or clumsy, but there are occasions enough, as in the example illustrated, to indicate that had

Gris lived longer and his last years not been shattered by illness, he, like Picasso, would have moved far beyond his own earlier analytical painting to more daring Cubist syntheses.

FERNAND LÉGER (1881-1955)

Léger is rightly ranked with Braque and Picasso as one of the three major Cubists, but his painting is not technically or expressively Cubist in the same sense as theirs. It would not be wrong to say that he passed from his early Impressionist work to the Synthetic phase almost without pausing to analyse the object-space relationship, as had Braque and Picasso. He accepted the fracture of the object, but not its fragmentation. But it is not quite correct to think that Léger was dominated by the aesthetics of the machine and that his painting merely reflects an enthusiastic discovery of the beauty of mechanical forms which he shared with many artists of his time. More than any other major Cubist painter, Léger wanted to do more than manipulate forms for exclusively artistic purposes. He wanted to create an art that would be accessible to the whole class structure of modern society. The conception of such an art came to him during the First World War, when he exchanged the isolation of his studio in Paris for the human relationships of the trenches. In a statement which deserves quotation at length he set forth the point of view which was to characterize his work for the rest of his life: 'During those four war years I was abruptly thrust into a reality which was both blinding and new. When I left Paris my style was thoroughly abstract: period of pictorial liberation. Suddenly, and without any break, I found myself on a level with the whole of the French people; my new companions in the Engineer Corps were miners, navvies, workers in metal and wood. Among them I discovered the French people. At the same time I was dazzled by the breech of a 75-millimetre gun

which was standing uncovered in the sunlight: the magic of light on white metal. This was enough to make me forget the abstract art of 1912–13. A complete revelation to me, both as a man and as a painter. The exuberance, the variety, the humour, the perfection of certain types of men with whom I found myself; their exact sense of useful realities and of their timely application in the middle of this life-and-death drama into which we had been plunged. More than that: I found them poets, inventors of everyday poetic images – I am thinking of their colourful and adaptable use of slang. Once I had got my teeth into that sort of reality I never let go of objects again.'[18]

From then onwards Léger's art was marked, to some degree or other, by just that 'exact sense of useful realities', and although it always had its share of that 'exuberance, variety, and perfection of types' (if not very much 'humour') which he admired among the men of the different social classes he had known, it is true that he 'never let go of objects again', however abstract they might at times appear. He was always the painter of 'everyday poetic images'. In his preoccupation with the qualities of actual objects, in his preference for those that were precise, logical, simple, clear, and definite (the words are those he used to describe the artistic epochs he most admired, 'the Chaldean, Egyptian, and so forth'), he found that the forms of machinery and forms mass-produced by modern machinery had a beauty that was intrinsic and absolute because it was independent of sentimental or descriptive values. 'Beauty is everywhere,' he said, 'in the order of the pots and pans on the white wall of your kitchen more perhaps than in your eighteenth-century salon or in the official museums. If you admit this type of aesthetic judgement it is possible to reach an understanding of the beauty of machines.'

The argument just outlined has been drawn from Léger's lecture delivered at the Collège de France in 1923 on 'The Aesthetics of the Machine: Manufactured Objects, Artisan, and Artist'.[19] By then he had established the premises for the logical, clear, and precise paintings executed throughout his long career. The most basic was his faith in the object as the 'principal personage' which he presented as clearly and characteristically as possible, so as to reveal its absolute sculptural value rather than its sentimental associations. To his early training as an architectural draughtsman we may credit his custom of defining objects in their simplest and broadest dimensions, as if projected in an architect's blueprint. This tendency also made him pre-eminently a painter of modern life, as *seen* perhaps, rather than felt, and led him to value, as it led him to discover, sculptural beauty in unpicturesque aspects of urban life. It was he, not Braque or Picasso, who for all the evidence of their paintings between 1910 and 1914 might never have left the studio except to visit the café, who saw the artistic significance of the artefacts of urban life, the bold designs and blatant colours of posters on hoardings and billboards, the movement of advertisements on passing vehicles, the spare tensile strength of electrical transmission towers, the ceaseless, changing lights in streets illuminated by flashing signs. All this and more, including human figures reduced to a mechanical participation in this machine culture, Léger put into a painting of mural dimensions, *The City* of 1919 [145]. It is executed in the Synthetic Cubist technique of overlapping, strongly coloured planes, although Léger's are always opaque and so can collide and intersect but not interpenetrate, and their movement defines no static still-life situation but communicates the restless pace of city life. The passage of fragments of objects, of a signboard or building, one behind another, suggests the instability of urban movement, as if the spectator himself were moving past and through the picture in a motor-car. The colours are as intentionally

145. Fernand Léger: The City, 1919.
Philadelphia Museum of Art

crude as their originals in nature: the primaries with black, white, and a vulgar violet. In contrast, the human figures moving up and down the flight of steps are colourless. Their grey clothes and featureless faces are those of the city-dweller who is less vital than the environment he has created. For Léger the human figure, as he later insisted, had no more importance than any other object.[20] It had only a formal value and so remained 'intentionally inexpressive'. But one may think that in *The City* its inexpressiveness has also an iconological significance.

The renunciation of traditionally humanistic values and the association of the figure with

mechanical elements appeared in Léger's first major work, the precocious *Nudes in the Forest* of 1909–10 (Otterlo), in which the figures and landscape are treated alike as blocky, cylindrical forms in an almost monochromatic, grey-green colour scheme. The idea that Léger had taken Cézanne's remark about natural geometry too literally can be counterbalanced by the 'primitive' aspect of these simplifications. At that time Léger knew and admired Henri Rousseau. His reduction of the complex forms of human beings and a woodland scene to such tubular shapes (Léger was called a 'tubist' for a time) resembles Rousseau's ability to describe objects in terms of their basic formal character.

Throughout his career his fondness for the actual object, for its tangible, demonstrable, spatial existence, was counterbalanced by his awareness of its more abstract aesthetic character. Thus at times his art tended towards a simplification so extreme that it touched pure abstraction. There are abstract paintings of 1913, the several *Contrasts of Form*, and in the mid 1920s a series of powerful non-representational designs, but he usually restricted his purely abstract work to mural compositions. Almost as non-representational are the machine paintings executed after his release from military service in 1917. The largest and most important, the *Discs* of 1918 [146], exemplifies his desire to create the equivalents of machinery. The mechanical forms are pictorial, not actual, and their task is to organize the picture surface. His wheels are circles divided by primary colours

146. Fernand Léger: Discs, 1918.
Paris, Musée des Beaux-Arts de la Ville de Paris

and worked by planes which suggest pistons and connecting rods. In such clear, orderly, and precise statements about the essential character of all machines, not just the limited function of any one, Léger created symbols for the new industrial, man-made environment with its new states of feeling.

Although he was always the creative artist, never succumbing to his own inventions, Léger took from the mechanical world a principle which he made artistically his own, that of interchangeable parts. His completed compositions were often built from elements which had occurred before in other works and could be combined in new and sometimes very different ways. On one occasion he put the *Discs* and *The City* together in a new painting (Paris, Collection Mme Léger) which made even more emphatic his integration of mechanical and human life. This principle was worked out on a monumental scale in the familiar *Three Women (Le Grand Déjeuner)* of 1921 (New York), for which many smaller and partial paintings were executed, too finished and in themselves complete to be classed as studies. Similarly in his famous 'film without scenario', the *Ballet mécanique* of 1924, he expressed his belief that 'sculptural beauty is totally independent of sentimental, descriptive, and imitative values' by contrasting inanimate objects, including moving machines in whole or in part, with human beings and parts of bodies in dance-like variations.

Throughout the 1930s Léger's compositions were filled with precisely delineated forms, both natural and man-made. In a series of *Objets dans l'espace (Objects in Space)* the plane of the background, whatever its colour, was a deep, open space as hard and clear as the things floating within it. The principal achievements of his later life were large paintings of popular, often proletarian subjects.[21] The final version of the *Cyclists* (1948-9, Paris) was also entitled *Homage to Louis David* to indicate his fondness

for the clearest and most comprehensible form and content, and his admiration for David's revolutionary political activities. The *Constructors* of 1950 (Biot, Musée Fernand Léger) and the *Country Outing* were more conspicuously proletarian, although the male protagonists in the latter, like the cyclists, looked uncomfortably overdressed in their middle-class suits and ties. In the last of these compositions, the *Great Parade* completed in 1954 [147], Léger summarized his aesthetic. The human beings, circus characters, are objects in a grand design where the monochromatic bodies, as simply drawn and modelled as his earlier machine forms and just as devoid of sentimental or anecdotal values, are inter-

147. Fernand Léger: The Great Parade, 1954.
New York, Guggenheim Museum

woven through an abstract sequence of broad stripes and circles in red, blue, yellow, orange, and green, the garish colours of commercial, mass-produced things. The contrast between figures and colours is an aesthetic device to attain, as Léger stated in 1941-2, 'the greatest possible dynamism with free colour and free form'. The dissociation of colour and form creates a visual interplay that almost sets his motionless figures in movement, and recalls his observation of the effect of moving light in the streets of New York at night: 'I was struck by the illuminated advertisements that swept the streets. You were there, talking to someone, and suddenly he became blue. Then the colour disappeared and another came, and he became red, yellow. That kind of projected colour is free, it is in space. I wanted to do the same thing in my canvases. This is very important for mural

painting because there is no scale, but I have only used it in my easel paintings.' And he added, characteristically: 'I could not have invented it. I have no imagination.'[22]

There is little evidence that Léger's efforts to create an art with wide popular appeal has met with much response from the people for whom he intended it. The quality of the large images offered the public, mostly by advertisers, has scarcely been affected by his theories or his style. In more special situations, in his mosaic for the façade of the church at Assy in Haute-Savoie (1946-9), and in his windows for the church at Audincourt (1951) and the University of Caracas (1954), his boldly coloured and broadly planned symbols have reached smaller but perhaps more sympathetic audiences.[23]

CUBISM AS A MOVEMENT: 1910-14

Although Braque and Picasso stayed close to their studios in Montmartre and refused to participate in group exhibitions, the results of their research, to be seen at Kahnweiler's gallery, attracted the attention of other painters less reluctant to appear in public. The rapid spread of Cubist ideas testifies to the vitality of the new concept of pictorial structure, however remotely or inaccurately the original premises may have been interpreted. The history of Cubism as a movement begins in 1910 with the appearance of a number of artists as avowed Cubists at the Indépendants and the Salons d'Automne during the hectic and, in retrospect, 'heroic' years between 1910 and 1914. It has been said that the influence of Cubism was perceptible in Paris as early as 1909, a year before its mature appearance in the work of Braque and Picasso, but this can only mean that other artists were aware of the formal structure of Cézanne's later work and were seeking a more objective and coherent basis for formal and expressive investigations than they found in Fauvism.[24] Certainly in 1909 and well into

1910, the work of Derain, Vlaminck, Delaunay, and Léger was closer to Cézanne than to the more analytical structures already created by Braque and Picasso. By 1911, however, so many artists knew the latters' work that a Cubist demonstration was possible. This occurred in March at the Salon des Indépendants, when Gleizes and Metzinger, supported by Delaunay, Le Fauconnier, and Léger, expressed their dissatisfaction with the random hanging of their works at the previous Salon and secured a separate room for themselves and their friends. This 'Salle 41', where they were joined by Archipenko, Picabia, Marie Laurencin, Roger de la Fresnaye, and Alfred Reth, created a *succès de scandale*. The next year the Cubists filled several rooms at the Indépendants, and the triumph of the movement seemed assured by the presence of Delaunay's canvas of mural proportions, *La Ville de Paris* (Paris). As usual the conservative critics were angry or indifferent, but the demonstrations elicited the enthusiastic response of Cubism's first and most eloquent champion, Guillaume Apollinaire, whose occasional essays of 1911 and 1912 were brought together in 1913 as *Méditations esthétiques, Les Peintres cubistes*.

Some of these artists and others who allied themselves with Cubism in 1910-11 must be considered before we examine the divergent movements of Orphic Cubism and Purism. A useful distinction between their works and the paintings of Braque, Picasso, and Gris can be found in their different attitudes towards iconography. Braque and Picasso invented their subjects and interpreted them in their own, very personal manner. The emotionally neutral still life, usually of ordinary domestic objects or of the musical instruments to be found in every studio, or the anonymous musician or person seated at a café table sufficed. Picasso's heads and half figures and the few portraits of his friends are as impersonal as Cézanne's. Because such subjects are only objects with no

traditional iconographic values and cannot be mistaken for anything other than themselves, the expressive content of each picture is the solution of a pictorial problem. The lesser Cubists did not share this rigorously anti-symbolic attitude towards subject matter, and were often satisfied with such conventional themes that their paintings might be described as 'cubified' rather than properly Cubist. As late as 1912 in the *Man on a Balcony* [148] by Albert Gleizes (1881-1953) there are descriptive passages of the sort that Braque and Picasso had banished two years before, especially in the figure where broad opaque planes preserve the appearance of a man existing in and yet apart from the space around him. Nor has the process of simplification eliminated a personal physiognomy in the face. In the work of Jean Metzinger (1883-1956) the separation of form and content is more obvious. When he inserted naturalistically rendered fragments of the subject within an abstract grid, the result is more a demonstration of 'how to cubify' than an invention of his own. But at his best, for a few years before 1920, he produced ingratiating variations of Synthetic Cubism. The colour and drawing of the *Woman with a Compote* [149] owe much to Gris, but the way the figure and still life emerge

148. Albert Gleizes: Man on a Balcony, 1912.
Philadelphia Museum of Art

149. Jean Metzinger: Woman with a Compote, 1918.
Private Collection

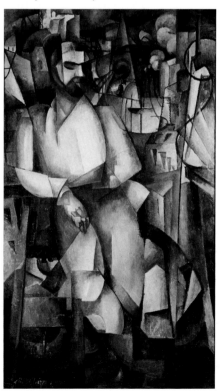

from a multi-layered pattern of superimposed and transparent rectangles and lozenges provides a continual challenge to the eye.

After 1920 Gleizes and Metzinger did not sustain the modest promise of their first Cubist work. When Gleizes tried to combine Cubist technique and Christian content his paintings became thin and dry. Metzinger lost himself looking for more monumental and decorative design. Yet whatever the value of their paintings, Gleizes and Metzinger must be remembered for their pioneer formulation of Cubist theory. Their book, *Du Cubisme*, published in August 1912, was the first treatise devoted to the new painting and preceded by seven months the appearance of Apollinaire's essays, *Les Peintres cubistes*. Although their interpretation of Cubism may have been unnecessarily metaphysical and their tone on the whole too Neo-Kantian, their insistence that form exists first in the mind and that 'to discern a form is to verify a pre-existing idea' became a basic postulate for much modern art. Their statement that 'certain forms remain implicit so that the place chosen for their actual birth is the mind of the spectator' is a useful clue to the visual mysteries of that 'noble enigma', a Cubist painting of the great period. It is some indication of the general interest in the new art that there were fifteen printings of *Du Cubisme* in less than a year, and an English translation appeared in 1913.[25]

A similar desire to take advantage of familiar subject matter while adopting Cubist fragmentation and multiple points of view held the work of other gifted painters to a compromise between naturalism and abstraction. By 1909 Henri Le Fauconnier (1881–1946) had exchanged opinions with Gleizes and Delaunay, but his principal work of the following winter, *Abundance* (The Hague, Gemeente Museum), which brought him to prominence at the Indépendants in 1911, is little more than a tritely allegorical nude woman and child laden with fruit. Although their bodies are carved into planes, they are set in an almost naturalistic landscape constructed according to a one-point perspective. The bright colours and the movement of the striding figure may have interested the Futurists, for Le Fauconnier's influence was greater than his talents and extended far beyond Paris. In 1910 Kandinsky invited him to the Neue Künstler-Vereinigung in Munich. *Abundance* and a landscape were reproduced in 1912 in the Blaue Reiter almanac, and the former was exhibited in Moscow the same year in the second 'Knave of Diamonds' exhibition. Le Fauconnier was so skilful an expositor that he, rather than a more creative artist, was a principal agent for the dissemination of the new ideas.

The compositions of Roger de la Fresnaye (1885–1925) were also based upon naturalistic situations. His ties to tradition are to be seen in his *Cuirassier* of 1910 (Paris), based on Géricault's painting of 1814. The *Conquest of the Air* of 1913 [150] is his most personal painting. The flattened red, blue, and white planes create a summery atmosphere for the figures of the

150. Roger de la Fresnaye: The Conquest of the Air, 1913. *New York, Museum of Modern Art*

painter and his brother, whose interest in aviation and yachting is indicated by the balloon and boat. After his health was ruined in the War, La Fresnaye abandoned the effort of spatial analysis for a linear and stylized realism. His *œuvre* is small, but his sensitive pen-and-ink drawings have a place in Cubist history.

The Cubists just mentioned were among the faithful exhibitors in the two independent Salons, but there were other artists, no less prominent, who should be mentioned. If they later failed to maintain a consistent level of invention, before 1914 they had created a few paintings that survive as contributions to the movement. The *Three Musicians* of 1919-20 (Paris) by the Polish artist Henri Hayden (1883-1970) holds its own with Braque's and Picasso's flat-patterned work of those years and may even have caught Picasso's eye before he began his more tightly geometrical *Musicians* of 1921 [141]. Alfred Reth (1884-1966), a Hungarian, was practising an accomplished form of Cubism by 1913, when Herwarth Walden presented eighty of his works at the Sturm Gallery. Like Delaunay, he was influential in the rapid diffusion of Cubist ideas in Central Europe before the First World War. He also may have produced between 1909 and 1912 some of the earliest purely abstract drawings.[26] Georges Valmier (1885-1937), the Russian (Finnish) painter Léopold Survage (1879-1968), and Louis Marcoussis (1883-1941), the Polish protégé of Apollinaire, produced personal variations of Cubism. André Lhote (1885-1962) worked in a more decorative, less distinctive style, but he was an ardent and successful teacher. Marie Laurencin (1885-1956) flirted with Cubism, but soon abandoned it for her very feminine, delicately coloured pictures of ethereal young women. Her amusing self portrait of 1908 with Apollinaire, Picasso, and the latter's companion of those days, Fernande Olivier (Baltimore), is a memorable association item. Jean Lurçat (1892-1966) belonged to the generation born within the next decade and came to maturity only after 1920, but the stretched and fragmented space in his figural scenes is essentially Cubist, and the shifting points of view of Cubist vision underlie the fantastically decorative surfaces of the tapestries with which he inaugurated the revival of tapestry design in a truly modern manner for the Aubusson factory after 1945.

Another Cubist manifestation occurred when the so-called Group of Puteaux arranged the Salon de la Section d'Or at the Galerie de la Boëtie in October 1912. Braque and Picasso did not contribute, but Delaunay and Le Fauconnier also abstained. The principal exhibitors were such familiar figures as Gleizes, Metzinger, La Fresnaye, Léger, and Picabia whose art belongs to the history of Dada. They had been meeting informally in the studios of Jacques Villon (Gaston Duchamp, 1875-1963) and of his brother, the sculptor Raymond Duchamp-Villon (1876-1918), in the Parisian suburb of Puteaux. An interested participant in the discussions was their younger brother Marcel Duchamp (1877-1968), whose *Nude descending a Staircase* of 1912 [153] was such a radical departure from the semi-naturalistic paintings of the others that he had had to withdraw it from the Indépendants earlier that year when several older Cubists objected. In hopes of presenting their work without prejudice and more effectively than it could be seen in the liberal but very large and unselective Salons, the artists of Puteaux decided to arrange their own exhibition. The title seems to have been suggested by Villon to express their dissatisfaction with the heterogeneous and meaningless term Cubism, but it also reflected the scientific and mathematical interests of the brothers Duchamp. To be sure, there was little that was specifically 'scientific' about their work at this time, certainly nothing to suggest that anyone felt obliged to plan it according to the mathematical proportion known as the

golden section, but Villon did occasionally use a delicate grid to control his dissolving and interpenetrating planes. In the grey, white, and brown *Still Life (La Table servie)* [151], painted in 1912–13 when the discussions at Puteaux were at their height, the grid enabled him to reverse an earlier series of drawings to obtain a more abstract and monumental design.[27] Years later Villon stated that although his starting-point was always in nature, each composition was based upon a proportional relationship. This mathematical bias was most apparent in his series of *Colour Perspectives* [152] of the early 1920s, which are among the earliest non-objective paintings by a French artist. Before 1900 Villon had made his name as an illustrator of Parisian life, a less sardonic

Lautrec, but after the First World War he endured decades of comparative obscurity, until he reappeared after 1945 as a consummate colourist and interpreter of landscape in an attenuated Cubist manner.

For the most part the paintings and sculptures at the Salon de la Section d'Or did not differ from those that had been seen in Paris for the past two years. But the Salon will be remembered for the first appearance of the mature work of Marcel Duchamp, which gave a new direction not only to Cubism but also to much modern art. Duchamp had just passed from a Late Impressionist and even slightly Fauve figural style to more disciplined and abstract inventions. In the second version of his *Nude descending a Staircase*, painted in the

151. Jacques Villon: Still Life, 1912–13. *New Haven, Conn., Yale University Art Gallery*

152. Jacques Villon: Colour Perspective, 1922. *New Haven, Conn., Yale University Art Gallery*

winter of 1911–12, the still recognizable female figure of the smaller first version was reduced to a sequence of straight and curved planes whose parallel multiplication represented not a figure in motion but the movement of the figure down and across the picture plane [153]. Like Braque and Picasso, Duchamp used an all but monochromatic palette of browns and tans to underline this statement of the mechanics of motion. Its resemblance to Futurist painting may be coincidental, for the first version of the *Nude* had been completed some months before the first Futurist exhibition in Paris, held in February 1912. Duchamp has acknowledged his interest in the cinema and in the chrono-photographs showing successive phases of a continuous movement which frequently ap-

peared in the contemporary press. In addition to these references, two prominent sequences of dotted lines in the centre of the picture, graphs of the torso's twisting rhythm, show his desire to translate natural forms into mechanical parts, and beyond that to a diagram of mental energies stripped of fleshly connotations.[28] After this Duchamp's paintings became increasingly anti-perceptual and finally so anti-pictorial that they belong to the history of Dada and Surrealism (see below, pp. 369–78).

If, except for Duchamp, these artists never equalled the continuous invention of Braque and Picasso or the manifestly original production of Gris and Léger, together they performed the task that history assigns to the followers of the great masters. They enlarged

the first highly individual premises of Cubism into a recognizable and acceptable style. The major Cubists cannot be said to have worked in a style; each was only himself. Their followers and successors made the multiple spatial situations, the visual and formal ambivalences of design accessible to artists throughout the world. Long after the heroic days before the First World War their methods contributed to the development of arts so seemingly remote from their investigations as the Abstract Expressionist movement after 1945 and the eruption of Neo-Dada in the 1960s.

ORPHIC CUBISM: 1909-14

We have seen how Léger's temperament led him to develop a kind of Cubist painting which by 1917 had little to do with the earlier investigations of Braque and Picasso. Similarly, and even sooner, an interest in the very colour which had been banished by the orthodox Cubists led Robert Delaunay (1885-1941) to the first completely abstract paintings created by a French artist. His earlier work after the usual apprenticeship to the Neo-Impressionists and Fauves, a series of interiors of the Late Gothic church of St Severin (1909), was close to Cézanne, but by 1910 a painting of the Eiffel Tower [154] proves that his mastery of Cubist fragmentation was almost as advanced as Braque's in the latter's *Violin and Palette* of the same year [136]. This painting, one of the first of a series, shows a dramatic and agitated unfolding of forms in space as the fragmented walls of the houses beside and beneath the tower collapse before the energies released by the great monument. The choice of the tower is typical of Delaunay's desire to embrace more than a few objects on a studio table. He appreciated the dynamic character of city life and was fascinated by height and aerial movement. Later he painted the Eiffel Tower as if seen from an aeroplane, and in his *Homage to*

153 (*above*). Marcel Duchamp:
Nude descending a Staircase, No. 2,
1912. *Philadelphia Museum of Art*

154 (*opposite*). Robert Delaunay:
The Eiffel Tower,
1910. *New York, Guggenheim Museum*

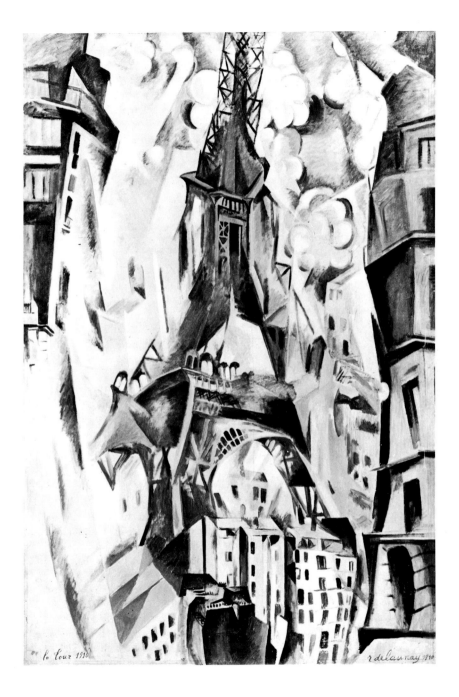

la Tour 1910 r delaunay 1910

Blériot of 1914 (Paris, Private Collection) cele-
brated the first flight across the channel.

Colour, however, became Delaunay's prime
concern. Through Seurat and Signac, whose
separated brush strokes he adopted for a while,
he re-examined the principal colour theories
of the nineteenth century and their application
to painting, and in Chevreul's 'law of the
simultaneous contrast of colours' found the
title 'Simultanéisme' for his own theory and
practice. He believed he could create effects
of recession and movement in space solely
through contrasts of colour. 'In *purely coloured*
painting it is colour itself,' he insisted, 'which
by its interplay, interruptions, and contrasts
forms the framework, the rhythmic develop-
ment, and not the use of older devices like
geometry. Colour is *form and subject*; it is the
sole theme that develops, transforms itself
apart from all analysis, psychological or other-
wise. Colour is a function of itself.'[29]

His discovery of these properties and ways
to present them can be followed in his series of
Windows of 1910–13. Their Neo-Impressionist
mosaic of small coloured squares applied to a
Cubist grid of larger square and triangular
planes yielded by 1912 to a less literal configura-
tion of luminous, flattened planes in his
Simultaneous Windows, where the city archi-
tecture can scarcely be discerned. Then, in the
same year, he found how to release colour from
any association with nature in his *Disc* (Col-
lection Mr and Mrs Burton G. Tremaine,
Meriden, Conn.). This, perhaps the first
entirely and intentionally non-representational
painting created by a French artist, is a circular
canvas on which seven concentric bands of
colours are divided into quarters. The pro-
gression from the vivid primaries and com-
plementaries in the centre to less intense hues
on the perimeter is not strictly scientific, but
the effect is more like a demonstration of colour
theory than a freely created work of art. The
colour wheel, the source of Delaunay's most

155. Robert Delaunay: Circular Forms,
Sun and Moon, 1912–13. *Zürich, Kunsthaus*

original inventions, in time became almost an
obsession with him.[30] In his *Circular Forms* of
1912–13 (New York and Zürich) [155], the
less dogmatic arrangements of wheels produce
convincing effects of movement in depth as
well as across the surface.

Apollinaire was the first to describe the
paintings of Delaunay, Léger, Picabia, and
Duchamp as 'orphic', by which he seems to have
meant that they shared a tendency towards
abstraction which he felt had analogies with
the abstract art of music. His term now seems
applicable only to Delaunay, in so far as the
'works of the orphic artist must simultaneously
give a pure aesthetic pleasure, a structure
which is self-evident, and a sublime meaning,
that is, a subject. This is pure art.'[31]

Delaunay's position is secure as the first
French artist to create a totally non-objective
painting, but his later variations on his circular
themes became brittle and dogmatic. Never-
theless, by 1914 his ideas had been accepted
by several younger artists, and in Germany,
where a group of his paintings was shown in

the First German Salon d'Automne, he was considered one of the most important contemporary artists. One of his *Windows* (New York, Guggenheim) was exhibited in Munich by the Blaue Reiter, and his advice was sought by Marc, Macke, and Klee. His colour wheels even recur in Kandinsky's work after 1920 [201]. In Paris the American painters Stanton Macdonald-Wright and Morgan Russell based their theories of 'Synchromy' squarely on his work. But as time passed Delaunay was more and more ignored, until the large retrospective exhibition of 1947 in Paris called attention to his historical and artistic significance. His closest associate, his wife Sonia Terk Delaunay (1885-1979), continued until her death to develop his theories of colour 'simultaneity' in designs for textiles and tapestries, as well as in her own paintings.

PURISM: 1918-25

The decorative adulteration of Cubism that had set in by 1914 was soon criticized by Amédée Ozenfant (1886-1966) and the Swiss artist Charles-Édouard Jeanneret (1888-1965, better known as Le Corbusier), who wanted to create a system of aesthetics and painting which would be immune from personal interpretations. Ozenfant began the attack in 1916 with an article in his own periodical, *L'Élan*, and developed it two years later with Jeanneret in a small book, *Après le cubisme*, which contained the core of the doctrine later elaborated in their periodical, *L'Esprit nouveau* (1921-5), and summarized in a treatise, *La Peinture moderne* (1924). At first glance their enthusiasm for machinery and machine forms seems only an extension of Léger's acceptance of the commonplace as symptomatic of all that was modern in modern life and of his dictum that 'a work of art must bear comparison with any manufactured object'. Their aesthetic, however, was more rational and systematic. Its logical bias lives on in

Le Corbusier's much quoted and misunderstood aphorism that 'a house is a machine for living in',[32] but it was more fully expressed in their contention that the need for order is fundamental to human experience, that nature moves us aesthetically only when seen in intellectual terms, and that the contemporary expression of this sense of order is identical with the machine age because in modern urban culture the forms of everything visible approach geometrical shapes. From these premises they drew the conclusions that art as the expression of constant, universal 'invariants' of experience shares with science the task of expressing the contemporary world, and that it can best do this by discovering those forms in modern life which are common to all classes of society. Cubism to their minds was little more than 'embroidery and lace-making' because it had become more a matter of individual than of impersonal expression.

Their criticism was telling. Why, they inquired, had Picasso and Braque preferred the eccentric shapes of unusual objects to the regularities of universal (and mass-produced) forms? For themselves they would use, not picturesque items fron studio and café, the guitar and playing cards, but just those things which in Jeanneret's words were 'the elements which determine the character of our time', machine-made objects of everyday use, earthenware pots and vessels, pitchers and bowls and bottles, 'so extremely intimate and banal that they scarcely exist in themselves'. For the few years of their association Ozenfant's and Jeanneret's paintings demonstrated that a common purpose required a common technique, a fact already conspicuous in the Cubism of Braque and Picasso a decade earlier. In their drawings, which are as precise and anonymous as an engineer's blueprint, and in their paintings, executed in subdued colour schemes of dark red, blue, ochre, and other earth colours, each object appears in its broadest profile. In

Jeanneret's paintings transparency creates thin layers of space, where the circular rims of drinking glasses become relaxed as squarish ovals and resemble the lines and curves in his later architecture. In Ozenfant's work the typical appearance of each object is reinforced when the closed curves of its outline form a common contour with its neighbour. This was,

156. Amédée Ozenfant: The Jug, 1926. *Providence, R.I., Museum of Art, Rhode Island School of Design*

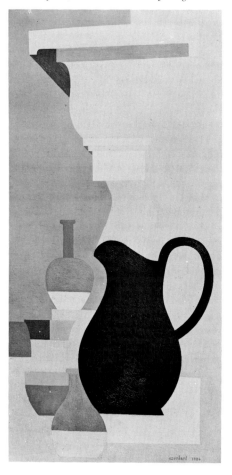

indeed, the image of a machine-tooled world: accurate, precise, ordered, geometrical, invariant, pure [156]. Since these are also qualities often considered 'classic', Purism can be thought of as another aspect of the reappearance of neo-classical imagery after the First World War.

The very purity of Purism, however, was its undoing. Although Ozenfant and Jeanneret denied the viability of a non-objective art and inveighed against what they felt were the in-human abstractions of De Stijl, there was very little which could be called humane in their own paintings. The accessories of the kitchen when deprived of everything palatable do not invite a lasting aesthetic response. After 1930 Ozenfant turned to a mannered figural style in which he built up simplified human forms with an intricate impasto. As Le Corbusier, his partner created in architecture a more enduring 'system capable of expressing the synthesis of present events and not the appearance of just a personal caprice'.[33] He continued to paint. Some of his later buildings contain his own murals, and from time to time he showed a selection of his easel works. The later compositions are looser, with line, colour, and shape interwoven in more intricate ways, but the basis of his design remained Cubist, and his articulation of space suggests interesting analogies with his architecture.

The surviving examples of Purist painting might seem too few to require much comment, but Purist theory was more important than Purist work. Undoubtedly the conception of an art so precise that it would be the spiritual expression of an age dominated by science and its technological application to practical affairs was utopian, for the men of the machine age have rarely endorsed or exemplified a life dominated by order and reason. But at a less exalted level of thought and action Purism did encourage a serious look at the products and the methods of producing objects in modern times. The Dadas had already called attention

to the strange and even poetic qualities of ordinary things; Purism insisted that they also had a universal aesthetic value. This concept, contemporary with the investigations of the German Bauhaus, led to the appreciation of industrial artefacts, especially when presented in exhibitions of machine-produced 'useful' objects.[34] Whenever we admire the simple contour or refined shape of an article of daily use, we share in the Purist aesthetic.

CUBIST SCULPTURE

Although the concept of a Cubist sculpture may seem paradoxical because the fundamental Cubist situation was the representation on a two-dimensional surface of a multi-dimensional space at least theoretically impossible to see or to present in the three dimensions of actual space, the temptation to move from a pictorial diagram to its spatial realization proved irresistible. Picasso had taken the first step in 1909 with his *Woman's Head* [134], which was less adventurous than his paintings of that and the following year, but in the painted bronze *Absinthe Glass* of 1914 he pierced the surface so that the interior volume could be seen and touched. His investigations of visual ambiguities in collage also led him to use actual materials in three dimensions, frequently as amusing visual puns [142]. But in all this there was still a pictorial bias; the fact that the *Absinthe Glass* is painted (with the Neo-Impressionist dots of Picasso's Synthetic Cubist paintings of the same year) puts it almost as much within the aesthetic of painting as of sculpture. Picasso's constructions are more reliefs than free-standing sculpture. But although they can be seen from only one position, and so have only partially emerged from the flat planes of painting, their physical and visual ambiguities are extraordinarily provocative. The musical instruments in particular, such as the cardboard model for the sheet metal

guitar of 1914 (New York), are more than once removed from their origins in Cubist paintings. They are no longer images of pre-existing objects but rather three-dimensional extrusions from the artistic configurations of the flat patterns of their two-dimensional pictorial prototypes. By 1914, when the Cubist painters had begun to abandon suggestions of depth in favour of paper-thin spaces defined by flattened overlapping planes, the sculptors who wished to be accounted Cubist had to reconcile such virtual but non-existent depths with actual masses in space.

HENRI LAURENS (1885-1954)

Although some time before 1913 the Hungarian sculptor Joseph Csáky (1888-1971) had made figures of cones, cylinders, and spherical segments, a more convincing translation of the two dimensions of Cubist painting into three was the work of the French sculptor Henri Laurens during the first decade of his mature activity (1915-25). In 1911 he had met Braque, who is said to have shown him some paper constructions, and he had exhibited at the Salon de la Section d'Or in 1912, but the first sculpture in which he used different materials in the manner of collage appeared only in 1913. In the next five years he produced many compositions, mostly still lifes in which the familiar objects of Cubist painting - the bottles, glasses, and fruit - were of painted wood and sheet metal [157]. Whether these are properly sculpture or, like Picasso's constructions, still partially pictorial, is debatable. Nor does Laurens's polychromatic treatment of his materials clarify the issue. He insisted that he 'wanted to do away with variations of light and, by means of colour, to fix once and for all the relationship of the components, so that a red volume remains red regardless of the light', because 'polychromy is the interior light of sculpture'.[35] But polychromy is also the 'in-

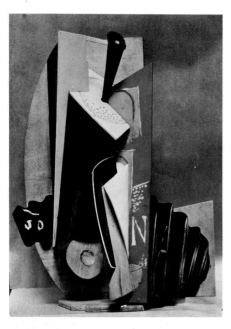

157. Henri Laurens: Bottle and Glass, 1915.
Paris, Galerie Louise Leiris

158. Alexander Archipenko: Walking, 1912.
Denver Art Museum

terior light' of painting, in fact the light without which it could not exist, and to minimize variations of light upon a three-dimensional form is to deprive it of just the visual effects that make it unmistakably sculptural. Ambiguous though Laurens's earlier reliefs and constructions may be, they have character. They are refined, witty, more delicate than Picasso's. Simultaneously, he made *papiers collés* which are comparable to Braque's and Picasso's, if less spatially complex. Were he known only for them, he might rank but a little way below Gris as a Cubist painter.

After 1920 Laurens abandoned his painted surfaces for a more conventional treatment of wood and stone, and about 1925 discarded the abstractive processes of Cubism for a figural style which he practised until the end of his life. His constant subject was the female nude, for a while attenuated in curvilinear arabesques, then during the early 1940s gradually inflated into monstrous bloated forms collapsed upon themselves. One may think that their uneasy somnolence corresponded to the sculptor's emotional distress during the years of the Second World War.

ALEXANDER ARCHIPENKO (1887-1964)

An earlier, more aggressive, and at first more imaginative assault upon sculptural tradition was made by the Ukrainian artist Alexander Archipenko, who arrived in Paris in 1909. In his first works he alternated between a simplified but sophisticated treatment of the nude female figure and a rough primitivistic manner which owed much to current interest in Egyptian, African, and other primitive arts. From Léger, whose studio was near by, Archipenko learned about Cubism, and from his study of the interpenetration of exterior and interior forms created his first abstract sculpture. Unlike Laurens, who preferred immobile still lifes, Archipenko put his figures in motion. The best known is *Boxing Match* of 1913 (New York, Guggenheim Museum) in which violent physical action has been abstracted and simplified into the clash of cylindrical forms. More prophetic and more influential was the earlier *Walking* of 1912 [158]. The striding female figure, its posture not unlike Boccioni's *Unique Forms of Continuity in Space* of the next year [171], is treated as a series of interlocking convex and concave surfaces. The sculptural reality of the interior forms is made doubly clear by the empty spaces which stand for the head and body. This is the first instance in modern sculpture of the use of a hole to signify more than a void, in fact the opposite of a void, because by recalling the original volume the hole acquires a shape and structure of its own.

In the same year Archipenko created the first of his sculpture assembled from various materials. *Medrano I* (whereabouts unknown), a kneeling figure inspired by the Paris circus, was made of wood, glass, and wire. *Medrano II* (New York, Guggenheim Museum) and *Woman in front of a Mirror* (destroyed), in which the mirror was an actual looking-glass, anticipated the Dada assemblages of odds and ends of

159. Alexander Archipenko: The Bather, 1915. *Philadelphia Museum of Art*

materials two years later. The combination of actual and simulated dimensions led him to invent his 'sculpto-paintings', also in 1912. In the *Bather* of 1915 [159], cut and fitted elements of metal and wood project from the drawn and painted background as continuations of the same forms. In later years, during the 1920s, such 'sculpto-paintings' became more and more abstract.[36]

Archipenko's use of concave and convex volumes within the same figure, and his discovery of the volumetric significance of the void, were important contributions to modern

art, but his later sculpture did not fulfil his early promise. Endlessly inventive, Archipenko became distracted by superficial stylizations of the human figure in various materials, often polychromatic. One wonders whether his facility did not act as a substitute for the content with which his forms might have been endowed. Unlike the work of other artists who have concentrated on a few iconographic themes, Archipenko's endless variations on the nude seem to have no meaning beyond or even in themselves.

For a few years around 1920 Archipenko was the most influential European sculptor working in the Cubist idiom. His works, which had been seen in Berlin since 1910, were decisive for the German sculptor Rudolf Belling (1886–1972), who developed, in even more abstract terms, Archipenko's alternations of voids and solids. His group of two stylized male figures, *Kampf* (*Combat*) of 1916, is related to Archipenko's *Boxing Match* of 1913, and his *Drei Klang* (*Triple Tone*) of 1919 was a more completely abstract treatment of three rhythmically interconnected figures. Both works exist in examples executed in wood as well as in metal. Belling's later sculpture, although often somewhat self-consciously formalized, included an abstract head of 1923 composed of machine-like geometrical volumes in chrome metal.

OSSIP ZADKINE (1890–1967)

For the Russian sculptor Ossip Zadkine, Cubism was a means to dramatically expressive ends. He had studied briefly in London and at the École des Beaux-Arts in Paris for six months (1909) before he encountered African sculpture and Cubist painting. His first one-man exhibition was held in Brussels in 1920, and he has always been admired in Belgium and Holland, where his distortions are compatible with Northern Expressionism. His first works were carved directly in wood and stone, but after 1925 he more often modelled in clay. One cannot but admire his lifelong investigation of the problems of monumental sculpture, but too often his figures seem merely melodramatic, the movements and gestures more violent than the subjects and their content require. Zadkine always admired Rodin, and in Rodin he admired most the treatment of man as a psychological rather than anatomical entity. But in his own search for forms expressive of psychological conditions he was often indifferent to the materials from which sculpture must be made and which largely determine the expressive character of its forms. Evidence of this appears in the collision of the formal, the material, and the intellectual in so much of his work. Zadkine was one of the most learned of modern artists, but the devices by which he sometimes conferred classical meaning upon his figures – the incised lines and two-dimensional drawings on three-dimensional surfaces – did not always enhance the sculptural form. Yet there are occasional works like the *Orpheus* of 1948, whose body is his lyre, where the metaphor is visually as well as intellectually convincing. And once, when the theme was as stupendous as his imagination, he created his most formally and expressively integrated figure. In Rotterdam the monumental bronze symbolizing the *Destroyed City* [160] discharges in the space around it the grief, anger, and courage that enabled the community to rise again from its ruins.

RAYMOND DUCHAMP-VILLON (1876–1918)

The premature death of the French sculptor Raymond Duchamp-Villon, a casualty of the First World War, may have deprived modern sculpture of an intelligence as acute and iconoclastic as his brother Marcel Duchamp's, to judge by his last large sculpture, the *Horse* of

160. Ossip Zadkine: The Destroyed City, 1947. *Rotterdam, Plein 1940*

161. Raymond Duchamp-Villon: The Horse, 1914.
New York, Museum of Modern Art

1914 [161].[37] His earlier work, like Duchamp's, is less interesting in itself than as a series of steps by which he recapitulated the development of contemporary art and arrived at a startling reformulation of the sculptural image. His plaster relief of the *Lovers* of 1913 (New York) cubifies an almost academic theme. His design for a Cubist house, exhibited at the Salon d'Automne in 1912, was a timid essay towards a Cubist architecture. The principal masses were entirely traditional; only a few surfaces had slightly faceted sculptural decoration.[38] By 1914 the volumes of the *Seated Bather* were more abstract, more precise, one might almost say more machine-tooled. But two years earlier the bust of *Maggy* [162] was a more vigorous simplification of sculptural mass. Beside it Matisse's only slightly earlier *Jeannette V* [89] seems arbitrary and old-fashioned.

Like Léger, who was present at the discussions in the Villon brothers' studios at

Puteaux, Duchamp-Villon was deeply interested in machines, in the curious likeness of their rhythms to human movements which are then annihilated by mindless repetition. In the *Horse* Duchamp-Villon created an image in which vital animal energies are embodied in mechanistic elements. The concentration of forces in this crouching form, an abstract diagram of the muscular tensions developed by

even Synthetic Cubism to a more impersonal and abstract treatment of natural forms, very much as the *Nude descending a Staircase* had already led Marcel Duchamp to the robot-like turbines of the *King and Queen surrounded by Swift Nudes*. The end terms of the sequence, which Duchamp-Villon did not live to complete, were achieved in the non-objective sculpture of the Russian Constructivists.

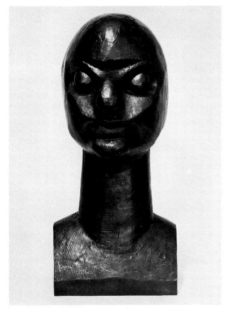

162. Raymond Duchamp-Villon: Maggy, 1912.
New York, Guggenheim Museum

163. Jacques Lipchitz: Bather, 1915.
Washington, D.C., Hirshhorn Museum

a leaping horse, can be compared with much contemporary Futurist painting. Boccioni had visited Duchamp-Villon in 1913, and the circular rhythms of the *Horse* resemble the Italian's representation of human and mechanical motion in the *Dynamism of a Cyclist* of 1913.

The *Horse*, which is the most powerful piece of sculpture produced by any strictly Cubist artist, was based upon studies of an equestrian figure which can be related to the earlier Analytical phase of Cubism, but it reaches beyond

JACQUES LIPCHITZ (1891-1973)

A slightly later convert to Cubism, who accepted it as a discipline and contributed to it as a style, eventually passed beyond it to create sculpture profoundly meaningful as symbolic interpretations of human experience. In 1909 Jacques Lipchitz (who was born at Druskieniki in Lithuania) came to Paris, where his visits to the Louvre were more important for him than occasional studies in the schools. His

lifelong interest in primitive and archaic art, which led him even in the days of his poverty to collect such examples as he could afford, accounts for the mild *gaucherie* of his otherwise conservative, even academic *Woman and Gazelles* which was remarked upon at the Salon d'Automne in 1913. Meanwhile he had met Picasso through his friend the Mexican painter Diego Rivera, already an accomplished Cubist, and in 1916 he came to know Juan Gris. He was at first unsympathetic to Cubism, but capitulated in 1914 with his bronze *Sailor with Guitar*, a jaunty and angular treatment of the familiar Cubist musician. The next year he created the more original *Bather* [163], a favourite theme of Archipenko's. The figure is flattened into a series of superimposed rectangles so strict as to suggest the truth of Lipchitz's statement that his early Cubist sculpture 'was so highly planned that I even used blueprints sometimes'.[39] Although he denied that the Cubists were influenced by African sculpture, he admitted that 'we shook hands with Negro art, but this was not an influence – merely an encounter'. The *Bather* must have been just such an encounter, for her geometry recalls the angular rigidity of Dogon or Gabun ancestor figures, and her bent leg, which is as stylized as a Bakota figure's, resembles the spread legs of the woman on the right in the *Demoiselles d'Avignon* [131]. Nevertheless, Lipchitz was right to imply that this brittle mixture of primitive elements and a traditional subject, hallowed by Cézanne, was only an episode in his life. His investigations of Cubism led him much further, especially after his meeting with Gris. The coloured stone reliefs of Cubist still-life subjects which he made in 1918 may be little more interesting than Laurens's work of the same period, but the stone figures, the harlequins, seated musicians, and standing bathers, were more three-dimensionally and successfully Cubist. Their interlocking and interchangeable curvilinear and angular elements are convincing sculptural counterparts of the Synthetic Cubist painting of Juan Gris.

In 1925 Lipchitz produced the first of his 'transparents', small bronzes cast from pieces of cardboard cut and bent to the shape of musicians and carnival figures resembling those in Picasso's Synthetic Cubist works of 1921. In these little figures, where the volumes consisted of empty spaces slightly defined by thin strips of metal [164], the transparency of earlier Cubist painting was projected in three dimensions far more successfully than in the opaque stone sculpture. The references to Picasso's painting that recur from time to time in Lipchitz's work provide interesting contrasts between comparable formal but different expressive purposes. Lipchitz said

164. Jacques Lipchitz: Mardi Gras, 1926. *Private Collection*

that for him 'there is no difference between painting and sculpture',[40] so that we should not be surprised by such exchanges. But the forms in his monumental sculpture have wider connotations than do those in Picasso's paintings; not Lipchitz's feelings only, but older cultural memories are concerned.

Lipchitz discovered the forms for such content when he opened up the masses of his bronzes. By revealing the interior volumes he became literally more Cubist, but at the same time escaped from Cubism as a style externally imposed upon arbitrarily determined Cubist subjects. He always insisted that his sculpture was rooted in the Cubist 'imagination', and certainly it was based upon the Cubist manipulation of planes in space, but he made it a more personal and more universal mode of

165. Jacques Lipchitz: Figure, 1926–30.
Washington, The Hirshhorn Museum and Sculpture Garden

expression. His characteristically dramatic and passionate treatment of symbolic themes first appeared on a large scale in 1927 in the dancing couple, entitled *Joie de vivre*, which the Vicomte Charles de Noailles commissioned for his garden at Hyères on the Mediterranean. The now familiar device of a piece of sculpture revolving on a turntable before the spectator's eyes was as new as the intensity of these figures animated by the frenetic energy of modern jazz.

In the *Figure* of 1926–30 [165], originally conceived as a piece of decorative sculpture for a private house, the sources of expression were less civilized and more remote: they came from the primitive sculptures he had long studied and collected, and from the Surrealists' injunction to accept the promptings of unconscious feeling.[41] Like a presence suddenly arrived from some unexplored region of space or of the mind, this mysterious form has stood through fifty years as a totemic image of the powers of darkness within us. Its eyes, if eyes they are, stare from the same mindless space of Picasso's exactly contemporary *Seated Woman* [270].

In his study of primitive art Lipchitz was looking, as he said later, for a 'universal language' of form. By casting his and our experience in the situations of the Hebrew, Greek, and Christian traditions he was attempting to 're-establish man as psychology instead of as anatomy'.[42] After 1930 he chose for his figural sculptures the perpetual and basic themes of human existence, those moments of crisis – of love, conflict, and dedication – in the lives of individuals and of the race, in the relations between human beings, and in those nightmare encounters between men and beasts when the supreme facts of human experience, of life and the consciousness of life, are at stake. In this process the private symbolism of his later Cubist work became public and universal in his first truly monumental sculpture, the over-life-size *Prometheus strangling the Vulture* for the Palace of Discovery and Inventions at

the Paris Exposition of 1937. As Lipchitz worked on his model the world darkened towards war, and the theme changed from the familiar statement of Prometheus bringing men light and knowledge to the demi-god as the champion of human freedom.

In 1941 Lipchitz left Paris for New York, where he soon became one of the foremost sculptors in America. In works such as *Sacrifice* of 1948 [166] his Cubist bias is still apparent in the construction of the human figure; the 'baroque' fluidity he developed in the 1930s controls the cock. But this rabbinical image of the propitiation of evil has an awesome expressive power for which stylistic labels do not account. The feeling of physical and psychic forces at work within the forms is Lipchitz's way of 'bringing mythology up to date, of making it reflect our own lives'.[43]

In technique as well as in content, in his preference for modelling (his use of plasticine instead of clay may account for his sometimes lumpy surfaces) and for symbolic themes presented with maximum expressive intensity, Lipchitz was Rodin's successor. The play of light over his carefully worked surfaces, enhancing and completing the movement originating in the sprawling forms, is Rodinesque, as well as his belief that great sculpture can and should be public. But Lipchitz had comparatively few opportunities to put his work in public places.[44] An age dominated by abstraction feared the emotional commitment required by subjects whose content is the conquest of fear itself.

FUTURISM: 1909-16

Only seven years separated the first Futurist manifesto of 1909 from the extinction of the movement as a vital force in modern art in 1916, yet in that short time Futurism became an inter-

national, even an intercontinental phenomenon, out of all proportion to the quantity of its actual achievements and to the quality of all but a few. Futurism was formally launched on 20 February 1909, when the poet Filippo Tommaso Marinetti (1876-1944) published the first literary manifesto in the Parisian newspaper, *Le Figaro*. In bombastic language he demanded the obliteration of the cult and culture of the Italian past and the creation of a new society, a new poetry, and a new art based on *velocità* or speed, the dynamic element which he believed to be fundamental and peculiar to modern life. His political programme of extreme nationalism and colonial expansion even at the price of war with Austria was intended to awaken the Italian public to the realities of modern times. Much of it was unhappily fulfilled in the First World War and the Fascist dictatorship which followed. Marinetti's language and the tactics which he and his friends adopted in order to shock the public, tactics suggested by contemporary anarchist activities, were so extravagant that the Futurist movement to many has always seemed slightly ludicrous. The word itself, especially in English as 'futuristic', has been used to condemn quite as much as to characterize the more extreme aspects of modern art. Nevertheless, the force as well as the bravado of Marinetti's call to action still sounds in the famous phrases from his first manifesto: 'We shall sing the love of danger, the habit of energy, boldness . . . We declare that the world's splendour has been enriched by a new beauty: the beauty of speed. A racing automobile, its hood adorned with great pipes like snakes with explosive breath . . . a roaring automobile, which seems to run like a machine-gun, is more beautiful than the *Victory of Samothrace*.'

Marinetti's arrogant rejection of all traditional values, political as well as cultural, and his insistence on experiencing the present in all its intensity and immediacy, can be understood as a necessary, even as an inevitable expression

166. Jacques Lipchitz: Sacrifice, 1948.
Buffalo, N.Y., Albright-Knox Art Gallery

of discontent among the younger generation of artists and writers, bored by Italy's long economic and cultural stagnation and her inferior position among the European powers. At the same time they understood that the new technology was bringing into being an entirely new way of life, one which Italy should not only share but help to create. But it was less easy for artists who were inspired by such sentiments to discover the pictorial and sculptural means with which to present the expressive potentials of modern existence. Enthusiasm was no substitute for style and technique, and the most conspicuous stylistic and technical aspects of fully-fledged Futurist painting, the simultaneous representation of multiple phases of movement, might never have been discovered had not Cubism already existed in Paris. Yet Futurism cannot be defined in terms of Cubism, because from the first its members programmatically rejected the concept of an analytical art based on studio experiences. They called for the immediate identification of artist and spectator with the particular character of modern life which for them was to be found in the city, in an environment of men and machines moving at a new and exhilarating tempo. In Later Impressionism, and especially in the divisionist technique which suggested the transformation of substances into the velocities of light, they saw an identity of form with feeling that enabled them to express the dynamic motion which, they believed, was fundamental to every experience of form. As Severini wrote in 1913: 'We choose to concentrate our attention on things in motion, because our modern sensibility is particularly qualified to grasp the idea of speed. Heavy powerful motor-cars rushing through the streets of our cities, dancers reflected in the fairy ambiance of light and colour, airplanes flying above the heads of the excited throng . . . These sources of emotion satisfy our sense of a lyric and dramatic universe, better than do two pears and an apple.'[45] And in the same year

Carrà could say: 'We strive with the force of intuition to insert ourselves into the midst of things in such a fashion that our "self" forms a single complex with their identities.' This concept of material objects existing in a state of continuous change and flux which can be known only by the perceiving subject is clearly Bergsonian and links their investigations to those of the later Monet and Cézanne. When they finally came to Cubist painting at first hand (in the autumn of 1911, when Boccioni and Carrà visited Severini, who had been living in Paris), they saw that such devices as the Cubist interpenetration of planes and simultaneous projection of multiple views of an object could serve their very different purposes.

The 'Manifesto of the Futurist Painters', published on 11 February 1910 by Boccioni, Carrà, Russolo, Balla, and Severini, contained resounding general principles for artistic action but nothing in the way of practical method. In this, and in the 'Technical Manifesto of Futurist Painting' published in April, they repeated Marinetti's attacks on the past in the same abusive language and proclaimed their right 'to exalt every kind of originality, even if foolhardy, even if utterly violent', and 'to render and glorify the life of today, incessantly and tumultuously transformed by the victories of science'. To Marinetti's elemental principle of velocity they added a 'universal dynamism' to be portrayed as 'dynamic sensation', and declared that 'motion and light destroy the materiality of bodies'. 'We are', they proudly concluded, 'the primitives of a new and completely transformed sensibility.'

These were brave words with which to attack academic idealism and naturalism, but the pictorial and sculptural correlatives for them had still to be found. In the Italy of 1909–10 the progressive movements in Paris and Central Europe were still little known. The mild atmospheric realism of the Macchiaioli of the later 1860s had not transformed contemporary vision

as had Impressionism in France, nor was there an individual Italian genius such as Belgium and Norway possessed in Ensor and Munch. For the time being Italian painting was represented abroad by the dazzlingly superficial portraitist Giovanni Boldini (1842-1931), and by Antonio Mancini (1852-1930), who interpreted his sentimental genre subjects with a skilfully blurred Impressionist brush. Although an international exhibition of modern art, commonly known as the Biennale, had been held in Venice every other year since 1895, very few examples of advanced contemporary painting had been included. Not until 1905 were the Impressionists seen in any quantity, and the Post-Impressionists not until 1910, in

Florence.[46] Consequently, the first works of the Futurists were really more revolutionary in content than in technique, for even in the manifesto of Futurist painting the only technical innovation proposed was a version of Neo-Impressionist Divisionism renamed *complementarismo congenito* (innate complementarism). When Umberto Boccioni (1882-1916), who had been studying with Balla in Rome, moved to Milan in 1907, his decision could be explained as a desire to embrace the dynamic life and opportunities for European contacts available in Italy's largest industrial city. In his first major Futurist painting, *The City Rises* of 1910 (New York), the energies unleashed by the expansion of Milan are represented by 'immense

167. Carlo Carrà: Funeral of the Anarchist Galli, 1910-11. *New York, Museum of Modern Art*

horses symbolizing the growth and the desperate labour of the great city, thrusting her scaffoldings towards the sky'.[47] This quasi-allegory is saved from convention by his dashing version of *complementarismo congenito* applied to the naturalistically drawn scaffoldings and construction in the background and to the semi-abstract horses and workmen crowding the foreground. This, with other works by Boccioni, Carrà, Balla, and Russolo, was seen at the Mostra d'Arte Libera in Milan in May 1911, the first

exhibition to include specifically Futurist paintings. The *Funeral of the Anarchist Galli* [167] by Carlo Carrà (1881–1966) revealed another and more dramatic aspect of the Futurist programme. In this representation of the disorders attending the burial of Galli, who had been killed in the general strike of 1904, the flickering patterns of light passing through the agitated forms, and the portrayal of violent motion by the repetition of a form seen many times through the arc of its movement show that

168. Luigi Russolo: The Revolt, 1911.
The Hague, Gemeentemuseum

169. Umberto Boccioni:
The Street enters the House,
1911. *Hanover, Niedersächsische Landesgalerie*

Carrà was already aware of Cubism. The 'Free Exhibition' of 1911 is also interesting, because it included 'spontaneous paintings by the untrained, in order to prove that the artistic sense ordinarily regarded as an exceptional gift is innate in everyone's soul'. Thus for the first time drawings and paintings by children and labourers were shown on the same terms as the work of professional artists, as evidence that 'the forms in which the artistic sense manifests itself are but the exponents of the varying

degrees of pictorial sensibility of different individuals'.[48] Carrà's and Boccioni's respect for such forms of expression is exactly contemporary with Kandinsky's and Franz Marc's interest in 'primitive' art which led them to reproduce children's drawings in the Blaue Reiter almanac the next year.

The Revolt [168] by Luigi Russolo (1855–1947), also of 1911, incorporated the Futurist principle of 'force-lines'. The sequence of obtuse angles embracing segmented and inter-

penetrating glimpses of a mob attacking a factory simultaneously suggests the actual, irresistible movement of the mob and the abstract, dynamic quality of motion as the absolute, metaphysical *velocità* of human experience. The significance of these famous 'force-lines' was described in the catalogue of the first Futurist exhibition, held in the galleries of Bernheim-Jeune in Paris in February 1912. The preface was signed by Boccioni, Carrà, Russolo, Balla (who did not exhibit), and

Severini, but the tone is Boccioni's. According to this document they wanted to portray the sum of visual and psychological sensations as a 'synthesis of *what one remembers* and of *what one sees*'. In addition to the visible surface of objects, there are the dynamic sensations conveyed by the invisible extensions of their 'force-lines', which reveal how the object 'would resolve itself were it to follow the tendencies of its forces'. Since the work of art, through this

170 (*below*). Umberto Boccioni: Development of a Bottle in Space, 1912. *New York, Museum of Modern Art*

171 (*opposite*). Umberto Boccioni: Unique Forms of Continuity in Space, 1913. *New York, Museum of Modern Art*

process of 'physical transcendentalism', can be considered the representation of a state of mind, and the force-lines, as perspective elements, tend towards infinity, the spectator is placed 'in the centre of the picture'. Lacking in clarity though this argument may be, it forms the basis for Boccioni's best Futurist work, for such paintings as *Dynamism of a Cyclist* of 1913 (Milan, Collection Dr Gianni Mattioli), and his remarkable sculpture. In order to present memory and vision simultaneously, the Futurists used the Cubist device of interpenetrating planes to represent interpenetrating objects and events. The derivation from Cubism may be seen by comparing the tottering, fragmented architecture of Delaunay's *Eiffel Tower* [154], in itself a 'dynamic' situation, with Boccioni's *The Street enters the House* [169]. The latter was

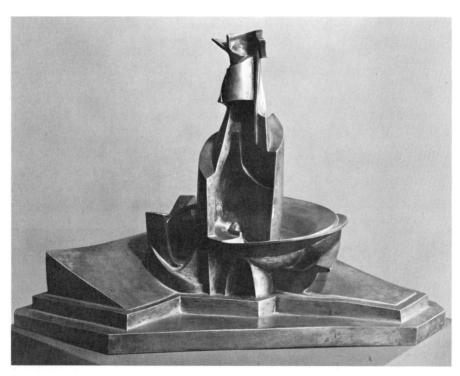

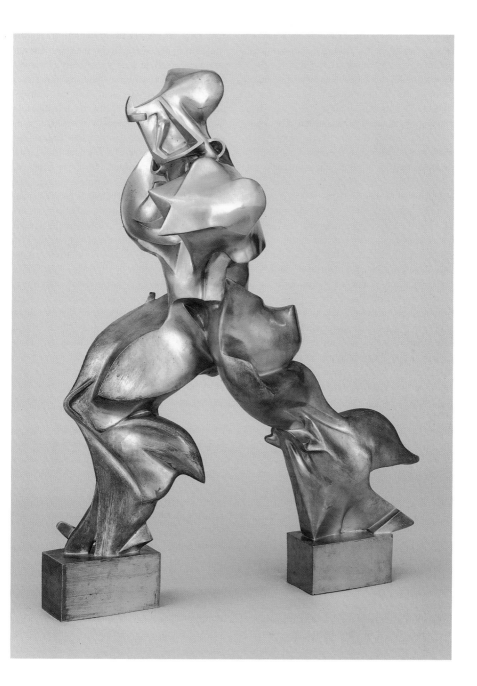

seen in the first Futurist exhibition, where it was discussed in the catalogue: 'In painting a person on a balcony, seen from inside the room, we do not limit the scene to what the square frame of the window renders visible; but we try to render the sum total of visual sensations which the person on the balcony has experienced . . . This implies the simultaneousness of the ambient, and, therefore, the dislocation and dismemberment of objects, the scattering and fusion of details, freed from accepted logic, and independent of one another.'

In his manifesto of Futurist sculpture dated 11 April 1912 Boccioni proclaimed the 'absolute and complete abolition of the finite line and closed sculpture. Let us break open the figure and enclose the environment in it', and in the first exhibition of his sculpture, held at the Galerie de la Boëtie in Paris in June 1913, he presented several works in which he expanded his two-dimensional pictorial fragmentation into three-dimensional interpenetrations of solid objects. According to the manifesto, in 'the intersection of the planes of a book with the angles of a table, in the straight lines of a match, in a window frame, there is more truth than in all the tangles of muscles, in all the breasts and thighs of the heroes and Venuses which arouse the incurable stupidity of contemporary sculptors'. This was easier to say than to prove, and some of Boccioni's first attempts seem, in the photographs that are all that remain, grotesque and unconvincing as three-dimensional forms. But in the *Development of a Bottle in Space* of 1912 [170] he mastered another principle set forth in the manifesto: 'What is created is nothing else but the bridge between *exterior plastic infinity* and *interior plastic infinity*. Hence objects never end. They intersect in infinite combinations of sympathy and repercussions of aversions.' In this work the planes of the table top, dish, and bottle, conceived as abstract positions in space, not only intersect but generate a series of unexpected inter-

relations, in the midst of which the bottle 'unfolds' to reveal its exterior mass and interior volume. Created at least a year before Picasso's bronze *Absinthe Glass and Spoon*, this was a more original achievement, and as a three-dimensional diagram of the development of internal and external spatial energies it preceded and possibly influenced Duchamp-Villon's more mechanistic *Horse* of 1914 [161].

The dynamism which, Boccioni believed, could be conveyed only through motion, 'the means whereby the object enacts its drama and establishes the conditions for artistic creation', was most successfully revealed in the *Unique Forms of Continuity in Space* of 1913 [171]. This is the sole survivor of a series of four striding figures whose titles – *Synthesis of Human Dynamism*, *Muscles in Swift Motion*, and *Spiral Expansion of Muscles* – are aphoristic versions of his conviction that sculpture should consist of actively open rather than passively closed forms. In this last and finest version only a few rectangular forms near the head suggest the 'co-penetration' of objects. Elsewhere the surfaces of the body have been transformed into curved planes which melt into each other or separate along angles suggesting the tempo of the underlying motion. What we see is not so much a figure decomposing into abstract but static planes symbolizing movement, as a scheme of action presented through a sequence of surfaces constantly dissolving and as constantly renewed. It is not, as Boccioni insisted, merely the trajectory of its passage from one state of rest to another, as in the Myronic canon, but an attempt to 'fix the form which expresses its continuity in space'.[49] One can see that here Boccioni has found, as he said, 'not pure form, but *pure plastic rhythm*, not the construction of the body, but the construction of the *action* of the body'. And he made this action manifest with such grandeur and power that his figure, although small in size, achieves a scale that has led to its comparison with that very *Victory of*

Samothrace which Marinetti had so vehemently denounced.

In an earlier construction, now lost, the *Fusion of a Head and a Window* of 1911, in which a cubistically fragmented plaster head was bisected by part of an actual glass and wooden window and by three-dimensional plaster rays of light, Boccioni demonstrated his theory of *arte polimaterico*, or the combination not only of different elements but also of different materials. In his sculpture manifesto he had called for the destruction of the 'entirely literary and traditional nobility of marble and bronze' and for the use of quite other materials

172. Gino Severini:
Dynamic Hieroglyphic of the Bal Tabarin, 1912.
New York, Museum of Modern Art

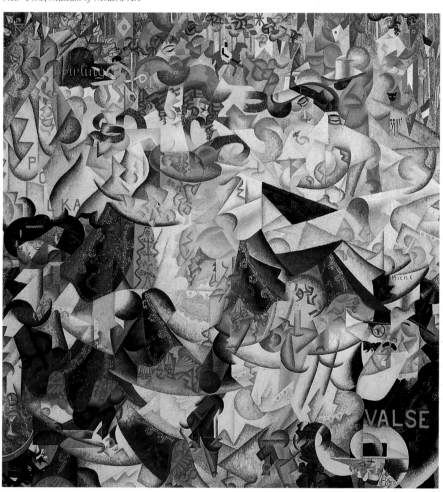

for the expression of sculptural emotion. These he enumerated as 'glass, wood, cardboard, cement, horsehair, leather, cloth, mirrors, and electric light bulbs'. This proto-Dada accumulation of scrap must have been inspired by the early Cubist *papiers collés* and collages he could have seen in Paris in 1912, but Boccioni carried his investigations farther. At his exhibition in Paris in 1913 Apollinaire noted the use of human hair, glass eyes, and fragments of a staircase. Carlo Carrà also explored the dustbins; his collages were often equal in design to those by the French Cubists, and in the choice of materials more adventurous. His analysis of the sensations evoked by materials led him to publish a manifesto on the pictorial expression of 'sounds, noises, and smells'. Its principles have a place in the development of Dada painting and sculpture, and in experimental music.

Gino Severini (1883–1966), whose *Pan-pan Dance at the 'Monico'* (now destroyed) had been a sensation of the first Paris exhibition, chose to remain in France for the rest of his life. His most notable painting, the *Dynamic Hieroglyphic of the Bal Tabarin* of 1912 [172], which must have been in his mind when he wrote the next year of 'dancers reflected in the fairy ambiance of light and colour', glitters with sequins sewn to the surface. This is a more joyous, unpolitical interpretation of the dynamism of modern life, but it is also more 'French', its Futurist energies checked by Metzinger's Cubism. At the outbreak of the War, which some of the Futurists welcomed, Severini painted a number of military subjects, including the well-known *Armoured Train* of 1915 (New York, Collection Richard S. Zeisler), but this was the end of his strictly Futurist activity. After 1920 he contributed to the neo-classical reaction with elegantly stylized landscapes and figure studies.

Giacomo Balla (1871–1958) painted the most familiar as well as the most amusing Futurist picture, *Leash in Motion*, also known as

Dynamism of a Dog on a Leash, of 1912 (Buffalo, Albright-Knox Art Gallery), with its photographic effect of horizontal streaks caused by the rapid passage of small objects, gravel on the pavement, past the eye. In this instance the painter's and spectator's vision remains stationary, like a camera registering with the shutter open. His many *Iridescent Interpenetrations*, begun in 1912, were predominantly geometrical patterns in which he analysed the interaction of colours as light. Although they now have somewhat the look of studio exercises, they must be numbered among the earliest examples of non-objective painting. In other works, notably a series of variations on birds in flight and speeding automobiles, he represented through abstract patterns the dynamic energies of modern life which can be more felt than seen. The rapid trajectories of line and the multiple phases of movement in *Study for the Materiality of Lights plus Speed* [173] almost solved the dilemma that modern painting shares with modern physics. Just as the physicist can determine the position or the velocity of a particle but not both simultaneously, so the painter could represent a form or its movement, but not both at once. Balla's painting of 1914, *Mercury passing before the Sun as seen through a Telescope* (Milan, Dr Gianni Mattioli), is a token of his awareness of the astronomical implications of the new physics. But unfortunately, and all too soon, his looping rhythm became an end in itself, one of the decorative mannerisms which vitiated the 'Second Futurism' of the years after the First World War.

Russolo also remained in Paris, where he worked on his 'Russolophone' or 'Intona-rumori' (Noise-organ) for producing controlled combinations of mechanical sounds. Intellectually, if not technologically, it was a remote ancestor of present-day electronic instruments.[50] A more fruitful Futurist conception was Marinetti's typographical use of 'words set free' (*parole in libertà*). In the printed version of

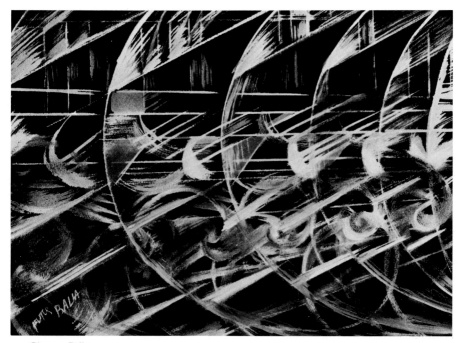

173. Giacomo Balla:
Study for the Materiality of Lights plus Speed, 1913.
Private Collection

his *Zang Tumb Tuum, Adrianapoli, Octobre 1912*, a poem based on his experiences in the Balkan wars and published in Milan in 1914, he freely distributed various type faces, often increasing and decreasing in size, across the page without regard for conventional horizontal or vertical symmetry, in order that words set free from syntax could immediately communicate with the reader's 'wireless imagination'. His ideas were soon adopted by the Dadas, the Russian Constructivists, and the De Stijl artists in Holland. Even today in commercial typography some vestiges of Futurist design may be seen.

Boccioni, Carrà, and Russolo had participated with Marinetti in Futurist demonstrations from 1909 and had exhibited together in Milan in 1911, but the first extensive Futurist exhibition was held in Paris at the galleries of Bernheim-Jeune in February 1912. It was greeted by many critics with dismay and derision, but popular interest was such that the exhibition as a whole was shown at the Sackville Gallery in London the next month, and afterwards at the Sturm Gallery in Berlin, in Brussels, Amsterdam, Munich, Zürich, and eight other cities. In addition to the paintings by Boccioni, Carrà, and Russolo discussed in this text, it included Boccioni's three large *States of Mind* (New York, Collection Nelson A. Rockefeller) and Carrà's *What the Tramcar Told Me* (Milan, Collection G. Bergamini). A second exhibition, held in Rome in February 1913, included Severini's *Dynamic Hieroglyphic* as well as

paintings by Balla and Ardengo Soffici (1879–1964), whose work was close to Parisian Cubism. This exhibition was also seen at Rotterdam, and portions of it later that year in the First German Salon d'Automne in Berlin. The last important exhibition was the First Free International Exhibition of Futurist Art, held in Rome in April–May 1914. It included works by several younger artists, among them Mario Sironi (1885–1961) and Giorgio Morandi (1890–1964), who were only briefly Futurists and whose major achievements were made within other traditions. Everywhere the Futurists appeared, their conduct as well as their art aroused the keenest interest, but it is some indication of the seriousness with which their ideas were received that all the paintings in their first exhibition were sold by the time it left Berlin. Such travels, more extensive than those yet accorded the works of any other group of modern painters, spread Futurism throughout Europe. Traces of its iconography and technical devices soon appeared in the work of the Blaue Reiter artists in Munich, of the English Vorticists, and of the progressive Russian painters briefly in 1912–13. In the United States a group of Futurist paintings was seen at the Panama-Pacific Exposition in San Francisco in 1915.

Italy's entry into the First World War in May 1915 disrupted the movement, which came to the end of its energies the next year with the deaths of Boccioni and of the architect Antonio Sant'Elia (1888–1916), whose manifesto of Futurist architecture (1914) and imaginative drawings of the city of the future are the Futurist contribution to the aesthetics of modern architecture. Meanwhile Carrà had sensed the waning intensity, and in 1916 renounced Futurism to join de Chirico in the Scuola Metafisica. After the War Marinetti continued his literary and political activities with a number of second-generation Futurist artists, but the Fascist dictatorship inhibited the violent individualism which had been the source of earlier strength, and encouraged the weaker decorative tendencies of the surviving artists.[51] Giacomo Balla continued as the leader of this 'Second Futurism' of the 1920s and 1930s, but his earlier invention and humour were missing. Among the later and younger Futurists Gerardo Dottori (1884–1977), Fortunato Depero (1892–1960), and Enrico Prampolini (1894–1956) may be remembered. Prampolini participated in the Dada movement in Zürich and was a member of the Novembergruppe in Berlin in 1918. He was almost alone among Italian artists in maintaining relations with artists outside Italy in the years between the Wars. This came about thanks to his residence in Paris from 1925 to 1937.

Now that more than half a century has passed, the dangers and difficulties of the Futurist programme are apparent. Since its origins were literary and polemical, the pictorial and sculptural concepts were constantly threatened by the dialectical dilemmas which beset movements more verbal than formative. In practice as well as in theory the Futurist aesthetic could not be much more than a support for the weak and a handicap for the strong, since both the vituperative attack on traditional culture and the invocation of war as the supreme expression of a mechanized culture cut off the artist from the future as well as from the past. The manifestos described the tension and pace of modern life, but they failed to provide for the organization of that life in meaningful forms, as the artists of De Stijl, of the Bauhaus, and of Russian Constructivism were soon to do. Futurist painting, even Boccioni's best, remains an unstable combination of Neo-Impressionist brushwork, harsh Expressionist colour, and Cubist drawing, rather than a new synthesis of form and feeling. Nor in retrospect does it seem as if the Futurists' talents were equal to their argument. Most of them are interesting only when they subscribed to Futurism; Boccioni

alone might have achieved distinction without it. But they deserve their moment in history for their concern with motion and their attempt to represent it through unconventional materials and techniques. Their recognition of the inherent restlessness of modern life expressed in man's obsession with technology added a new psychological dimension to modern art.[52]

VORTICISM: 1913-20

So far this history has been limited to establishing certain points of contact between French and British art in the first decade of the twentieth century rather than to charting any distinctively original contributions by British artists to the modern movement as a whole. But, then, in the years just before the First World War – suddenly, unexpectedly, and as it turned out, all too briefly – signs of great promise appeared in the activities of a small group of artists related in varying degrees of sympathy or hostility to Wyndham Lewis (1882-1957) and his Vorticist programme. Lewis had attended the Slade in 1898-1901 and had then lived abroad for eight years, mostly in Paris, where he studied desultorily, but where he read widely in modern continental literature and thought deeply about the place of art in modern society. When he returned to London in 1910 he must have known the emerging Cubism of Picasso and Léger, for there is something of their geometric practice in his own geometrical and mechanical shapes. But what for Picasso and Léger was usually a process of disinterested visual research became for Lewis a means for his polemical assault upon the hypocritical complacency, as he saw it, of contemporary British culture, comparable in function and purpose to his verbal attacks, beginning with his first novel *Tarr*, written in 1914 and published serially in 1916-17.

Lewis's art, although basically Cubist in structure, often seems Futurist in expression, a quality he contracted, although involuntarily, from his exposure to Italian Futurism. Marinetti, who lectured in London in 1913 and 1914, infuriated Lewis, who saw in his aesthetics, if such they were, as well as in the Futurists' paintings which were exhibited at the Sackville Gallery in March 1912, only a 'picturesque, superficial, and romantic rebellion of young Milanese painters against the academies which surrounded them'.[53] He reproached the painters for being 'too mechanically reactive, too impressionistic', and, rightly as we now think, for failing 'sufficiently [to] dominate the content of their pictures'. Lewis believed that an artist should 'pass the test of seriousness in weeding sentiment out of his work', in order to leave it 'hard, clean, and plastic'. But, whether consciously or not, he could not ignore the dynamic vitality implicit in the Futurists' position, however rarely it had been realized in practice, and he founded his own Vortex as a counter-expression of the necessity for artistic involvement in the innermost processes of contemporary experience. The interest and antagonism Lewis's activities provoked subsequently obscured the shades of meaning in the choice of his term. The American poet Ezra Pound, who suggested the word in 1913, defined 'vortex' in the first *Blast* as 'the point of maximum energy'; for Lewis it meant the still circle in the centre of the whirlpool where a degree of 'classic' detachment would allow one to take the measure of the surrounding flux; but through the inevitable association of Lewis and Vorticism with Marinetti and Futurism, as well as by Lewis's use of the Futurists' techniques of clamour and provocation, it acquired some of the connotations of furious, random energy and ceaseless movement associated with the Italian development.[54] Such effects can be seen as early as 1913-14 in Lewis's drawings for *Timon of Athens* (symptomatically a drama of the problems of 'modern' life), where mechanistic armoured and severely geometrical figures clash

in landscapes whose converging perspectives are as hard and brittle as any Léger would shortly paint.

Whether Lewis was properly a painter is debatable, for although he believed himself equally gifted as artist and writer, his literary satire now seems more pertinent, more trenchant, and more sustained than do his paintings and drawings. After about 1920 he almost entirely abandoned polemical painting and drawing for portraiture, but for a while, and as a Vorticist, his work was the most original contribution by any English artist to the modern movement. Drawings like *Planners* (*Happy Day*) of 1913 (London) and *Composition* of 1913 [174] are not only totally abstract, an achievement remarkable enough at that date, but their

174. Wyndham Lewis: Composition, 1913.
London, Tate Gallery

semi-architectural character foretells effects not to be realized until a few years later in the Constructivist work of El Lissitzky, Eggeling,

and Richter (see below, pp. 313 ff., 347-9). These drawings were produced in rare moments of calm while Lewis was pursuing his aggressive activities, so often discounted as self-advertisement by his contemporaries, but which can be seen now to have been dictated by a passionate if tactless attempt to awaken the British public to the nature of the very life it was leading. This culminated in his establishment of the Rebel Art Centre in the spring of 1914, in opposition to Roger Fry's Omega Workshops, from which Lewis had resigned a few months earlier, accusing Fry of having defrauded him of a decorative commission. Fry's attempt to introduce advanced design into decorative production had about it too much of the Arts and Crafts Movement ever to have much chance of success at so late a date, and Lewis was, if anything, not an easy man to work with, so that his relations with Fry would probably have foundered in the end; but the public quarrel did Lewis no good with Fry's friends in Bloomsbury.[55] Nor did the Rebel Art Centre last for long, despite its provocative title: it succumbed a few weeks before Lewis published the first issue of *Blast: Review of the Great English Vortex*. This was a shocking publication for the time, and even today there is a sense of excitement in reading the lists of names of those whom Lewis and his associates wished to 'blast' or 'bless'. The reproductions of paintings and drawings by Lewis and Edward Wadsworth (1889-1949), Frederick Etchells (1886-1973), later an architect, William Roberts, and Jacob Epstein reveal, in their common use of a semi-abstract, semi-mechanical description of form, a community of purpose that can be defined as Vorticist at least to the extent that they were all engaged in creating diagrams to reveal the characteristic, and maximal, energies of modern life.

So propitious a beginning, one which seems to have been on the verge of giving Britain not only a truly modern British art but one which

could have held its own with continental work, as that of no previous artist or group of artists had yet been able to do, was abruptly halted by the outbreak of the War. In 1915 Lewis published a second issue of *Blast* and arranged at the Doré Gallery the first and only Vorticist exhibition; but by then his associates were scattered, and he himself entered military service the next year.[56] After the War Lewis attempted to reassemble the fragments of his Vortex, but the one and only exhibition of his Group X in 1920 proved only that the original excitement had been dissipated.

In his foreword to the catalogue of the 1915 exhibition Lewis, in the manner usual to such pronouncements, defined Vorticism in general terms as 'Activity, Significance, and Essential Movement'. He had been more specific in the second issue of *Blast*, where he stated that modern art should be 'clean, hard, and plastic', qualities he also associated with a 'classic' point of view in opposition to the muddy sentimentality, whether academic or Futurist, which he abhorred. And those are the qualities of his own best work, to be seen on a monumental scale in his commissioned war paintings and, more intimately, in his later portraits. *A Battery Position in a Wood* of 1919 (London, Imperial War Museum) and *A Canadian Gunpit* of 1918 are, above all else, hard and clean, the organic forms geometrical in the mechanical Vorticist manner; for Lewis considered 'the world of machinery as real . . . as nature's forms', and comparable, in these instances at least, to

175. Wyndham Lewis: Portrait of Ezra Pound, 1938. *London, Tate Gallery*

Léger's contemporary pre-Cubist works like the *Nudes in a Forest* of 1909-10. Today, almost seventy years and another war later, we can see that Lewis's refusal to sentimentalize the ugly facts he was called on to record was at the least one way to give them enduring artistic, as apart from documentary, value. Among his portraits the most successful are those of the great modern poets who best understood his genius, the *Edith Sitwell* of 1923-35 (London) and *Ezra Pound* of 1938 [175], and the first portrait of *T. S. Eliot* of 1938 (Durban, South Africa). During those same years, when literature might have consumed all his energies in works so significant as *Time and Western Man* (1927), *The Childermass* (1928), and *The Apes of God* (1930), he produced water-colours and drawings in which abstract yet oddly organic forms establish him as a contemporary of such younger artists as Henry Moore and Graham Sutherland.

Among Lewis's associates only C. R. W. Nevinson (1889-1946) became a convert to Marinetti's brand of Futurism, so much so that in 1914 he committed the tactical error of letting Marinetti sign the name of Lewis and several others of the Vorticist persuasion to the joint manifesto on 'Vital English Art'. Lewis's reply was unexpectedly temperate, and he even invited Nevinson to exhibit in the Vorticist exhibition the next year as a 'Futurist', but the extent of the latter's commitment to Futurism was not apparent until the exhibition of his war paintings at the Leicester Galleries in 1916. By then he had experienced the harrowing effects of trench warfare while serving in the Royal Army Medical Corps. In the best of his early pictures, like *Returning to the Trenches* of 1914 [176], he, like Lewis, saw the war in semi-mechanical terms, really as much Vorticist as Futurist. Technically, his brand of Futurism was heavily

176. C. R. W. Nevinson: Returning to the Trenches, 1914. *Ottawa, National Gallery of Canada*

seasoned by the Cubist conventions of painters like La Fresnaye, and expressively, it was dominated more by the visual appearances of modern life, as in his later paintings and prints of London and New York, than by a truly Futurist desire to disclose the dynamism of violent internal forces.

William Roberts (1895-1980) was the youngest of those invited by Lewis to contribute to *Blast* and to exhibit with the Vorticists, and for that reason his early works were sometimes as close to Lewis as they were to contemporary French Cubism, which he always insisted was the true source of his style. But despite his later protestations that he was, all the time, only 'a plain English Cubist',[57] the drawings he contributed to both issues of *Blast* must be considered commendable examples of Vorticism. They present similar geometrical elements crisply rendered in black-and-white configurations symbolizing the mechanical bias of modern culture. Roberts, like Lewis and Nevinson, was also an official war artist, and in his *Shell Dump* (London, Imperial War Museum) and *The First German Gas Attack at Ypres* (Ottawa, National Gallery of Canada), for the Canadian War Memorial Commission, applied the discipline of Vorticist geometrical patterning to the visual disorder of war. His war pictures, as he said, diverted his interest from abstract design to figure painting. Roberts knew T. E. Hulme (1883-1917), whose philosophical speculations were consequential for the Vorticists, and Hulme's belief that modern art should be 'angular . . . hard and geometrical [with] the presentation of the human body . . . often entirely non-vital, and distorted to fit into stiff lines and cubical shapes' reads like a description of the work Roberts was to do after Hulme's death.[58] But Roberts's figures, however stiff and wooden, with faces like masks and expressions frozen into fantastic grimaces, are neither mechanical nor lifeless. The often elegant equilibrium of his static and hence 'classic' composi-

tions seems imposed only momentarily and with difficulty upon the normally intense animal energies of his lower-class London subjects. Through the singularly crude power of his later work, Roberts is entitled to the unique position in British art which he claimed as his own.

Angular and abstracted figures, much like those of Lewis and Roberts, also appeared in the first mature works of David Bomberg (1890-1957). He was a founder member of the London Group (1914) and exhibited with them until the year before his death, but he was never an official Vorticist, appearing in the Doré Gallery exhibition of 1915 only as an 'invited guest'. Nonetheless the skeletal nudes of his large *Mud Bath* (London) have the same tantalizing but apparently independent resemblances to the geometrical forms in Léger's 'tubist' paintings of a few years before. But not even the large size of *The Mud Bath* hinted of the commanding assurance of *In the Hold* of 1913-14 [177]. In this immense canvas (78 by 101 in.) Bomberg superimposed a grid of sixty-four rectangles upon an even more abstractly conceived composition of men working below decks. The rectangles act, as it were, as prisms refracting the lighted surfaces of the coloured forms in a pattern of complexly interrelated circular rhythms as prophetic as its scale of the much later optical art of the 1960s. At the London Group exhibition in March 1914 *In the Hold* attracted such favourable attention, including a guarded commendation from Roger Fry, that Bomberg, although only twenty-four, was recognized as a leading modern artist. In 1917 he received, like Lewis and Roberts, a commission from the Canadian War Records Office, and his *Sappers at Work under Hill 60, Near St Eloi* of 1919 (Ottawa, National Gallery of Canada) was similarly an accommodation of an abstract Vorticist vocabulary to the realities of a military situation. Bomberg's version is certainly in those terms just as successful and had it remained in England might have helped his reputation.

177. David Bomberg: In the Hold, 1913-14.
London, Tate Gallery

Unfortunately his merits were never adequately appreciated in his lifetime, and poverty forced him to remain abroad for long periods. An indefatigable painter, his later works, particularly his landscapes, show a knowledge of the sensuous properties of paint that has only recently, with the acceptance of Abstract Expressionism and *tachisme*, become better understood.

The only sculptors who can be associated with Vorticism were the Frenchman Henri Gaudier-Brzeska (1891-1915), whose brilliant promise was cut short by his death in action with the French Army, and the American-born Sir Jacob Epstein (1880-1959), who was to enjoy an illustrious if stormy career as a portraitist and creator of controversial monumental works. The fact that both were foreigners who, like the American poets T. S. Eliot and Ezra Pound, found London a more congenial place to live and work than Paris or New York, is a token of the increasing vitality of British art just before 1914. Gaudier-Brzeska's life was too short – he settled in London in 1911 and was active as a sculptor only from 1912 to 1914 – for him to have done more than suggest the directions his art

might have taken, but so quickly were his conventional and tentative experiments in portraiture succeeded by the powerful bust of *Horace Brodzky* (London and Bristol), clearly 'cubified' but with an arrogant thrust of the head recalling Rodin, that it was apparent to his contemporaries that the young man had exceptional gifts. Similarly, he soon passed from the graceful but faded attenuation of the bronze *Dancer* of 1912 (London, private collection) to a strenuously compressed marble *Seated Figure* of 1914 (Paris) which is comparable to Modigliani's *Caryatid* (New York), probably produced in Paris that same year.

In 1914 Gaudier-Brzeska defended modern sculpture against those who would condemn it for lacking Greek qualities, and declared that it 'is continuing the tradition of the barbaric peoples of the earth (for whom we have sympathy and admiration)'.[59] His own response to primitive sculpture can be seen in works whose geometrical properties can be described as Vorticist. Among them are some small brass objects, consistently abstract although entitled *Toy* or *Fish*, and the *Red Stone Dancer* of 1913 [178]. The reduction of various anatomical details to a triangle, circle, and rounded rectangle is 'barbaric' in the sense that they resemble similar abstractions in primitive sculpture, but the tube-like fingers are close both to Léger and to Lewis's figure drawings of this time. Seen from the side, the *Dancer* reveals a complex interweaving of almost abstract sculptural volumes precocious for the date and surpassed only by Lipchitz a few years later. As a draughtsman, Gaudier-Brzeska was a vigorous interpreter of the nude and of animals in delicate line drawings which he described as in his 'chinese manner'.

Epstein had been born and brought up in New York, where his early surviving drawings provide a vivid account of the Polish-Jewish environment of his youth. He worked for a time as an assistant to George Grey Barnard, 'the only American sculptor one could have any

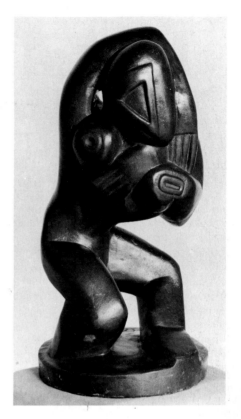

178. Henri Gaudier-Brzeska: Red Stone Dancer, 1913. *London, Tate Gallery*

respect for',[60] but soon felt the American artist's usual urge to find out more about his art, and himself, in Paris. During his three years there, 1902–5, he studied at the École des Beaux-Arts and Julian's, and was among the first artists of the new century to discover, apparently on his own, the treasures of primitive art in the Louvre, especially the 'early Greek work, Cyclades sculpture, . . . the Lady of Elche, and the limestone bust of Akenaton'. When in 1905 he was wondering whether to settle in London, a visit to the British Museum, where he saw similar collections of ancient and primitive art, 'settled the matter' for him.[61] In his first important commission, the eighteen over-life-size nude figures for the British Medical Association building in the Strand, his study of primitive and early classic art can be detected in the self-conscious striving for expressive disproportion as well as in the complete nudity which so offended the public at the time. Although the figures were wantonly mutilated in 1935, ostensibly for safety's sake, by the government of Southern Rhodesia, which had taken possession of the building, they must from the beginning have been not entirely pleasing. Epstein's early primitivism was still contaminated by a strain of melancholy Symbolism not unlike Minne's, and the combination of a frigid idealism in the naked bodies with extreme realism in certain heads resembles the contemporary, but quite unrelated work of Vigeland in Norway. This uneasy association of realism and symbolism was more powerfully and more decoratively resolved in the tomb of Oscar Wilde, finished in 1912 and installed that summer in the cemetery of Père Lachaise in Paris. Once again the nudity of the male figure proved so shocking that for many months it was hidden by the French government under a tarpaulin, but apart from that the rigid horizontals of the limbs of the figure flying in profile to the right, and the parallel striations of its gigantic rectangular wing, are impressively contrasted with the heavy brooding face beneath its exotic figural tiara. If this 'symbolic work of combined simplicity and ornate decoration', as Epstein described it, seems a strangely ponderous memorial for the author of some of the wittiest comedies in the English language, it is appropriate for the man who also composed, in French, the heady perversities of *Salome*.

During the months he spent in Paris in 1912 Epstein encountered Picasso and Brancusi, and Modigliani, with whom he thought for a time of sharing a studio. Any of the three could have introduced him to primitive art, had he not already known it, but his association with them may have encouraged him to take a new and longer look at such artefacts. During the next five years he created those of his works which were closest in form and spirit to primitive art as well as among his most original contributions to British modernism. They include two versions of *Venus* (Baltimore Museum of Art, The Wurtzburger Collection, and New Haven, Yale University Art Gallery). In the second and larger version – it is 8 feet tall – the limbs and features are more emphatically geometrical, the face merely a straight undifferentiated plane, and the total effect is that of some austere and icy fetish of a mechanistic culture. Something of the same totemic effect is communicated by Gaudier-Brzeska's colossal white marble head of *Ezra Pound* (estate of Ezra Pound), which was originally to have had a phallic significance. Epstein's *Venuses* stand upon coupled doves, a subject developed by the sculptor in at least three separate groups of birds. These sculptures, with a few smaller figures in flenite and plaster, the marble *Mother and Child* in New York, and the *Rock Drill* [179], comprise the works which brought Epstein into communication with the London Group and with Vorticism, although he was never actually a member of Lewis's Rebel Art Centre.

That Lewis published a drawing for the

179. Jacob Epstein: The Rock Drill, 1912–13. *New York, Museum of Modern Art*

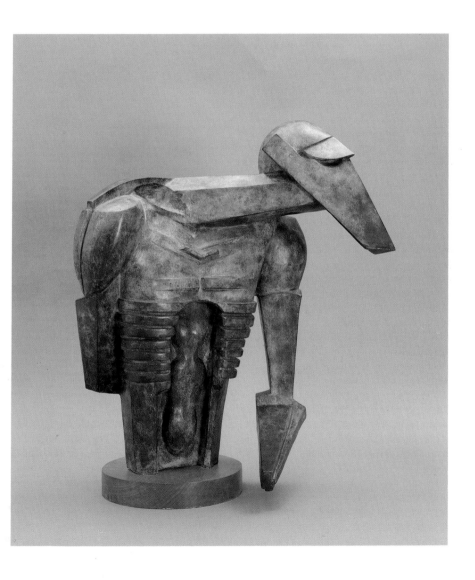

Rock Drill in the first issue of *Blast* and that Pound named a group of his later *Cantos* (Nos 85–95) after it suggest how closely it corresponded to their conception of the new art (the *Rock Drill*'s head and shoulders can be almost exactly matched in Lewis's contemporary *Timon* drawings). Even if the work had only a passing interest for Epstein and was unique in his *œuvre*, it remains, none the less, a singular sculpture, alarming as a bleak prognostication of the mechanization of human society, and human sex, and remarkable as one of the earliest instances of the combination of actual and artistic forms. Epstein had purchased a second-hand drill upon which, as he later wrote, he 'made and mounted a machine-like robot, visored, menacing, and carrying within itself its progeny, protectively ensconced. Here is the armed, sinister figure of today and tomorrow. No humanity, only the terrible Frankenstein's monster we have made ourselves into'. Unfortunately, the sculptor 'later lost interest in machinery', discarded the drill, and had only the figure itself cast in bronze. This was a pity, because without its real drill the work was meaningless and soon slipped from sight. Although examples are now in a number of museums, the disappearance of this uncanny combination of an invented and a mechanical, mass-produced form deprived Epstein of his rightful place in that sequence of technical experimentation which includes Malevich, Schwitters, and Duchamp.[62]

The War put an end to Epstein's brief activity as a Vorticist – he did not exhibit with the others in 1915 – and to the kind of extreme and original use of materials exemplified in the *Rock Drill*. Only a few months later, in his bronze bust of *Lord Fisher* (Imperial War Museum), he hit upon the now familiar formula for expressive pathos which henceforth separated his much admired portraits from those in a moderately Renaissance or Rodinesque manner which he had made during the

previous decade. He stressed the projection of the features, treated the eyes and mouth as dark pits, and let the surface of the clay remain roughened by his tools and fingers [180].

180. Jacob Epstein: Bust of Kramer, 1921. *London, Tate Gallery*

Even when the likeness eluded him, as sometimes happened, more often with women than with men, the final object always put the spectator in touch with the seemingly turbulent encounter of the artist with his subject and his material.

Most of his later sculpture, including the portraits and the large commissions which came towards the end of his life, was in metal and demonstrated his immense talent, when he took the time, for creating the most lustrous surfaces that had been seen since Rodin's. Earlier there had been only two important commissions after the *Oscar Wilde* – the *Rima* of 1925 for the W. H. Hudson Memorial in

Hyde Park, and *Night* and *Day* of 1929 for the London Transport Headquarters. His other carvings, immense and cumbersome, were made for his own pleasure and usually met with violent public and critical disapproval. Even today one can sympathize with those who at first sight disapproved of the swollen *Genesis* (1930), the abrupt and summary *Ecce Homo* (1934), or the naked, straining *Adam* (1938), but one can also think that such figures were proof of his ability to obtain the maximum expressive content with the minimum manipu-

lation of form. In them, and in the gentler *Lazarus* of 1947 (New College, Oxford), the energies which were too often dissipated in his mannered and rhetorical bronze groups are contained and controlled by his understanding of the stoniness of stone. Epstein's reputation has been curiously compounded of praise for his bronzes and vilification for his carvings, but by enduring the blame without deviating from his intentions he kept the sculptor's art more squarely before an antagonistic public than any other artist was able to do elsewhere.

CHAPTER 6

ABSTRACT AND NON-OBJECTIVE ART

The premises for the creation of works of art having little or no relation to phenomenal appearance had long been implicit in post-Renaissance artistic theory. Artists and critics so various and so committed to the creation and evaluation of representational images as Reynolds, Ruskin, and Baudelaire had been aware that the shapes within a painting or sculpture could be conceived and even seen as existing independently of the appearances they stood for. When the concept of a form as an independent artistic entity was thus separated from the network of representational shapes in which it occurred, the possibility existed for the creation of works abstracted from nature, or 'abstractions', as well as for the invention of totally new forms having no relation at all to objective nature, the so-called works of 'non-objective' art. It is proper that the latter adjective usually denotes objects of a geometrically constructed or architectural character because the term was first widely used with reference to the early works of the Russian Constructivists. 'Abstract' is a more general term. An abstraction may be non-objective, but the word also refers to many kinds of non-realistic painting and sculpture, especially to those in which references to nature are remote or oblique, as in Cubist, Futurist, and Expressionist art.[1]

Towards the middle of the nineteenth century there was a quickening awareness of the expressive character of artistic form considered apart from its representational function. In his *Salon* of 1846 Baudelaire insisted that 'painting is only interesting in virtue of line and colour', and in 1855 he wrote that

Delacroix's colour *'thinks for itself* independently of the objects which it clothes'. Walter Pater, in his essay on 'The School of Giorgione' (1877), pointed out that the 'essential pictorial qualities must first of all delight the sense'. before they can address themselves, as poetry or science, to the understanding. His famous statement that 'all art constantly aspires towards the condition of music', which in itself is the least objective form of expression, found an echo in the American philosopher George Santayana's lectures at Harvard University in the early 1890s. After noting that colour may produce a disagreeable as well as pleasant effect, 'almost like a musical discord', he told his students that 'a more general development of this sensibility would make possible a new abstract art, an art that should deal with colours as music does with sound'.[2]

These were only a few of the occasions when the fundamental artistic character of a work of art was traced to its constituent elements of line, colour, shape, and texture, rather than, as in academic and idealist systems, to the character of the events or things portrayed. A declining interest in representation was counterbalanced by an increasing awareness of such subjective aspects of creativity as the particular stylistic mannerisms of a given artist and his right to self-expression, meaning his freedom to adapt and control references to objective experience according to his own conception of artistic process rather than to any external, *a priori*, general tradition. The more articulate artists expressed this point of view in their writings. Van Gogh and Gauguin were as much concerned with the way a subject could

be treated as they were with the subject itself. While still in Holland, Van Gogh had said that 'colour expresses something in itself', and Gauguin's argument can be detected behind his statement from Arles in November 1888 that 'one may make a poem merely by arranging colours in the same way that one can say comforting things in music'.[3] Both painters were clearly aware that shapes, colours, and lines could be manipulated for expressive rather than descriptive purposes. Throughout Later Impressionist and Symbolist painting the connexions between the work of art as an object of interest for itself and the object in nature to which it referred became more and more tenuous. In landscape painting especially, in the harbour scenes of Seurat [18] and in the later works of Monet [11], the tactile qualities of the orderly or agitated brushwork led the eye to explore the surface rather than to look through it to forms conceived as existing behind or beyond it. When in 1890 Maurice Denis proclaimed that a picture, before it is anything else, is 'an arrangement of coloured shapes', he defined an existing situation quite as much as he declared for a new one.

It may now seem odd that so many years intervened before the hypothecation of artistically self-sufficient forms and the creation of objects held to be of value entirely in and for themselves. But that may only be because we have forgotten that the creation of such forms required the interruption of a hitherto unbroken connexion between works of art and their sources in nature. Nor should we worry that the exact circumstances under which that bond was finally severed are still and indeed may always be disputed, for it is probable that there never was a particular moment when a particular individual for the first time self-consciously set out upon the new path. Rather, a number of artists in several different places and at various times, although on the whole within

a year or so of 1910, came gradually to understand the limitless potentials of design divorced from representation. In some instances the discovery may have been largely accidental, as Kandinsky implied. In others it may have been a more gradual process, fostered by the realization that certain elements in decorative design, especially those of Art Nouveau, when isolated from their functional context, possessed independent expressive properties. After 1900 there were many occasions when a decorative motif or a compositional study, as yet unencumbered with figures, attracted attention to itself, just as there were occasions when representational factors were so slightly indicated, as we have seen in the work of Gustave Moreau, that a study for a figural composition could be taken for a problem in abstract design. It is difficult, if not actually misleading, to distinguish too closely between the abstract formal character of certain decorative configurations and non-representational works specifically created for aesthetic rather than decorative purposes. But the increasingly independent character of certain subordinate and decorative elements in the works of such painters as Gauguin, Van Gogh, Toulouse-Lautrec, and Munch [37, 44, 55, 59] encouraged the development of the totally abstract art which followed soon after.

If priority of place, date, and person cannot be assigned with any certainty, no active artistic centre was immune from these discoveries. We have already observed a form of abstract expressionism in Munich after 1910 in the work of Kandinsky and Franz Marc. They had been encouraged by the colour experiments of Robert Delaunay, whose Orphic work included what was probably the first totally abstract painting by a French artist, the *Disc* of 1912. Shortly thereafter the same degree of abstraction was achieved within Futurism by Giacomo Balla. In Germany

Schmithals's Jugendstil designs [64] and Adolf Hölzel's colour studies during the decade after 1900 may have been less intentionally independent of decorative theory, but they contributed to the understanding of abstract expression. And by 1915 it would have been difficult to detect the sources in nature in the paintings of the Swiss Augusto Giacometti (1877-1947). Even if flowers or water were the source for his brilliant and boldly brushed canvases, the references to actual objects are so faint that the pictures can confidently be enjoyed as very nearly total abstractions.

These were, however, isolated and sporadic episodes in comparison with the sustained and continuous development of abstract theory and practice by groups or associations of artists in Russia, the Netherlands, and Germany during and immediately after the First World War. The coherence of their programmes, developed in relation to contemporary political and social problems, and exemplified by works of the highest integrity and interest, have established abstract and non-objective art as fundamental and apparently permanent components of twentieth-century artistic expression.

ABSTRACT AND NON-OBJECTIVE ART
IN RUSSIA: 1904-22

In Russia before 1914, as in France and Germany during the first few years of the new century, Symbolist art was quickly superseded by Expressionist and abstract tendencies which culminated, just before and during the First World War, in important and influential contributions to the modern movement. The members of the Russian avant-garde may not have been as numerous as their colleagues in Paris, but they were more aggressive, and also in comparison with those in London and New York more inquisitive and adventurous. The

history of Russian modern art could be written in the succession of independent exhibitions, large and small, where contemporary Russian work held its own beside advanced art from other countries. These were to be seen not only in St Petersburg and Moscow but in such provincial centres as Odessa, Kharkov, and Kiev. Only in geographical terms was pre-war Russia remote from Western Europe. And if the Russian contribution is still less known and less clearly documented, it is in one respect at least as crucial as that of any other country's. In Moscow and St Petersburg between 1913 and 1920 the aesthetic presuppositions for a completely abstract, or as it is more accurately called, non-objective, art were defined and put into practice.[4]

In St Petersburg the Mir Iskusstva group continued to hold exhibitions of contemporary Russian work until 1922, but its effective direction of the modern movement faltered after 1904, when publication of its journal ceased, and Benois, Diaghilev, and Bakst began to spend more time in France than in Russia. Moscow then took the place of St Petersburg as a centre for experiment in modern forms of expression. Perhaps nowhere else in Europe were young artists so well acquainted with advanced French art which could be seen in exhibitions and in the extraordinary collections of the wealthy Moscow merchants. The best known were those of Sergei I. Shchukin and Ivan A. Morozov, which were open to the public at stated times. Shchukin admired the Post-Impressionists, particularly Cézanne and Van Gogh, but he also recognized the quality of Matisse before 1906 and acquired thirty-seven examples, including the murals of *The Dance* and *Music*, which he commissioned in 1909. An early and avid collector of Picasso, he owned forty paintings, among them important 'Negro' and Cubist canvases. Morozov preferred the Post-Impressionists and Nabis. His Cézannes

and Gauguins [38] were among the finest, he owned a much admired series of panels by Maurice Denis illustrating the legend of Cupid and Psyche, and he also commissioned two murals of the Mediterranean from Pierre Bonnard.[5]

A smaller but excellent collection of French art containing important paintings by Rouault had been formed by Nikolai Riabushinsky. It was destroyed by fire in 1911 and is known only from reproductions in *Zolotoe Runo* (*The Golden Fleece*, 1906-9), the periodical which Riabushinsky founded to continue the work of *Mir Iskusstva*. In the earlier issues much space was devoted to late Symbolist painting and to the exhibition in 1907 of the group known as Golubaya Roza (The Blue Rose) which included admirers of the Symbolist painter Viktor Borissov-Mussatov (1870-1905). Ria-bushinsky, however, was more interested in increasing his compatriots' understanding of contemporary French art, and to that end sponsored three exhibitions in the name of his magazine. The first in 1908 contained complementary sections of French and Russian paintings hung separately and so discussed in successive issues of *Zolotoe Runo*.[6] The Russian works were still faintly Impressionist or Symbolist in the tired traditions of St Petersburg, but the French selections brought to Moscow the latest developments in Paris. In addition to paintings by Degas, Gauguin, and Van Gogh, whose *Night Café* [43] was lent to the exhibition by Morozov, there were extensive contributions by the Nabis, by the Neo-Impressionists then enjoying renewed favour throughout Europe, and by all the Fauve masters responsible for the recent sensations at the Salon d'Automne. The remaining *Zolotoe Runo* exhibitions, in January and December 1909, marked the Russian painters' assimilation and then rejection of Fauvism, whose pictorial abbreviations they exchanged for coarser and more consciously naïve symbols.

LARIONOV, GONCHAROVA, AND RAYONISM

This assertive Russian primitivism, which is a parallel to the discovery of non-European art by the German and Russian members of the Blaue Reiter in Munich, can be followed in the works of Riabushinsky's young colleague Mikhail Larionov (1881-1964) and of Larionov's friend and pupil Natalia Goncharova (1881-1962). The latter was one of the first younger Russian artists to appreciate the non-naturalistic design of ancient Russian icon painting, well before the epochal exhibition of cleaned and restored icons held in Moscow in 1913. Her admiration for peasant embroideries, wood carvings, and early Russian enamels accounts for the boldly simplified outlines of her paintings of peasant life, Russian counterparts of French Fauvism but with more emphasis, in the manner of German Expressionism, on theme and content. Her ability to control large and brilliant decorative ensembles attracted the attention of Diaghilev, who commissioned her to design the settings and costumes for *Le Coq d'or* (1914), *Les Noces* (1923), and the revival of *The Firebird* (1926).[7]

Larionov's primitivism was less learned but more profound. He, too, was aware of Russian folk art, especially the *lubki* (singular, *lubok*), popular wood engravings circulated among the peasantry much like the French *images d'Épinal*, and of children's art. During his nine-months' military service in 1908-9 he discovered the pictorial expressiveness of vulgar symbols scrawled on walls and fences by the totally untutored. They soon appeared in his 'soldier' series, where the coarse drawing, inept perspective, and commonplace subjects (soldiers at cards, in the barracks, at the barber's) were intentional affronts to tradition, whether academic or Parisian.[8] A more lyrical primitivism emerged in his work by 1912, in paintings of the seasons, where the two-dimensional figures

were drawn with childish, more than childlike, clumsiness, and the combination of pictorial signs and lettering awkwardly disposed in rectangles spelled out a banal allegory [181]. Such artistic crudity was without parallel in earlier European art; beside it Campendonk's painting looks self-conscious and the Douanier Rousseau's refined. In 1922 Larionov reworked *Winter* as a backdrop for Diaghilev's production of Stravinsky's *Renard*, in its own way a 'primitive' reduction of the sumptuous polyphony of his earlier style to stark and dissonant tones.

Larionov's primitive paintings were shown in 1910 at the first Bubnovyi Valet (Knave of Diamonds) exhibition, which he helped to arrange after he had parted company with Riabushinsky, whose French tastes he now rejected. The meaningless title, which Larionov chose because he liked its sound, covered a mixture of tendencies. Cubist paintings by Le Fauconnier, Lhote, Gleizes, and Metzinger were seen beside the work of four Russian artists who had just been expelled from the Moscow art school for 'leftist' tendencies, which meant too pronounced an admiration for Cézanne. In the work of Aristarkh Lentulov (1878-1943), Piotr Konshalovsky (1876-1956), and Ilya Mashkov (1884-1944), Fauvist drawing and colour were combined with subjects reminiscent of German Expressionism. Only the more directly Cubist work of Robert Falk (1886-1958) justifies the description of all four as 'Cézannists'. On the other hand, Larionov's lack of refinement was matched in paintings by Vladimir and David Burliuk. Both brothers had participated in many independent exhibitions and by 1910 were working in a consciously simple manner. They had studied in Munich and had been invited by Kandinsky to participate in the Blaue Reiter exhibitions. Through their influence a group of German paintings were seen in the second and third Bubnovyi Valet exhibitions of 1912-13. Vladimir Burliuk (1886-1917) died in the First World War. David (1882-1967) left Russia in 1920 for the United States, where for many years he interpreted a variety of subjects, often socially critical, with

181. Mikhail Larionov: Autumn, 1912.
Paris, Musée National d'Art Moderne

182. David Burliuk: The Headless Barber, 1912.
Private Collection

a heavy Expressionist hand. In an early work, the *Headless Barber* of 1912 [182], a fantastic subject, reminiscent of Gogol's fragmented images, has been taken apart, in the manner of the Cubists, and rearranged with a wild élan suggestive of Futurist dynamics.

Larionov and Natalia Goncharova resigned from the Bubnovyi Valet in 1911, accusing their colleagues of decadence and conservatism. Larionov then organized a series of exhibitions on his own. In the first, Oslinyi Khvost (The Donkey's Tail) in 1912,[9] he and Natalia showed

their primitivist works, but they also introduced the early and still representational paintings of Vladimir Tatlin and Kasimir Malevich, the leaders of Russian modernism during and just after the War. The next year in his Mishen' (Target) exhibition Larionov launched the movement he called Rayonism (in Russian Luchism), because his compositions were constructed of rays of light struck from invisible surfaces, intersecting and dissolving in constantly changing patterns. This was scarcely a movement in the usual sense, for there were

never more than a few Rayonist works, all executed by Larionov and Natalia Goncharova, but as a stage between primitivism and the non-objective and constructive developments which followed, Rayonism was an important focus of artistic theory. The irritable modernity of Larionov's manifesto of 1913 recalls the tone of Italian Futurist pronouncements: 'We declare the genius of our days to be: trousers, jackets, shows, tramways, buses, aeroplanes, railways, magnificent ships – what an enchantment – what a great epoch unrivalled in world history . . .'[10] The sources of Larionov's inspiration in the dominant contemporary European movements, as well as his original contribution, are clear. In a typically Rayonist painting the structure is fundamentally Cubist, the feeling for dynamic movement Futurist, yet the whole is so totally abstract that no evidence of the position or presence of any natural object can be seen [183].

Larionov's few completely Rayonist works were his last contributions to the Russian modern movement. Like Diaghilev he was drawn to Paris, where he and Natalia Goncharova held a large retrospective exhibition in 1914 which drew a favourable notice from Guillaume Apollinaire. He was recalled to Russia at the outbreak of war, but was soon invalided out, and in 1915 he and Natalia returned to Paris, where they lived thereafter. In his designs for the ballets *Soleil de nuit* (1915), *Les Contes russes* (1917), and *Renard* (1922) he revived his earlier primitive and folklorist manner.

Natalia Goncharova shared his researches and painted a few compositions with spiky clusters of rays, although the object was usually recognizable, as in *Cats* (dated 1910 but probably painted in 1911) [184]. In her more abstract *Electricity* of 1911–13, and the *Cyclist* of 1912–13 (Paris, the artist's estate), she interpreted energy and motion according to more orthodox Cubist and Futurist principles.

183. Mikhail Larionov: Rayonist Construction, c. 1912. *Present location unknown*

184. Natalia Goncharova: Cats, c. 1911. *New York, Guggenheim Museum*

MALEVICH AND SUPREMATISM

In the paintings which Kasimir Malevich (1878–1935) sent to the Donkey's Tail and Target exhibitions in 1912 and 1913, and which he described as 'Cubo-Futurist', the peasant themes already used by Natalia Goncharova were treated as massive figural constructions much like Léger's early 'tubular' works. Large cylindrical forms sharply lighted along one vertical edge served for limbs and bodies. The landscape backgrounds, at first in a simplified perspective, were soon broken into sequences of smaller angular planes which supplied only as much space as the principal figures required.

185. Kasimir Malevich: The Knife Grinder, 1912. *New Haven, Conn., Yale University Art Gallery*

The reduction of the body to a curved, triangular plane, like the stylizations of the figure in peasant embroideries and other folk art, was close to Natalia's work at that time. Malevich later acknowledged their relationship: 'Goncharova and I worked more on the peasant level. Every work of ours had a content which although expressed in primitive form revealed a social concern. This was the basic difference between us and the Bubnovyi Valet group which was working in the line of Cézanne.'[11] The reference to content places Malevich squarely between the socially conscious realism of the nineteenth-century Peredvizhniki ('Wanderers') and the official Socialist Realism of the 1930s; for he always insisted on the ethical and philosophical values of his art.

Meanwhile he explored the new pictorial techniques which were succeeding each other so rapidly in the West. There are Futurist as well as Cubist ingredients in the *Knife Grinder* of 1912 [185], exhibited in Moscow at the Target in 1913. The cylindrical, machine-tooled fingers and the architectural forms, the stairs and section of a banister, anticipate Léger, but the mechanistically repeated fragments of the figure representing the sideways movements of the man's head, arms, left leg, and foot are Futurist. The brilliant colour, rising through blues and greens to clear yellow, is typical of Malevich's work at this time and more original. It is 'primitive' in its intensity and sets his painting apart from French Cubism and Italian Futurism.

The clumsy label of 'Cubo-Futurist' suggests its double derivation, even if in Russia 'Futurist' usually had literary rather than pictorial connotations. Marinetti is known to have visited Russia in 1914 and may have been there earlier, but his influence was felt more by poets than by painters. Even so, the Russian Futurist poets were less interested in a strict application of dynamism and *velocità* than in celebrating the excitements of contemporary life in a poetic diction enriched with Symbolist images. A distinctive aspect of Russian Futurism was the close relation between poets and painters. The Burliuk brothers were poets, the poet Alexei Kruchenikh had been a painter, and painters frequently illustrated Futurist poetry. What counted was their common desire to express the intensities of modern life, not their espousal

186. Kasimir Malevich:
Suprematist Composition, White on White, c. 1918.
New York, Museum of Modern Art

of a Futurist technique in the strictly Italian sense.

The Futurist elements disappeared very quickly from Malevich's work. By 1915 he had mastered the technique of collage and discarded it for a totally abstract design. The development towards abstraction can be traced in *Woman beside an Advertising Pillar* (Amster-dam) and *Private of the First Division* (New York), both of 1914, in which the figural elements can be reconstituted only with difficulty. The combination of cut paper, fragments of actuality (postage stamps, package labels, and the like) and actual objects (a clinical thermometer in the *Private*) anticipate Schwitters's *Merz* collages by several years (see below,

pp. 384–5). Even more remarkable are the painted geometrical elements, the squares and rectangles. Placed as if in front of the pasted paper, they live their own lives, freely suspended in a space devoid of the ambiguity and multiplicity created by the superimposed shapes behind them. When Malevich exhibited these collages and other paintings composed of strangely assorted elements at Tramvai V (Tramway V), the first Futurist exhibition in St Petersburg early in 1913, he called them 'nonsense realist works'.[12] The odd term may indicate that for him they were no longer so important as the pictorial reality he was in the process of discovering and which he first publicly proclaimed as Suprematism the following year.

Malevich always insisted that he had painted the first Suprematist 'element', a black square on a white square ground, in 1913, and he could summon as supporting evidence a study for the backdrop of a Futurist opera, *Victory over the Sun*, produced in St Petersburg in December of that year, in which a square divided diagonally into black and white areas was placed within a square border.[13] His independent Suprematist paintings were not seen until two years later, when the *Black Square on a White Ground* and other paintings containing polygonal and trapezoidal forms were shown in St Petersburg at O.IO, the 'Latest Futurist Painting Exhibition'. Three years later he painted his most famous Suprematist canvases, the series entitled *White on White* [186]. In each painting the two squares are identical in hue, so that the smaller diagonal one is only perceptible through differences in the brush strokes.

Like many of his contemporaries, Malevich believed that the external world was no longer of use to the artist. Painting was the art of discovering visual analogues for the values of consciousness (including unconscious as well as conscious experience), the only medium in which feeling can be known and re-experienced. By Suprematism he understood 'the supremacy of feeling in creative art', which could best be stated by the square, the most elementary, fundamental, and hence supreme artistic element, and he pointed to his drawing of the black square on a white ground where 'all references to ordinary objective life have been left behind and nothing is real except feeling . . . the feeling of non-objectivity'.[14]

Malevich was not trapped by his squares but developed a logical progression of shapes which gradually became more elaborate as they corresponded to more complex states of feeling.

187. Kasimir Malevich: Suprematist Composition, Black Trapezium and Red Square, after 1915. *Amsterdam, Stedelijk Museum*

The square was followed by the circle, the triangle, two equal squares side by side, two squares unequal in size but balanced by differences of colour (a small red square outweighs a large black square), by squares in different positions (a small square tilted compensates for a large static square). His elements became more varied in size, shape, and in their relation to the rectangular picture surface. From the end of 1916 he used curved shapes and lines, and even introduced effects of the third dimension when he allowed the farther edges of tilted planes to become indistinct and merge with the background. At the same time, to his first few colours, black, red, grey, and white, he added more, not only primaries and complementaries but mixed hues in different values. This increasing complexity can be seen in the large Suprematist composition *Black Trapezium and Red Square*, which must be dated after 1915 [187]. A dynamic activity occurs in the relations between the groups of large and small geometrical elements (among which is the 'supreme' element, the square), floating against the white ground ('the free white sun, infinity'). In the presence of such paintings it is possible to understand why Malevich felt that he had with his 'own will' and 'on the basis of criticism and philosophy, drawn out of existing elements new phenomena'.

If, in retrospect, the first and last demonstrations of the purest Suprematism, the *Black Square on a White Ground* and the bafflingly indeterminate *White on White*, seem his most imaginative works, the intermediate and more spatially intricate paintings were more influential. They were closely studied, for example, by Lissitzky (see below, pp. 317-19), who turned their lofty philosophical implications to more practical account. Malevich, moreover, was a devout Christian mystic who often manoeuvred his geometrical elements into formations resembling a Latin cross, not unlike similar shapes found on the decorative borders of saints' gar-ments in early Russian icons. Vladimir Tatlin (1885-1953), on the other hand, was a dedicated materialist. The conflict between the former's belief in art as an independent spiritual activity and the insistence of Tatlin and the younger Constructivists that its primary purpose was social and utilitarian eventually cost Malevich the leadership of the modern movement in Russia. As early as 1915 at the O.IO exhibition in Petrograd he and Tatlin disagreed so strongly that they and their followers had to be shown in separate rooms. Malevich exhibited in Moscow in the first years after the Revolution and taught briefly at Vitebsk, but in 1922 he was sent to Petrograd, where he taught at the Museum of Artistic Culture for six years. By then he had announced that Suprematism was finished. His own painting became figurative, and he turned to architectural theory and design. Few of his highly abstract architectural models seem to have been preserved, but photographs which circulated in the West influenced the development of that phase of European architectural theory and practice known as the International Style (see below, p. 333). His Suprematist paintings were seen in Berlin in 1922, and in Germany again in 1926, when he visited the Bauhaus. In 1958 the Stedelijk Museum in Amsterdam acquired thirty-five paintings, with architectural drawings and other materials, which he had left behind in Germany. They have been exhibited in various countries in recent years and confirm his position, with Mondrian in Holland and Kandinsky in his German period, as one of the principal inventors of abstract geometrical art.[15]

CONSTRUCTIVISM

The new society became a reality within a few months in 1917, with the abdication of the Czar in March and the overthrow of Kerensky's provisional government by the Soviets the

following November (October, according to the Julian calendar then in use in Russia). The confusion during the first years of the Communist régime, increased by conflict with Russia's former allies and the Civil War with the Whites which lasted until late in 1920, worked to the advantage of the pre-revolutionary members of the avant-garde in St Petersburg and Moscow, most of whom cast their lot with the new government. Other artists, especially those who had been associated with Mir Iskusstva, the decorative Symbolists and belated Impressionists, chose to emigrate, like their patrons among the aristocracy and upper middle-classes. In Berlin, Paris, London, and New York they maintained for two decades the traditions of pre-war Russia, but were powerless to affect the course of artistic events.[16] At home the more academic painters, skilled in naturalistic techniques, were dispossessed when the academies and schools were dissolved, but they lay low. When conditions were more settled, they re-emerged to play a determining part in the development of Socialist Realism. Meanwhile, many of the leaders of the avant-garde were given positions in the new state institutions, where they worked to formulate Constructivism. This was the last of the modern Russian movements, but long after it had been discredited at home it continued to affect the development of modern art throughout the western world. In its brief and strictly Russian phase Constructivism encompassed two divergent and even antagonistic attitudes towards the creation and function of art. The first in date, although ultimately the shorter-lived, can be identified with Tatlin's conviction that art has a social purpose, that it is, in the words of a contemporary apologist, 'the product of social life',[17] and that consequently the artist must subordinate his individuality to the common good. In this sense of the term, which was in general use by 1920, the stress fell on structuring, on building new forms in new materials

appropriate for new social organizations. The other point of view descends from Kandinsky's and Malevich's belief that art is primarily a personal rather than public experience, however universal its eventual application may be, and that its highest results are independent of political or social considerations. This attitude, with its moral and spiritual overtones later reinforced by the formal dialectic of Gabo and Pevsner (see below, pp. 352 ff.), remains after half a century a vital factor in contemporary abstract art. In both developments, however, the insights and discoveries of scientific theory and their application to technology and modern methods of mass-production are considered essential and inescapable aspects of contemporary experience.

Because the decade between the October Revolution and the commencement of the first Five-Year Plan in 1928 was one of almost continuous social and economic crisis, and because the artistic history of this period was subsequently obliterated from the Soviet record after the promulgation of the doctrine of Socialist Realism in 1932, the history of Constructivism is not easy to follow.[18] Between 1918 and 1924, when official opposition to progressive art hardened, many new schools, artists' organizations, and museums were projected, combined, and dissolved under different government agencies in a sequence so swift and bewildering that even the participants have found it difficult to set the record straight. In addition, special pleading by and for certain surviving artists has not clarified the issues. Until a complete documentary history can be written, we must be content with a general outline. Notwithstanding these limitations the significance of the principal events is reasonably clear, as well as the relation of the arguments which accompanied them to the general premise that a new society requires a new art.[19]

The first attempts to lay the bases for the new art were undertaken in 1918 under the

tolerant but watchful eye of the famous first Commissar of Education, Anatoly V. Lunacharsky (1875-1933). A dramatist and playwright interested in art and aesthetics, he had seen something of the modern movement at first hand during his years of exile (1906-17) in Western Europe and was more sympathetic to progressive forms of expression than Lenin, who had been living in Zürich almost next door to the Cabaret Voltaire during the hey-day of Dada. In Petrograd (as St Petersburg had been renamed in 1914), the old Academy of Fine Arts was suppressed in the summer of 1918, but in October it reopened as the Petrograd Free Studios for anyone over sixteen, even if without certification of previous training or experience. This arrangement soon proved unworkable, and in 1922 the Academy was re-established with a stricter curriculum, partly devised by Kandinsky. Kandinsky also participated in an ambitious programme for the creation of new museums of 'artistic culture' in the principal provincial centres. Thirty-six museums are said to have been opened, and twenty-six more had been planned before the programme was abandoned in 1921, but as early as 1918 there were complaints in *Pravda* that government funds were being used to buy works by artists whose reputations were still unproved.

The most vigorous experiments were carried out in Moscow, which had become the capital in 1918, in the Vysshie Khudozhestvenno-Tekhnicheskie Masterskie (Higher Artistic-Technical Studios), familiarly known from its initials as Vkhutemas, which combined the functions of the old Moscow College of Painting, Sculpture, and Architecture and of the Stroganov School of Applied Arts. The combination in one institution of theory and practice in both the fine arts and the crafts (in this instance, ceramics, metalwork, woodwork, textiles, and typography) was symptomatic of the Soviets' desire to eliminate class distinctions

between artist and artisan, as well as to emphasize the structural, materialistic basis of all artistic production. It also may account for the fact that Constructivist design had a more lasting effect in the crafts, especially in typography, than in the major arts after further 'leftist' experimentation was prohibited.

In the workshops of Vkhutemas and in the meetings of the new Institut Khudozhestvennoi Kulturi (Institute of Artistic Culture), or Inkhuk, whose programme had first been written by Kandinsky, the pre-revolutionary disagreements between Malevich and Tatlin developed into a fundamental and finally irreconcilable divergence of opinion about the basic function of art. For Malevich 'every social idea, however great and important it may be, stems from the sensation of hunger; every art work . . . originates in pictorial or sculptural feeling . . . [and] it is high time to realize that the problems of art lie far apart from those of the stomach or the intellect'.[20] Tatlin insisted on stressing the utilitarian character of artistic order, both in practice and purpose, and declared that the artist, like the engineer, must know his materials and use his skills for society rather than for himself. For a time he worked in a factory and designed clothing, furniture, stoves, and other household objects to be mass-produced for the proletariat. Ironically, however, it is not as a designer of consumer goods that Tatlin is remembered, but as one of the first masters of totally abstract form. His early work had been influenced by Cézanne and by Larionov's primitivism, until in 1913, during a month in Paris, he met Picasso and saw his wooden reliefs [142]. There he may have heard of Futurist sculpture and the manifesto of 1913 in which Boccioni urged the use of all sorts of materials in preference to marble and bronze. Tatlin's first *Painting Reliefs* and *Relief Constructions* of 1913-14 (one of the first appearances of the word 'construction') were already more abstract than Picasso's figurative or

188. Vladimir Tatlin: Relief, 1914 (destroyed)

Boccioni's symbolic forms. A *Relief* of 1914 [188], composed of a worn board, a broken piece of glass, a bit of old iron, and a tin can with part of its label still attached, was, if the date is correct, one of the first 'works of art' in Western culture to have been assembled from untreated junk. It preceded by at least two years the objects put together by Schwitters and the Berlin Dadas. The lack of a frame or background for this *Relief* should also be noted; the abolition of any distinction between 'art' and 'life',

intrinsic to Tatlin's later Constructivist philosophy and an important aspect of Dada and Neo-Dada aesthetics, had been stated.

These relatively flat *Painting Reliefs* were first exhibited at the Tramvai V in St Petersburg in 1913. Two years later at O.IO Tatlin showed his new *Corner Counter-Reliefs*. The earlier constructions were 'countered' by projecting elements so that they existed in three-dimensional space and had to be hung in the corner of a room or suspended by wires. Unhappily almost all this work seems to have been lost or destroyed and is now known only from photographs. His most memorable achievement was his proposed *Monument to the Third International* (1920), an open spiral metal tower some 1,300 feet high containing on a slanting axis three geometrically-shaped chambers for legislative and scientific purposes which were to revolve once a year, once a month, and once a day respectively. Photographs of the large model of this 'union of purely artistic forms (painting, sculpture, and architecture), for a utilitarian purpose', as Tatlin described it, indicate that it was as much a work of sculpture as of architecture.[21]

Tatlin's sociological theories were energetically propagated by Alexander Rodchenko (1891-1956). He had been influenced by Malevich, and in 1918 exhibited a painting, *Black on Black*, in which curved forms were offered as a challenge to the older artist's rectilinear Suprematism. His own abstract pen-and-ink drawings, made with compass and ruler possibly as early as 1914-15, were more typical of the rigorously abstract method which he developed in his typographical designs. Other Constructivists were his wife, Varvara Stepanova (1895-1958), Ivan Puni (Jean Pougny) (1894-1956), Olga Rosanova (1886-1918), Liubov Popova (1889-1924), Alexander Vesnin (1883-1959), Georgii Yakulov (1884-1928), and Alexandra Exter (1884-1949). The stage designs of the last three artists, especially their

open, lathe-like constructions and multiple platforms and stairs for the Meyerhold and Kamerny Theatres in Moscow, are important contributions to theatrical history.[22] Yakulov's set and costumes for Prokofiev's *Le Pas d'acier*, produced by Diaghilev in 1927, was a prime example of the Constructivists' belief that machinery and machine forms were truly expressive of modern life.

EL LISSITZKY (1890–1941)

One of the most enthusiastic propagandizers for Suprematism and Constructivism, and the man through whose exertions the new Russian ideas became generally understood in Western Europe, was El (Eleazar) Lissitzky. He had studied engineering at Darmstadt and travelled in Europe before the First World War. In 1919 he met Malevich and Tatlin, and was appointed a professor of architecture and graphic arts in the school at Vitebsk, then directed by Marc Chagall, with whom he produced his first typographical designs and book illustrations. At first these were in a Cubo-Futurist manner, but by 1920 he had designed his amusing *Story of Two Squares* (published in 1922), a set of ten lithographs telling a Suprematist 'science fiction' tale of how two squares from outer space established harmony in a world of geometrical chaos. Also in 1919, influenced by the work of Malevich and Rodchenko at the famous 'Tenth State Exhibition of Non-Objective Production and Suprematism', he painted his first *Proun*, the title he afterwards gave all his abstract paintings. It seems to have signified 'Project for the affirmation of the New', from 'Pro' (For) and the initials of the first two words of Uchilishche Novago Iskusstva (Institute for New Art), the name Malevich gave the Vitebsk school after he forced Chagall to return to Moscow.[23] In these the influence of Suprematism is paramount, but by converting Malevich's squares and planes into images of

three-dimensional forms, now tipped and tilted to secure effects of multiple perspectives, Lissitzky created strongly architectural paintings [189]. 'A. Proun', he said, 'is a station for changing trains from architecture to painting.'[24] A spectator who watched him drawing in 1923 has told how he 'arranged lines, planes, and

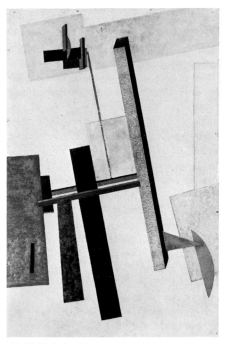

189. El Lissitzky: Construction – Proun 2, 1920. *Philadelphia Museum of Art*

cubes in such a way that they had not only one meaning but two or even more. A line did not have one direction into depth but had two or more contradictory directions at the same time which made it move constantly and so change its essential identity. The whole composition became a self-changing field of abstract signs.'[25]

For a time Lissitzky was the principal interpreter of Constructivist ideas in the West. From 1922 to 1928 he lived in Germany,

Holland, and Switzerland, where through his associations with Arp, Van Doesburg, Mies van der Rohe, Moholy-Nagy, Schwitters, Eggeling, and Richter he contributed Constructivist ideas and elements to Dada, De Stijl, the Bauhaus, and the abstract film.[26] His contributions to modern museum techniques were also important. In 1923 he installed a 'Proun Room' according to Constructivist-Suprematist principles at the Grosser Berliner Kunstausstellung, and in 1927 he designed for Alexander Dorner, then director of the Landesmuseum in Hanover, a room of abstract art in which the paintings and sculpture were asymmetrically arranged on walls covered with vertical projecting strips of tin. The strips were painted black on one side, grey on the other, and white on their edges, so that the walls changed colour and character as the spectator moved through the enclosed space. Although this room was destroyed by the Nazis in 1936, the principle that works of contemporary art should be seen in surroundings appropriate to their essential style had an incalculable influence on subsequent installations of modern and abstract art.[27] Lissitzky returned to Russia in 1929 and continued to produce typographical and exhibition designs until his death.

With the departure of Malevich for Vitebsk in 1919 to take over Chagall's art school, opposition to the materialistic direction of Tatlin's and Rodchenko's teaching at Vkhutemas fell to two artists, Anton Pevsner (1886–1962) and Naum Gabo (1890–1977), who had been away from Russia for several years before the Revolution. But because their theories, expressed in their 'Realistic Manifesto' published in Moscow in 1920, and their work after their departure from Russia have become so inseparably a part of the modern tradition in Western Europe and America, they will be considered later (see pp. 352–8). Meanwhile, when the Constructivists failed to attract any widespread popular response to their efforts

to create a new art for the new proletarian society, they encountered official disapproval. Even Lunacharsky's sympathetic interest was not enough to support forms of artistic expression that no longer seemed economically or socially necessary. Lenin was neither insensitive nor antipathetic to artistic expression. He is known to have enjoyed traditional music, literature, and painting whenever time and circumstances permitted, but in a revolutionary state uncertain of its existence and chronically short of funds, he put first things first. To Lunacharsky's request for money for the progressive theatres, one of the most fertile areas of experimentation during the revolutionary period, he replied: 'During the famine, let the avant-garde theatres live on their enthusiasm! It is essential that we exert every effort lest the fundamental pillars of our culture collapse.'[28] Nor, as we can now understand, could it easily have been otherwise. The sudden extinction in a still largely agrarian society of the only classes which had supported contemporary art and had been familiar with recent developments abroad, and the emergence of a new public of workers, soldiers, and peasants who had no experience of art beyond the traditional forms of religious and folk expression, and of nineteenth-century naturalism, meant that there were few to understand and almost none to love the radical Constructivist experiments. This discrepancy between the experience of the artist on the one hand, and of his patrons and public on the other, was nothing new, if we recall the efforts of the Impressionists and Post-Impressionists to have their work looked at without prejudice, but in Russia the misunderstanding of modern art for the first time had political implications. Because the artist of necessity was supported by government schools and subsidies, he was held ideologically responsible to the state.

When it became apparent that the Vkhutemas workshops would be closed and that the

forces opposed to 'leftist' art were rallying to the revival of nineteenth-century illustrational naturalism, perpetuated by the academic artists and by the members of the Peredvizhniki who, for almost sixty years, had been circulating exhibitions of mildly socialist painting throughout the provinces,[29] Kandinsky, Chagall, Pevsner, Gabo, and others understood that they would have to continue their work elsewhere.[30] The occasion for their departure was the large exhibition of recent Soviet art of all tendencies, sponsored by Lunacharsky and held at the Van Diemen Gallery in Berlin in the autumn of 1922. This was the first and for many years the most extensive showing of Suprematist and Constructivist art in Europe, and brought the movement to the attention of scholars, critics, and collectors in many countries. At home the development of individual talent was hampered by the shift in Constructivist doctrine from the earlier 'experimental' or 'laboratory' art to 'production' art with a more specifically functional and utilitarian purpose. But until all modern forms were suppressed as 'leftist deviations' in the early 1930s, Constructivism can be followed in the theatre, cinema, typography, and in the brief but brilliant phase of Constructivist architecture, in projected designs as well as in a few executed buildings.[31]

DE STIJL IN THE NETHERLANDS: 1917-32

Another collective search for a new style occurred in Holland simultaneously with the emergence of Constructivism in Russia. The political circumstances were very different, and the Dutch artists showed little or no interest in specific measures for political or social reform, but their ideas were as utopian and their programme perhaps more radical. They wanted to create a style appropriate for every aspect of contemporary life, one so coherent, so intelligible, and so complete that the distinctions between art and life would eventually be erased

when everything produced by human agencies, from teacups to town plans, would participate in a universal visual and intellectual harmony. This ideal was to be achieved through the rigorous analysis of the primary elements of artistic structure and expression, and their presentation in the simplest, most definite, and most logical terms. Of all the movements of the twentieth century De Stijl has seemed the most doctrinaire and at first glance the least accessible, yet ultimately and paradoxically it may have been the most influential. Modern architecture has been in large measure shaped by the basic principles and examples of De Stijl; in painting and sculpture its geometrical tradition has never been negligible, however often it may momentarily have been eclipsed by contrary tendencies.

The principles of De Stijl were formulated by a small group of Dutch artists and architects in 1916-17. The painters Piet Mondrian (1872-1944) and Bart van der Leck (1876-1958) had passed from Impressionism through Symbolism under the influence of Van Gogh and Toorop. Van der Leck had by then reduced his figural scenes to flat, poster-like silhouettes on bright backgrounds. From December 1911 until July 1914 Mondrian had been in Paris, where he had seen Analytical Cubism at first hand, but he had come to believe that 'Cubism did not accept the logical consequences of its own discoveries; it was not developing towards its own goal, the expression of *pure plastics*'.[32] Therefore he had narrowed his range of colours, changed curved lines to straight, and held the direction of planes to the two-dimensional surface of the canvas. By 1914, when he left Paris for a summer holiday in Holland only to be caught there by the outbreak of the War, he had created a series of paintings in which the tilted and intersecting planes of earlier Cubism were flattened, arranged in order, and firmly held in place by the dark lines which bound them. It is difficult to detect even vestiges of

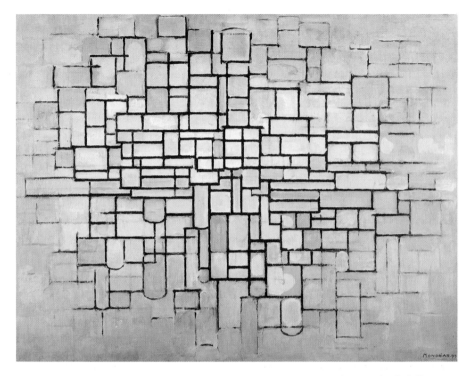

190. Piet Mondrian:
Composition in Line and Colour, 1913.
Otterlo, Rijksmuseum Kröller-Müller

the natural appearances upon which such designs were based (church façades are occasionally recognizable, and Mondrian is known to have admired the patterns exposed on the walls of half-demolished houses), but in the *Composition in Line and Colour* of 1913 [190], the organization of planes around the vertical and horizontal axes which intersect in the centre of the picture, and the fading away of the pale blue, lavender, and ochre planes along the edges, so characteristic of earlier Cubism, place the network of irregular rectangles within a surrounding and therefore separate Cubist space.

The spectator may also see the dark lines as a stationary grid suspended before a changing natural situation, such as a light-shot but cloudy sky. Nature for Mondrian was still a source of inspiration, and its presence could be noted in the more simplified 'plus-and-minus' compositions of 1914–15 in which the sea and projecting piers were suggested by clusters of short vertical and horizontal lines. It is difficult now to retrace the sequence of events, and it may be that Mondrian's patterns of short lines led Van der Leck to experiment with small rectangles of primary colours. On the other hand, by 1916–17 Van der Leck's regularly disposed bars and rectangles in his *Geometrical Compositions* [191] may have encouraged Mondrian and Theo van Doesburg (C. E. M. Küpper, 1883–1931) to carry their researches farther. Van Doesburg's famous *Composition*

(The Cow) of 1916-17 [192] is directly, even dogmatically, related to phenomenal appearance.[33] When compared with the photograph of a grazing cow which Van Doesburg provided, the sequence of black, red, yellow, blue, and green rectangles becomes the simplified structure of the animal's body with lowered head and neck to the right. Van Doesburg's *Rhythm of a Russian Dance* (New York) and *Three Graces* (Washington University, St Louis), two important works of 1918, were also variations on distant but no less natural themes.

Through these exchanges of ideas and Van Doesburg's conversations at Leiden with the architects J. J. P. Oud and Jan Wils, the formal vocabulary of De Stijl was determined. The basic elements were the square and its three-dimensional extension, the cube, both derived from the intersection of two primary directional forces expressed as vertical and horizontal lines meeting at right angles. In architecture a rectangular order could be as consistently applied to the disposition of cubical volumes as it could be deduced from current engineering practice (the right-angled cantilever is a case in

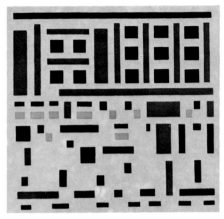

191. Bart van der Leck:
Geometrical Composition II, 1917.
Otterlo, Rijksmuseum Kröller-Müller

192. Theo van Doesburg:
Composition (The Cow), 1916-17.
New York, Museum of Modern Art

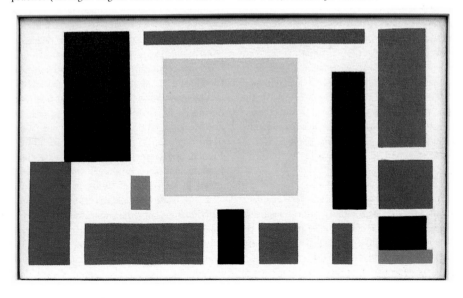

point). In painting and sculpture the right angle and square were equivalents for the forces underlying nature and its discordant appearances. The ultimate visual equivalents of all physical and organic events, whether active or at rest, were to be subsumed in the vitalistic vertical and the tranquil horizontal, the lines and dimensions symbolizing the fundamental polarities of life and death. By a similar induction all colours could be expressed by the three primary hues, red, yellow, and blue, and by the non-colours, white and black, standing for the fundamental oppositions of day and night, life and death (Mondrian was a master of subtle greys until he abandoned them as too indeterminate; Van Doesburg, however, retained grey and even green in his palette). When the formal principles of De Stijl are reduced to these bare premises, they disclose their historical descent. The ethical desire to create a harmonious total environment through a radically new design for all manufactured objects was a legacy from the Arts and Crafts Movement modified by the aesthetics of Art Nouveau. The belief that a universal rule can be discovered within all artistic structures recalls the methodical research of Seurat as well as the more intuitive studies of Cézanne and the Cubists. The stripped geometrical schemes of the De Stijl architects Oud, Wils, Robert van 't Hoff, and Gerrit Rietveld were influenced by the work of Frank Lloyd Wright, whose aesthetic was imbued with the ethics of the Arts and Crafts and whose design contained a number of Art Nouveau elements.

THEO VAN DOESBURG (1883–1931)

The aesthetic and eventually philosophical justification of De Stijl was Mondrian's achievement, and will be discussed in relation to the development of his painting. Van Doesburg, however, was always the dominant personality in the movement. His tireless energy, inex-haustible intellectual curiosity, and powers of persuasion made him an irresistible proselytizer. It was he who first had the vision of an inclusive modern style, one which would embrace all the arts and all the productions whereby the man-made environment is created as specifically human. 'Strip nature', he had told himself as early as 1912, 'of all its forms, and you will have style left.' And he chose the unmodified substantive 'style' as the name for the movement to indicate that he and his companions were searching for a design purged of everything formally reminiscent and expressively unessential.

The programme of De Stijl was publicly announced by Van Doesburg in October 1917 in the first issue of his monthly of the same title. The opening statement was deceptively indefinite: '. . . this little magazine proposes to state the logical principles of a style now ripening, based on the pure equivalence of the spirit of the age and of the means of expression . . . We wish to pave the way for a deeper artistic culture, based on collective realization of the new plastic awareness.' But he did call for a renunciation of 'an individualism in quest of honours', because 'only by the logical and precise application of this principle [of collective effort] can plastic beauty, through the new relations between the artist and the world, reveal itself as a style in everything that exists'.

The magazine's circulation was restricted during the first year by the continuing war, but in the issue for November 1918 the 'First Manifesto' of De Stijl appeared in Dutch, French, and German.[34] It contained the three fundamental propositions of the movement stated in very general terms: that, since the War had destroyed the old world dominated by individualism, in the new world universal values would emerge; that the reform of art, culture, and life would be accomplished by 'the new plastic art' in which natural forms which impede the proper expression of art would be

suppressed; and that all artists were invited to participate in what was, by implication, an international undertaking. The document was signed by Van Doesburg, Mondrian, Van 't Hoff, the poet Antony Kok, the Hungarian architect and designer Vilmos Huszar, and the Belgian sculptor Georges Vantongerloo. Van der Leck and Oud had just resigned, the former to return to a flat but representational manner of painting, the latter in order to have a free hand as city architect of Rotterdam. Oud's place was taken by Gerrit Rietveld (1888-1964), whose furniture, especially his wooden chair of 1917 painted in the ritual colours of red, blue, yellow, and black, and his Schröder House at Utrecht of 1924 are the best-known De Stijl contributions to architecture and the decorative arts. These early members were later joined by the architect Cornelis van Eesteren (b. 1897) and by the painter-sculptors César Domela-Nieuwenhuis (b. 1900) and Friedrich Vordemberge-Gildewart (1899-1962). With Van Doesburg's and Mondrian's paintings, and Vantongerloo's sculpture, theirs are the productions we now associate with De Stijl. Others who were members for varying periods were Severini, Richter, Arp, Hugo Ball, Lissitzky, Brancusi, the Austrian architect Friedrich Kiesler, and the American musician George Antheil, but except for Kiesler's *City in Space*, a cleverly suspended wooden frame for the Austrian display at the Paris Exhibition of 1925, their works had little relation to Dutch ideas, and their adherence was rather a token of their admiration for Van Doesburg and their support of the modern movement in general.

Van Doesburg carried his message abroad when he went to Germany in 1920 and 1921 to lecture in Berlin and at the newly established Bauhaus in Weimar. He spent much time in Germany during the next few years; for a while the editorial offices of *De Stijl* were established at Weimar, where a large retrospective exhibition of his work was held in 1923, and his

treatise, *Grundbegriffe der neuen gestaltenden Kunst*, was published by the Bauhaus in 1925. Although he was never a member of the Bauhaus faculty, he so successfully 'scattered the poison of the new spirit' that his influence on the modern movement in Germany was considerable. The architecture of Walter Gropius and Mies van der Rohe shows perceptible influences of De Stijl after their association with Van Doesburg. His denunciation of Expressionism was largely responsible for the greater attention paid to abstract design in the Bauhaus curriculum after 1923.[35] In Germany he also met Kurt Schwitters and briefly practised Dada, less one may think for its anarchic and anti-artistic elements than for the poetic and structural character of Schwitters's work. He was always interested in whatever was radically new (much as Mondrian, a devotee of jazz, endorsed the Futurists' disorderly 'noise-music' in an essay published in *De Stijl* in 1921).

Van Doesburg was soon drawn to Paris, where Mondrian had settled in 1920. There in 1923 he arranged at Léonce Rosenberg's Galerie de l'Effort Moderne the first comprehensive exhibition of De Stijl architecture, including his own projects executed with Van Eesteren. He also protested against the Dutch government's refusal to permit the members to represent their country in the international exhibition of decorative arts held in Paris in 1925. Although his efforts were futile, the influence of De Stijl could be seen in the design of Le Corbusier's Pavillon de l'Esprit Nouveau and in Léger's abstract painting within it.

Until about 1920 Van Doesburg's painting had kept pace with Mondrian's, when indeed it had not outrun it. The compositions of irregularly disposed rectangles floating on light grounds which both artists painted in 1917 were derived from Van Doesburg's *Cow*. The next year Mondrian's tightly arranged rectangles bordered with thick black lines were so

nearly matched by Van Doesburg's that it is easy to confuse the work of one with the other's, a justification of Van Doesburg's desire for a collective rather than an individualistic aesthetic. Thereafter their conceptions diverged. While Mondrian continued to explore the potentials of the square and rectangle, Van Doesburg was busy spreading the doctrine of De Stijl in Germany. When he returned to painting about

lished the argument for 'Elementarism', as he called his new theory, in *De Stijl* in 1927. He considered the new 'elementary (anti-static) counter-composition' as the fourth and last stage of development from classic (symmetrical) through Cubist (concentric) and Neo-Plastic (peripheral) composition. Through the diagonal he believed he had resolved the opposition of vertical to horizontal so that 'the composition

193. Theo van Doesburg:
Counter-composition in Dissonances XVI, 1925.
The Hague, Gemeentemuseum

1924, he had seen the work of the Russian Constructivists and Suprematists, especially Lissitzky's and Malevich's squares which were often tipped from the vertical. Their example may have convinced him that by shifting the axes of his structures forty-five degrees he could achieve more movement without sacrificing the obligatory right angle [193]. He called such designs *Counter-compositions*, a term he also gave to his isometric architectural projections, which are like three-dimensional developments of his paintings. Van Doesburg pub-

has to be considered as a phenomenon of tension rather than as one of relation in the plane'.

Two years later he wrote to Antony Kok that he had 'totally finished with any arrangement or composition guided by sentiment . . . What I am trying to realize is a universal form which entirely corresponds to my spiritual vision,' and that what he needed was 'a controllable structure, a solid surface without chance or individual caprice'. This conception of an art purified of all individualistic sentiment, 'but not without

spirit, not without universality, not empty', was the basis for his last important contribution to the theory of non-objective art, the manifesto for a new movement to be called 'Art Concret', published in 1930. He again insisted that 'before its materialization, the work of art exists completely conceived and formed in the imagination', and declared that the new artist would not work, as did 'the majority of painters, in the manner of pastrycooks or milliners', but on the contrary, 'with scientific and mathematical (Euclidian or non-Euclidian) data'. So objective and impersonal a method required that the execution of the work 'show a technical perfection equal to the perfection of its conception. It should show no trace of human weakness, no trembling, no lack of precision, no unfinished parts . . . Typewriting is clearer, more legible, and more beautiful than handwriting. We do not want artistic handwriting'.[36]

Van Doesburg was too sensitive an artist ever to achieve such mechanical effects, if indeed they are ever possible without sacrificing the basic components of every work of art, its conception and execution at whatever remove by a human agent. Certain younger members of De Stijl came very close to the point where their works might have been indistinguishable from technological exercises. In his earliest abstract sculpture, like the precisely articulated *Construction of Volume Relations* of 1921 [194], Georges Vantongerloo (1886-1965) projected Mondrian's and Van Doesburg's hovering planes of 1918-19 into three dimensions. The mathematical titles he gave his later sculpture and painting in which the volume relationships were 'verified by geometry' were not intended as exact equations of the objects so much as indications of the scientific source of his inspiration. Between 1917 and 1931 Vantongerloo's constructions were the most important as well as the most typical De Stijl sculpture. Thereafter he continued his investigations into the realization of space in two and

194. Georges Vantongerloo:
Construction of Volume Relations, 1921.
New York, Museum of Modern Art

three dimensions, but his use of curves and colours took him far from the strict aesthetic of Mondrian and Van Doesburg. Another attempt to reconcile art and technology can be seen in the reliefs of Vordemberge-Gildewart. This German member of De Stijl had been an architectural student at Hanover in the early days of Dada and had seen the De Stijl exhibition there in 1924. In his constructions actual objects, such as a T-square, may be juxtaposed with painted geometrical shapes, suggesting that no distinction is to be drawn between

theory and practice, between art and techno-
logy, between forms in the mind and the
instruments by which they are materialized.
Domela-Nieuwenhuis's constructions also in-
corporate material elements with impeccably
painted geometrical shapes.

With the last issue of De Stijl in 1932, a
memorial number dedicated to Van Doesburg,
the movement came to an end. Art Concret had
already disappeared, but the word 'concrete'
entered the critical vocabulary of abstract art
through Van Doesburg's insistence that abstract
painting is actually 'concrete because nothing
is more concrete, more real, than a line, a
colour, a surface'. Thereafter the collective
effort to achieve an absolutely objective artistic
expression which would be, as Van Doesburg
had promised, 'the shape of the spirit of
modern times' was continued for a few years
by his friends and followers through the
organization Abstraction-Création (see p. 349).

PIET MONDRIAN (1872-1944)

The principal pictorial accomplishment, as well
as the philosophical justification for geometri-
cally non-objective painting, was the work of
Mondrian. His theoretical writings have some-
times been dismissed as incoherent and even
unimportant, but some attention must be paid
to his ideas if we are to understand how for him
even the barest skeleton of pictorial geometry
could have ethical and philosophical as well as
artistic and social significance.

Mondrian had come of age in a strict Calvinist
environment and in his youth was deeply
interested in religion and philosophy. In his
early work, after the obligatory landscapes in
the tradition of nineteenth-century Dutch
naturalism, the influence of Symbolist painting
can be seen, especially in a series of studies of
withered chrysanthemums. Ostensibly still lifes,
such works can also be read as statements on the
passing away of all things. In 1909 he joined the

Theosophical Society and remained a member
all his life. More important for his mature
speculation on art and life were the ideas of a
Dutch author of popular books on philosophy
and religion, Dr M. H. J. Schoenmaekers,
whom Mondrian and Van der Leck knew at
Laren in 1916-17. Schoenmaekers's Het Nieuwe
Wereldbeeld (The New Image of the World, 1916)
was one of the few books Mondrian is known to
have kept by him all his life. Whatever Schoen-
maekers told him, it confirmed the painter in
his search beyond Cubism for 'a new plastic
art' (the Dutch phrase, de nieuwe beelding, is
Schoenmaekers's; Mondrian made it his own
in French as Néo-plasticisme). The mystical
tenor of Schoenmaekers's philosophizing runs
through Mondrian's first published work, the
long essay 'De Nieuwe Beelding in de Schilder-
kunst' (Neo-Plasticism in Pictorial Art), pub-
lished in eleven instalments during the first
year of De Stijl (1917-18).[37] Schoenmaekers
had already written that 'Nature, as lively and
capricious as it may be in its variations, funda-
mentally always functions with absolute regu-
larity, that is to say, in plastic regularity.' In the
second instalment of his essay Mondrian wrote
that 'the new plastic art starts where form and
colour are expressed as a unity in the rectangular
plane. By this universal means of expression,
the versatility of nature can be reduced to more
plastic expression of definite relations.' Even
Mondrian's transcendental vision of the totality
of nature expressed by the intersection of two
lines has its precedent in Schoenmaekers's con-
cept of the (Christian) cross as 'above everything
else a construction of nature's reality . . . The
more he will meditate about the construction of
the cross the more exactly the mystic will see
reality as a created fact.'[38] Further parallels
could be quoted, but all would suggest that
Schoenmaekers and his books were the agents
which turned Mondrian's attention from the
abstraction of pictorial facts from nature to the
creation of pictorial structures which as *real*

abstractions (real in themselves, not derived from nature; the term is Mondrian's) would have a reality equivalent to the underlying forces of nature rather than to her innumerable and deceptive appearances. Painting would not only express but also be that reality.

To follow Mondrian's painting in relation to the development of his ideas after his return to Paris in 1920 until the last works left unfinished in New York in 1944 is to be persuaded that his was no search for merely decorative harmonies, nor even for a style in the functional and practical sense conceived by Van Doesburg and his associates in De Stijl. Certainly he shared with them the vision of a society in which all the forms and activities of life would be controlled by a universal visual harmony. In 1920 he wrote that 'at present Neo-Plasticism manifests in painting what will one day surround us in the forms of architecture and sculpture', and in 1937 he foresaw 'in a future, perhaps remote, . . . the end of art as a thing separated from our surrounding environment which is the actual plastic reality', and 'the creation of an environment not merely utilitarian or rational but also pure and complete in its beauty'.[39] But the search for a beauty so pure and complete that it would redeem mankind through the revelation of universal harmony drove him towards ever more personal and private research.

Since Mondrian believed that 'the task of art is to express a clear vision of reality', and that 'particularities of form obscure pure reality', his own task was to discover the 'pure means' whereby he could reveal the ultimate reality beyond appearance. The means he used were those already clarified in earlier De Stijl discussions, the right angle, the square and rectangle, the primary colours, black and white. With these he had to create 'the equivalence of reality'. For Mondrian equivalence was neither equilibrium nor symmetry, which are essentially static and therefore lifeless conditions, but rather a state of dynamic tension between two 'equivalent terms', one of which is changing and dynamic, the other constant and at rest. Equivalence could be obtained in the tension between the abstract quantities of rhythm and relation, between measurement and position, between colour and shape. To maintain these elements in a state of maximum intensity without emphasizing one to the detriment of others was the artist's most difficult task. If successful he could, 'through the rhythms and relations of colour and size, make the absolute appear in the relativity of time and space'.

The first works executed after Mondrian's return to Paris were not notably different from Van Doesburg's. There were many squares and rectangles in each composition and they were loosely arranged. The black lines sometimes stopped short of the edges, so that the rectangles looked detached from the ground behind them. An effect of overlapping in depth was reinforced by grey squares which created another dimension because they were usually seen as if in front of the white areas. This disruption of the plane of the canvas by traces of individual and hence

195. Piet Mondrian:
Composition in Yellow and Blue, 1929.
Rotterdam, Museum Boymans-van Beuningen

subjective expression so annoyed Mondrian that he continued to seek a simpler and more tightly controlled solution. Gradually lines were taken to the edges, grey was abandoned, the number of rectangles diminished, and the primary colours reduced to two or even one, until by 1925, at the latest, he had found the kind of rigidly flat-patterned design which is unmistakably his own. The result of this effort can be seen in the *Composition in Yellow and Blue* of 1929 [195]. Five lines of slightly varying thicknesses intersect to create six rectangles, all of different sizes, four white, one yellow, and one blue. The means could scarcely be 'purer', nor the result more 'complete'. There is no conventional balance or symmetry, but the elements of line, shape, and colour are disposed on the flat surface so that each is held in a subtle but inescapable relation to every other. Mondrian even eliminated the centrality of traditional design. His compositions are 'peripheral', to use Van Doesburg's term. They have no centre, no focus, and their tensions are so distributed across the entire surface that each square inch is essential to the whole. There is no fading away at the edges, as in Cubism. We can also see how Mondrian's conception of form as space (not form *in* space) necessarily took him far from Cubism in which the object, the form, was still presented within a surrounding space. For him 'the action of plastic art is not space-expression but complete space-determination'. In his *Composition in Yellow and Blue* space is neither expressed, nor suggested, nor represented. The 'plastic' form *is* the space, since each part is inseparable from the two-dimensional space which it creates and defines.

When his paintings are arranged in chronological order it can be seen that not one was determined by caprice or 'inspiration': each is a part of a larger sequence steadily unfolding with variations through a period of time. The *Composition in Yellow and Blue* has many companions in the years 1929–32, although no two are alike. In each some slight shift in the position or width of a line alters the sizes and hence the relations of the rectangles to each other and to the whole. In another group of 1930-1 the square in the upper right is enlarged at the expense of the others arranged along the sides and bottom.

Mondrian disapproved of Van Doesburg's *Counter-compositions* and stated that by tilting his squares at an angle 'in opposition to the natural aspect of reality [he] had put the accent on the expressive means', thus introducing personal, subjective, and distracting elements. But even Mondrian was aware of the dynamic effects of the diagonal and produced his own versions by tilting a square canvas at an angle of forty-five degrees so that his constant verticals and horizontals were countered by the shift of the whole pictorial plane. In these works, which at first (1918–19) were covered with dense networks of lines and squares, the number of elements was gradually decreased until in *Fox Trot A* of 1927 [196] there are but three black lines of differing widths, only two of which intersect on the canvas. The fact that a second intersection can be foreseen beyond the lower left edge suggests that what is visible is merely a fragment of a larger whole, a spare and precise diagram in which much space, perhaps all space, may be comprehended in the intersections and returns of the three lines.

In the later 1930s groups of vertical and horizontal lines created dense patterns of many small squares of various sizes, relieved by a few areas of primary colour. These were the paintings Mondrian took with him to London when he left France in September 1938, convinced that Paris would be among the first cities to be attacked in the inevitable war. In London he found good friends who understood his art, especially Ben Nicholson, Barbara Hepworth, and Naum Gabo, but after his studio was destroyed in the bombing of Britain he sailed for America in September 1940. The work of his

196. Piet Mondrian: Fox Trot A, 1927. *New Haven, Conn., Yale University Art Gallery*

last years in New York was unexpectedly colourful. Black lines were spread in intricate grids across the canvas, and when the lines themselves were coloured and the squares left white, the optical vibrations created by the juxtapositions of complementary colours at the points of intersection seemed like flashing lights. These large compositions, *Place de la Concorde*, *Trafalgar Square*, and *New York*, were his artistic homage to the great capitals he had known and loved. In the last of all, *Broadway Boogie-Woogie* (New York) and the unfinished *Victory Boogie-Woogie* [197], the lines were made of small squares of brilliant colours with smaller coloured rectangles interspersed between them. References to the syncopated rhythms of city life were as evident as to the jazz music which Mondrian loved and in which he found one of his first formulations of the equivalence between fixed rhythms and changing relations (harmonies). But to interpret these last paintings as abstract cityscapes is to misunderstand Mondrian's meaning. It is much more as if he were imposing upon the endless chaos of the modern metropolis his own diagram of universal harmony. If his interwoven lines look like the

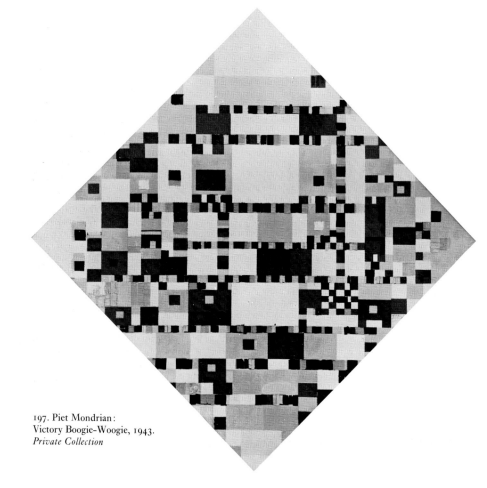

197. Piet Mondrian:
Victory Boogie-Woogie, 1943.
Private Collection

grid-iron pattern of city streets, it is because he has shown us where to look for the beginning of order. But he, the artist, did not find it there; he had seen it first in his mind.

Mondrian's conception of ultimate reality may have been philosophically unsystematic, vague, and repetitious, but it was an inseparable part of his lifelong attempt to create a visual reality which would reach beyond sensuous pleasure to a point where human experience would lose its aspects of pain and disappointment in the serenity of an absolute order based upon values which transcend appearance as well as passion. For many there are frequent hints of this in his images, where the inevitability of place and proportion was achieved after unremitting effort. Only Kandinsky and the Russian Constructivists have had similar visions of an art which could do so much to life.

The actual effect of Mondrian's work since his death in 1944 has been disconcertingly different from what he wanted. A few gifted disciples, especially in America, have maintained the purity of his means while varying his own invariable formats, and through their efforts a current of geometrical simplification, at times limpid, at others brittle and mechanistic, continues to the present. The wider public has become familiar, more than it may have wished, with the principles of Neo-Plasticism through the commercial discovery that Mondrian's rectilinear design is suitable for almost every publicity purpose. But if the purity and truth of his art have often been dissipated in cocktail napkins and travel posters, perhaps in these indirect ways the ultimate harmonies envisaged by the artists of De Stijl are gradually being revealed to our society.

THE BAUHAUS AND ABSTRACT ART IN GERMANY

In Germany, too, many thoughtful persons believed that the artist could help to bring about the desired social conditions through the creation of a new visual environment, especially through the design of objects for ordinary use. This was partly a reaction to the subjective morbidness of Expressionism, and to the political and military catastrophes of 1918–19 (see below, pp. 474 ff.), but it was also related to German theories of decorative design which had been taken from the English Arts and Crafts Movement during the decade of the Jugendstil and further developed after 1907 through the Deutscher Werkbund, an association for the improvement of industrial design sponsored by German manufacturers. The meeting and exhibition of the Werkbund in Cologne in 1914 occurred in the midst of a protracted discussion over the relation of art to the machine in the design and production of useful objects. A model industrial administration building by Walter Gropius (1888–1969), which stood not far from Henry van de Velde's mildly Jugendstil theatre, proved that architectural quality could be achieved with such non-traditional and mass-produced materials as metal and glass. Two years later Van de Velde, who had been unwilling to subordinate the individuality of handicraft to the conformity which he felt industrial production required, recommended Gropius to the Grand Duke of Saxe-Weimar as his successor in the Weimar School of Arts and Crafts.[40] With the Grand Duke's approval, subsequently ratified by the new republican government in 1919, Gropius combined the faculties and curricula of the academy and the school in order that theory and practice might be pursued without distinction between 'fine' and 'applied' art. In the new school, which he called the Bauhaus, the principal energies of abstract art in Germany were concentrated during the few years of political and intellectual freedom between the Armistice of 1918 and the rise of Nazism.

Although the word Bauhaus is untranslatable into English, it has become a familiar term for a

school devoted primarily to principles of artistic structure and of construction in the arts and crafts (the German root, *bau-*, means building, constructing). Because Gropius was himself an architect, he thought of the various arts less as independent entities than as tributaries to an inclusive, pre-eminently architectural synthesis. The first, four-page announcement of the Bauhaus bore on its cover an abstract-Cubist woodcut by Lyonel Feininger depicting a lofty and quite medieval cathedral. The subject disclosed the source of Gropius's ideas in the theories of Ruskin and Morris, as well as his belief that the 'collective unity of artistic creation [would be achieved in] the reunion of the disciplines of productive art in a new architecture . . . The ultimate if distant aim of the Bauhaus is the *collective* work of art – the Building – where there is no distinction between structural and decorative art . . . where the many arts are unified in an indivisible whole in which man himself is bound and wins a living consciousness and meaning.'[41]

Such words contained not only the hopes of Gropius and his colleagues that their efforts would contribute to the creation of a new society but also the seeds of their eventual differences of opinion. In retrospect, it seems that the principal source of the dissensions which developed at the Bauhaus lay in Gropius's insistence that the artist 'is an exalted craftsman' and that 'no distinction should be made between disinterested artistic expression and the design of practical objects for industrial mass-production'. Gropius believed in the necessity of craft experience for every artist and designer if there were ever to be an effective co-ordination between industrial design and machine production. Like Ruskin and Morris earlier, he recognized that 'the loss of creative unity which has resulted from technological development' had been caused by 'the much too materialistic attitude of our times and by the loss of contact between the individual and the community'. But unlike the English critics, or the individualistic designers of Art Nouveau, whose work often preserved the appearance of handicraft even when it had been executed by machines, he knew that the machine as an instrument of technical precision was superior to the craftsman's tools, and that the use of machinery and the division of labour must be maintained in the modern industrial state. But it was no longer true, as he had stated in his proclamation of 1919, that 'there is no essential difference between artist and craftsman'. However sociologically desirable it may be to have objects of everyday use of the finest design, it does not follow that they are always best designed by the best painters and sculptors, nor that such artists will always profit by an exhaustive understanding of the craft techniques. The conception as well as the execution of a painting or a work of sculpture requires quite different conditions, physical as well as intellectual and spiritual, from those which prevail in the designer's workshop. The proof of this can be seen in the gradual separation which occurred at the Bauhaus between practical and theoretical instruction. In the first year each student, after he had passed a six-months' trial course in the basic principles of materials, entered a workshop (preferably that of a craft whose material properties he had come to understand best), where he studied under two masters, the *Formmeister*, with whom he investigated theoretical principles of form and space, and the *Technischer Meister*, who taught him the practice of the craft in preparation for designing objects to be mass-produced by modern industrial methods. As differences of opinion developed certain *Formmeister* gradually withdrew from active instruction. Although they still enjoyed the title of Master, their presence in their own studios was more effective than their intervention in the classrooms.[42]

Despite the success of many industrial designs produced in the workshops, the names

of the *Formmeister* are more prominently linked with the Bauhaus search for a new synthesis of design and production; for in most of their work there was little evidence of any concern with applied design as such. It was greatly to Gropius's credit that he understood the creative stature of the artists he invited to Weimar and Dessau and entrusted them with the execution of his ideas at a time when every artistic decision was subject to searching and often bitter criticism from reactionary civil authorities as well as from the conservative German public. As this criticism was often directed towards the presumed political implications of modern art, the development of the Bauhaus was hazardous from the start. To allay these suspicions, Gropius forbade political activity among the staff and students, and arranged a comprehensive exhibition of the productions of the various workshops at Weimar in the summer of 1923. The exhibition attracted international attention, much of it favourable, but the Weimar authorities were not satisfied. Two years later, when the annual municipal subsidy was curtailed, Gropius and the masters closed the school at Weimar and moved it to Dessau, where the authorities had promised autonomy and agreed to construct a new building. The new Bauhaus, designed by Gropius and completed late in 1926, was immediately recognized as an outstanding example of modern architecture.[43] Gropius also designed a series of single and double residences for himself and the masters in the same functional and severely geometrical manner, devoid of ornament, which has become known as the 'International Style'. Less than two years later Gropius resigned as director to continue his private architectural practice in Berlin. His successor, the Swiss architect Hannes Meyer (1889-1954), put primary emphasis on industrial design, so that for the next few years the sleek, undecorated forms of Bauhaus products became identified abroad with contemporary German industrial art, especially after their display at the German Werkbund exhibition in Paris in 1930, arranged by Gropius, Moholy-Nagy, Breuer, and Bayer.

From the early 1930s the Bauhaus was attacked by the Nazis, who objected to Meyer's political views and revived the war-time slogan that modern art was *Kunstbolschewismus*. When they gained control of the Dessau government in 1930, Meyer resigned. He was succeeded by Mies van der Rohe (1886-1969), who moved the school to Berlin. But it was too late; the Bauhaus was finally closed by the police in March 1933. Several of the masters had resigned before then (Klee, Schlemmer, Moholy-Nagy, Muche); others emigrated soon after (Kandinsky, Feininger, Albers). They settled in France and England and in the United States, where their arrival coincided with the serious acceptance of the modern movement. They were soon so influential as teachers, architects, and designers that the result of the official dissolution of the Bauhaus was a far wider dissemination of its ideas than might have occurred had its enemies allowed it to remain where it began.

One of the first members of the faculty, Johannes Itten (1888-1967), laid the groundwork for Bauhaus theoretical studies for years to come. He was a Swiss who had studied with Hölzel at Stuttgart, had been a progressive teacher in Vienna, and was deeply interested in philosophy and mysticism. With Hölzel he had investigated the psychological properties of artistic form, and at Weimar he created the basic course required of all entering students, eventually the most influential contribution of the Bauhaus to modern educational theory. After his departure in 1923 the course was revised by Moholy-Nagy, and later by Josef Albers, who continued it after Moholy-Nagy resigned in 1928. They eliminated its Expressionist and mystical aspects and concentrated on basic perceptual rather than psychological properties of form and material.[44]

LYONEL FEININGER (1871-1956)

Two of the masters first called to the Bauhaus belonged to the earlier individualistic tradition of German Expressionism. Gerhard Marcks (1889-1981), who came as *Formmeister* for the pottery workshop, was a distinguished sculptor working in a modified Expressionism (see below, p. 485). He resigned in 1925, when the Bauhaus left Weimar, and continued his teaching elsewhere. Lyonel Feininger, an American who had lived in Germany since the age of sixteen, had been associated with Walden and the Sturm artists since 1913, when he showed four paintings in the First German Salon d'Automne. He had begun painting seriously only in 1907 after a successful career as a social and political cartoonist for various Berlin papers. As his acquaintance with modern art in Paris and Berlin increased, he gradually adapted his oddly jagged lines and extreme figural distortions to the transparent and intersecting planes of Cubism and Futurism. Although he never lost his romantic taste for such far-off, forgotten things as sailing ships, paddle-wheel steamers, and early locomotives, his best works are his visionary abstractions of medieval architecture and the sea which recall the poetic imagery of an earlier German landscape painter, Caspar David Friedrich.

Feininger's mature architectural manner appeared in 1912 when he painted the first version of *High Houses* (formerly Koehler Collection, Berlin, destroyed), a cubistically abstract version of those half-demolished Paris houses which during the next year attracted the attention of Piet Mondrian. In 1913 he created the first three of an eventual series of thirteen paintings of the village church at Gelmeroda. In the earliest of them, a tall pine-tree provides a contrast between natural and man-made forms; in later paintings [198] the natural elements have been eliminated, the architectural forms refined and dematerialized, until, as

translucent planes, they define a crystalline space. In Cubism and Futurism Feininger found the multiple perspectives for his architecture, which so often looks as if it had been built from several points of view taken from within the picture. This effect is further accentuated by the constantly shifting lights, of varying intensities and from various sources, which bring the walls and towers slowly into view and then allow them gradually to disappear. These multiple illuminations are like the moving beams of lighthouses and ships' lanterns in Feininger's many pictures of the sea. The sense of shapes casting their own reflections, as if they themselves were made of light, or creating their own reverberations, as if they were tones within the painting, may be related to Feininger's musical interests. He was a talented composer of organ fugues.

Although an alien, Feininger stayed in Germany throughout the First World War and remained at the Bauhaus until the end. In 1937 he returned to the United States, where he was accepted as a leading American painter. In his last works, especially the water-colours executed with a subtle and nervous line along which the changing pressure of his hand deposited droplets of pigment, he interpreted the architecture of Manhattan which had soared skyward since he had left it fifty years before.

OSKAR SCHLEMMER (1888-1943)

In 1920 Georg Muche (b. 1895) and Oskar Schlemmer arrived to take charge of the weaving and sculpture workshops. Muche had been associated with Walden and had taught at the Sturm school towards the end of the War. His own painting was at first entirely abstract, with the familiar Expressionist colour scheme of red, orange, purple, and green embedded in a network of black lines which owed something to Van Doesburg's example. After leaving the Bauhaus in 1927 he taught in Berlin and

198. Lyonel Feininger: The Church at Gelmeroda XII, 1929.
Providence, R.I., Museum of Art, Rhode Island School of Design

Breslau, gradually turning from abstraction to a semi-Cubist figurative manner.

Oskar Schlemmer's mechanistic human figures now seem very close to the essential principles of Bauhaus design, but such was scarcely his intention, because he hoped through severe simplifications to redeem the human figure from soulless abstraction, at the same time submitting the promptings of intuition to rational, numerical control. His characteristic compositions are those in which figures, naked or clothed, in tight-fitting garments and seen in strictly frontal, rear, or profile positions, move mysteriously within a space whose perspective dispositions are as equivocal as the errands the figures undertake [199]. The few architectural elements which support these spaces, as naked as the figures, are the perfect complement of the Bauhaus aesthetic. His *Bauhaus Staircase* (New York), although painted in 1933 after he had left Dessau, has often been considered the prime example of the Bauhaus synthesis of architecture and the figural arts.

Schlemmer was also a sculptor and stage designer. His bas-reliefs for the Weimar Bauhaus, created for the exhibition of 1923, were later destroyed by the Nazis, but his mechanistic treatment of the human figure can be seen in the *Abstract Figure* of 1921. A later cast in polished metal of the original plaster perpetuates his reduction of organic form to streamlined surfaces conforming more to a mechnical than to a biological order [200]. His *Triadic Ballet*, once performed with music by Paul Hindemith for a mechanical organ, was projected as early as 1916 and successfully staged at the Bauhaus Festival

of 1923 and thereafter elsewhere in Germany. The dancers' heads, arms, and legs were concealed in stiff spherical or cylindrical shapes to emphasize the total movement of the figure in space. In the dance, as well as in his sculpture and painting, Schlemmer presented man as a finite rational form capable of infinite psychological expansion within a multi-dimensional irrational space. His metaphysics are not easy to follow, and perhaps not even essential to the pleasure his cool precise forms communicate.

KANDINSKY AT THE BAUHAUS: 1922-33

Gropius next appointed two former members of the Blaue Reiter whose residence at the Bauhaus, although only an interval in their total careers, indelibly marked their work. Paul Klee was a master from 1921 until 1930, when he resigned to accept a professorship at Düsseldorf. His art has been so consequential for the development of painting in Europe and America that it will be examined in a separate section (see below, pp. 494-9). Here we may note that he had been invited to take charge of the stained-glass and bookbinding workshops (vestiges of the Werkbund background of the Weimar school), but from the first he ran courses in the theory of pictorial art. In 1922 Vasily Kandinsky came as *Formmeister* for the painting class. He had returned to Germany from Russia the previous December, disillusioned by the official reaction to the kind of modern art he had done so much to establish. During his years in Moscow (1914-21) he had had little opportunity to paint, having been occupied with administrative tasks in the

199 (*opposite*). Oskar Schlemmer:
Group of Fourteen Figures
in Imaginary Architecture, 1930.
Cologne, Wallraf-Richartz Museum

200 (*left*). Oskar Schlemmer: Abstract Figure,
1921. *The Baltimore Museum of Art*

201. Vasily Kandinsky: Variegated Circle, 1921.
New Haven, Conn., Yale University Art Gallery

Commissariat for Education and as a professor at the Moscow Art School. Of his own work during those years little can be said, because it has been kept in storage by successive Soviet administrations. Nevertheless, by 1921 a noticeable change had occurred in his painting. The exuberantly coloured, dramatic, and improvisatory character of his *Compositions IV* and *VII* [118], which he had taken with him when he left Munich in 1914, had yielded to the more geometrically ordered *Variegated Circle* [201], which he brought with him to Berlin. This large picture is composed of more or less regular geometrical elements, straight and curved lines, edges, bars, and planes, and significantly a

triangle, circles, and a small square which emerges from behind the broad diagonal to the left. Only behind the triangle and below the square are there traces of the iridescent palette of the Munich years. Elsewhere the mark of the brush has been suppressed in favour of flat, neutral surfaces within orderly shapes. This picture provides the clearest indication of how much Kandinsky had learned from his association with the Suprematists and Constructivists in Moscow. Although as long ago as 1912 he had published his thoughts on the expressive values of the fundamental geometrical figures, it is impossible not to see in this painting the suggestions he had received from Malevich (the

202. Vasily Kandinsky: Balancing Act, No. 612, 1935.
New York, Guggenheim Museum

square) and Lissitzky (the dynamic opposition of bars and planes). But the arrangement of these non-objective elements in a state of the highest expressive tension cannot be recognized as anything other than the personal creation of Kandinsky himself.

Variegated Circle may be said to have inaugurated his Bauhaus (1922–33) and later Paris (1933–44) periods. These remaining twenty-two years of his life were among the most productive of his career, but his later paintings have long been depreciated in favour of the more obviously 'Expressionist' work from the Munich period. Perhaps, as they become better known, they will be seen as continuations of his earlier

manner and as ultimate resolutions of his theories of form and colour developed before 1914. Evidence for this point of view can be found in his theoretical treatise based on his work with the Bauhaus students. In *Punkt und Linie zu Fläche* (*Point and Line to Plane*) of 1926 he analysed the progressive development of non-objective composition, beginning with a single point which as it moves creates a line, to a moving line which in turn brings forth a plane upon the 'basic plane' of the picture surface. When these elements are made to obey the laws of their 'inner nature', they can be arranged in a composition which 'is nothing other than an exact, law-abiding organization of vital forces which,

in the form of tensions, are shut up within the elements'. The content of a work of art 'finds its expression in the composition: that is, in the sum of the tensions inwardly organized for the work.'[45]

With these principles in mind, it is possible to examine Kandinsky's later work in terms of the success with which the composition as a whole resolves the tensions he introduced among his selected elements by contrast or comparison, isolation or repetition, position or direction (all aspects of design stressed in his treatise). If sometimes certain elements, in themselves or in combination, seem discordant or arbitrary, Kandinsky reminds us that although 'the universal harmony of a composition can consist of a number of complexes rising to the highest point of contrast . . . these contrasts can even be of an inharmonious character, and still their proper use will not have a negative effect on the total harmony, but, rather, a positive one and will raise the work of art to a thing of the greatest harmony'.

Part of the difficulty in understanding Kandinsky's later work may be due to our inability to master the total complex of tensions which he tried to establish, for the composition is not based solely upon the interaction of points, lines, and planes. The basic plane itself is subject to the pressures of the forms upon it, and although by and large it appears in his later work as a two-dimensional surface upon which the separate elements seem to hang or float, it is always a spatial element subject to visual distortions. Colour then adds its counterpoint to the integrated complex through its capacity to suggest synaesthetic sensations of the greatest intricacy. Colour, like music, has its 'sounds' and 'tones'. Like line and curve, it can range from loud to low, from hard to soft, from hot to cold; it can be lyric or dramatic in endless permutations of audible, tactile, and visual sensations. Upon the sanded surface of *Balancing Act* of 1935 [202] the movement of

points, lines, and planes develops a contrast of organic and geometrical forms with biological overtones like those in the contemporary work of Miró. To mention the Spanish artist is to emphasize Kandinsky's central position in modern art. The whiplash curves of this and many other paintings of his Paris period recall his Jugendstil origins in Munich and Moscow, even as the leaf-like perforations of the major shapes suggest Matisse's cut-paper patterns which were still to come.

In contrast to the relatively passive acceptance of perceptual experience in his pre-war *Impressions*, or to the intuitive promptings solicited in his *Improvisations*, the paintings executed after his return from Russia are constructive to the degree that Kandinsky planned the effects he achieved. His own interest in music again suggests a parallel with his compatriot and fellow-exile Igor Stravinsky, whose early ballets, the *Firebird* of 1910 or the *Rite of Spring* of 1913, had released a torrent of audible sensations analogous to Kandinsky's turbulent work of the same years. After 1920, Stravinsky's music, like Kandinsky's painting, was increasingly controlled and composed of elements pre-invented and placed in orders more intellectual than instinctive. Stravinsky's later acceptance of the twelve-tone serial mode discovered by Arnold Schoenberg may be said to have brought the wheel full circle, for Schoenberg had been a friend of Kandinsky's since the days of the Blaue Reiter.

LASZLO MOHOLY-NAGY (1895-1946)

The presence at the Bauhaus after 1923 of the Hungarian artist Laszlo Moholy-Nagy led to a much closer relation between Bauhaus theory and practice, between problems of form in the abstract and the application of formal solutions to articles of use. When Gropius met Moholy-Nagy in Berlin, where the younger man had been working since 1922, he had been impressed

by his inexhaustible enthusiasm for the pictorial and structural possibilities of new materials, especially the translucent and transparent plastics. Moholy-Nagy wanted to surmount the restrictions imposed by the traditional substances of painting and sculpture. He was convinced that painting could be surpassed or sublimated through the manipulation of actual rather than virtual light, just as static sculptural mass could be supplanted by a new art of transparent open volumes in motion. When he took over the preliminary course at the Bauhaus he replaced the philosophical and historical aspects of Itten's teaching with carefully controlled laboratory exercises in the potentials of materials and their effects in space. He also directed the metal workshop, where his interest in light encouraged the students to develop designs for lighting fixtures which were among the most successful of the Bauhaus contributions to industrial production.

Moholy-Nagy had studied law before 1915 and took his degree in Budapest after his release from military service in 1918, but he was already interested in art and with a group of young Hungarian intellectuals founded the short-lived association MA (Today), which published a journal of the same title. His first paintings recapitulated the development of Expressionism and Cubism until he discovered Russian Constructivism, especially the work of Lissitzky. By 1920, when he settled in Berlin, his own painting had become purely non-objective and he had made his first experiments in light with his 'photograms' or 'camera-less photographs', in principle much like those Man Ray was producing in Paris at the same time (see below, p. 378). Moholy-Nagy's first important publication, the *Buch neuer Künstler* (*Book of New Artists*), published in Vienna in 1922 with Ludwig Kassàk, shows that at an exceptionally early date he understood the historical sequence of modern art and could relate the different national developments to a

coherent, emergent tradition. He continued as a chronicler of his own times when he edited with Gropius the fourteen Bauhaus books, a series which appeared between 1925 and 1930 and included important treatises by Malevich, Mondrian, Van Doesburg, Oud, Gropius, Klee, and Moholy-Nagy himself.

In 1928 he returned to Berlin, where for a few years he had a brilliant career as stage designer for the State Opera and the Piscator Theatre, carrying out his theories of transparency and the use of light in the creation of forms on the scale of life. In 1935 he moved to London, where he produced documentary films and designed the memorable special effects for Alexander Korda's film version of H. G. Wells's *The Shape of Things to Come*. In 1937 he was invited by a group of Chicago industrialists to direct a 'New Bauhaus'. After it failed the following year he founded his own School of Design in Chicago, where he taught until his death in 1946. In his teaching he developed further the principles worked out at the original Bauhaus. Much of his basic theory has entered the curricula of many American institutions, effectively disseminated through his books, *The New Vision* (1938), an expanded version of *Von Material zu Architektur* of 1929, and *Vision in Motion* (1947).

In his own painting after 1920 he was deeply influenced by the Russian Constructivists. The tell-tale squares and crossing diagonals of Lissitzky and Malevich appeared as early as 1922, the year in which he described himself as a Constructivist. His definition of Constructivism as 'the activation of space by means of a dynamic-constructive system of forces actually at tension in physical space, and their construction within space, also active as force (tension)', tells how he was led from painting as two-dimensional design to the play of forces in three dimensions.[46] The transition occurred in his *Space Modulators*, when he created cast shadows upon the background plane by painting and

342

203. Laszlo Moholy-Nagy: Space Modulator, 1936.
Private Collection

204 *(right)*. Laszlo Moholy-Nagy:
Light-Space Modulator, 1922–30.
*Cambridge, Mass., Busch-Reisinger Museum,
Harvard University*

might almost say the anonymity of his works, which have less the mark of the man than of the times he laboured so strenuously to change. We tend to look at them less as objects in their own right than as preparatory exercises for later developments in the many fields of his competence, in typography, advertising design, photography, and the stage. Since Moholy-Nagy did not aspire to the isolation of the 'fine' artist, this opinion may be just. Yet each example of his art may be examined in and for itself, provided we remember his austere insistence that the properties of dynamic spatial extension and the effects of light as a formal medium in itself are the expressive content of artistic experience.

JOSEF ALBERS AND MAX BILL

The few years of intensive exploration and experiment at Weimar were fulfilled at Dessau, when the first generation of Bauhaus students came to their maturity as masters and creative artists in their own right. Among them three in particular have had long and important careers elsewhere. While still at the Bauhaus, Marcel Breuer (born in Hungary in 1902) created one of the most successful of all Bauhaus designs, the tubular steel chair which in one form or another has been a staple article of modern interiors around the world. Since 1937, when he settled in the United States, he has become an architect with an international practice and reputation. Two German artists, Herbert Bayer (1900–85) and Josef Albers (1888–1976), also had long and distinguished careers in America. Bayer continued to investigate the principles of typographical design developed at the Bauhaus by Moholy-Nagy. Much commercial

drawing on translucent planes in front of it [203]. Among his later works the *Light Modulators* combined the transparency of the new plastics with continuously changing effects of light produced by the actual movement of the object, freely suspended or turned by mechanical devices within it [204]. Moholy-Nagy insisted that such works were the forerunners of controlled light effects on the largest scale, such as abstract images projected on natural or artificial clouds, sky-writing, and the use of light in urban and industrial planning, but we may rather admire them for their suggestions of that mysterious borderline between art and technology, between free expression and the limitations imposed by materials and the principles of mechanics.

Believing that the day of the 'fine arts' had passed and that a new integration was necessary between the artist, the craftsman, and the public, Moholy-Nagy cast himself in the role of an 'anonymous agent' in the public service. His attitude accounts for the impersonality, one

205. Josef Albers: Skyscrapers, 1927. *Private Collection*

printing and publicity owe their quality to his example. Albers's career as a teacher in Germany and the United States has already been noted, but it was surpassed by his artistic accomplishments. In his first years at the Bauhaus, where he worked in the glass and furniture workshops, he invented new designs for windows, ceramics, typography, and furniture, including one of the first and most influential types of laminated wood chair. His principal work, however, was as a painter, draughtsman, and graphic artist. His own words succinctly define his art in terms of the Bauhaus ideal: 'Economy of form depends on function and material: the study of materials naturally precedes the investigation of function.' But the end, for his students as for himself, was always the presentation of new visual insights: 'Through discussion of the results obtained from the study of the problems of materials, we aim at exact observation and new vision. We learn which formal qualities are important today: harmony or balance, free or measured rhythm, geometric or arithmetic proportion, symmetry or asymmetry, central or peripheral emphasis. We discover what chiefly interests us: complicated or elementary form, mysticism or science, beauty or intelligence.'[47] Harmony, proportion, intelligence, these are the expressive qualities of Albers's work and those through which it is related to the constructive art of others in which, as he said, he found 'affirmations for his feelings, not answers to his questions'. The clean clarity of a glass painting of 1927, *Skyscrapers* [205], resembles the elegant severity of the early architecture of Mies van der Rohe and Gropius, but it is a pictorial structure in its own right. The few but varied elements combine in several visual patterns to create an optical effect which is both logically and numerically irreducible. Here is the result of Albers's belief that art originates in 'the discrepancy between physical fact and psychic effect'. The latest demonstration of this belief occurs in the long series of *Homage to the Square*, which he began in 1950. Although each of the several hundred paintings is constructed upon an invariable system of proportions, repetition and monotony are avoided by the endless combinations of colours, and by the omission of either of the two inner squares in compositions of only three superimposed squares. The discrepancy between invariable physical facts, the squares, and the extraordinary variety of psychic effects created by the contrasts of colours reinforces the philosophical distinction between a mathematical, almost Platonic absolute, and the multiplicity of psychological and hence organic reactions.

In the work of the Swiss artist Max Bill (b. 1908), who has had a distinguished career as an educator, the fundamental premises of spatial and visual geometry are just as essential, except that where Albers drastically restricted his formal means, Bill has continued to explore the enigmatic expressive qualities of forms in two and three dimensions and in many media. As a pupil of the Bauhaus in 1927-9 he studied with Moholy-Nagy as well as with Albers, and the character of his research resembles the former's ceaseless experimentation. Although much of his work suggests the solution of ingenious theoretical puzzles, in certain of his later spiral sculptures – where the bronze or marble plane twisting upon itself is the three-dimensional projection of the mathematical formula for a plane generated by a single continuous line – Bill has made an impressive as well as important contribution to the strict Constructivist aesthetic.

WILLI BAUMEISTER (1889-1955)

Outside the Bauhaus such extremely abstract and non-objective art was rarely practised in Germany, where Expressionism remained the dominant artistic force between the Wars. One painter, however, developed and maintained a

206. Willi Baumeister: Siduri, 1942.
Private Collection

personal form of abstraction in the face of public indifference and official, political hostility. Willi Baumeister was a native and lifelong resident of Stuttgart, where he studied at the Academy under Hölzel. He was also a close friend of Oskar Schlemmer, with whom he visited Paris in 1914. Although at that time he was principally interested in Lautrec and Gauguin, he was not unaware of Cubism. He was there again in 1924, when he met Léger, Ozenfant, and Le Corbusier. In his paintings of the 1920s the rounded,

figural elements are as close to Schlemmer's first Bauhaus reliefs as to the works of Léger and the Purists. After 1937 his work became more personal when freer, more intuitive elements appeared, often like the signs and figurations in prehistoric cave painting. His use of sand and plaster on his painted surfaces strengthens the impression of ancient, cryptic messages originating in much earlier and preconscious experience [206]. The inclusive titles for such works – the 'Eidos' paintings from 1938, the 'African' and 'Peruvian' series of 1943 and 1945, executed while he was proscribed by the Nazis – are evidence of his interest in the psychological

significance of primitive and non-European forms of expression, a subject examined in his treatise, *Das Unbekannte in der Kunst* (*The Unknown in Art*), written in 1943-4 and published in 1947. In such work Baumeister created for Germany an art much like the abstract Surrealism of Masson and Miró. Like theirs it has a wide expressive range between hints of ancient, unmentionable events and witty improvisations on colour and form. After 1945 and until his sudden death Baumeister enjoyed the respect to which he was entitled as the oldest of the new generation of German abstract artists.

THE ABSTRACT FILM:
VIKING EGGELING AND HANS RICHTER

A new direction as well as a new dimension was added to non-objective art with the invention of the abstract film by the Swedish artist Viking Eggeling (1880-1925) and by the German painter Hans Richter (1888-1976), who was active in Berlin before joining the Dadas in Zürich in 1917 on his release from military

207. Viking Eggeling: Three drawings for the scroll painting Horizontal-Vertical Mass, 1919.
New Haven, Conn., Yale University Art Gallery

service. In a series of highly abstract paintings, his *Dada Heads* of 1918, Richter had alternated between Dada wilfulness and his feeling that what would be most urgently needed in the post-war world would be a new kind of artistic order. But while he explored the interactions of positive and negative relationships in black and white he became impatient with the restrictions imposed upon his design by lingering traces of the natural object. Eggeling meanwhile had been teaching in Switzerland, had been to Paris in 1911, where he knew Arp, and in 1915 met Tzara at Ascona. When the latter introduced the two men in 1918 they found themselves, in Richter's words, in 'complete agreement on aesthetic as well as philosophical matters', and through their mutual interest in 'the dynamics of counterpoint' they began experimenting with the continuous transformation of abstract configurations by changing and altering their component parts.[48] In 1919 they settled in Germany, where their experiments in all the possible transformations of a given form in a series of separate and hence static drawings led to the composition of groups and sequences of images spaced on long rolls of paper. Of these 'scrolls' Eggeling's *Horizontal-Vertical Mass* of 1919 has been lost, but three of the preliminary

208. Hans Richter: Prelude, 1919, detail.
New Haven, Conn., Yale University Art Gallery

drawings [207] show how the geometrical elements could be multiplied, subtracted, shifted, and combined with curving lines in such a way that the spectator 'remembering' one image as he turned to the next might have the sensation of forms in movement. In Richter's *Prelude* of 1919 [208] – its title indicates his interest in musical counterpoint – the sixth, seventh, and eighth of the ten images are built of many multiplied and interlocking parts, rectangular and curved, and in black and white. Their 'symphonic orchestration' was implicit but not apparent in the first three of the series, which were composed of a minimum number of similar but much simpler shapes.

By 1920 Eggeling and Richter were aware that the motion suggested in these changing forms could be created as actual movement in film. Eggeling's *Diagonal Symphony* was essentially an animated version of the drawings on his scroll of the year before. In *Rhythm 21* Richter accepted the rectangular frame of the cinema screen as his basic form, shifting within its boundaries a number of smaller rectangles and squares, in light and dark, so that the virtual movement of *Prelude* was actually visible to the spectator. However interested Eggeling and Richter had been in the spatial dissections of Cubism and the geometrical polarities of De Stijl (through their acquaintance with Van Doesburg, who visited them in 1920, they learned the philosophical hypotheses of 'absolute' and 'universal' forms), in these short films they went beyond the static description of movement in such earlier works as Duchamp's *Nude descending a Staircase* [153] or the Futurists' less disciplined description of the velocity of moving objects [167]. They were concerned with the nature of motion itself, presented through abstract designs which appeared as if in actual motion, and by doing so they introduced into the work of art the 'orchestration of time'.

In 1923 Richter added colour to his scrolls in *Fugue 2*, in red and green, and in his films

Rhythm 23 and *Rhythm 25*, which were hand-coloured. Then, after Eggeling's premature death, he returned to the world of appearances with short films of fantasy and social irony, such as *Ghosts before Breakfast* and *Inflation* of 1927-8. When his work was condemned by the Nazis he emigrated to the United States, where he was influential as a documentary film-maker and as the professor of cinema at the City College of New York. His later films, *Dreams that Money Can Buy* (1946-8) and *8 × 8* (1954), owe much to Surrealist imagery and subconscious connotations.

When in 1926 Richter prepared a special issue (Nos 5-6) of the Berlin journal of modern art, *G*, which he had founded with Mies van der Rohe and Werner Graeff, he could look back upon an extraordinary development of the experimental cinema. In addition to his own works he reproduced stills from such pioneering and authentic cinematic experiences as René Clair's *Entr'acte* (1924) and Léger's *Ballet mécanique* (1924), and the films of Man Ray (see below, p. 378). Although theirs were representational rather than abstract, in many instances they had incorporated his own presentation of movement through repetitive images and a highly formal design.

In later years Richter returned to painting, investigating in black, white, and grey – the restricted colours of his earliest films – the dynamics of movement across extended pictorial spaces. In so late a work as the vertical canvas *Liberation of Paris* of 1944-5 (Paris), the interpretation of rectangular and curvilinear shapes imparts to the upright format, reminiscent of a Japanese kakemono, an effect of motion in time. The inclusion of contemporary newsprint and photographs reminds us of his Dada experiences in Zürich long ago and prepares the way for the effects of violent contemporaneity in the work of the newest Pop Art of today.

ABSTRACT ART IN FRANCE

The major developments in abstract and non-objective art just before and during the First World War had occurred, as we have seen, throughout Europe – in Germany, especially in Munich in the circle of the Blaue Reiter, in Holland, and in Russia. After 1918 the prestige of the School of Paris (see below, pp. 425 ff.) attracted many artists from these and other countries. Mondrian and Van Doesburg were in Paris by 1920, the Spaniard Joan Miró, whose biomorphic compositions will be considered in the context of Surrealism, had come in 1919, and Kandinsky lived in Paris for eleven years after he left Berlin in 1933. There were also sculptors, among them the Romanian Constantin Brancusi, the Alsatian-born Jean Arp, and the Russians Anton Pevsner and Naum Gabo, whose works will be considered separately.

Meanwhile organized efforts had commenced as early as 1925 with the large exhibition by advanced contemporary artists entitled 'Art d'Aujourd'hui', where work by Larionov and Natalia Goncharova, by the De Stijl painters and sculptors, and by artists from other European countries were seen beside contributions by the Cubists and Surrealists. Many of the same artists were included in the exhibitions presented by the group 'Cercle et Carré', founded in 1930 by the Uruguayan Cubist painter Joaquín Torres-García (1874-1919) and the Dutch-born critic Michel Seuphor (Ferdinand Berckelaers, b. 1901). This demonstration coincided with Van Doesburg's short-lived Art Concret (see above, p. 325), and most of the same figures came together again in a new association, Abstraction-Création, founded in 1931 by Vantongerloo, Auguste Herbin, and Jean Hélion. For five years their exhibitions and annual publications under the same title promoted the work of more than four hundred artists from many countries, dedicated to the

purest non-objective principles. Although the actual accomplishments of the French members, with the exception of Arp, were on the whole peripheral to the work of the major European masters, Paris could for a few years (1930-40) be considered a capital of abstract expression.

Amidst all this activity one of the true pioneers of the movement worked almost unnoticed. The Czech painter Frank (František) Kupka (1871-1957) had been living in Paris since 1895, earning a precarious living as an illustrator and spiritualist. After the turn of the century he had a studio beside those of Jacques Villon and Raymond Duchamp-Villon at Puteaux, where he joined in the analytical discussions of Cubism by the 'Group of Puteaux' which led to the joint exhibition of 1912, the Salon de la Section d'Or. From these discussions came not only Duchamp's mecanthropomorphic forms (see below, pp. 369 ff.) but also Kupka's two-dimensional explorations of the rhythmic and harmonic properties of line, shape, and colour. His *Amorpha, Fugue in Two Colours* (Prague) was exhibited at the Salon d'Automne in 1912, and if, as seems probable, it had been begun in 1911 it must rank as one of the earliest intentionally non-representational paintings in Western art. The syllables 'orpha' in the title of this and of his other contribution to the same Salon may be related to Apollinaire's exactly contemporaneous description of the works of Delaunay as 'orphic'. Lingering traces of Symbolist (and hence Art Nouveau) synaesthetic theory are apparent in Kupka's combination of colour, sound, and touch sensations in these titles. His interest in the spiritual as well as perceptual properties of shape and colour, which he shared with Robert Delaunay, whose Orphic *Discs* of 1912 was probably the first non-representational painting by a French artist, can be traced to the synaesthetic theories of the Symbolists as well as to the more empirical analyses of Seurat. The title alone of Kupka's *Discs of Newton* of 1912 (Philadelphia)

209. Frank Kupka: Around a Point, 1910-15. *Private Collection*

indicates his study of the physical properties of colour; the design of interpenetrating circles divided radially into the hues of the spectrum proves his association with Delaunay in these years. A small gouache, *Around a Point* [209], undated but close in time to his first abstract paintings, shows the origins of his personal style in the linearism of Jugendstil and Art Nouveau. From the central core of red, orange, green, and yellow, the ellipses expand and pass into lavenders and blues at the sides. But the total design is a poor support for the sensitive colour harmonies and betrays that inherent structural weakness which prevented Kupka from holding the position in the forefront of the modern movement to which his historical priority might have entitled him. His works are closer to the misty philosophizing of a Čiurlionis, for example, than to the rigorous and more powerful colour constructions of Kandinsky and Delaunay.

During the War, and for a few years thereafter, Delaunay painted figure compositions, but he returned to his abstract chromaticism

in 1930. His later works, as noted above, are harsh and drier than his first abstract paintings, but in their simplicity and bold confrontation of primary colours they have much visual force. Jacques Villon, too, for a time painted pure abstractions. His *Colour Perspectives* of the 1920s are geometrically precise, but he rejected the restricted palette of De Stijl and Suprematism for more personal harmonies. In the example illustrated [152], the yellow, blue-green, and pale blue planes are suspended against a glowing red ground.

After the War other painters who had once been associated with Cubism turned to abstraction. Albert Gleizes, who, like Kupka, wanted to express supra-pictorial spiritual values, purged his designs of all vestiges of three-dimensional space and figuration and presented his message, fundamentally a Christian one, in unmodulated colours and flat patterns whose sweeping rhythms were based on his study of Romanesque art. This desire to recover certain older principles of pictorial order was symptomatic of his belief as early as 1925 that Cubist research could only end in a return to traditional principles of design. Another member of the Section d'Or, Auguste Herbin (1882–1960), after 1926 developed an unusually austere style based on the regular juxtaposition of triangles, circles, and rectangles of many different sizes, executed in flat bright colours. His paintings may remind one of Kandinsky's theories, stated in *Concerning the Spiritual in Art* as early as 1912, on the changing expressive properties of geometrical figures which differ in shape, size, and colour. The analogy is pertinent, for Herbin also attributed symbolical meanings to his compositions.

In much of the work of these painters an uneasy alliance between a doctrinaire belief in the objective artistic reality of the art object itself, formulated by Gleizes in his phrase 'le tableau-objet', and the desire to communicate supra-pictorial feelings and ideas compromised

when it did not vitiate the immediate pictorial effect, a situation from which even Kandinsky was not always exempt. A similar indecision can be seen in the early paintings of the German artist Otto Freundlich (1878–1943). He had been in Paris in 1908–9, where he knew Picasso and Braque in the Bateau-Lavoir but remained untouched by their proto-Cubist research. After travelling extensively in Europe he returned to Germany and participated in the social movements at the end of the War as a member of the Arbeitsrat für Kunst in Berlin and the Novembergruppe (see below, p. 474). His work at that time was almost entirely abstract, the human figure as the vehicle of his mystical belief in the spiritual unity of mankind

210. Otto Freundlich: Ascension, 1929.
Paris, Galerie Claude Bernard

being reduced to rhythmical bands of flat colour. In 1924 he returned to Paris, where he participated in such manifestations of non-objective art as Van Doesburg's Abstraction-Création. His relation to earlier developments in the decorative arts, specifically to certain aspects of Jugendstil, can be traced in his life-long interest in designing tapestries, mosaics, and stained glass. With the confiscation of his studio during the occupation of Paris and the destruction of a number of paintings during the bombing of Germany, much of this work was lost, especially his early canvases, but from what survives it is apparent that his would have been a personal but minor contribution to the history of abstract art had he not left a number of large works of sculpture. The broad planes of a colossal plaster mask of 1915 have something of the awesome detachment of the Easter Island heads. In the entirely abstract *Ascension* of 1929 [210] the feeling of sombre mystery is present in the heavy, hovering forms. Freundlich believed that pictorial structure depended upon the strong opposition of values as well as colours, and the success of his sculpture depends in large measure on his disposition of lighted protuberances and darkened recesses. Its expressive character can be compared to the later work of Henri Laurens; its artistic potentials have been understood and developed by a younger generation of sculptors since 1945.

LATER CONSTRUCTIVIST SCULPTURE:
PEVSNER AND GABO

In Russia, even before 1917 (see above, pp. 313, 315), the controversy between Malevich and Tatlin concerning the nature and purpose of art had led to an irreconcilable difference of opinion. For the first few years after the Revolution Tatlin's and Rodchenko's ideas of an art subservient to social needs had triumphed over Malevich's conception of an art free from practical considerations and dedicated to the expression of spiritual experience. As Malevich's influence declined, the task of opposing the materialistic direction of Tatlin's and Rodchenko's teaching fell to two artists, Naum Gabo (1890–1977) and his elder brother Anton Pevsner (1886–1962), who had been in Germany and France for several years before 1917 and had seen the early successes of modern art at first hand. During their participation in the revolutionary artistic movements in Moscow they reached a new formulation of abstract art, one which embodied Tatlin's conviction that the new art must accept the technology of the modern age, its tools and materials if not its means of production, but which was a non-, even anti-materialistic concept of artistic expression.[49] Long after they had left Russia, where Socialist Realism had become the dominant Soviet aesthetic, Gabo and Pevsner through their work and activity in Western Europe and America maintained the tradition of Russian abstract design. It is only an historical accident that their mode of expression, which they had first defined as 'Realist', has since been known as 'Constructivist' and was eventually so accepted by the artists themselves. The latter term properly should be identified with a social and political point of view which would grant the artist none of the autonomy, and the work of art none of the spiritual primacy, which they have demanded.

Naum Gabo (he dropped his family name to avoid confusion with his brother) had gone to Munich in 1910 to study medicine and the natural sciences, but had been diverted from a scientific career by the lectures of the art historian Heinrich Wölfflin. In 1911 his brother Anton (later Antoine) settled in Paris, where Gabo visited him on two occasions before 1914. When the War broke out Gabo made his way to Norway where Pevsner joined him in December 1915. By then Gabo had created his first sculpture from pieces of coloured cardboard carefully

cut and fitted to define spatial volumes. From these came his first two *Constructed Heads* of 1915-16, in small planes of wood or metal set at right angles to the ostensible natural surfaces so that the interior of each head was revealed as a series of open and interpenetrating volumes. The method might be traced to the transparent planes in Picasso's Cubist paintings of 1909-10, but Gabo's work was more abstract. There was no trace of portraiture, such as was still evident in Picasso's pictures, and the ponderous mass of Picasso's bronze *Head* of 1909 [134] had been abolished. Gabo's heads were composed of small separate spaces defined by the edges of planes, rather than by a single even if fractured mass enclosed by impenetrable surfaces. Space, rather than substance, was and remained his primary material. As he remarked many years later: 'I can use the same space in different positions in the same image.'[50]

In April 1917 Gabo and Pevsner returned to Moscow, and the following year Pevsner joined the staff of Vkhutemas as instructor of painting. His work at that time was still Cubist with a few Futurist elements, although it was becoming more abstract. Gabo kept apart from any group or institution, but participated in the discussions at Vkhutemas, and students from the workshops were always welcome at his studio. Although a project for a radio station (a drawing of 1919-20), and his models of monuments for an observatory (1922), for an airport (1924-5), and for an institute of physics and mathematics (1925) indicate that he could envisage public and symbolic functions for his works, his and Pevsner's objections to the growing dominance of Tatlin's sociological conception of art led them to make their own demonstration. In August 1920 they exhibited their works, a first one-man show for each, in a bandstand on the Tverskoy Boulevard, having overnight posted on hoardings a printed broadside entitled 'Realistic Manifesto'.[51]

This had been written by Gabo, but Pevsner asked to sign it. By then he had accepted the implications, even if he had not yet tried to apply his brother's principles. After the impassioned opening phrases: 'Above the tempests of our weekdays. . . . Before the gates of the vacant future . . .', which are like echoes of Russian Futurist poetry, Gabo announced a new and unprecedented era in cultural history. He condemned the Cubists and Futurists for their failure to go beyond their announced analysis of space and time – 'Space and time are the only forms on which life is built, and hence art must be constructed' – but his insistence that 'the realization of our perceptions of the world in the forms of space and time is the only aim of our pictorial and plastic art' put the brothers squarely in opposition to any materialistic ideology. The Manifesto was thus more a challenge than a plan of action; even the five-point programme with which it ended offered little in the way of suggestions for actual work. Only the statement that they would affirm 'a new element, kinetic rhythm, as the basic form of our perception of real time' promised a different kind of sculpture, in which actual as well as apparent movement would occur. Gabo's investigations of this kind of movement included the *Kinetic Construction* of 1920, in which a metal rod set vibrating by an electric motor created oscillating virtual volumes, and a drawing, *Design for a Kinetic Construction*, of 1922, in which the oscillating rod, now occupying the central axis, would generate interacting movements of actual planes and theoretical forces which would seem to defy realization in the three dimensions of ordinary physical materials. Gabo later decided that actual motion was a disturbing element in his sculpture, and that the visual properties of kinetic rhythms could be evoked by formal relations moving only in the eye of the beholder. How effective such virtual movement could be when developed according to Gabo's con-

tention that line is no longer descriptive but indicates the direction of forces and their rhythms in objects, and that space can no longer be expressed by opaque volumes but only by 'depth as the one form of space', can be seen in one of the most complex of his works of these years, the lost project of 1922 for a *Monument for an Observatory* [211]. It is almost as if the two-dimensional and hence by definition static

211. Naum Gabo: Monument for an Observatory, 1922. *Present location unknown*

rhythms of Malevich's later Suprematist compositions [compare 187] had been detached from their flat pictorial surfaces and set swinging in actual space in conjunction with circles and ellipses. Gabo's use of transparent as well as translucent materials increased the

visual depth and spatial complexity of such structures (the celluloid *Heads* of 1916 and 1920, the latter executed after his return to Russia, were probably the first sculpture ever made in that material).

In the long run the most important principle in the Manifesto and in Gabo's work at that time, more implicit than pronounced, was the assertion that works of art are not abstracted from nature, deduced from scientific speculations, nor intended for any utilitarian function. They are 'real' objects, hence the reason for a 'Realistic Manifesto', each absolute in itself, and their use is their beauty. But such art was impossible to justify in a totally materialistic society, for the artist required for its creation a degree of independence greater than other workers could be granted. Failing that, he would have to go elsewhere. This the brothers understood when official disapproval of further artistic experimentation became apparent in 1922. The occasion for Gabo's departure was the large exhibition of recent Soviet art of all tendencies held at the Van Diemen galleries in Berlin in the autumn of 1922. This was the first and for many years the most extensive showing of Suprematist, Constructivist, and, as we should say, 'Realist' art to be held in Western Europe, and brought the recent Russian developments to the attention of Western scholars, critics, and collectors. As a result of the interest it engendered, Gabo and Pevsner, the latter having reached Paris the next year, held a joint exhibition at the Galerie Percier in Paris in 1924, and two years later received a commission from Diaghilev to design the setting and costumes for a Constructivist ballet, *La Chatte* (the choreography by Balanchine, the music by Henri Sauguet). This, with Yakulov's sets for *Pas d'acier* of 1928, was Diaghilev's farthest venture into an abstract style and one of the last of his productions.

Gabo's programme was incorporated in one of the earliest of the surviving pieces of sculp-

ture executed after he left Russia, *Construction in Space with Balance on Two Points* of 1925 [212]. The precise articulation of glass, clear plastic, and painted bronze could only have been created by a man to whom science, like art, was a source of knowledge and a means of communication among human beings. But unlike a scientific instrument or equation whose function is distinct from its form, the form of this *Construction* is identical with its purpose. Its function is its meaning, its content its form, for it is an image only of itself. Such phrases are the barest summary of Gabo's thoughts, in which he insisted that the word art means 'the specific and exclusive faculty of man's mind to conceive and represent the world without and within him in forms and by means of artfully constructed images . . . [and] that these mentally

212. Naum Gabo: Construction in Space with Balance on Two Points, 1925.
New Haven, Conn., Yale University Art Gallery

constructed images are the very essence of the reality of the world which we are searching for'. From this it follows that 'all the other constructions of our mind, be they scientific, philosophic, or technical, are but arts disguised in the specific form peculiar to these particular disciplines'.[52] In the dispute between scientists and artists for our exclusive attention, this conception of art as the highest form of intellectual and spiritual activity deserves consideration, for it reclaims science for the humanities.

In 1932 Gabo left Berlin for Paris, and in 1935 settled in England, where he participated in the first purely non-objective movement in British art. After 1947 he lived in the United States. During his English years he made more use of the new and stronger transparent plastics, and in several works wound skeins of plastic thread round frameworks composed of a few planes, cut as identical parts but placed in reverse to each other. As the threads converge and interpenetrate to find

their exact but opposite positions, hitherto unimaginable harmonies of line and light are disclosed [213]. In 1954 he returned to metal for the largest, most commanding example of Constructivist sculpture ever executed, the free-standing form in steel and bronze wire, eighty-five feet high, beside the Bijenkorf department store in Rotterdam.

Pevsner's work after leaving Russia was at first partly painted and partly constructed, and he was more reluctant than Gabo to discard the vestiges of representation. As late as 1926 his *Portrait of Marcel Duchamp* (Yale University) was a witty paraphrase of Gabo's earlier *Heads,* but the darker colours of the celluloids and the zinc ground against which it was placed foretold his growing interest in opaque rather than translucent materials. A few months later his distinctive qualities emerged in his *Bas-relief in Depth* [214] of polished brass and bronze. In comparison with Gabo's *Construction on Two Points,* where the doubled and reversed rela-

213 (*left*). Naum Gabo:
Linear Construction No. 2, 1949.
Private Collection

214 (*above*). Antoine Pevsner:
Bas-relief in Depth, 1926-7.
St Louis, Mo.,
Washington University Art Collection

215. Antoine Pevsner: Dynamic Projection in the 30th Degree, 1950-1. *The Baltimore Museum of Art*

tionships are easily read, the intersections of Pevsner's planes correspond to less rational directions. Because we cannot always wholly see one form when it lies behind another, a mystery is present which analysis cannot dispel. Even in such later works as *Developable Surface* of 1936 or *Dynamic Projection in the 30th Degree*

of 1950-1 [215], whose titles suggest a more intentional analogy with mathematical and geometrical properties than Gabo would venture upon, the striated and boldly curving forms capture and enfold the surrounding space with dark and mysterious energy. Towards the end of his life, in structures whose curved surfaces

are built of closely aligned and welded metal rods supported on intricate frameworks, impenetrable counterparts to Gabo's shimmering webs, he hinted at organic and spiritual experiences. In the compacted lights and darknesses of *Germ* (1949), *Phoenix* (1957), and *Spectral Vision* (1959) one can believe that Pevsner, who was a deeply religious man, remembered the remote, hieratic structures of the ancient Russian icons he had admired in his youth.[53]

ABSTRACT ART IN ENGLAND

In contrast to the development of abstract art on the Continent in the decade after the First World War, when the discoveries of Kandinsky and the ideas of the De Stijl artists and of the Russian Constructivists were pursued to their logical and expressive conclusions at the Bauhaus and in the studios of Paris, there was in England little in the way of progress towards abstraction. The 1920s were dominated in painting by the mature performances of Sickert, Steer, and Augustus John, and in sculpture by Epstein's bronze portrait busts. Even the 7 and 5 Society, founded in 1919 to promote painting of a more aggressive character than that sanctioned by Roger Fry and his aesthetics of pure form, attracted no great attention, although among the first members were painters of such achievement and promise as Paul Nash (1889–1946), Christopher Wood (1901–30), Frances Hodgkins (1870–1947), and Ivon Hitchens (1893–1979). Wood had been much in Paris, where he was known to Picasso and Cocteau, and, had he not died so early, might have helped to bring his colleagues into the main stream of Parisian modernism, although in his own paintings he remained attached to schematic but recognizable representations. Hitchens all along retained vestiges of nature, even in his exceptionally simplified but deftly brushed landscapes. Frances Hodgkins, by

age a younger contemporary of Sickert and Steer, but through her experience and understanding of French painting, especially Fauvism, closer to Wood's generation, eventually resigned from the group in a dispute over the increasing dominance of non-objective painting, which finally accounted for the majority of the works in the society's fourteenth and last exhibition in 1936. By that time the implications of purely abstract art had been accepted by several younger painters and sculptors whose association with certain European artists who had settled in London after 1933 led to a brief but brilliant production of abstract art in the years just before the Second World War.

This new direction was announced in 1933, when Paul Nash organized Unit One, a group of eleven painters, sculptors, and architects variously interested in abstract art but united in their determination 'to stand for the expression of truly contemporary spirit, for that thing which is recognised as peculiarly of *today* in painting, sculpture, and architecture'.[54] If Nash's syntax was weak and it proved impossible to define 'that thing' in positive terms, none the less he did suggest the general character of Unit One's effort by stating what he felt were the negative aspects of English art at that time, 'its crippling weakness – the lack of structural purpose', and its 'immunity from the responsibilty of design'. If the talents of some of the members proved less enduring than others, the presence of Barbara Hepworth (1903–75), Ben Nicholson (1894–1982), Henry Moore (1898–1986), not to mention Nash himself, assured the historical importance of Unit One as an affirmation of the validity of abstract art for England.

Nash claimed for his group no unanimity of technique or style, only a common interest in design 'considered as a structural pursuit', and in 'imagination explored apart from literature or metaphysics'. Both terms of artistic effort were exemplified in his own work. Although

he had not reached Paris and experienced the full revelation of contemporary French painting until 1922, he was already known as a war artist for his drawings of 1917, in which the desolation of the Western Front appeared all the more poignant for having been seen through eyes trained to love nature through prolonged study of the Pre-Raphaelites and Samuel Palmer. That he was able to sustain so personal an interpretation of the apocalyptic devastation on a larger scale in his painting of 1917–19, *The Menin Road* (Imperial War Museum, London), may have been due to his feeling for design as a 'structural pursuit'; the geometrical masses in the foreground and the taut position of the blasted trees control the composition in a way basic to the Cubism of Léger. Towards 1930 Nash constructed landscapes where fanciful lattices and scaffoldings define an invented space [216]. There were elements of Constructivism here, of the sort familiar in Wyndham

216. Paul Nash: Northern Adventure, 1929.
Aberdeen, Art Gallery and Regional Museum

Lewis's more architectural drawings, but the visual tensions set up between the space and the forms within it were more imaginative than intellectual. In this situation one senses the true bent of Nash's talent. In his preface to his work reproduced in *Unit 1* (1934), he spoke of Blake and of the present necessity of finding 'new symbols to express our reaction to environment'. Such 'imaginative research' was shortly to lead Paul Nash to make his own, very English contribution to internationl Surrealism (see below, pp. 421–2).

The challenge of Unit One, which gained wide recognition in 1934 with a volume of reproductions, edited and introduced by Herbert Read, was taken up in 1935 with the first issue of *Axis*, 'a quarterly review of abstract painting, sculpture, and construction'. In this and the successive issues which ran into the winter of 1937 the editor, Myfanwy Evans, who simultaneously presented the case for modern art in *The Painter's Object* (1937), an anthology of statements by prominent European and British artists, offered an international survey of abstract and non-objective art which for the time was as coherent and perceptive as any published elsewhere. At this distance one remarks particularly the attention given the French painter Jean Hélion, whose broadly patterned abstractions with their curiously curving planes, ultimately to be traced to Léger's more mechanistic paintings of the early 1920s, were echoed with many personal nuances in the abstract work of John Piper (1903–92).

The scope of *Axis* was generously inclusive; Kandinsky and Miró figured as prominently as Mondrian. Meanwhile a more exclusive attitude had been adopted by the members of the Circle group, especially by those who published in 1937 a volume by that title, as an 'international survey of constructive art'. The editors were the architect J. L. (now Sir Leslie) Martin, Ben Nicholson, and Naum Gabo. The Russian

sculptor Gabo (see above pp. 352 ff.), who had been in England since 1935, and Mondrian, who came in 1938, brought with them the most advanced doctrines of non-objective design.[55] Their ideas are prominent in the texts and illustrations of *Circle* (which also included brief essays by Nicholson, Herbert Read, Barbara Hepworth, and Moore), even as their influence can be seen in the productions of their British colleagues. Therein lies the importance of *Circle*, both as an instrument of opinion and information about the abstract movement, and as an assertion, through the evidence of the works reproduced, of the position British artists had assumed in the modern movement as a whole. In the confrontation, on opposite pages, of work of 1936 by Mondrian and Nicholson, the evidence was incontrovertible.

Ben Nicholson is said to have painted his first abstract picture in 1923, but even if that is

so his work during the 1920s was more remarkable for his gradual advance from a point of departure not far from the restrained realism of his father, Sir William Nicholson (1872–1949), to a kind of semi-abstract still life in which objects, often quite literally observed, were suspended in a structure of flat intersecting and transparent planes, occasionally very subtly coloured but usually defined only by the thinnest of contours. In this Nicholson, whose academic education, limited to slightly more than three terms at the Slade in 1910–12, had been amplified by his father's encouragement and by his own habit of prolonged concentration on pictorial problems, was adapting the later Cubism of Braque's and Picasso's still lifes after 1920 to his own sensibilities. For many years he worked slowly and infrequently, but after 1932, when with Barbara Hepworth he visited Paris, where they met Picasso and

217. Ben Nicholson: White Relief, 1935.
London, Tate Gallery

Brancusi and explored Arp's studio at Meudon, his pace quickened. His bottles and jugs and teacups became less recognizable as their contours expanded, joined, and succumbed to a discursive geometry, somewhat reminiscent of the Purism of Ozenfant and Jeanneret, until in 1933 he produced the first of the plaster reliefs which have been his most original inventions. Carved in no more than three or four planes so shallow that their depths and projections are best seen only in a raking light, they remain to this day remote and poetic events [217]. From Mondrian Nicholson may have learned the power of straight lines to create space, and from Miró something of the magical properties of circles, for there are hints of Miró's freely floating forms in his work around 1933. But his combinations of straight lines – properly one should speak of his edges – and shallow circular depressions were never so relentlessly confined to the single plane to which Mondrian fixed his rectangles. Nicholson intended the spectator to sense 'subconsciously' a mysteriously receding space in which the circle may have pierced 'the lower plane without having touched it'.[56] The sensation of observing the multiple interaction of planes moving towards and away from the surface of the picture is, of course, Cubist in origin, and had earlier been so treated by Nicholson in his *Au Chat Botté* of 1932 (Manchester), in which the picture plane embodies reflections in the shop window of objects which were actually behind the artist, but the reduction of so many visual planes had never been pushed to such extremes in Paris. As exercises in the poetics of geometry, whether dazzlingly white or painted in warm earth colours, they have also served to purify his painting; thenceforward the picture was essentially a configuration of shallow coloured planes from which there might tantalizingly emerge a sign – a clue as it were – to the commonplaces of experience, to the handle of a cup or the profile of an ordinary drinking glass.

Sometimes, as if seeking to re-establish his points of departure from nature, Nicholson has abruptly inserted a more naturalistic fragment of the world outside his mind, but when this occurs, and it is usually in his landscapes, the results have not always been his happiest. Then he returns to his sculptured geometries, which in recent years have gained additional textural dimensions, though becoming smaller in size, through rich but sober colours and subtle variations in the plaster surfaces.

Barbara Hepworth's interest in abstract art can be followed from 1932, when she and Nicholson accepted Herbin's and Hélion's invitation to join the Abstraction-Création group in Paris. Until then her work had been figural, although strongly simplified by suggestions from the Egyptian, Assyrian, and Pre-Columbian sculpture which had also interested Henry Moore. They had been students together at the Royal College of Art and friends thereafter, so that Moore's influence upon her work, if that is not too one-sided a way to describe a relation of shared enthusiasms, which included an awareness of the sculptural implications of Picasso's drawings of the early 1930s, is not surprising. Both, moreover, believed that the contemporary sculptor should carve, not model, his work. Barbara Hepworth was to move farther than Moore towards non-objective expression, and so rapidly that in *Two Forms with Sphere* of 1935 and *Two Segments and Sphere* of 1935-6, in alabaster and marble (both in private collections in the United States), she was exploring a spatial geometry as unadorned as Giacometti's had momentarily been in 1934 and, unlike his, devoid of extraneous expression. In wooden sculpture such as *Single Form* of 1935 and *Darkwood Spheres* of 1936 (both reproduced in *Circle*, but now destroyed) and the *Forms in Échelon* of 1938 [218] the departures of their circumferences from the geometrical norm determine their existence as objects of art rather than of mathematical

218. Barbara Hepworth: Forms in Échelon, 1938. *London, Tate Gallery*

calculation. But strict geometry was exceptional. It was her habit rather to suggest by her titles (the wooden *Wave* of 1943-4, for instance), and by her understanding of her materials, a relation to nature as the source both of the materials themselves and of the forms which then received the impress of her artistic decisions when she chose to paint a hollowed interior of a stone in bright flat hues or hold a wooden arc in tension by wires or strings. In her later work there were even occasions when the figure reappeared, more by suggestion than by definition, as in the large stone *Contrapuntal Forms* of 1950 for the Festival of Britain (now at Harlow New Town, Essex) or *Monolith (Empyrean)* of 1953 beside the Royal Festival Hall in London. In such work the comparison with Moore is again instructive; where his abstracted forms seem to move constantly towards rather than away from organic life, Barbara Hepworth's may be thought to be departing for more speculative regions of the mind.

With work as authentically conceived and executed as Nicholson's and Barbara Hepworth's, supported by statements as closely argued as those by Mondrian and Gabo in *Circle*, the case for a totally abstract or non-objective British art had been proved. But it was not to rest unchallenged. Already in the summer of 1936 the International Surrealist Exhibition (see below, p. 420) presented a startling alternative to the cool reflections of the Circle group, an alternative embraced by several artists, among them John Piper, who turned from abstraction to investigate ruins and other ancient architectural splendours, bringing to contemporary British art something of that neo-romantic nostalgia for the past which had been exploited by Eugène Berman and other painters in Paris a few years before (see below, pp. 439 ff.).

DADA AND SURREALISM

The technical and stylistic analyses which helped to clarify the development of Cubism and Futurism are of little use in unravelling the complex history and deliberately anti-stylistic course of Dada, the most violent, disruptive, and controversial movement in twentieth-century art. Since its leading theorist, the Romanian poet Tristan Tzara, always insisted that Dada was, and is, 'a state of mind' rather than a technique or a style, the sources of its remarkable energies must be sought in psychic and intellectual as well as in strictly formal circumstances. It was no coincidence that the first manifestations of the Dada spirit occurred in 1915–16 in two neutral capitals, Zürich and New York. There various young artists and writers acted out their revulsion at the course of the war that was annihilating the very culture it had been invoked to defend. Given the energetic experimentation and search for new means of expression by the avant-garde in Europe just before 1914, it would have been strange if some of their members had not felt, as Henry James did, that 'to have to take it all now for what the treacherous years were all the while really making for and *meaning* is too tragic for any words'.[1] The ageing American author could only resign himself to the course of events, but the young could at least protest. The Dada spirit was that protest, beginning as a somewhat self-conscious sense of relief at one's own immunity from the butchery, but soon finding means whereby audible words and visible forms expressed a total rejection of everything false and hypocritical which could be held responsible for the catastrophe and the accompanying 'incredible brutalization of common judgements', as Carl Jung wrote in the very place,

Zürich, and at the very time, 1916, that European Dada appeared.[2] What better point of attack could have been found than the cultural symbols of a culture that seemed bent on suicide? To destroy the concept of art the Dadas proposed anti-art, and non-art. 'Dada', Tzara declared in 1918, 'signifies nothing.' From the first the Dadas were committed to the destruction of all established values, yet by an unexpected but not entirely illogical turn of events their intentionally negative and anti-artistic attack was transformed, with little abatement of its initial violence, into the affirmation of a new artistic reality, the super-reality of the Surrealists. This consequence should not seem too strange, for the essence of Dada, at least in its major manifestations in Zürich, New York, Cologne, and Paris, was fundamentally one of artistic expression. The German poet Richard Huelsenbeck, later influential in transforming Dada in Berlin into political action, wrote in 1920 that the 'energies and ambitions of those who participated in the Cabaret Voltaire in Zürich were from the start purely artistic. We wanted to make the Cabaret Voltaire a focal point of the "newest art"'.[3]

DADA IN ZÜRICH: 1916–21

Although the Dada movement erupted almost simultaneously in Europe and America, and, as Arp once said, its members 'were all Dadas before Dada came into existence', the fact that the word itself was first used in Zürich entitles that city to pride of place in the historical context. There, on 5 February 1916, when the French and German armies were stalemated at Verdun, Hugo Ball (1886–1927), a German

poet, musician, and theatrical producer, opened the Cabaret Voltaire in a narrow side street in the older quarter of town. A notice inserted in the newspapers invited the disaffected to rally under the name of that earlier genius of social criticism. The response was so immediate that a few months later Ball announced that he had founded the cabaret to 'remind the world that there are independent men, beyond war and nationalism, who live for other ideals'.

The entertainment at first consisted of nothing more subversive than a balalaika orchestra; songs by Emmy Hennings, Ball's wife; and piano selections, including compositions by Tchaikovsky and Scriabine, played by Ball himself. The arrival of other young men put an end to all that. Richard Huelsenbeck (1892–1974), a German poet and medical student recently invalided out of the army, appeared on 26 February. He was to stay only eleven months, but when he returned to Germany he took with him the ideas and techniques with which he launched the Dada movement in Berlin in 1918. Tristan Tzara (1886–1963), a young poet who had fled from Romania to avoid military service, introduced more aggressive entertainments. Acquainted with the most recent developments of European modernism, he took from the Futurists their brash publicity, including the deliberately provocative manifestos to be read in public in an insulting manner, as well as 'bruitism' or noise-music. By 30 March matters at the Cabaret had progressed to such an extent that a performance of 'Negro' music, improvised on drums and gongs, was the accompaniment for 'simultaneous poems' in which three or more speakers recited quite unrelated texts in as many languages, all at the same time. In an excerpt from Tzara's elliptical account of the first major Dada demonstration, the Dada Night at the Salle Waag in Zürich on 14 July(!) 1916, we can hear echoes of the total confusion: 'Boxing resumed: Cubist dance, costumes by Janco, each man his own big drum on his head,

noise, Negro music/trabatgea bonoooooo oo ooooo/5 literary experiments: Tzara in tails stands before the curtain, stone sober for the animals, and explains the new aesthetic: gymnastic poem, concert of vowels, bruitist poem, static poem chemical arrangement of ideas, "Biriboom biriboom" saust der Ochs im Kreis herum [the ox dashes round in a ring] (Huelsenbeck), vowel poem a a ò, i e o, a i ï, new interpretation the subjective folly of the arteries the dance of the heart on burning buildings and acrobatics in the audience. More outcries, the big drum, piano and impotent cannon, cardboard costumes torn off the audience hurls itself into puerperal fever interrupt. The newspapers dissatisfied simultaneous poem for 4 voices + simultaneous work for 300 hopeless idiots.'[4]

A name was needed to focus and define these activities. Of the several accounts of the discovery of the word Arp's is the best known, the most amusing, and the most 'Dada': 'I hereby declare that Tristan Tzara found the word on February 6, 1916, at six o'clock in the afternoon; I was present with my twelve children when Tzara for the first time uttered this word which filled us with justified enthusiasm. This occurred at the Café de la Terrasse in Zürich, and I was wearing a brioche in my left nostril.'[5] Huelsenbeck states that he and Ball found it accidentally by inserting a knife at random in a German-French dictionary while looking for a pseudonym for their new star at the Café. Ball's testimony is the simplest and most convincing. In his diary for 18 April he wrote of his wish to publish a review of the activities at the Cabaret and stated: 'Tzara is worried about the magazine. My proposal to call it Dada is accepted. . . . Dada means in Romanian "Yes, yes!", in French a rocking- or hobby-horse. In German it is a sign of absurd naïvety.' Two points are important. Tzara's Romanian accent may quite possibly have influenced Ball. More significant, however, is the choice of a word with childhood

associations. 'Dada', especially when repeated, sounds like a baby's 'meaningless' babble, but it also suggests the true naïvety of the child, its dependence upon instinct and intuition as ways and means of knowledge. Ball stated this more explicitly in his diary on 5 August 1916: 'Childhood as a new world, and everything childlike and fantastic, everything childlike and direct, everything childlike and symbolical in opposition to the senilities of the world of grown-ups . . . The distrust of children, their shut-in quality, their escape from our recognition – their recognition that they won't be understood anyway. : . . Childhood is not at all as obvious as is generally assumed. It is a world to which hardly any attention is paid, with its own laws, without whose application there is no art, and without whose religious and philosophic recognition art cannot exist or be apprehended.' Ball not only was aware of the need for a new understanding of the sources of feeling and so of artistic expression but also probably knew of Kandinsky's and Klee's interest in children's art. He had recently been in Munich, where he could have seen the Blaue Reiter almanac, and in 1917 he lectured on both artists in Zürich. Ball first used the new word in print when, in the only issue of his *Cabaret Voltaire*, he announced that his artists would publish an international review to be called '"DADA" Dada Dada Dada Dada'.

Because Huelsenbeck and Tzara were primarily men of letters, the Dada protest at first was almost exclusively a literary manifestation. Ball, too, was concerned with language as a means of expression; he had stated in 1916 that 'We should withdraw into the innermost alchemy of the word, and even surrender the word, in this way conserving for poetry its most sacred domain.' But through his work for the Berlin theatre before 1914 he was familiar with the visual arts and had tried his hand as an Expressionist painter. From the start he wanted his cabaret to be a centre of artistic expression,

and for the opening he arranged a small exhibition, largely of graphic works by contemporary German, French, and Italian artists. The exhibition, as it can be reconstructed from the names of the exhibitors, was more a summary of current developments than an indication of a new direction, but the mixture of Cubist, Expressionist, and abstract works was typical of Ball's interest in all that was original and new. If as yet there were no specifically Dada pictorial or plastic mannerisms, they were soon to be discovered by Arp, the leading artist of the Zürich group.

Jean (Hans) Arp (1887-1966) was born in Alsace. Although of German nationality, his sympathies were French, and he had spent some time in Paris, where he admired the *papiers*

219. Jean Arp:
Collage with Squares arranged according to the Laws of Chance,
1916-17. *New York, Museum of Modern Art*

collés of Braque and Picasso. In collaboration with the gifted dancer and designer Sophie Taeuber (1889-1943), whom he married in 1922, he began experimenting with accident and automatism. According to his own testimony he drew the same design every day until his hand automatically began to create variations on the original shapes. He tore up coloured papers or his own drawings and let the fragments fall as they would [219]. When their positions had been fixed as abstract patterns arbitrarily arranged according to conditions over which the artist, theoretically at least, had no control, new designs were sometimes elaborated by additional lines and contours. For Arp these methods and the principles upon which they were based remained fundamental for his later art, as we shall see when it is examined in the context of the School of Paris between the Wars (see below, pp. 466 ff.). But if for Arp the 'law of chance' was a serious matter, because, as he said, it 'embraces all laws and is unfathomable like the first cause from which all life arises [and] can only be experienced through complete devotion to the unconscious',[6] for others the exploitation of accident was an invitation to combine the irrelevant and insignificant in unartistic and often unattractive combinations. Although the more pointless antics and artefacts did much to conceal from an astonished public the true and even tragic inner reality of the Dada experience, it must be said that when the laws of chance are manipulated by a master, by an Arp, a Schwitters, or a Duchamp, the artistic integrity of the object is undeniable despite the later protests of the Dadas themselves that Dada, as anti-art, was totally unconcerned with artistic value. Other and less sensitive hands could, and did, produce objects which still appear utterly devoid of artistic qualities, and so can properly be considered anti-artistic. Such is the *Construction 3* by Marcel Janco (b. 1895), the Romanian artist now living in Israel, who was

220. Marcel Janco: Construction 3, 1917. *Present location unknown*

one of the most energetic members of the Zürich group. This was reproduced in the first issue of *Dada*, the Dadas' magazine, published in Zürich in July 1917 [220]. It has long since disappeared, so that it is difficult to tell of what it was made, but even the inferior photograph suggests the haphazard nature of its assemblage. Set upon a pedestal and presented in a gallery, it could not fail to disturb a public traditionally suspicious of innovations.

In March 1917 the Cabaret Voltaire was superseded by Ball's Dada Gallery, which opened with an exhibition lent by the Sturm Gallery in Berlin. Ball's presentation of Kandinsky, Klee, Feininger, Kokoschka, de Chirico, and certain Futurists suggests his reluctance to pursue Tzara's principles of 'continuous con-

tradiction' and 'immediate spontaneity' to the end. A man of deep faith, he withdrew from Dada in 1917 to devote much of his life to works of Christian charity, leaving the dialectically impossible task of directing the movement to Tzara.

The phrases just quoted are from Tzara's second Dada manifesto of 1918, a much longer and more coherent analysis of the Dada position. This document, read in Zürich on 23 July 1918, was published in Dada 3 the following December.[7] That issue, the first to incorporate Picabia's ideas of informal typography, was the principal channel through which Dada ideas reached Paris. There such young writers as Breton, Eluard, and Soupault eagerly accepted Tzara's iconoclastic denunciation of beauty ('A work of art should not be beauty in itself, for beauty is dead') and his call for 'works that are strong straight precise and for ever beyond understanding'. Again we may note that Tzara's appeal was directed to men of letters; on strictly pictorial and sculptural matters he had little to say. Nor, indeed, did many of the Zürich Dadas. The works of Arp and Sophie Taeuber-Arp belong to the larger movement of abstract art in Europe, however much Arp in his poetry and memoirs cherished his Dada past. Similarly the work of Hans Richter (born in Germany in 1888), who also joined the Zürich group in 1916, matured within the aesthetic of abstract art and of the avant-garde cinema (cf. pp. 347-9). With the disappearance of Ball and the departure in 1919 of Arp and Tzara for Cologne and Paris, the movement subsided in Zürich, only to flare up elsewhere. But before examining Dada events in Germany and France we must turn back to New York, where Dada in spirit, if not in name, had been at work since 1915.

DADA IN NEW YORK: 1913-21

As early as 1912 two of the younger artists in Paris, Marcel Duchamp and Francis Picabia, had found ways to express not only their contempt for middle-class artistic standards as exemplified by the schools and the salons but also their disillusion with the modern mode as a whole. As we have seen, the mechanistic anatomy of Duchamp's Nude Descending a Staircase of 1912 [153] had irritated his Cubist colleagues of the Section d'Or almost as much as it did the American public at the Armory Show the next year. In that work the key to the successive positions of the body is the set of three semicircular dotted lines which chart the movement of the pelvis. As he said much later: 'the reduction of a head in movement to a bare line seemed to me defensible. A form passing through space would traverse a line; and as the form moved the line it traversed would be replaced by another line – and another and another.'[8] The Coffee Mill of 1911, a schematic representation of a commonplace household object painted for Duchamp-Villon's kitchen, was a pitiless attack upon the conventional still life. By showing successive positions of the handle, and by indicating its direction with an arrow, Duchamp reduced the traditional difficulties of depicting forms in motion to a tidy graph. The Coffee Mill has been little seen in recent times, but as much as any of his later works it demonstrates his principles of 'ironical causality' and of the 'beauty of indifference'.

In 1910 Duchamp met Francis Picabia (1879-1953), a Cuban citizen of French and Spanish descent, ironic, wealthy, and extravagant, with whom he shared a taste for paradox and a delight in pursuing the most complex situation to its reductio ad absurdum. Picabia had first painted as an Impressionist, but by 1912 his work was superficially cubified. The following year he was briefly in New York for the Armory Show, the first important exhibition of modern European painting in the United States, where his own contributions, including the abstractly Cubist Dances at the Spring (Philadelphia), were almost as much remarked

JE REVOIS EN SOUVENIR MA CHÈRE UDNIE Picabia

as Duchamp's *Nude*. Soon afterwards he abandoned conventionally picturesque subjects, still treated in terms of sense perception, which he called *matière pensée*, for invented and imaginary themes interpreted by psychic perception or *pensée pure*. The large painting of 1914, *I See Again in Memory my Dear Udnie* [221], may be considered the first spectacular result of his discussions with Duchamp. The treatment of abstract but machine-like forms in constant motion through a variously lighted space is close to Duchamp's *King and Queen surrounded by Swift Nudes*. If, as has been suggested, the 'actual subject of the painting is a middle-aged businessman's memory of sexual intercourse with Udnie, represented in ideographic terms, both the male and female

principles [being] clearly represented',[9] then *Udnie* is a crucial stage in the mecanthropomorphic progression which reached its climax in Duchamp's *Bride Stripped Bare by her Bachelors, Even* [224], conceived in 1912 but not elaborated until 1915.

By then Picabia, like Duchamp, had renounced the emotionally indifferent Cubist themes of still life and figure for objects capable of conveying intricate if very private symbolic meanings. Before examining the most baffling of such configurations, Duchamp's *Bride Stripped Bare . . .*, we must observe Picabia's sudden rejection of the last vestiges of an abstract Cubist technique, still dominant in *Udnie*, for a satirically simplified draughtsmanship with which, through actual or invented

222. Francis Picabia: Universal Prostitution, 1916-19. *New Haven, Conn., Yale University Art Gallery*

mechanical forms, he presented his equally satirical and simplified comments on society. In 1915 he was again in New York, ostensibly on a mission for the French army, where he encountered Duchamp, who, unfit for active service, had found the chauvinistic climate of Paris insupportable. Together they became the particular stars of the most progressive circle in New York, which gravitated between Alfred Stieglitz's Photo-Secession Gallery at 291 Fifth Avenue and the residence of the poet and scholar, Walter Conrad Arensberg, and his wife. The Arensbergs endlessly entertained the European artists then in New York, among them Albert Gleizes and Duchamp's brother-in-law, Jean Crotti. Mme Buffet-Picabia's recollections of this 'motley international band . . . living in an inconceivable orgy of sexuality, jazz, and alcohol'[10] hint that some of the symptoms of unrest in Zürich in 1916 had been present in New York the year before. Certainly Picabia's *Universal Prostitution* of 1916–19 [222] is as insolent as any object produced by any Dada elsewhere. Everything about it – the mocking title, the off-hand composition, the inept lettering – was offensive to many kinds of taste.

In 1917 Picabia was in Barcelona, another neutral capital with its little group of exiles. Here he published the first issues of his own journal, *391*, a satirical continuation of Stieglitz's short-lived house paper, *291* (which had devoted much space to Picabia while he was in New York). In addition to his own incoherent poems and satirical essays, *391* contained his most trenchant visual statements, from the *Portrait of a Young American Girl in a State of Nudity* (a mechanical drawing of a spark-plug labelled 'For-Ever') to the electric-light bulb reflecting the words 'Flirt' and 'Divorce' and entitled *Américaine*. Subsequent issues of *391* were published in New York, Lausanne, Zürich, and Paris until 1924. The issue for March 1920 (No. 12) contained his most

extreme iconoclastic and blasphemous statement, a large ink blot labelled *La Sainte Vierge*.

After the War Picabia was more an agitator than an innovator. His presence in Zürich contributed to the final flurry of Dada, and through Arp his mechanical forms reached Max Ernst in Cologne. For a time after 1920 he participated in Dada events in Paris, but his effect on French art was slight. Only Georges Ribemont-Dessaignes (1884–1974), who became a prominent Surrealist propagandizer, adopted his comic-strip technique. In 1921, aware that Dada had outlived its own necessities, Picabia deliberately quarrelled with the Parisian Dadas and renounced the movement. He remained as intransigent as ever, but his later painting was more conventional. Since it seemed to bear little relation to the problems of the day, it has been almost entirely, perhaps unjustly, ignored.

Duchamp meanwhile had reached a further stage in the reduction of visual elements to symbols in the paintings which followed hard upon the *Nude descending a Staircase*. In *The King and Queen surrounded by Swift Nudes* (Philadelphia) one can see, as Duchamp says, 'where the forms are placed' rather than the forms themselves. From the title we know that these turbine-like images derive from chessmen, but in setting down only the positions which their sides and angles have occupied or are about to occupy, Duchamp transformed the heraldic figures into menacing machines. Here, more than in any work by Léger, the machine is presented as a threat to modern life. Léger's machines are man's companions in his social and industrial existence; Duchamp's are self-created, self-perpetuating forms whose activity is independent of ourselves. He reveals an appalling prospect of human beings gradually transformed into machinery, a mecanthropomorphic state of affairs which was further investigated in the paintings preceding and following the *King*

and Queen. In the drawings for the unexecuted *Virgin* (Philadelphia), in the *Passage of the Virgin to the Bride* (New York) and *The Bride* (Philadelphia), he gradually translated what heretofore had sentimentally been considered the most intimate aspects of a woman's physical life into a mechanistic biology. In these works internal anatomical functions have been equated with mechanical contraptions, and in *The Bride* the thought that these presumably organic, machine-tooled forms are the seat of life is the more unsettling for the pink, mucous colours.

The last two pictures had been painted in Munich, where Duchamp spent the summer of 1912, ostensibly to investigate the activities of Kandinsky and the Blaue Reiter artists. But he had gone too far in his understanding of the nature of modern art to be interested in the problems of symbolic colour and design which the Munich painters set themselves. He had already decided to make an end to what he called 'retinal painting', appealing only to the eye, which he believed began with Courbet and reached its greatest splendours and deceptions with Picasso and Matisse. 'I was interested', he has confessed, 'in ideas – not merely in visual products. I wanted to put painting once again at the service of the mind.'[11] The individual work of art, no longer an imitation of the merely actual but a new reality in itself, would be both an object within the physical world of other objects and a fact in consciousness, a 'brain fact' to use his own word (*cervellité*).

The 'ready-mades' are the most mystifying of Duchamp's 'brain facts'. They are outrageous but entirely logical demonstrations of the suspension of the laws of artistic causality through the substitution of ordinary, mass-produced, machine-made articles for the traditionally 'handmade' work of art. The first, a bicycle wheel set upside down on a kitchen stool (1912), was technically a 'ready-made assisted', but others followed quite in a state

of nature, like the metal rack for drying bottles (a familiar object in small French restaurants but now looking like some baleful instrument of torture), or the snow shovel [223]. The title he gave the latter, *In Advance of the Broken Arm*, added something sinister to the utterly commonplace. By wrenching such artistically indifferent objects from their everyday world and depriving them of all functional, technical, or commercial value, Duchamp conferred artistic status upon them by fiat. In their mysterious yet beguiling banality these objects,

223. Marcel Duchamp: In Advance of the Broken Arm, 1915-45. *New Haven, Conn., Yale University Art Gallery*

standing over against ourselves, exert their puzzling spells, not least because they are visual demonstrations of Duchamp's contention that it is futile to define a work of art except as an intellectual or philosophical decision, as a mental fact, as a victory of consciousness over matter and of will over taste.

When Duchamp arrived in New York in 1915 he brought plans and drawings for what became his most enigmatic and important work. This is the large composition in oil, wire, and lead foil on two glass panels entitled *The Bride Stripped Bare by her Bachelors, Even* [224], sometimes known as the *Large Glass*. Duchamp worked upon it in New York at intervals between 1915 and 1923, although it had been in his mind and several of the principal elements already determined as early as 1912. In 1923 he abandoned it as definitely unfinished. It was first owned by Walter Arensberg, who sold it to Katherine S. Dreier in 1921, when he moved to California, because he thought it too fragile to transport. His fears were justified when it was shattered in 1927 while returning from an exhibition in Brooklyn. Ten years later Duchamp repaired it, piecing the fragments together with infinite patience and securing them between two heavier panes of glass, the whole bound in a new metal frame. The fact that the two halves had been transported one above the other explains the complementary direction of the cracks. The fortuitous effect came to seem so much a part of the whole that Duchamp declared it finally completed 'by chance'.

Although the *Large Glass* remained in virtual seclusion until 1952, when by Miss Dreier's bequest it joined other works by Duchamp in the Arensberg Collection in the Philadelphia Museum of Art, it was not un-

known to many artists who respected it, even if only by hearsay, as one of the most problematical works of modern times. To the public it has always seemed an incomprehensible joke. So it may be, and we must not ignore Duchamp's irony, but with the help of the pertinent documents which he published in elaborate facsimile in 1934 it is possible to discover his principal intentions.

The general scheme is clear if the first drawing of the *Virgin*, executed in Munich in the summer of 1912, is compared with the small *Bride* upon which Duchamp was also working. The forms are more mechanistic, but there is the same fusion of mechanical and biological functions. In the *Large Glass*, Duchamp concluded the erotic history begun in the *Virgin* and developed in the *Passage from Virgin to Bride* (1912, New York). Secure in the upper portion of the glass, the Bride disrobes as she simultaneously attracts and repulses her suitors, whose orgasmic frustrations are diagrammatically indicated by channelling 'love-gasoline' through the capillary tubes connecting them with the 'Bachelor Machine' in the lower panel. The Bachelors themselves, as 'Nine Malic Moulds', are seen in the 'Cemetery of Uniforms and Liveries' at the lower left. Reminiscent of de Chirico's mannequins, these abstractions symbolize aspects of masculine activity in which the individual is stifled by official clothing. In front of them the 'Water Mill' and 'Glider' set in motion the scissors at the top of the bayonet projecting from the 'Chocolate Grinder'. The latter elements stand for the principal male organ in the glass. The suggestion seems to be that erotic desire is susceptible to voluntary, pseudo-mechanical control. In the upper section the Bride floats, below and to the left of the 'Milky Way'. The shapes of the three holes in the 'Milky Way' were determined by chance; a square of gauze was hung in front of an open window and the deformations caused by a current of air were

224. Marcel Duchamp:
The Bride Stripped Bare by her Bachelors, Even,
1915-23. *Philadelphia Museum of Art*

carefully noted. The Bride herself is an emaciated version of the Bride of 1912. Frequently mentioned in Duchamp's notes as the *Pendu femelle* (which may be ponderously rendered as a 'female hanging thing'), she lacks the flesh colour which made the earlier Bride seem remotely organic. The *Pendu femelle*, however, has other connotations; besides being the schematic representation of female sexuality, she is, as Duchamp recorded in his notes, an intimation of the fourth dimension: 'The *Pendu femelle* is the form in ordinary perspective of a *Pendu femelle* for which you could perhaps try to discover the true form. This comes from the fact that any form is the perspective of another form according to a certain vanishing point and a certain distance.' More simply, if a two-dimensional drawing may stand for a three-dimensional object, may not a three-dimensional object be considered as the perspective rendering of one in four dimensions?

Effects of both planned and unpremeditated chance in the *Glass* are reinforced by disturbances intentionally introduced by its transparency. In the photograph here reproduced the view through the window into Katherine Dreier's garden is to be taken as an integral part of the total design; in Philadelphia, where it now stands in a large gallery, spectators passing behind contribute fortuitous effects of movement and 'absurdity'. But the significance of the whole is still elusive. Is it a meaningless and cruel ruse, a cynical rejection of every value that could possibly be called humane, or a reflection upon the multiple and antagonistic tensions existing between art and life? André Breton first outlined its major implications in his sensitive and poetic tribute of 1935, 'The Lighthouse of the Bride'.[12] He recognized Duchamp's 'determined intention of negation' and the astonishing steps he had had to take to 'unlearn painting and drawing'. Even today we can agree that 'in this work it is impossible not to see at least the trophy of a fabulous hunt through virgin territory at the frontiers of eroticism, of philosophical speculation, of the spirit of sporting competition, of the most recent data of science, of lyricism, and of humour'.

Duchamp's last painting in the conventional medium of oil on canvas, *Tu M'* of 1918 (Yale University Art Gallery), includes the shifting shadows of two 'ready-mades' (a coat-rack and a corkscrew), as well as two of his most amusingly destructive conceits. Because every painting, by definition, contains colours, this has a sequence of colour samples secured to the canvas with a bolt. The irony is that the samples are painted, the bolt real. Near by a painted rent is fastened with actual safety pins, and a realistic hand is signed by A. Klang, a commercial painter hired for the job. For its many levels of meaning, its mock-serious confusion of pictorial realism with real objects, *Tu M'* is the most important extant Dada mural.

But is it quite correct to classify Duchamp as a Dada? He himself distinguished between his own work and that of his Dada friends and contemporaries when he declared that he had supported Dada and Surrealism because they were hopeful signs, but that they never had enough attraction to absorb him. 'I wished', he said, 'to show man the limited place of his reason, but Dada wanted to substitute unreason.'[13] There lies the difference between Duchamp's conceptions and a narrowly Dada object. However fantastic or unfathomable they may appear at first sight, they eventually lead us to unsuspected imaginative discoveries, but the intentionally irrational Dada gesture is topically effective as a protest only until the need to protest disappears.

About 1920 Duchamp renounced artistic activity to devote himself to chess, 'a mechanistic sculpture that presents exciting plastic values', at which he became a master. From time to time a 'ready-made', usually 'corrected' or 'assisted', made an unexpected appearance,

such as *Why Not Sneeze?* in 1921 (Philadelphia). Signed by 'Rose Sélavy' (the feminine pseudonym Duchamp used after 1920), this is an ordinary wood and wire bird-cage filled with a cuttle-bone, lumps of marble 'sugar', and a thermometer. But by and large Duchamp stuck to his resolve. His rare intrusions into the contemporary scene, such as the miles of string with which he entwined the Surrealist Exhibition in New York in 1942, kept him close to the continuing currents of Surrealism and to the recent revival of certain aspects of Dada. Since 1945 his influence has been important for several younger American artists who also have had to unlearn the traditional uses of art. For them his bleak conviction that all artistic standards are basically subjective and relative and hence meaningless was warmed by his interest in what was really and radically new. His last work, upon which he had secretly worked from 1946 to 1966 and which has been installed since his death in the Philadelphia Museum, turned out to be the most surprising of all. *Étant donnés: 1° la chute d'eau. 2° le gaz d'éclairage* (the lengthy title refers to the two abstractly erotic motivating forces in the *Large Glass*) is a bizarre *tableau-assemblage*. Behind a rough double wooden door with neither hinges nor handles, and visible only through two small peepholes, on a mass of twigs and leaves reclines a startlingly life-like nude woman, cleverly contrived from leather and other materials. The Bride is at last quite literally 'stripped bare', surrounded not by anagrams of reality but by a hilly wooded landscape, painted to be sure, but from which a small trickle of water, actually flowing, creates a disturbing illusion of depth where little is known to be. For the last time, and on an unexpected scale, Duchamp dissolved the boundaries which delimit art from life.

The earliest effect of Picabia and Duchamp on American art was due to their friendship with Man Ray (1890-1976), an architectural and engineering student who had begun painting in 1907 and been encouraged by the Armory Show to study Cubism and the possibilities of abstract design. Man Ray helped Duchamp with his later glass machines and is even said to have been almost decapitated when one of them accidentally splintered while revolving at high speed, so narrowly did the artistic nihilism of Dada miss translation into action. With

225. Man Ray: Black Widow, 1915.
Private Collection

Duchamp he also edited one issue of their *New York Dada* in 1921, the year he moved to Paris, where his ingratiating wit led to his immediate acceptance by the French Dadas.

Man Ray's prolonged residence abroad, interrupted only by six years in California during the Second World War, may be responsible for the neglect he suffered in his own country. Certainly his historical significance is beyond dispute. By 1916, in such paintings as *The Rope Dancer accompanies herself with her Shadows* (New York), or *Black Widow* [225], he had enlivened the solemnity of Synthetic Cubism with flat, silhouetted forms seemingly derived from dress-patterns. The relation to Duchamp's dummies in the *Cemetery* is more easily explained than the hints of de Chirico's mannequins of 1916 and 1917 which were still to come. Although they were not published until 1926, his *Revolving Doors*, coloured reproductions of ten gouache drawings partly executed with an air-brush in 1916–17, were precociously abstract and technically inventive. In Paris Man Ray devised his own camera-less photography by exposing oddly assorted objects to sensitized paper. The resulting 'rayographs', each a unique proof, were the principal Dada contribution to photography. Man Ray was also a leader in the experimental cinema. With Duchamp he produced *Anemic Cinema* in 1926 ('anemic' is an anagram of 'cinema'). His own productions include *Le Retour à la raison* (1923), *Emak Bakia* (1927), *L'Étoile de mer* (1928), and *Les Mystères du Dé* (1929), commissioned by the Vicomte de Noailles.

In his portrait photography Man Ray created an impressive psychological record of his notable friends and contemporaries. But the fact that his photographs, paintings, and sculpture (like the painting of an enormous pair of lips floating over the Luxembourg gardens in his *Observatory Time* of 1934) are more interesting as images than as aesthetic objects delayed his recognition as a creative artist.

His work is often insensitive in texture and ungracious in form, but perhaps that is all the more reason why he preserved the Dada spirit long after it was officially defunct.

In 1920 Man Ray joined Duchamp and Katherine S. Dreier (1877–1952), one of the earliest American abstract artists, in founding an organization to advance the understanding of the modern movement in the United States through exhibitions, lectures, and a permanent collection of progressive art. The tautological name he suggested, 'Société Anonyme, Incorporated', was a Dada jest, but the work of the society, as developed by Miss Dreier, was a serious matter. Through some eighty-three exhibitions in New York and elsewhere she presented more than seventy contemporary European artists for the first time to the American public, among them Schwitters, Klee, Malevich, and Miró, and held first one-man exhibitions in New York for Archipenko, Kandinsky, Klee, and Léger. After 1929 her activities were curtailed by the economic depression and eclipsed by the foundation of the Museum of Modern Art in New York, but through their gift of the Société Anonyme's permanent collection to Yale University the founders assured the perpetuation of their pioneering activities.

DADA IN BERLIN AND COLOGNE: 1918–20

Towards the close of the First World War Dada erupted in three other cities. In January 1917 Richard Huelsenbeck returned from Zürich to Berlin, a city already on the verge of starvation where defeat was known to be inevitable. More interested in politics, literature, and psychology than in the arts, he interpreted the crisis in European culture as a moral and social rather than aesthetic situation. 'To make literature with a gun in hand had for a time been my dream,' he wrote in 1920.[14] For these reasons he cast his influence on the side of

revolutionary politics. However idealistic he
and his companions may have been, their
challenge, 'Dada is German Bolshevism', had
unfortunate repercussions later, when the
National Socialists indiscriminately denounced
all aspects of modern art as *Kunstbolschewismus*.

Huelsenbeck launched the movement with a
lecture in February 1918, followed by a
manifesto read publicly in April and signed by
Tzara, Janco, and Arp, and by the German
artists George Grosz and Raoul Hausmann. He
also published that year an issue of *Club Dada*,
edited by Franz Jung, a writer, Hausmann, and
himself. Its disordered typography anticipated
the third issue of the Zürich *Dada* published in
December. It was followed by three issues of
Der Dada, edited by Hausmann, with the help
of Huelsenbeck and Johannes Baader, an older,
messianic adherent. These periodicals, with
Huelsenbeck's *Dada Almanach* and *En Avant
Dada*, both published in 1920, are the literary
records of the Berlin phase of the movement,
which reached its artistic climax in the First
International Dada-Fair held in Berlin in June
1920. A placard by Grosz and Heartfield
announced that 'Art is dead, long live Tatlin's
machine art'. The reference to the Russian
Constructivist sculptor and architect was less
an affirmation of their interest in abstract art
than a declaration of sympathy for the expected
triumph of modern art in Russia. Dada opinion
of recent German history was expressed by
suspending a pig-headed dummy dressed in
an officer's uniform from the ceiling of the
main room. Although the majority of the works
exhibited were German, there were also con-
tributions from Arp and Picabia. A footnote
to the catalogue announced that certain starred
items would later be shown in New York by the
Société Anonyme as the first Dada exhibition

226. Raoul Hausmann: Evening Toilet, *c.* 1920
(as originally reproduced, apparently upside-down).
Present location unknown

in America, an event which unfortunately did not occur.

Although the Berlin Dadas produced little painting and sculpture, their contributions to the development of collage and caricature were influential and important. Pasted superimposed photographs (hence the term *photomontage*) compensated for the costlier materials of painting and sculpture, which were in short supply after 1917. Their methods were so quickly exploited by the advertising profession that their mordant criticism of contemporary society in bizarre combinations of visual images is sometimes forgotten, as well as their typically Dada rejection of artistic idealism through the use of ready-made, worthless materials. The most accomplished masters of photomontage were John Heartfield (1891–1968) and Raoul Hausmann (1886–1971). Heartfield had been born Helmut Herzfelde, but anglicized his name to emphasize his sympathy for America as well as to avoid confusion with his brother Wieland Herzfelde, owner of the leftist Malik-Verlag, the principal publisher of the Berlin Dadas. Heartfield's pasted pictures were incisively satirical, Hausmann's more subtly Dada through unexpected visual as well as political connotations. In his sensitive manipulation of materials Hausmann showed his awareness of the formal structure of the Cubist *papiers collés*, but his *Evening Toilet*, which was reproduced upside-down in *Der Dada 3* in 1920 [226], is a more daring essay in anti-art. This assemblage of odds and ends, including the label 'Dada Wins', is contemporary with Kurt Schwitters's first *merz* pictures (see below, p. 384) and thus is one of the earliest examples of junk culture. Independently of Hugo Ball he also invented 'sound-poems' in which language was reduced to syllables and even single letters. After the decline of Dada he abandoned painting for photography and the study of optics. The collages of Hannah Höch (1889–1978), Hausmann's companion during the Dada years,

are scarcely inferior to his. Her abstract paintings, not unlike the work of Sophie Taeuber-Arp, were among the earliest examples of purely non-objective painting in northern Germany. The most considerable artist among the Berlin Dadas was George Grosz [227], but

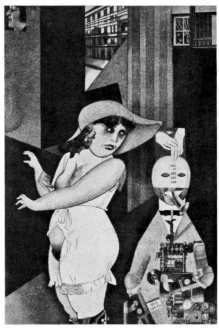

227. George Grosz: 'Daum' Marries her Pedantic Automaton 'George' in May 1920, John Heartfield is Very Glad of It (Meta-Mechanical Construction after Professor R. Hausmann). *Present location unknown*

since his work enlarged and eventually passed beyond the principles of Dada, it will be considered in another context (see below, pp. 475 ff.).

In 1919–20 there was a brief outburst of Dada activity in Cologne, instigated by Max Ernst (1891–1976) and Johannes Baargeld (d. 1927), a wealthy dilettante attracted to radical

politics. By their antic behaviour they hoped to aggravate the political situation, Cologne then being occupied by British troops. But Ernst's gifts were so unusual that the history of Dada in Cologne is of more artistic than political significance. He had begun painting before the War, encouraged by August Macke and influenced by the Sonderbund Exhibition at Cologne in 1912. Herwarth Walden recognized his talent and included two Cubist-Expressionist works in his First German Salon d'Automne in 1913. Then came four years of military service filled with 'the disgust and fatal boredom that military life and the horrors of war create', until, in November 1918, he was 'resurrected as a young man who aspired to find the myths of his time'.[15] In search of them he went to Munich, where he met Paul Klee and saw the publications of the Zürich Dadas and reproductions of the work of de Chirico. The Italian's mannequins and emptied spaces reappeared in Ernst's album of eight lithographs, *Fiat Modes* of 1919, his first postwar attack on the pretensions of bourgeois culture. In 1919 Jean Arp, whom Ernst had met in 1914, arrived in Cologne with first-hand reports of the events in Zürich. The disruptive behaviour of the Swiss Dadas encouraged Ernst and Baargeld to publish their provocative reviews, *Die Schammade* and *Der Ventilator*, and to arrange in 1920 one of the most notorious of all Dada manifestations. The entrance to their exhibition, which was held in a room adjacent to a restaurant, was through the public lavatory. Visitors were met by a young girl in Communion dress reciting obscene poetry and were provided with an axe with which to destroy a large wooden sculpture.

With Arp's encouragement, Ernst began making collages which he and Arp certified as 'Fatagaga' (Fabrication de tableaus garantis gazométriques). In random combinations of photographs, newspaper cuttings, and illustrations from scientific, technical and commercial catalogues, Ernst discovered new images which suggested unexpected and indeterminable sensations. A few lines, a touch of colour, or the addition of lettering were enough 'to transform the banal pages of advertisement into dramas which reveal my most secret desires'. Where Arp, investigating the laws of chance with precision and sensibility, had arrived at poetic but abstractly formal effects, Ernst discovered how to produce hallucinatory situations. The element of accident was also present when the artist became, as he said on a later occasion, the spectator of his own work.

Among the masters of modern art, Ernst is remarkable in that he had no professional training. His father, a devout Catholic and superintendent of a school for the deaf and dumb in Brühl, was an amateur landscape painter and copier of religious pictures. For him, as for many a naïve painter, the borderline between artistic and material reality could become indistinct. Once, having painted a landscape of his garden, he felt that a certain tree was an obtrusive element in the composition. He promptly rubbed it off the canvas and then chopped it down. This assertion of the primacy of artistic reality may not have been lost on his impressionable son. Certainly Max Ernst was familiar with the production and use of images for symbolic purposes, and from childhood he drew and painted. In 1909 he entered the University of Bonn as a student of philosophy and psychiatry. There he studied Charcot and Freud, and in visits to the asylum saw the expressive power of the art of the mentally disturbed. Soon he abandoned academic studies in order 'to surrender passionately to the most gratuitous activity there is – painting'.

Three fundamental aspects of his mature aesthetic emerge from even so short an account. Even before the War and his disillusionment with bourgeois culture, Ernst believed that painting is an essential, not a contingent,

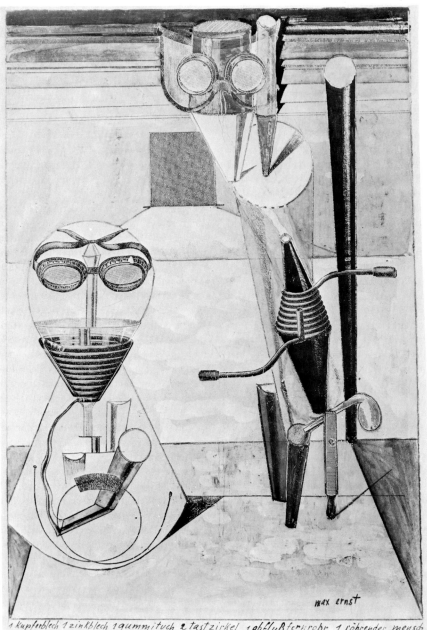

max ernst

1 kupferblech 1 zinkblech 1 gummituch 2 tastzirkel 1 abflußfernrohr 1 röhrender mensch

experience; that the primary element in pictorial art is the symbolic image; and that the image is not only the result but also, in part, the cause of psychic configurations. In this attitude there was little room for artistic considerations. For Ernst art always had so much more meaning as a sign than as form that his works resist conventional analysis. Unless the spectator is aware of his indifference to strictly formal values, that his art exists 'beyond beauty and ugliness, beyond questions of good or bad taste', he will not appreciate its special quality. Yet it is not easily accessible to him who possesses only the usual iconographic keys. The symbolism is based upon an extensive historical culture, its signs derive from magical, theological, scientific, and erotic lore transformed by the pressures of Ernst's own psychic experiences and presented with unmistakably Dada and Surrealist overtones of irony and 'black bile'. Such are his frequent avian images. Ernst's description of the shock he experienced at the age of sixteen, when his favourite cockatoo died the night his youngest sister was born, illuminates his obsession with birds and their anthropomorphic mutations, as well as his identification of himself with his own creation, 'Lop-lop, the Bird Superior'.

The projection of a psychologically subversive situation through inoffensive materials, a 'fortuitous meeting of distant realities', as Ernst called it, can be seen in one of the earliest 'Fatagaga' collages, the *Two Ambiguous Figures* of *c*. 1920 [228].[16] The mechanical elements, cut out from a catalogue of chemical supplies, would be quite harmless if we knew their original purpose, but as assembled by the artist with additional contours and colours their ambiguity conjures up that nightmare world of mechanical man which has haunted the twentieth century. Since Arp was with Ernst at this

228. Max Ernst: Two Ambiguous Figures, *c*. 1920. *Private collection.*

time, the influence of Picabia's contraptions, which were known to the Zürich Dadas, and through him of Duchamp's 'Bride' and 'Bachelor Machine' seems not unlikely.

Ernst's reputation soon spread beyond Cologne. André Breton, already interested in automatic composition, learned of the collages and arranged an exhibition in Paris in 1920. Although 'Dadamax' could not obtain a visa to leave Germany, the opening of his exhibition precipitated one of the first Dada demonstrations in Paris. The next year Paul Eluard visited Cologne to select collages as illustrations for a volume of his poetry. That summer Ernst spent a few weeks with the Arps and Tzara in the Tyrol, where they wrote and published *Dada Augrandair*, the Tyrolean issue of the Zürich–Paris Dada magazine. To Ernst's association with Tzara we may attribute the sinister tone of his last purely Dada works.

Ernst left Germany in 1922 and settled in Paris, where he found the French Dada movement about to expire. The mood of anguish and impending doom in such early Paris pictures as *Woman, Old Man, and Flower* of 1923 (New York) and *2 Children frightened by a Nightingale* (see below, p. 396) won him admittance to the inner circle of the Surrealists. Consequently his work after 1924 must be discussed in terms of the development of Surrealism.

DADA IN HANOVER: KURT SCHWITTERS

The most uncompromising artistic Dada activity in Germany, as well as the longest-lived, occurred in Hanover, where Kurt Schwitters (1887-1948) worked in comparative isolation from the political manifestations in Cologne and Berlin. He had studied before 1914 at the Academy in Dresden, the home of the Brücke, so not unnaturally his earliest independent work was Expressionist, but it was as an abstract painter that he first exhibited at the Sturm

Gallery in 1918. Although his poetry appeared in 1919 under a Dada title, his indifference to politics set him apart from the Berlin Dadas, who rejected his writings in 1920. By the end of 1918 he knew that for him the source of art lay in the nature of materials and their combinations and not in any predetermined and hence idealistic 'striving for expression'. In his attempt to free art, 'a primordial concept, exalted as the godhead, inexplicable as life, indefinable and without purpose', from the constraints of traditional materials and techniques, he was led to investigate the detritus of civilization.[17] 'The medium', he said, 'is as unimportant as I myself. Only the forming is essential.' But the hand and eye were unusually sensitive that turned such despicable materials, odds and ends of lumber, broken bits of glass and plaster, the contents of the wastepaper-basket and dustbin, torn tram tickets and chocolate wrappers salvaged from the gutter, into objects of indubitable artistic quality

229. Kurt Schwitters: Merz 19,
1920. *New Haven, Conn., Yale University Art Gallery*

[229]. He treated these humiliated remnants of other people's lives with affection and respect and allowed them to preserve, even in the most unexpected combinations, their identities (words, for instance, keep their meanings even in meaningless situations). In his collages the texture, colour, and shape of each scrap of cut or torn paper is carefully adjusted to every other so that the apparent effect of accident is carefully controlled. Schwitters went beyond the traditionally pictorial situation of a Cubist collage, where the bit of newsprint or coloured paper is only a part of an intricate spatial illusion and its existence as a thing in itself is ambiguous. But it is not quite true to say that the subjects of Schwitters's collages are objects or things in their raw, naked reality. Unlike the Dada 'ready-made', or the Surrealist 'found object', Schwitters's things were never independent of his taste. They have become what his taste determined they should be. Schwitters himself disclosed a secret of his craftsmanship in a remark on the possibility of a Dada drama: 'The materials are not to be used logically in their objective relationships but only within the logic of the work of art. The more intensively the work of art destroys rational objective logic, the greater become the possibilities of artistic building.'

Early in 1919 Schwitters included in a collage the syllable 'merz', cut out from a letterhead of a 'Kommerz- und Privatbank'.[18] He liked the sound and sight of the meaningless syllable so much that he used it as a generic title for his collages when they were first exhibited at the Sturm Gallery in 1919. He called them *merz* pictures to indicate that the familiar labels of Cubist, Expressionist, Futurist, or even Dada, did not quite apply. Soon the term covered all his activities as artist, architect, poet, and publisher of his own *Merz* review. Like Dada, the word stood for a way of life. He needed such an expression if he were to emphasize his uncommitted artistic

integrity, as well as his adherence to Dada's anti-idealism.

In his house at Hanover Schwitters worked from 1920 on an architectural construction, his *Merzbau*, which was unfinished when he left Germany in 1935. This accumulation of junk gradually filled the room and rose through the house until it threatened the roof. One part of it, the 'Great Column' or 'Cathedral of Erotic Misery', built of tag-ends of poverty and neglect, was described by a contemporary critic as a prime example of 'absolute architecture, since, its interior being so filled with wheels that there is no room for people, it has an artistic meaning and no other'.[19] This first construction was destroyed during an air raid in 1943; another, begun in Norway and interrupted when Schwitters fled to England in 1940, was accidentally burnt in 1951.

Schwitters's first poems, dedicated to an imaginary love, 'Anna Blume', were catch-pots for sentimental metaphors, advertising clichés, and other verbal scraps. Like his collages, they combined vulgarity and delicacy, bad taste and a true poetic design. As parodies of German love poetry they were popular and frequently reprinted. More strictly Dada, or *merz*, was his investigation of linguistic sounds detached from meaning for his *Ursonate*, which appeared in the last issue of *Merz* (1932). For its conception he was indebted to Hausmann's recitation of a phonetic poem, *fmsbw*.

In appearance only does Schwitters's architecture and poetry approach the lunatic fringe. His concept of 'forming' explains his enthusiasm for such stricter intellectual developments as Dutch De Stijl and Russian Constructivism. With Theo van Doesburg he travelled to Holland in 1922 to see the work of the De Stijl artists, and in 1924 he invited Lissitzky to collaborate on a double issue (Nos. 8/9) of his review. It has been said that he betrayed his principles when he published the work of such non-*merz* artists as Malevich, Léger, and Mies

van der Rohe, but the charge takes no account of the constructive element in all his work. In his collages this can be seen in the careful disposition of squares and rectangles upon which the random positions of the other forms depend, and from 1924 to 1930 many of his wooden constructions have something of the geometrical

230. Kurt Schwitters: Merz 1003, Peacock's Tail, 1924. *New Haven, Conn., Yale University Art Gallery*

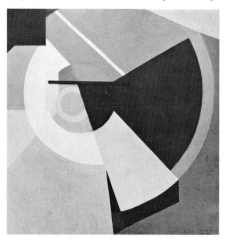

precision of De Stijl[20] [230]. This constructive tendency also explains why his freely expressive typography appealed to Van Doesburg, who adopted certain *merz* devices in the four issues of his *Mecano* (1922–3).

In his Norwegian and English exile Schwitters continued his activities without significant change, except when poverty forced him to paint representational portraits, for which he had little talent. Although looser in structure his last collages were as delicately composed as ever, and the bits of English lettering as witty as any in German. At the end of his life a grant from the Museum of Modern Art in New York enabled him to start construction on a third *Merzbau* near Ambleside, but he died before he could finish it.[21]

DADA IN PARIS: 1919-22

The climax and decline of Dada occurred in France, but Dada did not thereby become a fundamental strain in the School of Paris, nor is there much to say for the works produced there during those three hectic years. One might explain the paucity of Dada objects by the presumably obligatory French taste for order, but that would be to overlook certain rowdy manifestations before 1920, as well as the fact that one of the greatest of the Dadas, Marcel Duchamp, was and remained inalienably French. Rather the reason should be sought in the predominantly literary character of the proto-Dada reproaches of Pierre Reverdy and Jacques Vaché, and in the continued presence of an aggressive man of letters, André Breton, who was determined to bend Dada to his own purposes.[22] Their techniques of insult and provocation, designed to foster 'a permanent revolt of the individual against art, against morality, against society', were already so expert by the time the Dadas arrived in Paris that little more could be expected than a higher degree of refinement, principally in social action and literary expression. Such, for instance, were the numerous Dada 'festivals' and other events. These were often held in such respectable environments as the Salle Gaveau, one of the principal concert halls in Paris, and usually ended in scenes of frantic confusion. Even the *Exquisite Corpses*, drawings on folded paper made by several persons in turn, each completing a portion of a figure but unaware of what the others had drawn, were mostly executed by the writers around Breton and are more interesting as chance projections of psychological possibilities than as independent works of art. Only occasionally was the pontifical tone of the Paris Dadas, which suggests that they were working too hard for their fun, spiced with Gallic wit. Such was the rendezvous in the churchyard of St Julien-le-Pauvre on 14 April 1921, to visit

'selected sites, particularly those which have no reason to exist'. The public events which marked the history of Dada in France on the whole lacked the spontaneity as well as the humour which had been so perceptible in Zürich and New York a few years before. One misses the combination of naïvety and guile which characterized the proto-Dada musings of the composer Erik Satie (1866-1925). In his prose *Memoirs of an Amnesic*, Satie had called the academic bluff as early as 1913. Nothing could have been more Dada than the disconcerting results of his application of metrics to music: 'The first time I used a phonoscope, I examined a B flat of average size. I have, I assure you, never seen anything more disgusting. I had to call my servant to show it to him.'[23]

The first instigators of Dada in Paris were Tzara and Picabia, who arrived in 1919 to find that André Breton, already searching for new forms of verbal expression, had just begun publishing his review, *Littérature* (1919-24), with the cooperation of Louis Aragon and Philippe Soupault. They were joined by Georges Ribemont-Dessaignes, who became secretary of the Dada movement in Paris. In 1920 Arp arrived, Man Ray during the following year, and Max Ernst in 1922, each artist looking to Paris after the extinction of Dada activities at home. Duchamp was there from July 1919 to January 1922, except for the winter of 1920-1, which he spent in New York, but he never participated in any organized activities. Although such work as these men accomplished in France counted for little in the development of their individual styles, two images remain from this period which are remarkable for their clarity and wit. The first is Marcel Duchamp's photograph of the Mona Lisa with a pencilled moustache and beard, scabrously entitled *L.H.O.O.Q.* [231].[24] It was first published by Picabia in Paris in the twelfth issue of *391* (March 1920), but the obscurity of that journal has not handicapped its notoriety. It has

231. Marcel Duchamp: L.H.O.O.Q., 1919.
New York, private collection

232. Man Ray: Gift, 1921.
Private Collection

become the archetypal symbol of the Dada point of view now that the public has accepted it as an attack on the whole structure of European culture in so far as that had become enshrined in Leonardo's portrait. Reflection may persuade us, however, that Duchamp's and Picabia's method was more subtle, as well as more Dada. By calling our attention to the kind of defilement to which visual images are subjected, on public hoardings and in the sanctuary of the museum, they emphasized the alarming contradictions between belief and performance, between the reverence of cult objects by the few and their misunderstanding by the many, between art as art and the sordid uses to which it is put.

Whatever else *Mona Lisa's Moustache* may have done, it made the student of modern art rethink his own thoughts.

Duchamp's photograph, however, is more directly and intensely Dada than the other object, Man Ray's *Gift* of 1921 [232]. In this ordinary, mass-produced flat-iron adorned with a row of carpet tacks Man Ray continued the series of 'ready-mades assisted' begun by Duchamp with the bicycle wheel of 1913, but in contrast to the expressive indifference of most of Duchamp's decisions, Man Ray's contained another ingredient, that sardonic spite which we detected previously in some of Max Ernst's work in Cologne. Man Ray's object, to be sure,

is less sinister than some of Ernst's; there is in it an echo of that wild laughter which had been heard in Zürich and New York. But it is still an alarming object. Whether we consider its possible effect in the laundry or the ungracious connotations of its title, it is only intermittently amusing. Unlike Duchamp's *Mona Lisa*, its reality lies more in its implications than in its existence; it points to a place beyond where it is at the moment.

French Dada from the first was doomed by the humourless ambitions of Breton. Although contemporary photographs show that he had thrown himself into the Dada revels, by 1922 he could declare that 'Dadaism cannot be said to have served any other purpose than to keep us in the perfect state of availability in which we are at present, and from which we shall now in all lucidity depart towards that which calls us'. As a point of departure he demanded an international congress 'to establish directives for the modern spirit and to defend it'. Whatever the advantages might have been, the thought of submitting Dada disgust to committees aggravated the internal dissensions among the remaining Dadas, but the demise of the movement was postponed until a year after the first large Dada exhibition at the Galerie Montaigne in June 1922. The final episode was enacted in July 1923 when, amid scenes of 'indescribable disorder', Aragon and Breton demonstrated against Tzara at a performance of the latter's play, *Le Cœur à gaz*.[25] After Tzara's discomfiture Breton became the undisputed champion of the literary avant-garde, but in establishing the dimensions of his new super- or sur-reality, he was under a heavy debt to Dada. The most serviceable tools of Surrealism – the unexpected juxtaposition of elements alien to each other; the abrupt focus on banal elements of daily experience; automatism, and the exploitation of chance, soon to be thought of as a kind of poetic, Mallarméan hazard – all these had been brought to a fine temper elsewhere before the time when they became available in Paris.

No less significant than Dada's contribution to Surrealism has been the continued vitality of an attitude, a state of mind, an activity which so often, even from its birth, declared that it was already dead, as Tzara had stated in 1920. Its survival was partly effected by the continued and authentic production of Arp, Schwitters, and Ernst, however their later works may have differed from their Dada ones. Quite as important for the future was the Dada spirit itself, which had plucked artistic life from the dying remnants of cultural academism by insisting on the furious and incalculable energy of the creative principle, and on the necessity for allowing the artist his freedom, in all psychic essentials. If the price of the Dadas' spontaneity was a social and aesthetic irresponsibility which at times was more a hindrance than a help, it must be said that they, as much as any artists since and more than most, proved that the artist's decision alone determines what art is, and what is art. They inserted deep in the aesthetic of modern times the inescapable conviction that even if the material existence of the work of art claims our attention first, the work itself originates only in the confrontation of matter with mind.

FROM DADA TO SURREALISM:
ANDRÉ BRETON

The Surrealist movement was officially inaugurated late in 1924 by the critic and poet André Breton (1896–1966) with the publication of his first Surrealist Manifesto.[26] This lengthy and difficult document was not a plan for artistic action but rather, consecrated as it was to the definition of poetic Surrealism, an eloquent appeal for the emancipation of the imaginative life from the arbitrary limitations imposed upon it by reason and the social order. For Breton, who had practised psychiatry briefly during his

military service in the First World War, the imaginative life embraced the total psychic experience of the unconscious as revealed by Freud. As a poet he believed that the instrument with which this life could be released was the word, the poetic metaphor, freed from the trammels of common usage through the techniques of automatic writing. By means of such 'systematic exploration of the mechanics of inspiration' Breton hoped to establish not only a poetics but a code for political, economic, social, and intellectual conduct. Although he later confessed that his first definition of Surrealism was too narrow, it is worth recalling now if we are to understand his extra-artistic ambitions as well as the authoritarian trend of his thought: 'SURREALISM, n. Pure psychic automatism, by which we propose to express, verbally, in writing, or by any other means, the real process of thought. The dictation of thought, in the absence of any control exercised by reason and outside any aesthetic or moral preoccupations. ENCYCL. *Philos.* Surrealism is based on the belief in the superior reality of certain forms of association neglected heretofore, in the omnipotence of the dream, in the disinterested play of thought. It tends to destroy definitively all other psychic mechanisms and to substitute itself for them in the solution of the principal problems of life.'

Then followed a list of sixteen persons who had professed with Breton their adherence to 'Absolute Surrealism', among them such poets and men of letters as Louis Aragon, René Crevel, Robert Desnos, Paul Eluard, and Philippe Soupault. No painters or sculptors were included, nor were any cited in an imposing list of those who had been Surrealist in the past (Chateaubriand, Victor Hugo, Poe, Baudelaire, etc.). Only in a footnote did Breton admit that he 'could have said as much of certain philosophers and painters', among them Uccello, and 'in the modern epoch Seurat, Gustave Moreau, Matisse (in *Music* for instance), Derain, Picasso

(much the most pure), Braque, Duchamp, Picabia, de Chirico (so admirable for so long), Klee, Man Ray, Max Ernst, and, so close to us, André Masson'.

Breton later deplored the historian's habit of verifying Surrealism by ransacking the past for evidence of proto-Surrealist expression, but he had sanctioned such research by his own list of earlier literary Surrealists.[27] Even the term was not his; it had been used by Apollinaire for his fantastic farce, *Les Mamelles de Tirésias* (1917), which he subtitled 'un drame surréaliste'. But Breton and Soupault intended to supplant what they considered its too literal Apollinairean usage by the more mystical and spiritual sense of Gérard de Nerval's 'supernaturalism'. They also invoked Rimbaud and the Comte de Lautréamont (Isadore Ducasse, 1846–70), author of the malevolent *Chants de Maldoror*. Both poets had disdainfully rejected, by deed as well as word, the world of appearance for intense subjective and imaginative experiences, conveyed to the reader through powerful and original imagery. Rimbaud's boast that 'in the end I hold my spiritual disorder to be sacred' could have been the Surrealists' motto, just as Ducasse furnished them with their best-known and most succinct metaphor for the appearance of the marvellous within the banal: 'As beautiful as the chance meeting on a dissecting table of a sewing machine and an umbrella.'[28]

Since the juxtaposition of three such unrelated objects would be improbable in ordinary experience, the image must have emerged from regions inaccessible to the waking consciousness. Therefore Breton and Soupault began experimenting with automatic writing, placing themselves in as passive a condition as possible and allowing the hand, in the absence of all control, to transcribe 'the real process of thought' as a continuous flow of verbal images. Their results were first published as *Les Champs magnétiques* (1920), and the method was again described in the Manifesto. Despite the apparent

lack of any structure, of a 'plot' in the simplest sense, the cumulative effect of a succession of such images may induce in the reader the sensation that he, too, is participating in that pre-conscious experience which we know as the dream state. But Breton was a poet, and his words were not easily transformed into visual equivalents: 'You could read in the lines of the palm that the most fragrant vows of fidelity have no future.' But again and again objects emerge with a startling clarity: 'The clocks, in despair, were fingering their rosaries.'[29] The Surrealists' pictorial problem, not yet clearly understood in 1924, was to find artists capable of transposing such words into visual images.

In these investigations Breton insisted on the objective reality of psychic experience, thereby associating his own thought with Freud's (the Surrealists celebrated the fiftieth anniversary of Charcot's investigation of the causes of hysteria in 1928, and Breton had already visited Freud in Vienna in 1921). But the events which impelled Breton to the construction of his own programme were his experiences of Dada in Paris between 1919 and 1922. He was an indefatigable contributor to the Dada uproar, but all the while he was aware of the inherent futility of the Dada position. His increasing disgust with Dada's 'forlorn negation, [its] merciless iconoclasm' and essential anarchy led him to look for his new super-reality in the 'transmutation of those two seemingly contradictory states, dream and reality, into a sort of absolute reality, of sur-reality, so to speak'. This belief in the unity of psychic experience and material reality, and the resolution of their apparently contradictory appearances in a new situation suggests the Hegelian tenor of his thinking, modified later by the familiar Marxist reversal of Hegel's idealism into dialectical materialism.[30]

Breton's statement in 1936 that he had passed from the conviction expressed in the first Manifesto that 'thought is supreme over matter' to a belief in the 'supremacy of matter

over mind' cannot be taken seriously, given his lifelong insistence on the reality of mental processes. Unlike Freud, who interpreted the dream as a result of the dreamer's adaptation to conscious as well as unconscious experience, Breton insisted on the objective reality of the dream and its effect on conscious life. We live our dreams rather than dream our lives, a distinction which may be more useful artistically than clinically. But it contributes to the definition of a properly Surrealist art. For Freud the dream image was a symbol of experience, for Breton it *was* the experience, a condition he expressed in this statement: 'Oneiric values have once and for all succeeded the others, and I demand that he who still refuses, for instance, to *see* a horse galloping on a tomato should be looked upon as a cretin. A tomato is also a child's balloon – Surrealism, I repeat, having suppressed the word "like".'[31] By consolidating the two terms of the metaphor he forced us to believe that the clocks *are* fingering their rosaries.

Although Breton had been inspired by Nerval, Rimbaud, Ducasse, and others who had explored the visual situations inseparable from dream and hallucination, he at first saw little necessity for pictorial or sculptural support for his programme. But when Pierre Naville, co-editor with Benjamin Peret of *La Révolution Surréaliste*, denied the possibility of a Surrealist art, Breton replied with his notable essay, 'Le Surréalisme et la peinture' (1925–8), in which he postulated the existence of such a painting within the historical conditions of modern art.[32] Although he still referred to painting as 'that lamentable expedient', he reaffirmed the importance of the eye, 'present at the conventional exchange of signals that the navigation of the mind would appear to demand' (the conditional mood is symptomatic of his hesitations), before stating that the work of art, if it is to respond to 'the undisputed necessity for thoroughly revising all real values', must refer to a purely

interior model, to those things we begin to see which yet are not visible in the usual sense. Surrealist art provides visual instead of verbal statements to 'fully compensate us for what we have left behind [on that] mysterious path where fear dogs our every step and our desire to turn back is only overcome by the fallacious hope of being accompanied'. It depicts those pregnant moments 'when we expect the least to happen'. And he defined the fundamental principle of Surrealist aesthetics: 'The marvellous is always beautiful, anything that is marvellous is beautiful; indeed, nothing but the marvellous is beautiful.' Henceforth, when searching for the Surrealist object we know that only if it possesses some disturbing, uncanny magic can we consider it properly Surrealist, and that if it does, it is therefore beautiful in the Surrealist sense, however deficient it may appear in all other aspects of formal or intellectual harmony.

The artists who participated in the first Surrealist exhibition, held at the Galerie Pierre in Paris in November 1925, included some who had been named by Breton in the first Manifesto (Picasso, de Chirico, Klee, Ernst, Masson, and the American photographer Man Ray). The others were Arp, Miró, and Pierre Roy, a painter of meticulously realistic still lifes of oddly assorted objects. Although it was a small exhibition of only nineteen items and represented more a community of interest among former Dadas and their sympathizers than an original stylistic or technical point of departure, the principal and divergent currents of later Surrealist art were already apparent. Breton's poetic gifts encouraged many to look for visual counterparts for the images which fairly cried out from the flow of his automatic writing, but a contradiction existed between the act of submitting oneself to instinctive responses and the process of fixing the images which thus arose so that they would be perceptible to others. There are such painters as Masson and Miró who have investigated the spontaneous reaction of the

hand to the medium, and there are those who have found for their hallucinations visual metaphors of great clarity and precision, among them Tanguy, Dali, Magritte, Delvaux, and Brauner. Although the latters' images were first recognized as Surrealist by the public, the other and earlier direction contributed its particular violence to the development of Abstract-Expressionist painting. Between the two groups Max Ernst long furnished fertile suggestions for the exploration alternately of abstract and representational expression.

Breton had commenced his canon of those artists who had been Surrealist in modern times with several we would find hard to accept today. Gustave Moreau was certainly not so influential for the Surrealists as he had been for the Symbolist painters of the 1890s, but we might concede a slight Surrealist element in Seurat's magic stillnesses. Matisse, Braque, and Derain have certainly been too concerned with structure, Duchamp and Picabia too anti-mystical, to deserve the title. Nevertheless, Breton may have seen more sensitively in 1924 than we can today, for his interpretation of Picasso's Cubism enlarges it with a different dimension: '. . . our heroic determination systematically to let go our prey in favour of its shadow exposes us far less to the risk of finding that this shadow, this second shadow, this third shadow, have cunningly been given all the characteristics of the prey. We leave behind the great grey and beige "scaffoldings" of 1912, the most perfect of which is undoubtedly the fabulously elegant *Man with a Clarinet* [compare 138], upon whose "aside" existence we shall never cease to meditate.'[33]

GIORGIO DE CHIRICO (1888-1978) AND THE SCUOLA METAFISICA: 1913-19

Although Picasso, that 'creator of tragic toys for adults', as Breton called him, was never an official member of the group, he lent his name and works to Surrealist exhibitions and there is

evidence in the late 1920s of a more than formal savagery in his painting (see below, p. 454). But despite the fact that he had been one of the first to discredit ordinary reality – hence his interest for Breton – he cannot be considered more than a peripheral Surrealist. Central to Breton's thesis was the remarkable achievement of Giorgio de Chirico, who in the brief span of four years created a series of paintings of the condition Breton described as the 'irremediable human anxiety'. De Chirico had been born in Greece of Italian parents, and lived there until the age of seventeen. After the death of his father, who had been an engineer for the Greek railways, he went to Munich in 1906, where his studies at the Academy were less important for him than the discovery of the imaginative and fantastic imagery of Böcklin, Klinger, and, briefly, Kubin. The revelation of what Kubin

called 'the other side' of life destroyed de Chirico's interest in naturalistic painting. In an essay written before 1915 he rejected Impressionism because a painting which has only the appearance of sunlight 'for its purpose will never be able to give me the sensation of something new, of something that, previously, *I have not known*'.[34] That strange sensation of the new, of the surprising, of the 'whole enigma of sudden revelation', de Chirico also found in the writings of Friedrich Nietzsche, who had described his own 'foreboding that underneath this reality in which we live and have our being, another and altogether different reality lies concealed', a reality which could be apprehended in the mysterious relationships established between ordinary objects when they are released from the conventional logic of commonsense causality.

233. Giorgio de Chirico: The Joys and Enigmas of a Strange Hour, 1913.
Private Collection

From 1911 to 1915 de Chirico was in Paris, where his first mature paintings of figures dreaming in deserted city squares attracted the attention of Apollinaire, who noted 'these curious landscapes, full of new intentions, of a powerful architecture, and of great sensibility' at the Salon d'Automne in 1913.[35] The *Joys and Enigmas of a Strange Hour* [233] exemplifies these aspects of his work, as well as de Chirico's troubling combination, embodied in Apollinaire's description of him as 'inapt and much endowed', of technical simplicity and psychological subtlety. This deserted piazza, with the colossal, sleeping statue which looks more mortal than marble, and in the distance two diminished figures whispering near an oddly detached, arcaded structure, seems situated on the frontier between sleep and waking. The locomotive, possibly a reference to de Chirico's relationship to his father, is a sign of that romanticism of modern life which Klinger had expressed in 'the nostalgia of railroad stations, of arrivals and departures'. The scene as a whole is infused with the 'strange and profound poetry, infinitely mysterious and solitary', which de Chirico considered Nietzsche's most remarkable innovation: 'the *Stimmung* (which might be translated . . . as atmosphere) based on the *Stimmung* of an autumn afternoon when the weather is clear and the shadows longer than in summer, for the sun is beginning to lower'. In de Chirico's first landscapes the combination of elements may have been improbable if not impossible, but his interest in the 'troubling connexion that exists between perspective and metaphysics' soon led him to more startling dislocations of ordinary visual reality and to the invention of logically impossible objects. The word 'metaphysical', which frequently occurs in the titles of his paintings before 1919 and which was the name he gave to his pictorial activity with Carlo Carrà, need not be tied to any specific philosophical system. We may read it in the literal sense that his works express

meanings which lie beyond the physical appearance of things. De Chirico defined this aspect of his art in his description of the 'two lonelinesses': 'Every serious work of art contains two different lonelinesses. The first might be called "plastic loneliness", that is the beatitude of contemplation produced by the ingenious construction and combination of forms, whether they be still lifes come alive or figures become still – the double life of a still life, not as a pictorial subject but in its supersensory aspect, so that even a supposedly living figure might be included. The second loneliness is that of lines and signals; it is a metaphysical loneliness for which no logical training exists, visually or psychically.'[36]

The loneliness of his 'figures become still' is even more acute when the desolate spaces are inhabited by mannequins. In *The Duo* [234] these faceless creatures, mutilated and unsexed,

234. Giorgio de Chirico: The Duo, 1915.
New York, Museum of Modern Art

whose erotic frustrations are suggested by that most banal of symbols, a heart drawn in outline on the breast of the taller one, are physically as well as emotionally suspended in their endless green-and-rose-coloured afternoon by the iron and wooden supports behind them. Half animate and half contrived, they are the eldest of those semi-mechanical beings who stand in Duchamp's *Cemetery of Uniforms and Liveries*, or come together out of tailors' patterns in the works of Man Ray and Max Ernst. The elements drawn from dressmaking and shop windows which are common to these iconographies suggest that in the arts of adornment and display these painters found ironic symbols for man's monstrous self-deceptions.

The ambivalent spatial reality of *The Duo*, where the wooden planking deceives us into thinking that the scene may be taking place indoors, was carried a stage farther in the metaphysical still lifes painted during de Chirico's association with Carrà in 1917. De Chirico was the more original painter, but Carrà created the best definition of their common programme in his *Pittura Metafisica* (1919), published soon after the two had parted company. There he stated that in the process of creation 'we instinctively carry out an operation of knowledge preceding knowledge itself – this operation is nowadays called intuition, and here we move towards the metaphysical . . . The creative spirit gropes somewhat like a sleepwalker in the fields of the absolute, but our trained sensibility comes into play when we are confronted with an art that is susceptible to multiple interpretations.'[37]

If the process of creation is basically instinctual and the pictorial images so produced are formed in the pre-conscious dream state, then artistic experience for artist and spectator alike must be 'susceptible to multiple interpretations'. Several such interpretative possibilities occur in de Chirico's *Grand Metaphysical Interior* [235], where our enjoyment of the *trompe l'œil*

235. Giorgio de Chirico:
Grand Metaphysical Interior, 1917.
New York, Museum of Modern Art

illusion of the loaves of bread hanging in their box like bones in a coffin is disturbed by the garish colour-postcard landscape of a resort hotel. If even for a moment we accept its commonplace elements – the mountains, clouds, and patch of lake in the distance – as an image of reality, then we find ourselves not once but thrice removed from life, for this is a painting of a painting within a painting. Between these extremes of pictorial illusion there exist, in de Chirico's pictorial space, the only 'real' objects, those strange accumulations of wooden elements resembling tools and dismembered stretchers upon which the box of loaves and the framed landscape have been hung. But since the relationship of the constructed elements is illogical (we cannot even imaginatively complete them because of the discontinuity between the parts

visible above and below the frames suspended from them), their reality is more than ours, it is super-real, a discovery made by 'a sleepwalker in the fields of the absolute'. Even the colour scheme supports this interpretation. The crusty loaves and the landscape are painted in impeccably commonsense hues. The colours of the other objects, especially the red-and-green geometrical forms in the foreground and the bright pink wooden ones behind, belong to another and different experience.

As early as 1914 de Chirico's first Italian critic, Ardengo Soffici, described his work as 'dream writing', a phrase appropriate for the paintings which followed until the end of the war.[38] No other contemporary painter so masterfully mingled the pathos of the irretrievably remote (in time as much as in space) with the anguish of the present moment, symbolized by its inescapable trivia of biscuits, matchboxes, and discarded sticks. De Chirico's great gift was to present this world of dreams with such technical simplicity, as a set of incontrovertible visual facts whose alienation one from another is reconciled by the monumental compositions within which they find themselves, that the history of Surrealism is unimaginable without him. But he himself did not follow where he had begun to lead. His last metaphysical paintings were executed in 1919, among them *The Sacred Fish* (New York), whose iridescent herrings captivated the Surrealists. Thereafter for several years he worked with a contrived mythology, possibly influenced by Picasso's neo-classicism of the 1920s, in which mythical horses and ruins appear in modern landscapes and gladiators destroy each other in second-rate hotel rooms. But the ironic confrontation of past and present was not supported by the intense imaginative vision or the primitivist technique of his earlier work. The Surrealists were deeply disappointed, but, when they by turn denounced him or encouraged him to recover his earlier manner, he retaliated by denying the authorship of his best paintings or executing inferior copies, thus confusing the attribution and chronology of his most important works. His interest in the past then led to elaborate explorations of academic technique and subject matter in an attempt to re-establish the grand manner of the Cinquecento.

The Scuola Metafisica, the name given by de Chirico and Carrà to their joint activity while both were recovering from nervous disorders in the military hospital at Ferrara, was never literally an academy, nor was it long-lived. Carrà was there only from January 1917 until the early summer, when he received convalescent leave and left for Milan, where at the end of the year he held an exhibition of his paintings. This led to his rupture with de Chirico, since the latter believed that Carrà had taken an unfair advantage by prematurely exhibiting his work, and he adversely reviewed Carrà's *Pittura Metafisica* when it appeared in 1919. De Chirico deserves all credit for the formulation of the magic unreality and poetic sensibility of metaphysical painting, but Carrà's contribution was not negligible. Although he painted little more than a dozen such works between his abandonment of Futurism in 1916 and his rejection of the Scuola Metafisica in 1921, and the influence of de Chirico is paramount in each, he interpreted his mannequins and other objects in a more lyrical and less elegiac mood. The simplicity of his figures may be traced to his admiration for Giotto and Uccello, the gentler colours and diffused light to his study of Piero. The denser surfaces and occasional humour are his own. Except for the last, these are the qualities that marked his worthy but unexciting work for the next forty-five years.

Of the other artists who were associated in one way or another with the Scuola Metafisica only Giorgio Morandi continued the metaphysical manner. His bottles and jars, exclusive staples of the still lifes he painted during his long

career, still communicate something of the magical stillness of de Chirico and Carrà at their best, but their purely formal monumentality was Morandi's own contribution. Ardengo Soffici and Mario Sironi painted only a few metaphysical pictures and are better known as minor Futurists and later contributors to the Italian Novecento after the War. Filippo de Pisis (1896–1956), one of the best Italian painters of the thirties and forties, befriended de Chirico at Ferrara and probably introduced him to the enchantments of Ferrarese architecture, but his few metaphysical paintings of the mid twenties have been pre-dated. He was too young and undecided in 1917 to make any decisive contribution to the movement.

The Surrealist Image

MAX ERNST (1891–1976)

Because Max Ernst never qualified his admiration for de Chirico, whose mannequins and empty spaces appear in *Fiat Modes*, Ernst's album of lithographs of 1919, we may consider the Italian painter's work as the principal source for the pictorial and psychological transition between Ernst's Dada and Surrealist activity. But just as there is a difference between Dada disgust and the Surrealists' affirmation of a new reality, so there is a distinction between the tone of de Chirico's pre-Surrealist and Ernst's mature Surrealist paintings. It may be simply stated as a contrast between the trance-like reverie of de Chirico's pictures and the more aggressive mood of Ernst's, where the sense of an unfolding nightmare is communicated by logical and formal incongruities in a 'hallucinatory succession of contradictory images'.[39] This is seen in *2 Children are threatened by a Nightingale* [236], painted in 1924, the year the Surrealist movement was launched. The combination of painted figures with the actual materials of the wooden house, the knob, and

the gate which swings on a hinge, continues the mixture of media of the earlier collages and is the first of several levels upon which Ernst exploited 'the chance meeting of distant realities on an unfamiliar plane or, to use a shorter term, the culture of systematic displacement and its effects', as he defined the technique of collage. The title, clumsily hand-lettered on the inner frame as in the earlier pasted pictures, is another clue to the displacement and alienation of the psychic situation, and is significant because Ernst stated that, although he never imposed a title on a picture, preferring to wait until it presented itself, in this instance the title existed before the picture was painted.[40] It occurred in a prose poem he had just written beginning: 'At night fall, at the edge of the city, two children were threatened by a nightingale . . .' Since so unlikely a situation could only occur in a dream-state (the nightingale being the least vicious of birds), it is only by the suspension of our rational consciousness that we can hope to understand why a girl, whose sister lies unconscious on the ground, should pursue a bird with a knife while a faceless phantom flees over the roof (of the 'real' house) with a child in his arms. All this happens in an empty green field stretching away to a triumphal arch where the pink walls don't quite meet. The pink and green, and the uneasiness communicated by the stretched perspective, are de Chirico's but the presentation of childhood terror is Ernst's, as well as his method of increasing the unpleasantness of the picture by disregarding conventional principles of design and technique. Such work as this, and indeed possibly every Surrealist object which has with any success communicated in visual terms a psychic condition, must necessarily avoid conventional composition, since not to do so would be to fall into the trap imposed by the false and arbitrary logic of the waking world.

The source of this painting in a verbal phrase demonstrates the literary bias of Ernst's paint-

236. Max Ernst: 2 Children are threatened by a Nightingale, 1924.
New York, Museum of Modern Art

ing. His emphasis upon irrational fear recalls not only 'Gothick' tales of the late eighteenth century but also the horrifying elements in German fairy stories whose happy endings cannot always banish the terrors developed earlier. Other and more pictorial Germanic sources may be mentioned: Grünewald, in whom Ernst saw that faculty for presenting the psychologically marvellous, as in the vision of the translucent Risen Christ of the Isenheim altar, and the Romantic landscape-painter Caspar David Friedrich, whom Ernst admired and whose advice 'to close your physical eyes in order to see first your painting with the spiritual eye' he never ceased to follow.[41]

The Surrealists have been accused, and often properly so, of having self-consciously skimmed the cream of Freudian theory to whip up configurations which might superficially be interpreted in Freudian terms, but which are actually not the revelations of unconscious processes they are said to be. But the difficulties they faced must be recognized. Every genuine psychic situation is inevitably personal, and hence private. Its compelling interest and meaning for the individual consists in the fact that it is his experience and no one else's. What, after all, is more tedious than another's dreams? But the work of art, if it is to be seen at all, should communicate something or it will remain inaccessible and unknown. The Freudian elements in any Surrealist work must participate in a public exchange of symbols having some aspects of shared experience, even if this dilutes its visual and psychological intensity. If this is so, and Surrealism, as it has been suggested, is only 'applied Freud', Ernst was an early and successful practitioner of artistic Freudianism in his two remarkable collage novels, *La Femme 100 têtes* of 1929 (awkwardly translatable as *The Hundred Headless Woman*, the figure '100' sounding as either 'hundred' or 'without' when read aloud), and the *Rêve d'une petite fille qui voulut entrer au*

Carmel of 1930, containing 149 and 80 collages respectively. With images cut out from the most various sources, principally nineteenth-century illustrations for sentimental and melodramatic novels, cultural histories, journals of current events, and scientific treatises, Ernst composed 'with violence and method' these 'ready-made realities' as sequences of bafflingly improbable but emotionally convincing situations. In each novel there is no text, only running captions on each page which infrequently coalesce in a logical order only to be contradicted by the pictures above them. The 'irritable' tone of the whole is suggested by the image of his first heroine, *Germinal, my Sister, the Hundred Headless Woman*, whose air of nineteenth-century innocence has been compromised by the startling indication of her latent sexuality [237]. Sexual precocity coupled with false innocence, sadism (a child playing with a severed head), and blasphemy (a minuscule figure of the Eternal Father caged in the upper right corner), these are the themes Ernst devises from cuttings, each of which may originally have been emotionally quite neutral.

237. Max Ernst: Germinal, my Sister, the Hundred Headless Woman, 1929

Meanwhile Ernst had discovered the 'true equivalent' of automatic writing, whereby hallucinatory images could be produced at will. The discovery of this method, which he called *frottage* (rubbing), occurred on the rainy evening of 10 August 1925 in a room by the sea. He described how he was 'struck by the obsession that showed to my excited gaze the floorboards, the grain of which had been accentuated by a thousand scrubbings. I decided then to investigate the symbolism of this obsession and, in order to aid my meditative and hallucinatory faculties, I made from the boards a series of drawings by placing on them, at random, sheets of paper which I began to rub with black-lead. In gazing attentively at the drawings thus obtained, the dark passages and those of a gently lighted penumbra,[42] I was surprised by the sudden intensification of my visionary powers and by the hallucinatory succession of contradictory images superimposed, one upon the other, with the persistence and rapidity peculiar to amorous memories. My curiosity awakened and astonished, I began to examine indiscriminately, using the same means, all sorts of materials found in my visual field: leaves and their veins, the frayed edges of a bit of sackcloth, the brush strokes of a "modern" painting, a thread unwound from a spool, etc. etc. . . . I insist that drawings thus obtained through a series of suggestions and transmutations which occur spontaneously, like hypnagogic visions, more and more lose the character of the material examined (wood, for example), to become images of an unhoped-for precision, in such a way as to reveal the original cause of the obsession, or to produce a simulacrum of that cause.' More than that, Ernst believed that since *frottage* depends on nothing less than 'intensifying the irritability of the imaginative faculties, by appropriate technical means, excluding all conscious mental transmission (of reason, taste, or morals), reducing to the extreme the activity of him who

up to now has been called the "author" of the work, this procedure is revealed as the true equivalent of what was already known as *automatic writing*. The artist assists as a spectator, indifferent or passionate, at the birth of his work and observes the phases of its development.' In 1926 the first *frottages* were published in an album of thirty-four phototype reproductions of pencil drawings as *Histoires naturelles*.

At this point one may wonder whether the method and the results of *frottage* are actually so analogous to Breton's and Soupault's automatic writing as Ernst believed. Absolute chance and accident cannot be contrived by a human agency, preliminary choice and decision, even in the production of random results, being inescapable aspects of the human condition. Had Breton and Soupault been able to place themselves in a situation where thought arose free from all controls, the manual activity of recording it would have introduced traces of consciousness. If this is so, then Ernst's elaborate precautions, including the selection of the object to be traced, the placing of papers upon it, and the combination of the resulting rubbings in new arrangements, resulted in objects which by any definition are works of art; that is to say, artificial rather than natural products. His attempts to take nature by surprise by discovering in her complex structures equivalents to his own mental states led to a series of original but in no way naïvely accidental images, notably in his 'forest' pictures of 1927 to 1933.

Ernst's forests, which often show traces of *frottage* in the congested clumps of trees, are alarming places. Uninhabited by living creatures and inadequately illuminated by an artificial moon drawn as two concentric circles with a compass, they defy man to penetrate their mysteries. Ernst once described a forest as a situation where his ready-made objects, in that instance a canoe and a vacuum cleaner, would feel themselves 'displaced', and the forest has

served as an area for human displacement and alienation in some of his most memorable pictures. In several works of 1936-9, the period of the international triumph of the Surrealist movement (from which he resigned in 1938), he created a microscopic, insect's-eye view of a world inaccessible to human feeling. Like the Douanier's, his thrashing vines and looming leaves may be only enlargements of common plants and trees, but seen so close they suggest a para-human world whose malevolence is matched by the disagreeably organic forms cowering among them.

This was still the private world of French Surrealism which was to be dispersed at the outbreak of the Second World War. Ernst, an alien in France, was three times interned before he made his way in 1941 to the United States. His experience of the collapse of European culture and his flight to a new world were distilled in a remarkable painting, *Europe after the Rain*, executed largely in a new technique somewhat misleadingly described as decalcomania. This was a method, invented in 1935 by the Spanish Surrealist artist Oscar Dominguez (1906-57), whereby tacky or semiliquid paint, if compressed between two layers of paper or canvas, would, when the upper layer was peeled off, form accidental configurations suggesting a host of new images to the

238. Max Ernst: Europe after the Rain, 1940-2, detail. *Hartford, Conn., Wadsworth Atheneum*

attentive artist. The proportions of *Europe after the Rain* (it is almost 5 feet long by slightly less than 2 feet high) make it difficult to reproduce, but a detail from the central portion [238] shows the quality of Ernst's Surrealist work at its best, the towering monuments, half organic and half stone, forming themselves from the unpredictable activity of the paint. All is ruin and silence, and worst of all, in the evening skies there is no hint of the brightening hope often felt after a storm. The Second World War, so thoroughly documented by its photographers, inspired few pictorial works of a high order. *Europe after the Rain*, begun when the artist was hiding from the Gestapo, may be one of them.

During his stay in America (1941–53), Ernst lived for some years in Arizona, where he painted landscapes in which the vegetative and geological formations prefigured in the last of his European paintings took on the coloration of the American Southwest. During this time his works were frequently exhibited in America, but they failed to attract any general interest. After his return to France a succession of European exhibitions established his position as one of the masters of modern art. His lack of recognition in America is all the more regrettable because in 1942 one of his technical inventions, which he called 'oscillation', foretold the methods soon to be used by Jackson Pollock and other action painters. Ernst let the paint drip on the canvas through a hole punched in a tin can freely swinging from a cord. The intentionally accidental and cumulative rhythms so created can still be seen in the only important painting executed in this manner, the *Man's Head disturbed by the Flight of a Non-Euclidian Fly* (Zürich, private collection), later altered by the inclusion of the semi-geometrical elements which appeared in much of his later work. Ernst's sculptures in plaster and bronze are perhaps more interesting as three-dimensional extensions of his pictorial images than as sculptural works in their own right. Neverthe-

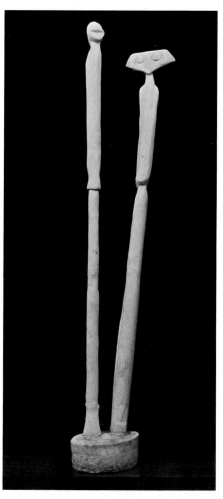

239. Max Ernst: Lunar Asparagus, 1935.
New York, Museum of Modern Art

less, *Lunar Asparagus* [239] of 1935, related in shape and texture to the forest paintings and *frottages*, is an unforgettable conception.

Ernst was not a prolific writer, but his few essays contributed to the development of Surrealist doctrine. In the most important, 'Au delà de la peinture' of 1936, he explained his

discovery of *frottage*. In an earlier draft of 1932, 'Comment on force l'inspiration', he defined the conditions for the revelation of the unconscious through collage, the medium in which his first characteristic and perhaps still most profound works were produced. His literary bias and incessant search for symbolic equivalents, to which he sacrificed, if necessary, the usual felicities of design and technique, may inhibit one's acceptance of his art as an artistic rather than psychological experience, for much of it is undeniably unpleasant and obscure. But by visualizing 'the magisterial eruption of the irrational in all domains of art, of poetry, of science, in the private lives of individuals, in the public life of peoples', Max Ernst justified his own definition of the purpose of Surrealism in 'pushing back appearances and upsetting the relations of "realities" . . . to hasten the general crisis of consciousness due in our time'.[43]

YVES TANGUY (1900–55)

The eerie atmosphere permeating the landscapes of Yves Tanguy is the result of projecting imaginary, wholly invented forms with extreme clarity and precision of detail. His discoveries were substantially his own, since he was self-taught and had come to an understanding of 'metaphysical' painting before he encountered Breton in 1925.[44] The influence of de Chirico's geometry is perceptible in a few of his earliest works, such as the inverted pyramidal form in *He Did What He Wanted* (Collection André Breton, Paris), of 1927, the miraculous year in which he came to a precocious maturity by enlarging de Chirico's perspectives until, as in *Mama, Papa is Wounded!* (New York), the earth became a vast plain stretching away to a remote horizon under a sky of the same colour.

Tanguy's talent was soon recognized by the Surrealists, who reproduced his paintings and drawings in *La Révolution surréaliste* from 1926. Certain elements, especially a freely flowing line, prove his awareness of the work of Ernst, Miró, Masson, and Arp. Each of these artists in different ways had been studying the properties of automatic suggestion, and Tanguy's belief that forms can grow upon the canvas like crystals, generated more by the necessities of their own structure than by their master's preconceived ideas, is related to their earlier attempts to free thought from all conscious control. His concern with artistic creativity as a means for probing the unconscious was encouraged by Breton, even to their Dada-like search through psychiatric literature for statements of patients which could be used as titles for the paintings in his first Paris exhibition of 1927 ('Mama, Papa is wounded!' is one). Tanguy later said: 'I found that if I planned a picture beforehand it never surprised me, and surprises are my pleasure in painting', and he is said to have painted some of his earlier pictures upside down 'in order to be surprised by his own creation when he placed it right side up'.[45] By submitting to the promptings of the forms on his canvas Tanguy discovered those uncanny objects which people his invented landscapes. People them they do, for although his forms are almost entirely fantastic, owing little to suggestions from ordinary nature, they are persuasively animal and vegetable as well as mineral and mechanistic, somehow capable of continuous organic metamorphosis.

In *Indefinite Divisibility* of 1942 [240], painted after he had settled in the United States, the gifts which Breton had recognized in 1928, when he devoted a section to Tanguy in 'Le Surréalisme et la peinture', reached a monumental climax. Breton had asked: 'Just what are these images? At these frontiers of the mind, where any relation with the exterior world is denied, where man's only justification is his actual existence . . . what are we seeking and what will we find?' We no longer ask such questions because we accept such images as

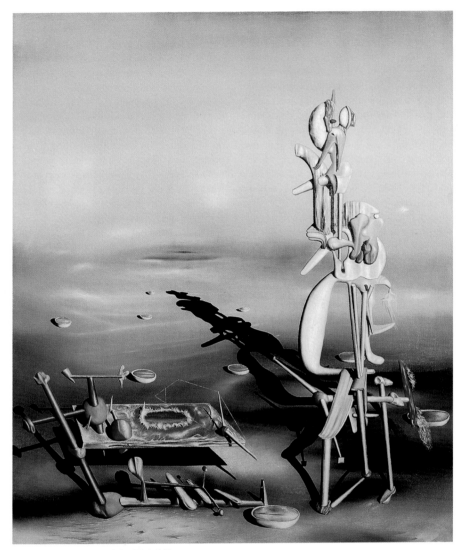

240. Yves Tanguy: Indefinite Divisibility, 1942.
Buffalo, N.Y., Albright-Knox Art Gallery

mental configurations, arising in a region where earth and heaven have dissolved into each other, where, as Breton said, a bale of feathers weighs as much as a ball of lead, and a towering structure composed of unrelated shapes and textures casts a sharp shadow, not exactly its own, on earth, mist, and sky. Several small pottery bowls reflecting blue sky invisible elsewhere within the picture space add still another dimension to this lunar landscape.

Unlike Dali, Tanguy said little and wrote even less about his art, but in a remark from his later years he revealed one reason for his effects in his desire to see what lies concealed from daily sight: 'It amuses me to imagine what is beyond a hill. I want so much to represent those things behind the hill that I will never see.'[46] But that he said this in no mood of childlike curiosity is evident from the expressive tone of his pictures. Calm and immaculate they may be, these silent and extraordinarily lonely places, but their serenity barely conceals some present menace. As Breton wrote: 'There are no landscapes. There is not even a horizon. There is only, physically speaking, our immense suspicion which surrounds everything.'

SALVADOR DALI

The public misbehaviour of Salvador Dali (b. 1904) during the later Surrealist years in Paris and for some time after his arrival in the United States in 1941 cast much discredit upon the Surrealist movement in general and his own works in particular. 'The massive architecture of his egoism', as he himself describes it,[47] expressed through a carefully calculated megalomania, a talent for making financial capital out of society's taste for psychological obscenities, and a contempt for the modern movement in general have done little to endear him to critics, who often dismiss him in the tone André Breton used when he read Dali out of the Surrealist party in 1942.[48] Be that as it may, no serious student of modern art can ignore Dali's contributions to the Surrealist aesthetic, or forget some of the paintings that embody his ambition 'to materialize images of concrete irrationality with the most imperialist fury of precision'.[49] If, rightly or not, Surrealism has become identified by the general public with Dali's art, it is because his best paintings exceed in imaginative intricacy and visual intensity those of any other Surrealist master.

Through his Catalan heritage – he was born at Figueras near Barcelona – Dali may have been congenitally irascible. From childhood he was subject, or so he writes in his autobiography, to hallucinations and acts of sudden and uncontrollable violence. For such a youth there was little beyond the technical conventions to be learned at the academy in Madrid, where he studied in his early twenties, except the opportunity to insult his superiors. Told to paint a copy of a Gothic Virgin, he painted a pair of scales. They were, he said, what he saw when others saw the Virgin, and he may have been right. He did, however, discover the Futurists' manifestos and their conception of spatial and temporal simultaneity. The shifting and interpenetrating planes of Boccioni's sculpture may have contributed something to his later taste for organic distortion as a process of growth. More important were the reproductions of the work of de Chirico and Carrà which he saw in the Italian periodical *Valori Plastici*. A passing interest in Cubism led him at first to imitate Carrà's more formal version of *Pittura Metafisica*, before his imagination was captured by the endless spaces of de Chirico, his manipulation of light for psychological reasons (as in the shadows cast by objects invisible to the artist and spectator), and by the peculiar transposition and intensification of space and time through the *trompe l'œil* detail of the framed pictures within the pictures. In the works Dali presented at his first one-man exhibition in Paris in November 1929, these elements of the Italian artist's iconography were clearly perceptible, but they were only pretexts for a new and formidable iconography. Although Dali has always insisted on his hatred of abstract art,[50] it must not be forgotten that he had briefly practised it in 1928-9 after meeting his compatriots, Picasso and Miró, in Paris. Since a savage irritability marks the paintings of these, their most Surrealist years, it is tempting to interpret the tenor of

Dali's work as peculiarly Spanish in its emotional intensity.

After settling in Paris, Dali commenced the twin activities which he has successfully pursued ever since, of teasing and placating high society while offending everyone else. Among his patrons the Vicomte Charles de Noailles acquired two of his most important works, *The Invisible Man* of 1929–33, his first large exposition of the mechanics of the double image, and *The Old Age of William Tell* of 1931, one of several re-interpretations of the Swiss story as an act of incest rather than of filial piety. On the other hand, the films he produced with Luis Buñuel, *Le Chien andalou* in 1929 and *L'Âge d'or* in 1930, were greeted with public riots. Even today such images as the eyeball sliced with a razor blade, the dead donkeys rotting in the grand pianos, and the cadavers dressed in archiepiscopal raiment withering on the rocks at Cadaqués are so disagreeable that we can sympathize with those whose artistic and religious sensitivities were outraged.

In such an atmosphere, dominated by 'the three cardinal images of life: blood, excrement, and putrefaction', Dali developed his 'paranoiac-critical' method. Its principles were simply stated in the essay *L'Âne pourri*, which introduced his short book of 1930, *La Femme visible*. In essence, Dali proposed to substitute for the passive conditions of self-induced hallucination favoured by the earlier Surrealists 'a paranoiac and active advance of the mind' which would release from the unconscious images of such force and power that they in turn would react upon it, thereby affecting the deepest sources of individual and social action. The distinction between the passive and active experience of sur-reality appears in his account of the paranoiac faculty. This he defined more in the sense of obsession and systematic delusion than of persecution. It enables one who possesses it 'to see at will the form of any real object change, just as in voluntary hallucina-

tion, but with this important difference, in the destructive sense, that the various forms the object in question can take can be controlled and recognized by everyone, as soon as the paranoiac has merely indicated them'.[51]

Given a sensibility as keen as Dali's – and his ability to see multiple images in the most harmless circumstances is extraordinary – we are almost persuaded that the second and subsequent images provoked by the preliminary phenomena are the true realities, especially since his 'hand-painted dream photographs' are so realistic. In Paris he had early professed his admiration for the microscopically detailed works of Meissonier and Fortuny, and for the literal realism of ordinary commercial art, but the sources of his method, as of his style, were actually more respectable. In the work of the seventeenth-century Spanish still-life painters, in early Velázquez, and in Vermeer, whose name he has invoked in the titles of his paintings, he found how to represent objects in space and light with the utmost precision. But spectacular as his painted surfaces appear at first glance, closer inspection reveals a coarseness in even the smallest details that no seventeenth-century Dutch or Spanish master of the minute would have tolerated. Nevertheless, this is the only technique with which he could have presented his remarkable paranoiac inventions as visual truths, especially his continuous transmutation of causes and substances through multiple images, organic distortion, and the animation of the inanimate. Since these are all constant factors in dream experience, Dali's best work communicates within the necessarily static limitations of the physically motionless picture space much of the strain and anguish induced in dreams by the ceaseless flux and transformation of form. Such is the condition expressed in his best-known painting, *The Persistence of Memory* of 1931 (New York), where watches hang limply over a wall and the bough of a tree. He has written of his obsession

for softness, and has said that the idea of the watches came to him as he sat at table finishing a ripe camembert cheese.[52] The combination of metallic and lactic substances, attacked in the painting by the iridescent ants, may plausibly be interpreted as an allegory of the endurance of time beyond human experience, but it also seems a pictorial metaphor of the artist's belief

that the moment had come when he could 'systematize confusion and thus help to discredit completely the world of reality'.

Many of Dali's paranoiac images now seem too premeditated to have been produced by actual hallucination and hysteria. Few can see in Millet's *Angelus*, as he has, an image of repressed sexuality.[53] Nor does a telephone

241. Salvador Dali: Soft Construction with Boiled Beans – Premonition of Civil War, 1936. *Philadelphia Museum of Art*

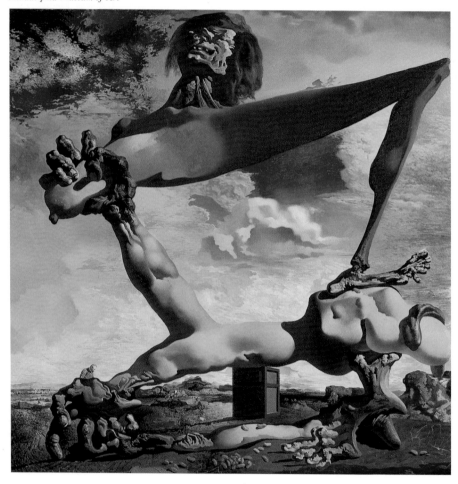

suspended over two fried eggs still communicate his shock at the betrayal of Europe in 1938, the Munich conference having been arranged by phone. Yet there are paintings which still repay attention. The Surrealist irony in the title of his *Soft Construction with Boiled Beans* of 1936 [241] is cancelled by its subtitle, *Premonition of Civil War*. Here Dali placed his gruesomely organic distortions at the service of something more important than himself, much as Picasso a year later raised the formal devices of Cubism to the highest expressive power in *Guernica* [271]. Dali's distorted man-monument, whose hands and feet are hideously diseased, is an appalling but impressive statement of the actual horrors which the Spanish Civil War was soon to unfold. And this 'materialization of concrete irrationality' (in its way a good definition of civil war) becomes all the more real as dream or nightmare when we discover the tiny figure in the lower left, a well-dressed bearded scholar, who had last been seen in another painting of that year 'lifting with extreme precision the cuticle of a grand piano' on a vast and empty beach dominated by the seated figure of Richard Wagner in the foreground. The composer, with Nietzsche and Ludwig II of Bavaria, was one of the nineteenth-century virtuosi of megalomania and madness whom de Chirico had taught Dali to admire. But Dali has said that 'the only difference between me and a madman is that I am not mad', and the suspicion that his delirium could be put on and off at will worked to his disadvantage in later years. His decision in 1938 'To Become Classic' by imitating the Florentine Mannerists and Palladio led to disappointing eclectic exercises, and it is difficult to accept his recent Catholic imagery as authentically pictorial, although an exception should be made for the Christ of St John of the Cross (Glasgow, Art Gallery), where the curious inverted perspective is based on the only drawing attributed to the saint himself. In 1958 Dali claimed

Heisenberg as his master, but uncertainty proved an uncertain support for his art.

RENÉ MAGRITTE AND PAUL DELVAUX

For some time the clamour which accompanied Dali's 'paranoiac-critical' efforts obscured the work of two Belgian painters who were quietly demonstrating that the 'interior perceptions' Breton considered essential to pictorial Surrealism could be communicated less shrilly, indeed in what by contrast seems almost a dead silence. René Magritte (1898–1967) had become aware of de Chirico and Ernst by 1925 through his friendship with E. L. T. Mesens (1903–71), the leading Belgian Surrealist agitator and a gifted artist in collage, and in his first exhibition in the following year proved that he had passed through abstraction to a provocative and poetic imagery of his own. For three years (1927–30) he lived near Paris, where he was accepted by Breton, who later commended him for having 'put the visual image on trial, stressing its weakness and demonstrating the subordinate character of figures of speech and thought'.[54] He then returned to Brussels, where he continued to paint in his beguilingly imitative manner, only briefly distracted by experiments in treating Surrealist subjects in an Impressionist (1940–5) or Fauve (1948) technique.

In his first and only major contribution to *La Révolution surréaliste* (it appeared in the last number, in 1929), Magritte explained the difference between objects, their images, and their names. In the manner of a child's primer he set forth eighteen propositions illustrated with ingenuous pen drawings. The statement 'Sometimes the name of an object takes the place of an image' was followed by a drawing of a clenched fist, a box, and the word 'cannon', each image supposedly synonymous with the others. So far, so simple, but other propositions were less disarming. 'An object is not so attached to its name that one cannot find another which

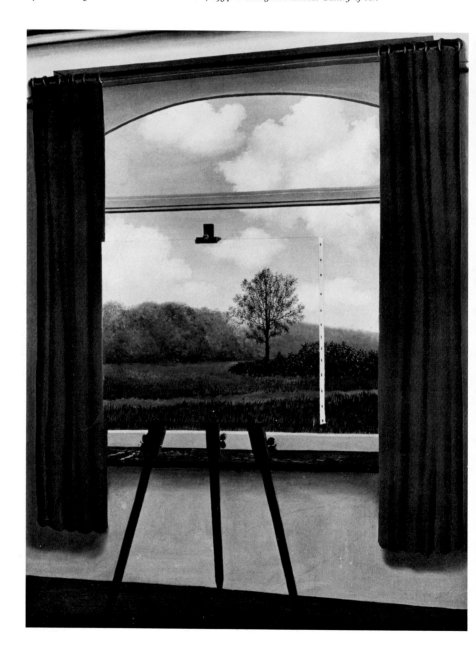

might suit it better' was illustrated by a leaf labelled 'cannon'. Farther on, a drawing of a horse, an easel on which rests a painting of a horse, and a man saying the word 'horse' proved that 'an object never fulfils the same function as its name or its image'.

These equations were the major premises of Magritte's mature work, in which he patiently insisted that similarity does not imply identity and that relations between objects, their images, and their names need not conform to the laws of commonsense causality. By refusing to mistake life for art, or art for nature, he contra-

dicted nature with a 'deadpan' naturalism and affirmed the essential character of the work of art as a reality superior to illusion. His visual logic is as irrefutable and as absurd as Gertrude Stein's in her statement that 'an oil painting is an oil painting',[55] a fact many forget. In a picture of a smoker's pipe Magritte wrote in large letters 'This is not a pipe', which, of course, it isn't. It is a picture of a pipe, but as a picture, an image, its reality is different from a pipe's. With a limpid palette and a scrupulously banal technique, acquired when he designed advertisements and wallpapers, Magritte paint-

243. Paul Delvaux: Procession, 1939.
New Haven, Conn., Yale University Art Gallery

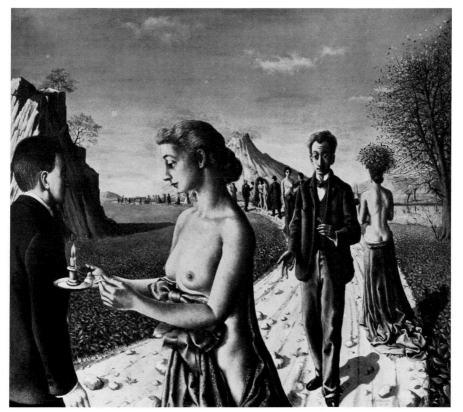

ed things as they look to us but in situations where neither they nor we could occur, and then added titles which 'accompany them in the way that names correspond to objects, without either illustrating or explaining them'.[56] *The Human Condition* [242] is not human but artistic, unless we are to assume that we, as part of nature, are also and only continuous with the painted illusion of a natural scene. These baffling inconsistencies between pictorial, physical, and literary facts create psychic as well as visual discontinuities which look humorous but are not. Magritte's images are the more disturbing because they cannot be discounted as private reveries. Because he insisted that painting represents 'through pictorial techniques the unforeseen images that might appear to me at certain moments, whether my eyes are open or shut', his images were not dredged from private consciousness. They were present to his waking mind, and they are possible to ours. Insoluble visual rebuses, they reveal, as Magritte said, 'the present as an absolute mystery'.

Paul Delvaux (b. 1897) came later to Surrealism, encouraged by the work of Dali and Magritte as well as by de Chirico's. In the latter's paintings he found his disquieting perspectives; in the others', especially in Magritte's, methods for exact description of things unseen. Two visits to Italy before 1940 confirmed his prediliction for classical architecture and classical canons of ideal beauty. Delvaux's classicism, however, is not archaeological but traumatic. His cities could never have been constructed, and his statuesque female figures, whether nude or dressed in the fashions of 1900, are identical images of an unattainable woman who appears only in dreams. In such a trance-like state his clothed men, types and conditions of masculine frustration, approach and pass the ladies gently offering them the gifts of love [243]. Worst of all, when Delvaux invokes the state of suspended animation which we know in dreams, and thus obliges us to identify our-

selves with his dreamers, we discover to our dismay that each dreamer is constantly encountering himself, as he is, as he was when younger, and as he will be. In the best pictures of his Surrealist years (1936–42), Delvaux added to the Surrealist iconography an unforgettable and Freudian *danse macabre* of love caught between time and death.

ABSTRACT SURREALISM: ANDRÉ MASSON AND JOAN MIRÓ

The term 'Abstract Surrealism' may seem self-contradictory, since as an instrument for the intensification of reality Surrealism so often dealt with images of 'real things (as we have seen, some of the most 'abstract' verbal metaphors in *Les Champs magnétiques* could suggest visual configurations). But it may serve to characterize the important contributions to Surrealist expression by two artists who abhorred the 'hand-painted dreams' of the orthodox image-makers as much as they did the 'deserted house' of Mondrian and the non-objective painters (the phrases are Dali's and Miró's). Few if any of the works produced by André Masson (b. 1896) and Joan Miró (1893–1986) can be considered intentionally or totally abstract. Their most cabalistic scrawls are deduced from signs and situations meaningful in terms of human experiences for which there are often poetic analogies, in a quite literary sense. Not the ends of their art but their means are abstract, and both painters are masters of the techniques of automatic inspiration and execution which André Breton considered quintessentially Surrealist.

When Breton met Masson in 1924 the painter was at the end of his self-imposed apprenticeship to Juan Gris, in whose works and writings he had discovered the 'synthetic' method of shaping images from primary, unrepresentational forms. Already the Cubist structures loosely dispersed across his canvases were

threatened by curving arabesques and clumps of scrolls whose patterns seemed the result of spontaneous, unpremeditated actions of the hand. No wonder that Breton in his footnote to the first Manifesto closed his list of artists possibly Surrealist with Masson, whom he called 'so close to us'.

Masson in his turn welcomed Breton's support for the attack which he and Miró, whose studio was beside his own in the rue Blomet, were waging against a Cubism already hardened into the dogmatic designs of a Gleizes or a Herbin, or into the abstractions of Mondrian. Miró wanted 'to smash the Cubists' guitar', Masson to 'seize at last the knife immobilized upon the Cubist table'. The knife as a symbol of violent and bloody aggression typified the new iconography with which Masson proposed to destroy the 'petrified' figures of Cubism. In his *Massacres*, where animals, birds, and fish are devouring each other and themselves, he expressed the basic human emotions of insatiable hunger, love, and love of death which were alien and even impossible to Cubism. But because the intensity of his expressive needs could not be conveyed even by erotic and sadistic images, Masson was driven to explore the abstract violence of form and line. In 1926 he began to scatter sand, sometimes in various colours, over canvases previously saturated with glue applied in accidental patterns. The images thus spontaneously suggested by these half-random configurations were defined by a few abrupt brush strokes apparently set down with dazzling speed [244]. The basic patterns remained Cubist, but Masson had transformed Cubist statics into his own restless dynamics. In 1927 he added one spot of brilliant red to the sand (in the *Battle of Fishes*, New York), and soon after feathers completed the suggestion of sudden, animal death. By 1930 his work was almost as brutal as Picasso's contemporary and half-Surrealist expression, but unlike Picasso he was not content to follow the dictates of his

244. André Masson: The Villagers, 1927.
Paris, Musée National de l'Art Moderne, Centre Georges Pompidou

unconscious, and chose, after his disagreement with Breton and withdrawal from the Surrealist movement in 1929, to devise a new mythology of nature and man's place within it as a way to reconcile the claims of modern art with the great past. But these 'metamorphoses', a key word in Masson's aesthetics, proved too taxing for his formal imagination and the nature images of the later 1930s, centred in the metamorphic concepts of germination, gestation, and blossoming (*éclosion*), were indebted to the more literal imagery of Dali, and were scant improvements on the traditional transformations of Daphne or Arethusa. Much to be preferred were his close studies of insects and grasses, through which, in delicate drawings and graphic work, he reached his visualization of nature seen 'from within'.

Masson lived in Spain from 1934 until 1936, when the Civil War drove him back to France, but by then the experience of El Greco had

confirmed his belief that the greatest art is basically tragic and humane. El Greco's Mannerist compositions also helped him to dissolve the lingering traces of Cubist pattern into a new, densely organized space where the interstices between the larger elements are filled with distant views in differing perspectives. The horrors in Spain, the outbreak of the War and the fall of France which drove him to the United States, and his own memories of service in the First World War, in which he had been wounded, account for the convulsive conflicts in a series of large canvases painted in America. The mindless monsters of *There is No Finished World* of 1942 [245], forming and

disintegrating before our eyes, symbolize 'the precariousness of human life and the fate of its enterprises, always threatened, destroyed, and recommenced'.[57] In these signs of pain and psychic suffering, the automatic play of the hand, described by Breton once as 'enamoured of its own movement', expressed the most serious, Surrealist disgust with a world run mad. They revealed Masson at his best, and although little acknowledged at the time, profoundly affected contemporary American painting. Their content may have led Jackson Pollock (1912–56) to a modern mythology of sexual violence (Masson's *Pasiphaë* of 1943 preceded Pollock's of the same year), and the

245. André Masson: There is No Finished World, 1942. *Baltimore Museum of Art*

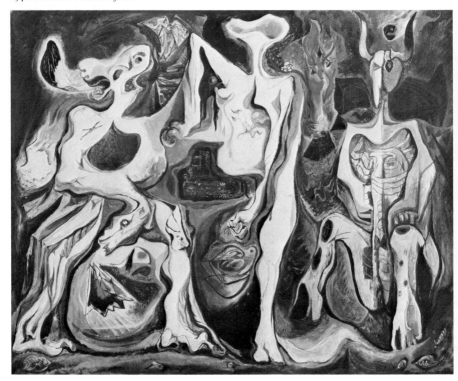

automatic methods may have suggested to Pollock his techniques of drip and splatter. Masson returned to France in 1945 and settled in Provence, where he has explored the landscape from the point of view of Turner and Zen Buddhism, but skilful as the results have been, the appeasement of his turbulent emotions has diminished the intensity of his art.

Although Miró has been considered a master of Abstract Surrealism, he often protested against totally non-objective art. He refused to join the Abstraction-Création group in Paris in 1931 because he wanted to have nothing to do with their 'deserted house'. On the contrary, he always insisted that for him 'form is never something abstract; it is always a sign of something . . . always a man, a bird, or something else', and that his intentions were illustrative, even literary: 'I do not distinguish', he said, 'between poetry and painting.'[58] That he was not an illustrator or realist in the literal sense is due, of course, to the fact that he illustrated neither the visible world of waking experience nor the usual Surrealist images of hallucinatory reality, but the pre-concious world, where emotional tensions strive towards formal visual realization.

Miró was born in Barcelona in 1893 and thus belonged to the generation of artists, slightly younger than the first masters of Cubism, who revised Cubist theory and practice. By 1919, when he arrived in Paris for the first time and paid his respects to Picasso, whose family he had known at home, he had already been painting for seven years. He had recognized and accepted the significance of Cézanne and Van Gogh, and had already achieved his own synthesis of Fauvism and Cubism in a series of luminously coloured landscapes of the fields and villages of his native Catalonia. Unremarkable as they may be in view of his later more abstract inventions, they embody a curious and very characteristic combination of extreme realism in certain areas and details with a highly geometrical treatment of others. The simultaneous presence of the actual and the abstract was not yet pictorially unified, but the visual as well as psychological difficulties which such a juxtaposition poses for the spectator became an essential component of his mature style.

For him, as for so many young artists who came to Paris after the War, the revelation of the modern movement was so unsettling that some months passed before he could begin painting again. Then, as if in rebellion against the degree of abstraction to which Braque, Picasso, and Gris had brought Cubism, he turned to an exaggerated, even obsessive realism of which the famous *Farm* of 1921–2 (New York, Estate of Ernest Hemingway) was both the climax and conclusion. Begun on his family's property at Montroig in the Catalan countryside, and finished in Paris (with the help of dried grasses brought from home), this was a minutely detailed inventory of peasant life. But the scrupulously painted animals, tools, and buildings share the picture surface with the witty calligraphic treatment of the dominant tree and severely geometrical elements such as the white disc of the sun and the echoing black one at the base of the tree. These so disturb the pictorial equilibrium that the realistically painted objects have the intense clarity of things seen in dreams and hallucinations. This quality, taken a step farther towards abstraction, pervades *The Farmer's Wife* [246], where our attention fastens on the cat, the woman's face, and the rabbit (developed from a quite literal rabbit in a still life of 1920), just because they are so abruptly separated from their geometrical surroundings. Yet the total effect depends less upon the clarity of the separate images than on the abstract scheme of light and dark shapes supporting and enclosing them, a scheme which so firmly controls the composition that the woman's grossly enlarged feet, an early instance of Miró's metamorphosis

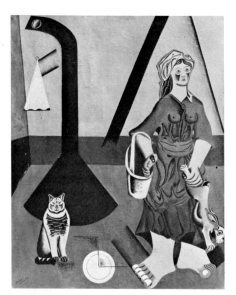

246. Joan Miró: The Farmer's Wife, 1922-3.
Private Collection

of organic form, seem to belong less to the woman than to the design as a whole.

Much has been written about the naïvety, the childlike delight in grasping the essential appearance of objects, and, by extension, the guileless gaiety of Miró's work. Gaiety there is, as well as a lively wit, in the works which followed *The Farm* in 1923-5, in the odd little animals and half-human creatures who populate such diffuse and calligraphic paintings dominated by bright yellows and reds as *The Tilled Field* (Private Collection), or the *Harlequin's Carnival* (Buffalo, Albright-Knox Art Gallery). This aspect of his work reached a climax in 1926 in two canvases upon which his reputation rested for several years, the *Person throwing a Stone at a Bird* (New York) and the more succinct *Dog barking at the Moon* (Philadelphia). In the former the 'person' had become a continuously bulging and contracting silhouette with one huge foot, its outline suggested

by the sculpture of Jean Arp. In both paintings the division of the background into two broad zones of earth and sky by a horizon cutting the picture horizontally midway recalls the similar division in another dream-like painting, *The Sleeping Gypsy* by Henri Rousseau, whose work Miró admired and with whom he shared the same 'primitive' insistence on defining the immediate, almost physical reality of the object. Rousseau's landscape, however, is at least a plausible desert; Miró's are inaccessible realms where beings, although named as 'person' and 'dog', look more like the original stuff of dreams only partially materialized into vital shapes. This shift from the vividness of hallucinations to the indetermination of traumatic forms just coming into view coincides with Miró's association with the Surrealists and his acceptance by André Breton as 'the most Surrealist of us all'.[59] Miró provided Surrealism with a new kind of imagery (most of the paintings mentioned above were reproduced in Breton's magazine, *La Révolution surréaliste*), an imagery more sensitive to the flux of oneiric experience than were the literal, 'hand-painted dreams' of Dali or the protoplasmic configurations in Tanguy's no-man's-land. Surrealism was also important for Miró because it verified the artistic and technical premises of his art. Henceforth the Surrealist literary bias supported his belief that painting is not narrowly to be distinguished from poetry and that his own painting could even admit poetic words and phrases (most notably in *Le Corps de ma brune . . .* of 1925). Breton's equation of the creative act with 'pure psychic automatism' revealed the technical surprises to be suggested by accident and exploited through chance. Finally, Surrealism exposed a new pictorial content in the subliminal reaches of psychic life. In this world within us, as individuals and as members of a species, there is little humour, and what there is, as Breton observed, is 'black'. What is felt, even before it can be seen,

is not form but forming, a process of becoming whereby the fundamental psychic substance, impelled by primordial sexual drives, struggles to define itself as male or female in a region where what is animal and what will become human are not yet clearly to be told apart.

Miró's control of these aspects of Surrealist theory and practice was brilliantly disclosed in a series of large canvases painted in 1933 in which his colours, restricted to his characteristic reds, blacks, and whites, may stand for the ultimate realities of human experience, for day and night, life and death, earth and the heavens [247]. The shapes suspended before muted backgrounds deep as the space of

dreams are so placed as to create patterns of tangential and interpenetrating relations whose meaning is gradually disclosed as an unceasing process of metamorphosis. There is scarcely a shape which is not about to become something other than it is, or was. Forms apparently limp or lifeless acquire organic protuberances, genitalia as often as not, which turn into rudimentary heads, hands, and feet, or, reversing the process, subside again into the realm from which they had only partially emerged. There are still witty passages where an irrelevant little face mocks us from the gloom, but such wit can cut when we discover that we might be laughing at ourselves, since what is happening in the

247. Joan Miró: Painting, 1933.
Hartford, Conn., Wadsworth Atheneum

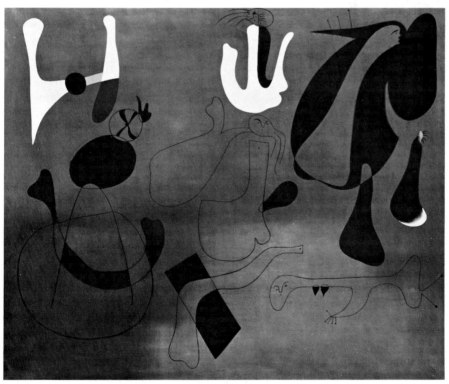

picture could be the history of our own psychic life.

These large, dark pictures justify Miró's statement of the same year that his painting was 'always born in a state of hallucination, provoked by some shock or other, objective or subjective, for which I am entirely irresponsible'.[60] We may take it as a measure of Miró's imaginative intensity that the organic metamorphoses of these paintings were provoked by inorganic images. On sheets of paper he assembled cut-outs of mechanical objects, tools, and machines (perhaps suggested by Ernst's early collages), and then waited for 'automatic' inspiration to suggest his forms. Possibly the choice of objects, certainly the changing images they provoked, can be considered automatic in that Miró first voluntarily surrendered to the promptings of intuition, but in actual execution he was never less than the master whose creations obeyed his artistic will: 'After the first shock of suggestion has cooled', he worked 'coldly, like an artisan, guided strictly by rules of composition.' However brutal his creations may be, one's initial dismay or embarrassment is soon dissipated by his supreme pictorial control.

Miró always kept apart from politics. *The Reaper* (lost), a large mural in his 'savage' style of the 1930s for the Spanish Pavilion at the Paris Exposition of 1937, and the anti-Franco poster related to it are rare instances of a concern with extra-artistic affairs, but it is noteworthy that the 'savage' style itself occurred on the eve of the Spanish Civil War. Monstrous metamorphoses threatening the very structure and stability of human existence had appeared as early as 1933 in collages of pasted photographs extended by drawings of weirdly elongated figures, often obsessively sexual or scatological. By 1936 the human figure had been cruelly transformed into an image simultaneously beast and insect, ogre and man. One of the most appalling of these images, the *Head*

of a Woman of 1938 [248], is as alarming as a nightmare by Kafka or Kubin, and as tragic a comment on our plight. Painted midway through the Spanish War, when the full horror of that conflict could no longer be ignored, it takes its place despite its diminutive size with those other twentieth-century images of man's inhumanity towards himself, Dali's *Soft Construction with Boiled Beans* of 1936 [241] and Picasso's *Guernica* of 1937 [271].

When the Second World War began, Miró returned from France to Spain, at first to Mallorca, where in 1941 he completed the small gouache *Constellations*, and then to Barcelona, where in 1942 he executed the fifty 'Barcelona' lithographs, his first important set of prints. Unrelieved by the brilliant and clear colours that throb in the gouaches, the lithographs are as dark and brutal as the works of the 'savage' period. By contrast the *Constellations* were, as Miró has said, a means of escaping from the horrors of the contemporary scene. Upon intricate networks of lines and small forms are hung the most elementary of Miró's ideograms, circles and stars suggesting the serene detachment of heavenly bodies from the affairs of men. To many of these paintings Miró gave magical titles, such as *Women by the Lake with an Iridescent Surface, After the Passage of a Swan*, less to explain their abstract structure than to create complementary poetic situations in the mind as well as in the eye of the beholder.

After 1945 Miró turned to mural painting, to prints, ceramics, and occasional sculpture. Through the larger scale of murals and by collaborating with printers and ceramic artists, he hoped to pass beyond what had become for him the artificial restrictions of easel painting. His most important murals are those for the Terrace Hilton Hotel at Cincinnati, Ohio (1947), and the Harvard University Graduate School (1950–1). In 1958 his two ceramic walls were erected at the UNESCO headquarters

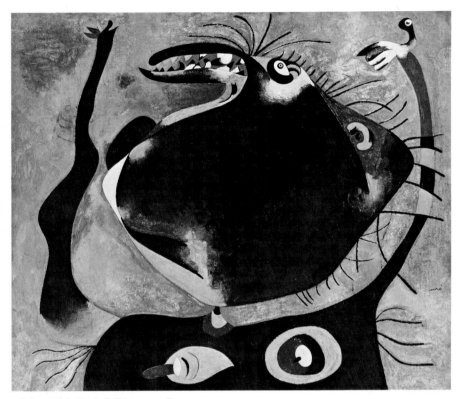

248. Joan Miró: Head of a Woman, 1938.
Minneapolis Institute of Arts

in Paris. In his ceramic sculpture, executed with the assistance of the master potter José Lloréns Artigas in his studio at Gallifa above Barcelona, Miró allowed the manifold and unpredictable accidents which occur during glazing and firing to suggest ever more daring metamorphoses.[61] Certain works inspired by the stony landscapes of Catalonia look miraculously like natural substances, for in his hands two formal procedures, the evolutionary processes of nature and the psychological intentions of a human mind, could coincide in a pre-rational order of creation. Yet for all his admiration of primitive art, especially for the paleolithic cave

paintings in Northern Spain, Miró's art is more learned than it may appear at first sight. Although it is primarily instinctual rather than intellectual ('the word comes first – the thought thereafter', he once said), it embraces, even as it transposes, the most formidable inventions of his great contemporaries. He is the only major artist to have succeeded in taking as much as he wanted from Picasso without falling into imitation or plagiarism. And if his debts to Klee and Arp are incontestable, to Kandinsky he gave more than he received. In the course of a long life he found forms, whether nature's, his own, or others', for what surpasses purely

formal meaning, for that true pictorial content, 'the sources', as he said, 'of human feeling'.

THE SURREALIST OBJECT

If to the Surrealists, and to Breton in particular, the art of painting had at first seemed less capable than poetry or prose of communicating 'concrete irrationality', sculpture might also have been thought an inappropriate medium, because the creation of three-dimensional form allows few opportunities for the expression of subconscious experience through automatic techniques. And, indeed, sculpture only gradually found its place in the Surrealist canon. At the first Paris exhibition in 1925 the only objects were Arp's two reliefs, which incorporated more Dada mockery than Surrealist unease. The following year an exhibition of sculpture was announced in *La Révolution surréaliste*, but it was never held, and ten years passed before any group of objects which with any accuracy could be described as Surrealist were exhibited as such. In 1936 Breton, Eluard, and others defined 'the crisis of the object' in a special number of *Cahiers d'art*, and there was an exhibition at the Galerie Charles Ratton in which Surrealist objects were shown with primitive sculpture, followed by the large international exhibitions in London and New York. In each instance works by professional as well as amateur Surrealists were shown in conjunction with 'found objects' and things produced by the mentally deranged, thus farther confusing the categories of intentional and spontaneous 'irrationality'.

The sort of objects that could be considered instances of 'concrete realizations of the dream' can be inferred from later Dada and early Surrealist collages like Man Ray's pasted engraving illustrating Lautréamont's umbrella and sewing-machine on a dissecting table. But to imagine the existence of such an image in three dimensions, whether as an assemblage of actual objects or imitations of them, is to realize that when the poetic metaphor is extruded into everyday space, it risks losing much of its magic. To retain that magic, to recreate the marvellous, was not easy. The difficulty accounts for the rarity of anything that can be called sculpture of artistic quality, and for the production of much that now seems merely contrived or silly. And the sculptor faced obstacles which the painter could ignore. He has only one space and one kind of perspective in which to work, and little if any control over the lighting of his objects after they leave his studio. To mention the mysteries de Chirico evoked by his manipulation of light, space, and perspective is to suggest some of the Surrealist sculptor's limitations.

Duchamp's conviction, embedded in his first 'ready-mades', that art is not so much made as discovered where one decides it is to be, encouraged a search for things, whether natural or manufactured, which by their unexpected isolation from their customary purpose and environment could open magic casements on interior psychic seas. Such 'found objects' (*objets trouvés*), whether assisted by their discoverers or not, illuminated the darker recesses of the spirit by revealing the existence of a life in things standing over against ourselves. But the technique was easily abused, especially by interior decorators, until no bit of driftwood or broken bone was safe from Surrealist implications.

Bolder and certainly more amusing were the occasions when a rare imaginative fancy combined disparate shapes, materials, or conditions of things into objects so truly irrational that it seems as if they must have come from quite another kind of world. Such was the *Fur-lined Teacup, Saucer, and Spoon* of 1936 (New York) by Meret Oppenheim, a German member of the French Surrealist group. When it was seen at the exhibitions that year in London and New York it was immediately recognized as a unique

and 'marvellous' metaphor, soon to be used, like Duchamp's *Mona Lisa*, as a symbol of artistic anarchy by those who feared and distrusted the modern movement.[62]

The Surrealist object could also be found in the work of certain painters. The structures rising so eerily from the aqueous depths of Tanguy's landscapes might have been fashioned in actual substances, and indeed they may have influenced the sculpture which the American artist Isamu Noguchi (b. 1904) put together in the 1950s from rounded and interlocking marble slabs. Both Ernst and Miró created sculpture in which Surrealist irrationality is communicated by violent combinations of materials or strange images, but such objects are not expressively or even formally independent of their pictorial ideas. In his reliefs of the 1930s Miró used rope, nails, and assorted bits of metal in combinations as brutal as his paintings of those years. And even Ernst's most idiosyncratic sculpture, the towering *Lunar Asparagus* of 1935 [239], is essentially a materialization of the weird growths which clogged his later forest scenes. Picasso's sculpture and painting of 1929–36 can also be related to the movement, but since he was never actually a Surrealist they can be more profitably examined in relation to his work as a whole.

ALBERTO GIACOMETTI (1901–66)

The one artist who emerged as a major Surrealist sculptor was Alberto Giacometti, the son and nephew of the Swiss Post-Impressionist painters Giovanni and Augusto Giacometti. He had studied at the School of Arts and Crafts at Geneva and travelled at length in Italy before settling in Paris in 1923, where he worked for a time with Bourdelle. The first piece of sculpture which he recognized as distinctly his own, a torso of 1925, was a solid and very abstract Cubist conception. But from the first he was bothered by the difference between what the

sculptor sees inside and what he sees outside his mind, and began, as he said, 'in desperation, to work at home from memory'. There he discovered the conditions essential for his 'vision of reality': that he would have to replace the dense, compact masses of conventional sculpture by a sharp, 'transparent construction . . . a kind of skeleton in space', and that reality meant movement which must not be simulated but real. He first solved his problems in a series of open boxes made of metal rods, like cages without bars, in which he suspended free constructions, executed in wood by a carpenter. In one of the first of these *Mobile and Mute Objects*, subsequently known as *L'Heure des traces* (1930), a ball suspended from a cord swung like a pendulum above a crescent-shaped form. For the time and place the simplicity of the whole construction was as remarkable as its totally abstract design. By his own account the *Palace at 4 a.m.*, a delicate structure of wooden sticks, glass, wire, and string (New York), gradually formed in his mind through the summer of 1932, and by autumn it 'was so real that its execution in actual space required only one day'. The dreamer's dream had been made visible in three dimensions. That same year he created in wood and bronze such cruel and erotic forms as the *Disagreeable Object* (New York, Collection James Johnson Sweeney) and the *Woman with her Throat Cut* (Venice, Guggenheim Museum). Finally, in 1934 he created the *Hands holding the Void* or, as it became known from Breton's description, the *Invisible Object* [249]. In the longest and most sympathetic passage he ever devoted to sculpture, Breton described how, during visits to the artist's studio in the spring of 1934, he had watched the object undergo successive modifications, principally in its proportions, because the eyes (which are two wheels, one broken and the other intact), the position of the hands, and the relation of the legs to the inexplicable plane

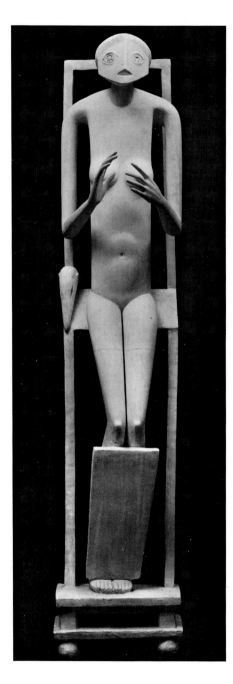

249. Alberto Giacometti: The Invisible Object, 1934. *New Haven, Conn., Yale University Art Gallery*

which compresses them within the frame remained constant. For Breton the artistic quality of the figure lay more in its expressive meaning than in its technique or in its oddly awkward and fetishistic stance. With poetic insight he told how he immediately understood the figure as 'the emanation of the desire to love and to be loved in search of its true human object and in its sorrowful ignorance'.[63] And he pointed to the truly Surrealist aspect of this melancholy figure, the 'existence' of the invisible object which the hands both grasp and seek, and which if present would add still another dimension to the mystery by concealing its breasts.

This was Giacometti's last piece of Surrealist sculpture; in the same year he parted company with the movement and turned to new pictorial and sculptural studies of the human figure which led him, after years of effort and disappointment, to the elongated and emaciated figures of 1947 and after. Although they were no longer narrowly Surrealist and spoke of wider human concerns, of man's enforced isolation from his fellows, their tenuous mystery was already implicit more than a decade earlier in *Hands holding the Void*.

THE SURREALIST MOVEMENT IN ENGLAND

Surrealism officially reached London, in full force, with the opening of the International Surrealist Exhibition at the New Burlington Galleries in June 1936. Breton, Eluard, and Dali sanctioned it by their presence. Artists and critics of such stature as Paul Nash, Henry Moore, Herbert Read, and Roland Penrose were members of the British organizing committee. In the exhibition itself – the first to be held on such a scale and to be equalled only by the exhibition of Fantastic Art, Dada, and

Surrealism at the Museum of Modern Art in New York the following December – the principal European Surrealists, especially de Chirico, Masson, Miró, Dali, Ernst, Magritte, and Tanguy, could be seen extensively and at their best. The British contributors could show no such coherence or consistent application of Surrealist principles over the past ten to fifteen years. Indeed, they may be said to have escaped the constraints of doctrinaire Surrealism through their refusal to push to their pictorial conclusions the implications of Freudian psychology. Even so Surrealist an object as Roland Penrose's *Captain Cook's Last Voyage* (a small plaster torso of a Praxitelean Aphrodite caged within a wire sphere) was more witty than wicked. Many of the most apparently Surrealist elements in English painting of this period actually have their sources farther in the English past. When Herbert Read in his introduction to the catalogue asserted that 'Superrealism [the term he then preferred] in general is the romantic principle of art' he was thinking, as he made clear in an extended discussion of the subject in his book *Surrealism* in 1937, of Surrealism as the specifically contemporary manifestation of a much older English preoccupation with the reality of values whose origin in the realms of imaginative and spiritual experience prevents their qualitative evaluation according to the principles of academically classic or idealistic art. For a people that could number among the masterpieces of its national artistic expression the pictorial and poetic visions of William Blake, the traumatic images of *Kubla Khan*, and the uncanny emotional suspense of such Pre-Raphaelite paintings as Millais's *Christ in the House of his Parents*, the fundamentally irrational and hence by definition 'romantic' aspects of Surrealism offered few novel challenges, once the intentionally odd and provocative effects of the contemporary Surrealist objects had worn off. For these reasons the imported Surrealist shockers were something of a nine-days' wonder, and whatever can be called properly 'superrealist' may be found to be more traditional than the attempts by certain artists to adapt the style and mannerisms of Dali or Miró to their own work.

In a note in *Unit One* (1934), Douglas Cooper had already described Paul Nash and Edward Burra (1905–76) as Surrealist artists, not because of any resemblance between their works and those being done in Paris, but because they too, in Hegel's terms, were 'concerned with the greater reality behind the reality'. This is now harder to see in Burra's paintings, where the heavily stylized figures, clumsy in the manner of caricature, are not so much irrational as socially critical, than in Paul Nash's landscapes and still lifes, where the scenes and objects seem to correspond to a state of inner tension experienced by the spectator. In the late 1920s and early 1930s Nash and Edward Wadsworth, who had abandoned the abstract geometry of Vorticism, constructed imaginary architectural and landscape perspectives which were slightly touched by de Chirico's ambiguous space. This is particularly notable in Nash's water-colour drawings for an edition of Sir Thomas Browne's *Urne Buriall* and *The Garden of Cyprus* (published 1932), where he adopted even the attributes – the bust, the broken column, and the deserted beach – of de Chirico's neo-classical designs. Soon after that a more powerfully suggestive architecture than the Italian's made its appearance in his work when he discovered the prehistoric monuments of Avebury and Stonehenge, as in his haunted *Landscape of the Megaliths*, a water-colour of 1937 (Buffalo). Simultaneously Nash was exploring, as the orthodox Surrealists had done, the visual evidence of unconscious experience, in his *Landscape from a Dream* (London), where a falcon contemplates its image in a mirror mysteriously stranded on a headland high above a bay. Nash's most

specifically Surrealist works were, however, not his paintings so much as his 'found objects', odds and ends of weather-worn sticks and stones which he presented, with or without additional manipulation, in the attitude of traditional sculpture. The first to make its appearance was the wooden *Found Object Interpreted* in the Surrealist Exhibition of 1936, where it held its own with other troubling structures only half divorced from nature. The visual discrimination which enabled him to see the expressive possibilities of such fragments led soon after to such paintings as *Monster Field* of 1939 [250], in which the stump and broken trunk of a recumbent tree in an apparently peaceful and empty field were interpreted with threatening implications. This power to intensify the inanimate led eventually to the most poignantly eerie of Nash's paintings of the Second World War, the *Totes Meer* of 1940-1 (London), where the waves of the 'dead sea' are actually the crumpled bodies of shattered German aircraft.

In 1938 the London Gallery in Cork Street became the more or less official centre for Surrealist activities under the direction of the Belgian artist and poet E. L. T. Mesens. In addition to arranging exhibitions by the foremost contemporary European and American Surrealists, Mesens edited, with the assistance of Humphrey Jennings and Roland Penrose, twenty issues of *The London Bulletin* (1938-40) which contain much useful literary and photographic documentation relating to the gallery's

250. Paul Nash: Monster Field, 1939.
Durban Art Gallery, South Africa

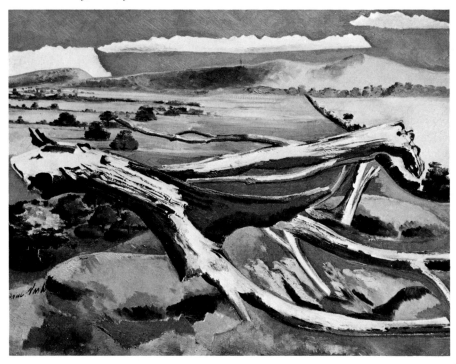

artists and exhibitions. In January 1939 he held an exhibition of Living Art in England by thirty-five men and women, including foreigners resident in Great Britain like Kokoschka and Mondrian who could be considered active in the modern movement. The work of those then described as Surrealist was, with the exception of Henry Moore's, largely derivative and undistinguished. But among the 'independent' artists were to be found Nash, Wadsworth, Ceri Richards (1903-71), and the sculptor F. E. McWilliam (b. 1909), whose work at the time had definite Surrealist overtones. The latter two, who kept up their reputation for imaginatively adapting the mannerisms of certain European artists, most often Picasso, to their own expressive purposes, were represented in the appropriate issue of the *Bulletin* (Nos 8-9) by characteristic and original work. Richards's *Two Females* of 1937-8 [251] clearly has points of reference to Max Ernst's Dada collages and to Breton's 'exquisite corpse' drawings, but the combination of wooden forms with a painted ground was as fresh in 1938 as his treatment of the human figure strikes us as witty still today. McWilliam's violently skeletonized heads and figures could not have been conceived without Picasso and Henry Moore, but he turned Picasso's sophisticated irony into a kind of savage ridicule which Moore never desired and which now seems entirely consistent as an expression of the increasing despair of the later 1930s. With the outbreak of war Surrealist activities became both impossible and inappropriate but the disturbing flavour of Surrealist agitation is still, as in the United States, a continuing element in the total artistic activity. Graham Sutherland (1903-80) in his landscapes and still lifes and Francis Bacon (1910-92) in his figure scenes have continued to investigate the irrational aspects of man's encounter with nature, although with more explicit concern for the monstrous and horrible experiences which lie in wait for him.

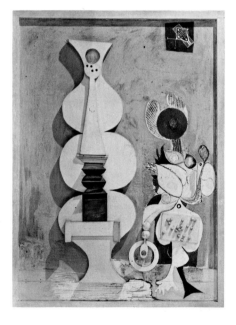

251. Ceri Richards: Two Females, 1937-8. *London, Tate Gallery*

THE SCHOOL OF PARIS: 1920–40

The first performance of Sergei Diaghilev's new ballet *Parade* on 18 May 1917 proved that even in the midst of a terrible war Paris had not lost the pre-eminence it had won during the past century as the world's capital of progressive art. But the event was also of interest because Diaghilev had enlisted the talents of avant-garde artists from more than one country. The libretto, to be sure, was by Jean Cocteau and the music by Erik Satie, but Picasso had designed the scenery and costumes, the choreography was by Massine, who, like Diaghilev himself, was Russian, and the conductor, Ernest Ansermet, was Swiss. This collaboration was symptomatic of the international character of the so-called School of Paris, for the term signifies not so much the continuation of French art as exemplified by the descendants of the Nabis and Fauves as it does the presence in Paris after 1900 of painters and sculptors from almost every civilized country of the globe. They had come because Paris offered the freest of conditions in which to live and work, as well as unparalleled opportunities for the discussion and exhibition of their work. In spite of the persistent conservatism of official French taste, the hard-won battles of the Impressionists and Symbolists for the right to have their art seen and seriously criticized had not been in vain.

The international members of the School of Paris are too numerous to name, but as an indication of the character and quality of those who settled in France before 1914 one may think of Picasso, Gris, and the sculptor Julio Gonzalez from Spain; Chagall, Soutine, Archipenko, Lipchitz, and Zadkine from Russia; Brancusi from Romania; and Modigliani from

Italy. Some came from even greater distances. The Japanese Foujita, whose delicately linear pictures of cats were once very popular, settled permanently in Paris in 1913. During several visits to France, in 1907 and during the decade 1911–21, the Mexican painter Diego Rivera became a creditable Cubist. To such as these we may add the artists from England and the United States whose experiences in Paris, whether their residence lasted a few months or several years, were important for the spread of the modern movement in their own countries. Twentieth-century English art would have been quite a different matter had not Duncan Grant, Wyndham Lewis, C. R. W. Nevinson, Ben Nicholson, William Roberts, and Matthew Smith seen Fauvism and Cubism at first hand before 1914. Similarly, the history of the modern movement in America is largely the record of the enthusiastic discovery of contemporary European art by Charles Demuth, Arthur G. Dove, William Glackens, Marsden Hartley, Edward Hopper, John Marin, Alfred Maurer, and Maurice Prendergast, who were in France after 1900. Two Americans, Stanton Macdonald-Wright and Morgan Russell (who stayed there forty years), contributed a minor diversion to the School of Paris; their Synchromism was based on theories of abstract colour closely related to Delaunay's Orphism.

Although most of the foreign artists had settled in Paris before 1914, there were new arrivals after the Armistice, displaced from Central and Eastern Europe by revolution and civil war, by economic inflation and political repression. The Russian Constructivists Pevsner and Gabo came in 1923 and 1932. Kandinsky arrived from the Bauhaus in 1933. The German

sculptor Otto Freundlich came to Paris in 1924; his compatriot the painter Hans Hartung (b. 1904) lived there from 1935. Among the Americans who worked in Paris after 1920 Stuart Davis (1894-1964) and Alexander Calder (1898-1976) incorporated Cubist and abstract elements into their indubitably American styles. Calder, in fact, with his sculptures in motion, the famous 'mobiles', exhibited for the first time in 1932 in Paris, was the first American of the twentieth century to win and hold a European reputation.

After the War the centre of Parisian activity passed from Montmartre, which was surrendered to the tourists, to Montparnasse on the Left Bank. Picasso had transferred his studio there in September 1912, and other artists soon followed. Along the Boulevards Montparnasse and Saint-Michel such cafés as the Flore, the Deux Magots, and the Dôme assumed the importance that the Café Guerbois, the Nouvelles-Athènes, and the Closerie des Lilas had had for the Impressionists and Symbolists. Before the beginning of the economic depression these were the rallying grounds for a brilliant, restless, international community of artists, critics, and writers. Much of the atmosphere of the times pervades the many memoirs of the period, so that we need not try to recapture it here, except to note that in the midst of much foolishness, much serious work was done.[1] In letters alone Paris numbered among its temporary citizens Ezra Pound and James Joyce, Ernest Hemingway and Gertrude Stein, Ilya Ehrenburg and Ford Madox Ford. The economic troubles of the 1930s drove most of the expatriates home, but the last decade before 1939 was little less brilliant than the first after 1918. The older masters of Fauvism and Cubism, Matisse, Rouault, Braque, and Léger, strengthened and refined their individual styles; Picasso continued his incessant formal metamorphoses,

which coincided with the promulgation and climax of surrealism; and Derain reached the height of his international reputation before losing himself in the revival of past styles.

There were also less protean artists who had attracted some attention before the First World War and who continued in more predictable directions. The contributions of Vlaminck, Dufy, Gromaire, and Marie Laurencin, among those who had been associated with the first Fauve and Cubist efforts, were always agreeable, well-made, and, considering the quantity of their work, almost standardized productions of the School of Paris. André Dunoyer de Segonzac (1884-1974), who never considered himself tied to any one group, produced many landscapes and nude studies, somewhat too much alike in the long run and rather too sober in colour, but notable for his serious, impeccable craftsmanship, an example of that famous *belle facture* which has been one of the constituent elements in French painting for centuries and which enables many minor artists to hold a worthy position beside the more imaginative masters.

From the names which have been cited it becomes apparent that the general tenor of the painting and sculpture of the School of Paris was figurative and representational. The leading French artists, with the exception of Léger, have been little interested in non-objective art, perhaps because it had been developed beyond the French frontiers and always seemed a bit harsh and alien in Paris. Picasso, also, was always a master of figurative painting and his example was inescapable. Thus the traditional types of post-Renaissance painting – figure composition and portraiture, landscape and still life – were the basic themes of the School of Paris. The fact that these themes were usually treated in various degrees of distortion or exaggeration reminiscent of earlier German and Central European Expressionism may be traced

in many instances to the national origins of the artists themselves.

When towards 1910 the visual excitements of Fauvism subsided, the pursuit of intensified personal expression was taken up by a group of artists, mostly non-French in origin, whose miserable lives earned them the title of *les peintres maudits*. Because three of them were Jews (Modigliani, Soutine, and Pascin) there have been attempts to explain the morbid and tragic aspects of their art as peculiarly Jewish contributions to modern painting; but such a racial interpretation ignores the disparities between the cool elegance of Modigliani, derived from the early Tuscan masters he had admired in his youth, and the chromatic violence of Soutine, who looked to Rembrandt and Van Gogh. Nor would it take account of the profound gaiety and humour of Chagall's art, the most specifically racial in his use of themes from Jewish life, which are conspicuously absent from the work of the others. One may rather think that their art was basically part of the European tradition as a whole and that it was created without regard for racial and religious origins which would have proved almost insuperable handicaps had they remained at home. Chagall, for instance, was jailed in St Petersburg, where Jews could not live without a permit, until he secured a licence as a sign painter. To such social disfranchisement there was added the Hebraic religious injunction against the making of images. For Chagall, as for Lipchitz and Soutine, the several freedoms, artistic, intellectual, and religious, tolerated by French law and custom, safeguarded their creative activity. These painters belong together less for any racial or spiritual traits they had in common than because they endured a similar pattern of misery induced by poverty, illness, and despair only temporarily relieved by over-indulgence in alcohol and drugs. Their often erratic and offensive behaviour,

the last genuine manifestations of Bohemianism associated with the artists' life in Montmartre and Montparnasse, increased their loneliness through social isolation.

AMEDEO MODIGLIANI (1884–1920)

Modigliani's brief life was so spectacular a story of the self-destruction of a talent that for many years it prevented a just evaluation of his work. Even now conscientious efforts to dispel the legend of the wild roisterer cannot strip the few incontrovertible facts of their pathos. Modigliani was born at Leghorn of an ancient Jewish family, traditionally intellectual and liberal, but then living in much reduced circumstances. He began painting at fourteen, but his studies were interrupted by an attack of tuberculosis from which he never entirely recovered. From his first teacher, a belated follower of the Macchiaioli, the nineteenth-century Italian *plein-air* painters, and from a few months at the academies of Florence and Venice, he retained little beyond a love for the great masters of the Italian past. His discovery of himself required the discovery of advanced contemporary art which began only when he arrived in Paris in 1906. The *fin-de-siècle* nostalgia reminiscent of Beardsley, Lautrec, and the Picasso of the Blue Period in his first Paris paintings seems more the result of psychological than of stylistic affinities. In the next few years he took from Cézanne, whose important retrospective was held in 1907, the broken planes and firm compositions of his first mature portraits and figure studies. From Cézanne, too, came the soft grey-blue of his backgrounds.

About this time, presumably in 1909, Modigliani, who had always thought of himself primarily as a sculptor, met Brancusi. In the absence of documentary evidence the relations between the two men must be read in their

works. Brancusi may have urged Modigliani to carve directly, although the latter used softer stones, often ordinary blocks begged or borrowed from a building site. The primitive look and pinched features of Brancusi's lost head of 1907 (see below, p. 465), with its long nose and small pursed mouth, led directly to the elongated heads, often extremely drawn-out, which Modigliani is believed to have carved between 1909 and 1914 [252]. Even Brancusi's unfinished eyeballs, left in the rough, foreshadow the hypnotic effect of the eyes, half closed or all pupil, in Modigliani's later portraits. Since the source for these stylistic exaggerations is obviously African, his interest in Negro sculpture may have preceded Brancusi's. He also shared Brancusi's taste for cylindrical and elliptical masses. The geometry of *Mlle Pogany* re-echoes through many drawings and crouching caryatids and reappears in portraits after 1912.

Without any secure dates the chronology of Modigliani's sculpture and the related drawings remains obscure. We know only that he abandoned sculpture for painting about 1915, probably discouraged by his failure to attract clients, and because the stone dust aggravated his illness. In the portraits he painted between 1909 and 1915 the rigid poses and angular contours prove that he was aware of Cubism, but after 1916 he interpreted his sitters in his own fashion, seeing the head as an oval delicately tilted on a slender neck set slightly askew on the sloping shoulders. The noses grew longer and sharper, often concave and splayed at the end like those in African masks. But if

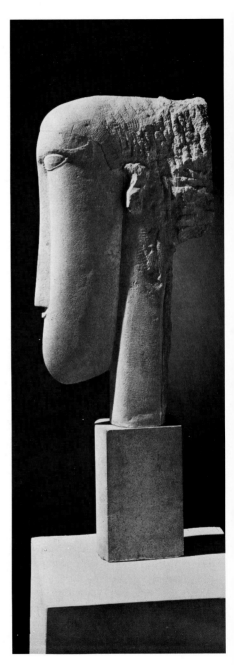

252. Amedeo Modigliani: Head, *c.* 1911–12. *London, Tate Gallery*

253 (*opposite*). Amedeo Modigliani: Jeanne Hébuterne, 1920. *Pasadena, Calif., Norton Simon Museum*

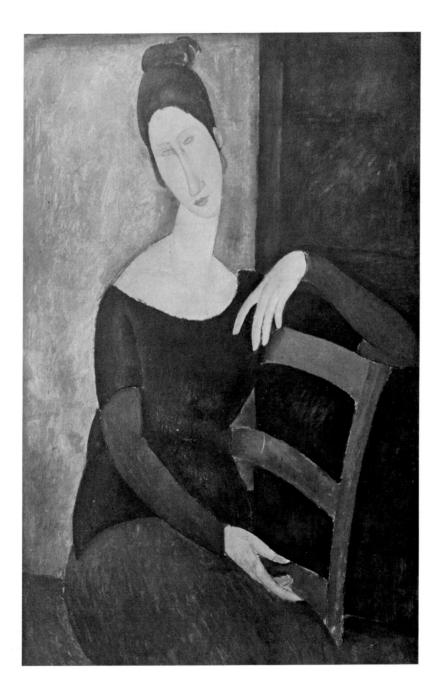

his manner became almost too personal a mannerism, he never totally sacrificed the individuality of his sitters. Even if the unfortunate Jeanne Hébuterne [253], his last mistress, who compounded their tragedy by killing herself the day after his death, looks less like her photographs than a typical 'Modigliani' (she was certainly not quite so slender), she will never be mistaken for others whose appearance and personality we know only because they sat for him, among them the South African poet Beatrice Hastings, Anna Zborowska, the wife of his devoted dealer, or the wistful Polish woman Lunia Czechowska. Among his portraits of contemporary artists and writers there are several whose places in the iconography of twentieth-century culture he made secure, among them Max Jacob, Jean Cocteau, and Jacques Lipchitz.

Gifted as he was as a sculptor and painter, Modigliani was pre-eminently a draughtsman, and the linear bent of his vision is apparent throughout all his work. In his late portraits, as in the Jeanne Hébuterne and in the large and sensuous nudes he painted in the last two years of his life, as if by celebrating such vitality he could cheat the death he knew was imminent, the pictorial structure consists of a few spaces, simply brushed with colour and divided by firm but delicate linear rhythms. Many critics have been reminded of Botticelli, but the conscious awkwardness within the grace is more modern and at the same time more traditional, suggesting rather the earlier Sienese masters of design.

CHAIM SOUTINE (1893-1943)

The discrepancy between the outer and inner events of an artist's life and the misunderstandings which arise when he is categorized as 'cursed' by circumstances beyond his control are illustrated by the career of Soutine. Ten years after he arrived in France in 1913 this son of a poor tailor from a village near Smolensk in Russian Lithuania suddenly became known to all Paris when the American collector Dr Albert C. Barnes of Merion acquired many of his works. Twelve years later his first major one-man exhibition was held at the Arts Club in Chicago. So enthusiastic were his first patrons and critics that he could have had whatever worldly success he wanted had he not distrusted his own talent. He seems to have been unusually beset by artistic doubt, perhaps the inescapable concomitant of a method which required him to put upon his canvas at one sitting the totality of the emotion which had seized him. So unpremeditated and unreflective a method prohibited second thoughts; an impulse cannot be corrected.

Neither at Vilna, where he studied briefly, nor in Cormon's studio in Paris could Soutine find what he needed. That waited for him in the Louvre, in the canvases of Tintoretto, El Greco, and Rembrandt, where he saw the power of colour, whether dark or light, and of pigment itself, to translate the artist's excitement through the direction of the brush. Nor was he indifferent to Cézanne and the masters of the French classic tradition; without their lessons in pictorial design his own impassioned surfaces could scarcely have held together. Of less interest were the masters' subjects. Soutine preferred the uncommitted themes of modern art - landscape, still life, figure, and portrait. These were Van Gogh's, whose art Soutine's so often resembles, despite his professed dislike of the Dutchman's painting. In this instance similarity may have bred contempt, for there can be little doubt that Van Gogh, far more than the Fauves or the German Expressionists, was an early and for a time a dominant influence. The resemblance between the two painters is most marked in the landscapes Soutine painted during his three years' residence at Céret in Provence (1919-22). He even exaggerated the turbulence of Van Gogh's last works at Auvers

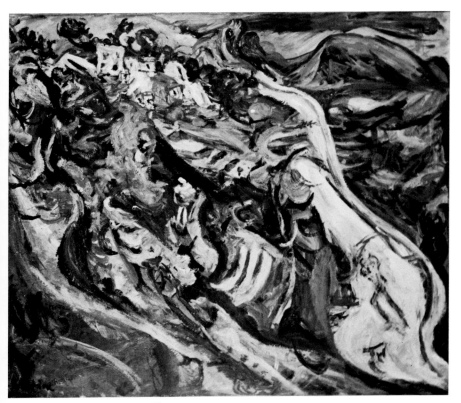

254. Chaim Soutine: Landscape at Céret, *c.* 1920-1.
Private Collection

by a diagonal impulse which rises from right to left, dragging everything with it, trees, houses, earth, and sky [254].

The earlier Céret landscapes are among the most distorted, and in their effect on the spectator the most distraught, of Soutine's work. After his return to Paris, and with his growing reputation, he found a different discipline in Rembrandt. Four times he visited Holland, once, it is said, only to sit for hours before the *Jewish Bride* in Amsterdam. The subdued yet smouldering brilliance of Rembrandt's pigment inspired him to create his own incandescent palette, with as many as forty hues and as many different brushes for a given painting. In his four versions of the *Carcass of an Ox* and his several paintings of hung poultry, painted under nauseating conditions as the subjects putrefied in the studio, he transcribed the luminosity of putrescence with dazzling visual truth.

Although composed of the most various tints, his palette was usually constructed around a dominant colour, yellow and green for landscapes, red or a livid blue and yellow for dead animals and poultry, white, black, or scarlet for pastrycooks, page boys, valets-de-chambre, and acolytes. By distorting their features, by exaggerating the shape and size of an eye or ear,

255. Chaim Soutine: The Old Actress, 1924.
Present location unknown

Matisse. Soutine's present reputation rests as much on the form as on the feeling in his work. Whenever the subject can be subtracted from his canvas, as when a detail is isolated from the whole, one can see how he contributed to the independence of the pictorial elements in much modern painting, especially in Abstract Expressionism. Soutine, however, was more traditional. He never painted except in the presence of his motif, and he despaired whenever he and his subject were out of tune with one another.

Although he was urged to go to the United States after the outbreak of war in 1939, he remained in France, where, despite his race and nationality, he was not molested. He died suddenly in the summer of 1943 after an operation for ulcers, a malady which had tormented him for many years.

JULES PASCIN (1885-1930)

The career of the Bulgarian painter Jules Pascin (born Julius Pincas) has sometimes been considered symbolic of the alienated and homeless outcast whose art was the only focus in a life of endless and aimless wandering. He had been born of Italo-Serbian and Spanish-Jewish parents in the Danubian town of Viddin, where at an early age he was initiated into the world of vice and women from which he drew the subjects for his lifelong preoccupation with the female nude. He was a precocious draughtsman and his early drawings, published in the Munich journal *Simplicissimus*, were later admired by George Grosz. Pascin worked for brief periods in Berlin, Vienna, and Prague before he reached Paris in 1903. By 1913 he was so well known that a dozen of his water-colours, drawings, and prints were seen at the Armory Show in New York, where six were acquired by John Quinn, one of the first and most discriminating American collectors of modern art. In 1914 Pascin himself came to the United States, where he acquired American citizenship and for a few

Soutine communicated an unexpected tenderness for the young who must stand and serve. In his portraits, especially those of women, he went farther. The distortions seem induced less by the painter's response to his subject than by the sitters' psychological fate. Extreme as they may become, at their best they are pictorially flawless, formally persuasive presentations of complex and even irrational personalities [255].

An art so personal, so sensitive, and so dependent upon spontaneous decision admits of little development. There are few 'periods' in Soutine's art. Even in the early 1930s, when he reworked certain themes of Courbet's – a fish, a calf, or the reclining woman in the *Demoiselles aux bords de la Seine* – the results were unmistakably his own, belonging to the Central European Expressionist tradition, closer to Nolde and Kokoschka than to Rouault or

years enjoyed considerable success and influence, but by 1928 he was back in Paris. Two years later he committed suicide the day his exhibition was to open at the Petit Gallery.

Pascin's early work reveals his awareness of Fauve distortion and Cubist planes, but his more lasting concern was with Lautrec's and Degas's treatment of the nude. His women are less cruelly characterized than theirs, and for that reason are perhaps less interesting. There is an unavoidable sameness in his repetition of the seated or reclining female model, nude or half clad: she is so obviously posing for the painter rather than secretly surprised while about her own occupations, as in the work of Degas and Lautrec. But Pascin projected the model's ennui, her mindless somnolence, and the pathos of her soiled youth with an exquisitely tentative line and washes of sensitively iridescent colour [256]. Indeed, through the

256. Jules Pascin: Young Girl Seated, c. 1929.
Paris, Musée d'Art Moderne de la Ville de Paris

delicacy of his workmanship, in such astonishing contrast to the squalid disorder of his life, he redeemed by his artistic integrity what might otherwise have been only monotonously erotic.

MAURICE UTRILLO (1883–1955)

The lamentable chronicles of the *peintres maudits* came to an end in 1955 with the death of Maurice Utrillo, whose miserable life might be considered retribution exacted for the heedless pleasures enjoyed by the inhabitants of Montmartre when it was the capital of artistic Bohemia. His mother, Suzanne Valadon (1867–1938), had been a model for Puvis de Chavannes, Renoir, and Lautrec, and was herself a respectable draughtsman if an indifferent painter; his father's name is unknown.[2] Whether or not Utrillo became an alcoholic while in his teens and was encouraged to take up painting as a therapeutic measure matters less than that his indubitable talent was not destroyed by his addiction. His earliest landscapes, from about 1904, exhibit the virtues as well as the faults of the untrained artist who began painting before Cézanne's work became well known. There are reminiscences of Impressionist design in the carefully casual placing of a house and wall behind a tree, and occasional attempts to create atmospheric effects, but the drawing has the uncertain hesitations of the typically naïve or primitive painter. Soon, however, the composition became simpler, the handling more solid, even lumpy, in a manner suggesting that the early Cézanne of the *House of the Hanged Man* (Paris) may have interested Utrillo more than the complex chromaticism of the late landscapes from Aix. The motif of a house and village street was perhaps also pertinent, for Utrillo all his life remained the painter of houses and street scenes, whether of Montmartre, itself then a village on top of Paris, or of the characteristically characterless suburbs of the city. Some time between 1910 and 1916 (precise dates are dif-

257. Maurice Utrillo:
La Petite Communiante (Church at Deuil), *c.* 1912.
Private Collection

ficult to determine because he rarely dated his canvases), his composition became extremely simple. In this 'White Period' a few buildings are seen in sharp perspective, their greyish-white walls enlivened only by the green shutters and reddish-brown signs of the archetypal village street. After 1920 Utrillo's palette grew brighter and his empty squares were often enlivened by minuscule figures.

The disparity between the number of Utrillo's works – for he had nothing else to do but drink – and the size of his contribution to modern art, which is certainly slight, should not obscure his talent. As a topographical painter he captured, as none of his imitators have, the suffocating loneliness and emotional poverty of urban and rural backwaters, and he presented this expressive content with a technical subtlety, restricted and linear though it may be, which can still be appreciated within the context of Later Impressionism. His most firm and massive compositions are the cathedrals and parish churches seen in isolation from other buildings, remote and alone in the clarity of their architectural structure [257]. Because the perspectives of these views are more conventional than those in his street scenes, one may assume that he worked from postcards.[3] It is a measure of Utrillo's ability that he could give such insignificant sources such pictorial solemnity.

MARC CHAGALL

Chagall (1887–1985) was born in the provincial capital of Vitebsk in Western Russia near the Polish frontier. From memories of his childhood in a large and deeply religious family which followed the Chassidic doctrine he drew many images for his early work: the rabbis and wandering pedlars, village musicians, peasants and their animal familiars, the River Dvina and the buildings of Vitebsk lining its banks. Often he presented these in combinations recalling the folk and religious festivals which were the only social diversions in this remote community. It is easy to believe that Chagall's particularly intense and affectionate interpretation of people, animals, and objects was related to his Chassidic heritage, to the belief that God is present in every manifestation of life on earth, just as his awareness of the distinctive shape and character of each object may have been heightened by his having been briefly a sign painter in his youth.[4]

Chagall, from the first too impatient to submit for long to academic training, was a 'primitive' rather than a 'naïve' painter. In his earliest extant works a self-consciously clumsy and literal mode of representation, related to folk painting and not unlike Larionov's contemporary 'soldier' series of 1908–9, alternated with a more sophisticated primitivism based on Gauguin and the Fauves, whose works he saw in exhibitions in St Petersburg. He had been admitted only to an inferior art school, but in 1909 he studied briefly with Léon Bakst, through whom he came to know the Mir Iskusstva taste for late European Symbolist art. In 1910 the generosity of a Russian patron enabled him to go to Paris, where he remained for four years.

His encounter with the most advanced developments in contemporary art was immediate and decisive. Years afterwards he remembered that he had gone at once 'to the heart of French painting', to the Salon des Indépendants and other exhibitions, where 'everything showed a definite feeling for order, clarity, an accurate sense of form', which gave him a 'clear idea ... of the almost insurmountable difference which, up to 1914, separated French painting from the painting of other lands'. Nor did he neglect tradition. He wrote later that in the Louvre, 'before the canvases of Manet, Millet, and others, I understood why I could not ally myself with Russia and Russian art'.[5]

He took lodgings in La Ruche (The Beehive), a ramshackle counterpart of the Bateau-Lavoir near the Vaugirard slaughterhouses, where his studio was beside Modigliani's and near those of Léger, Archipenko, and Soutine. Quite as important for his development, however, were his friendships with poets, with Blaise Cendrars, his first enthusiastic supporter, with Ricciotto Canudo, and with Guillaume Apollinaire, who declared that his work was *sur-naturel*, a step towards the *sur-réalisme* which for Apollinaire was the highest poetic value. By 1913 Chagall was combining figures and objects, sometimes surprisingly different in size and scale, at peculiar angles to each other, even upsidedown, and held together more by the intangible unity of the pictorial process than by any coherent perspective in a space more instinctual than rational. His poet friends saw his paintings as visual metaphors comparable to their verbal inventions, to be explained neither by pictorial nor grammatical logic. Chagall was never an orthodox Surrealist, but thirty years later André Breton wrote that with him alone 'the metaphor made its triumphant entry into modern painting'.[6]

Chagall always rejected literary interpretations of his work. As late as 1946 he said of his paintings: 'I don't understand them at all. They are not literature. They are only pictorial arrangements of images that obsess me ... The theories which I would make up to explain

myself and those which others elaborate in connection with my work are nonsense . . . My paintings are my reason for existence, my life, and that's all.'[7]

Chagall's protest, however, cannot prevent us from reading his work as a celebration of his love of the world, his joy in human beings, and his sorrow when love is withdrawn, nor from seeing how much his truly personal vision owes to the discipline of Cubism, especially in its Orphic phase. From Delaunay he learned that colours, like planes, can be transparent, and the Orphic equation that colour equals light and creates space. Gradually he subdued the strong contrasts of his folk palette, that green, blue, violet, yellow, and red which another painter,

Vasily Kandinsky, had brought from Russia to Germany a few years before. In Delaunay's concept of *simultanéité* Chagall found confirmation for his own synoptic presentation of time through the juxtaposition in a single image of temporally different events. In the *Double Portrait with Wineglass* [258], painted in 1917 after his return to Russia, the sharply defined planes of the figures and the superimposed circles around the head of the descending angel were derived from Delaunay, even as the vertical format of the picture with the teetering figures recalls Delaunay's paintings of the Eiffel Tower [154]. Perhaps there is also a hint of the Douanier Rousseau, whose work Chagall would have heard of from Léger. One is reminded of

258. Marc Chagall:
Double Portrait with Wineglass, 1917.
Paris, Musée National d'Art Moderne

Rousseau's *Self Portrait* (Prague), where the standing figure similarly towers over the river, a bridge, and the buildings on both banks.

Through Apollinaire, Chagall met Herwarth Walden, who accepted three paintings for his First German Salon d'Automne in 1913 and arranged a first one-man exhibition at the Sturm Gallery for the early summer of 1914. For the occasion Apollinaire composed his poem *Rotsoge*, in which his verbal images are as beguilingly illogical as Chagall's visual ones: 'The chimney smokes far away from me Russian cigarettes.' Chagall went to Berlin for the opening and then to Vitebsk, where he was caught by the outbreak of the War. There, in 1915, he married his beloved Bella, upon whose shoulders he rides in the *Double Portrait*. After the October Revolution he became Commissar for Fine Arts at Vitebsk, where he reorganized the art school. He related how he commissioned all the house painters in town to execute banners for a revolutionary festival after his designs, but that the upside-down green cows and horses dismayed the members of the local political committee. In the end his untraditional methods were so unrevolutionary that during one of his absences in Petrograd, the faculty, led by Malevich, voted to oust him. He then went to Moscow, where he created important murals and stage designs for the State Jewish Theatre, in some of which he managed a sprightly compromise between his own folk fantasies and the geometry of the Constructivists. When, in 1922, it became clear that his personal blend of fantasy and folklore was acceptable neither to the conservative right nor to the Constructivist left, he emigrated.

He went first to Berlin, where Paul Cassirer commissioned illustrations for a German edition of his autobiography. Because of difficulties with the translation the text was not published then, but the prints were issued in a portfolio under the title *Mein Leben* (*My Life*). In these, the first of a long series of graphic works, he retold in delicate etched lines, with humour and sympathy, some of the episodes which had already been seen in his paintings of Vitebsk. In 1923 he returned to Paris, after Ambroise Vollard had invited him to illustrate Gogol's *Dead Souls* (*Chichikov's Journeys*). For the next fifteen years he worked to appease Vollard's appetite for illustrated books, following the 118 Gogol etchings with 100 prints, originally planned as coloured etchings in the manner of the eighteenth century, for La Fontaine's *Fables* (1927–31), and 105 illustrations for the Old Testament (1929–39). Vollard died before the books could be published; they appeared only in 1948, 1952, and 1957. As Chagall mastered the techniques of etching, drypoint, aquatint, and lithography, his prints became visually and texturally denser – complex black-and-white counterparts of his paintings, which were more subtly colouristic after his travels to Holland in 1932 and to Spain in 1934 to see Rembrandt and El Greco. To the Russian and peasant themes in his iconography, he added circus scenes and subjects inspired by his marital happiness, notably the pairs of lovers floating through the sky or blossoming within immense bouquets of flowers.

In the later 1930s the troubles of humanity clouded Chagall's concept of art as an expression of his pervasive joy in life. In 1938 the plight of the German Jews inspired his *White Crucifixion* [259], in which his favourite method of dispersing his figures underlines the tragic theme of terror and flight. In the centre a pallid Christ, his loins wrapped in a prayer cloth, hangs upon the Cross, while from the heavens one broad ray of light leads the eye to the lighted candlestick at its foot. In this twilit, snowbound landscape it is uncertain whether the Old Law really will be fulfilled by the New. Chagall never accepted the claims of formal religion for himself, but he never rejected the interpretation of life as a religious experience. Although theologically unorthodox, his imaginative con-

frontations of Hebrew and Christian symbols in the *White Crucifixion* and in the paintings which followed, the *Yellow Crucifixion* of 1943, and the *Martyr* of 1940 (both owned by the artist), in which the figure tied to the stake is not Christ but a Jew in a Russian peasant's cap, are among the few modern paintings truly religious in content as well as in form.

In 1941 Chagall left France for New York, where Bella died in 1944. These were bitter years, and the darker colours and more turbulent technique of his work reflected his isolation and

259. Marc Chagall: White Crucifixion, 1938.
Art Institute of Chicago

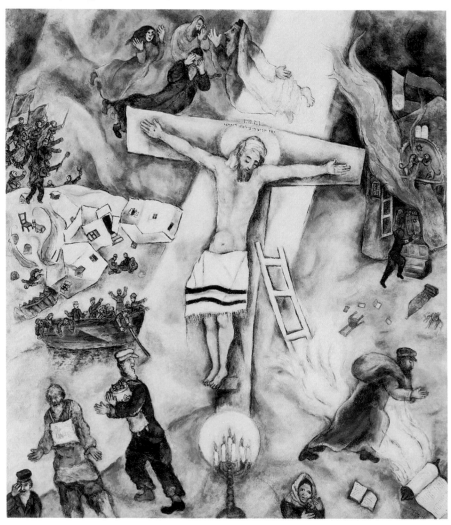

distress. But there were brighter occasions, too; among them his designs for Ballet Theatre's *Aleko* (1942) and *Firebird* (1945), with drop curtains like colossal enlargements of his water-colours. After his return to France in 1948 the thirteen coloured lithographs for the *Arabian Nights* and the series of paintings *Hommage à Paris* proved that he had recovered his own colour and fantasy. After settling in Vence in 1950 he worked unremittingly, with the prodigality sometimes granted artists in their later years. To his paintings and prints he added ceramics, a few pieces of sculpture, and large stained-glass windows for the cathedral of Metz and for the Hadassah-Hebrew University Medical Centre near Jerusalem. For these he mastered a new and difficult technique, working closely with the manufacturers and craftsmen who produced and cut the glass to his designs. Although religious law prevented the use of human figures in the Jerusalem windows, his animals, flowers, and signs which stand for the Twelve Tribes unfold their symbolic message in his inimitable blues, greens, yellows, and reds.[8] In 1964 he created a new ceiling for the Opéra in Paris, a task which required him once again to solve a new problem.

NEO-ROMANTICISM:
BERMAN, TCHELITCHEW, AND BALTHUS

In the early 1920s several young painters, of whom three had recently reached Paris from Russia, turned to figural painting of an unusually introspective character, as if in opposition to what they conceived to be the increasingly dogmatic tendency of abstract art to eliminate all traces of individual experience. They were soon described as Neo-Romantics, because in so many of their works the human situation was revealed in terms of nostalgia for the past, estrangement, or loss.[9] In ruined landscapes and deserted city squares the melancholy figures of Eugène Berman (1899–1972), who

was born in Russia, seemed immobilized by the frustrations of exile, strangers wandering through architectural space less menacing but no less inscrutable than de Chirico's. Berman's ambiguous perspectives were in the best sense theatrical, and it is upon his success as a designer for ballet and opera that his reputation rests. His opulent sets for the productions of *Rigoletto* (1951), *Don Giovanni* (1957), and *Otello* (1963) at the Metropolitan Opera House in New York are the most authentic survival of the dRomanticism of the 1920s. His brother Leonid (1896–1976) was primarily a landscape-painter of salt marshes populated by solitary fisherfolk dwarfed by the immensity of sea and sky.

The third of these painters, Pavel Tchelitchew (1898–1955), was the most intellectual, the most inquisitive, and the least easily satisfied by any one mode of pictorial expression. He had learned of the modern movement while still a student at Kiev (1918–20), where he worked with the Constructivist artist Alexandra Exter. Soon after he reached Berlin in 1921 he was noticed for his theatrical sets and costumes. In the paintings executed after he settled in Paris in 1923 he skilfully investigated Cubist and abstract devices, among them the double image, multiple perspectives, and the mixture of foreign substances such as sand and coffee grounds with his pigments. By 1930 he had found his characteristic iconography of circus figures, among them his 'metamorphic' clowns whose bodies are composed of assorted objects – plaster hands and feet, dish towels, and shopping bags. The sensitive mood of these figures appears in his large gouache, *The Sleeping Zouave*, of 1931 [260]. The subject and the dark tonality were derived from Picasso's Blue and Circus Period paintings, but the disposition of the figure's uniform and cloak, resembling the arrangements of tablecloths in Cézanne's late still lifes, hints at the monumental power that Tchelitchew might have commanded had it not been dissipated by his

relentless pursuit of extra-pictorial meanings. Of his two large symbolic canvases, *Phenomena* of 1936-8 (Moscow, Tretyakov Gallery), a collection of hideously deformed figures, is a gruesome indictment of contemporary social corruption; *Hide-and-Seek* of 1941 (New York) is an elaborate allegory of the relation of human life to nature through the metamorphosis of children into a gnarled tree. They seem to have been intended as metaphysical accounts of human Hell and Purgatory.

In the 1940s Tchelitchew made many 'X-ray' studies of the body, in dazzlingly iridescent gouache and pastel, as if searching for the ultimate source of mind and emotion deep within man's physical being. Among his last works were other drawings in which abstract, almost Constructivist geometries might be taken as intellectual counterparts of his investigations of our blood vessels and our nerves.

After 1936 and until 1950 Tchelitchew lived principally in or near New York, so that he has often been considered an American painter, but it is more appropriate to think of him as a member of the international School of Paris. His European reputation was in large part the result of the enthusiasm of certain English collectors, among them Dame Edith and Sir Osbert Sitwell and Mr Edward James.

Although the artistic integrity of Berman's and Tchelitchew's work is not in doubt, the significance of Neo-Romantic painting now

260. Pavel Tchelitchew: The Sleeping Zouave, 1931. *New Haven, Conn., Yale University Art Gallery*

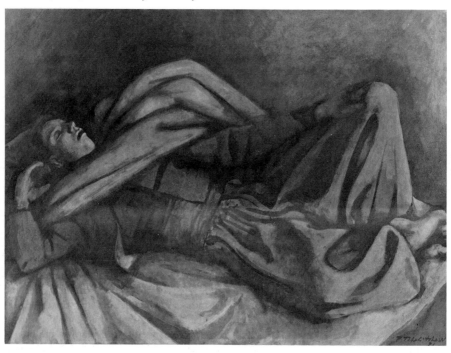

seems to lie more in its implications than in its achievements. Surrealism provided more subtle means for analysing the psychic maladies of modern times; the various developments of Cubism and abstract art suggested plastic solutions of much greater force and inventiveness. But Neo-Romanticism did serve to remind us that man and the environments he creates are not negligible for his understanding of himself.

From time to time an artist appears for whom such concerns are central to his artistic purpose. The painter Balthus (Balthasar Klossowski de Rola, b. 1910) is a French citizen of Polish descent. He lives in France but was brought up in Switzerland, where as a boy he knew Rilke,

and he has spent long holidays in England. At his first one-man exhibition in Paris in 1934 his large painting *The Street* (New York) announced his decision, like Seurat's, to present the ordinary banalities of contemporary urban life with the monumental dignity of a Piero della Francesca. But where Seurat was overwhelmingly imperturbable, Balthus, remembering also the unconscious awkwardnesses of other Quattrocento painters – Uccello and Carpaccio, for example – uses such departures from conventional grace to emphasize the disconcerting irrationality of human behaviour. He is at his best with adolescents whose clumsiness physically inhibits the communication of their emotions.[10] In *The Living Room* [261], painted

261. Balthus: The Living Room, 1941-3.
Minneapolis Institute of Arts

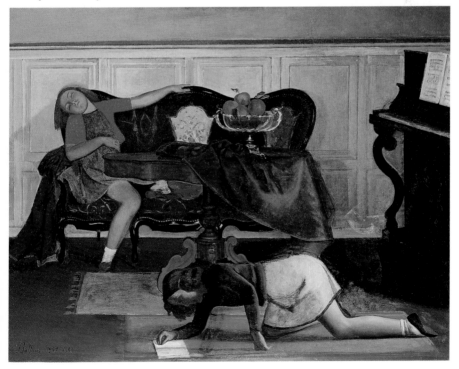

in Switzerland in 1941-3 after he had been discharged from the French army, there are unresolved visual and psychological tensions between the bourgeois interior with its old-fashioned furniture, serenely illuminated by the afternoon sun, and the ferocious absorption of the girls in their books and dreams. No other painter has so shockingly depicted the stresses of adolescence, just as few others have had the courage to adapt traditional realism to contemporary purposes on such a monumental scale.

THE LATER WORK OF MATISSE

In 1917 Matisse, who was then forty-eight years of age and had been declared unfit for military service, left Paris for the south of France in search of a warmer climate and a less distracting atmosphere in which to work. Thereafter he lived for the greater part of each year at Nice or near by, and the principal stylistic developments in his later work were usually to some degree related to his pleasurable surroundings. The change in his painting from his austere and sometimes dryly coloured 'Cubist' manner of between 1913 and 1917, a Cubism more schematic than analytical which had led to such triumphs as the Bathers by a River [90] and the second and third versions of the Back, appeared as early as 1919 in the White Plumes [262]. This was long considered one of his greatest accomplishments, and it signally contributed to his growing reputation in the later 1920s. The first impression of totally unselfconscious spontaneity, of the complete obedience of the hand to the eye's response to form and colour, is misleading. Although his works had not yet been photographed in successive stages, the existence of several preliminary drawings, varying in their degree of finish and interpretation of the model's personality, proves that this final version is the result of a series of progressive simplifications of form, colour, and line.[11] Even in black-and-white photographs a comparison of this painting with the Woman with the Hat of 1905 [81] shows that his earlier intuitive response to many colours simultaneously, each of the highest intensity, was now so controlled that the reduction of his palette to yellow, brown, red-brown, black, and white meant no loss of weight or depth. Line, which had been almost entirely absent in the earlier portrait, is now the binding agent, whether it is seen as such in the looped black ribbons beneath the brim of the hat and the slight accentuation of the neckline of the dress, or by implication as the boundary between coloured areas. The linear structure is so certain that the painter can almost dispense with modelling; only in parts of the dress, in the plumes, and in the face are the flat colour patterns even slightly shaded to suggest three-dimensional form. Yet Matisse made no concessions to naturalism or illusionism. The picture is strong because the pattern is so flat, and it is bold because red-brown and yellow are sufficient foils for the emphatic black ribbons and white plumes. In 1908 Matisse had written that he 'wanted to reach that state of condensation of sensations which constitutes a picture'.[12] Henceforth until his death forty-six years later, each of the works which we now recognize as his masterpieces would be, like this picture, a 'condensation of sensations'. But they never quite became mere decorative abstractions. Their grace and charm, qualities with which Matisse could always endow his images when he wished, were 'enriched by a wider meaning, a more comprehensively human one', through the artistic insight of a man to whom human beings were the supreme source of those sensations we describe as beautiful.

For a time, however, the superficial and more easily comprehensible aspects of line and colour threatened to extinguish the 'ugliness' that had been a source of strength in much of his earlier work. The many Riviera landscapes, interiors, and odalisques of the early 1920s were saturated with the sensual colours of the Mediterranean

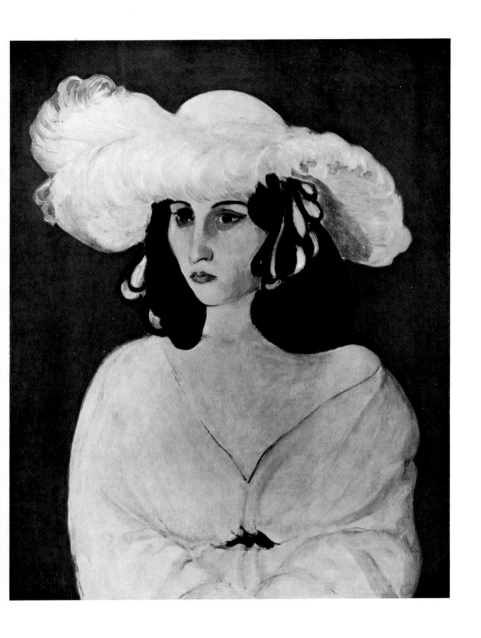

262. Henri Matisse: White Plumes, 1919. *Minneapolis Institute of Arts*

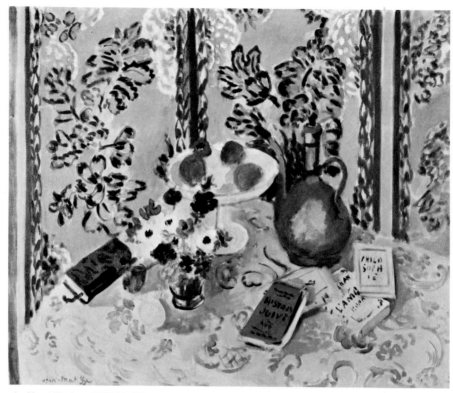

263. Henri Matisse: Still Life, 'Histoires Juives', 1924. *Philadelphia Museum of Art*

world, with the intricate and multiple patterns of southern flowers and textiles, and the seductive charms of the model languorously posing in the warm reflections of southern light. But for some observers the still lifes of anemones against floral wallpapers and the scantily clad odalisques have seemed little more than up-to-date versions of a Romantic orientalism that had died with Delacroix, and could better be left to specialists of a lesser order, to a Dufy, whose reclining nudes were even more ingratiating and made no serious claims upon aesthetics. The world has had little use for an art so 'devoid of troubling or depressing subject matter', for an art, in

Matisse's own words, as soothing as the up-holstered chairs on which his ladies often sat.

Such criticism can be countered only with a masterpiece, like the *Still Life* of 1924 [263], where the sumptuous yet delicate colour and the supreme ease of line and shape create an atmosphere in which everything has human meaning. Such a painting was also Matisse's tribute to Cézanne, whose small *Bathers* he had owned since 1896 and in which he never ceased to see new pictorial meanings. This *Still Life* is proof that the meanings Matisse found in Cézanne were decorative rather than structural, and that, far from resisting the seductions of

Cézanne's colour, as the Cubists had done in their pursuit of the secrets of design, Matisse could create the most intense visual delights without loss of structure, indeed with the structure of colour itself.

Just then the artist himself seems to have begun to distrust such felicities, and in 1926 he strengthened his drawing and restricted his palette. The first hint of this new tendency occurred in the *Nude against a Decorative Background* (Paris) in which the familiar arabesques in the wallpaper, rugs, and mirror frame are interrupted by the abrupt vertical of the model's back. A similar difference appears in the flattened planes of the bronze *Seated Nude* of 1922–5 [264], its pose as languid as the odalisques', but held in precarious tension (a human being in such a position would topple over). Thereafter his work became increasingly bold in scale and spacious in design, very often to the exclusion of the grace that had brought him perilously close to the merely pretty.

264. Henri Matisse: Seated Nude, 1922–5.
Baltimore Museum of Art

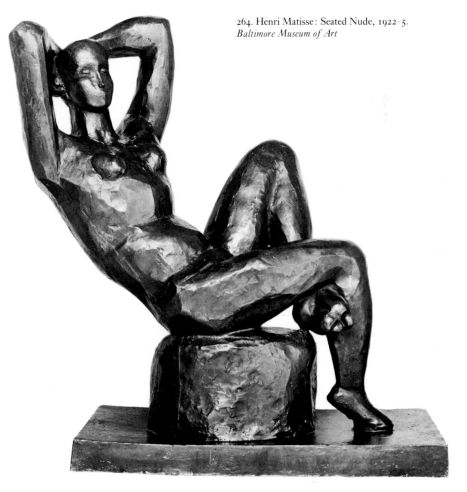

Yet on occasion his success was not unqualified, as in the murals of 1931–3 for the Barnes Foundation at Merion, Pennsylvania. For these three large lunettes, awkwardly placed above the windows of the main hall, Matisse remembered the swinging figures of the *Dance* of 1910 (Moscow). Three pairs of dancers, alternating with seated figures partially obscured by the springing of the vaults, are joined in rhythms which are continuous across the entire space and even seem, through the apparent projection of their bodies beyond the semicircular areas, to overflow into the surrounding space. At the same time they are bound to the wall by a shifting pattern of wide pink-and-black bands behind them. Although the Dionysiac energies are controlled by a supreme care for the relation of figure to ground and of both to the space they must fill, the whole sequence is a bit brittle and flat.[13]

Work on such a scale led Matisse to ever more simplified and schematic drawing, as we can see in a photograph of the artist working on the full-size first version of the Barnes murals with a piece of charcoal secured to the end of a bamboo pole. The difficulty of controlling the direction of such an instrument, added to the psychological as well as physical distance between the hand and the charcoal, forced him to set down only the most generalized contours and foreshadowed the bolder synthesis of his last years, when he was bedridden and had to invent new means of projecting his ideas. In a much smaller format the etchings of 1930–2 for Albert Skira's edition of Mallarmé's poems were the results of a similar rejection of everything unessential, from the first drawings of actual swans in the Bois de Boulogne for the etching of *Le Cygne* to the final plates, in which each line and curve summarized the multiplicity of nature without any loss of vitality. In the last state of the etching ten casually hooked lines stand for the fifty or so secondary feathers on the bird's wing in an earlier study.

To say that Matisse in these works of the 1930s, when he was over sixty, dared all is not to say that he took risks. His boldest simplification, his most startling distortion, was the end, not the beginning of a rigorously logical pictorial process. The history of the *Pink Nude* of 1935 [265] can be traced in preliminary drawings and in twenty-two photographs taken while the artist was working on it. The extravagant disproportions were not spontaneous but the result of calculated pictorial decisions which transformed an unexceptional charcoal drawing of a nude model sprawling on a bed into this heroically scaled picture (it is actually quite small, measuring only 26 by 36 inches). The most crucial decision occurred when the model's left leg, which in the original pose and earlier versions had been thrust over the right leg back into the picture space, was brought forward and parallel to the picture plane. Matisse then was free to construct the figural architecture which in the final version is so overwhelmingly positive and right for its purpose. Similarly, the picture space, which originally included a corner of the room and the mattress seen in perspective, was flattened as a support for the figure, and the colours, judging from the scale of values preserved in the photographs, were reduced to their present limited range of pink, black, white, and blue.

The flowing contours and few colours of the *Pink Nude* were the principal components of Matisse's painting for the remainder of his life. During the Second World War he lived in Nice, and from 1943 to 1949 in the hill town of Vence, where, despite the inevitable anxieties and deprivations, he produced fresh variations on his favourite themes of the still life and the model in an interior. When confined to bed he discovered new excitements in cutting and pinning large sheets of paper which he had had painted with his inimitable colours. Scissors became an instrument with which he could both draw and carve: 'To cut right into colour makes me think

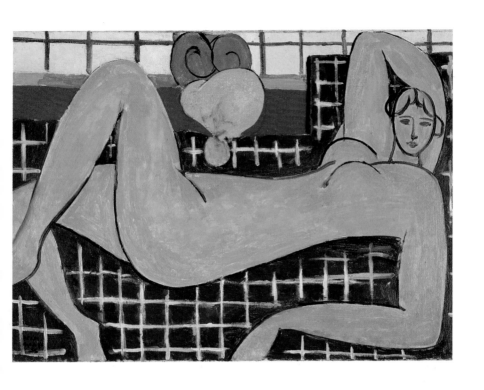

265. Henri Matisse: Pink Nude, 1935. *Baltimore Museum of Art*

of a sculptor's carving into stone,' he wrote in 1947.[14]

From 1947 to 1951 he planned the construction and decoration of the Chapel of the Rosary at Vence as a token of friendship for the nuns of a small convent across the road from his villa.[15] In design and structure the building is extraordinary only for its decoration. The interior is entirely white, the only source of colour being the windows with their floral patterns in blue, yellow, and green resembling the simple shapes of his cut papers. For the ceramic murals of the Virgin and Child and of St Dominic, he made preliminary drawings on large sheets of paper with a brush at the end of a stick, and then redrew them in thick black lines on the tiles before they were glazed. In contrast to their sparse grandeur (the faces have no features, and none are needed), the Stations of the Cross were sketched in a crowded sequence on a single wall. The fourteen episodes, like popular graffiti, are astonishingly succinct. The Christ exhorting the women of Jerusalem is little more than two parallel lines. And all the lines are broken and unexpectedly harsh for Matisse. They can be read as a tribute from an unbelieving artist to those whose faith he respected but could not share. The furnishings of the chapel were completed with a slender Crucifix for the altar, one of Matisse's last works of sculpture and the first since 1932, and designs for vestments, in which he found new simplifications for the traditional Christian symbols.

Although aged and ill, Matisse worked until the very end of his life. Such dedication, which enabled him to surmount grievous physical handicaps, indicates the supreme value he placed upon art as an attribute of life and suggests that the proper criticism of his work should stress the function of each object as an enhancement of human experience, for the spectator as well as for the artist. The content of his work is not to be judged in terms of the slight and repetitious themes he treated, but rather, to use one of his earlier titles, as an expression of an inexhaustible *joie de vivre*. His art was thoughtful and considered only in an artistic sense. It said nothing about the human condition in his time, as Picasso, Léger, and even Mondrian did, except that it was good to be alive and to enjoy every sensuous delight which nature and humanity afford. Its source is in some area of consciousness that is less than logical, in an intuitive, profoundly sensational response to visual experience. We can see this for ourselves in his colours, for no other artist of the twentieth century has wrought such magic with such ease. To see his corals beside his pinks, his greens and reds against orange, his reds and purples together, or any other of his unexpected combinations, is to share his joy that such pleasures can occur. But his colours conformed to no theory, nor have they yet been reduced to a system. Whenever they are 'right', and they almost always are, it is because he felt them to be so.

THE LATER WORK OF BRAQUE

Picasso said that when he and Braque invented Cubism they had no intention of doing quite that, but rather 'wanted simply to express what was in us'.[16] It is as the continuous unfolding of a singularly sensitive personal expression that Braque's work continues the formal and technical constituents of Cubist vision. His art, like his life, was less conspicuous than Picasso's, his touch more discreet, and his formal metamorphoses less cataclysmic, but within the stated range of his intentions he, more than Picasso or Léger, strengthened and enlarged the Cubist conception of pictorial space. Picasso also said that when he parted from Braque in the railway station at Avignon in 1914, when the French painter was called up at the outbreak of the First World War, they said farewell for ever. In life this was true, for they were never to work together again; but

occasions of resemblance and contrast recurred in the decades ahead, so that now, as in the past, their names are linked in their profound and continuous re-evaluation of painting in modern times.

Braque suffered a severe head wound at the Front in 1915, and during a long convalescence was able to think deeply about the problems of art and of his own in particular. His meditations, confided over the space of many years to his notebooks in the form of aphorisms and cryptic philosophical statements, inform us that although his pictures in themselves are devoid of 'ideas' (he once denied that they contained any symbols or symbolic values whatever), the subject of each and of all is the act of painting as that is conducted in time and realized in changing spatial perspectives upon and behind the painted surface.

Braque said that he no longer believed in anything, and the extent of his unbelief can be read in the absence of extraneous subject matter in his pictures. Even his 'classic' themes are only excuses for pictorial invention, not for iconological comment, and there has never been a hint of a commitment to any situation outside the studio, either to politics or to our sorry humanity, which engaged the anger and pity of Picasso, or to the specific conditions of 'modern' existence which we can trace in the work of Mondrian and Léger. 'Objects', Braque added, 'do not exist for me except in so far as a harmonious relationship exists between them and also between them and myself. When one attains to this harmony, one reaches a sort of intellectual non-existence which makes everything possible and right.'[17] His frankness disarms and encourages criticism. If he is not the greatest modern artist in the sense that his work has not enlarged our understanding of ourselves, we can understand why he has been called the greatest modern painter, one who has sharpened our sensibility to painting itself. Purely as painting, his work contains the highest

formal perfection and the highest functional integrity.

In his choice of subject Braque was faithful to the early Cubist iconography, to the still-life objects and the single seated or standing figure with which he and Picasso had explored the new pictorial space. In his first pictures after the War he continued the flat patterning of Synthetic Cubism, but with a darker, more sober tonality. The canvases which followed were more personal, especially in their restricted palette of green, ochre, and white over a black priming which increased their sobriety. Within ten years he had created a memorable series of still lifes which brought him international success. From the widened horizontal arrangement of objects upon a table-top he progressed to the vertical format of the *Chimneys* of 1922 and the *Tables* (*Les Guéridons*) of 1928. *Le Guéridon* of 1929 [266] is a composition of impeccable order and

266. Georges Braque: Le Guéridon, 1929.
Washington, Phillips Collection

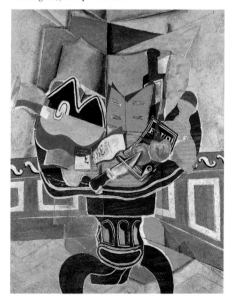

decorative harmony based, like most of the larger still lifes, on a simple, quadripartite division of the surface, here announced by the folded and parallel planes in the background which were once the pages of an open book or sheet of music. From these abstract planes one's eyes pass down and seemingly forwards over the picture plane as if the objects upon the table were pushed towards the spectator and out of the pictorial space behind them. Braque said that for him the basic principle of Cubism had been 'the materialization of the new space', and that he was interested in painting not forms but the relations between them. By 1928 the new space had become even richer in visual suggestions. In his notebooks he distinguished between two kinds of space and their pictorial representation: 'Visual space separates objects from one another. Tactile space separates us from objects.' In the *Round Table* we can almost feel as well as see the relations between the forms, as our eyes, extensions of our fingers, reach between and beneath the objects. But the space in which these visual adventures occur is not uniform, as the description of it as 'tactile' might imply. Not only is it seen from several points of view (as our eyes rise from the floor to the ceiling objects seem to change their position in relation to each other and to us), but upon the surface of the picture the guitar may move from the illusion of three-dimensional space in its lower part to the assertion of pictorial two-dimensionality in its black, patterned upper side. So, too, it participates in the interplay of illusion and abstraction which extends from the impersonal planes behind the table to the declarative statements of prosaic fact in the knife and pipe in the foreground. Braque's interest in tactility led him to elaborate his surfaces with various substances which increase the tangibility of picture and object. Trained as a *peintre-décorateur*, he was adept from his Cubist days in imitating marble and wood-graining, but now he added sand, wood-shavings, metal

filings, and even coffee grounds to his pigments and priming. In several of these still lifes the dusty colours filled with sand and other substances have the visual and tactile density of a fresco painted on a plastered wall.

Unlike Picasso's still lifes of the 1920s and 1930s with their vestiges of the painter's struggle with recalcitrant objects, Braque's paintings seem remote and still, thanks not only to their subtle and delicate colours – pinks, pale greens, yellows, and lavenders replacing the duskier palette of the early 1920s – but also to the aesthetic detachment in which they seem to exist, the result of the artist's detachment from life beyond the studio, and of his method of working from drawings and sketches and from other paintings rather than from nature itself. Thus twice removed from the contingencies of ordinary vision these still lifes are truly composed, even as they are truly decorative, because they adorn and enrich the world with their elegance. In this, of course, they are most French. Despite their inimitably twentieth-century formal complexity they could hold their place upon the walls even of seventeenth-century Versailles.

Braque said that he changed 'the meaning of objects, giving them a pictorial significance which is adequate to their new life . . . Objects are recreated for a new purpose; in this case that of playing a part in a picture . . . Objects always adapt themselves easily to any demands one may make of them.' This adaptability to his pictorial will which Braque attributed to objects is also seen in his infrequent paintings of the human figure, especially in his *Canéphores*, the large canvases and drawings of half-nude women bearing baskets of flowers and fruit, executed between 1922 and 1926 [267]. Whether or not they were painted in emulation of Picasso, who had been passing through his own 'classic' phase, or more probably of Renoir, whose massive late nudes were seen in a retrospective exhibition at the Salon d'Automne in

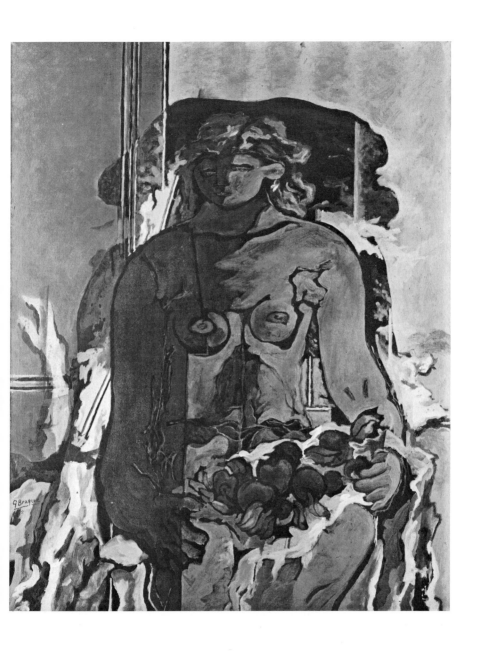

267. Georges Braque: Nude Woman with Basket (Canéphore), 1926. *Washington, National Gallery of Art*

1920, they contain many felicities for those who can overlook the difference between the monumental theme and the casual treatment of their anatomies. The still-life arrangements are among Braque's best, the two-dimensional drawing of the nude is full of spatial surprises, and expressively they are more Greek than Picasso's figures which were derived from Roman marbles. Serene daughters of Demeter, transfixed in their autumnal reveries, they were the first instances of the Greek themes which provided Braque with the only specific subject matter, apart from Cubist objects and landscape, which he cared to treat. In 1931-2 he

created the first of his Greek heroes and divinities as patterns of white lines incised on large black plaster panels, and the sixteen etchings for Vollard's edition of Hesiod's *Theogony*, perhaps his most important illustrated book. Greek subjects returned in lithographs of Helios and Phaeton after 1945, in his few and very flat sculptures, and on a larger scale in the painting on paper of *Ajax* of 1949-54 (New York, Collection Mrs Florene May Schoenborn). We must, however, accept these works as formal exercises in an intricate and ultimately Cubist calligraphy without symbolic inferences, as peripheral annotations to the

268. Georges Braque: Atelier V, 1950.
Private Collection

widespread return of classic subject and content which occurred after the First World War.

In his studios in Paris and in Varengeville, his summer home in Normandy, Braque had discovered the meaning of painting as a way of life, and in a series of eight canvases, each entitled *Studio* (*Atelier*), created between 1948 and 1955, he summarized and crowned his life's work [268].[18] The subject of these paintings is less the studio and the things within it than that strange space which Braque found between things themselves. Objects are presented in a drift of time, constantly changing their positions, so that nothing is ever completely visible in any one instant. To speak of these canvases as if the physical structure of the painting were itself in motion is only to suggest the visual complexities which they present, and which, Braque warned us, we must never attempt to reduce to a logical explanation lest we lose their mystery. But we have one clue, at least, to the sources of these effects. In the studio itself flat metal cut-outs of still-life objects have been seen hanging from almost invisible wires.[19] Slowly turning in the slightest breeze, they gradually appear and disappear, like their counterparts within the paintings, into the thinnest of silhouettes. The visual experience so created by the cut-outs can be thought of as the realization in physical space of Braque's much earlier Cubist discovery that the mass of an object can be represented in two dimensions by juxtaposing a profile to a full-face view or, even earlier, by painting half of it as an opaque black silhouette and the other half in outline. That the subject of these commanding works is the act of painting, and beyond that of art as a supreme and independent aspect of human experience, can be read in the large bird passing through the upper portion of the picture's space. It is not an actual bird but the 'memory' of one which existed in Braque's own paintings. Its shadowy appearance in several of the *Studios* transports the spectator not outwards into the world of nature but farther inwards to the heart of Braque's pictorial matter, where, as he wrote in his notebook, 'the present is perpetual'.

THE LATER WORK OF PICASSO

To the spectators and critics of Picasso's work a generation ago his changes of manner seemed so abrupt and arbitrary that certain conventions were introduced to impose formal order and stylistic sequence upon an already considerable body of painting and sculpture. The work was often divided according to colour or subject matter (the Blue or Circus Periods, for instance), or formal-philosophic distinctions (Analytical and Synthetic Cubism).[20] These were useful so long as the artist was formulating the basic attributes of his style, but as he grew older the technical and formal distinctions between the different 'periods' became blurred. According to another methodology, the distortions of his earlier work could be justified by comparing them with arts of the past which Picasso either was known to have admired or might have been expected to know.[21] Here again the confrontation of figures in such paintings as the *Demoiselles d'Avignon* [131] with Egyptian, Iberian, and African sculpture helped to explain the external appearance of his forms, but historical parallels are easily abused and seem less persuasive after the artist himself selected certain works of the past for his voracious analysis and reconstitution. Since his later paintings and sculpture exhibit such intricate interweavings of expressive ideas and formal inventions, it is no longer meaningful to divide his life's work into neat sections. Piecemeal interpretation distorts the actual evidence and impedes the historian's obligation to account for the consistency, not to say continuity, of the whole, if, as there seems reason to believe, Picasso's was an integral talent which enlarged the meaning of art in our time.[22] When the student of Picasso discards these

divisive rationalizations and examines a considerable sequence of work, whether in originals or in reproduction, he cannot but see a consistency which is easier to point to than to explain because it is a matter of expression as the source rather than the product of formal diversity. The recurrence of certain themes such as episodes from the bull-ring, the artist and model, or the sleeping nude indicates that there are certain constants of expression which underlie apparently arbitrary changes of manner. And since Picasso subjected each of these to numerous transformations with changes of meaning upon form as well as of form upon meaning, his manipulation of form seems not to be an end in itself or a random aesthetic choice, but the result of expressive necessity. What is wanted now is a psychology of Picasso's form, rather than an index to the forms themselves.[23]

The expressive consistency of his earlier work has already been noted. The introspective calm of the Circus Period, which followed the monochromatic melancholy of the Blue, in both form and subject, has been considered symptomatic of his increasing artistic confidence and material success in the years 1904–8. The Cubist works which followed seemed at first shockingly disparate, but now that the formal discoveries of 1906–10 can be traced step by step the development of Cubism is seen to be not accidental but an attempt to create a new and modern object in a new pictorial space. Picasso's Cubism, consequently, is essentially a mental process, rather than a series of empirical visual deductions. His Cubism, however, did confirm and strengthen a mental and visual habit which became constant in his subsequent work. This was the device of seeing into and through solid objects, of integrating the space beyond and around them with their transparent volumes, and, as a result of this visual mobility, of seeing one thing in terms of another, of making one form do the work of

two. There is here a hint of Surrealist metamorphosis and of the double images so brilliantly revealed by Salvador Dali. But whatever Picasso may have learned from the Surrealists in the decade after 1921, his own meanings were rarely so perverse, so obscure, or even, despite the publicity which often attended their first appearances, so egocentric. Like every modern artist, Picasso had to speak from his own condition, but like all artists of more than ordinary stature, he speaks in the end to all.

Picasso has for so long been the most prominent artist of the twentieth century that it is difficult to realize how little is known about him. And that little is not much more interesting than what we know about his less publicized contemporaries. His work was the most important part of his public as well as private life, and only through the work can we come to know his life in any sense in which we need to know it. Nevertheless, such help as biographical facts can afford cannot be ignored. Perhaps the most startling of all Picasso's changes of style occurred towards the close of the First World War, when he seemed to have abandoned Cubism for subjects derived from antique art and a mode of interpretation based on line and a broadly simplified modelling in emulation of Ingres and the European idealist tradition. The immediate source of his sudden interest in classical sculpture can be traced to the weeks early in 1917 when he was in Italy preparing the sets and costumes for *Parade*. In the museums of Rome and Naples he saw marbles and frescoes whose spacious dimensions and majestic rhythms revealed a world apart from the tensions to which, even though a neutral, he had been subjected in war-time France. More than that, this revelation of an ideal existence coincided with his love for a young Russian dancer in Diaghilev's company, Olga Koklova, whom he married the next year. In February 1921 his first son, Paolo, was born, and during the next four years we can follow

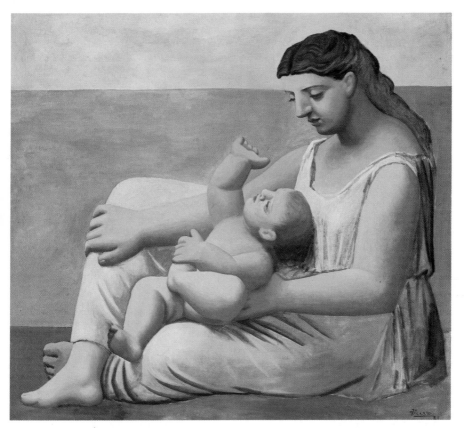

269. Pablo Picasso: Mother and Child, 1921.
Art Institute of Chicago

the boy's development in a series of unusually tender portraits, and in 'classic' images of a woman and child. The mother, in a long straight garment with her hair loosely tied behind, is seen as a colossal maternal figure enfolding the body of the child, over whom she watches with the imperturbable calm of the empty sky and sea behind them [269]. In attributing to his wife the values of primordial maternity, Picasso saw beyond the technical excitement of solving a pictorial equation in terms of second-rate Roman sculpture to the point where he found for the pleasures of domesticity a monumental and universal artistic form. These massive bodies with their slowly unfolding contours and simply shaded planes were so readily recognizable that the break with his Cubist past seemed to cancel any possibility of stylistic continuity. Seventy years later our familiarity with the construction of Cubist figures enables us to look beneath the surface of the pseudo-classic forms and see how the arms and legs of the woman and child are treated as interdependent parts of a tightly integrated

structure. In his *Mediterranean* of *c.* 1901 [77] Maillol had also reinterpreted the large slow forms of antiquity, but between Maillol and Picasso the differences are greater than the similarities. The sculptor's woman dreams her days away; the painter's is a dream from which at any moment artist and spectator may be awakened to another way of life.

In addition to these large and sculpturesque figures, which often reached a monumental scale even when the paintings were actually very small in size, there were other works in which a more lyrical attitude towards antiquity appeared. In drawings of ballet dancers resting or rehearsing (always for the 'classic' ballet), and in drawings and etchings for such texts as Ovid's *Metamorphoses* (1931) or Aristophanes's *Lysistrata* (1934), the contours which in his paintings had followed the bloated curves of Hellenistic sculpture were treated with the sensitivity of Greek vase-painting or of the engraved designs on Etruscan bronze mirrors. The multiple sources of his classicism included Poussin and Ingres for certain figural compositions and highly finished portrait drawings in hard pencil of his friends and patrons. Picasso's 'classic' period also coincided with a widespread revision of antiquity in terms of modern experience by many artists of the avant-garde. His own paintings remain the most convincing, but mention may be made of Gino Severini's still lifes and Giorgio de Chirico's white horses and templed hills. More profound examples in literature and music, comparable to Picasso's in their expressive phrasing of modern spiritual tensions in antique terms, were Cocteau's dramas *Antigone* (1922, scenery by Picasso), *Orphée* (1926), and *La Machine infernale* (1934, a modern version of Sophocles's *Oedipus Rex*), and Stravinsky's oratorios *Oedipus Rex* (1927) and *Persephone* (1934).

The awakening from this classic dream was sudden. It may have been related to the deterioration of his marriage and to an im-

perative desire to escape from a way of life imposed by his wife's conventional tastes. In deference to her he had played the part of a fashionable artist with an apartment on the rue de la Boëtie, where he entertained all Paris. The personal troubles through which he was passing, ending in his separation from Olga in 1935, may have hastened the transformation of the image of classic maternity into figures as alarming as the *Seated Woman* of 1927 [270], one of his most concentrated portrayals of an ambivalent attitude towards woman as wife, mistress, and mother. The encompassing bulk of the mother image has been changed into an ideogram of neurosis, threat, and domination. The figure simultaneously comes together as we look at it, the head forming itself from several profiles, but just as we grasp its bulk and outline it retreats into the picture plane. The colours,

270. Pablo Picasso: Seated Woman, 1927. *New York, Museum of Modern Art*

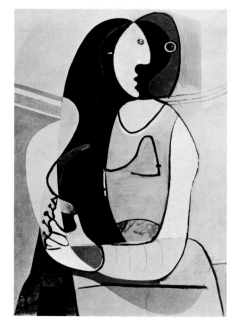

too, are appropriate counterparts of these spatial uncertainties – earth-reds, pinks, and browns rising to black in the head. Worst of all, at the top, where the four profiles meet, the head suddenly becomes an empty cavity in which floats a blank eye. We then know that its mind has retreated to some region where we cannot follow. To describe this work as Cubist, even as Later Cubist, may be technically accurate, but it reduces its expression to a formal trick. Cubism had been, as Picasso always insisted, not a method of research but a means of expression. 'When I paint,' he remarked in 1923, 'my object is to show what I have found and not what I am looking for.'[24]

Picasso once said: 'To my misfortune – and probably my delight – I use things as my passions tell me.'[25] In so few words he induces us to look for the meaning of his work within him, and within ourselves. The spaces in which his metamorphoses occur are the spaces of feeling, spaces where the mind reflects upon its own experiences as well as upon its perceptions of the world without. Because Picasso insisted that there cannot be a wholly abstract, in the sense of a non-objective or non-representational, work of art, it follows that he did not so much abstract from the actual as make actual what had previously been real only as a passionate apprehension. He made visual what he had thought and felt. Since the activities we describe and distinguish as thought and feeling are integrated in the total personality, Picasso's work can be read as a continuing and changing dream. But, as in dreams, nameless fears acquire stupendous visual shapes whose reality can be measured only in terms of the feelings they express and inspire, so there are moments which are hallucinatingly 'real', when objects are seen with dazzling and deadly clarity. Picasso was a master of such moments. With disarming simplicity he drew or modelled some slight detail so accurately that the remainder of the nightmare must be considered equally true.

He expressed this equivalence of the world and the dream through two recurrent motifs. In the many paintings and drawings of the artist and his model he reflected upon the complex relationships which are felt between what exists before one's eyes and what appears in the work of art. The theme can be sensed in La Vie [69], where the drawings in the background are artistic comments on the fate of the principal figures, but it was announced more directly in the Painter and His Model of 1928 (New York) in which a schematic and linear artist, studying an equally abbreviated model, draws a conventionally 'classic' and 'realistic' profile on his canvas. Perhaps we are to understand that life is less true to itself than to art. He pursued the subject through numerous variations in the etched illustrations for Balzac's Chef-d'œuvre inconnu, published in 1931, in the forty-six etchings of the Sculptor's Studio (1933-4), and much later in a notebook of 1953-4 where the melancholy and wry reflections of several doddering elderly artists in the presence of the nude were presumably inspired by the collapse of his relationship between 1946 and 1953 with Françoise Gilot, the young mother of his younger son and daughter.[26]

During the 1930s the themes of the bull, the bull-fight, and the bull-headed male figure reappeared in ever more intricate situations. Picasso's changes of meaning upon the same forms may be traced in the last of these, the Minotaur who first appears as an aggressor and then as a blind, pathetic victim, who acquires heroic stature when he dies. The relation of the female figure to these animals and animal-men is equally ambiguous. A bacchante drunkenly slung across a bull's back becomes Europa and then the enigmatic half-nude female matador in the large print of 1935, Minotauromachia. The relation of the horse to these women and bulls is also puzzling; as the victim of the bull the horse is simultaneously contemptible and pitiful. Then in 1937 the themes were suddenly

gathered, condensed, and given monumental expression in the mural painting commemorating the bombing of the Basque town of Guernica on 26 April 1937 [271]. Picasso had accepted a commission from the Spanish Republic for a large painting for the pavilion at the International Exposition that year in Paris, but he had been at a loss for a subject until the brutal slaughter of a defenceless population of refugees and unarmed civilians aroused his rage and sorrow. *Guernica* has been accepted by both the supporters and antagonists of modern art as an important artistic and social document, and there is no doubt that it did prove to many people, despite its difficult symbolism, that the most modern pictorial techniques, hitherto associated with the most private Cubist ex-

271. Pablo Picasso: Guernica, 1937.
Madrid, Centro de Arte Reina Sofia

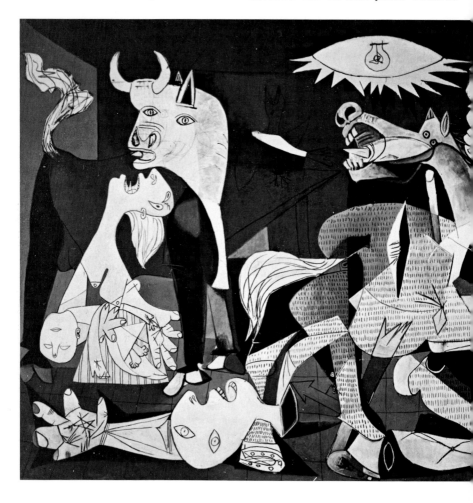

pression, could be used for a generous, humane, and public statement, especially when the artist's private dream had become everyone's public nightmare.[27] After more than forty years it has lost none of its compassion or its visual interest. With a small cast of characters – four women, one with a dead child in her arms, the head and arms of a dead soldier, a horse, and a bull – Picasso created a metaphor of violence, horror, fear, despair, and resolute courage (reading from right to left, from the figure of the woman falling from the burning house past the wounded and screaming horse to the impassive bull) entirely by pictorial means, by the strong opposition of a monochromatically black, grey, and white colour scheme, by unexpected and breathtaking foreshortenings in two as well as in three dimensions, and by the spatial illusions of Later Cubism. The first impression of horror and confusion is communicated by the firm and very simple design, based on the central triangle of the horse extended by the soldier's out-

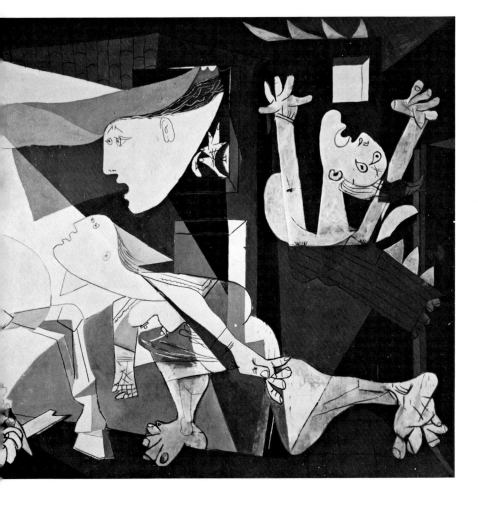

stretched arms and the distorted leg of the woman entering from the right.

Guernica could never have been painted within the short space of six weeks, even by an artist who worked as rapidly as Picasso, if the motifs had not previously existed in his work and in his memory. The synthesis of the separate themes, each of which had a long history of its own, was an act of extraordinary imaginative power whose surplus energies were expended in many works contributing to and deriving from the formal violence and tragic feeling of *Guernica* itself. The studies of women weeping and the drastically distorted mothers and children are convincing proofs that for Picasso art could be 'an instrument of war for attack and defence against the enemy'.[28] But if, as one critic has maintained, 'modern painting is only explicable in its political context',[29] Picasso's deliberately political painting has not always been the most artistically successful. Although *War* and *Peace*, two large mural paintings of 1952-4, impressively hold their place on the awkwardly sloping walls of a disestablished chapel at Vallauris, the *Massacre in Korea* of 1951, attacking the military intervention of the United States, seems more like an illustration for science fiction than a serious humanitarian protest.

Picasso has been known principally as a painter, draughtsman, and graphic artist, but he was always interested in sculpture, or perhaps one should say in the problems not only of sculpture in three dimensions but of those that arise when two-dimensional forms are physically displaced from the surface of the canvas and participate in actual as well as in imagined space. His earliest bronzes, of 1901, were related to the withdrawn figures of the Blue Period, as if by their pose and expression they could help him to resolve certain pictorial problems. The *Woman's Head* of c. 1909 [134] and the *Absinthe Glass* of 1914 were extensions of Cubist space into physical substances. The combination in the latter of painted surfaces and of an actual object, the perforated metal strainer, was prophetic of much that was to come later. The *papiers collés*, the collages, and the wooden constructions of 1912-14 [139, 142] further transgressed the limitations of painting proper. But then Picasso abandoned sculpture until the late 1920s, when studies for monuments and figures to be executed life-size and larger appeared in his paintings and drawings. Encouraged by the Spanish sculptor Julio Gonzalez (see below, p. 470), he transferred some of these painted forms to actual materials. In the structures of thin metal rods of 1930 he translated from virtual to actual space the forms he had previously 'thought' as sculptural in his paintings. From Gonzalez came suggestions for welding odds and ends of metal and other substances into figures to be cast in bronze. Suggesting Schwitters's *merz* compositions and other Dada objects, they were also, like the *Absinthe Glass,* forerunners of the assembled sculptures of the 1940s and 1950s. At Boisgeloup in 1930-2 he made a number of large, often swollen and distorted heads and figures in plaster, inspired by the placid features of Marie-Thérèse Walter, his model and companion from 1932 to 1937. Few of these have been cast or exhibited, but two of the largest were placed outside the Spanish Pavilion in Paris in 1937. The group as a whole is related to the sculpture seen in the engravings of the sculptor in his studio of 1933-4.

During the Second World War, when materials for painting were scarce, Picasso turned his hand to anything he found, to bones and pebbles which he engraved or painted, to bits of wood, matchboxes and cigarette packets, to paper bags filled with liquid plaster and then squeezed, to torn and twisted papers.[30] His double sight endowed many with eerie connotations. Three holes torn in circular scraps of paper made them frighteningly like skulls, frail reminders of the years when death waited at

every corner in Europe. The largest work of the time, the *Man with a Lamb* of 1944, a cast of which has been erected in the public square at Vallauris, is also the most conservative of his sculpture.[31] Its prototypes in archaic Greek calf-bearers and Early Christian images of the Good Shepherd carrying a lamb have endeared it to art historians, but one may prefer a more modest work whose form is not at all archaeological but whose psychological content is more provocative, the tattered and broken figure

272. Pablo Picasso: The Orator, 1939. *Paris, Musée Picasso*

[272], originally composed of cardboard and wire mesh, who approaches us as if it were one of those 'powers of the soul' invoked by Paul Valéry, 'who come strangely up out of the night . . . charged with clarity and error'.[32]

A decade later Picasso's sculpture had become as sprightly as his painting. Birds and animals were conjured out of the most unlikely materials. There is a bronze crane whose head was once a water tap, its body and tail a gardener's trowel, and its legs two forks. There is a baboon whose belly was a pot and its head two toy automobiles. When some of these pieces are painted the distinction between sculptural and pictorial expression is again confusing. Many of his countless ceramics executed in the pottery at Vallauris similarly could be described as painted sculpture or as three-dimensional painting.

After 1945 Picasso lived in the south of France, drenched both by the sun and by the harsh light of publicity.[33] At a time of life that is usually accounted venerable he was as physically and artistically active as a much younger man. In a torrent of work and play he showed himself as visually witty, as formally inventive as ever. But just because he was so facile, wanting to paint, so he said, 'as one writes, as fast as thought, to the rhythms of the imagination',[34] and was apparently immune to self-criticism, he produced many objects of less than top quality which have encouraged the belief that his work is basically superficial and monotonous. It is true that after the heroic years of Cubism he avoided serious investigations of the new pictorial space. Even *Guernica* is less rather than more complex than the *Accordionist* of 1911 [138]. But no other artist excelled Picasso at his best in his inexhaustible transformations of human and animal forms. If his metamorphoses in origin are, as I have tried to show, intellectual and psychological, as visualizations of intense emotional experience they have deeply affected the progressive art of our time. It will not matter that

he had no really distinguished followers or that he founded no school. One does not judge Leonardo by Luini. What is important is that the most serious European and American artists, Miró and Arp, Lipchitz and Henry Moore, Arshile Gorky and Jackson Pollock, were not too proud to accept his suggestions, however much they remade them as their own. Whatever the future valuation of his work will be, and it is still the most problematical of any major artist's of modern times, his stature as a master is assured. Many years ago Gertrude Stein, one of his first patrons, found words for the quality his best work has always had and which his least has rarely lacked. 'Pablo is never dragged,' she wrote. 'He walks in the light and a little ahead of himself, like Raphael.'[35]

CONSTANTIN BRANCUSI AND JEAN ARP

The sculptures of the Romanian artist Constantin Brancusi (1876–1957) and of the Alsatian Jean (Hans) Arp (1887–1966) have been notable contributions to the development of abstract modes of expression, although for each man the term 'abstract' is only a partial definition. In all Brancusi's sculpture, and certainly in Arp's after 1930, the sources of inspiration in the natural and human landscape are perceptible and important. For this reason their works are often described as organic or bio-morphic, in contrast to those by sculptors of more geometrical persuasions who avoid all references to natural events. The vitalistic current in the work of Arp and Brancusi can be traced to their interest in the human body as well as to their rejection of the tired traditions of academic figural sculpture. Arp denounced such 'bourgeois art' as 'sanctioned lunacy. Especially these naked men, women, and children, in stone or bronze, . . . who untiringly dance, chase butterflies, shoot arrows, hold out apples, blow the flute [and who] are

the perfect expression of a mad world. These mad figures must no longer sully nature'.[36] Brancusi put it more succinctly: 'Sculptured nude bodies are less sightly than toads.'[37] Yet the work of each is inconceivable without reference to human and natural biology. Both may be said to have created their finest work in exemplification of Arp's statement that he wanted 'to find another order, another value for man in nature. He was no longer to be the measure of all things, no longer to reduce everything to his own measure, but on the contrary, all things and man were to be like nature, without measure'.

Brancusi was born in Romania, the son of prosperous peasants, and graduated from the academy in Bucharest in 1902. When he enrolled two years later at the École des Beaux-Arts in Paris he was already proficient in the technique of academic naturalism and could look beyond the studio to the work of Rodin, whose *Balzac* of 1895 he considered the 'starting-point of modern sculpture'. He declined, however, to become Rodin's pupil, and although the first works he exhibited in Paris were in the older man's manner, he soon rejected Rodin's pathos and restless surfaces. He realized that for him 'what is real is not the external form but the essence of things. Starting from this truth it is impossible for anyone to express anything essentially real by imitating its exterior surface'.[38] This 'essence' Brancusi gradually discovered as a primal ovoid shaped in stone with the highest technical and formal refinement. From the Rodinesque marble head of *Sleep* (1908) to the *Sleeping Muse* (1909), *Prometheus* (1911), and the *New Born* of 1915 [273], the mass of the human head was progressively simplified until in the appropriately titled *Sculpture for the Blind* (1915) and the similar *The Beginning of the World* (1920?), the egg-like shape reached its ultimate, absolute form.[39] The titles indicate Brancusi's interest in the philosophical significance of his work,

273. Constantin Brancusi: The New Born, 1915.
Philadelphia Museum of Art

for we are invited to contemplate, so to speak, the nature of the creative gift, the thing created, and finally the source of creation itself. In the *New Born*, midway in the series, the head has lost the features still discernible in the *Prometheus*, but the purity of the whole mass, whose curves recall the rhythms of the human body, is interrupted by the sharp edges and the sliced-off end, as if the life of the mind intervened, even at birth, in the natural event.

Brancusi's first stone sculpture was an unusual technical achievement; unlike Rodin's and the vast majority of contemporary work, it had been cut and finished by the artist

himself. Brancusi's belief that direct carving was 'the true road to sculpture' had considerable influence on twentieth-century art until the invention of easily welded and brazed metals and the more recent revival of traditional bronze-casting from wax or plaster models. In his time, however, no other sculptor so patiently sought such impeccable surfaces or so carefully concealed all trace of his hand and tools. Brancusi's name is also linked with a peculiarly twentieth-century respect for the qualities of each material, but, although he chose his marbles with the greatest care for their colour and texture, it is difficult to believe that he was

much concerned with stone as a means of achieving a particular kind of form. He often transposed his marbles into bronze, having the metal replicas cast from the actual stones with only minimal changes. Clearly he was more interested in the abstract or absolute value of a form distinct from its manifestation in a given substance. There are three marble versions (1912, 1919, 1931) of the portrait of the young dancer Mlle Pogany [274], and at least nine bronzes cast from them, some with slight

274. Constantin Brancusi: Mlle Pogany, 1912. *Philadelphia Museum of Art*

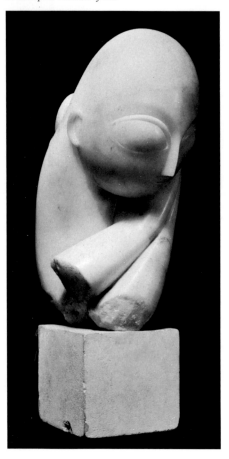

variations. But over the space of nineteen years the simplified form remained in the condition it had reached by 1919, the face retaining only the arch of the eyebrows and nose, the forearms and hands having become a single sweeping curve to the side of the head. Since none of these changes was dictated by the intrinsic character of metal or stone, the simplification must have been suggested by intellectual rather than material considerations.

Mlle Pogany proves that, even when reduced to its basic factors, Brancusi's aesthetic was more complex and contradictory than it first appeared, and that his art is still subject to critical revaluation. Recent observers have been disturbed in such works as this by a quality of over-refinement, of self-conscious sophistication inappropriate in an artist who was considered by his contemporaries, and who considered himself, the greatest sculptor of the twentieth century. A feeling for Parisian *chic* is certainly present in some of his later work, especially when the subject called for it, as in the *Negress* of 1924, or the *Sophisticated Young Lady* of 1925, a portrait of Nancy Cunard. But it is well to remember that these svelte rounded forms, reminiscent of the shingled coiffures and tubular silhouettes of the 1920s, had been invented by Brancusi some time before. Brancusi helped to create a *mode*, he did not follow it.

The stylistic sources of *Mlle Pogany* and Brancusi's other early sculpture are actually of quite another order and involve at least three different kinds of primitivism. That this young dancer of 1912 should be considered the embodiment of high Paris fashion of the 1920s is not just the result of Brancusi's mastery of abstract form. For that form he was indebted to Negro sculpture. The resemblance between the huge convex eyes in wooden masks such as those of the Luba tribe in Katanga is incontestable. African sources are even more noticeable in the wood-carvings. As early as *The First*

Step of 1913 (destroyed), *Caryatid* of 1914
(Fogg Art Museum, Harvard University), and
Chimera of 1915 (Philadelphia), the combina-
tion of geometrical and organic shapes was
derived from African art, and it communicates
something of that mood of ritual mystery which
we feel in the presence of African objects.
Another kind of primitivism may be traced to
Brancusi's Romanian memories. In his wood-
carvings there are references to folk art, to the
repetitive geometrical ornament on peasant
houses, and to the carved cogs and screws of
wooden farm machines and wine presses in the
massive notched and grooved bases he devised
for his sculpture. Preceding these decorative
devices, still a third kind of primitivism had
appeared as early as 1907 in a *Girl's Head* (lost),
supposedly his first direct carving in stone, and
a small stone *Double Caryatid* (New York).
In both the deliberately crude carving may
indicate that he had been studying Gallo-
Roman or Celtic sculpture in the Louvre.

One of the most enigmatic of Brancusi's
pieces of abstract sculpture is the *Adam and
Eve* of 1916, of oak and chestnut [275], in
which there is an ascending progression, both
formally and iconographically, from simplicity
to complexity. Upon the square stone base
stands the lower half of the group, more
'decorative' and folklorist, and executed earlier
than the upper part. This again rests on a
simple block, but is now more polished and
expands into perceptibly physiological shapes.
The whole makes an inexplicable modern
totem, a Freudian 'Mars and Venus', suitable
for an age aware that unconscious impulses can
be identified and described even when they are
not given conventional or familiar signs. Despite
their figurative titles, such wood sculpture as
this, the *Prodigal Son* of 1915, and the *Chimera*
were Brancusi's most abstract pieces in the

275. Constantin Brancusi: Adam and Eve, 1916.
New York, Guggenheim Museum

sense that in them references to the natural world are most difficult to detect. In his marbles specific natural situations are clear. The *Fish* (1922), the *Seal* (1924), and the birds, *Maiastra* (1910?) and the motionless *Golden Bird* (1919), resemble their prototypes in nature. Even in the versions of the *Bird in Space* (from 1923), where the problem was to suggest continuous rising motion, the elongated tapering form has analogies with the bodies of birds.

In his sophistication Brancusi stood apart from the major sculptors of his day; in his inventive primitivism he resembled others. In the Paris of 1910-14 his friends and acquaintances were also discovering new aspects of expressive form in non-European and exotic traditions. Upon Modigliani (see above, p. 428), who was as fine a sculptor as he was a painter, Brancusi's influence was considerable. The early work of Archipenko and of Jacob Epstein has many analogies with his, and Ezra Pound wrote of Gaudier-Brzeska's admiration for him. Brancusi also shared Léger's enthusiasm for machine forms, although his sculpture, however much critics might later enjoy comparing the *Bird in Space* with an aeroplane propeller, was always based on natural rather than mechanistic rhythms.[40]

For Brancusi beauty was 'absolute balance', a condition to be achieved by an exquisite and precise adaptation of intention to technique. We may never again attribute to his forms the mystic profundities which he encouraged others to see in them; indeed, to a later age they may seem to suffer from a lack of human distress. But we should not forget that, as Brancusi himself said, 'simplicity is not an end in art, but one arrives at simplicity in spite of oneself, in approaching the real sense of things. Simplicity is complexity itself, and one has to be nourished by its essence in order to understand its value'.

For thirty-seven years Brancusi lived in a high white studio hidden in the heart of Paris. There, in his white sculptor's clothes, 'surrounded by the calm of his own creations', he persuaded his visitors to see in them meanings no photograph or museum installation could ever quite reveal. Upon his death he bequeathed to the French government not only the contents of his studio, which included examples of all his principal works, but also the studio itself, so that the total environment of his life's work might be preserved.

Arp's later sculpture, in common with Brancusi's, shows a similar precision of shape and surface, and concern with nature as the source and background of human experience. Both artists looked for the final and enduring form beneath or beyond transient appearance. But there are significant differences between them. Brancusi discovered 'the real essence of things' by subtraction, by the removal of individual distinctions until the ultimate form emerged stripped of all individuality. His *Fish* is every fish, his *Bird* all birds, and his world consists of a few, discrete symbols. In Arp's, reality is the process of growth, found in primary organisms like seeds or cells which strive towards but never achieve the condition of identifiable species. For Arp himself the activity of creation was as important as the product created. Only when he discovered what his pieces had become could he give them names, those witty, ironic, or magical titles which join botany with biology, and dreams with prosaic fact: *Necktie in a State of Tension, Snake Bread, Shepherd of Clouds*. The two sculptors' working methods were different. Because Brancusi's forms were carved directly, they were impenetrable and self-enclosed. Arp worked in plaster, letting the curved surfaces diverge and suggest others, a rounded protuberance engender another, so that when transferred to stone (usually by craftsmen under his direction) or cast in bronze the pieces reached out to embrace the space around them like living things.

Arp's search for elemental artistic form and meaning had begun even before his Dada days

in Zürich, but it was there that he met Sophie Taeuber. Her more rigorous and logical taste, expressed in the geometrical character of her paintings and designs for tapestry and wood-carving, was a foil for Arp's poetic fancy. Together they discovered, as early as 1915, that the elemental could be surprised through the operation of the 'laws of chance'. For Arp 'chance' in practice did not mean the preparation of situations whose resolutions could be determined by carefully planned 'accidents', as it did for Duchamp, but rather that by voluntarily refusing to force his materials into the likeness of something other than what they were the artist could encourage them to suggest, by chance as it were, hitherto unknown and unexpected configurations, necessarily abstract or even non-objective. Although the method or technique may be thus described in terms which attribute to the torn papers and the casually thrown string the active principles of artistic causation, the artist himself cannot escape his responsibility as the agent who discovers the potentials implicit within his materials and their arrangement. What is important is that in his decision to avoid representation Arp, quite as much as Kandinsky, placed a premium upon his instinctual, un-selfconscious response to the conditions he had devised.

Arp first studied at the School of Arts and Crafts at Strasbourg and then at Weimar (1905–7), where he saw the exhibitions arranged by Maillol's German patron, Harry Count Kessler. Maillol's presentation of the human body as a series of formal relations having more meaning in themselves than in any activity or situation in which the body might be put may have been one of his first important revelations of the character of modern art. On several occasions before 1914 Arp was in Paris, and by the outbreak of the First World War he had contributed semi-figurative drawings to some of the most important group manifestations,

including the second Blaue Reiter exhibition in 1912 and Herwarth Walden's Salon d'Automne in 1913. Meanwhile he had withdrawn to Switzerland in 1909 to live for some months almost as a hermit at the foot of the Rigi. There he was visited by a Russian painter, D. V. Rossiné, whose investigations seem to have matched his own and to have led them both to the threshold, if not into the realm, of non-figurative expression.[41] In Arp's own words, Rossiné showed him drawings 'in which he had, by using dots and coloured lines, expressed his interior world in an entirely new way. These were not abstractions of landscapes, of human figures or objects, as in Cubist pictures. I showed him canvases that I had covered with a black web, with a network of written signs, runes, lines, and bizarre spots. They were the result of long months of difficult work. The other painters, my Swiss colleagues, had shrugged their shoulders and saw in these studies only unfinished sketches. Rossiné, on the contrary, was very excited. I believe that his investigations and mine were "concrete art".'[42]

After these first abstractions came the non-objective paintings and constructions in cut and pasted paper (the paper was cut by machine rather than by scissors in order to eliminate any 'subjective' trace of the individual hand) with which Arp and Sophie Taeuber explored the possibilities of a communal, anti-individualistic expression, their particular contribution to the Dada doctrine of anti-traditionalism. Their serious purpose was seasoned by Arp's wit, which punctured bourgeois pretensions with the keenest Dada insight. The wooden relief of 1922, *Shirt-Front and Fork* [276], mocks all pompous ceremonial, but was not designed to wound.

Arp's early training in the crafts is perhaps the reason why he worked for so many years almost exclusively in two dimensions or in shallow relief, as in the compositions of string

276. Jean Arp: Shirt-Front and Fork, 1922.
Washington, National Gallery of Art

tied to canvas or the wooden constructions
whose separate elements average little more
than an inch in depth. In conformity with the
renunciation of individualism and pursuit of
anonymous craftsmanship which he and Sophie
Taeuber advocated, these reliefs were usually
sawn by carpenters working from his patterns,
a circumstance which accounts for the existence
of multiple versions of certain examples.

Arp's presence in Cologne after the War,
where be brought news of Dada to Max Ernst,
has been noted above. He exhibited in Berlin in
1920 in the first and last Dada exhibition there,

and in 1923 visited Schwitters in Hanover, but
Paris became the centre of his activities. In
1924 he had a studio in the rue Tourlacque
near Miró's, and from that year shapes re-
sembling his began to appear in the latter's
work, although Arp magnanimously insisted
that any influence must have been the other way
round.[43] He contributed two reliefs to the first
Surrealist exhibition in 1925 and maintained
friendly relations with the Surrealists there-
after. In the late 1920s his reliefs increased in
size, became detached from the wall, even as
earlier they had become separated from their

frames, and by 1932 developed into sculpture in the round, usually in stone or bronze, although he never entirely abandoned flat, cut-out shapes in wood or metal.

Arp's insistence that his sculpture was not 'abstract' but 'concrete', because it was real in the sense that it actually existed in space, was an important contribution to the dialectic of abstract art, but it was inseparable from his belief in art as a natural rather than conceptual process. In his most quoted statement he declared: 'Art is a fruit that grows in man, like fruit on a plant, or a child in its mother's womb. But whereas the fruit of the plant, the fruit of the animal, the fruit in the mother's womb, assume autonomous and natural forms, art, the spiritual fruit of man, usually shows an absurd resemblance to the aspect of something else.'[44] His works must be thought of as 'autonomous and natural forms', only differing from animals and fruit by having been produced by a human agent; hence they are, as he sometimes called them, 'human concretions'.

Through his lifelong investigation of materials and his sensitivity to the sources of unconscious inspiration Arp played a leading role in the major movements of his time. He must be reckoned a dominant personality in any account of Dada, Surrealism, and the general history of abstract art, but while he had worked with the men who were the movers and shakers of these 'isms', he maintained his individuality intact. His Dada works rise superior to the ruck through the elegance and technical control which marks everything he and Sophie Taeuber-Arp produced. The history of Surrealism cannot be written without him, but although he dealt in dreams, they have always been benign. A leader of abstract art, he never lost touch with nature and its power to replenish human life and feeling. He was also a poet whose verses have enriched both French and German literature. Even in English translation one senses how his words and his sculpture are

interchangeable metaphors for imaginative experiences which slip soundlessly between natural and human images and feelings, as in *Pyramid Leaf* of 1939 (Baltimore), a small, bent granite form which might well have come from the Pyramids had they ever put forth branches. In a more recent work, *Evocation: Human Lunar Spectral* of 1950 [277], of which there

277. Jean Arp: Evocation: Human Lunar Spectral, 1950. *Rio de Janeiro, Museu de Arte Moderna*

are other versions in marble and bronze, the human torso is metamorphosed in cosmic and spiritual terms. With such work Arp accomplished the sculptural task which Hugo Ball defined long before in the Dada days as a striving 'to purify the imagination'.

One would have thought that the cool impersonality of his later sculpture would have recommended it to those who commission monuments for public places, but twentieth-century patronage has evaded the challenge. In 1926 Arp and Sophie Taeuber-Arp, in collaboration with Theo van Doesburg, decorated the

Café Aubette at Strasbourg, but what would surely have been one of the most important and influential modern interiors was destroyed when the building was remodelled.[45] Arp also made large wooden and metal reliefs, *Constellations* and *Configurations,* of curved and angular shapes for the Harvard Graduate Center (1950), the University of Caracas in Venezuela (1956), and the UNESCO Headquarters in Paris (1958). The first two are on long walls within and without the buildings; the last is awkwardly situated beneath a first-storey projection.

In the serene perfection of their forms Brancusi and Arp perpetuated a classic poise well into the twentieth century, often in marked contrast to the violent imagery and technical innovations of their eminent contemporaries. But their classicism was neither antiquated nor sterile. In their revelation of the sources of form and feeling, in their Goethean concern with life's primal energies, they touched upon the sources of life itself, Brancusi in the glistening, phallic images of the *Princess* (1916) and *Torso of a Young Man* (1916?), Arp in surfaces and forms so female that his *Venus of Meudon,* a small bronze of 1956, by form and title links our modern sensibilities with those of the paleolithic sculptors of Grimaldi and Lespugue.

JULIO GONZALEZ (1876-1942)

The principal modern sculptors working in Paris between the Wars have already been considered in relation to the areas of contemporary expression which their work defined - Brancusi, Arp, and Pevsner in relation to abstract art, Laurens as a continuing Cubist, and Giacometti as a Surrealist, among others. To these names one remains to be added, that of the Spanish sculptor Julio Gonzalez, whose creative career lasted only sixteen years, from

his decision in 1926 to abandon painting for sculpture, when he was already fifty years of age, until his death in 1942.

Gonzalez came of a family of metal-workers in Barcelona. In his father's shop he had learned to weld and braze many kinds of metals so that they would take the shape and appearance of natural objects, fruits and flowers, as well as conform to the more abstract designs of screens and grilles. Gonzalez, however, wanted to be a painter, and in 1900, after studying in Barcelona, moved to Paris, where he came to know his younger compatriot, Pablo Picasso. His inability for many years to discover where his true vocation lay is the more puzzling because he so quickly attained artistic maturity once the decision had been made. With the exception of a few objects cast in bronze, the majority of his sculptures were openwork structures in welded iron. His techniques and materials had until then been used only for utilitarian and decorative work and thus were new to the fine arts as was his conception of the figure as open, skeletal, and almost totally abstract. The course of his creative imagination can be followed from the first small, semi-Cubist figures and masks of African inspiration of 1927-30 to the tall standing female figures after 1931. These slim constructions of rods and bars of iron, connected by gaping arcs of metal at the junctures where head, thorax, or pelvis must be indicated, define form as empty space for the first time in Western art on such a scale and with such authority.

In 1930 Gonzalez helped Picasso to construct a number of welded sculptures. The results show his extraordinarily refined handling of his materials, but Picasso's influence on Gonzalez's work is just as perceptible and more important. Picasso enlarged and deepened his friend's iconography, enriching the spatial emptiness of the figure through the recall, at however distant a remove, of antique prototypes for the standing

278. Julio Gonzalez: Seated Woman, 1935.
Paris, Musée d'Art Moderne, Centre Georges Pompidou

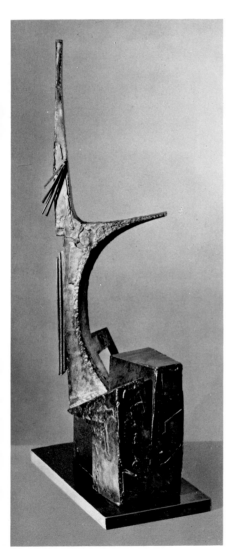

nude, and adding touches of his characteristically savage humour in a startlingly diminished knob for a head, or a cluster of spikes or actual nails for hair. By the mid 1930s Gonzalez had made this formidable imagery his own, and in certain figures put together of hollow, box-like forms of sheet metal he created a sculptural ideogram for a *Seated Woman* [278] comparable to and fully as powerful as any in Picasso's painting. Grim it may be, but as a diagram of the skeletal and muscular energies within the human figure it has a new and unsuspected power. Like Picasso's women, its strength is engendered by the ironic combination of a harsh abstract structure with witty references to the original natural form. In sum, it is a totally artistic analogue of human experience.

In 1936–7 Gonzalez created for the Spanish Pavilion at the International Exposition in Paris a life-sized peasant woman holding a child in her arms (Amsterdam, Stedelijk Museum). Formed of sheet metal, its volumes were continuous, opaque, and less adventurous than those in his earlier sculpture, but its title – he named it *Montserrat* after Spain's holy mountain – called attention to it as a symbol of popular resistance to foreign aggression in the Spanish Civil War. With the outbreak of the European War in 1939 Gonzalez had to give up working with acetylene torches, but many drawings and water-colours for sculpture, unhappily never to be realized, which he produced before his death show that he never ceased to explore, as he wrote, 'the union of real forms with imaginary forms, obtained and suggested by established points, or by perforation'.[46] During his lifetime his perforated sculpture was only rarely exhibited, but since 1945 it has proved so rich a source of inspiration for younger artists working directly in brazed and welded metals, especially in England and America, that it is difficult now to recall how truly original it was in its own time.

OTHER SCHOOLS AND MASTERS

Although the history of modern art might be, and indeed sometimes has been, written from so exclusive a point of view as to convey the impression that every important event occurred in France or has in some way been dependent upon the development of French art, the record reads rather differently. If there were few major artists of the late nineteenth and early twentieth centuries who did not spend at least some months in Paris, there were many who did not remain there. They returned to their own countries with new ideas which affected, even if they did not deflect, the course of their national painting and sculpture. To look for developments in other Western European countries comparable to those which had occurred in France is to encounter two distinct situations. In the sr ·ller countries there was often an exceptional a ust, in Belgium an Ensor for instance, whose talent developed in relation to local traditions (had Ensor settled in Paris, would he have become quite so 'Flemish'?), while, on the other hand, there may be a painter like Magritte, again a Belgian, whose art matured within an alien ideology, in this instance Surrealism, to which he continued to make important contributions regardless of his residence at home. Meanwhile other artists, whose gifts were unquestionably authentic, fertilized their national traditions with new ideas of form and content from the major centres, adjusting them to modes of feeling and expression whose significance is inseparable from the geographical region where they lived and worked. Such, for instance, was the experience and the accomplishment of Russian artists before, during, and just after the First World War. Many, however, remained largely unknown and unrecognized on the international scene. The mention of Dutch painting inevitably brings Mondrian to mind because he contributed to a store of ideas shared by artists and schools in many other countries, but Mondrian's image obscures the accomplishments of gifted Dutch artists of quite other stylistic interests. Thus the comprehension of regional and national schools is not easily accessible to those who have less affinity with their traditions or less experience of their art. English and American students, aware of the usual continental indifference to their own national arts, will understand why critics of other nations may not share their regard for Stanley Spencer or Marsden Hartley who so successfully, to their way of thinking, adapted certain formal aspects of European modernism to the traditions of English and American artistic experience.

An exception to this general situation, in which a few individuals dominant on the international scene have pre-empted the larger share of critical attention, must be made for Germany. Before the First World War Munich was a centre of truly international ferment, in Dresden the activity of the Brücke had consequences far beyond that city's limits, and after the War Berlin for a decade was a centre of radical and fruitful experimentation in many arts. Until political repression forced the German artists westwards to France, England, and America, the intellectual life of Germany was often so close to the central spiritual concerns of Europe that, even when they were most authentically German, the principal German artists could not be considered regional in a narrowly geographical or cultural sense.

After considering work by German and Austrian artists, and by the German-Swiss Klee, comparable activity in the Low Countries, Italy, and England will be examined.

ART IN GERMANY: 1920-40

In November 1918, in the very month of the armistice and the collapse of the German Empire, at a time of extraordinary political and social upheaval, a group of German artists challenged their colleagues to use their energies for the renewal of the national life through a closer union of artists and public. Max Pechstein and César Klein (1876-1954), a prominent decorative painter and early Expressionist, issued the original call for the Novembergruppe. By the choice of title they indicated their determination to turn from present humiliation to future progress. In December they were joined by other artists, including Otto Müller, Heinrich Campendonk, Hans Purrmann, the friend and follower of Matisse, and the sculptor Rudolf Belling. The founders described the organization as a 'union of radical artists' and expressed their political sympathies by the creation in 1919 of an Arbeitsrat für Kunst (Workers' Council for Art) which issued a questionnaire on the relations between artists and public, between artists and the socialist state, and on the unity of the arts for the social welfare.[1] Among the more than a hundred signatories were many well-known painters, sculptors, and architects, as well as several who were soon to become famous, representing various progressive tendencies in German art of the present and recent past. Although the membership was too inclusive and its interests too diverse for the Novembergruppe to represent a unified artistic front, by its activities, especially the many exhibitions held during the 1920s, it encouraged the parallel and contradictory development of an exaggerated, socially critical realism and of the purest non-objective expression. Despite the severe social and economic dislocation, aggravated by the disastrous inflation lasting into 1923, the revival of German art was as rapid as it was unexpected. By 1920 Berlin had become a focus of cultural energies not only for Germany but for Central Europe, a centre for brilliant experiment in music, theatre, cinema, and dance, as well as in the other arts.[2]

One of the most gifted propagandists for the new art forms was Herwarth Walden (1878-1941?), musician, composer, and man of letters, but best known as the energetic proprietor of the activities embraced under the title Der Sturm (The Storm). These consisted of a publishing house and journal, founded in 1910, to which Walden added an art gallery two years later. Through the first two institutions he published work by the leading and often still highly controversial German prose writers and poets, and in his gallery, where he held more than 100 exhibitions before he had to close it in 1932, he showed for the first time in Berlin the works of the principal German and European Expressionists, Cubists, Futurists, and Constructivists. Among them his First German Salon d'Automne (his first and only one), held in the autumn of 1913, ranks with Roger Fry's exhibitions of 1910 and 1912 as one of the few occasions when one individual comprehended the fundamental directions of the modern movement and was able to demonstrate them with paintings and sculpture, many of which are still of primary artistic and historical importance. Walden's own publications were often polemical and occasional, but even his brief treatises were essential contributions to the definition of the modern aesthetic. When the economic depression of the 1930s and the rise of National Socialism compromised his activities Walden emigrated, not westward, as had so many of the artists he promoted, but eastward to the Soviet Union, where he is said to have perished as a political prisoner in 1941.

Although by this time Expressionism had become generally recognized as a specifically German contribution to modern art, the original Expressionists played only a small part in the development of post-war painting. In the bankruptcy of traditional values that accompanied the political and military debacle, the subjective and individualistic works of the Brücke and Blaue Reiter artists were at a discount. The new painting of the 1920s was based on other artistic, social, and psychological premises. The differences may be traced in part to the activities of the Dadas in Berlin after 1917 (see above, pp. 378 ff.). Their iconoclastic rejection of all values, social as well as artistic, led to little in the way of actual production, but their attitude encouraged an exaggeratedly descriptive form of anti-idealistic, realistic painting.

GEORGE GROSZ AND OTTO DIX

The connexion between Dada disorder and a new concept of realism can be traced in the work of George Grosz and Otto Dix. While still a student in Berlin before 1914 Grosz (1893–1958) had encountered many aspects of European modernism, and during a six-months' stay in Paris in 1913 he came to know French Cubism and Italian Futurism, the dominant stylistic influences in his early work. He was primarily a draughtsman, and even before the War his drawings expressed what he later described as his 'profound disgust with life'. Military service confirmed his hatred of people and of the Prussian military caste, whose moral standards he had learned to know in childhood when his widowed mother ran an officers' club in Pomerania. In drawings of his military

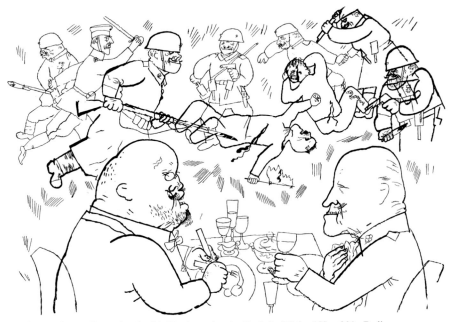

279. George Grosz: Illustration for *Die Tragigrotesken der Nacht* by Wieland Herzfelde, Berlin, 1920

experiences and of life in Berlin after his medical discharge in 1917 he combined Cubist and Futurist mannerisms with a deliberately childlike line, which in its nervous contours and hesitant cross-hatchings resembles Klee's adaptations of children's drawings of a few years before. His unforgettable images of the moral disintegration of German society can be considered a Dada protest in which he exposed the meaninglessness of human activity with a technique which was meaningless by traditional standards. During the Dada heyday in Berlin (1917–20) Grosz was a prominent member of the group and participated in its major exhibitions. His collages of photographs and drawings, many done in collaboration with John Heartfield, were among the most bitter Dada jibes at social hypocrisy, but their seriousness set them apart from the typical Dada jest [227].

Collections of his drawings, issued under such ironic titles as *The Face of the Ruling Class* (1921) and *Ecce Homo* (1927), earned him an international reputation as a leading artist of the Left. He later renounced Communism, and after 1920 the tenor of his satire became less incisive as his line grew softer, his colour brighter, and his themes less specifically critical. But at his most intense he had never shown the sympathetic understanding of the poor which made Käthe Kollwitz's lithographs so poignant. His workmen and soldiers are little less insufferable than their oppressors [279]. To the officer, the priest, and the profiteer they present an ignorance which may be quite as corruptible. Yet within these emotional limitations Grosz was a master satirist. No one since Daumier has left such a complete record of a particular historical situation, a horrifying, intensely circumstantial German report on Berlin between 1914 and 1924.

After 1921, when overt opposition to the Weimar Republic became more difficult, his work changed in content as well as in technique. Mutilated veterans begging at restaurants where bloated businessmen fondle their ladies of the evening disappeared, and the blatant depiction of sexuality was transformed into more subtle psychological explorations. He also abandoned his awkwardly naïve line for a painstaking treatment of detail in the manner of late medieval German painting. The gnarled hands in the portrait of the poet Max Hermann-Neisse of 1925 [280], as sharply focused as those in the work of Otto Dix, are in the expressive tradition of Grünewald.

When Grosz's career was endangered by the rise of National Socialism, so many of whose worst features he had foretold in visual terms, he emigrated to the United States, where he was welcomed as a social critic who might explore the problems of American life in the depths of the economic depression. But with an exile's nostalgia for the past and his own desire to complete his experience as an artist, he developed a style in oil painting devoted in turn to expressively neutral landscapes, figures, and still life, and to nightmare visions of an apocalyptic future which were too literal or too fantastic for American taste. Finally, after twenty-seven years' absence from Germany, Grosz returned to Berlin, but died unexpectedly a few days after his arrival.

In the 1920s Otto Dix (1891–1969) was less well known, even in Germany, than Grosz, but his indictment of society was as searching, and his visualization of social evils more circumstantial and shocking. Dix was always more a painter and print-maker than a graphic journalist, the role which Grosz had made his own. Before 1914 he was interested in traditionally Germanic pictorial realism. The stiff composition and flattened spaces in his early portraits owed as much to Hodler as their menacing facial expressions and his refusal to idealize the facts of physical existence did to such earlier artists as Cranach and Dürer. For him, too, the War was morally and emotionally disgusting, and his anger and revulsion were

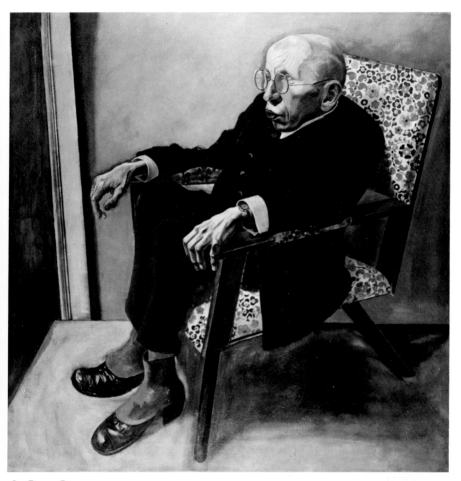

280. George Grosz:
Portrait of the Poet Max Hermann-Neisse, 1925.
Mannheim, Städtische Kunsthalle

later visualized in shattering images of pain and cruelty meaninglessly inflicted on the living, dying, and dead bodies of the common soldiers. The fifty etchings published as *Der Krieg* (*The War*) in 1924, and the large painting of trench life, *Die Schützengrabenbild* (now lost or destroyed), are perhaps the most powerful as well as the most unpleasant anti-war statements in modern art. In his genre pictures, if his unflinching depiction of the corruption of modern society can be so described, he attacked the pretences of modern life more in terms of personal weakness and folly than of class oppression. His triptych *Die Grosstadt* (*Metropolis*) of 1927 exposed the unsavoury aspects of the urban underworld and its night-life in a

manner as cynical as that of the contemporary operas of Kurt Weill and Berthold Brecht, *Die Dreigroschenoper* (*Beggars' Opera*) of 1928 and *Aufsteig und Fall der Stadt Mahagonny* (*Rise and Fall of the City of Mahagonny*) of 1930. Grosz, more politically conscious, saw his disagreeable figures as members of a class of oppressors or oppressed. Although Dix came from the industrial proletariat, his father having been an iron-worker, he, like Brecht, treated his people as individuals. However marked as members of a class by dress or posture, they suffer and exert themselves as individuals. In his portrait of the journalist Sylvia von Harden of 1926 [281], he condemned the social and spiri-

281. Otto Dix: Portrait of Sylvia von Harden, 1926. *Paris, Musée National d'Art Moderne*

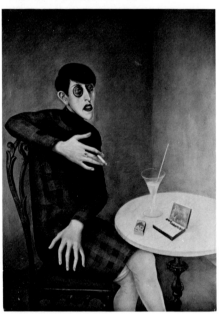

tual values of an era, as well as of a way of life, by a merciless analysis of a particular person.

In 1924 a sympathetic critic remarked that Dix 'didn't give a damn about aesthetic values',

and was concerned only with 'the most crass immediacy' of experience.[3] It was this quality of unmitigated truth, truth to the most commonplace and vulgar appearances, as well as to the ugly realities of psychological experience, that gave his work a strength and consistency attained by no other contemporary realist, not even by Grosz, and which in the last years of the Weimar Republic, whose chronicler in a way he became, brought him a measure of recognition. In 1931 he was elected to the Prussian Academy, but two years later was dismissed from his professorship. During the Nazi régime he lived quietly on the Bodensee, and after the Second World War his academic honours were restored.

By 1923 the contrast between the visual clarity of Dix, Grosz, and their followers, and the earlier more abstract art of the Brücke and Blaue Reiter had become so perceptible that the term Neue Sachlichkeit (New Objectivity) was adopted by G. F. Hartlaub, the director of the Kunsthalle in Mannheim, for an exhibition in which he planned to chart the development of post-war painting. Two years later the critic Franz Roh, in a book on 'Post-Expressionism', used the phrase 'Magic Realism' to distinguish the new painting from the more impersonal realism of Leibl, Thoma, and other German followers of Courbet.[4] Both terms emphasize the technical more than the expressive aspects of this painting, but the words are of less moment than the fact that the art which can be related to the concept of Neue Sachlichkeit reaffirmed the fundamental tendency of all Expressionist art to assert the priority of content over form, to the extent that form is considered the vehicle for pre-existing meanings. The term Magic Realism also suggested a connexion with Surrealism, which had been defined in Paris in 1924. Both movements were related to Giorgio de Chirico's discovery of the mystery and magic of spatial perspective (see above, pp. 391 ff.). De Chirico

was considered by the French Surrealists one of their important predecessors, and his works were known to both Grosz and Dix, but the Germans eschewed the automatic procedures of orthodox Surrealism, their psychological explorations were more descriptive than intuitive, and their interest in contemporary social problems, however critical, was more humane. Grosz and Dix had first stated the uncertainty of man's existence in the post-war world by describing, with frightening fidelity, the face of evil. The problem was formulated with less realistic techniques, but in more philosophical and spiritual terms, by Carl Hofer and Max Beckmann.

George Grosz and Otto Dix were the ablest, and they remained the most convincing exponents of Neue Sachlichkeit. Such painters as Kurt Günther (dates unknown) and Heinrich Davringhausen (1900–70) shared their social philosophy, but their methods were by comparison meagre and dry. A simplified, at times primitivistic, objectivity was practised by Alexander Kanoldt (1881–1939), once a member of Kandinsky's NKV in Munich, but his concentration on design at the expense of content led to quite empty formal harmonies. The spatial generalizations of Georg Schrimpf (1889–1938), a self-taught artist, occasionally have a naïve charm, but his realism lacked the sharp focus which would have made it truly 'magical'.

CARL HOFER AND MAX BECKMANN

The artistic ancestry of Carl Hofer (1878–1955) and Max Beckmann (1884–1950) may be traced to Hans von Marées, who earlier had sought to escape the restrictions of late nineteenth-century naturalism by recovering the ideal grandeur of classic art. Hofer discovered Marées and his classic sources when he studied in Rome from 1903 to 1908. During the following five years in Paris he learned to equate German and Italian idealism with Cézanne's structural space. Surprised in France in 1914 by the outbreak of hostilities, he was held three years a prisoner of war. His memories of that time must have been ineradicable, because even years later the constraint of his figures and their hesitant gestures seem affected by physical or psychical confinement.

After his return to Germany he settled in Berlin, where he was appointed to the staff of the Hochschule für bildende Künste and became a member of the Prussian Academy in 1923. His clear designs and usually static figures are deceptive, for they only just conceal the spiritual discontent moving below the surface of his work. Hofer rejected Expressionist 'ecstasy' as earnestly as he avoided the charms of Impressionist brushwork, preferring an apparently impassive order and an impersonal surface. 'One must', he said, 'have the courage to be unmodern.'[5] But this order was always phrased in terms of modern life, whether as appearance or as spiritual experience. The simplicity of his design and his cool, chalky colours were the means with which he could simultaneously hide and reveal his inner dismay. The hypocrisy and madness of modern life are unmistakably the content of his carnival scenes, and of such pictures as the *Men with Torches* of 1925, where nude figures grope through a thorny midnight wood, or *The Black Room* of 1930, where similar men, one beating a drum, are lost in a restricted and spatially ambiguous interior. More subtle, and in the end more moving, are his brooding figures, singly or in couples, whose only defence against the collapse of traditional values is their intimate and entirely human understanding of each other and of themselves [282].

Hartlaub included Beckmann in his list of 1923 as a master of the Neue Sachlichkeit, but to do so now would be to overlook the differences between his symbolic presentation of the human predicament and George Grosz's

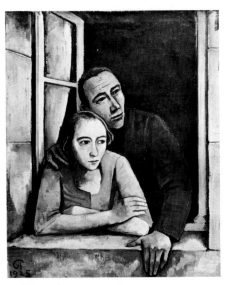

282. Carl Hofer: The Couple, 1925.
Fulda, Germany, private collection

or Otto Dix's cynical description of it. At the time, however, Beckmann's attention to the visual appearance of people and objects seemed a part of the new realism, just as his often caricatural treatment of figures and events in his drawings and etchings of the First World War contained traces of Dada irony and technical eccentricities.

As a student at the Weimar Academy and during his travels in Italy and France (1903-6), Beckmann's tastes were conservative. He was attracted by painters who had discovered a monumental pictorial form for the expression of dramatic and philosophical subjects. He admired Signorelli and Piero della Francesca for their majestic union of form and space (his first successful painting, the *Young Men by the Sea* of 1905 now at Weimar, was based on Signorelli's *Triumph of Pan*), and he looked to Tintoretto and then to El Greco for his early *Resurrections* of 1906 and 1916-18 (Munich-Gauting, Collection Dr Peter Beckmann) in

which he combined historical and contemporary personages in order to enlarge the expressive range of the theme.[6] Even more important was his discovery of medieval painting in the exhibition of French Primitives in Paris in 1904. Like others since, he was deeply impressed by the remote and rigid pathos of the Avignon *Pietà*. Among contemporary artists, he was aware of Edvard Munch's interpretations of the emotional climaxes of modern life, which affected his own *Great Death Scene* of 1906 (Munich, Collection Günther Franke). These early paintings were executed with an energetic brush stroke and even a bravura like that of the German Impressionists, Liebermann and Slevogt, and of Corinth, whose harsh retelling of biblical history with contemporary overtones was especially influential.

During his service in the First World War in the medical corps Beckmann contracted a serious illness. He spent a long convalescence in Frankfurt and remained to teach in the academy. Again like Grosz and Dix he knew the horrors of war, especially those perpetrated on living flesh, but he rarely depicted military scenes. Instead, throughout his work mutilated figures appeared as pitiful reminders of the extent of man's hatred of himself.

In Frankfurt Beckmann discovered, like the Expressionists of a decade before, the relevance of medieval design for his own problems. In two large paintings of 1917, *The Descent from the Cross* (New York) and *Christ and the Adulteress* (St Louis), the bodies are stiff and angular, the folds of clothing sharply delineated as if projected in relief from a steeply tilted background plane. In place of the earlier, densely painted surfaces, the brush is used like a draughtsman's tool, and shapes are as much drawn as modelled. A tendency towards vertical design, also characteristic of late medieval painting, obliged him to represent his figures from more than one point of view, as if seen from above and below a central point, in order

to maintain the two-dimensional unity of his picture plane. The result was an increasingly strong tension between form and space, the space of each picture seeming inadequate to contain the figures, which could move laterally more easily than into depth. In *Night* of 1919 [283], the most memorable of his first post-war paintings, Beckmann proved that this tight space was the appropriate arena for his peculiar kind of action. The scene presumably represents the violent intrusion of a criminal gang into an ordinary middle-class household, a reference to the civil violence which racked Germany at the

time. As a documentary artist Beckmann here rivalled the masters of the Neue Sachlichkeit, who must have admired the inhuman callousness of the shrill gramophone on the floor, or the pipe clenched in the teeth of the figure breaking the hanged man's arm. But the picture is more than a journalist's comment on the collapse of civil morality, for its figures, although contemporary, can be seen as personifications of human vice. The subject of the painting is also sadism, murder, and lust in action. Therefore it treats of constant as well as specific conditions, expressed not only by

283. Max Beckmann: Night, 1919.
Düsseldorf, Kunstsammlung Nordrhein-Westfalen

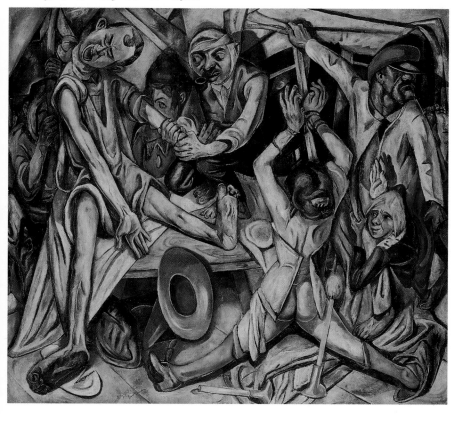

gesture and deed but also in the tension between form and space. So incoherent are the spaces of this picture (for instance, the distance which separates the body of the woman in the foreground from her hands, which are tied to the window frame on the other side of the table) that one cannot speak of a single, empty volume in which the figures are placed. And we can only believe that the reality of the events depicted is not so much physical as psychological. The interiors in the family scenes which followed are less alarmingly populated, but the psychological distress of the participants is even more marked in *The Dream* of 1921 (St Louis, Collection Mr Morton D. May), which was soon recognized as a profound rendering of mental disorientation.[7] In a densely compacted vertical composition an ill-favoured peasant girl contemplates, with open but unseeing eyes, four blind, drunken, mad, and mutilated figures who, like those in the works of Grosz and Dix, may stand for the mental and physical casualties of modern urban society.

With the end of the inflation and the momentary stability of the German economy in the later 1920s Beckmann's painting became less morbid but little less cynical. In his café, hotel, and beach scenes the hectic but superficial gaiety of the times was interpreted in less congested compositions in which the use of black as a foil for a few strong colours created a continuous and sober undertone. In a series of self portraits in many media and from almost every year of his life he recorded the changing physiognomy of his spiritual experience.

When Beckmann was forced to resign from the Frankfurt Academy in 1932, he moved to Berlin, where he began the first of nine large triptychs, the culmination of his artistic philosophy. In five of these he transposed the actual banality of ordinary life, with its casual cruelties and indirect assaults upon our persons, to a higher level of reality by treating it in terms of the stage, the carnival, and children's games (although played by adults). In two paintings the subjects were drawn from the classical myths of Perseus and the Argonauts, heroes who undertook perilous journeys and were beset by irrational and daemonic enemies. The fact that Beckmann, in order to deceive the Nazis should they search his house in Berlin, wrote on the back of the first canvas 'Scenes from Shakespeare's *Tempest*' invites us to consider *Departure* (New York), as it is now known, an allegory of flight and voyage. On one level it can be read as a statement of the artist's decision to emigrate from a Germany whose spiritual decay was symbolized in the side panels by mutilated, trussed, and tortured men and women, and on another as the artist's belief that wisdom, justice, and mercy, represented by the crowned king and the woman and child in the central panel, must depart for a more serene world beyond the brilliant blue sea on which they have embarked, guided by a mysterious hooded figure holding a large fish.[8] This is the most obvious reading of Beckmann's images, but since many of them had occurred in his earlier work, especially the bound and butchered men and women, the monstrous birds and fish with their sexual implications, and the jazz-age iconography drawn from life in de luxe hotels, theatres, and bars, each of these forms must have acquired for the artist a deeply personal meaning. Yet they are not completely hermetic. As with the metaphors in modern poetry, we can apprehend their general tragic significance before we can interpret their private meanings.

In *Temptation* [284], finished in 1937, the year of Beckmann's flight to Holland after he had been proscribed as a 'degenerate artist', the central figure, a painter made impotent by circumstances beyond his control (chained by his wrists and ankles), contemplates a nude model. Beside her stands a dark female fertility figure, and behind that lurks a larger, inscrutable

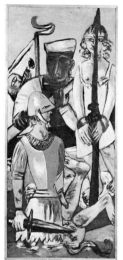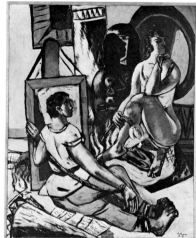

284. Max Beckmann: Temptation, 1937.
Munich, Bayerische Staatsgemäldesammlungen

black presence. These are, perhaps, the abstract and mysterious powers of art, opposed in the artist's imagination to the model's seductive, living flesh. The side panels, in which the Antonine themes of sadism and sexual frustration are the dominant expressive motifs, are among Beckmann's most complex and monumental compositions. Instead of a ' "philosophical conception" painted purely intellectually', which Beckmann considered ridiculous or irrelevant, the spectator is assaulted by the artist's 'terrible fury of the senses grasping each visible form of beauty and ugliness'.[9] But to describe is not to explain, and much is still mysterious. Few have noted that beneath the artist, if such he be, are some papers, on one of which is inscribed the first words of St John's Gospel: 'In the beginning was the Word . . .'

Even during the difficult spiritual and physical conditions of war-time Amsterdam, where Beckmann was unmolested by the invaders, he completed five more triptychs, including *Blind Man's Buff* in 1945, a depiction of the irrelevant pastimes of a society scarcely aware of its corruption. His diary of these years, continued through his life in the United States, is a remarkable psychological concordance to his art. In 1947 he was invited to teach at Washington University in St Louis, a city known for its appreciation of German culture. The powerful design and brilliant colours of his late works were admired by a small but discriminating public whose encouragement enabled him to paint with undiminished vigour until his sudden death three years later.

In adopting the form of the medieval triptych (which had already been used by Marées, Stuck, and Klinger among Beckmann's masters, and by such contemporaries as Heckel, Macke, and Dix), Beckmann called attention to the fact that painting can be, if the artist wills, a vehicle for the communication of specific spiritual values. The ecclesiastical and theological associations of a triptych suggest that

such a painting is a modern altarpiece whose didactic purpose, as in the past, is the setting forth in visual terms of man's plight and of his means of salvation. But in choosing so public a format Beckmann abrogated none of the privacy which is the essential condition of modern artistic creation. The problem he set himself could only be solved through the self: '. . . to find the Ego, which has only one form and is immortal – to find it in animals and men, in the heaven and in the hell which together form the world in which we live.'

We can now see that Beckmann's art, which had begun as an instrument of social and psychological criticism, became increasingly philosophical and spiritual, and that it can be thought, despite the predominance of secular imagery in his later work, to have an almost religious significance as a definition of the ultimate values of human life. The terms of this definition, like life itself, are contradictory, but Beckmann's art was based on a primary artistic contradiction between forms and a space too small to contain them. In his paintings such conflicts and contradictions are ultimately to be understood in relation to his concept of 'God as a unity creating again and again a great and eternally changing terrestrial drama', a drama in which, as Beckmann said, 'my figures come and go, suggested by fortune or misfortune . . . [but] divested of their apparent accidental quality'.

GERMAN SCULPTURE: 1920–40

By 1920 the principal directions that progressive sculpture was to take in Germany had been determined. Before his death in 1918 Wilhelm Lehmbruck had reached a degree of geometrical stylization that might have led him to abstraction, the direction taken by Rudolf Belling in Berlin, by Oskar Schlemmer at the Bauhaus, and by Otto Freundlich in Paris a bit later. Among the Expressionists the outstanding sculptor was Ernst Barlach, who succeeded in communicating intense emotion through posture and gesture (see above, pp. 188–9). If there was relatively little strictly Expressionist sculpture in Germany or elsewhere, the reason may be sought in the essentially pictorial character of the Expressionist position, which required above all a quality – spontaneity – which is the most difficult for the sculptor to achieve. In France, too, the contemporary counterpart to the Fauve work of Matisse and Derain, when it was not Matisse's own bronzes, was the massive sculptural repose of Maillol. In much of the best German sculpture of the period, most of it necessarily executed before 1933, the classicizing qualities of Maillol, who was well known in Germany through exhibitions and through Lehmbruck's interpretations, was variously combined with the pathos inherent in the Expressionist subject.

Classicizing tendencies are conspicuous in the work of Georg Kolbe (1877–1947), whose favourite subject was the nude figure. He owed his popularity in the 1920s to his rhythmical statements of fresh young bodies in motion, frequently recalling the expressive gestures of the contemporary dance. On one occasion, when his nude *Dancer* was chosen by the German government for the pool in Mies van der Rohe's pavilion at the Barcelona Exhibition of 1929, his work could be seen within the most advanced architectural context of the day. But that moment quickly passed. The National Socialists approved of his technique quite as much as of his subjects, and after 1933 Kolbe extolled the virtues of health and joy through increasingly monumental and proportionately stereotyped nudes, scarcely to be distinguished from innumerable others, no more but no less competent, which are so conspicuous a feature of German academic sculpture. None the less such work should not be allowed to conceal the rhythmic invention and technical perfection of his earlier figures.

Gerhard Marcks (1889–1981) shared Kolbe's preoccupation with the human figure, but his relatively static or at least undramatic poses appear at first deceptively simpler, although their expressive content is actually more complex. Marcks had taught at the Bauhaus in 1920-5, when Expressionism was still an operative factor – Feininger and Itten were there then – and he understood the relevance of medieval art for modern times, although, unlike Barlach and Beckmann, he did not seek the extremities of emotional expression. Gentler than the work of either, his elegiac figures have something of the rigidity of medieval carvings, which confers upon their otherwise unexceptional proportions a poignant naïvety [285]. Equilibrium between such expressive and formal values is difficult to maintain, and Marcks has been most successful in his smaller and very human figures. Upon a larger scale or a grander occasion, as in his mourning woman beside the church of St Maria im Kapitol in Cologne, neither gesture nor form is adequate as a memorial to the city's civilian dead in the Second World War.

The early animal sculptures of Ewald Mataré (1887–1965) were simplified almost to the point of abstraction, suggesting that he had taken up the bucolic theme where the members of the Blaue Reiter had had to leave it in 1914. After 1945 he executed several large religious commissions, including bronze and mosaic doors for the south transept of Cologne Cathedral, where his wit enlivens the serious subjects. The work of the Munich sculptors Toni Stadler (b. 1888) and Heinrich Kirchner (b. 1902) is more archaizing, but, in addition to the immediacy of expression which they admired in works as early as the eleventh-century Hildesheim doors, they have not ignored the robust humours of peasant and folk

285. Gerhard Marcks: Standing Youth, Johannes, 1936. *Hamburg, Galerie Rudolf Hoffmann*

art. Now that German sculptors are again in communication with artists elsewhere and the repertory of abstract and Constructivist sculpture is internationally dominant, the work of these artists, Marcks included, for all its fine qualities must seem somewhat out of touch with contemporary expression.

'ENTARTETE KUNST' (DEGENERATE ART)

Under the Weimar Republic the identification of modern art with political activity had led to the misrepresentation of artistic purpose and even the proscription of actual objects. The difficulties encountered by the Bauhaus at Weimar have been noted (see above, p. 333). In 1930 Oskar Schlemmer's murals in the stairway of the former Bauhaus building were whitewashed, and works by Barlach, Klee, Feininger, and others were removed from an exhibition in the Schlossmuseum at the suggestion of Paul Schultze-Naumburg (1869–1949), a prominent landscape architect whose *Kunst und Rasse* of 1928 was one of the influential treatises identifying art with theories of racial supremacy.[10] Upon Hitler's accession to power in January 1933, the National Socialist attack on modern art spread quickly across Germany. In the first exhibition designed to bring such art into disrepute, held that year in Karlsruhe under the title 'Regierungskunst von 1918 bis 1933', the emphasis was on the weakness of the Weimar Republic, which had permitted museum directors to spend for such art vast sums of public money (in devalued inflationary marks, to be sure). Soon after, similar exhibitions at Mannheim of 'Kulturbolschewismus' and at Stuttgart of 'Kunst im Dienste der Zersetzung' (Art in the Service of Demoralization) linked the political betrayal of the German people with Communism and immorality.

The Nazis' shrewd realization that art could be a useful instrument for the subjection of society was strengthened by the racial theories of Alfred Rosenberg. His notorious *Myth of the Twentieth Century*, first published in 1930 and many times reprinted, was a synthesis of earlier racist theories of art, but it contributed significantly to the official Nazi position, already sketched by Hitler in *Mein Kampf* (1926-7) and developed by the Führer in many party speeches. This position was made clear in 1937 when two exhibitions opened simultaneously in Munich. The first, installed with great care in the new Haus der Deutschen Kunst (now the Haus der Kunst), a dull semi-classical building by Hitler's favourite architect of the day, Paul Ludwig Troost, was a collection of scrupulously naturalistic portraits, landscapes, and genre scenes extolling the power of the Nazis and the virtues of German life in Hitler's terms of 'Church, Children, and the Home'. The next day, 19 July, the notorious exhibition of 'Entartete Kunst' (Degenerate Art) opened in the arcades of the Hofgarten near by, cunningly arranged to emphasize the supposed ugliness, subversiveness, and technical inferiority of modern art. By decree of the Minister of Education twenty-five of the principal museums had been required to surrender works for the exhibition. Most of the artists who then and since have been considered the leading painters and sculptors of twentieth-century Germany were included, but objects by artists of much lesser merit lent the exhibition a general air of artistic incompetence. In addition, works by the incurably insane were introduced as object lessons, and the identification of the Jewish race with the theoretical decline of German art was pointed out in explanatory, and defamatory, labels.[11]

Meanwhile the expropriation of works of art from the German museums was so drastic that a total of 16,550 objects, including prints and drawings, is believed to have been removed from public collections. The great majority were German, but many by such masters as

Gauguin, Van Gogh, Munch, Picasso, Braque, Matisse, and Chagall were also confiscated. A handful of these were sold at public auction in Lucerne in June 1939. More were privately disposed of through selected dealers, who were allowed to export them abroad. A thousand oils and almost four thousand prints and drawings which remained unsold or unsaleable were secretly burned in Berlin in March 1939. The cultural impoverishment of Germany was incalculable, and probably permanent. Since 1945 a few museums have succeeded in re-acquiring some of the works they had lost, but they are much in the minority.

In addition to the removal or destruction of works of art, the Nazis attacked the bodies and minds of independent artists. Those who were teachers were dismissed from their posts and stripped of their academic honours. Anyone who persisted in his own way was rendered powerless by the *Ausstellungsverbot*, which forbade an artist to exhibit his work, and in extreme cases by the *Malverbot*, which forbade him to work. This series of events and regulations differed only in thoroughness and brutality from similar practices in other totalitarian states which have recognized the threat to the *status quo* inherent in the free practice and experience of art. But the fact that the greatest number of objects by any one artist to be declared degenerate was the work of Emil Nolde, who had been a member of the party, was of pure 'Nordic' extraction, and not immune to ideas of 'blood and soil', suggests that political expediency and racial theories were only temporary incidents in the longer history of the public's antipathy to new forms of expression and its belief that modern art is an insidious attack upon traditional culture, an experience which was not Germany's alone. This hostility had been fostered by reactionary critics many times over before 1933, notably in such publications as Max Nordau's *Entartung (Degeneration)* of 1892–3, and in 1911 by the *Protest Deutscher Künstler*, written by a minor Worpswede painter, Carl Vinnen, who secured 120 signatures for his 'protest of German artists' against the importation of contemporary French painting into Germany and its supposedly deleterious effect on German art. But until the appearance of Hitler, both the artist's person and his production had been immune from legal action by the state.

AUSTRIAN EXPRESSIONISM: RICHARD GERSTL AND EGON SCHIELE

The development of twentieth-century painting in Vienna began, much as in Paris, Munich, and Moscow, with the discovery of the older Expressionist masters by younger men who were weary of the sophisticated refinements of Art Nouveau and Jugendstil. As in other European capitals between 1901 and 1910, there were exhibitions of Van Gogh, Gauguin, Cézanne, and Munch which opened the way to more personal, more immediate, and often more violent pictorial styles no longer controlled by arbitrary decorative patterns. Gustav Klimt himself, one of the founders and the first president of the Vienna Sezession, and Austria's principal master of flat-pattern painting (see above, pp. 135–6), withdrew from the Sezession in 1905, but his further explorations were confined to his own exotic territory. Although the Sezession's importance waned after 1905, it cannot be underestimated as a focus for progressive artistic energies, whether of attraction or repulsion. Its brilliant exhibitions at the turn of the century introduced to Vienna the major masters of *fin-de-siècle* painting, especially Hodler and Munch, whose introspective and even neurotic content and unnaturalistic forms found a sympathetic response in the city of Freud and Schoenberg, of Arthur Schnitzler, Hugo von Hofmannsthal, and Gustav Mahler.

One factor which had been conspicuous in the development of modern art elsewhere was lacking in Vienna. The major French Impressionists were so little known that the younger painters immediately before and after 1900, unlike their contemporaries elsewhere, could not experience the Impressionist discipline of seeing nature directly and stating one's vision as simply as possible. The torments and frustrations of Austria's art and artists, stylistically as well as biographically, were perhaps inevitable in a society whose cultural instability was soon to end in its political dissolution.

The brief life of Richard Gerstl (1883–1908), who died by his own hand, is almost a paradigm of the Austrian artist's dilemma, caught between exhausted academic and late Symbolist traditions, and the new and unexpected forms of expression imported from abroad. Gerstl was born in Vienna and studied there in the Academy. By 1905 he had outgrown the Sezession style of Klimt, whose decorative patterns are apparent in his early landscapes, and occasionally in the backgrounds of his figure paintings. Between then and his death at twenty-five he had only time to paint a remarkable series of portraits, including two groups of the composer Schoenberg's family. At his best he went quite beyond decorative linearism to a manner so painterly that it now seems prophetic of the later work of Munch and Kokoschka. It is difficult not to think that in such a portrait as *The Sisters* [286], probably of 1907, he was aware of the new psychological dimensions of human personality which were being investigated at this time by Austrian writers and physicians. His work was almost unknown until the early 1930s, when it was seen in several exhibitions in Austria and Germany. It is experimental, often contradictory, and even at times incoherent, for he died before his ideas and the influences to which he responded could coalesce in an entirely integrated manner, but his few finished paintings are

unforgettable examples of an intensely personal Expressionism.

Egon Schiele (1890–1918), born at Tulln on the Danube, was young enough to be influenced by the French Impressionists, whose works were seen more frequently in Vienna by 1907, but in that year he met Klimt and succumbed to the spell of the latter's emphatic linearism. Schiele was, however, the more modern of the two. He twisted the Sezession style to his own purposes, until the angular outlines of his figures were dictated less by decorative considerations than by an inner emotional stress which seems to have forced them, like some form of spiritual arthritis, into odd and ungainly postures. Their hands are bony and swollen, and their huge eyes, which look beyond the spectator, are like pools of despair [287]. Schiele 'wanted to look inside . . . such passionate people', as he wrote in 1911, '. . . for some of them recognized the gestures of insight, and they no longer asked'.[12]

In addition to figure studies and a number of remarkable portraits contemporary with Kokoschka's images of Viennese society, Schiele made many drawings and lithographs of nude figures, often in positions of anguished or lonely eroticism. Had his nudes been more robust, they might have the less offended, but their pitifully naked and emaciated state told too much about the agonies to which the body subjects the spirit. In 1912 Schiele was arrested, imprisoned for twenty-four days, and a number of his drawings were burned. In retrospect this premonitory warning of the cultural storm which was to overwhelm the Germanic countries on the eve of a later war seems symptomatic of the discrepancy between psychic reality and public morality in many modern societies. Although the range of Schiele's art was as narrow as its span was brief, it was widely known and admired through his participation in many exhibitions throughout Europe before his sudden death at the end of the First World

287. Egon Schiele: The Family, *c.* 1917.
Vienna, Österreichische Galerie

War. It deserves to be remembered for the intensity with which he recorded the postures of human anguish.

OSCAR KOKOSCHKA (1886–1980)

The origins and early development of Kokoschka's art are inseparable from the culture of the *fin-de-siècle* Vienna that nourished Gerstl's and Schiele's, but his long life was enacted on a much broader stage, and the difficulties which crippled their expressions were resolved by his more strenuous and on the whole more optimistic personality. As a student in the Vienna School of Arts and Crafts and as a member of Josef Hoffmann's Wiener Werkstätte between 1904 and 1909, Kokoschka was influenced by Klimt and the decorative artists of the Jugendstil. His earliest work, especially his graphic art, has the flat ornamental pattern,

the medievalizing subjects, and the tone of Maeterlinckian remoteness familiar in the late Symbolist productions of the Nabis, of Mir Iskusstva, and even of Kandinsky's contemporary work in Munich. In the delicate eroticism of his first important illustrations, the coloured lithographs for *Die träumenden Knaben* (*The Dreaming Boys*) of 1908, there is even a hint of the wistful melancholy at the loss of innocence which is found in the paintings of Picasso's Blue Period.

After Kokoschka had seen the work of Van Gogh in 1906 he began a series of portraits in which his sitters, often prominent in society or in artistic and intellectual circles, surrendered their 'closed personalities, so full of tension',[13] so that the painter could reveal their emotional and intellectual disequilibrium. It is difficult not to think that his pursuit of the most evanescent aspects of personality had been encouraged by Freud's insistence that psychic states were objective, scientific facts. The portrait of the *Marquis de Montesquiou* [288] is a brilliant characterization of an individual as well as a summary of an era. In this, as in most of his earlier paintings, colour was less important than the sensitive tracery of line upon and even below the painted surface, unravelling, as it were, the secrets of a spiritual physiognomy much as Van Gogh had done in his portrait of Dr Gachet [44].

At this time Kokoschka was driven to project his visionary awareness of life as a continual struggle against irrational forces in allegorical and violently Expressionist poetry and drama. In 1908 the public reaction to his decorative work, including *Die träumenden Knaben*, at the first Viennese Kunstschau, the successor to the Sezession as a rallying ground for progressive artists, had been so violent that he was dismissed from the School of Arts and Crafts. At the Kunstschau the next year the production of two of his plays, *Sphinx und Strohmann* (*Sphinx and Strawman*), a satiric comedy, and

288. Oskar Kokoschka: Le Marquis de Montesquiou, 1909–10. *Stockholm, Nationalmuseum*

Mörder Hoffnung der Frauen (*Murder Hope of Women*), a wild drama of blood and lust, caused such a commotion that the artist, described in the Press as a 'talented terror', was obliged to leave Vienna. He travelled in Switzerland and Germany, and in 1910 was invited by Herwarth Walden to contribute to the journal *Der Sturm*, where many of his most famous portrait drawings appeared during the next two years.

After 1910 the violent physical distortions of his portraits gave way to a more objective treatment of the figure, somewhat influenced by Munch, whose work had become known in Vienna. These were also the years of his relationship with Alma Mahler, the composer's widow. In 1914 Kokoschka created his first large allegorical painting to symbolize the intensity and the approaching end of their passion. In *The Tempest* or *The Bride of the Wind* [289], the artist and the woman sleeping beside him are tossed on a wild sea. Colour is of little moment; the greys and blues shot with white, green, and red underline but do not create the nightmare mood, which is conveyed by light and line. The storm-tossed

space, the tempestuous rhythms, and the representation of ecstatic emotion are Kokoschka's tribute to the most enduring of all his admirations, the Austrian Baroque, for here he showed himself a spiritual as well as technical disciple of Maulpertsch. One may also think of the nineteenth-century painter Anton Romako (1832–89), whose portraits foreshadow Kokoschka's psychological explorations.

Kokoschka was severely wounded on the Eastern Front in the First World War and in 1917 settled at Dresden to recuperate. There he underwent so severe an emotional crisis that his erratic behaviour earned him the name of the 'Mad Kokoschka'. A startling episode of this period was the creation of a life-sized doll to

289 *(left)*. Oskar Kokoschka: The Tempest, or The Bride of the Wind, 1914. *Basel, Kunstmuseum*

290 *(below)*. Oskar Kokoschka: View of Jerusalem, 1929. *Detroit Institute of Arts*

compensate for the absence of the human beings he feared to meet. The doll appears in the painting *Woman in Blue* of 1919 (Stuttgart), where the simple, block-like scheme of blue, green, and white shows a new understanding of colour gained from his closer acquaintance with such German Expressionists as Nolde. His emotional recovery was also hastened by his teaching responsibilities at the Dresden Academy, but it led to a loss of intensity in both form and content which was never entirely regained.

In 1924, he resigned his position at the Academy and set out upon seven years of wandering through Europe and the Mediterranean, with occasional sojourns in Switzer-land, Paris, and Vienna. He had long been a landscape-painter – in fact, his *Dent du Midi* of 1909 was his first picture to be acquired by a public museum (the Wallraf-Richartz Museum in Cologne; expropriated in 1937, and now in a private collection in Zürich), and in Dresden he had painted many views of the old Baroque town. Now on his travels he painted views of the historic cities he visited [290]. At first there may seem to be little difference between one painting and another, since the points of view are usually from a high position below which the land, the buildings, and the water, if there be any, reach outwards in a vast Baroque design, but the surging panoramic concept is peculiarly Kokoschka's. The spectator feels that the world

itself is a projection of the artist's cosmic vision, that the earth, as he wrote of Altdorfer's *Battle of Alexander* in Munich, 'really turns . . . one is aware of its movement at once – the turning of the sun's fire, space circling round the pregnant earth that brings all reality into existence'.[14] In these landscapes the touch was swifter than before, the colour brighter, the general effect in the tradition of German Impressionism, which had always been more subjectively emotional than French painting. But the pictures are also more lyrical than Liebermann's or even Corinth's, whose rocking rhythms were often echoed in Kokoschka's work.

In 1934 Kokoschka settled in Prague, his father's original home, where he painted some of his finest landscapes and his 'allegorical' portrait of President Masaryk beside the figure of the seventeenth-century humanist John Comenius, whose dream of a world at peace Kokoschka passionately shared. Three years later, his work having been denounced in Germany by the Nazis, he painted a defiant *Self Portrait as a Degenerate Artist* and moved to England, where he remained for a decade. These were difficult years of obscurity for an artist whose reputation had embraced Europe, and the works painted in England sometimes lacked the technical coherence he had attained in his landscapes, although the content of such paintings as *The Red Egg* and *Anschluss: Alice in Wonderland* were vigorous attacks upon the common enemy.

The struggle of the human soul with the powers of evil within and without was the recurrent theme of Kokoschka's most serious painting, and it is the subject of two large mural commissions, *Prometheus*, painted in 1950 for Count Seilern's house in London, and *Thermopylae* of 1954 for the University of Hamburg. In both paintings the Baroque heritage is evident in the buoyant compositions crowded with moving figures. The effect, though, is essentially traditional, and Kokoschka's style, although distinctly personal, existed apart from the principal currents of modern European art. He was unconcerned with the enthusiasm of his contemporaries in Central Europe and in France for the technical discoveries of Cubism, Futurism, and primitive art. But if at first his work seems formally unadventurous, it offers rewards in the psychological penetration of the early portraits, the dramatic scope of the landscapes, and the convincing, often savage visual reality in his many drawings and lithographs. To this may be added the interest of following his spiritual adventures in his dramas and in the inventive illustrations of his portfolios of lithographs, *Der gefesselte Kolumbus* (*The Fettered Columbus*) and for Bach's Cantata *O Ewigkeit Du Donnerwort* of 1916-17.

After his return to Europe in 1948, Kokoschka recovered his international reputation as a portraitist, landscape-painter, and teacher. The last major artist of the generation which emerged before 1914, he continued the Expressionist tradition in his total emotional identification with the object or event he contemplated.

PAUL KLEE (1879–1940)

If the reputation of the Bauhaus as a centre for experiment in painting as well as in industrial design depends in large part upon Paul Klee's presence there for ten years, it is also true that in his mature work the distinctive combination of free improvisation and an exhaustive study of the structure of pictorial form owes much to his teaching experience, to his students, and to the Bauhaus programme.[15] Klee had been working seriously and quietly as an artist since 1902, but until 1920, when Gropius invited him to Weimar, his work had attracted little attention outside professional circles in Munich, Berlin, and German-speaking Swit-

zerland. He had begun as a draughtsman and etcher working in the modest dimensions of the 'tiny, formal motif' which he always preferred. Despite their small size, his first works already revealed that poetic interpretation of organic and inorganic life which became the content of his finest paintings. Behind their grotesque figural exaggerations and the stylistic mannerisms which every alert young artist in the Munich of the Jugendstil years could not fail to admire in Redon, Ensor, and Hodler, there was his disconcerting wit, his awareness of man's tragi-comic predicament. The titles of his early etchings in themselves are summaries of his attitude: *Two Men Meet, Each Believing the Other to be of Higher Rank*, or the *Hero with One Wing* who symbolizes man's fatal dilemma, earth-bound yet world-minded, the only animal that can imagine himself an angel.

Klee had been born in Switzerland, in Münchenbuchsee near Bern, but his father, an organist, was German and his mother partly of French descent. Klee himself became a German citizen, served in the German army during the First World War, and considered himself a German artist, although his ties with Switzerland were always close. His artistic discoveries began in Munich, where he first went to study in 1898. He met Kandinsky in the studio of Franz von Stuck, but they only became friends a decade later, in the days of the Blaue Reiter. Klee's work was reproduced in the famous almanac, and he participated in the second Blaue Reiter exhibition of prints and drawings in March 1912, but in those years he took from the association more than he gave. His friendship with Franz Marc, the only contemporary artist mentioned at length in his journals, was probably his most important spiritual confrontation with another painter. Marc's love of animals must have encouraged his own hope of penetrating to the sources of organic creation; while thinking of Marc's death he noted in his journal: 'What my art

probably lacks is a kind of passionate warmth. I don't love animals and every sort of creature with an earthly warmth. I don't descend to them, or raise them to myself. I tend rather to dissolve into the whole of creation and am then on a footing of brotherliness to my neighbours, to all things earthly.'[16] The words might almost have been Marc's, but the conclusion was Klee's: 'I seek a distant point at the origins of creation and there I sense a kind of formula for man, animal, plant, earth, fire, water, air, and all circling forces at once.' The formula may have been undiscoverable, but Klee's search for it became the shape of his art.

His association with Kandinsky was also important, as he acknowledged later when he said: 'I could have been his pupil and in a certain sense I was, for some of his words managed to encourage, confirm, and clarify my striving.'[17] One can believe that his conversations with Kandinsky, then about to publish *Concerning the Spiritual in Art*, did clarify and confirm Klee's belief that artistic activity, at least for him, must mean the investigation of the 'primordial realm of psychic improvisation', of those experiences beyond appearance whence rose that 'inner necessity' which Kandinsky was striving to satisfy. But despite their exchanges of opinion, their mutual admiration, and their years of study and work together at the Bauhaus, there were immense differences between their arts. Kandinsky was moving always towards an art of majestic formal abstraction; Klee never entirely parted company with nature. Although his ties with natural impressions might be 'most indirect', and his images might symbolize qualities and quantities, measures and extensions, more than they depicted phenomenal or imagined appearances, such 'abstractions', as he told his students, were still situated in the realm of the human.

Klee shared Marc's and Kandinsky's enthusiasm for primitive art, folk painting, and children's drawings. He saw in those different

kinds of expression what he was always seeking for himself, formal structures at the most elementary cultural level, uncompromised by ready-made conventions. From them he could learn 'the very special kind of progress that leads towards a critical striving backwards, towards the earlier on which the later grows'.[18] He had felt this long before he joined the circle of the Blaue Reiter; in 1902, on his return to Bern from his first visit to Italy, where he became aware of the great past, he wrote in his journal: 'I want to be as though newborn, knowing absolutely nothing about Europe, ignoring facts and fashions, to be almost primitive.'[19] His most 'primitive' manner appeared in the drawings for *Candide*, done principally in 1911-12 but not published until 1920. This insubstantial interpretation of the satiric comedy emphasizes Voltaire's pessimism more than his wit, and may owe something to Kubin's ghoulish drawings which interested Klee at the time. It shares the same desperately directionless line, the same interest in the art of children, perhaps even of the insane. But no inexperienced or unstable hand could have scribbled traceries so mordant as these, so skilfully projecting the malaise lurking beneath the surface of this best of all possible worlds.

Another experience that taught Klee a more systematic method of treating the structural properties of colour than he would have found in Kandinsky's mystical theories was his brief visit to Delaunay in Paris in the autumn of 1912. In the latter's studio he saw some of the *Windows* in which Delaunay had straightened the tilted planes of Cubism into a net of small coloured squares and rectangles. When Klee at Kairouan in 1914 finally understood that colour is the supreme pictorial reality ('I and colour are one. I am a painter!'),[20] the first works to embody this belief were cast in Delaunay's grids.

The most important formal influence in Klee's artistic education was not the spiritual-ized Expressionism of the Blaue Reiter but Cubism in its Orphic and Futurist developments, the latter especially furnishing him with useful insights into the representation of simultaneous movement. Through many of the 9,000 drawings and paintings he executed between 1914 and 1940 one can trace the overlapping, interpenetrating planes of Cubist space. But Klee was no orthodox Cubist, primarily interested in the formal properties of pictorial design. He believed that form was less significant than forming, because 'formation determines form and is therefore the greater of the two'.[21] Because he insisted that the process is more important than the product, Klee is often supposed to have begun his works with no definite end in mind, letting the point, line, plane, or colour, even the medium, dictate its own evolution. Certainly he did not ignore the promptings of intuition, but he prized the activities and interactions of imagination and reason.[22] The exhaustive pursuit of the laws of pictorial structure which he undertook at the Bauhaus invalidates the conception of Klee submitting in any but exceptional instances to the vagaries of automatic suggestion. Like other painters he welcomed the accidental, the suggestion offered by the work itself while still upon the easel, but his art would have had no continuity, no content, and much less significance were it only a series of happy accidents. 'In the beginning', he wrote, 'is the act, yes indeed. But above it is the idea . . . The idea may be regarded as the more basic.'[23]

From the first Klee's presence at the Bauhaus encouraged the students to ask for more than he could give them in the glass-painting and book-binding workshops which he had been called to direct, so that soon he was committed to a course of lectures on his theories of painting and drawing. Through the notes which have been preserved for the first series, given in 1921-2, we can follow him as he showed his students how 'to dig deep and lay bare'.

The discovery of the laws of art, the ways by which points create lines, lines planes, and planes space, answered his own need to know as precisely as possible what he was doing. Only with a knowledge of such laws could he then experiment with many media and methods. Starting with the rules he had discovered, he looked for exceptions, for what could never in the end be reduced to rules, for the innermost essence, the latent reality hidden, in his memorable phrase, in 'the prehistory of the visible'.[24]

Early in life Klee understood that he was essentially a poet, and his art is best understood as his search for the poetic metaphor, for the succinct symbol, verbal or visual, which would manifest the dream, the psychic event, the reality of the unseen experience. For such an artist the categories of art and literature were indistinct. The pictorial symbol may generate a verbal phrase, like his mystifying titles, themselves illustrations of the work, in which the terms of art, music, science, history, philosophy, and of the most secret personal feelings become interchangeable: *Mountain under Compulsion, Carpet of Memory, Fish Magic, Early Sorrow.*

Through the Bauhaus years two general directions can be followed in Klee's painting. There are those many works in which he seems to pursue the principles of pictorial order: how an unsupported line can create a multi-dimensional space, how line and colour can suggest multiple movement, how layers of colour upon colour can create new architectures. But there are as many, or more, in which the logical order of architecture and geometry dissolves in the presence of pre-logical events, as in the mysteriously transparent and intersecting passages of *Remembrance of a Conception* [291], painted just before Klee went to Weimar.

In contrast to such fantastic paintings there are those which contain Klee's shrewd insights into the human situation. Some are magically,

291. Paul Klee: Remembrance of a Conception, 1918. *Pasadena, Calif., Norton Simon Museum*

humorously imaginative, like the *Voice Cloth of the Singer Rosa Silber* (apparently a towel with which Mme Silber 'wiped' her voice because some of the letters and sounds of her songs had rubbed off on it), or the *Precious Container for Stars* [292], a cubistically fenced enclosure where a skeletal star has been caught. Others contain poignant, even painful, inferences, like *Child consecrated to Suffering*, or *Mask of Fear*, a monstrous blank face which seems to hide the spiritual condition of Germany in 1932 ('I dare to depict what weighs upon my soul in an image only very indirectly related to an impression of nature').[25] In works such as these Klee came closest to discovering the object of his lifelong search, the image which,

292 *(below)*. Paul Klee:
Precious Container for Stars, 1922.
New Haven, Conn., Yale University Art Gallery

293 *(right)* Paul Klee: Death in Fire, 1940.
Bern, Paul Klee Foundation

as a 'synthesis of outward sight and inward vision', would bring man once again into harmony with the whole order of things natural and things cosmic.

In 1930 Klee left the Bauhaus for a professorship at Düsseldorf which promised more leisure for his own painting, but when his art was denounced by the Nazis in 1933 he was dismissed. During the remaining seven years of his life at Bern neither his failing health nor the threatened collapse of the European culture which had sustained his art could interrupt his work. His paintings grew somewhat in size and much in solemnity, although humour was not entirely absent. As the years passed the images became more concentrated, more prophetic,

more sign-like, until, as in *Death in Fire* (*Tod im Feuer*) [293], painted in the last year of his life, the hieroglyphs stood for ultimate things. Among them are his signs for angels, those familiar presences Klee had felt always beside him, knowledge of whom he shared with Rilke, whose verses so often confirm Klee's belief that 'art does not reproduce the visible, but makes visible'.[26]

Since 1945 Klee's art has reached a widening and ever more appreciative audience as his works have become better known through numerous exhibitions and publications.[27] At the same time his position as one of the major masters of the twentieth century has been questioned. The small size of his works encourages the belief that he was, after all, only a *petit maître*, and their content sometimes seems unequal to his professions. The 'latent realities' are not always so real or so unusual as he thought, the situations he made visible are often more witty or charming than portentous, and there is a littleness about some of his work which is not a matter so much of size as of spiritual dimensions. The justice of this criticism is not discounted by the seriousness of his last works, nor is it confirmed by the vulgarization of his most sensitive discoveries in the poetics of line and perspective by those who have plundered his works for popular caricatures and cartoons. Irony and humour are rare in art at any time and should be treasured. An age less racked by its uncertainties than ours may do so.

Klee's historical importance, however, is indisputable. Through a period dominated by systems of abstract and non-objective expression he maintained the primacy of the idea, of the relation of the verbal to the visual, of man to nature, to history, and to art. His belief in the validity of artistic converse through symbols is an example to a later generation of painters who once again know that the sign can be a pictorial situation.

PAINTING IN BELGIUM AND HOLLAND: 1900-40

Belgium's contributions to the international modes of modern art have not been negligible, as has been noted in the introduction to this chapter, but the efforts of a number of her painters to create a specifically Belgian tradition

in modern times have been largely unnoticed by historians and critics elsewhere. The reasons for this neglect are perhaps to be found in their choice and relatively realistic treatment of subjects from the Belgian countryside, whereas even the most narrowly national traditions of modern art – De Stijl or the Blaue Reiter, either of which is inconceivable without a Dutch or Bavarian locale – were based on abstractly formal principles which were easily assimilable by artists of other countries. This separatism appeared at the beginning of the twentieth century when a number of artists settled in the village of Laethem-Saint-Martin on the Lys, not far from Ghent. Ostensibly they were seeking the companionship of the poet Karel van de Woestijne and the sculptor Georges Minne (see above, p. 149), as well as a simpler economic existence, but their decision indicated their rejection of the cultural and spiritual environment of the large modern city. It meant that they turned away from Brussels, already a leading centre of Art Nouveau, where between 1884 and 1914 the association of Les XX under the leadership of Octave Maus, and its successor after 1894, La Libre Esthétique, introduced to the Belgian public the works of the principal artists, writers, musicians, and designers active in Europe during those thirty years. The departure of the leading Neo-Impressionist painter, Théo van Rysselberghe [20], for Paris in 1898, and the premature death, in 1899, at the age of twenty-seven, of Henri Evenepoel, a greatly gifted artist whose studies in Paris had taken him close to the French Nabis, deprived the young Belgians of two important talents which might have encouraged the development of a more internationally directed modern movement at home.

Among the first painters to settle in Laethem-Saint-Martin were Gustave van de Woestijne (1881-1947), the brother of Karel, Valérius de Saedeleer (1867-1941), and Albert Servaes (1873-?). Their simplified landscapes, peasant scenes, and religious subjects were as much a rebuke to the superficial responses of Impressionism as to the faded historicism of the Academy, which was no more invigorating in Belgium than elsewhere. Their poetic and religious symbolism was close, in its introspective and deeply personal expression, to the Flemish primitives on the one hand, and on the other to the contemporary poetry of Maeterlinck and to the evocation of the communal piety of the Flemish past in the writings of Georges Rodenbach, whose novel, *Bruges-la-Morte*, had appeared in 1892. The design of their work had also something of the attenuated linearism and morbidity, which we have already observed in Minne, of the Pre-Raphaelites, who were much admired in Belgium at the turn of the century.

The painters of the 'second group' to come to Laethem-Saint-Martin before 1910 were less melancholy and more interested in a vigorous pictorial structure. Their mature work was realized only after the First World War, whose miseries accentuated their feeling of identification with the underprivileged classes in the country and small towns. Gustave de Smet (1877-1943) and Frits van den Berghe (1883-1939) were interested in Holland, where they met, among others, the Dutch Expressionist Jan Sluyters (see below, p. 504) and the French Cubist Henri Le Fauconnier, and where they participated in the exhibitions of the modern art society in Amsterdam, the Moderne Kunstkring. After their return to Belgium they, with Constant Permeke (1886-1952), who had been wounded and evacuated to England, were responsible for Flemish Expressionism between the Wars. De Smet's interiors and scenes of rural life are somewhat like the peasant pictures of Marc Chagall and of the artists of the Blaue Reiter. If they are less mystical and less abstract, they are never-

theless firmly drawn and broadly painted, and not without a hint of caricature [294]. With the Belgian critic André de Ritter, De Smet founded the gallery 'Sélection' in Brussels which, with the journal of the same title, promoted the modern movement in Belgium.

The breadth and strength of the 'second school' of Laethem-Saint-Martin appeared at its pictorial best in the work of Constant Permeke. When he returned to Belgium after the War he stayed at Antwerp and then at Ostend, where he lived in a fisherman's hut, before settling in 1925 at Jabbeke near Bruges, where the large studios he constructed are now maintained as a museum of his work. In the coastal cities he found more substantial subjects than the peasants of the countryside. He treated his fishermen and sailors, with their wives and women, as massive, almost elemental human beings, as large if not so personally dynamic as himself, typifying resistance rather than submission to the forces of nature [295]. Permeke's palette was appropriately dark and monochromatic for such simple beings, and among his finest works are his life-size wash drawings of the nude. After 1935 he also worked in sculpture, treating clay with the powerful simplifications of his oils.

Frits van den Berghe, like De Smet and Permeke, was at first a painter of peasant scenes in an Expressionist manner analogous to theirs, but after 1927 he worked towards a more mystical, fantastic interpretation of experience. His masked and spectral figures are in line of descent from Bosch and Ensor, but with a special feeling for the corrupt and ludicrous character of modern life, with Surrealist overtones [296].

The artists we have just considered were born and worked in western Belgium, and their works are to be identified with Flemish Symbolism and Flemish Expressionism. In Brabant and the eastern provinces a comparable but

294. Gustave de Smet: Village Fair, c. 1930.
Ghent, Museum voor Schone Kunsten

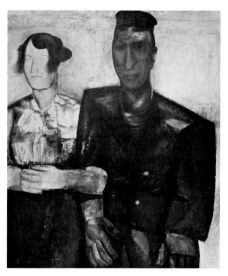

295. Constant Permeke: The Fiancés, 1923.
Brussels, Musée d'Art Moderne

296. Frits van den Berghe: 'Le Beau Mariage', 1928. *Private Collection*

297. Rik Wouters: Portrait of Mme Rik Wouters, 1912. *Paris, Musée National d'Art Moderne*

less solemn Expressionist development was carried on most wittily by Edgard Tytgat (1879–1957), with his consciously naïve carnival scenes and imaginative landscapes, and by Jean Brusselmans (1884–1935),whose simplified and strongly linear landscapes, as carefully controlled as his oversized copper-plate signature, gradually tended to become more like a series of abstract signs.

One of the most gifted Belgian painters, Rik Wouters (1882–1916), died before he could prove the possibility of accepting to the full the implications of modern French painting without losing one's native accent. He has lately been prized by his compatriots as an authentic 'Belgian Fauve', but his art was neither so aggressive nor so destructive as Fauve painting proper. The prominent influences were Renoir and Matisse, and after that Cézanne, whose work he saw in Paris in 1912. In the *Portrait of Mme Rik Wouters* [297], one first observes the ease with which he combined Cézanne's tilted composition with the decorative patterns of Matisse. From Matisse, too, he might have learned how to place a red-and-white striped skirt against pink, blue, and mauve wallpaper, but there is a residue of colour sensitivity which is his own and which runs through the still lifes and figure studies painted during the last four years of his life. Wouters was also a sculptor, modelling simply and energetically in the tradition of Rodin. In his *Foolish Virgin* of 1912 the movement of his wife's body is said to have been inspired by Isadora Duncan's dancing.

The contributions of Dutch artists to the international modern movement have been continuous since the middle of the nineteenth century, and occasionally crucial. The importance of Jongkind for French Impressionism, of Van Gogh for European Expressionism, and of Van Doesburg and Mondrian for the development of geometrical abstraction is incontestable. On a smaller scale Thorn-

Prikker as a teacher in the Schools of Arts and Crafts of Krefeld, Hagen, and Essen (1904-18) introduced a special note of Dutch Symbolism to the later phases of German Jugendstil. During his life in Paris Kees van Dongen maintained much of the intensity of early Fauvism long after it had been diluted or abandoned by his companions of the epic years between 1905 and 1910. Yet, as in Belgium, there were many Dutch artists who remained apart from the mainstream of modernism, but whose works are both interesting in themselves and significant as regional variations of the dominant international trends.

The development of Impressionism in Holland had been retarded by the great exemplars of seventeenth-century landscape painting, whose tonal interpretations of nature were difficult to ignore. In the atmospheric luminism of Anton Mauve (1838-88), whose delicate gradations of tone are perceptible in the earlier work of his distant relative Van Gogh, as well as in the city views of George Breitner (1887-1923), the colours are restricted to a narrow range of hues related to the local colours of the scenes depicted. Of the two, Breitner was the closer to his French predecessors and contemporaries. His Amsterdam street scenes are filled with hurrying figures, and his dull reds, browns, and greys evoke the poetry of overcast winter afternoons in a great northern city.

Towards the end of the century the Symbolist movement enlisted several Dutch adherents. The eerie linearism of Jan Toorop (see p. 132, above) and Thorn-Prikker, which has already been noted, was the most conspicuous aspect of Art Nouveau in Holland, within which may be placed the early Symbolist paintings of Mondrian, his stylized figure studies and still lifes of withered chrysanthemums. But in Holland, as in other European countries, the decorative aspects of Symbolist painting proved so vitiating that a radical break with everything hinting at an art-for-art's-sake aesthetic was

required. This occurred in the decade after 1900, when the new developments became known through a series of important exhibitions of contemporary painting, principally French and Belgian. The influence of Signac and the Neo-Impressionists, which had been notable in Belgium in the 1890s, became pronounced in the landscapes of Toorop and Thorn-Prikker by 1905. As the work of Van Gogh became better known, especially after the retrospective exhibition at the Stedelijk Museum in Amsterdam in 1905, his angular drawing and pronounced brush stroke reappeared in the work of such painters as Ludowijk Schelfhout (1881-1944) and Dirk Nijland (1881-1955). The revelation of Cézanne and the Cubists came in 1910 with the first exhibition by a new society, the Moderne Kunstkring (Modern Art Circle), founded by the painter and critic Conrad Kikkert (1882-1965). As a result of this exhibition Mondrian understood that he would

298. Leo Gestel: Tree in Autumn, 1910-11.
The Hague, Gemeentemuseum

have to go to Paris, with the consequences for European modernism which have been examined above. In September 1912 the first Futurist exhibition, already seen in Paris and London, reached Amsterdam, and in the second Moderne Kunstkring exhibition that year the work of Picasso and Braque was shown.

The more gifted younger artists could not remain immune to such excitements, and in their early work the influence of the Parisian masters is so strong as almost to overwhelm their own personalities. The landscapes of Leo Gestel (1881-1941), who was in Paris in 1904 and again in 1910-11, are entirely competent but not very individual exercises in the Cubist mode. More interesting is his *Tree in Autumn* [298], probably painted on his second visit to Paris. The colours have a Fauve brilliance and the brush stroke resembles Derain's broadened Neo-Impressionist technique of a few years before, but the decorative elements are more emphatic, looking backwards to Dutch Symbolism of the turn of the century, as well as forwards to the small blocks of colour in Mondrian's abstract painting soon after. Gestel's example was important for the School of Bergen (Mons), where he painted between 1911 and 1921, and where the French Cubist master Henri Le Fauconnier lived while in Holland during the First World War.

This process of accepting and absorbing the latest phases of French modernism can be followed in the work of the most variously talented painter of this generation, Jan Sluyters (1881-1957). He won the Prix de Rome at the Amsterdam Academy and was in Paris in 1904 and 1910. His *Bal Tabarin* of 1906-7 (Amsterdam), painted with hasty Neo-Impressionist strokes, interprets the hectic gaiety of Parisian night life with a Futurist frenzy. On the other hand, the *Child's Bedroom* of 1910 (The Hague) enlarges the intimate, unexpected interior spaces of Vuillard with the multiple decorative pat-terns of Matisse, but so French a painting is rare in his work. The presence in Holland during the First World War of the Belgian painters Gustave de Smet and Frits van den Berghe may have encouraged his Expressionist tendencies, for the masterpiece of those years, the *Peasant Family of Staphorst* [299], resembles the work of the 'second group' of Laethem-Saint-Martin. There is the same monumental treatment of peasant life, traceable in this instance to Van Gogh's paintings from Nuenen. Sluyters's work is less solemn and perhaps a bit sophisticated, but that may be because its rocking rhythms owe something to French Cubism and to Delaunay's Orphism, as can be seen in the sky. A few years later these foreign elements had been assimilated. In a *Self Portrait* of 1924 (Amsterdam), Sluyters interpreted the spatial complexity of Cézanne's self portraits with a sense of Rembrandt's revelation of the artist's personality.

The Expressionism of Herman Kruyder (1881-1935) was less learned but still more subjective. While serving an apprenticeship as a house painter, he studied at night school and at the School of Industrial Art at Haarlem, and then worked for a decade as a designer of stained glass before becoming a painter in 1910. He saw the world with the eyes of a folk artist, but his animals and birds are neither naïve nor whimsical [300]. Massively brushed in glowing impasto, they inhabit a world whose complexities they apprehend but cannot solve. How much Kruyder owed to Franz Marc, whose animal paintings were exhibited at The Hague in 1913, is difficult to say, but his figures have a solemn pathos very different from the tense energies of the German painter's animals. Hendrik Werkman (1882-1945) was a professional journalist who became a painter in 1917. He was associated with Walden's Sturm Gallery and his first works were abstract, but in 1939 he turned to figurative painting,

299. Jan Sluyters: Peasant Family of Staphorst, 1917. *Haarlem, Frans Hals Museum*

300. Herman Kruyder: Cat in a Crocus Field, 1925.
The Hague, Gemeentemuseum

under the influence of Dutch Expressionism. His typographical designs are important for the history of Dutch graphic art. In the late 1920s and 30s the innate tendency of Expressionism to become more rather than less abstract was countered by a concern for excessively realistic painting, often aggravated by psychological and Surrealist overtones. One of the most forceful of the figurative painters was Charley Toorop (1891–1955), the daughter of Jan Toorop, who sometimes achieved an alarmingly obsessive effect by enlarging the heads and features of her figures beyond the scale of life.

PAINTING AND SCULPTURE IN ITALY: 1920–40

The radical revision of Italian art by the Futurists before 1914 and by de Chirico and Carrà in their metaphysical paintings of 1917–19 was not continued after the close of the First World War. The Futurist movement, disrupted by Boccioni's death in 1916 and by Carrà's defection the year before, was maintained, more in name than in accomplishment, by the adherents of the Secondo Futurismo. This second phase, centred in Turin and Rome, lasted for some twenty years, but the works of Gerardo Dottori (1885–1977), Enrico Prampolini (1894–1956), and Fortunato Depero (1892–

1960), who were the principal representatives, became increasingly dry, dogmatic, and abstract. The inherent tendency of the Futurists to confuse artistic theory with political and technological concepts could be noted in 1929 in their Manifesto of Aeropittura.

De Chirico's and Carrà's rejection of their own 'metaphysical' principles and of modernism in general and their insistence that the state of painting required a reconsideration of the classic and idealist traditions were symptomatic of a general European desire to find a new order and stability, but in Italy the return to the values of the specifically Italian past coincided with the encouragement by the leaders of the new Fascist state of an art of wide public comprehensibility and national character. From 1920 until the outbreak of the Second World War Italian art can be divided between the gradually hardening concepts of a nationalistic classicism, more perceptible perhaps in architecture and monumental sculpture than in painting, and the reactions against it by certain individuals.

De Chirico had announced his attack on modernism in the name of a revival of traditional, in his terms of Quattrocento, practice as early as 1919. His essay 'Il Ritorno al Mestiere' ('The Return to the Métier') appeared that year in the first volume of Mario Brogli's journal *Valori Plastici*, which became the principal organ for the classical reaction. De Chirico himself was unable, for all his frequent polemical publications, to create a viable classical or idealist art; his pastiche of classical themes and Renaissance techniques rarely rose above the level of academic pomp. The work and example of Carlo Carrà were more persuasive. Through his teaching at the Milan academy and his own modest and severely simplified figures and landscapes, where the forms were few but broadly modelled, he demonstrated the artistic principles he had rediscovered in Giotto and Masaccio. Felice

Casorati (1886-1963), for many years a professor at the academy in Turin, was another prominent painter and gifted draughtsman whose tightly drawn figures in contemporary dress interjected a note of romantic malaise in compositions based on Mannerist perspectives.

Both Carrà and Casorati were painters and teachers rather than propagandizers for their way of painting. The programme for this kind of orderly yet modernized classicism was informally worked out in Milan in 1922 by the first group of painters associated in the movement known as the Novecento Italiano. By 1930 their work in many instances had become identified with the empty formalism of public painting for the régime, and somewhat unfairly at that, because conventional as some of it was – the nudes of Achille Funi (1890-1972) for example – much was sincerely conceived and ably if unadventurously executed. Indeed, at the start there were a number of gifted artists who gradually drifted away before the seven original members held their first group exhibition, in which they were joined by more than a hundred others, in Milan in 1926.[28] One does not now associate such painters as Massimo Campigli (1895-1971) or Filippo de Pisis (1886-1956) with the Novecento. By 1920 they were both living in Paris where they came to their artistic maturity. De Pisis had been briefly associated with the Scuola Metafisica as a young man, but in Paris he turned to the Impressionists and their successors. He excelled at the quick sketch of still life, the sudden glimpse of a landscape or of a brightly furnished interior, apparently unpremeditated but deftly brushed. With the exception of Modigliani, who also matured in Paris but under the influence of primitive art, no other Italian artist of modern times came closer to grasping the essentially pictorial qualities of French painting. For that reason his work, gracious as it always was, and important as a means of preparing the Italian public for French art, which was little known

301. Giorgio Morandi: Still Life, 1929. *Milan, Pinacoteca Nazionale di Brera*

until after 1945, seems more cosmopolitan, more 'School of Paris', than Italian.

Campigli, on the contrary, never surrendered to Parisian ways. Beyond doubt, Picasso's neo-classicism of the early 1920s was a telling factor in the development of his own manner, so impregnated with ancient Mediterranean references, but the antiquities in the Louvre must have meant as much, and the culminating event was a visit to the Etruscan Museum at the Villa Giulia in Rome in 1928. From such varied sources, which included the tubular figures of Seurat and Léger as well as Egyptian tomb paintings and Fayum portraits, Campigli composed his self-consciously archaic and humorous pictures, in which one is surprised to discover that his demure little ladies, flattened out like paper dolls, are actually contemporary figures translated into the past. The formal dissociations of his design, where the figures are more signs than participants in an event, combined with his pallid colours and the dry, fresco-like textures of his paint, enhanced the Mediterranean remoteness of his art.

Meanwhile in Italy the 'more solid base' that de Chirico and the traditionalists of the Novecento were looking for in the past had been quietly discovered by Giorgio Morandi (1890-1964). Alone among the progressive painters of Italy, he never went to Paris, and indeed scarcely ever left his native Bologna. His art was similarly circumscribed. With the exception of a few portraits, landscapes, and some exceptional prints his sensibilities were entirely concentrated on revealing the plastic properties of a few familiar objects huddled in his modest still lifes [301]. He had taken Cézanne as his exemplar, but his own intentions were still more restricted. Among his earliest paintings several of 1918-19 were in the manner of the Scuola Metafisica. Thereafter he used only the most ordinary and familiar bottles, glasses, pots, and other kitchen containers, often similar in volume and profile,

with which to explore the plastic possibilities of form in space. So subtle was his touch, so discreet his colour, so unpretentious the constancy if not the range of his imagination that in the classic control and generalization of his art he appears as the twentieth-century heir of Chardin as well as of Cézanne.

Expressionist tendencies were also present in Italy during this period. Even within the Novecento itself the Milanese Mario Sironi (1885-1961), who had exhibited as a Futurist in 1914 and been briefly attracted by the

302. Mario Sironi: Figure, 1935.
Milan, Galleria Blu

iconography of the Scuola Metafisica, achieved the powerful vision and technique that mark such paintings as the half-length *Figure* of 1935 [302]. In the proportions and in the massive distribution of light and shade it has more than a little of Picasso's classicism of the early 1920s, while the strong brushwork and the radiant but sombre colour recall Rouault. Despite these transalpine references, Sironi's

expressive qualities are not in the least French. His figures, for all their modernity, exist in a world defined by Italian space and gesture.

The efforts of numerous painters in Northern Italy to repudiate the ideals of the Novecentisti led to no radical revision of current values. The work of The Six in Turin, a group which included Carlo Levi (1902–75), but not the more aggressive Luigi Spazzapan (1889–1958), and of the Chiaristi in Milan (so-called because of the light backgrounds of their paintings, in reaction to academic chiaroscuro) were principally remarkable for their interest in Impressionism and Post-Impressionism, a token of their refusal to be considered merely nationalistic and hence provincial. In Rome a more vigorous Expressionism occurred in the work of two Romans, Scipione (Gino Bronchi, 1904–33) and Mario Mafai (1902–65). Scipione was the more radical in his fantastic and romantic imagery, in his mordant comments on contemporary society, and in his excitable drawing and brushwork, with its abrupt perspectives and fluid arabesques. His own religious unrest led him to El Greco and Van Gogh, the intensity of his formal vision to Soutine, but in no sense was he merely an imitator. His portraits of prelates owe less to Velázquez's *Innocent X* than to his encounter with the Church in his own time. Nor were his architectural subjects merely romantically retrospective. The view of the *Piazza Navona*, for which a preliminary sketch in a Roman private collection proves the coherence and premeditation of his design, could only have been seen in a city where contemporary political repression took the forms of the past. The work of Mafai has been calmer and more lyrically romantic, especially in his delicate flower studies and his evocations of past splendours in views of the demolition of old Rome during Mussolini's urban replanning of the 1930s.

The course of abstract art in Italy is partly to be followed through the second generation of Futurists, especially in the work of Prampolini and Dottori, although neither the former's linear abstractions or the latter's more mechanistic inventions would have been much remarked elsewhere. The first Italian abstract painter was Alberto Magnelli (1888–1971). He was in Paris by 1913, where he knew Picasso, Léger, and Gris, and where he reduced his figural subjects to a few flat planes bounded by strong black lines. After he returned to Florence in 1915, when Italy entered the War, he produced

303. Alberto Magnelli: Painting No. 0525 II, 1915. *Private Collection*

a series of abstract canvases based on Cubist principles of composition [303], and a number of abstract sculptures, somewhat like Henri Laurens's. They had, however, little or no effect on contemporary Italian art. Soon after, he succumbed to the 'call to order', and for almost twenty years painted landscapes and

figure studies. In 1933 he returned to France, and in 1935 to abstract art. The geometrical angularity in much of his later work has been traced to Kandinsky, but its freedom may be due to his long friendship with Arp.

The first exhibition of abstract art by an Italian artist occurred in 1933, when the Milione Gallery in Milan, for thirty years the most important centre for the promotion of progressive tendencies in northern Italy, showed the work of Atanasio Soldati (1896–1953). Soldati was intelligently eclectic, taking what he needed from de Chirico, Picasso, Kandinsky, and Mondrian, and always aware of the essential character of what he was using, but his work suffers from his very intelligence, since his skilful use of his sources conceals his own personality. In 1935 the first Collective Exhibition of Italian Abstract Art, held in Casorati's studio in Turin, introduced a number of other painters, including Osvaldo Licinio (1894–1958) and Mauro Reggiani (b. 1897). They had only just come to abstraction, and inevitably their works were derivative. With Soldati, however, their historical importance is considerable. Immediately after the liberation of Italy in 1944 they emerged to lead Italian abstract art to the international distinction it has attained since 1945.

The brilliance of Italian sculpture since that date could scarcely have been surmised before 1940. Sculpture by its nature lends itself easily to traditional concepts, and the weight of history lay heavy on the Italians. With the extinction of Futurism, abstract sculpture disappeared in Italy, so that we look to the rare figural artist like Arturo Martini (1889–1947) who could treat traditional forms and subjects with a degree of modern sensibility. Martini studied ceramics at Faenza and terracotta was always a favourite medium, but in 1907 he went to Munich, where Adolf Hildebrand taught him the discipline of monumental form. In his essay 'La Scultura, lingua morta'

('Sculpture, a Dead Language'), written towards the end of his life, he stated that 'The contrast of forms and diverse values resolutely assists, in other arts, in the rhythmical construction of the work [but] sculpture is burdened with the yoke of the human or animal figure'. In his own work the demands of rhythmical construction endowed his figures with a nervous vitality that did not entirely conceal his feeling for the sculptural grandeur of the Etruscan and Roman past [304].

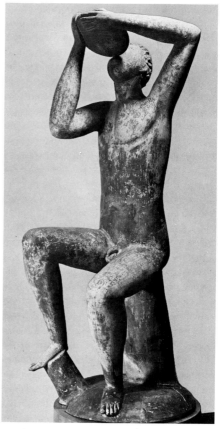

304. Arturo Martini: Boy Drinking, 1926.
Private Collection

STANLEY SPENCER AND HENRY MOORE

In earlier sections of this book, English art of the twentieth century has been examined in relation to contemporary stylistic developments abroad. In the perspective of Expressionism Matthew Smith can be seen as a painter whose work, however personal, would none the less not have taken quite the course it did had he not admired Van Gogh and known Matisse. Similarly, Ben Nicholson's plaster reliefs owe their incontestable authority to the example of Mondrian, but they are to be prized not as insular variations upon a certain aspect of European abstraction but as original contributions to the Constructivist movement as a whole. However, the work of two other artists, Stanley Spencer and Henry Moore, cannot be confined within the conventional categories of modernism. They were neither ignorant nor oblivious of events elsewhere in the 1920s and 30s, but they had things to say and found ways to say them that made their work modern in a peculiarly English fashion. Yet to regard them exclusively as English artists would be to ignore their contributions to the modern movement, even if the achievements of Stanley Spencer have been as little noticed within this wider reference as Henry Moore's have been internationally acclaimed.

Stanley Spencer's life (1891–1959) was almost as circumscribed as William Blake's; for although he preferred the hedgerows of Berkshire to the pavements of London, there is something much like Blake in his presentation of his beloved birthplace, the village of Cookham, on the Thames, as a 'holy suburb of Heaven'. There, as a member of a large and devoted family, he grew from childhood to young manhood, and there he returned at intervals throughout his life. His father, an organist and music teacher and an assiduous reader of the Bible, was an ardent but independent student of religion. No wonder, then, that in his son's eyes Cookham often entertained angelic visitors whose invisible presence irradiated what was otherwise a not unusual community. When Spencer entered the Slade at seventeen, he already knew that he most needed to become a draughtsman in order to produce works which, as he wrote during the First World War, 'would make me walk with God'.[29] So simple and sincere a faith, expressed towards the end of his life in the conviction that 'only goodness and love and Christian and other benign beliefs are capable of creative works', had not inspired many British artists since the days of the Pre-Raphaelites. Their art, which it is difficult not to think of in connexion with Spencer's, must have been well known to him, judging from the facial types and expressions in certain early drawings and the tense poetic stillness of such paintings of 1912–13 as *The Nativity* (University College, London) and *Zacharias and Elizabeth* (London, private collection). In his fondness, one wants to say his obsession, for detail, and in his somewhat dry and insensitive paint as well, he was most obviously Pre-Raphaelite, but whereas Hunt and Millais so often depicted only the external surfaces of things, Spencer, like Blake, could communicate that moment when interior vision transfigures earthly existence. Such moments necessarily, given the difficulty of visually setting down what is essentially indescribable in either words or pictures, were rare. One of the last occasions occurred in the disciples' expressions in *The Last Supper* of 1920 (London, private collection), painted just two years after the end of the war that had disturbed for ever the serenity of his existence and led to the doubts and the 'forsaking of the vision' that troubled him thereafter.

The last of his truly beatific visions was the immense *Resurrection, Cookham* of 1923–7 (London), where details already intrude upon the extraordinarily original conception of the dead clambering from their tombs in the village

305. Stanley Spencer: The Builders, 1935. *New Haven, Conn., Yale University Art Gallery*

churchyard by the Thames. While working on this canvas – it measures 9 by 18 feet – Spencer had already conceived and begun the murals for the Oratory of All Souls (the Sandham Memorial) at Burghclere in Berkshire. Based on his service during the First World War as an orderly in the medical corps and with the infantry in Macedonia, these consist of scenes from day-to-day life in camp and barracks, surmounted by landscapes of encampments and culminating on the altar wall with the most awesome of his interpretations of the Last Day, the *Resurrection of Soldiers* (1928–9). By then Spencer had reached his stylistic maturity, and the mannerisms which would so often irritate his critics had become fixed. The most persistent was his strangely unstable perspective, which forces the spectator's eye to travel ceaselessly across each picture's surface, exploring by turns the differing depths and the varying angles from which even adjacent figures had been observed. Something of this Spencer must have found in the early Italian and Flemish paintings in the National Gallery, but when used for the projection of his hypnotically intense vision – view is too mild a term – of people and places the result was unmistakably of our own times, closer to Léger's Cubism of 1917 than to the synoptic world of Memling and Pisanello.

These qualities may be seen in a painting of 1935 variously described, and apparently by Spencer himself, as *The Builders*, *Bird Nesting*, and *Human Efforts* [305].[30] One's first impression, that it deals only with the commonplace activities of the building trades, is belied by the deadly earnestness of the men's exertions, by the disturbing presence of the huge birds in the branches above them, and by the cross-shaped timbers of the centering that the men are removing from the arched recess in the brick wall behind. Given the cross, may one not think that these workmen are building a chapel, perhaps with reference to the Burgh-

clere Oratory, where God and men may be as much at home together as the birds who had their nests when 'the Son of Man had not where to lay his head'? To these thoughts should be added the knowledge that Spencer had planned another 'chapel in the air', as he described the Burghclere murals when they were merely drawings for a still improbable commission. The other chapel would have been hung with scenes from life in Cookham, comprising his principal paintings from 1932 on. There is no way now of telling whether *The Builders* had a place on those imaginary walls, but it would have held its own with such better-known paintings of that period as *Sarah Tubb and the Heavenly Visitors* (private collection) and *Separating Fighting Swans* (Leeds).

An age dominated by the aesthetics of abstraction has encountered as much difficulty in 'seeing' forms so intensely circumstantial as Stanley Spencer's as it has had in accepting religious themes and content as proper subjects for a secular society. Abstract art of itself cannot encompass the full range of contemporary experience. For the exaltations of faith, as well as for the communication of our fears and anxieties, Spencer's paintings, like those of Balthus, with whom he shared in his later paintings a concern for the complexities of sexual experience, have fulfilled an unexpected but not unimportant artistic function.

From the very first the sculpture of Henry Moore (1898–1986) demonstrated his interest in the most advanced aesthetic theories. While still a student just after the First World War at the Leeds School of Art, he came upon Roger Fry's *Vision and Design* (1920), and from Fry learned to admire carving more than modelling, to seek out the inherent nature of his materials, especially stone and wood, and to prefer the immediacy of form and expression in African and other primitive cultures to the supposedly exhausted traditions of idealist sculpture as it had descended from antiquity and the High

Renaissance. When he reached London in 1921 with a scholarship to the Royal College of Art, he was ready to discover in the British Museum the principal non-Western sculpture then so much admired by Fry and Clive Bell. His chief enthusiasms – for African wood-carving, Assyrian reliefs, Etruscan tomb figures, archaic Greek sculpture, and ancient American art – were almost identical with those types of art which, according to Bell in his treatise *Art* (1913), alone possessed the supreme artistic quality of 'significant form'.

During the later 1920s and into the 1930s, in his treatment of his favourite themes of the nude female figure and of the mother and child, Moore attacked his stones with such images deep in his mind. But the relation between his work and the remote traditions he so much admired was not merely a matter of 'influence'. Had it been so, his work, like that of other technically gifted but intellectually limited craftsmen, would at best have ended in a mildly agreeable eclecticism. What made the difference in Moore was not so much his conviction that the artist must reveal the nature of his materials, letting the stone or wood dictate at times the posture of a limb or the direction of a plane (a process which does in

306. Henry Moore: Composition, 1936.
Leeds, Henry Moore Foundation

large measure account for the characteristic stoniness and woodlike quality of his early work), as his belief that the artist's task is to communicate, through his forms, the character of life itself and our experience of life, which in his own words he has described as 'the human psychological content' of his work.[31]

Such works might have been admired only for the sculptor's technical control of his recalcitrant materials and for the assurance they offered that modern sculpture might once again equal in formal power the works of the primitive and archaic cultures of the past, had not Moore infused them with a specifically contemporary quality, as unmistakably visible as it is difficult to describe. It has something to do with the implacable generalizations that removed from his figures any connotations of the immediate present. To this was added the odd expressions in their eyes, ranging from the stricken glances of the earliest figures, where the mother might be defending herself and her child from some impending calamity, to the blank look of a single hole whereby the figure seems to be peering, not outward into our world but inward to unexplored regions of psychic life, knowledge of which is too terrible or wonderful for ordinary communication.

The feeling that towards 1930 Moore's figures were not only gradually discovered by the artist himself within the wood or stone but were also slowly forming themselves at some level below his concious awareness of the sculptural process is confirmed by such works as *Composition* of 1931 [306]. In acknowledging that he invited and accepted unconscious and accidental suggestions, Moore not only encouraged the interpretation of his works as archetypes of psychological experience with universal reference to the human condition but placed himself in direct relation to Surrealist developments. Resemblances between the *Composition* of 1931 and certain of Picasso's works, especially the drawings for imaginary monuments of 1928–9, and to the biomorphic forms of Arp's sculpture of about that time cannot be fortuitous. Were they so, Moore's projections of the dream-haunted anxieties of twentieth-century man would be the less impressive, and his contribution to the iconology of our times might appear as eccentric as Blake's rather than being, as it is, intimately related to the work of his most distinguished contemporaries.

In the later 1930s Moore came as close as he ever did to creating purely abstract art. A *Four-Piece Composition* (*Reclining Figure*) of 1934, another *Reclining Figure* of 1937 (both formerly in a private collection at Narragansett, Rhode Island), and several *Square Forms* and *Heads* were his farthest excursions towards non-objective expression. But even in these works the titles sanctioned the reading of holes and rounded protuberances as organic elements, so that the degree of abstraction did not refute Moore's insistence that in nature itself, in the water-worn pebble, the eroded bone, or the bent twig, he had found the source of many sculptural forms. At this point he could participate in the Surrealist exhibition of 1936, so charged was his abstract sculpture with a mysterious vital expression, yet simultaneously he contributed to the Circle group, so close to the aesthetics of Nicholson and Gabo were his geometrical abstractions and his metal and wire constructions.

Meanwhile he had announced the theme which was to absorb his imaginative and technical energies to a far greater degree than had the mother and child. This was the reclining female figure, suggested in the first of his public commissions, the *North Wind* of 1928–9 for the London Transport Headquarters in London, but emerging fully in the round and on an impressive scale in the *Reclining Figure* of 1929 (Leeds). He had found a source for it (as distinct from its relation to the immemorial tradition of the antique river god) in a Chacmool

307. Henry Moore: Reclining Figure, 1945–46. *Louisville, J.B. Speed Museum*

figure from Chichén Itza in Yucatán, a male warrior(?) reclining on his elbows with raised knees. Moore changed the sex, if that is not too literal a way of describing the anatomical differences whereby the ancient American prototype was transformed into the sculpture which followed year by year, in stone, wood, and metal, and in many sizes, until the authoritative stone figure of 1938 (London) and the wooden ones of 1936 (Wakefield), and 1945–6 [307]. These vast women, who evoke the archetypal fertility image of the *Magna Mater*, the primordial source of man's psychical as well as physical existence, sometimes seem to have only partially emerged from nature itself.[32] The brooding masses of their breasts and thighs are as much landscapes as anatomies, so often do the holes and rounded limbs resemble caves and hillsides, or, in the later bronzes, cliffs that drop sheerly to the sea. The metaphors from nature, quite as much as those from psychology, are apt, for Moore admitted that landscape has never been absent from his mind, and mankind itself, after all, is inseparably an aspect of the natural scene. This indissoluble relationship Moore further stressed by opening the body so that, in a sense, inside and outside are continuous and the space contained within the massive forms seems as dense, as tangibly perceptible as that occupied by the material itself.

The Second World War, which interrupted Moore's excursions into abstract art, brought him into unexpected contact with other than artistic problems when he was commissioned to depict the people of London sleeping in the Underground during the blitz. His many *Shelter Drawings*, in ink, chalk, and watercolour, were not, strictly speaking, the drawings of a sculptor preoccupied with the extension of forms in space, although from these bodies huddled in blankets and heavy clothing came ideas for certain draped figures soon after the War. They brought Moore the favour of a wider public, more easily attracted to pictorial art than to sculpture, and, as his audience grew, so did the commissions that established his reputation as the leading British sculptor of his time, the peer of the principal sculptors abroad. The commissions did not always lead to his happiest achievements. The *Madonna and Child* in St Matthew, Northampton (1943–4), is glumly self-conscious; the reclining figure at the UNESCO Headquarters in Paris (1957–8), although huge in itself, looks small where it is; and though no fault of his own the *Time-Life Screen* in London (1952–3), the most important of his later abstract works, lost much of its potential character when it was found impossible for the individual panels to turn on their vertical axes, as they had in the model. Nor do his more classical figures, created after a trip to Greece in 1951, always convince. The clinging garment on the *Draped Reclining Figure* of 1952–3 for the Time-Life Building is a sensitive interpretation of Phidian drapery, in the manner of the Parthenon figures he had once shunned in the British Museum, but the mutilated *Warrior with Shield* of 1953–4 and the *Fallen Warrior* of 1956–7 embody ideas of individual conflict and fate which are not always in accord with the generalizations of their bodies.

The change from wood and stone to bronze, his preferred material after about 1950, is indicative of his desire for the greater freedom that modelling permits. Yet bronze also can be treated in momumental terms, as Moore proved in the intricate relationships of the latest *Two-* and *Three-Part Figures*, and in the awesome *Upright Motifs* of 1955–6. Like totems of an unknown or forgotten faith, these towering, cross-like forms reconfirmed Moore's interest in those places and things where the distinction between nature and man is least perceptible, in the scarcely shaped monoliths of Stonehenge, in Romanesque carvings almost obliterated by nature and time, in a rock or a

bone where man sees a purpose, and it may be a kind of beauty, of which nature herself is unaware. It is possible to over-emphasize the psychological associations of Moore's sculpture, but not to ignore them. In his desire to assert the basic diginity and durability of human life as natural form, as form in nature, Moore may be considered a religious artist, or if not that at least a philosophical one. But in a secular age which could no longer comprehend cosmological truths in figural terms, he had to create his own mysteries, as well as his own icons.

NOTES

Bold numbers indicate page references

CHAPTER 2

21. 1. In the title of the exhibition *Manet and the Post-Impressionists*, London, Grafton Galleries, 8 November 1910–15 January 1911. For Fry himself, see Virginia Woolf, *Roger Fry, a Biography* (London, 1940); the Arts Council exhibition catalogue, *Vision and Design: the Life, Work and Influence of Roger Fry, 1866–1934* (London, 1966); and F. Spalding, *Roger Fry, Art and Life* (London, 1980), chapter 7.

2. Ambroise Vollard, *Renoir, an Intimate Record* (New York, 1930), 118.

22. 3. George Moore, *Impressions and Opinions* (London, 1891), 313. See also Douglas Cooper, 'George Moore and Modern Art', *Horizon*, XI (February 1945), 113–30.

4. For the influence of Japanese art in France, see Gabriel P. Weisberg, et al., *Japonisme. Japanese Influence on French Art, 1884–1910* (Cleveland Museum of Art, 1975); Colta Feller Ives, *The Great Wave: The Influence of Japanese Woodcuts on French Prints* (New York, 1974). For the contradictory evidence of Degas's interest in Japanese prints, see Ernst Scheyer, 'Far Eastern Art and French Impressionism', *Art Quarterly*, VI (1943), 116–43. The relations between photography and modern painting have been examined by Aaron Scharf in *Art and Photography* (London, 1968). In 'The Artifice of Candor: Impressionism and Photography Reconsidered', *Art in America* (January 1980), 66–78, Kirk Varnedoe contests Scharf's position by claiming that the conventions of nineteenth-century photography had nothing to offer the Impressionist painters.

5. In his definitive catalogue, *Degas et son œuvre* (Paris, 1946–8), P. A. Lemoisne identified the ten pastels under nos 717, 728, 765, 816, 847, 872, and 874–7. Of these, nos 728 and 872 can be documented by the initials of their original owners in the 1886 exhibition catalogue, and no. 877 corresponds to Huysmans's description in his contemporary review (reprinted in *Certains*, 1889, 24). Since Lemoisne's list contains no example of a woman 'se peignant', his no. 849 and a similar (unlisted) version in the Metropolitan Museum should be considered. The Farmington example here reproduced is no. 876.

24. 6. The quotations are from P. A. Lemoisne, 'Les Carnets de Degas au Cabinet des Estampes', *Gazette des Beaux-Arts*, III (1921), 219–31; and from Degas's letter to Henry Lerolle, 18 December 1897, in *Lettres de Degas* (Paris, 1945; English translation by Marguerite Kay, with additional letters, Oxford, 1947).

7. Henry Hertz, *Degas* (Paris, 1920), 55.

8. Georges Jeanniot, 'Souvenirs sur Degas', *Revue universelle*, LV (1933), 158. See also Degas's advice to Pissarro in Camille Pissarro, *Letters to his Son Lucien* (New York, 1943), 35, letter of 13 June 1883.

9. John Walker, III, 'Degas et les maîtres anciens', *Gazette des Beaux-Arts*, X (1933), 173–85. See also Theodore Reff, 'Degas's Copies of Older Art', *Burlington Magazine*, CV (1963), 241–51.

10. Twenty-two copies of each piece were cast between 1919 and 1921 (except for the *Fourteen-year-old Dancer*, which was cast later). The original waxes, most of which are now in the collection of Mr Paul Mellon, Upperville, Virginia, are poorly reproduced in Pierre Borel, *Les Sculptures inédites de Degas* (Geneva, 1949).

11. Alice Michel, 'Degas et son modèle', *Mercure de France*, CXXXI (1919), 457–78, 623–39.

25. 12. From Degas's letter to Albert Bartholomé, Naples, 17 January 1886.

27. 13. 'Journal inédit de Paul Signac', *Gazette des Beaux-Arts*, XXXIX (1952), 276, entry for 11 February 1898.

28. 14. Renoir to Mme Georges Charpentier, February (?) 1882, in Michel Robida, *Le Salon Charpentier et les Impressionnistes* (Paris, 1958), 140. For Renoir in Italy, see Barbara Ehrlich White, 'Renoir's Trip to Italy', *The Art Bulletin*, LI (1969), 333–51.

30. 15. For contemporary accounts of Renoir's technique, see Albert André, *Renoir* (Paris, 1928), 35–7; Walter Pach, 'Pierre-Auguste Renoir', *Scribner's Magazine*, LI (1912), 606–15, reprinted in *Queer Thing, Painting* (New York, 1938), 104–15.

16. Pissarro to Lucien Pissarro, 23 February 1887, in *Letters*, 99; Téodor de Wyzewa, 'Pierre-Auguste Renoir', *L'Art dans les deux mondes* (6 December 1890), 27–8. See also Edmond Renoir's description of his brother in *La Vie moderne* (19 June 1879), reprinted in Lionello Venturi, *Les Archives de l'Impressionnisme* (Paris and New York, 1939), II, 334–8. The poet Henri

de Régnier described Renoir as 'extremely nervous' in his *Renoir, peintre du nu* (Paris, 1923), 9.

17. These studies might have been suggested by Mounet-Sully's famous production of *Oedipe le roi*, first performed in the amphitheatre at Orange in 1881.

33. 18. In 1968 Richard Guino sued Renoir's heirs to have the 'co-authorship' of his work recognized. See *Gazette des Beaux-Arts*, suppl. (Jul.-Sept. 1968), 19.

34. 19. Monet, quoted by an interviewer at his exhibition in the galleries of *La Vie moderne* (12 June 1880); see Germain Bazin, *L'Époque impressionniste* (Paris, 1947), 31.

20. For Monet's popularity in England and the United States, see Douglas Cooper's introduction to his *The Courtauld Collection* (University of London, 1954), and Hans Huth, 'Impressionism Comes to America', *Gazette des Beaux-Arts*, XXIX (1946), 225-52.

21. It is tempting to think that the reappraisal of his work might have come sooner had not his centenary fallen in the first year of the Second World War. The principal documents for the recent revision are the catalogues of the 1957 exhibitions in Edinburgh and London, by Douglas Cooper and John Richardson; of those in St Louis and Minneapolis in the same year by William C. Seitz; the 1960 exhibition in New York and Los Angeles entitled 'Claude Monet, Seasons and Moments', with a catalogue by Seitz; and Clement Greenberg's essay, 'Claude Monet, the later Monet', *Art News Annual*, XXVI (1957), 132-48, 194-6.

22. In 1865-6 Monet painted a country road near Honfleur in midsummer and under winter snow. A year or so earlier the Dutch artist Johann Barthold Jongkind, whom he knew, had painted Notre Dame in Paris at different times of the day (reproduced in John Rewald, *History of Impressionism*, revised ed., 1961, 114-15). At the third Impressionist exhibition in 1877 Monet showed eight views of the tracks and the interior of the train shed of the Gare St Lazare, but they were too diverse to constitute a coherent group. The number of paintings exhibited in each of the later series were as follows: fifteen *Haystacks*, 1891; six *Poplars*, 1892; twenty *Cathedrals of Rouen*, 1895; seventeen *Water Lilies*, 1900; thirty-seven *Views of the Thames*, 1904; forty-eight *Water Lilies*, 1909; twenty-nine *Views of Venice*, 1912.

36. 23. See especially the letters to Gustave Geffroy of 7 October 1890 (Geffroy, *Claude Monet*, Paris, 1922, 189); to Durand-Ruel of 13 April 1892, 30 March 1893, 20 February and 20 April 1894 (Venturi, *Archives*, I, 344 ff.).

24. Typical of the opposition was Étienne Bricon's contention that the *Cathedrals* were 'magical studies but, perhaps like all Impressionist pictures, they are only studies because they are not the synthesis or idea

of anything at all'. See his 'L'Art impressionniste au Musée du Luxembourg', *La Nouvelle Revue*, CXIV (1898), 299.

38. 25. This and other aspects of the series have been examined in my Charlton Lecture of 1959, *Claude Monet's Paintings of Rouen Cathedral* (London, 1960). Whereas most observers have noted the indistinct effect of most of the pictures, Georges Clemenceau felt that the drawing, 'tightly constructed, clean, mathematically precise, reveals together with the geometric conception of the whole both the ordered masses and the sharp edges of the sculptural interlacings in which the stones are enshrined' (from his sympathetic review, 'Révolution de Cathédrales', first published 20 May 1895, reprinted in *Le Grand Pan* (Paris, 1896), 427-37, and in large part in translation in *Claude Monet, the Water Lilies* (New York, 1930), 119-39).

40. 26. Roger Marx, 'Les *Nymphéas* de M. Claude Monet', *Gazette des Beaux-Arts*, I (1909), 523-31, reprinted in *Maîtres d'hier et d'aujourd'hui* (Paris, 1914), 283-97.

41. 27. Léon Vallas, *Debussy* (Paris, 1926), 69. Debussy's description of his *Nuages* (1899) is apt for the later series of *Water Lilies*: '. . . the immutable aspect of the sky with the slow and melancholy procession of clouds, melting in an agony of grey, softly tinted with white.'

42. 28. According to Lionello Venturi's catalogue in his *Cézanne, son art, son œuvre* (Paris, 1936), the last dated work was the *Chaumière dans les arbres* (v. 139), of 1873. Between then and 1906 there were only thirty-one signed paintings. For revisions of Venturi's chronological sequence, see Douglas Cooper, 'Two Cézanne Exhibitions', *Burlington Magazine*, XCVI (1954), 344-9, 378-83; Lawrence Gowing, 'Notes on the Development of Cézanne', *Burlington Magazine*, XCVIII (1956), 185-92; Theodore Reff, 'A New Exhibition of Cézanne', *Burlington Magazine*, CII (1960), 114-18. See also J. Rewald, 'Some Entries for a new *Catalogue Raisonné* of Cézanne's Paintings', *Gazette des Beaux-Arts*, 86 (1975), 158-68.

29. In 'Cézanne and His Critics' (W. Rubin, ed., *Cézanne, the Late Work* (New York, 1977), 139-49), I have traced the changes in critical attitudes towards Cézanne's work from 1895 to his death in 1906 by examining the language used by his contemporary critics. Words originally pejorative (*brutal, fruste, enfantin, gauche, primitif*, etc.) within a few years were used to praise his achievement.

30. Émile Bernard, *Souvenirs sur Paul Cézanne* (Paris, 1921), 80. Bernard's account of his conversations with Cézanne must be used with caution. From the context of his neo-classical argument he appears in many instances to have twisted the older painter's

remarks in order to discredit Cézanne's empirical procedure.

44. 31. This excerpt from a letter written by Cézanne to Bernard about 1904 was first published by Bernard in the *Mercure de France* (1 October 1907), 400.

32. For a more detailed presentation of this point of view, see my 'Cézanne, Bergson, and the Image of Time', *College Art Journal*, XVI (1956), 2–12. See also Paul M. Laporte, 'Cézanne and the Philosophy of his Time', *trans/formation* [sic], I (1951), no. 2, 69–73. For the possible psychological symbolism of Cézanne's still lifes, see Meyer Schapiro, 'The Apples of Cézanne: an Essay on the Meaning of Still-life', *Art News Annual*, XXXIV (New York, 1968), 35–53; reprinted in M. Schapiro, *Modern Art, 19th and 20th Centuries* (New York, 1978), 1–38.

46. 33. The source of Cézanne's monumental standing *Bather* of 1885–90 (New York) in a photograph of a nude male model can be examined in Alfred H. Barr, Jr, ed., *Masters of Modern Art* (New York, 1954), 22–3.

48. 34. Joachim Gasquet, *Cézanne* (Paris, 1921), 80–1. Gasquet, like Bernard, amplified and exaggerated Cézanne's statements. For his reliability as a witness, see John Rewald, *Cézanne, Geffroy, et Gasquet, suivi de souvenirs sur Cézanne de Louis Aurenche et de lettres inédites* (Paris, 1960).

35. Cézanne to Bernard, Aix, 15 April 1904 (first published by Bernard in 1907). In this, the most quoted and misquoted of Cézanne's statements, the word 'cube' is often, and apparently unintentionally, substituted for one of the geometrical terms, as if to justify Cézanne as the ancestor of Cubism. The word 'cube' first appeared in the context of Cézanne's ideas, *after* the development of Cubism, in Bernard's 'Une Conversation avec Cézanne', *Mercure de France*, CXLVIII (1 June 1921). The precedents for geometrical reductions of natural forms have been traced by Werner Hoffmann in *Grundlagen der Modernen Kunst* (Stuttgart, 1966), 71. Hoffmann has also pointed out, in *Turning Points in Twentieth Century Art: 1890–1917* (New York, 1969), 78, Walter Crane's comparable statement of 1900: 'The cube and the sphere, the ellipse, the cone and the pyramid . . . present themselves to the student as elementary tests of draughtsmanship . . . being more simple and regular than natural forms.' Cézanne's remark, a commonplace of academic instruction, was less original than the Cubists thought.

36. Maurice Denis, 'Cézanne', in *L'Occident* (September 1907), reprinted in his *Théories, 1890–1910* (Paris, 1912), 244–61.

49. 37. This famous statement, ostensibly made by Cézanne to Bernard, was first published by Bernard in a footnote to his article in the *Mercure de France* (16 October 1907), 627: 'Imaginez Poussin refait entièrement sur nature. Voilà le classique que j'entends.' Its authenticity and relevance to Cézanne's work have been scrutinized by Theodore Reff in 'Cézanne and Poussin', *Journal of the Warburg and Courtauld Institutes*, XXIII (1960), 150–74, and 'Cézanne et Poussin', *Art de France*, III (1963), 302–10.

38. The majestic views of Mont-Ste-Victoire painted in the last years of his life (1900–6) are in no way compromised by the suggestion that, if Cézanne did suffer from diabetes, his vision may have been increasingly impaired. Such retinal deterioration, a natural and not unusual physiological condition, would account for his increasing discouragement and exasperation in attempting 'to realize his sensations'. It would also explain the difference between the controlled planes of the great landscapes of the later 1880s [12], and the agitation and lack of definition in the houses, trees, and mountains, which is not at all a 'baroque' characteristic, in the later work [15]. Cézanne's health is known to have declined from 1890. The over-sized apple on the floor in illustration 13 could be considered an indication of myopia (often a result of diabetes) which causes farther objects to appear larger than they are. Should this be so, Cézanne's optical difficulties were, in their way, comparable to those endured by Degas and Monet.

50. 39. Gustave Kahn, 'Seurat', *L'Art moderne* (Brussels, 5 April 1891), 110.

51. 40. Octave Mirbeau in *La France* (20 May 1886). For this and other contemporary criticism of Seurat's paintings, see Henri Dorra and John Rewald, *Seurat* (Paris, 1959), *passim*.

41. Gustave Kahn, 'Chronique', *Revue indépendante*, VI (January 1888), 143; quoted by John Rewald, *Post-Impressionism, from Van Gogh to Gauguin* (New York, 1956), 141.

42. Seurat to Maurice Beaubourg, 28 August 1890, first published by Robert Rey in *La Renaissance du sentiment classique* (Paris, 1931), opp. p. 132. For Charles Henry's relation to Seurat and Signac, and for Neo-Impressionism, see Rewald, *op. cit.* (Note 39), chapter II. Seurat is known to have read the works of Rood, Helmholtz, and Chevreul, and was certainly familiar with the ideas of Simler, Fechner, Maxwell, and others. See also J. A. Argüelles, *Charles Henry and the Formation of a Psychophysical Aesthetic* (Chicago, 1972).

52. 43. Although Seurat never went abroad, he knew the copies of Piero della Francesca's Arezzo frescoes which hung in the École des Beaux-Arts when he was a student.

44. The preliminary studies were first put in order and the design analysed by Daniel Catton Rich in

Seurat and the Evolution of 'La Grande Jatte' (Chicago, 1935). The painting itself, finished in March 1885, was soon after retouched with inferior pigments. By 1892 it had visibly deteriorated, and is now sadly faded. The once brilliant oranges and greens have turned towards brown.

54. 45. For the relation of *The Circus* to Jules Chéret's contemporary posters, see Meyer Schapiro, 'New Light on Seurat', *Art News*, LVII (April 1958), 22–4; and Robert L. Herbert, 'Seurat and Jules Chéret', *Art Bulletin*, XL (1958), 156–8.

55. 46. There is no catalogue or critical study of Signac's *œuvre*, but the lively play of his ideas can be followed in extracts from his journal, edited by John Rewald, *Gazette des Beaux-Arts*, XXXVI (1949), 97–128; XXXIX (1952), 265–84.

47. For the political and social interests of Pissarro and the Neo-Impressionists, see Benedict Nicolson, 'The Anarchism of Camille Pissarro', *The Arts*, no. 2 (1947), 43–51; Robert L. and Eugenia W. Herbert, 'Artists and Anarchism, Unpublished Letters of Pissarro, Signac, and Others', *Burlington Magazine*, CII (1960), 473–82, 517–22; and E. W. Herbert's *The Artist and Social Reform, France and Belgium, 1885–1898* (New Haven, 1961), chapter 6.

56. 48. Fénéon first used the term in his article 'L'Impressionnisme aux Tuileries', *L'Art moderne* (Brussels, 19 September 1886), 300–2, reprinted in *Félix Fénéon, au-delà de l'impressionnisme* (Paris, Miroirs de l'art, 1966), 73–80. For Fénéon's articles on Seurat and Signac, with additions, see Dorra and Rewald, *Seurat*, xi–xxxi.

57. 49. For the history of 'Les XX' see Madeleine Octave-Maus, *Trente Années de lutte pour l'art, 1884–1914* (Brussels, 1926); the exhibition catalogue, *La Groupe des XX et son temps* (Brussels and Otterlo, 1962); and a review of the exhibition by Bettina Spaanstra-Polak, 'De Tentoonstelling van de XX', *Museumjournaal voor Moderne Kunst*, no. 10 (Amsterdam, 1962), 239–48.

58. 50. For British attitudes towards French Impressionism see Douglas Cooper's *The Courtauld Collection* (London, 1954), chapters III–V.

60. 51. Marcel Proust, *Lettres à une amie* (Manchester, 1942), Lettre XXXIII, 9 February 1905.

62. 52. The quotations are from Francis Henry Taylor's 'Rodin', *Parnassus*, II (1930), no. 2, 10.

63. 53. 'Pensées inédites de Rodin', *L'Art et les artistes*, XIX (1919), 37.

54. Auguste Rodin, *L'Art, entretiens réunis par Paul Gsell* (Paris, 1911). Unless otherwise indicated, Rodin's remarks will be quoted from this work.

55. Rainer Maria Rilke to Lou Andreas-Salomé, 8 August 1903: '. . . he knows that even in the rise and fall of a quiet surface there is movement . . . since he sees only surfaces and systems of surfaces which define forms accurately and clearly', in R. M. Rilke, *Briefe aus den Jahren 1902 bis 1906* (Leipzig, 1930), 111. Rilke's relations with Rodin have been documented by Ursula Emde in *Rilke und Rodin* (Marburg, 1949), and in the exhibition *Rilke und Rodin* (Munich and Bremen, June–August 1955).

56. André Fontainas, 'La Statue de Balzac', *Mercure de France*, XXVI (1898), 378–99.

65. 57. For the history and criticism of the doors, see Wilhelm Boeck, 'Rodins "Höllenpforte", ihre kunstgeschichtliche Bedeutung', *Wallraf-Richartz-Jahrbuch*, XVI (1954), 161–95; and Albert E. Elsen, *Rodin's Gates of Hell* (Minneapolis, 1960).

58. Rainer Maria Rilke, *Auguste Rodin* (New York, 1919), 19.

59. Parker Tyler, 'Rodin and Freud, Masters of Ambivalence', *Art News*, LIV (March 1955), 39–41, 63–4.

66. 60. Rodin's interest in the fragment, and the influence upon his work of fragmentary antique sculpture, of which he possessed a considerable collection, have been discussed by several scholars in a symposium, *Das Unvollendete als künstlerische Form*, ed. J. A. Schmoll, *gen.* Eisenwerth (Bern and Munich, 1959).

68. 61. Quoted by Jacques des Gachons in *L'Ermitage* (1898), II, 65.

62. Louis de Fourcaud in *Le Gaulois* (7 May 1898), and Judith Cladel in *La Fronde* (2 May 1898). Gustave Coquiot, in *Rodin à l'Hotel de Biron et à Meudon* (Paris, 1917), 108, quoted Rodin as saying that no one had understood his wish to place the statue 'like a Memnon, an Egyptian colossus'. For suggested sources of the figure, see Cécile Goldscheider, 'La Genèse d'une œuvre: Le Balzac de Rodin', *Revue des arts*, II (March 1952), 37–44. See also Jacques de Caso, 'Rodin and the Cult of Balzac', *Burlington Magazine*, CVI (1964), 279–84, and the same author's 'Balzac and Rodin', *Bulletin of the Rhode Island School of Design, Museum Notes*, LII, no. 4 (May 1966).

69. 63. Rodin's *Balzac* is now at the intersection of the Boulevards Raspail and Montparnasse. The circumstances of its erection have been described by Georges Lecomte in his preface to *Chefs-d'œuvre de Rodin* (Paris, 1946). Falguière's statue is on the Avenue de Friedland, near the Étoile.

71. 64. Rosso's photographs are reproduced in Mino Borghi's *Medardo Rosso* (Milan, 1950).

72. 65. Rosso, quoted by Edmond Claris in *De l'impressionnisme en sculpture* (Paris, 1902), 51, 55. Could Rodin have been thinking of Rosso's ideas when he told a reporter that his *Balzac* should be seen from the

right at twenty paces, thus implying that one aspect was superior to others and that it need not be seen 'in the round'? For the possible influence of Rosso on Rodin, see Margaret Scolari Barr, *Medardo Rosso* (New York, 1963), 53-4. At the turn of the century it was thought that the *Balzac* owed something to Rosso's *Man in the Hospital*, but its stance more closely resembles that of *The Bookmaker*.

CHAPTER 3

75. 1. *Mercure de France*, II (1891), 155-65, reprinted in Aurier's *Œuvres posthumes* (Paris, 1893), 205-19. Despite his objection to Impressionism, Gauguin always used the word to mean progressive rather than conservative painting, as in his letter to Bernard from Le Pouldu, November 1889: 'But to send me, an Impressionist painter, in other words, an insurgent . . .'. Gauguin's letters, except for the correspondence with Daniel de Monfreid, will be quoted from his *Lettres à sa femme et à ses amis*, ed. Maurice Malingue (Paris, 1946; English translation by Henry J. Stenning, London, 1948, and Cleveland, 1949).

2. Jean Moréas, 'Le Symbolisme', *Figaro littéraire* (18 September 1886), partially translated by Rewald, *Post-Impressionism* (*op. cit.*, Chapter 2, Note 39), 147-8.

3. Although 'synthetist' had been used as early as 1876 to distinguish the artistic from the scientific aspects of Impressionism (Émile Blemont in *L'Appel*, 4 April, quoted by Gustave Geffroy in *Monet*, Paris, 1922, 61), it occurs more frequently in the 1880s in descriptions of anti-Impressionist art, as in Gustave Kahn's review of an exhibition of Impressionist painting at Durand-Ruel's in 1888: 'La résultante de cette exposition . . . serait . . . de démontrer assez synthétiquement par quelle marche l'impressionnisme s'est dirigé . . . jusqu'à un établissement plus complet d'un art d'harmonie du tableau et de coloration scientifique' (*Revue indépendante*, VII, June 1888, 546). In a letter of 14 August 1888 Gauguin described his latest work as 'a synthesis of a single form and a single colour'.

4. Honoré de Balzac, *Le Chef-d'œuvre inconnu*, quoted by the Symbolist poet and critic André Fontainas, in his review of Gauguin's exhibition at Vollard's gallery (*Mercure de France*, XXIX, 1899, 236); *Eugène Delacroix, sa vie et ses œuvres* (Paris, 1865), 444 (the phrase, which Gauguin entered in a notebook, had been copied by Delacroix from Mme de Staël's *De l'Allemagne*).

5. Gauguin to Charles Morice, Tahiti, July 1901.

76. 6. The idea came from Wagner's aesthetics, and was popularized in France through the pages of the *Revue wagnérienne* (1885-8). See Téodor de Wyzewa,

'Peinture wagnérienne', a review of the Salon of 1885, in the *Revue wagnérienne*, I (1885), no. 5, 154-6.

7. See the short section, 'Valeur de l'art dans la vie humaine', in Taine's *Philosophie de l'art* (Paris, 1876). Much later the Surrealists invoked his authority for the 'reality' of hallucinations.

8. Bergson's aesthetics, as eventually defined in *Le Rire* (1900), were implicit as early as 1889 in his *Essai sur les données immédiates de la conscience* (written in 1883-7).

9. Eugène Delacroix, *Journal* (Paris, 1932), I, 97, entry for 7 May 1824.

10. Maurice Denis, *Journal* (Paris, 1957), I, 140, letter to Vuillard, 22 February 1898.

11. Gustave Kahn, 'Réponse des Symbolistes', *L'Événement* (28 September 1886); quoted by Rewald, *Post-Impressionism*, 149.

12. Jules Laforgue, *Exil, poésie, spleen*, 61-2; quoted by Kenneth Cornell, *The Symbolist Movement* (New Haven, 1951), 39.

77. 13. Although primitive art became formally influential only after 1900, interest in the aesthetic values of anthropological artefacts increased after 1870. See Robert J. Goldwater, *Primitivism in Modern Painting*, 2nd revised ed. (New York, 1967), chapters I-III. See also Charles Morice's important essay on Gauguin in *Mercure de France*, IX (1893), 289-300.

14. *La Vogue*, no. 2 (1886), 70-1.

15. Émile Bernard, 'Paul Cézanne', *Les Hommes d'aujourd'hui* (Paris, 1890), no. 387.

16. For Carrière, see Fritz Novotny, *Painting and Sculpture in Europe, 1780 to 1880* (Pelican History of Art), 2nd ed. (Harmondsworth, 1971), 188. In the absence of any recent monograph on Carrière, Michel Florisoone's introduction to the exhibition catalogue *Eugène Carrière et le Symbolisme* (Paris, 1949-50) places the painter in relation to the ideas of his day. Of the four artists mentioned in the text, Carrière had the least to offer the younger generation. His art, like Rodin's, with whose sentimental and vaporous marbles his own misty, monochromatic painting may be compared, was closely tied to naturalist and positivist principles.

17. J.-K. Huysmans, *À Rebours*, chapter IV, English translation as *Against the Grain*.

79. 18. Quoted by Ragnar von Holten in *L'Art fantastique de Gustave Moreau* (Paris, 1960), 65.

19. This interest was aroused by the presentation in the Louvre, during the summer of 1961, of a number of works from the Moreau museum. See the catalogue by von Holten, *Gustave Moreau*, and the essay by Dore Ashton in the catalogue of the Redon, Moreau, Bresdin exhibition at the Museum of Modern Art, New York, 1961, where some of the 'abstract' sketches are reproduced in colour.

20. There is no modern study of Puvis de Chavannes, but the older works are listed in Rewald's *Post-Impressionism*, 594. Robert Goldwater's 'Puvis de Chavannes: Some Reasons for a Reputation', *Art Bulletin*, XXVIII (1946), 33–43, is an analysis of contemporary criticism. For Puvis's importance to his younger contemporaries, see Robert L. Herbert, 'Seurat and Puvis de Chavannes', *Yale University Art Gallery Bulletin*, XXV, no. 2 (October 1959), 22–9. See also the Bibliography for the Toronto (1975) and Ottawa-Paris (1977) exhibitions.

80. 21. August Strindberg to Paul Gauguin, 1 February 1895. See below, Note 36.

22. Émile Bernard, 'Le Symbolisme pictural, 1886–1936', *Mercure de France*, CCLXVIII (1936), 526–7.

23. Quoted by Bernard Dorival in his *Les Étapes de la peinture française contemporaine* (Paris, 1943), I, 43–4.

81. 24. Odilon Redon, 'Confidences d'artiste', in *À Soi-même, Journal. (1867–1915)* (Paris, 1922), 29–30. Further quotations in the text are from this work.

82. 25. Redon did not take his titles from Poe but invented them himself, possibly with the assistance of the critic Émile Hennequin. See Redon's letter of 21 July 1898 to Mellerio in *Lettres d'Odilon Redon* (Paris and Brussels, 1923), 31, and Sven Sandström, *Le Monde imaginaire d'Odilon Redon* (Lund, 1955), 111. In 1904 Redon disclaimed any influence from Poe: 'Je n'aime pas Edgar Poe. Il ne m'a jamais donné d'inventions plastiques. Il est trop cérébral pour inciter à représenter des formes vivantes.' See John Rewald, 'Quelques notes et documents sur Odilon Redon', *Gazette des Beaux-Arts*, XLVIII (1956), 81–124.

84. 26. Gauguin to his wife, Tahiti, March 1892.

27. Gauguin to Emile Schuffenecker, Copenhagen, 14 January 1885.

28. Charles Morice, *Paul Gauguin* (Paris, 1920), 50.

29. Gauguin to Daniel de Monfreid, March 1898, in *Lettres de Gauguin à Daniel de Monfreid* (Paris, 1950). Gauguin had asked himself these questions while contemplating his *Whence Come We . . .* [39].

85. 30. The quotations are from Octave Mirbeau's letter to Claude Monet, February 1891, in *Cahiers d'aujourd'hui*, no. 9 (1922), 172; and Gauguin to Schuffenecker, 14 August 1888. For Japanese elements in the *Vision*, see Yvonne Thirion, 'L'Influence de l'estampe japonaise dans l'œuvre de Gauguin', *Gazette des Beaux-Arts*, XLVII (1956), 95–114.

31. Bernard's painting and Van Gogh's copy are reproduced in Rewald, *Post-Impressionism*, 251.

86. 32. Gauguin to Bernard, Le Pouldu, early September 1889.

33. Gauguin to his wife, Paris, February 1888.

88. 34. For lists of works sold at this and the auction of 1895, see the catalogue, *Gauguin, exposition du centenaire* (Paris, 1949), 95–9.

89. 35. See Bernard Dorival, 'Sources of the Art of Gauguin from Java, Egypt, and Ancient Greece', *Burlington Magazine*, XCIII (1951), 118–22; Rewald, *Post-Impressionism*, 506–9.

36. They are reproduced in Jean de Rotonchamp, *Paul Gauguin* (Weimar, 1906; Paris, 1925). Strindberg's letter is also in Gauguin's *Avant et après*.

90. 37. Gauguin to Charles Morice, Tahiti, July 1901.

91. 38. André Fontainas, 'Art moderne', *Mercure de France*, XXIX (1899), 235–8. The painting's poetic title has a curious resemblance to the words spoken about the blind grandfather in Maeterlinck's one-act Symbolist drama *L'Intruse* (1891): 'Ne pas savoir où l'on est, ne pas savoir d'où l'on vient, ne pas savoir où l'on va, ne plus distinguer midi de minuit, ni l'été de l'hiver.' The play is said to have been first performed at the Théâtre de l'Art in Paris on 27 May 1891 as a benefit for Verlaine and for Gauguin, who was already on his way to Tahiti.

39. Gauguin to Monfreid, February 1898; to Fontainas, March 1899; to Morice, July 1901. The most recent study of this painting is Georges Wildenstein's 'L'idéologie et l'esthétique dans deux tableaux-clés de Gauguin', in *Gauguin, sa vie, son œuvre, réunion de textes, d'études, de documents* (Paris, 1958), a separate issue of nos 1044–7 of the *Gazette des Beaux-Arts*.

92. 40. Gauguin to de Monfreid, August 1901: 'These prints are interesting just because they recall the primitive period of engraving.'

93. 41. First published in the *Revue blanche*, XIV (October–November 1897); also in book form (Paris, 1901, and later editions), and in facsimile (1926, 1947). The definitive edition of the 'authentic' text has been edited, with extensive notes and bibliography, by Jean Loize (Paris, André Ballard, 1966).

94. 42. Octave Mirbeau, 'Chronique – Paul Gauguin', *Echo de Paris* (16 February 1891); see also Rewald, *Post-Impressionism*, 472–4.

43. From Van Gogh's letter to Theo, Arles, (summer) 1888, no. 503. The dating and numbering of quotations from the letters follows the standard translation, edited by Johanna van Gogh-Bonger and V. W. van Gogh, *The Complete Letters of Vincent van Gogh*, 3 vols (London and Greenwich, Conn., 1958).

95. 44. Letter 166, late December 1881.

45. Letter 223, to Theo, The Hague, (summer) 1882.

96. 46. See Letters 339–405. The preliminary version of *The Potato Eaters* is in the Rijksmuseum Kröller-Müller, Otterlo.

100. 47. Letters 518, 533–5, Arles, September 1888.

48. The episode has been studied and documented by Rewald in *Post-Impressionism*, chapter v. Gauguin's account, written fifteen years later, is in *Avant et après*.

49. For van Gogh's illness, see especially G. Kraus,

'Vincent van Gogh de Psychiatrie', *Psychiatrische en Neurologische Bladen* (Sept.-Oct. 1941), and summary of Kraus's bibliography in Rewald, *Post-Impressionism*, 578-9. Dr Humberto Nagera, in his undocumented monograph, *Vincent van Gogh, a Psychological Study* (New York, 1967), believes that precise diagnosis is impossible in the absence of accurate clinical records, and that 'we are observing in Vincent's illness a process of emotional disturbance, of mental instability, which follows a long line of development in historical terms all through the painter's life', and that 'many of his "crises" during this period were determined by specific psychological stresses related to factors and events of an internal and external nature' (113-14).

50. Letters 643 and 652.

102. 51. Van Gogh painted seven *Sunflowers* in a projected series of fourteen, and five versions of the *Woman rocking a Cradle*. From his summary sketch in Letter 592 from Saint-Rémy, 25 May 1889, it is impossible to tell which he had in mind for the triptych. See also Letters 573-5, 582, 592 from Arles and Saint-Rémy, January–May 1889. It is worth noting that in 1883 Monet had painted decorative panels for Durand-Ruel's dining-room, one of which, a narrow vertical canvas representing four sunflowers, was exhibited at Les XX in 1886 (reproduced in *Le Groupe des XX et son temps*, Brussels and Otterlo [1962], plate XX). Van Gogh himself sent two *Sunflowers* to Les XX in 1890. See also Konrad Hoffmann, 'Zu Van Goghs Sonnenblumenbildern', *Zeitschrift für Kunstgeschichte*, XXXI (1968), Heft 1, 27-58.

52. Letter 543, Arles, September 1888.

53. Such a tight repetitive pattern occurs in the cobblestones in one of Van Gogh's earliest drawings, *Au Charbonnage*, done in the Borinage in 1878; it is reproduced in the *Letters*, I, 178.

54. Anna Boch bought the painting, not at the Brussels exhibition, but from Père Tanguy in Paris before 29 June 1891. See T. Faider-Thomas, 'Anna Boch et le groupe des XX', *Miscellanea Jozef Duverger* (Ghent, 1968), 402-10.

105. 55. The vexed problem of Bernard's influence on Gauguin and Van Gogh awaits exhaustive and impartial study. In addition to the relevant passages in Rewald's *Post-Impressionism*, see Henri Dorra, 'Émile Bernard and Paul Gauguin', *Gazette des Beaux-Arts*, XLV (1955), 227-46; Pierre Mornand, *Émile Bernard et ses amis* (Geneva, 1957), and *Lettres de Paul Gauguin à Émile Bernard, 1888-1891* (Geneva, 1954), with a preface by Bernard's son, M.-A. Bernard-Fort. Bernard's *Yellow Christ* is reproduced in colour in the latter two works. If Bernard's zincograph, *La Promenade* (reproduced by Hans-Hellmut Hoffstätter in

'Émile Bernard - Schüler oder Lehrer Gauguins', *Kunstwerk*, XI (1957), no. 1, 3-10), could be securely dated 1886, his influence would have to be considered of the first importance. Hoffstätter's article is an excerpt from his thesis, *Die Entstehung des neuen Stils in der französischen Malerei um 1890* (Freiburg-im-Breisgau, 1954; summarized in Mornand, 89).

106. 56. See *Lettres de Vincent van Gogh ... à Émile Bernard* (Tonnerre, 1926; new edition Brussels, 1942), and *Vincent van Gogh, Letters to Émile Bernard*, translated by Douglas Lord (London, 1938).

57. Maurice Denis, L'Influence de Paul Gauguin', *L'Occident* (October 1903), reprinted in his *Théories, 1890-1910* (Paris, 1912), 166-78. There is another, longer account with a different choice of colours in Jan (Dom W.) Verkade, *Le Tourment de Dieu* (Paris, 1923), 75-6. Gauguin had probably developed the idea somewhat earlier; in the late summer of 1887 Van Gogh wrote to an English painter, Levens: 'I did a dozen landscapes, frankly *green*, frankly *blue*' (Letter 459a; italics his).

107. 58. In 1919 Denis founded with Georges Desvallières (1861-1950) the 'Ateliers d'art sacré', where they trained apprentices in Catholic philosophy and the theory and practice of religious art. They produced all manner of objects - mosaics, furniture, illuminations, and embroideries - as well as paintings. The wonder is that such bland performances were so long ignored by the ecclesiastical hierarchy.

59. First published in *Art et critique* (23 and 30 August 1890); reprinted in his *Théories*, 1-13.

108. 60. From 'Notes d'art et d'esthétique', first published in *La Revue blanche* (25 June 1892); reprinted in *Théories*, 17.

109. 61. For Vollard's principal portfolios, see Una E. Johnson, *Ambroise Vollard, Éditeur. Prints, Books, Bronzes* (New York, Museum of Modern Art, 1977), and Albert Skira, *Anthologie du livre illustré par les peintres et sculpteurs de l'École de Paris* (Geneva, 1946).

110. 62. Jacques Salomon and Annette Vaillant, 'Vuillard et son Kodak', *L'Œil*, no. 100 (April 1963), 14-25, 61. See also the exhibition 'Vuillard et son Kodak', London, Lefevre Gallery, March 1964.

112. 63. A. Lamotte, 'Le bouquet de roses, propos de Pierre Bonnard recueillis en 1943', *Verve*, V (1947), nos. 17-18; quoted by John Rewald in *Pierre Bonnard* (New York, 1948), 40.

114. 64. There is a biographical index of Lautrec's people in F. Jourdain and J. Adhémar, *T-Lautrec* (Paris, 1952), 85-107.

117. 65. The four-colour separation of the first Moulin Rouge poster may be studied, as well as colour reproductions of all Lautrec's posters, in Édouard Julien, *The Posters of Toulouse-Lautrec* (Monte Carlo,

1951). For the history and evaluation of the early posters, see Paul Wember, *Die Jugend der Plakate, 1887-1917* (Krefeld, Kaiser Wilhelm Museum, 1961).

66. For an analysis of Lautrec's treatment of forms in motion, see Lincoln F. Johnson, Jr, 'Time and Motion in Toulouse-Lautrec', *College Art Journal*, XVI (1956), 13-22.

118. 67. Joseph C. Sloane Jr's 'Religious Influences on the Art of Jean-Louis Forain', *Art Bulletin*, XXIII (1941), 200-6, contains an exchange of letters between Forain and Huysmans.

119. 68. From Ensor's lecture in Paris at the Musée du Jeu de Paume, June 1932, quoted by Paul Haesaerts, *James Ensor* (New York, 1958), 357-8.

121. 69. Blanche Rousseau, in *James Ensor, peintre et graveur* (Paris, La Plume, 1899), 5.

122. 70. Oskar Kokoschka, *Der Expressionismus Edvard Munchs* (Vienna-Linz-Munich, 1953), 14.

123. 71. From Munch's diary, entry dated St Cloud 1889; quoted from his 'Små utdrag av min dagbok' in Ingrid Langaard, *Edvard Munch, Modningsår* (Oslo, 1960, in Norwegian), 95, and in English by Frederick B. Deknatel, *Edvard Munch* (New York, 1950), 18.

124. 72. After several exhibitions from 1893 in Berlin, the Rhineland, and Stockholm the Frieze of Life (a title apparently not used by Munch until 1918), received its final form at the Berlin Sezession in 1905 as A Cycle of Moments from Life. Twenty-two paintings were hung, in groups of five or six, on four walls as Seeds of Love, Flowering and Passing of Love, Life's Anxiety, and Death. For this information and an account of Munch's life in the 1890s, see Reinhold Heller, 'Love as a Series and a Master of Life and Death . . .', *Edvard Munch, Symbols and Images* (Washington, National Gallery of Art, 1978), 87-111.

73. From Munch's statement when the *Frieze of Life* was exhibited in Oslo in 1918; translated in Otto Benesch, *Edvard Munch* (London, 1960), 26. The psychological aspects of his self-portraits have been examined by Gotthard Jedlicka in 'Über einige Selbstbildnisse von Edvard Munch', *Wallraf-Richartz Jahrbuch*, XX (1958), 225-60.

74. *La Revue blanche*, II (1895), 528.

75. Munch rarely 'illustrated' subjects from Ibsen, although in 1906 he designed the sets for Max Reinhardt's Berlin production of *Ghosts*. A water-colour sketch related to this production was sold at Sotheby and Co., London, 10 July 1969, no. 289 (reproduced in colour in the catalogue). As early as 1895 Ibsen noticed at an exhibition in Oslo a painting, now lost, representing three women and a man, and Munch himself called attention to the similarity between his women and the three female characters in

Ibsen's *When We Dead Awaken* of 1899. See Langaard, *Edvard Munch, Modningsår*, 214-17, 445. The monument in Munch's oil sketch *Mountain of Humanity* (Oslo, Munch-Museet) suggests a composition by the sculptor Rubek, the hero of *When We Dead Awaken* (see W. Hoffmann, *Turning Points . . .* , 249).

128. 76. For the tangled history of the commission, see Roy A. Boe, 'Edvard Munch's Murals for the University of Oslo', *Art Quarterly*, XXIII (1960), 233-46.

129. 77. The Rose-Croix was an artistic and aesthetic exemplification of Rosicrucian principles, directed by Joséphin Péladan, known as Sâr Péladan. His esoteric ideas are most easily approached through his *L'Art idéaliste et mystique, doctrine de l'ordre et du Salon annuel des Rose-Croix* (Paris, 1894). The few Rose-Croix exhibitions may be of little account artistically, but they deserve more attention than they have received from art historians. See also P. Grinke, 'Salons de la Rose-Croix', *Art and Artists*, III, no. 2 (May 1968), 12-15; R. Pincus-Witten, 'Ideal Interlude. The Salons of the Rose-Croix', *Artforum* (September 1968), 51-4; Ph.J. [Philippe Julian], 'Les Rose-Croix', *Connaissance des arts*, no. 210 (August 1969), 28-35.

130. 78. Hodler's participation in this exhibition has been documented in the Zürich Kunstgesellschaft's *Hodler und Wien* (Zürich, 1950), with texts by Hans Ankwicz-Kleehoven, Cuno Amiet, and Kolo (Koloman) Moser.

79. The most searching attempt to establish Hodler's position in modern painting as at least comparable to Cézanne's, and one still worth examining, was Fritz Burger's *Cézanne und Hodler, Einführung in die Probleme der Malerei der Gegenwart*, 2 vols (Munich, 1913).

132. 80. The principal architectural monuments of the style have been described by Henry-Russell Hitchcock in his *Architecture: Nineteenth and Twentieth Centuries* (Pelican History of Art), 3rd ed. (Harmondsworth, 1968, and paperback ed., 1971), chapters 16-17.

133. 81. 'Amo' was first published in *Essays* (Leipzig, 1910); reprinted in a volume of collected papers, *Zum neuen Stil*, ed. Hans Curjel (Munich, 1955), 200-5.

134. 82. Various aspects of Jugendstil activity in Munich, with useful biographical materials, were presented in the exhibition and catalogue *München 1869-1958, Aufbruch zur modernen Kunst* (Munich, 1958). See also *Du*, no. 341 (July 1969), special issue on 'München um 1900'.

135. 83. For this exceptionally fine and well-preserved example of the architectural and decorative style of the Viennese Sezession see Eduard F. Sekler, 'The Stoclet House by Josef Hoffmann', *Essays in the*

History of Architecture presented to Rudolf Wittkower (London, 1967), 238–44.

136. 84. For Mamontov's colony, see Camilla Gray, *The Great Experiment: Russian Art 1863–1922* (London, 1962), chapter 1; for the Slavic Revival and Mir Iskusstva, G. H. Hamilton, *The Art and Architecture of Russia* (Pelican History of Art) (Harmondsworth, 1954), chapter 27.

138. 85. Most recently by Naum Gabo in *Of Divers Arts* (New York, 1962), 155–6, 167.

139. 86. The issue of *Lituanus*, VII (1961), no. 2, contains several critical essays on Čiurlionis. For additional reproductions, see *Apollon* (1914), no. 3, with essays (in Russian) by Viacheslav Ivanov and Valerian Chudovskii.

141. 87. The influences to which Picasso was subjected during his life in Barcelona and early years in Paris have been analysed, with many comparative illustrations, by Anthony Blunt and Phoebe Pool in *Picasso, the Formative Years, a Study of His Sources* (London, 1962). See also A. Cirici-Pellicer, *Picasso avant Picasso* (Geneva, 1950).

144. 88. The phrase was used by Morice in his review of an exhibition at Berthe Weill's gallery in the autumn of 1902, published in the *Mercure de France* in December. It was first noted by L. C. Breunig, Jr, in 'Studies on Picasso, 1902–1905', *College Art Journal*, XVII (Winter 1958), no. 2, 188–95. See also H. Fierens-Gevaert, *La Tristesse contemporaine, essai sur les grands courants moraux et intellectuels du XIXe siècle* (Paris, 1899).

89. The 'interpretation' of the painting by Rainer Maria Rilke must be noted as an instance of the poet's sensitivity to other than the purely pictorial statement. The picture inspired his fifth *Duino Elegy*, when he saw in the 'D'-shaped group of acrobats the 'great initial letter of Thereness [*Dastehns*]'. See *The Duino Elegies*, translated by J. B. Leishman and Stephen Spender (New York, 1939), 101–4; and Alfred H. Barr, Jr, *Picasso, Fifty Years of His Art* (New York, 1946), 36–7.

146. 90. For the presence and effect of Pre-Raphaelite paintings in Paris, see Jacques Lethève, 'La connaissance des peintres pré-raphaélites anglais en France (1855–1900)', *Gazette des Beaux-Arts*, LIII (1959), 315–28.

147. 91. Émile Zola, in his deceptively entitled novel *La Joie de vivre* (1884), *Œuvres complètes* (Paris, 1928–9), XIII, 369, quoted by Sven Lövgren in *The Genesis of Modernism* (Stockholm, 1959), 17; Téodor de Wyzewa, quoted by R. Doumic, *Revue des deux mondes* (15 September 1917).

92. The quotations in this and the preceding sentence are from an anonymous critic in the *Magazine of Art*, I (1878), 81; and from Claude Phillips, *ibid.*, VIII (1885), 60–8, 228–33.

149. 93. Joris-Karl Huysmans's *Trois Primitifs* (Paris, 1905), with a chapter on 'Les Grünewald du Musée de Colmar', is a significant literary expression of this interest in late medieval painting.

151. 94. Arne Brenna, *Form og komposisjon i nordisk granittskulptur 1909–1926, Carl Milles, Kai Nielsen, Gustav Vigeland* (Oslo, 1953), 52, 214.

153. 95. Rodin, quoted in John Rewald, *Maillol* (London and New York, 1939), 161.

96. Maillol, quoted in Carola Giedion-Welcker, *Contemporary Sculpture* (New York, 1955), 24. Maillol's ideas on art were collected by Judith Cladel in *Aristide Maillol, sa vie, son œuvre, ses idées* (Paris, 1937).

155. 97. André Gide, 'Promenade au Salon d'Automne', *Gazette des Beaux-Arts*, XXXIV (1905), 476. Although Maillol had scant respect for Ingres, it may be worth noting that Gide began his criticism by remarking that Ingres (whose works were to be seen in a small retrospective exhibition at the same Salon) 'would stop before Maillol'. The sumptuous relaxation of the *Femme accroupie* may have reminded Gide of the figures in Ingres's *Turkish Bath*, a detail of which was reproduced in Gide's article. This shows the woman in the centre holding her breast in her right hand, a pose adopted by Maillol for his last work, *Harmonie*, left unfinished at his death in 1944. Maillol's conception of the nude may also be compared with Ingres's *Baigneuse de Valpinçon* (1808) and *Grande Odalisque* (1814).

98. From Denis's essay on Maillol, first published in *L'Occident*, November 1905; reprinted in *Théories* (1912), and with additions as *A. Maillol* (Paris, 1925).

99. C. Giedion-Welcker, *op. cit.*, xii.

156. 100. The posture of the girl doing her hair in the far right background of Renoir's *Bathers* of 1884–7 [4] is almost identical with the upper torso and arms of Maillol's *Woman arranging her Hair* of 1898.

CHAPTER 4

158. 1. The term may have been used by Vauxcelles at the Salon d'Automne of 1905, but it became current in 1906. See Alfred H. Barr, Jr, *Matisse, His Art and his Public* (New York, 1951), 56 and note 8.

2. Pierre Courthion, *Raoul Dufy* (Geneva, 1951), 66.

159. 3. It was reproduced for the first time in 1951 in Barr, *Matisse*, 54, 317.

160. 4. Derain to Vlaminck, Collioure, 28 July 1905, in *Lettres à Vlaminck* (Paris, 1955), 155.

164. 5. The elaborate Bernheim-Jeune volume was a belated tribute to Cézanne from the Nabis. In addition to colour reproductions and plates in photogravure it

contained original lithographs after Cézanne's paintings and drawings by Vuillard, Bonnard, Denis, Roussel, Signac, Vallotton, and Matisse. By this time (1914) Picasso and Braque had turned Cézanne's art to quite another account.

6. Barr, *Matisse*, 40. The painting (Venturi 381), now in the Musée des Beaux-Arts de la Ville de Paris (Petit Palais), is reproduced in colour in Maurice Raynal, *Cézanne* (Paris, 1954), 60.

7. The evidence for Vlaminck's discovery of African sculpture in 1905 is his statement in his autobiography, *Tournant dangereux* (Paris, 1929), 88; for Matisse's, Gertrude Stein's account in her *Autobiography of Alice B. Toklas* (New York, 1933), 77-8. See also the discussion in Robert Goldwater, *Primitivism in Modern Painting* (New York and London, 1938), 74-84. Guillaume Apollinaire in a short biographical notice written in 1909 (Barr, *Matisse*, 553) described Matisse as liking 'to surround himself with . . . those sculptures in which the Negroes of Guinea, Senegal, or Gabun have demonstrated with unique purity their frightened emotions'. For Derain's use of Negro art, especially in his large *Bathers* of 1906-7, see John Golding, *Cubism: a History and an Analysis, 1907-1914* (London, 1959), 138-41. The problems of chronological precedence have been examined by Jean Laude in *La Peinture française (1905-1914) et l'art nègre* (Paris, 1968).

165. 8. See Derain's letters of 1952 and 1953 in Ronald Alley, *The Foreign Paintings, Drawings, and Sculpture* (London, Tate Gallery Catalogues, 1959), 64-5.

166. 9. For Derain's ballets, and those by other artists mentioned in this book, see George Amberg, *Art in Modern Ballet* (New York, 1946).

168. 10. First published in *La Grande Revue*, Paris, 25 December 1908; English translation by Margaret Scolari in Barr, *Matisse*, 119-23.

169. 11. Benedetto Croce, *Aesthetic as Science of Expression and General Linguistic*, first read 1900, translation from the revised edition of 1922 (New York, 1953), 11). I have developed this argument in 'In Memory of Henri Matisse', *Yale Literary Magazine*, CXXIII (1955), 17-23.

171. 12. Félix Vallotton reviewing the Salon d'Automne in *La Grande Revue* (25 October 1907); quoted by Barr, *Matisse*, 96.

13. From Sarah (Mrs Michael) Stein's notes taken in Matisse's class in 1908; published as 'A Great Artist Speaks to His Students' in Barr, *Matisse*, 550-2.

173. 14. John Hallmark Neff, in 'The Shchukin Panels', *Art in America*, 63 (July 1975), 38-48, indicates that the *Bathers*, which is the same size as *Dance* and *Music*, may be the third of the series which

was to hang in the three-story stairwell of Shchukin's house. Beneath the present black, white, grey, and green composition is an earlier study in 'vivid red, blue, and green'. The present picture must then have been repainted in 1916-17.

174. 15. For the dating of the four versions of *The Back*, see the Zürich exhibition catalogue, and Ronald Alley, *The Foreign Paintings . . .* (Tate Gallery), 150-2.

16. For Matisse's illustrations of 1930-2 for Mallarmé's *Le Cygne*, see Barr, *Matisse*, 244-6, 466-7. See also above, p. 446.

176. 17. Charles Morice in the *Mercure de France* (1 December 1905). The word 'pitre' in Rouault's *Filles, Forains, Pitres* is not accurately translated as 'clown', which is also a French word. The distinction was noted by the artist's friend André Suarès in a letter of 11 October 1917: 'Le pitre est une victime de la vie, et de la Cité. Comme tel, il est serf; il est misérable. Il est un objet de compassion, et vous l'avez bien fait ainsi: vous l'avez vu avec les yeux de la charité. Le clown, lui, mène le jeu, bien loin de le subir: le clown est la sagesse ou la folie, sa parodie: il est plein d'une ironie parfois terrible, et d'un rire éternel.' See *Georges Rouault - André Suarès, Correspondance* (Paris, 1960), 151. In such terms Rouault's clowns are almost without exception *pitres*.

18. Quoted by James Thrall Soby in *Georges Rouault* (New York, 1945), 8.

19. Rouault in Georges Charensol, *Georges Rouault, l'homme et l'œuvre* (Paris, 1926), 23.

20. William Rubin in *Modern Sacred Art and the Church of Assy* (New York and London, 1961), 86-93, asserts that the black contours around Rouault's colour areas do not fulfil the same function as the leading in medieval glass. Lionello Venturi in his *Rouault* (Geneva, 1959), 26, wrote that the painter had told him that he had been 'staggered' by the poor quality of modern glass, even as a boy of fourteen. From this one might conclude that the combination of glowing colours and heavy black boundaries is aesthetically, even if not functionally, derived from Rouault's early experiences.

177. 21. From a letter by Bloy, of 30 May 1886, quoted by Joseph Bollery in '*Le Désespéré*' de Léon Bloy (Paris, 1937), 127, and Soby, *Rouault*, 10.

22. From an undated letter to Édouard Schuré, quoted by Pierre Courthion, *Georges Rouault* (New York, 1962), 86.

179. 23. Rouault in Charensol, *Rouault*, 1.

24. Edgar Wind, in 'Traditional Religion and Modern Art', *Art News*, LII, no. 3 (May 1953), 18-23, 60-3, pointed out that Rouault never depicted the wounds of the Passion in any of his Christs Crucified, hence his figures did not conform to orthodox tradi-

tion. But see William Rubin's emendations to Wind's article in his *Modern Sacred Art and the Church of Assy*, 98, as well as his account of Rouault's participation in that attempt to create a contemporary religious structure.

180. 25. An English translation of the plea of Rouault's attorney and the court's decision, from the official *Gazette du Palais* for 11-13 September 1946, will be found in *Liturgical Arts*, XVI (1948), 91-104.

26. Werner Doede's *Berlin, Kunst and Künstler seit 1870. Anfänge und Entwicklungen* (Recklinghausen, 1961) is a chronology, with appropriate documentation, of the pace of artistic events in the capital.

27. After the Munich and Vienna Sezessions, founded in 1892 and 1897, the most influential organizations were the Berlin Sezession (1898) and Neue-Sezession (1910). See Kurt Glaser, 'Die Geschichte der Berliner Sezession', *Kunst und Künstler*, XXVI (1927-8), 14-20, 66-70, and the exhibition catalogue, *Secession. Europäische Kunst um die Jahrhundertwende* (Munich, Haus der Kunst, 1964).

181. 28. Marées and Hildebrand are discussed in Fritz Novotny, *Painting and Sculpture in Europe, 1780 to 1880* (Pelican History of Art), 2nd·ed. (Harmondsworth, 1971), 182-4, 235-6. See also Bernhard Sattler, ed., *Adolf von Hildebrand und seine Welt. Briefe und Erinnerungen* (Munich, 1962).

29. Konrad Fiedler, *On Judging Works of Visual Art*, translated by Henry Schaefer-Simmern and Fulmer Mood (Berkeley and Los Angeles, 1957), 11.

184. 30. For the origin and early use of the word, see Peter Selz, *German Expressionist Painting* (Berkeley and Los Angeles, 1957), 255-8, and Donald E. Gordon, 'On the Origin of the word "Expressionism" ', *Journal of the Warburg and Courtauld Institutes*, XXIX (1966), 368-85.

187. 31. Paul Westheim, *Wilhelm Lehmbruck* (Potsdam, 1922), 61.

189. 32. Barlach's experiences in his later years are described in Alfred Werner, 'Ernst Barlach, Artist under a Dictatorship', *Art Journal*, XXII (Winter 1963), 81-7.

191. 33. One of Käthe Kollwitz's most moving works is a pencil drawing of Barlach on his death-bed, her farewell tribute to the friend who had used her likeness for the face of the angel in his Güstrow memorial.

34. Hans Kollwitz, ed., *The Diary and Letters of Kaethe Kollwitz* (Chicago, 1955), 140-1, letter of 19 December 1912.

35. Kollwitz, *The Diary . . .* , 104, entry for November 1922.

192. 36. Rainer Maria Rilke's *Worpswede* (Bielefeld and Leipzig, 1903) is an account of the place and the principal artists, although with no mention of Paula Becker.

37. Paula Modersohn-Becker, *Briefe und Tagebuchblätter* (Berlin, 1920), entry for 1 October 1902.

193. 38. Heinrich Petzet, *Das Bildnis des Dichters: Paula Becker-Modersohn* [sic] *und Rainer Maria Rilke, eine Begegnung* (Frankfurt-am-Main, 1957), analyses their relationship and the ambiguities of Rilke's memorial poem for the painter, *Requiem*.

194. 39. The text is included in the first volume of Nolde's *Jahre der Kämpfe* (Berlin, 1934), 172-3.

40. The influence of Grünewald was pervasive. For an example of actual dependence, see Heinrich Nauen's *Pietà* of 1913, reproduced in Selz, *German Expressionist Painting*, plate 1, a and b.

197. 41. Wilhelm Worringer, *Form in Gothic* (London, 1927), 44.

42. As early as 1820 the young Dr Georget, for whom Géricault painted the portraits of the criminally insane, stated that madness would greatly increase with the growth of large cities, industrialization, and political democracy. His expectations have been statistically fulfilled. See Margaret Miller, 'Géricault's Paintings of the Insane', *Journal of the Warburg and Courtauld Institutes*, IV (1940-1), 151-63.

198. 43. The influence of primitive art on the work of the Brücke painters is discussed by Robert J. Goldwater in *Primitivism in Modern Painting*, chapter IV. Kirchner, in his 'Chronik der Brücke' (1913, see Note 46 below), wrote that he had found Negro sculpture and Polynesian carving 'a parallel to his own creations'. For Kirchner's use of reproductions of the Ajanta wall paintings, see Donald E. Gordon, 'Kirchner in Dresden', *Art Bulletin*, XLVIII (1966), 335-66. See also the exhibition catalogue, *Das Ursprüngliche und die Moderne* (Berlin, Akademie der Künste, 1964), with texts by L. Reidemeister and K. Krieger.

44. The programme is reproduced in facsimile in Lothar-Günther Buchheim, *Die Künstlergemeinschaft Brücke* (Feldafing, 1956), 89. Schmidt-Rottluff's letter to Nolde quoted below was published by the latter in his *Jahre der Kämpfe*, 90-1; it is quoted in English translation by Peter Selz in *German Expressionist Painting*, 84.

45. For the contents of these portfolios, see the exhibition catalogue by Hans Bolliger and E. W. Kornfeld, *Künstlergruppe Brücke, Jahresmappen 1906-1912* (Bern, Klipstein and Kornfeld, 1958). The communal intentions of the Brücke artists led them to interpret each other's paintings in the graphic media. The chapter by William S. Lieberman in the exhibition catalogue *German Art of the Twentieth Century* (New York, Museum of Modern Art, 1957) is a revealing analysis of the quality and technique of Expressionist prints.

199. 46. Kirchner's 'Chronik der Brücke' contains

misstatements, such as that Nolde joined the group in 1905. The historical section has been reprinted in the exhibition catalogue *Brücke* (Essen, 1958), 28–9. For the woodcuts which accompanied it, see Bolliger and Kornfeld, *op. cit.*, no. 62.

200. 47. For the Brücke artists' knowledge of Fauve painting, which may have been more extensive than is usually acknowledged, see Bernard Dorival, 'L'Art de la *Brücke* et le fauvisme', *Art de France*, I (1961), 381–5.

201. 48. The pseudonym deceived earlier critics. A complete bibliography of his writings under both names is in Will Grohmann, *E. L. Kirchner* (Stuttgart, 1958), 135–6.

205. 49. Kandinsky's autobiographical notes were first published in German as *Rückblicke* (Berlin, Der Sturm, 1913). A slightly revised Russian translation appeared in 1918 as *Text Khudozhnika*. The French translation by Gabrielle Buffet-Picabia, *Regard sur le passé* (Paris, 1946), is from the German text. The Solomon R. Guggenheim Foundation (New York) published English translations of both texts on the occasion of a memorial exhibition in 1945, the Russian as *Text Artista* in the catalogue, the German as *Retrospects*, with other writings by the artist, in *Kandinsky*.

50. Stravinsky simultaneously reached his stylistic maturity with a fairy-tale ballet, *The Firebird* (first performed in Paris, 1910). The similarities between Kandinsky's and Stravinsky's art and theories have been pointed out elsewhere, especially by Herbert Read in *Kandinsky* (London, Faber and Faber, 1959), 6–7. Kandinsky's interest in music led not only to his musical titles (*Improvisation, Fugue*, etc.), but also to the composition of *Der gelbe Klang* (*Yellow Sound*, 1909), an almost abstract drama combining lights, voices, words, and music.

51. W. Kandinsky, *Concerning the Spiritual in Art* (New York, 1947), 34.

206. 52. Gabriele Münter, in Edouard Roditi, *Dialogues on Art* (London, 1960), 148.

208. 53. The first English translation of Kandinsky's treatise, by M. T. H. Sadleir, was published as *The Art of Spiritual Harmony* (London, 1914). The first American edition, translated by Hilla Rebay as *On the Spiritual in Art*, was published by the Solomon R. Guggenheim Foundation in 1946. A revised and more faithful version of the Sadleir translation, authorized by Mme Kandinsky, was published by Wittenborn, Schultz (New York, 1947), as *Concerning the Spiritual in Art and Painting in Particular*. The quotations here are from that edition.

54. W. Kandinsky, *Regard sur le passé*, 20.

55. Kandinsky's definitions of the types are in *Concerning the Spiritual in Art*, 77.

209. 56. Roger Fry in *The Nation*, 2 August 1913, 677.

212. 57. The so-called *First Non-objective Water-Colour* of 1910 (estate of Nina Kandinsky) has been shown by Kenneth Lindsay to be a study for *Composition VII* of 1913 [118], and therefore probably accidentally pre-dated by the painter.

In his 'Vasily Kandinsky: Abstraction and Image', *Art Journal*, XXII (Spring 1963), 145–7, Daniel Robbins pointed out the formal similarity between *Composition VII* and *Study for Composition II* of 1910 (New York, Guggenheim), and suggested that the water-colour might actually have been done in that year. It is possible, given Kandinsky's habit of re-working his imagery, that the water-colour is an abstraction *after Composition II*, not a study *for* it, and thus a stage in the preparation of *Composition VII*. The resolution of this problem may hang on further study of the persistence of Kandinsky's symbolic images, as Lindsay has suggested, even after they became submerged in abstract design.

Although representational elements in *Compositions V to VII* are not immediately apparent, it is probable that they were suppressed rather than eliminated. Comparative studies of Kandinsky's iconography, still in progress, by Kenneth Lindsay and Rose Carol Washton-Long indicate that his most 'abstract' forms were evolved from representational images, usually derived from a medieval repertory of horsemen, armed knights, castles, oarsmen, and mysterious shrouded figures or 'souls'.

213. 58. Works by the remaining members of the NKV are reproduced in Otto Fischer, *Das neue Bild* (Munich, 1912), published by the then well-known critic to justify their position.

59. Gabriele Münter's art is well reproduced in Johannes Eichner, *Kandinsky und Gabriele Münter von Ursprüngen moderner Kunst* (Munich, 1957). For a descriptive inventory of the Münter-Kandinsky-Stiftung, see Lorenz Eitner, 'Kandinsky in Munich', *Burlington Magazine*, XCIX (1957), 193–9.

214. 60. In his selections from Marianne von Werefkin's diary, published as *Briefe an einen Unbekannten, 1901–1905* (Cologne, 1960), Clemens Weiler reproduced a number of her vigorous brush drawings and emphasized the similarity between her ideas and Kandinsky's expressed later in *Über das Geistige in der Kunst*.

61. The archives of the Blaue Vier, including many paintings, drawings, and prints, are now in the Norton Simon Museum, Pasadena, Calif. Galka Scheyer chose the name Blaue Vier because 'a group of four would be significant though not arrogant, and the colour blue was added because of the association with the early group of artists in Munich that founded

the "Blue Horseman" . . . and also because blue is a spiritual colour'. Klee wanted a title that would in no way suggest an 'ism'. See *The Blue Four, Galka E. Scheyer Collection*, Pasadena Art Museum (n.d.), a check-list.

215. 62. The artists were Albert Bloch, David and Vladimir Burliuk, Campendonk, Delaunay, Elizabeth Epstein, Eugen Kahler, Kandinsky, Macke, Marc, Gabriele Münter, J. B. Niestlé, Henri Rousseau, and Arnold Schoenberg.

63. The formal and symbolic significance of the Blaue Reiter theme has been analysed by Kenneth Lindsay in 'Genesis and Meaning of the Cover Design for the First *Blaue Reiter* Exhibition Catalogue', *Art Bulletin*, xxxv (1953), 47-52.

216. 64. For the Futurists' first public exhibition of children's productions as works of art in 1911, see p. 282. See also Ardengo Soffici's remark of 1913(?): 'For me this is axiomatic: whoever is not sensitive to the pictorial savour of a line drawn across a wall with charcoal by a child . . . will never be able to enjoy the beauty of plasticity', quoted by Rosa Trillo Clough in *Looking Back at Futurism* (New York, 1942), 79. The first exhibition in New York of children's work was held by Alfred Stieglitz at the Little Galleries of the Photo-Secession ('291') in 1912. Interest in and recognition of the artistic quality of children's art can be traced to the pioneer work of Franz Cizek (1865-1946), who founded a Jugend-Kunstschule in Vienna in 1897 for children aged three to fourteen. For his pedagogical methods, which attracted considerable attention before and after the First World War, see W. Viola, *Child Art and Franz Cizek* (Vienna, 1936), his *Child Art* (London, 1948), and L. W. Rochowanski, *Die wiener Jugendkunst. Franz Cizek und sein Pflegestätte* (Vienna, 1946).

65. W. Kandinsky and F. Marc, eds., *Der Blaue Reiter* (Munich, 1912), 22-3. For contemporary attitudes towards folk art, see Max Picard, *Expressionistische Bauernmalerei* (Munich, 1918).

217. 66. Klaus Lankheit, *Franz Marc. Watercolours, Drawings, Writings* (New York, 1960), 16.

67. See Peter Selz, 'The Influence of Cubism and Orphism on the "Blue Rider" ', *Festschrift Ulrich Middeldorf* (Berlin, 1968), 582-90.

68. Franz Marc, *Briefe, Aufzeichnungen, und Aphorismen* (Berlin, 1920), 1, 121.

219. 69. Marc's enthusiastic acceptance of the theory of matter as the transformation of energy was in contrast to Kandinsky's earlier feeling that 'the most important basis [of science] is but an illusion', when he learned of the bombardment of the atom.

222. 70. Kubin met Kafka in Prague in 1911 and illustrated the latter's *Country Doctor* (the drawings are still unpublished). For Kafka's admiration for Kubin, with bibliographical references, see Paul Raabe, *Alfred Kubin, Leben, Werk, Wirkung* (Hamburg, 1957), 207.

223. 71. W. Kandinsky, 'Über die Formfrage', *Der Blaue Reiter*, 74-100. Kandinsky introduced his remarks on Rousseau with the words: 'Christ said, Suffer the little children to come unto me, for of such is the Kingdom of Heaven.'

72. Rousseau was 'discovered' in the mid 1890s by Alfred Jarry (they were both natives of Laval) and by Rémy de Gourmont, who commissioned a lithograph of *War* for his periodical *L'Imagier*. The first critical interpretations were Wilhelm Uhde's short *Henri Rousseau* (Paris, 1911) and Guillaume Apollinaire's anecdotal and ironic essay, 'Le Douanier', published in *Les Soirées de Paris*, 15 January 1914, and reprinted in *Il y a* (Paris, 1925). Uhde acted as Rousseau's dealer, which accounts for the large number of works in German collections before 1914. In 1923 Charles Chassé, in a series of articles later reprinted as *Dans les coulisses de la gloire: D'Ubu-Roi au Douanier Rousseau* (Paris, 1947), attacked Rousseau's reputation as an intentional mystification. Tristan Tzara, in 'Le Rôle du temps et de l'espace dans l'œuvre du Douanier Rousseau', *Art de France*, II (1962), 323-6, insisted that Rousseau's personality and his art have been misinterpreted by the satirical attacks of contemporary journalists.

224. 73. The best account of the banquet, drawn from contemporary sources, is in Roger Shattuck, *The Banquet Years* (New York, 1958).

74. The painting has been identified as his own portrait by Edmond Frank in a letter of 20 August 1952, addressed to the Galerie Charpentier and now preserved in the Kunsthaus, Zürich (published by Henry Certigny in *La Verité sur le Douanier Rousseau*, Paris, 1961, 255-7 and 477-8), wherein he stated that it had been painted in 1909-10, then borrowed by the artist, ostensibly to make a copy of it, and that he himself had destroyed the original in 1911, thinking of no value. A photograph of Pierre Loti, taken in Constantinople in 1904 (reproduced by Certigny, after p. 246), shows the writer with the fez, curling moustaches, and high collar worn by the figure in the painting. The resemblance cannot lightly be dismissed.

75. Guillaume Apollinaire, *Il y a*, 166. Perhaps Picasso was thinking of Rousseau's method when he told Kahnweiler, before 1915: 'In a Raphael painting it is not possible to establish the distance from the tip of the nose to the mouth. I should like to paint pictures in which that would be possible' (in Kahnweiler's *Der Weg zum Kubismus*, Munich, 1920, English

translation by Henry Aronson, New York, 1949, 8).
Edmond Frank, in the letter quoted in Note 74, wrote
that Rousseau had drawn the eyes in his portrait with
a compass. According to George Bernard Shaw, when
Rodin 'was uncertain he measured me with an old
iron compass and then measured the bust'. See G. B.
Shaw, 'Rodin', *Annales politiques et littéraires* (Paris,
2 December 1932).
226. 76. Apollinaire was the first to state that the pain-
ter had been to Mexico, but that, when questioned,
Rousseau remembered only the exotic fruits the
soldiers had been forbidden to eat. Rousseau was a
private in the 51st Infantry from December 1863 to
July 1868. He might have heard tales of the Mexican
campaign from the veterans of two battalions of the
51st who served in Mexico between September 1866
and April 1867. Rousseau himself did not mention
Mexico in an autobiographical statement prepared in
1895.
77. An instance of this transformation is the lion in
the *Sleeping Gypsy* (New York). From the unbroken
division between the mane and the coat one can tell
that they were joined by a seam. The eyes are not
placed within sockets but seem to be glass eyes sewn
to the surface. Such toy lions are a staple item in Paris
shops today.
227. 78. The intensity of this interest in naïve painting
produced the exhibition and catalogue *Masters of
Popular Painting, Modern Primitives of Europe and
America* at the Museum of Modern Art (New York)
in 1938. It was offered as 'the third of a series of
exhibitions . . . intended to present some of the major
divisions of modern art', and followed the memorable
exhibitions of *Cubism and Abstract Art* (1936) and of
Fantastic Art, Dada, Surrealism (1936), and preceded
the Bauhaus exhibition of 1938. For recent studies,
see Oto Bihalji-Merin, *Modern Primitives, Masters of
Naïve Painting* (New York, *c.* 1959), and the ex-
hibition catalogue *Das naive Bild der Welt* (Baden-
Baden, Frankfurt-am-Main, and Hanover, 1961),
with a useful historical definition, 'Was ist ein
"peintre naïf"?' by Georg Schmidt.
231. 79. The exhibition catalogue *London Group* (The
Tate Gallery, 1964) contains a 'historical note' by
D. Farr and A. Bowness, and lists of members and
exhibitions.

CHAPTER 5

235. 1. Albert Gleizes and Jean Metzinger, *Du
'Cubisme'* (Paris, 1912), 17; Dora Vallier, 'Braque, la
peinture et nous', *Cahiers d'art*, XXIX (1954), 15.
2. It was first publicly exhibited at the Paris Exposi-
tion Universelle of 1937, and was acquired by the
Museum of Modern Art in New York in 1939. The
most careful study of the painting is in John Golding,
Cubism: a History and an Analysis, 1907-1914
(London, 1959).
237. 3. For the probable date and circumstances of
Picasso's 'discovery' of African sculpture and its
influence on his work (an influence rejected by the
artist), see Robert J. Goldwater, *Primitivism in Modern
Painting* (New York, 1938); Alfred H. Barr, Jr,
Picasso, Fifty Years of His Art (New York, 1946),
257-8; Golding, *Cubism*, 56, 58, 123-5. Daniel-Henry
Kahnweiler, in 'Negro Art and Cubism', *Horizon*,
XVIII (December 1948), 412-20, denies the 'direct'
influence of African art on Picasso and Braque. In her
Autobiography of Alice B. Toklas (New York, 1933),
78, Gertrude Stein shrewdly remarked: 'The effect of
this African art upon Matisse and Picasso was entirely
different. Matisse through it was affected more in his
imagination than in his vision. Picasso more in his
vision than in his imagination.' For the *Demoiselles
d'Avignon*, see also Jean Laude, *La Peinture française
(1905-1914) et l'art nègre* (Paris, 1968), 243-69.
238. 4. The ambiguous perspectives in much Cubist
painting which prevent the spectator from deter-
mining the exact position of an object in relation to its
neighbours have been noted many times. In *Art and
Illusion* (New York, 1960), 281-5, E. H. Gombrich
traces the Cubists' use of 'contrary clues', which
destroy the traditional illusionist space, to other and
earlier systems of visual ambiguity.
241. 5. Even so simplified a description of Cubist space
suggests a possible connexion between contemporary
pictorial and scientific theories. The extent of the
Cubists' understanding of Einstein's space-time con-
tinuum has often been questioned, but Apollinaire's
statement cannot be ignored: 'Today, scientists no
longer limit themselves to the three dimensions of
Euclid. The painters have been led quite naturally,
one might say by intuition, to preoccupy themselves
with the new possibilities of spatial measurement
which, in the language of the modern studios, are
designated by the term: the fourth dimension' (from
Lionel Abel's translation of Apollinaire's *Méditations
esthétiques, les peintres cubistes* as *The Cubist Painters*,
New York, 1949, 13). This 'language of the studios'
may have been taught them by an obscure government
clerk and amateur mathematician, Maurice Princet,
who would have played the same role towards the
Cubists as Prichard did to Matisse. See the important
article by Linda Dalrymple Henderson, 'A New Facet
of Cubism: "The Fourth Dimension" and "Non-
Euclidean Geometry" Reinterpreted', *Art Quarterly*,
XXXIV, no. 4 (Winter 1971), 410-33. Nevertheless,
Picasso's warning of 1923 should not be forgotten:

'Mathematics, trigonometry, chemistry, psychoanalysis, music, and whatnot, have been related to Cubism to give it an easier interpretation. All this has been pure literature, not to say nonsense, which brought bad results, blinding people with theories' (quoted in Barr, *Picasso, Fifty Years of His Art*, 270-1).

6. These terms were first used in this sense by Juan Gris in 1924 (see below, Note 14). They entered the vocabulary of contemporary criticism in 1936 through Barr's catalogue for the exhibition *Cubism and Abstract Art*, at the Museum of Modern Art, New York, in which for the first time the development of the several aspects of modern art was presented according to historical principles. William Rubin, in 'Cézannisme and the Beginnings of Cubism', *Cézanne, the Late Work* (New York, Museum of Modern Art, 1977), 151-202, argues that 'Braque's formation of a syntax for Analytic Cubism was the basis on which, beginning in 1909, he was able to engage Picasso in a probing four-year dialogue of a kind that Picasso - to judge by his personality and habits over the rest of his career - was instinctively inclined to avoid'.

7. Apollinaire, *Méditations esthétiques* (Paris, 1913), 25.

243. 8. Vallier, *loc. cit.*, 16.

246. 9. Ramón Gómez de la Serna, *Completa e veridica istoria di Picasso e del cubismo* (Turin, 1944), 26.

247. 10. Vallier, *loc. cit.*, 16.

11. For the invention of collages and *papiers collés* and their aesthetic implications, see Golding, *Cubism*, 103 ff.; Herta Wescher, *Die Collage. Geschichte eines künstlerischen Ausdrucksmittel* (Cologne, 1968); 'Le Papier collé du cubisme à nos jours', *XXe Siècle*, no. 6 (January 1956). Robert Rosenblum in 'Picasso and the Typography of Cubism' (Roland Penrose and John Golding, eds., *Picasso in Retrospect* (London, 1973), 49-75) has examined the texts of the *papiers collés* and found many puns and visual jokes, sometimes slightly *risqué*. See also Harriet Janis and Rudi Blesh, *Collages, Personalities, Concepts, Techniques* (New York, 1962).

249. 12. Picasso to Zervos, 1935: 'There is no abstract art. You must always start with something. Afterwards you can remove all traces of reality.' For the complete text of Picasso's important remarks, see Barr, *Picasso, Fifty Years of His Art*, 272-4.

250. 13. Picasso's other ballets for Diaghilev (*Le Tricorne*, 1919; *Pulcinella*, 1920; *Cuadro Flamenco*, 1921; *Trepak*, 1924; and the curtain for *Le Train bleu*, 1924), and the controversial *Mercure* for *Les Soirées de Paris* (1924), have been described by W. S. Lieberman in 'Picasso and the Ballet', *Dance Index* (New York), v (1946), 261-308. The curtain for *Parade* is now in the Musée National d'Art Moderne, Paris.

251. 14. The lecture is published in Douglas Cooper's translation of Daniel-Henry Kahnweiler's *Juan Gris, His Life and Work* (new enl. ed., London, 1969), 195-201.

15. From Gris's statement quoted by Ozenfant in *L'Esprit nouveau*, no. 5, 1921; reprinted in Kahnweiler, *op. cit.*, 193.

16. The presence of the golden section and of a modular system in two still lifes of 1912 (which may possibly have been shown at the Salon de la Section d'Or that year) has been demonstrated by William A. Camfield in 'Juan Gris and the Golden Section', *Art Bulletin*, XLVII (1965), 128-34.

253. 17. From Gris's letter of (about) 25 March 1921, in *Letters of Juan Gris, 1913-1927* (London, 1956), translated and edited by Douglas Cooper.

254. 18. Quoted and translated by Douglas Cooper in his *Fernand Léger et le nouvel espace* (London and Paris, 1949), vii, 74-5.

19. English translation in *The Little Review*, IX (1925), no. 3, 45-9; no. 4, 55-8.

255. 20. Fernand Léger, 'À propos du corps humain considéré comme un objet', in M.-A. Couturier and others, *Fernand Léger, la forme humaine dans l'espace* (Montreal, 1945), 63-75.

256. 21. The large compositions with numerous preliminary studies are listed and illustrated in the catalogue *Fernand Léger : Five Themes and Variations* (New York, Solomon R. Guggenheim Museum, 1962). The problems which the paintings raise for present-day criticism have been discussed by Max Kozloff in 'Fernand Léger: Five Themes and Variations', *Art International*, VI, no. 4 (May 1962), 73-5.

258. 22. Léger, quoted in the catalogue of the exhibition *Fernand Léger, 1881-1955* (Paris, Musée des Arts Décoratifs, 1956). See also Peter de Francia, *Léger's 'The Great Parade'* (London, 1969).

23. Léger might not have been discouraged. In 1946 he told an interviewer: 'I always hate to see "good taste" come to the people. For painters like me who are robust it is very dangerous to frequent the *beau monde*, ballets and the like. French "taste" is a pitfall for the creative artist' (quoted in 'Eleven Europeans in America', *Museum of Modern Art Bulletin*, XIII, 1946, no. 4-5, 15).

24. Such an early and improbable chronology was presented in the exhibition and catalogue *Le Cubisme* (Musée National d'Art Moderne, Paris, 1953).

260. 25. Apollinaire's poetic insights and the arguments of Gleizes and Metzinger have usually been discounted by recent critics, the first because of their hyperbole, the second because of their metaphysical bias. Nevertheless, both contain much contemporary opinion which cannot be ignored, however irrelevant

it may seem to present-day (and hence *post facto*) criticism. For an exposition of the philosophical hypotheses of Cubism, see Christopher Gray, *Cubist Aesthetic Theories* (Baltimore, 1953).

261. 26. Edouard Roditi, 'The Autonomous Style of Alfred Reth', *Arts*, XXXII (September 1958), 46–51.

262. 27. Four preliminary drawings and a later, un-reversed version of 1913 are reproduced in Dora Vallier, *Jacques Villon, Œuvres de 1897 à 1956* (Paris, 1957), 43–5. For Villon's synthesis of an abstract composition from multiple views of an actual object, see my 'The Dialectic of Later Cubism: Villon's *Jockey*', *Magazine of Art* (New York), XLI (November 1948), 268–72.

263. 28. In an interview published by Katherine Kuh in *The Artist's Voice* (New York, 1962), Duchamp said: 'The fact that I had seen chronophotographs of fencers in action and horses galloping (what we today call stroboscopic photography) gave me the idea for the *Nude*.' The pioneer studies of human and animal locomotion by Étienne Jules Marey, *Physiologie du mouvement* (1890) and *Le Mouvement* (1894), contain charts and graphs which may be related to the *Nude*. Marey's work, and Eadweard Muybridge's photographs of animals in motion, were known to Duchamp's brother, Raymond Duchamp-Villon. See also Aaron Scharf, *Art and Photography* (London, 1969), 199–201.

266. 29. The relevance of Chevreul's theories to Delaunay's art has been examined by Herschel B. Chipp in 'Orphism and Colour Theory', *Art Bulletin*, XL (March 1958), 55–63. The quotation is from Delaunay's 'Notes sur le développement de la peinture de Robert Delaunay', written about 1939–40, in *Du Cubisme à l'art abstrait*, ed. Pierre Francastel (Paris, 1957), 30.

30. Scientific sources for Delaunay's colour wheel have been proposed by Étienne Souriau in his 'Y a-t-il une palette française?', *Art de France*, II (1962), 34–5, 40–1, where he describes and illustrates the colour 'discs' which the Alsatian engineer Rosenstiehl published in 1877. Rosenstiehl's public demonstrations of optical mixtures in 1877 and thereafter may have been known to Seurat and the Neo-Impressionists. Although Delaunay's work was much admired in Germany, Feininger (see p. 334) was aware of its dogmatic character when he wrote to Kubin, after having seen Delaunay's paintings at the First German Salon d'Automne in 1913: 'I can see in the work of Delaunay only sterile, stubborn, and not even well-clarified experiments with purely physical problems of light. An *instrument* can make a much clearer and more valuable analysis of the spectrum. One recognizes a pretentious manner and a poverty of

creation, which makes one conclude that there is a very mechanical inner life' (from Hans Hess, *Lyonel Feininger*, New York, 1961, 67–8).

31. Orphic was the third of Apollinaire's four categories of Cubism, the others being Scientific, Physical, and Instinctive. The term is also said to have been first pronounced by Apollinaire in a lecture delivered at the Salon de la Section d'Or in October 1912 (although Delaunay was not then among the exhibitors). See Golding, *Cubism*, 35–7. The word also had connotations of 'original' in the sense of 'primal, primitive'.

267. 32. Le Corbusier, *Vers une architecture* (Paris, 1923), English translation by Frederick Etchells as *Towards a New Architecture* (London, 1927), 10.

268. 33. From Le Corbusier's preface to his *Œuvre complète de 1910–1929* (Zürich, 1930).

269. 34. The first exhibition of objects made by machines and of objects influenced by a machine aesthetic was the *Machine-Age Exposition*, arranged by the *Little Review* (New York) in May 1927. A more orderly demonstration was the exhibition of *Machine Art* held at the Museum of Modern Art, New York, March–April 1934, with an illustrated catalogue by Philip Johnson.

35. 'Henri Laurens', *XXe Siècle*, no. 2 (January 1952), 73.

271. 36. 'Sculpto-painting' is not to be confused with 'Archipentura', Archipenko's creation of paintings on movable strips of metal. For this, as well as for the dates cited in this text, see Alexander Archipenko, *Archipenko, Fifty Creative Years, 1908–1958* (New York, 1960).

274. 37. In its present form the *Horse* is an enlargement of the original model, prepared after the sculptor's death by his brother Jacques Villon and the sculptor Albert Pommier in accordance with Duchamp-Villon's instructions.

38. For photographs of the façade and interiors of the full-sized maquette with decorations by La Fresnaye and Marie Laurencin, see Marie-Noëlle Pradel, 'La Maison Cubiste en 1912', *Art de France*, I (1961), 177–86.

276. 39. Katharine Kuh, *The Artist's Voice* (New York, 1962), 160.

277. 40. In his preface to an exhibition of Rodin's works at the Curt Valentin Gallery, New York, May 1954; reprinted in A. M. Hammacher, *Jacques Lipchitz, His Sculpture* (New York, 1960), 72.

41. In 1955–6 Lipchitz created thirty-three 'Semi-automatics', so-called because they 'originated completely automatically in the blind'. Some of these bronzes, each a unique *cire-perdue* cast, incorporated actual objects, natural or artificial, recalling Rodin's habit of inserting objects in his clay sketches.

42. Julian Levy, *Surrealism* (New York, 1936), 3.
279. 43. Reported by Rosamund Frost in 'Lipchitz Makes a Sculpture', *Art News* (April 1950), 39.

44. A revised version of the *Prometheus* on a pitifully small scale was placed at the Ministry of Education and Health in Rio de Janeiro. In New Harmony, Indiana, where a cast of the *Notre Dame de Liesse* (commissioned for the font of the church at Assy, Haute-Savoie, see p. 179) has been erected as a memorial to Robert Owen, his work can be seen in an architectural setting (by Philip Johnson) which is worthy of it.
280. 45. From the catalogue of Severini's exhibition at the Marlborough Gallery, London, April 1913; reprinted with many political and artistic manifestoes, lectures, prefaces, and correspondence by Maria Drudi Gambillo and Teresa Fiori in the first volume of their *Archivi del Futurismo* (Rome, 1958). The translations of the quotations from Carrà and Severini are from Joshua C. Taylor's *Futurism* (New York, 1961), 11, 13.
281. 46. The artistic situation in Italy in the later nineteenth century has been little studied by English and American scholars. See Fritz Novotny, *Painting and Sculpture in Europe, 1780 to 1880* (Pelican History of Art), 2nd ed. (Harmondsworth, 1971), 176-9, and bibliography, 258-9. Guido Ballo's *Modern Italian Painting from Futurism to the Present Day* (London, 1958) contains a chronology of events between 1900 and 1956. See also his *Preistoria del Futurismo* (Milan, 1960) for an account of Impressionist and Symbolist influence on the earliest Futurist painting. For the Biennale, see Lawrence Alloway, *The Venice Biennale, 1895-1968* (London, 1969).
282. 47. From the catalogue *Exhibition of the Works of the Italian Futurist Painters*, Sackville Gallery, London, March 1912. According to Boccioni the descriptive sub-titles were added by the English dealer, but they are quite in the spirit of the paintings. Boccioni's huge horses have sometimes been considered anachronistic symbols of contemporary industry, but this can scarcely be true, since mechanical equipment on the scale required in the painting was not available anywhere until after the First World War.
283. 48. Quoted from the exhibition circular by Rosa Trillo Clough in *Looking Back at Futurism* (New York, 1942), 41. The Italian scholar Corrado Ricci, in his *L'Arte dei bambini* (Genoa, 1887), was the first to study children's art and to point out the relation between it and the earliest stages in human artistic history.
286. 49. From Boccioni's preface to the first exhibition of his sculpture in Paris, June 1913 (*Archivi*, 1, 118-20).
288. 50. Russolo's speculations about sound no

longer seem so aggressively *avant-gardiste*. In his 1913 manifesto, *L'Arte dei rumori* (translated by R. Fillion, *The Art of Noise*, New York, Something Else Press, 1967), he declared that 'Noise was not really born before the nineteenth century, with the advent of machinery. Today noise reigns supreme over human sensibility'.
290. 51. The later Futurists are presented in the exhibition catalogue *Il Futurismo* (Rome, 1959), edited by Aldo Palazzeschi, and in *After Boccioni, Futurist Paintings and Documents from 1915 to 1919* (Rome, 1961), edited by C. Bruni and M. D. Gambillo.
291. 52. After decades of neglect, Futurist art was re-examined in the extensive exhibitions at the Venice Biennale of 1959, and at the Museum of Modern Art, New York, in 1961, the latter exhibition also having been shown in Detroit and Los Angeles. Reyner Banham took Futurist doctrine as a primary position from which to survey much of modern art in his *Theory and Design in the First Machine Age* (London, 1960).

53. The quotations in this and the following paragraphs are from Lewis's 'A Review of Contemporary Art' in the second issue of *Blast* (1915), reprinted with many verbal changes as 'Art Subject to the Laws of Life' in his *Wyndham Lewis the Artist, from 'Blast' to Burlington House* (London, 1939), 133-62.

54. Violet Hunt, in her *I Have This To Say* (New York, 1926), 211-12, quoted Lewis as having said: 'You think at once of a whirlpool. At the heart of the whirlpool is a great silent place where all the energy is concentrated. And there, at the point of concentration, is The Vorticist.' 'Vortex' occurs in the title of several drawings and paintings of 1913 by Balla.
292. 55. The quarrel may be followed in Virginia Woolf's *Roger Fry* (London, 1940), 192-4, and from Lewis's side, in John Rothenstein's *Modern English Painters, Lewis to Moore* (London, 1956), 26-7. Lewis's 'round robin' letter to the press, signed also by Frederick Etchells, Charles Hamilton, and Edward Wadsworth, is reprinted in W. K. Rose, ed., *The Letters of Wyndham Lewis* (London, 1963), no. 47. Additional documents published by Quentin Bell and Stephen Chaplin in 'The Ideal Home Rumpus', *Apollo* (October 1964), suggest that an original misunderstanding had been intentionally aggravated by Lewis. See also Bell's *Bloomsbury* (London, 1968), *passim*.
293. 56. For the exhibition, Lewis invited Bernard Adeney, Lawrence Atkinson, David Bomberg, Duncan Grant, Jacob Kramer, and C. R. W. Nevinson to join the Vorticist regulars: Jessie Dinsmorr, Etchells, Gaudier-Brzeska, William Roberts, Helen Saunders, and Wadsworth.
295. 57. From Roberts's *Abstract and Cubist Paintings*

and Drawings (London, 1957), 3, in which he expressed his annoyance at being included among 'other Vorticists' in the exhibition *Wyndham Lewis and Vorticism*, circulated by the Arts Council in 1956.

58. This quotation from Hulme's *Speculations* has been noted, with reference to Roberts's paintings, by John Rothenstein in his *Modern English Painters, Lewis to Moore*, 285. For the relations between Hulme's ideas and Lewis's, see Geoffrey Wagner, *Wyndham Lewis, a Portrait of the Artist as the Enemy* (New Haven, Conn., 1957), *passim*.

297. 59. From his letter of 16 March 1914 to *The Egoist*, reprinted in Ezra Pound, *Gaudier-Brzeska, a Memoir* (London, 1916), 33-5.

298. 60. The quotations in this and the following paragraphs are from Epstein's *Epstein, an Autobiography* (London, 1955), 10, 12, 51, 56.

61. Epstein gathered a notable collection of primitive sculpture during his lifetime. It is recorded in the Arts Council's exhibition of *The Epstein Collection of Primitive and Exotic Sculpture* (London, 1960).

300. 62. For his first bust of *Nan* (1909) Epstein had actual earrings cast in bronze, and in *The Tin Hat* (1916) he placed a steel military helmet on the head of a British soldier. In both instances, however, the function of the actual objects was formal and visual rather than symbolic.

CHAPTER 6

303. 1. Although the terms 'abstract' and 'non-objective', like 'Cubist' and 'Fauve', are ambiguous and on occasion even inaccurate, they have become entrenched in the vocabulary of modern criticism. Josef Albers has pointed out that 'non-representational' art is logically quite as 'objective' and actual as representational art and proposed the term 'presentational'. Van Doesburg's and Arp's conception of *art concret* (see pp. 325 and 467) were similar attempts to replace the negative and slightly derogatory connotations of 'abstract' and 'non-objective' with a more positive, 'concrete' terminology. The recurrent conceptions of non-representational form, from Antiquity to the present, have been examined in historical sequence by Frances Bradshaw Blanshard in *Retreat from Likeness in the Theory of Painting* (2nd ed., New York, 1949). Additional arguments, historical and critical, will be found on p. 561 in the bibliography under the heading 'Abstract Art'.

2. George Santayana, *The Sense of Beauty* (New York, 1896), 75.

304. 3. *The Complete Letters of Vincent van Gogh*, Letters 429 and w9.

305. 4. For the still scattered and fragmentary documentation of twentieth-century Russian art, see the bibliography, and especially the works in Russian, in Camilla Gray, *The Great Experiment: Russian Art 1863-1922* (London, 1962).

306. 5. For contemporary accounts of these collections with lists of works, see IA. Tugendhold, 'Frantsuzskoe sobranie S. I. Shchukina', *Apollon* (1914), no. 1-2, 5-46; Sergei Makovskii, 'Frantsuzskie Khudozhniki iz sobraniia I. A. Morozova', *Apollon* (1912), no. 3-4, 5-24. The Shchukin and Morozov collections were nationalized by special decrees in 1918 and formed the basis for the famous Museum of Modern Western Art in Moscow, founded in 1923. For photographs of the installation and partial list of contents, see 'L'Art moderne français dans les collections des musées étrangers, Musée d'art moderne occidental à Moscou', *Cahiers d'art*, XXV (1950), no. 2, 334-48. After 1953 the Museum's collections were divided between the Pushkin Museum in Moscow and the Hermitage in Leningrad. See Charles Sterling, *Great French Painting in the Hermitage* (New York, 1958), and Pierre Descargues, *The Hermitage* (London, 1961). For Shchukin's commissions, see J. H. Neff, 'Matisse and Decoration: the Shchukin pànels', *Art in America* (July-August 1975), 38-48.

6. *Zolotoe Runo* (1908), no. 7-9, 5-66, and no. 10, 5-20. Among the notable works exhibited were Van Gogh's *La Berceuse* and *Night Café* and Derain's *Charing Cross Bridge*.

7. Goncharova's and Larionov's ballet designs are recorded in the catalogue of the Arts Council's retrospective exhibition, *Larionov and Goncharova* (Leeds, Bristol, and London, 1961), with introductory essays by Camilla Gray and Mary Chamot.

8. The subject of a soldier at the barber's enjoyed a certain currency at this time. It appears in the work of Burliuk [182] and Chagall, and of Heckel and other German Expressionists. One is reminded of the shaving scene in Georg Büchner's *Wozzeck* (1836), which Alban Berg used as the libretto for his opera of the same title (1925).

308. 9. The title is another instance of Larionov's deliberate 'primitivism'. He chose it after hearing that a group of artists in Paris had exhibited a picture 'painted' by a donkey with a brush tied to its tail. See Gray, *The Great Experiment*, 308.

309. 10. From the English translation in Gray, 124-6.

310. 11. Quoted by Gray, 124, from Malevich's 'unpublished biography'.

312. 12. Since the exhibition was held in rooms rented from the Imperial Society of Arts, the alternative and explanatory title 'Plevok' (spit, saliva) was deliberately provocative. Photographs of Malevich's exhibitions in St Petersburg in 1913-15, from the collection of

Mme Bogoslavskaya-Puni, have been published by Guy Habasque in 'Documents inédits sur les débuts du Suprématisme', *Aujourd'hui* (1955), I, no. 4, 14–16. See also Antoine Pevsner, 'Rencontre avec Malévitch dans la Russie d'après 1917', *Aujourd'hui* (1957), III, no. 15, 4–5.

13. Other designs for the curtains and costumes were quite Cubist, in the manner of his figures of 1911. The *Black Square*, now in the Russian Museum, Leningrad (reproduced in Gray, figure 100), is not signed, but the variant in the Tretyakov Gallery, Moscow, is inscribed: 'This initial element first appeared with *Victory over the Sun.*'

14. Malevich published his theory of Suprematism for the first time as a small brochure, *Ot Kubizma k Suprematismu* (St Petersburg, December 1915). For an English translation of the third edition (1916), by Xenia Glowacki-Prus and Arnold McMillin, see *K. S. Malevich, Essays on Art, 1915–1928* (Copenhagen, 1968), I, 19–41. Two expanded texts of 1922, edited by Werner Haftmann, have been published in German as *Suprematismus – Die gegenstandslose Welt* (Cologne, 1962). A further version, the familiar Bauhaus book of 1927, *Die gegenstandslose Welt*, is available in an English translation by Howard Dearstyne as *The Non-Objective World* (Chicago, 1959).

313. 15. For the preservation of Malevich's paintings and the destruction of his architectural models in the bombing of Berlin, see Hans von Riesen's notes in *Das Kunstwerk*, XI (1958), no. 10, 42; and Guy Habasque, 'Malévitch', *L'Œil*, no. 71 (November 1960), 40–7, 88–90. The most useful catalogues of the exhibitions are those of the Stedelijk Museum, Amsterdam (1958), and of the Whitechapel Art Gallery, London (1959), with an essay and additional information by Camilla Gray.

314. 16. The activities of the Russian émigrés in Berlin and Paris are recorded, with many coloured reproductions, in the periodical *Zhar-Ptitsa (Firebird)*, Berlin, 1921–6, 14 issues. Among the contributors were Nicholas Roerich; the semi-Cubist portraitist Boris Grigoriev (1886–1939); and Sergei Sudeikin (1883–?), whose decorative folklorism had for many years enlivened Nikita Baliev's Moscow cabaret, *Letuchaia Mysh'* (The Bat), later known in Paris, London, and New York through the popular review of the 1920s, *La Chauve-Souris*. Alexander Benois, Mstislav Dobujinskii (1875–1957), and Léon Bakst maintained the traditions of Mir Iskusstva for many years, especially in designs for the theatre and ballet.

17. From an essay, 'Konstruktivizm', by Alexei Gans, dated 1920; partial translation in Gray, 284. Gans himself then quoted Alexander Bogdanov (Malinovskii), the Marxist philosopher and an opponent of Lenin: 'During the primitive age art was not the basis of a formal expression of ideologies. It served purely practical purposes and had only a utilitarian significance; it was the organizing element in work, creating that "unity of mood" among those taking part and a coordination of this mood with the work in hand.'

18. The short entry 'Konstruktivizm' in the *Bol'shaia Sovetskaia Entsiklopediia (Great Soviet Encyclopedia)*, 2nd ed., vol. XXII (1953), 437, begins: 'A formalistic tendency in bourgeois art, which developed after the First World War 1914–18. Anti-humanistic by nature, hostile to realism, Constructivism appeared as the expression of the deepest decline of bourgeois culture in the period of the general crisis of capitalism.' Rodchenko's *Black on Black* is attributed to Malevich in the *Malaia Sovetskaia Entsiklopediia (Small Soviet Encyclopedia)*, 3rd ed., VIII (1960), 1247.

19. Succinct accounts of the period 1917–24 from a recent Soviet point of view will be found in *Istoriia Russkogo Iskusstva*, XI (1957), the enlarged and rewritten edition of Grabar's monumental history of Russian art (1909–16), published by the Akademiia Nauk S.S.S.R. (Soviet Academy of Sciences). The events discussed in our text are scarcely mentioned in the chapters by P. I. Lebedev on 'The First Steps Taken by Soviet Authority in the Field of Art', and by R. S. Kaufman on 'Painting'. The only illustrations of Constructivist work are a drawing for Tatlin's *Monument*, a semi-abstract piece of wood sculpture of a *Bridge-builder* by E. Chaikov (now destroyed), and K. Mel'nikov's familiar I. V. Pusakov Workers' Club in Moscow of 1938, one of the rare examples of a thoroughly mechanistic Constructivist building (in plan and elevation it resembled a cog-wheel). The exhibition catalogue by Stephanie Barron and Maurice Tuchman, *The Avant-Garde in Russia, 1910–1930. New Perspectives* (Los Angeles County Museum of Art, 1980), contains much important information, especially on the relation between artists and writers.

315. 20. Malevich, *The Non-Objective World*, 100.

316. 21. Tatlin, quoted by Gray, 218. For a reconstruction of 1967–8, now in the Moderna Museet, Stockholm, of Tatlin's fifteen-foot model (destroyed), see the exhibition catalogue, *Vladimir Tatlin* (Stockholm, 1968), and K. G. Pontus Hultén, *The Machine as Seen at the End of the Mechanical Age* (New York, Museum of Modern Art, 1968), 107–9. Tatlin's tower has a curious resemblance to Hermann Obrist's Art Nouveau *Sketch for a Monument, c.* 1902 (Zürich, Kunstgewerbemuseum), in which an ascending spiral member encloses a similarly slanted cluster of (open?) vertical elements.

317. 22. For photographs of the most important early Soviet theatrical productions, including Cubo-Futu-

rist decoration of the Winter Palace Square in October 1918 for the re-enactment of the events of the Revolution (with many of the original participants playing their by then 'historic' roles), see V. E. Rafalovich, ed., *Istoriia Sovetskogo Teatra* (Leningrad, 1933); Joseph Gregor and René Fulöp-Müller, *The Russian Theatre, Its Character and History* (Philadelphia, 1929). A late reflection of Constructivist design in the professional theatre was the use of a step-ladder for a house on an otherwise empty stage in the production of Thornton Wilder's *Our Town* (New York, 1938).

23. Ella Winter, 'Lissitzky, a Revolutionary Out of Favour', *Art News*, LVII (April 1958), 62 (Winter quotes the Polish painter Henryk Berlewi (b. 1894) who met Lissitzky in Warsaw in 1921); Edouard Roditi, 'The Background of Modern Russian Art', *Arts* (New York, October 1960), 44. More recently S. Lissitzky-Küppers in *El Lissitzky* (Dresden, 1967), 14, states that the word is based on 'proyekt utverzhdeniye novova' (project for the affirmation of the new). J. E. Bowlt, in *Russian Art of the Avant-Garde* (New York, 1976), 151, offers 'establishment' (ustanovleniya) for 'affirmation'. Lissitzky surely did not consider the word meaningless.

24. 'Proun ist die Umsteigestation von Malerei nach Architektur', Lissitzky and Hans Arp, *Die Kunstismen* (Erlenbach–Zürich, 1925), n.p. Alan C. Birnholz has analysed the formal structure of a number of Proun paintings in 'El Lissitzky's Prouns', *Artforum*, VIII, nos. 2–3 (October–November 1969), 56–64.

25. Alexander Dorner, quoted by Ella Winter, *loc. cit.*, 63.

318. 26. The influence of Lissitzky's architectural and typographical Constructivism can be studied in his publications: *Vesch-Gegenstand-Objet* which he edited with Ilya Ehrenburg (Berlin, 3 issues, 1922–3); in Hans Richter's *G. Material zur elementaren Gestaltung* (Berlin, 6 issues, 1923–6), of which Lissitzky was co-editor of the first issue; the issue of *Merz*, nos 8–9 (1926) which he edited for Kurt Schwitters; and in *Die Kunstismen*, which is still a pertinent visual anthology of early modern art.

27. In his 'Proun Room' of 1923 Lissitzky included the floor and ceiling as additional planes to be considered in relation to the total environment for the work of art. See *G*, no. 1 (July 1923). In 1926 Lissitzky had designed a room in Dresden somewhat like the more famous one of 1927 in Hanover. For his activities in Hanover see the exhibition catalogue, *Die zwanziger Jahre in Hannover* (Hanover, Kunstverein, 1962). For a near-contemporary account of the room in Hanover, see Sigfried Giedion, 'Lebendiges Museum', *Cicerone* (1929), 103 ff.; Alexander Dorner, *The Way Beyond 'Art'* ... (New York, 1949), 114–16; and Samuel

Cauman, *The Living Museum* ... (New York, 1958), 100–5.

28. See 'Lénine et les théâtres d'avant-garde', in Jean Fréville, ed., *Les Grands Textes de Marxisme sur la littérature et l'art* (Paris, 1937), II, 149. Lenin's opinions of modern art from about 1920 were recorded by Klara Zetlin in her memoirs (English translation as *Reminiscences of Lenin*, London, 1929, 13–14): 'Why worship the new ... just because it is "the new"? That is nonsense, sheer nonsense. There is a great deal of conventional art hypocrisy in it, too, and respect for the art fashions of the West ... I cannot value the works of Expressionists, Futurism, Cubism, and other isms as the highest expressions of artistic genius. I don't understand them. They give me no pleasure.' But he had just stated his conviction that 'every artist, and everybody who wishes to, can claim the right to create freely according to his ideal, whether it turns out good or not'.

319. 29. The last of the Peredvizhniki exhibitions, which had begun in 1871–2, was held in 1923. The biographical register by G. K. Burova, O. I. Gaponova, and V. F. Rumiantseva, *Tovarishchestvo Peredvizhnykh Khudozhestvennykh Vystavok*, 2 vols (Moscow, 1952–9) contains interesting excerpts from contemporary criticism. See also E. Valkenier, *Russian Realist Art. The State and Society. The Peredvizhniki and Their Tradition* (Ann Arbor, 1977).

30. The post-war emigration of artists from Russia began with Kandinsky's departure for Berlin in December 1921. Within the next few years he was followed by Gabo, Pevsner, Chagall, Archipenko, Puni, Zadkine, and many others, including such talented younger men as Tchelitchew, Berman, and Leonid. Before criticizing the mediocre quality of Soviet painting and sculpture after 1925, account should be taken of Russia's loss of first-rate creative talent between 1914 and 1932, which was greater even than that sustained by Germany after 1933.

31. Lissitzky's *Russland, die Rekonstruktion der Architektur in der Sowjetunion* (Vienna, 1930), written in Moscow in 1929, is one of the last contemporary reports of Constructivist architecture in the U.S.S.R.

32. When the words 'plastic', 'plastics', and 'plasticism' (derived from the Greek *plastikos, plastos* from *plassein* meaning to form as well as to mould) occur in this text, either when quoted from Mondrian himself or in the analysis and criticism of his work, they are to be understood as somewhat loose translations of the Dutch *beelden* and its derivatives, meaning to form, to shape, in the sense of the German *gestalten*. Mondrian's usage, which has been known in English at least since 1937, when his essay 'Plastic Art and Pure Plastic Art' appeared in *Circle* (see p. 363), has been

accepted in the sense of characterizing a 'concern with or emphasis upon form' by the editors of *Webster's Third New International Dictionary* (Springfield, Mass., 1963). They cite its use to denote creative and formative impulses by such English critics as Charles Lamb, Sir Herbert Read, and David Sylvester.

321. 33. See Donald McNamee, 'Van Doesburg's Cow: a Crucial Transition in the Structure and Reality of Art', *The Structurist* (Saskatoon, 1968), no. 8, 18–26.

322. 34. The spiritual rather than political programme of De Stijl is conveyed in the statement: 'The ridiculous, socialistic 1-2-3-internationals were only external; they consisted of words. The international of the spirit is internal, unspoken. It does not consist of words, but of visual deeds and inner strength.' The second and third manifestos, published in *De Stijl* in 1920 and 1921, dealt with literature and politics. Portions of the manifestos, with other important documentation, are accessible in English in the catalogue of the De Stijl exhibition at the Stedelijk Museum, Amsterdam, 1951.

323. 35. Van Doesburg's influence on the leaders of the Bauhaus has not been over-emphasized in the literature. An interesting testimonial to the enthusiasm which his presence aroused among the students is Peter Roehl's 'Der Beginn und die Entwicklung des Stils 1921 in Weimar', in the tenth anniversary issue of *De Stijl*, XIV (1927), nos 79-84, 103-5, with a photograph of student work in the De Stijl manner. See also Helmut von Erffa, 'Bauhaus, First Phase', *Architectural Review*, CXXII (August 1957), 103-5.

325. 36. From Van Doesburg's 'Base de la peinture concrète' and 'Commentaire sur la base de la peinture concrète' in *Numéro d'introduction du groupe et de la revue Art Concret* (Paris, 1930), the only issue published.

326. 37. Mondrian's principal works are available in English as 'Art and Life' and 'The True Value of the Oppositions' in H. L. C. Jaffé's *De Stijl, 1917-1931. The Dutch Contribution to Modern Art* (Amsterdam, 1956), 209-58; 'Natural Reality and Abstract Reality' in Michel Seuphor's *Piet Mondrian, Life and Work* (New York, *c.* 1956); and the collection of his essays, *Plastic Art and Pure Plastic Art* (New York, 1945). The quotations in this text are from the last work, unless otherwise indicated.

38. The quotations from Schoenmaekers's writings are from Jaffé's *De Stijl*, 53-62.

327. 39. Mondrian in *De Stijl*, III (1919-20), and in *Circle, International Survey of Constructive Art* (London, 1937), 56.

331. 40. Extracts from Van de Velde's letters to Gropius, with numerous documents for the history of

the Bauhaus, both textual and visual, are in Hans M. Wingler's *Das Bauhaus, 1919-1933* (Berlin, 1962). See also Walter Gropius, 'My Conception of the Bauhaus Idea', in his *Scope of Total Architecture* (London, 1956), 23-34. Norbert Lynton corrects the 'Bauhaus myth' in his 'London Letter', *Art International*, VI (1962), no. 4, 95. For the Werkbund, see the exhibition catalogue *50 Jahre Deutscher Werkbund* (Frankfurt-am-Main, 1958).

332. 41. From Gropius's 'Idee und Aufbau des Staatlichen Bauhauses, Weimar', in *Staatliches Bauhaus Weimar, 1919-1923* (Weimar and Munich, 1923), 9. A slightly shortened version in English translation is in *Bauhaus, 1919-1928*, the catalogue of an exhibition of the work of the Bauhaus during the years of Gropius's directorship, at the Museum of Modern Art, New York, 1938. In his Manifesto of 1919 Gropius had stated the subject more nakedly: 'Das Endziel aller bildnerischen Tätigkeit ist der Bau . . . Architekten, Maler, und Bildhauer müssen die vielgliedrige Gestalt des Baues in seiner Gesamtheit und in seinen Teilen wieder kennen und begreifen lernen, dann werden sich von selbst ihr Werke wieder mit architektonischen Geiste füllen, den sie in der Salonkunst verloren.' The Manifesto is reproduced in facsimile in Wingler, 38-41.

42. By 1923 there were the following workshops with their *Formmeister*: cabinet-making, Gropius; wood- and stone-carving, Schlemmer; mural-painting, Kandinsky; glass-painting and book-binding, Klee; metalworking, Moholy-Nagy; pottery, Marcks; weaving, Muche; printing, Feininger; theatrical workshop, Lothar Schreyer and Schlemmer. Architecture was studied as 'Space' under Gropius. It is significant that in July 1923 Lyonel Feininger recorded in his diary, after seeing in the Weimar railway station a poster proclaiming 'Art and Technics': 'I reject it with all my heart, this misconception of *art* is a symptom of our time. The demand to couple the two movements is nonsense in every respect. A real technician will rightly reject every artistic interference, and, on the other hand, even the greatest technical perfection can never replace the divine spark of art.' See Hans Hess, *Lyonel Feininger* (New York, 1961), 105.

333. 43. The twelfth of the Bauhausbücher (Bauhaus Books), Gropius's *Bauhausbauten Dessau* (Munich, 1930), contains 203 illustrations of his work in Dessau, including photographic documentation of the Bauhaus building itself. The first Bauhausbuch, *Internationale Architektur* (Munich, 1925), was a collection of 102 photographs of contemporary architecture in many countries, edited by Gropius. The term 'International Style', derived from Gropius's book, gained currency through the 'International Exhibition of Modern

Architecture' at the Museum of Modern Art, New York, prepared by H. R. Hitchcock and Philip Johnson in 1932, and their accompanying book, *The International Style: Architecture since 1922* (New York, 1932).

44. The changing character and content of the course as well as the philosophical and aesthetic theories of the instructors can still be followed, at a distance, in Itten's *Kunst der Farbe* (1959), English translation as *The Art of Colour* (New York, 1961); in Moholy-Nagy's *Von Material zu Architektur* (1929), English translation as *The New Vision* (New York, 1938); and in Albers's *Interaction of Colour* (New Haven, 1963).

340. 45. The quotations are from Kandinsky, *Punkt und Linie zu Fläche, Beitrag zur Analyse der malerischen Elemente* (Munich, 1926); English translation by Howard Dearstyne and Hilla Rebay as *Point and Line to Plane* (New York, 1947), 33, 92, 97. Klee also demonstrated the point–line–plane sequence to his students at the Bauhaus; see the diagrams in his 'Pedagogical Sketchbook', reproduced in *The Thinking Eye* (London, 1961). L. D. Ettlinger, in his Charlton Lecture, *Kandinsky's 'At Rest'* (London, 1961), has examined a painting of 1928 in relation to the artist's published writings and contemporary psychological theories, with special reference to Gestalt psychology.

341. 46. From his manifesto (written with Alfred Kemény), 'The Dynamic-Constructive System of Forces', *Der Sturm* (1922), no. 12; partially reprinted in English translation in *The New Vision, Fundamentals of Design, Painting, Sculpture, Architecture* (New York, 1938), 138.

345. 47. For Albers's aphorisms and poetic presentation of his aesthetic, see the catalogue of the exhibition *Josef Albers, Paintings, Prints, Projects* (Yale University Art Gallery, 1956); and Josef Albers, *Poems and Drawings* (New Haven, Conn., The Readymade Press, 1958).

347. 48. The phrases quoted in this section are from Richter's 'Easel – Scroll – Film', *Magazine of Art*, XLV (1952), 78–86.

352. 49. Gabo to A. L. Chanin, in 'Gabo Makes a Construction', *Art News*, LII (November 1953), 34–7: 'Constructivist artists must have a larger mind than the traditional sculptors. They must know something of physics, and the technology of materials. And most of all they must have constructive hearts and minds contemporaneous with our time. But if an artist hates a machine overwhelmingly he cannot be a Constructivist. Not that he must copy a machine, but science and the spirit must be sympathetic.'

353. 50. Gabo to the author, 4 January 1959.

51. The Manifesto is published in reduced facsimile in *Gabo, Constructions, Sculpture, Paintings, Drawings,*

Engravings (London and Cambridge, Mass., 1957), opp. p. 151. It should be noted that, although this is sometimes called the 'Constructivist Manifesto', the Russian word 'Konstruktivizm' does not occur in the text. The French and English verbs, 'construire' and 'to construct', used in current translation, are equivalents of the Russian words 'stroit'' and 'postroit'', meaning 'to build', 'to construct'. 'Konstruktivizm' reached Russian from the Latin by way of Germany.

356. 52. The quotations are from Gabo's Trowbridge Lecture at Yale University in April 1948, 'On Constructive Realism', published in K. S. Dreier, J. J. Sweeney, and N. Gabo, *Three Lectures on Modern Art* (New York, 1949). It is still the most succinct and eloquent statement of his philosophical position.

358. 53. The works mentioned in this paragraph are reproduced in black and white and in colour in *Antoine Pevsner* (Neuchâtel, 1961).

54. The quotations are from Nash's letter of 2 June 1933 to *The Times*, reprinted in *Unit 1, The Modern Movement in English Architecture, Painting, and Sculpture* (London, 1934). The eleven original members were the architects Wells Coates and Colin Lucas; the sculptors Henry Moore and Barbara Hepworth; the painters Edward Wadsworth, Ben Nicholson, Paul Nash, Frances Hodgkins (who resigned, her place being taken by Tristram Hillier), Edward Burra, John Bigge, and John Armstrong.

360. 55. In addition to Gabo and Mondrian, the German architects Walter Gropius and Erich Mendelsohn and the younger Hungarian architect Marcel Breuer were in England before 1939. Gropius and Breuer also contributed to *Circle*. All five subsequently settled in the United States.

361. 56. From Nicholson's 'Notes on Abstract Art', *Horizon* (October 1941), 272–6, reprinted in *Ben Nicholson, a Retrospective Exhibition* (London, Tate Gallery, 1955).

CHAPTER 7

365. 1. Henry James to Howard Sturges, 5 August 1914, in Percy Lubbock, ed., *The Letters of Henry James* (New York, 1920), II, 384.

2. From Jung's preface to the first edition of *Die Psychologie der unbewussten Prozesse* (Zürich, 1917); English translation by R. F. C. Hull in *Two Essays on Analytical Psychology* (New York, 1953).

3. Richard Huelsenbeck, *En Avant Dada, die Geschichte des Dadaismus* (Hanover, etc., 1920); English translation by Ralph Manheim in Robert Motherwell, ed., *The Dada Painters and Poets: an Anthology* (New York, 1951), 20–47.

366. 4. Tristan Tzara, 'Chronique Zurichoise', in R. Huelsenbeck, ed., *Dada Almanach* (Berlin, 1920), 14, English translation by Ralph Manheim in Motherwell, 236. For a more straightforward recital of the fundamental ideas of Dada, see Tzara's 'Dada 1957' in *Als Dada begann* (Zürich, 1957), 76–84. Malevich and the Russian poet Kruchenikh are said to have composed sound poems before 1917. See Louis Lozowick, 'A Note on the New Russian Poetry', *Broom*, I, no. 4 (February 1922), 306–11.

5. For the principal accounts, see Arp in *Dada Intirol Augrandair, Der Sängerkrieg* (Paris, 1921), cited by Georges Ribemont-Dessaignes in 'Histoire de Dada', *Nouvelle Revue Française* (June–July 1931), English translation in Motherwell, 99–120; Huelsenbeck, *En Avant Dada*; and Hugo Ball's diary, *Die Flucht aus der Zeit* (Lucerne, 1946). One recalls also Gauguin's remark: 'I have gone far back, farther back than the horses of the Parthenon . . . as far back as the dada of my childhood, the good rocking-horse' (*Intimate Journals*, New York, 1921, 33).

368. 6. Jean Arp, *On My Way, Poetry and Essays, 1912 . . . 1947* (New York, 1948), 77.

369. 7. Translations of this and six other manifestos by Tzara are in Motherwell, 75–97.

8. *Bulletin*, Museum of Modern Art (New York), XIII, nos. 4–5 (1946), reprinted in Michel Sanouillet, ed., *Marchand du Sel* (Paris, 1958), 108–14.

371. 9. Philip Pearlstein, 'The Symbolic Language of Francis Picabia', *Arts*, XXX (New York, January 1956), 37–43. See also William A. Camfield, 'The Machinist Style of Francis Picabia', *Art Bulletin*, XLVIII (1966), 309–22; F. Will-Levaillant, 'Picabia et la machine: symbole et abstraction', *Revue de l'Art* (1969), II, no. 4, 74–82.

372. 10. Gabrielle Buffet-Picabia, 'Some Memories of Pre-Dada: Picabia and Duchamp', in Motherwell, 259. See also *Arts Magazine*, LI, no. 9 (May 1977), spécial issue on New York Dada and the Arensberg Circle.

373. 11. *Bulletin*, Museum of Modern Art (New York), XIII, nos. 4–5 (1946), 20; Sanouillet, 111.

376. 12. First published in *Minotaure*, no. 6 (1935), 'Phare de la mariée' was included in Breton's *Le Surréalisme et la peinture* (New York, 1945); English translations in *View*, V (1945), no. 1, reprinted in Robert Lebel, *Marcel Duchamp* (New York, 1959), 88–94.

13. Duchamp, in conversation with the author, New York, January 1959.

378. 14. Huelsenbeck, *En Avant Dada*, Motherwell, 28.

381. 15. This and the following quotations are from Ernst's 'An Informal Life of M.E.', in the exhibition catalogue *Max Ernst* (New York, Museum of Modern Art, 1961).

383. 16. The collage is inscribed as follows: '1 kupferblech 1 zinkblech 1 gummituch 2 tastzirkel 1 abflussfernrohr 1 röhrender mensch' (1 copper plate 1 zinc plate 1 rubber towel 2 calipers 1 drainpipe-telescope 1 roaring (tubular) man). Röhrend is a pun, as it is also reminiscent of Rohr=tube; so the tubular man is a roaring man as well.

384. 17. This and the following statement by Schwitters are from his 'Merz', *Der Ararat*, II (1921), no. 1, 3–11; reprinted in *Das Kunstwerk*, XI (1958), no. 7; English translation in Motherwell, 55–65. He had apparently used tram tickets for collages while still a student at Dresden before 1914.

18. Schwitters in *Merz* 20 (Hanover, 1927). This issue contains an incomplete catalogue of his *merz* works. *Merz* was also used as a verb, the action so indicated being untranslatable. The Bauhaus painter Georg Muche has an amusing story of Schwitters's asking Muche to *merz* with him. Muche didn't understand and thought Schwitters quite mad when he invited Muche to help him arrange shreds of paper on a blank postcard. The incident occurred in Berlin in 1919. See G. Muche, 'Ich habe mit Schwitters gemerzt', in H. M. Wingler, ed., *Wie sie einander sahen* (Munich, 1957), 86–7.

385. 19. C. Spengemann in *Der Zweemann*, nos. 8–12 (1920?), quoted by Schwitters in *Merz 1920*.

20. An undated wooden model for his father's gravestone (Yale University Art Gallery) is rigorously and geometrically abstract, a middle term between the aesthetics of De Stijl and the architectural projects of Malevich.

21. For the recent removal of the essential elements of the Ambleside Merzbau to the University of Newcastle on Tyne, see Fred Brookes, 'Schwitters' Merzbarn', *Studio International* (May 1969), 224–7; John Elderfield, 'Kurt Schwitters' Last Merzbau', *Artforum*, VIII, no. 2 (October 1969), 56–64.

386. 22. Pierre Albert-Birot's review *Sic* (1916–18) and Pierre Reverdy's review *Nord-Sud* (1917–18) are important sources for the literary prototypes of Dada and Surrealism. For the Dada personality of Jacques Vaché (1896–1919), see his *Lettres de Guerre* (Paris, 1919, second enlarged ed., 1949), and André Breton, *Les Pas perdus* (Paris, 1924).

23. Motherwell, 18. Just as these remarks seem prophetic of Paul Klee's *Voice Cloth of the Singer Rosa Silber* (see below, p. 498), so Satie's 'I breathe with care (a little at a time)' suggests one of Duchamp's notes in *The Green Box*: 'Establish a society in which the individual has to pay for the air he breathes . . . in case of non-payment simple asphyxiation if necessary (cut off the air).' For a typographical facsimile of Duchamp's manuscript notes, see G. H. Hamilton

and Richard Hamilton, *The Bride Stripped Bare by her Bachelors, Even* (London and New York, 1960).

24. 'L.H.O.O.Q.' becomes 'Elle a chaud au cul' when read aloud. The latest episode in the idolatrous history of the *Mona Lisa* occurred in Washington and New York in the winter of 1962–3, when unprecedented crowds came to see the painting at the National Gallery and the Metropolitan Museum. For comment, see especially the editorial 'Great Lady and Her Public Relations' in *Art News*, LXI (January 1963), and Salvador Dali, 'Why They Attack the *Mona Lisa*', *Art News*, LXII (March 1963), 36, 63–4. See also T. H. Robsjohn-Gibbings's *Mona Lisa's Mustache* (New York, 1947). The author, an interior decorator, contends that all progressive painting since the Pre-Raphaelites has been a deliberate mystification of the public. It is also well to remember that the sensational theft of Leonardo's painting from the Louvre had occurred only in 1911, and that Guillaume Apollinaire had been briefly jailed on a false accusation.

388. 25. For the complex intellectual and political cross-currents of the notorious *Soirée du cœur à barbe*, to which Tzara's play was the most controversial contribution, see Michel Sanouillet, *Dada à Paris* (Paris, 1965), 380 ff.

26. Breton's two manifestoes, the first published separately, and the second, although usually dated 1930, in the twelfth and last issue of *La Révolution surréaliste* (15 December 1929), were reprinted with new introductions by their author in *Les Manifestes du Surréalisme* (Paris, 1955). The two manifestoes, their prefaces, the 'Prolegomena to a Third Surrealist Manifesto or Not', and the important text, 'Soluble Fish', have been translated, with other writings, by Richard Seaver and Helen R. Lane as *André Breton. Manifestoes of Surrealism* (Ann Arbor, 1969).

389. 27. For an extensive historical exposition of Surrealist precedents, see the exhibition catalogue, *Fantastic Art, Dada, Surrealism* (New York, Museum of Modern Art, 1936). Of 585 items, 261, or forty-four per cent, were the work of earlier artists or twentieth-century 'pioneers'.

28. The poet Pierre Reverdy (1889–1960) had enlarged the definition of the literary (and artistic) image in his review *Nord-Sud* (March 1918): 'The image is a pure creation of the mind [*esprit*]. It cannot arise from a comparison but from the rapprochement of two more or less distant realities. The more the two realities which are brought together are remote and accurate, the stronger the image will be – the more it will have emotive power and poetic reality.' Breton quoted this passage in the first manifesto and confessed that it had deeply impressed him, although Reverdy's 'entirely *a posteriori* aesthetic' had made him mistake effects for

causes. For Reverdy's influence, see Anna Balakian, *Surrealism: the Road to the Absolute* (New York, 1959), chapter 5.

390. 29. From the translation of a fragment of *Les Champs magnétiques* in Motherwell, 232.

30. Because Surrealism was first proposed as a way of life for the solution of 'all human problems', it was inevitable that the question of political intervention would arise; but it was not until the outbreak of the Moroccan War in 1925, when the 'intuitive' epoch yielded to the 'reasoning' one, that the Surrealists declared their adherence to Communism. The Soviets, however, were distrustful, and the only political activity worth recording is Aragon's resignation from the group in 1932, after the publication of his poem *Red Front*, to secure his own freedom of action within the Communist party. His decision was denounced by, among others, Crevel, Eluard, Ernst, and Tzara, who had made his peace with Breton two years before. The Surrealists' statement of their political position, 'La Révolution d'abord et toujours', published in *La Révolution surréaliste*, no. 5 (15 September 1925), was signed by forty-nine writers, but by only three artists (Ernst, Miró, and Masson). The difficulty of accommodating their artistic programme to the reactionary doctrines of contemporary Soviet art was mentioned by Breton in his Prague lecture, 'Position politique de l'art d'aujourd'hui', delivered on 1 April 1935, and in his pamphlet of the following August, 'Du temps que les Surréalistes avaient raison', both reprinted in his *Position politique du Surréalisme* (Paris, 1935). The clearest exposition in English of the political engagement of the Surrealists is Herbert Read's introduction to *Surrealism* (London, 1936), a collection of essays by Breton, Eluard, H. S. Davies, and Georges Hugnet.

31. From Breton's 'Exhibition X . . . Y . . .', in a collection of his essays translated by David Gascoyne as *What is Surrealism?* (London, 1936), 25.

32. The first instalment of 'Le Surréalisme et la peinture' appeared in *La Révolution surréaliste*, no. 3 (15 July 1925). The complete version with additions was issued as a book in 1928 and republished in a volume of essays under the same title (New York, 1945). A partial English translation will be found in Breton's *What is Surrealism?* Two other papers are important: his 'Genesis and Perspective of Surrealism', published as the preface to the catalogue of Peggy Guggenheim's collection, *Art of This Century* (New York, 1942), and 'Situation du Surréalisme entre les deux guerres', a lecture delivered at Yale University in December 1942, published in *VVV* (New York, nos. 2–3, March 1943).

391. 33. From 'Surrealism and Painting', translated by David Gascoyne in *What is Surrealism?*

392. 34. From a manuscript by de Chirico, published in translation by James Thrall Soby in *Giorgio de Chirico* (New York, 1955), 244–50. Although usually referred to as Chirico in early Surrealist literature, the artist preferred the full Italian form of his name. The multiple literary as well as pictorial sources of de Chirico's early style have been carefully examined by Soby (for Nietzsche, see pp. 27–8). See also the important article by Joseph C. Sloane, 'Giorgio de Chirico and Italy', *Art Quarterly*, XXI (1958), 2–22, in which de Chirico's statues, stalled trains, and fragmentary objects are interpreted as symbols of the artist's conscious concern with Italy's social and economic backwardness after the Risorgimento. In this light de Chirico's position can be read as a negative aspect of the Futurists' optimistic and aggressive programme.

393. 35. G. Apollinaire, 'Le Vernissage du Salon d'Automne', *L'Intransigeant* (16 November 1913), reprinted in his *Chroniques d'art, 1902–1918* (Paris, 1960), 340. See also Soby, 44–7.

36. From de Chirico's essay, 'Sull'arte metafisica' (1919), quoted by Soby, 66.

394. 37. Soby, 119.

395. 38. Apollinaire published a long quotation from Soffici's criticism in *Lacerba* in a review in *Paris-Journal* (15 July 1914) (reprinted in *Chroniques d'art*, 411–12).

396. 39. This and the quotations which follow, unless otherwise noted, are from Ernst's 'Au delà de la peinture', *Cahiers d'art*, nos. 6–7 (1936), also published separately in Max Ernst, *Œuvres de 1919 à 1936*, ed. Christian Zervos (Paris, 1937); English translation as 'Beyond Painting' in Max Ernst, *Beyond Painting and Other Writings by the Artist and His Friends* (New York, 1948), 3–25.

40. Max Ernst, 'An Informal Life of M. E.', 13.

398. 41. Quoted by Patrick Waldberg in his *Max Ernst* (Paris, 1958), 288, a detailed biography prepared with the artist's assistance.

399. 42. The last phrase is from Leonardo's *Treatise on Painting*. Ernst had prefaced his account of his discovery with a long quotation from Leonardo's description of the images to be seen in chance configurations on spotted walls, in glowing coals, clouds, water, etc. 'In these confused things', Leonardo concluded, 'genius becomes aware of new inventions.' Earlier speculations about such abstract images have been traced by H. W. Janson in 'The "Image Made by Chance" in Renaissance Thought', in *De Artibus Opuscula XL, Essays in Honor of Erwin Panofsky* (New York, 1961), I, 254–66. See also Werner Spies, *Max Ernst, Frottages* (London, 1969).

402. 43. From Ernst's 'Comment on force l'inspiration', *Le Surréalisme au Service de la Révolution*, no. 6 (15 May 1933); English translation as 'Inspiration to Order' in *Beyond Painting*, 20–5.

44. Tanguy said that he, like Breton, had discovered de Chirico in 1924 when he caught sight of a painting in a dealer's window while riding on a bus. Such a sudden revelation of the marvellous is a typically Surrealist experience. See Tanguy's statement in 'Eleven Europeans in America', *Bulletin*, Museum of Modern Art (New York), XIII, no. 4–5 (1946), 22–3.

45. James Thrall Soby, *Yves Tanguy* (New York, 1955), 17; Marcel Jean, 'Yves Tanguy', *Les Lettres nouvelles*, III (1955), 367–79.

404. 46. Julien Levy, 'Tanguy, Connecticut, Sage', *Art News*, LIII (September 1954), 24–7. The title is a pun on the name of Tanguy's wife, the American painter Kay Sage. The original quotation has, with Mr Levy's permission, been retranslated.

47. Salvador Dali, *The Secret Life of Salvador Dali* (New York, 1942), 272.

48. André Breton, 'Genesis and Perspective of Surrealism', *Art of This Century* (New York, 1942), 24: 'In spite of an undeniable ingenuity in staging, Dali's work, hampered by an ultra-retrograde technique (return to Meissonier) and discredited by a cynical indifference to the means he used to put himself forward, has for a long time showed signs of panic, and has only been able to give the appearance of weathering the storm temporarily through a process of systematic vulgarization.' An instance of the difficulty of distinguishing between Dali's art and his life can be found in Herbert Read's *Concise History of Modern Painting* (London and New York, 1959), 140–2. After quoting Breton's remarks in full, the author charges Dali with having put his theatricality 'at the service of those reactionary forces in Spain whose triumph has been the greatest affront to the humanism which, in spite of all its extravagance, has been the consistent concern of the Surrealist movement'. But this statement is not accompanied by any critical examination of Dali's work.

49. S. Dali, *Conquest of the Irrational* (New York, 1935).

50. Most recently and wittily expressed in Dali's *Les Cocus du vieil art moderne* (Paris, 1956); English translation by Haakon M. Chevalier with the original French text as *Dali on Modern Art, the Cuckolds of Antiquated Modern Art* (New York, 1957).

405. 51. S. Dali, *La Femme visible* (Paris, 1930), 16.

406. 52. Dali's interest in softness led him to study the 'edible' aspects of architecture. His essay, 'De la beauté terrifiante et comestible de l'architecture "moderne style"', *Minotaure*, nos. 3–4 (1933), 69–75 (reprinted in translation in *Dali on Modern Art*, 31–

45), was one of the earliest reappraisals of Art Nouveau architecture. He was chiefly concerned with the work of Gaudí in Barcelona, which he described as 'undulant-convulsive'.

53. But in his 'Interprétation paranoiaque-critique de l'image obsédante "L'Angélus" de Millet', *Minotaure*, no. 1 (1933), 65-7, Dali presented some unusual evidence of scatological and uterine symbolism in Millet's painting. See also his *Le Mythe tragique de l'Angélus de Millet* (Paris, 1963).

407. 54. André Breton in 'Genesis and Perspective of Surrealism', *Art of This Century* (New York, 1942), 22-3.

409. 55. Gertrude Stein, *Lectures in America* (New York, 1935), 71.

410. 56. This and the following quotations are from Magritte's statement to Mr and Mrs Barnet Hodes, printed in *Magritte* (Chicago, William and Noma Copley Foundation, n.d.), 7-8.

412. 57. From the inscription on the artist's diagram, preserved in the Baltimore Museum of Art.

413. 58. The quotations are, in order, from Miró's interview with Georges Duthuit in *Cahiers d'Art*, XI (1936), nos. 8-10, 261, and with James Johnson Sweeney in *Partisan Review*, XV (1948), no. 2, 206-12.

414. 59. André Breton, *Le Surréalisme et la peinture* (New York, 1945), 68 (addendum to the original essay of 1925-7).

416. 60. Miró in *Minotaure*, nos. 3-4 (1933), 18.

417. 61. For Miró's remarks on his pottery, see Rosamond Bernier, 'Miró céramiste . . . une interview par correspondance . . .', *L'Œil*, no. 17 (1956), 46, 49-53.

419. 62. An early and provocative expression of this point of view was Emily Genauer's 'The Fur-lined Museum', *Harper's Magazine* (July 1944), 129-38. See also the section 'Surrealist Objects' in William S. Rubin, *Dada, Surrealism, and Their Heritage* (New York, Museum of Modern Art, 1968), 143-54.

420. 63. André Breton, *L'Amour fou* (Paris, 1937), 41-3.

CHAPTER 8

426. 1. Of the memoirs in the English language the following are of interest for the School of Paris in the 1920s and 1930s: Gertrude Stein, *The Autobiography of Alice B. Toklas* (New York, 1935); Robert McAlmon, *Being Geniuses Together, an Autobiography* (London, 1938); Caresse Crosby, *The Passionate Years* (New York, 1953); Matthew Josephson, *Life Among the Surrealists* (New York, 1962); Alice B. Toklas, *What is Remembered* (New York, 1963).

433. 2. In 1891 Maurice Valadon was legally adopted by Miguel Utrillo, a Spanish friend of his mother and stepfather, who played, however, no part in his life. Utrillo later added 'V' (for Valadon) to his signature.

434. 3. Ronald Alley, in 'Notes on Some Works by Degas, Utrillo, and Chagall in the Tate Gallery', *Burlington Magazine*, C (1958), 173, figure 33, has reproduced the postcard which Utrillo seems to have used for his *Porte Saint Martin* of about 1905, now in the Tate.

435. 4. Signboards are frequently seen in Chagall's early village pictures. In his *Marc Chagall* (New York, 1946), 42, James Johnson Sweeney pointed to 'a possible iconographical relationship to the famous English inn sign, The Man with a Load of Mischief, rather questionably attributed to Hogarth', in which a woman holding a glass sits on a man's shoulders. Ilya Ehrenburg, in *People and Life, Memoirs of 1891-1917* (London, 1961), 174, recalled meeting Léger at La Ruche 'long before' 1914, when the influence of Cubism was so great 'that even Chagall . . . whose art owed a great deal to the barber's shop and greengrocer's signs executed by the local painter, was momentarily swayed'.

5. From Chagall's account of his life from childhood until his final departure from Russia in 1922, English translation by Elisabeth Abbott as *My Life* (New York, 1960), 100-2.

6. André Breton, 'Genesis and Perspective of Surrealism', in *Art of This Century* (New York, 1942), 19.

436. 7. Chagall to Sweeney, *Marc Chagall*, 7.

439. 8. The relation of Chagall's symbolism to earlier Jewish iconography is discussed by Alfred Werner in 'Chagall's Jerusalem Windows', *Art Journal*, XXI (1962), 224-32. Chagall's work on the windows at the glass-makers' in Reims is described by Carlton Lake in 'Artist at Work: Marc Chagall', *Atlantic Monthly* (July 1963), 85-112. See also H. M. Rotermund, 'Der Gekreuzigte im Werk Chagalls', *Mouseion, Studien aus Kunst und Geschichte für Otto H. Förster* (Cologne, 1960), 265-75.

9. The most extended account of the aesthetics of Neo-Romanticism, which had been called 'Néo-humanisme' the year before by Waldemar George, is in *After Picasso* (Hartford and New York, 1935) by James Thrall Soby, one of Tchelitchew's first American collectors. Other artists considered as Neo-Romantics by Mr Soby were the French painter Christian Bérard (1902-49) and Kristians Tonny, born in Paris in 1906 of Dutch parents. See also Victor Koshkin-Youritzen, 'Tchelitchew's Hide-and-Seek', *Art Journal*, XXIV (Winter 1964-5), 124-9.

441. 10. In his catalogue for the Balthus exhibition at the Museum of Modern Art in 1956, James Thrall Soby pointed to the painter's interest in the 'choreographic grace of young awkwardness' in Courbet's

portrait of *P. J. Proudhon and his Children*. There is also evidence in Balthus's landscapes of his admiration for Courbet, but one can add to that both painters' frequent representation of sleeping figures, which have fascinated several other painters of a romantic persuasion, among them Fuseli, Berman, and Picasso. See also John Russell, 'Master of the Nubile Adolescent', *Art in America*, LV (November–December 1967), 98–103.

442. 11. For the preliminary drawings and earlier versions of *White Plumes*, and of the *Pink Nude* discussed below, see Alfred H. Barr, Jr, *Matisse, His Art and His Public* (New York, 1951), 427–9 and 472–3.

12. The quotations in this paragraph are from Matisse's 'Notes of a Painter' (1908), reprinted in Barr, 119–23.

446. 13. This effect may be largely the result of an unfortunate mistake in the measurements sent the artist. He might have adjusted the completed paintings, but he preferred to rework the compositions entirely. The first series is now known only from photographs (Barr, 241–4 and 462–5), but so far as can be seen the rhythms were livelier, the patterned bands more active, and the bodies more physical and less abstract.

448. 14. Henri Matisse, *Jazz* (English ed., New York, The Museum of Modern Art, 1960), 40.

15. Matisse's well-known agnosticism was difficult to reconcile with the design and decoration of a religious edifice. When asked if he had returned to Catholicism, he replied: 'My only religion is love for creating a work, a love of creation, and of great sincerity. I made this chapel with the sole idea of *complete* self-expression. There I have had the opportunity of self-expression in a totality of form and colour.' Matisse to André Verdet in *Prestiges de Matisse* (Paris, 1952), 53.

16. From the artist's important statement reported by Christian Zervos in 'Conversations avec Picasso', *Cahiers d'art*, X (1935), 173–8; English translation in Myfanwy Evans's *The Painter's Object* (London, 1937), 81–8, reprinted in A. H. Barr, Jr, *Picasso, Fifty Years of His Art* (New York, 1946), 272–4.

449. 17. From *Cahier de Georges Braque, 1917–1947* (New York and Paris, 1948), *passim*.

453. 18. For these pictures, see the analyses by John Richardson in his 'The "Ateliers" of Braque', *Burlington Magazine*, XCVII (1955), 164–70, and 'Le Nouvel "Atelier" de Braque', *L'Œil*, no. 6 (1955), 20–5, 39.

19. Described by Patrick Heron in his critique of the artist's late work in *The Changing Forms of Art* (London, 1955), 81–95.

20. This system seemed ineffective as early as 1939, when Alfred H. Barr, Jr, in his catalogue of the Picasso

exhibition at the Museum of Modern Art in New York listed no periods after the Classic. But it was reaffirmed in New York in April 1962, when nine exhibitions were held simultaneously in as many galleries to mark the artist's eightieth birthday. The presentation of the work by decades enforced an artificial sequence, explicitly stated in the otherwise informative catalogue notes: 'So wide is the gulf between the two styles [Cubist and Classic] that we are entitled to regard the Picasso of 1920–25 as two separate artists.' But the unity of the 'styles' in Picasso's own mind can be seen in a single painting, *Études* of 1920–1, in which six Cubist still lifes are interspersed among three studies of classic heads, two of hands, and one of a couple in modern dress standing on a beach (reproduced in Christian Zervos, *Pablo Picasso*, IV, no. 226).

21. One of the best art historical explications was Helen F. Mackenzie's portfolio *Understanding Picasso, a Study of His Styles and Development* (Art Institute of Chicago, 1940). Although the author acknowledged the lack of documentary proof for her comparisons, the juxtaposition of an eighth-century German cloisonné enamel with the *Seated Woman* of 1927 (our illustration 270), however visually piquant, was psychologically and historically disconcerting.

22. This is written with due consideration for the serious misgivings about Picasso's work, especially the later paintings, which have been expressed by, among others, so perceptive a critic as Lawrence Alloway in his 'Against Picasso', *Art International*, IV, no. 8 (1960), 40–1, and in 'The Late Picasso', *ibid.*, VI, no. 4 (1962), 47–51. See also John Berger, *The Success and Failure of Picasso* (Harmondsworth, 1965).

454. 23. For the construction of such a psychology, see Jan Runnqvist, *Minotauros, en studie i förhållandet mellan ikonografi och form i Picassos konst, 1900–1937* (Stockholm, 1959), with summary in French; also Vincente Marrero Suárez, *Picasso and the Bull* (Chicago, 1956). See also Hilton Kramer's review of the exhibition *Pablo Picasso, a Retrospective* (New York, Museum of Modern Art), *The New York Times*, 1 June 1980: 'Simply stated, this inner life of Picasso's art – the very crux of the spirit animating it through every change of form – centers on two all-consuming and, for Picasso, closely connected passions: making art and making love. The world that exists beyond the boundaries of the artist's studio and his bedroom, or seraglio, is quite conspicuously lacking in what philosophers call ontology. It lacks, in other words, reality or being.'

457. 24. From Picasso's statement to Marius de Zayas, first published in English as 'Picasso Speaks', *The Arts* (New York, May 1923); reprinted in Barr, 270–1.

25. From Zervos, 'Conversations avec Picasso', 173–8.

26. The notebook has been published with prefaces by Michel Leiris and Rebecca West as *Suite de 180 dessins de Picasso* (Paris and New York, 1954). See also Françoise Gilot and Carlton Lake, *Life with Picasso* (New York, 1964).

459. 27. For the symbolism of *Guernica*, see Juan Larrea, *Guernica, Pablo Picasso* (New York, 1947); Rudolf Arnheim, *Picasso's Guernica, the Genesis of a Painting* (Berkeley and Los Angeles, 1962); Carla Gottlieb, 'The Meaning of Bull and Horse in *Guernica*', *Art Journal*, XXIV (Winter 1964-5), 106-12; Anthony Blunt, *Picasso's Guernica* (London, 1967). In 1935, in his conversation with Zervos, Picasso had said: 'It would be very interesting to preserve photographically, not the stages but the metamorphoses of a picture. Possibly one might then discover the path followed by the brain in materializing a dream.' The photographs taken by Dora Maar of eight 'metamorphoses' of the whole painting, with many studies, enable us to follow this important oneiric 'manipulation'. They have been published in Christian Zervos, 'Histoire d'un tableau de Picasso', *Cahiers d'art*, XII (1937), 105-54, and in Arnheim.

460. 28. Picasso in 1945; Barr, 248.

29. Herbert Read, *A Concise History of Modern Painting* (New York, 1959), 244, apropos of Kokoschka.

30. The 'sculpture' of the war years is reproduced in photographs by Brassai in Daniel-Henry Kahnweiler's *Les Sculptures de Picasso* (Paris, 1949).

461. 31. Paul M. Laporte in his 'The Man with the Lamb', *Art Journal*, XXI (1962), 144-50, has attributed to the figure considerable anthropological and philosophical (existential) significance.

32. Paul Valéry, 'Eupalinos, or The Architect', in *Dialogues* (New York, 1956), Bollingen Series, XLV, 4, 14, translated by William McCausland Stewart.

33. Picasso's ambivalent attitude towards the invasion of his privacy can be studied in two books by the American photographer David Douglas Duncan, *The Private World of Pablo Picasso* (New York, 1958), sub-titled 'the intimate photographic profile of the world's greatest artist', and *Picasso's Picassos* (New York, 1961).

34. Picasso quoted by Claude Roy in *Picasso, la Guerre et la Paix* (Paris, 1954), 42.

462. 35. From an unpublished notebook of 1909 by Gertrude Stein, quoted by Donald C. Gallup in 'Picasso, Gris, and Gertrude Stein', *Picasso Gris Miró*, exhibition catalogue (San Francisco Museum of Art, 1948), 16. Miss Stein shrewdly added, however, '. . . therefore his things often lack a base'.

36. The quotations in this paragraph are from Arp's *On My Way, Poetry and Essays, 1912 . . . 1947* (New

York, 1948), 69, 47. The English translations are by Ralph Manheim. Jean and Hans Arp were the same person; as an Alsatian, the artist used either form of his Christian name according to the language in which he was writing.

37. Brancusi's rare aphorisms, translated by Maria Jolas and Anne Leroy, will be found in Carola Giedion-Welcker's *Constantin Brancusi* (New York, 1959), 219-20.

38. Brancusi, quoted by Paul Morand in his preface to the catalogue of the artist's first one-man exhibition, at the Brummer Gallery, New York City, November-December 1926.

39. Because Brancusi's works exist in multiple replicas in different materials, the location of each example will not be given. The most extensive collections are in the Musée National d'Art Moderne, Paris, where the sculptor's studio has been re-erected, and the Philadelphia Museum of Art (Louise and Walter Arensberg Collection). The dates in this text are those of the first versions in Sidney Geist's *Brancusi, the Sculpture and Drawings* (New York, 1975), except for the three birds which are from Athena T. Spear's *Brancusi's Birds* (New York, 1969). For the complex dating of the originals and variants, see Mrs Spear's 'A Contribution to Brancusi Chronology', *Art Bulletin*, XLVIII (1966), 45-54, as well as Mr Geist's letter to the editor and Mrs Spear's reply, *ibid.*, 462-8, and her review of his earlier *Brancusi* (1968) in *Burlington Magazine*, CXI (1969), 154-8.

466. 40. Léger stated that before 1914 he, Duchamp, and Brancusi had visited the Salon de l'Aviation. Duchamp there said to the sculptor: 'Painting is done with. Who could make anything better than that propeller?' Léger added that he and Brancusi were also attracted to such precise objects, but not 'so completely' as Duchamp (Léger, quoted in the catalogue of the retrospective exhibition of his work, Paris, 1956, 30). Brancusi became the centre of an American *cause célèbre* in 1926 when the United States Customs declared that his *Bird in Space* was not a work of art and therefore was dutiable as raw material. The artist appealed against the decision and a judgement was returned in his favour by the United States Supreme Court in 1928, to the effect that although the *Bird* was not a 'realistic' work of art, it did belong to 'a new direction'. For an account of the case, see Giedion-Welcker, 212-17.

467. 41. Daniel Vladimir Baranov-Rossiné exhibited at the Salon des Indépendants and the Salon d'Automne from 1911. Reproductions of his freely geometrical works indicate that he accepted influences from Léger, Picabia, and Archipenko. He also invented an optophonic piano which was capable of

producing compositions in coloured lights. See Michel Hoog, 'Pour un oublié', *Cimaise*, nos. 85–6 (1968), 88–9.

42. From the revised version in the exhibition catalogue *Arp* (Paris, Musée National d'Art Moderne, 1962), 36. The original German with English translation is included in *On My Way*, 72, 99.
468. 43. See the letter from Marguerite Hagenbach to Sam Hunter, in the latter's *Joan Miró, His Graphic Work* (New York, 1958), XX and note 20.
469. 44. *On My Way*, 50, translated by Ralph Manheim.
470. 45. The Café Aubette interiors were illustrated and described by Van Doesburg in the Aubette-Nummer of *De Stijl*, nos. 87–9 (1928). See also Théo Wolters, 'L'Aubette de Strasbourg (1928). Monument disparu d'art concret', *L'Information d'histoire de l'art* (1968), no. 3, 143–9.
471. 46. From a statement by Gonzalez, first published in *Cahiers d'art*, X (1935), 32–4, quoted by Andrew C. Ritchie in his catalogue of the Gonzalez exhibition at the Museum of Modern Art, New York, 1956, 42.

CHAPTER 9

474. 1. The terms of the questionnaire have been published in English translation by Hellmut Lehmann-Haupt in *Art under a Dictatorship* (New York, 1954), 18–20. The optimistic and ultimately hopeless ideal expressed by many members of the November-gruppe for a new art closely related to the people's will was summed up by Adolf Behne in his answer to the questionnaire: 'The State is by nature inimical to art. The People is the supporter of art because it is alive ... Cooperation with the People, whose instinct we must again awaken to purity. If our alliance with the People succeeds, we have won the game.' Work by members of the Novembergruppe, many of them now little known, is conveniently examined in the exhibition catalogue *Berlin: Ort der Freiheit für die Kunst* (Nationalgalerie, Berlin, 1960).
2. Werner Doede's *Berlin, Kunst und Künstler seit 1870, Anfänge und Entwicklungen* (Recklinghausen, 1961) is useful for this period. See also Peter Gay, *Weimar Culture. The Outsider as Insider* (New York, 1968); J. Willett, *Art and Politics in the Weimar Period. The New Sobriety, 1917–1933* (New York, 1978).
478. 3. Willi Wolfradt, 'Otto Dix', *Jahrbuch der jungen Kunst* (Leipzig, 1924), 279–88.
4. For the history of the term 'Neue Sachlichkeit', see Fritz Schmalenbach, 'The term Neue Sachlichkeit', *Art Bulletin*, XXII (1940), 161–5, German text in the author's *Kunsthistorische Studien* (Basel, 1941),

22–32. In his *Nach-Expressionismus, Magischer Realismus, Probleme der neuesten europäischen Malerei* (Leipzig, 1925), Franz Roh listed no less than twenty-two contrasting qualities between Expressionism and 'Post-Expressionism', but since his mixed bag of 'Magic Realists' included such painters as Picasso, Metzinger, Herbin, Miró, and Severini the distinctions failed to gain currency. See also the exhibition catalogue, *Aspekte der 'Neuen Sachlichkeit'* (Munich and Rome, 1968), and F. Schmalenbach, *Die Malerei der 'Neuen Sachlichkeit'* (Berlin, 1973).
479. 5. Carl Hofer, *Aus Leben und Kunst* (Berlin, 1952), 30.
480. 6. The second version is discussed by Dr Peter Beckmann under the provocative title 'Verlust des Himmels' (Loss of Heaven) in *Blick auf Beckmann* (Munich, 1962), 23–4, the second volume of studies published by the Max Beckmann Gesellschaft.
482. 7. As early as 1924 the art historian Wilhelm Fraenger published an essay on *Der Traum (The Dream)*, subtitled 'A Contribution to the Physiognomy of the Grotesque', reprinted in *Blick auf Beckmann*, 36–49.
8. The iconology of Beckmann's triptychs and other symbolic pictures is only in its initial phase. Preliminary studies include Charles S. Kessler, 'Max Beckmann's *Departure*: the Modern Artist as Heroic Prophet', *Journal of Aesthetics and Art Criticism*, XIV (1955), 206–17, and the same author's 'The Vision of Max Beckmann', *Arts Yearbook*, IV (1961), 133–40, with an important statement by Beckmann on *Departure*; Harold Joachim, 'Blindman's Buff, a Triptych by Max Beckmann', *Minneapolis Institute of Fine Arts Bulletin*, XLVII (1958), 1–12; Armin Kesser, 'Das mythologische Element im Werk Max Beckmanns', *Blick auf Beckmann*, 25–35; Eleanor Anderson, 'Max Beckmann's Carnival Triptych', *Art Journal* (Spring 1965), 218–25.
483. 9. This and the quotations in the following paragraphs are from Beckmann's lecture 'On My Painting', delivered at the New Burlington Galleries, London, 21 July 1938; complete text published by the Buchholz Gallery, New York, 1941; excerpts in the catalogue of the retrospective exhibition at the City Art Museum, St Louis, 1948, with a critical introduction by Perry T. Rathbone.
486. 10. For the history of the Nazi persecution of art and artists, see Franz Roh, *'Entartete' Kunst, Kunstbarbarei im Dritten Reich* (Hanover, 1962); Joseph Wulf, ed., *Die bildenden Künste im Dritten Reich, eine Dokumentation* (Gütersloh, 1963); Hildegard Brenner, *Die Kunstpolitik des Nationalsozialismus* (Reinbek bei Hamburg, 1963).
11. These arguments can be followed in the official

handbook, *Führer durch die Ausstellung Entartete Kunst*, prepared by Fritz Kaiser, reproduced with the original illustrations in Roh, *'Entartete' Kunst*. See also the useful catalogue of the retrospective exhibition, *Entartete Kunst, Bildersturm vor 25 Jahren*, held in the Haus der Kunst, Munich, October–December 1962.

488. 12. From a letter of 6 January 1911 to Arthur Roessler, quoted in the exhibition catalogue *Egon Schiele* (Boston, Institute of Contemporary Art, 1960), n.p.

491. 13. From Kokoschka's essay, 'On the Nature of Visions', translated by Hedi Medlinger and John Thwaites in Edith Hoffmann, *Kokoschka, Life and Work* (London, 1947), 285–7.

494. 14. From Kokoschka's essay 'Das Auge des Darius', in which he asserts his belief in the eternal vitality of traditional figurative art, originally published in *Schweizer Monatshefte* (1956), reprinted in Hans Maria Wingler, *Oskar Kokoschka, das Werk des Malers* (Salzburg, 1956), 79–90.

15. Klee's notes for his lectures at the Bauhaus, with others of his theoretical writings, have been edited by Jürg Spiller in two volumes as *Das bildnerische Denken* (Basel, 1956) and *Unendliche Naturgeschichte* (Basel, 1970): English translations as *The Thinking Eye, The Notebooks of Paul Klee* (London and New York, 1961) and *The Nature of Nature* (London and New York, 1973). While at the Bauhaus in Weimar, Klee published a synopsis of his teaching method as *Pädagogisches Skizzenbuch* (Munich, 1925); English translation as *Pedagogical Sketchbook* by Carl Nierendorf (New York, 1944) and by Sibyl Moholy-Nagy (New York, 1953).

495. 16. *The Diaries of Paul Klee, 1898–1918* (Berkeley and Los Angeles, 1964), 232, entry dated Munich 1916 (probably late March or April). These sentences may be compared with those from his journal of 1909 which were engraved on his tombstone years later: 'I cannot be understood in purely earthly terms. For I can live as happily with the dead as with the unborn. Somewhat nearer to the heart of all creation than is usual. But still far from being near enough.'

17. From Klee's testimonial to Kandinsky on the latter's sixtieth birthday in 1926, reprinted in *The Thinking Eye*, 521–2.

496. 18. From Klee's 'Exakte Versuche im Bereiche der Kunst', first published in the Bauhaus *Vierteljahrzeitschrift für Gestaltung* (Dessau, 1928), ii, no. 2; English translation as 'Exact Experiments in the Realm of Art', *The Thinking Eye*, 69–75.

19. *Paul Klee* (New York, Museum of Modern Art, 1945), 8.

20. *Tagebücher*, entry for 16 April 1914. This famous trip to North Africa, undertaken by Klee and Macke, was interpreted as an important episode in the development of modern art by Wilhelm Hausenstein in *Kairuan, oder eine Geschichte vom Maler Klee und von der Kunst dieses Zeitalters* (Munich, 1921), one of the first monographs on Klee's painting. Klee had already translated Delaunay's essay 'La Lumière' into German; it appeared in *Der Sturm*, iii (1913), no. 144–5, as 'Über das Licht'.

21. From Klee's lecture notes for 5 December 1921; *The Thinking Eye*, 169.

22. Klee's remark to his wife in a letter of February 1918, 'My hand is simply a tool remotely controlled. It is not my head that is functioning but something else, something higher and more remote, somewhere' (in *Paul Klee, Dokumente und Bilder aus den Jahren 1896–1930*, Bern, 1949), must be offset by the statement in his Jena lecture 'On Modern Art' (1924): '. . . our pounding heart drives us down, deep down to the source of all. What springs from this source, whatever it may be called, dream, idea, or phantasy, must be taken seriously only if it unites with the proper creative means to form a work of art' (translation by Paul Findlay, as *On Modern Art*, London, 1948, 51). The incantatory, semi-automatic aspects of Klee's creative process, which make some people link him, perhaps erroneously, with the Surrealists, have been stressed by Werner Haftmann in his *Paul Klee: Wege bildnerischen Denkens* (Munich, 1950); English translation as *The Mind and Work of Paul Klee* (London and New York, 1954).

23. From Klee's 'Schöpferische Konfession', first published in *Tribüne der Kunst und Zeit*, xiii (1920); English translation in *The Thinking Eye*, 76–80.

497. 24. 'Exakte Versuche im Bereiche der Kunst', *loc. cit.*

498. 25. From the *Tagebücher*, 242 (November–December 1908).

499. 26. 'Schöpferische Konfession', *loc. cit.*

27. The Paul Klee-Stiftung (Foundation) contains a notable collection, including the documents published in *Das bildnerische Denken*. For a list of its paintings, drawings, and prints, see the exhibition catalogue *Paul Klee. Ausstellung in Verbindung mit der Paul Klee-Stiftung*, Bern, Kunstmuseum, 1956.

507. 28. The development of tendencies more progressive than those represented by the Novecentisti can be followed in the exhibition catalogue *Mostra del rinnovamento dell'arte in Italia dal 1930 al 1945* (Ferrara, 1960), ed. Eugenio Riccomini, with bibliographies of individual artists.

512. 29. The quotations in this paragraph are from Spencer's letter of 1917 to Eric Gill, quoted by John Rothenstein in *Modern Painters, Lewis to Moore*

(London, 1956), 169, and from the artist's introduction to the catalogue of his retrospective exhibition at the Tate Gallery, 1955.

514. 30. The painting, a companion to *Workmen in the House* of 1935 (Collection W. A. Evill), has been studied by Aimée B. Brown in 'Stanley Spencer's "The Builders" ', *Yale University Art Gallery Bulletin*, XXIX, no. 2 (December 1963), 22–33.

516. 31. From Moore's 'Notes on Sculpture', first published in *The Listener*, XVIII (18 August 1937), 449, and frequently reprinted.

518. 32. This interpretation of Moore's female figures has been pursued by Erich Neumann in *The Archetypal World of Henry Moore* (New York, 1959). See also G. F. Wingfield Digby, *Meaning and Symbol in Three Modern Artists: Edvard Munch, Henry Moore, Paul Nash* (London, 1955). In his 'Notes on Sculpture' Moore wrote of 'universal shapes to which everybody is subconsciously conditioned and to which they can respond if their conscious control does not shut them off'.

BIBLIOGRAPHY

The bibliography of modern art is now so large, and has increased so rapidly, especially since 1945, that any list of essential works for a general history can only be an interim report. In selecting the books to be included here preference has been given to those containing extensive, scholarly bibliographies of the earlier literature, the clearest and most comprehensive illustrations, and the results of the most recent bibliographical and critical research. For artists who could be little more than mentioned in the text the entries are proportionately more generous in order that the reader may, should he wish, investigate them further. He should also, for any given artist, consult the appropriate notes, where additional texts and periodical literature are cited.

When the place of publication is followed by the name of a museum, gallery, or institution the work is an exhibition catalogue. An asterisk indicates that the publication is, or contains, a catalogue raisonné. The bibliography is arranged under the following headings:

I. GENERAL

A. REFERENCE WORKS

Arntz, W. F., ed. *Werkkatalog zur Kunst des 20. Jahrhunderts: catalogues raisonnés*. Haag/Ober-bayern, 1975.

Documentation of Modern Art. A Handlist of Resources. Lund, 1975.

Huyghe, R. *Larousse Encyclopedia of Modern Art from 1800 to the Present Day*. London, 1965.

Kindlers Malerei Lexikon. 5 vols, Zürich, 1964–8.

Knaurs Lexikon der moderner Kunst. Munich, 1955.

Osborne, H., ed. *The Oxford Companion to Twentieth-Century Art*. Oxford and New York, 1981.

Phaidon Dictionary of Twentieth-Century Art. London and New York, 1973.

Vollmer, H. *Allgemeines Lexikon der bildenden Künstler des XX. Jahrhunderts.* 5 vols. and supplement. Leipzig, 1953–62.

B. GENERAL WORKS

Argan, G. C. *Die Kunst des 20. Jahrhunderts, 1880–1940* (Propyläen Kunstgeschichte, XII). Berlin, 1977.

Arnason, H. H. *History of Modern Art. Painting, Sculpture, Architecture.* Rev. and enl. ed. New York, 1977.

Les Avant-Gardes de L'Europe Centrale 1907–1927. Paris, 1988.

Cassou, J., Langui, E., and Pevsner, N. *Gateway to the Twentieth Century.* New York, 1962.

Chipp, H. B. *Theories of Modern Art. A Source Book by Artists and Critics.* Berkeley and Los Angeles, 1968.

Cooke, L. *In Tandem. The Painter-Sculptor in the Twentieth Century.* London, Whitechapel Art Gallery, 1986.

Delevoy, R. *Dimensions of the 20th Century, 1900–1945.* Geneva, 1965.

Demisch, H. *Vision and Mythos in der Modernen Kunst.* Stuttgart, 1959.

Einstein, C. *Die Kunst des 20. Jahrhunderts.* 3rd ed. Berlin, 1931.

Ferrier, J-L. (ed.) *Art of Our Century. The Story of Western Art 1900 to the Present.* London, 1990.

Frascina, F., and Harris, J. (eds.) *Art in Modern Culture: An Anthology of Critical Texts.* London, 1992.

Frascina, F., and Harrison, C. *Modern Art and Modernism. A Critical Anthology.* New York, 1982.

Goldberg, R. *Performance. Live Art 1900 to the Present.* London, 1979.

Golomstock, I. *Totalitarian Art in the Soviet Union, The Third Reich, Fascist Italy and The People's Republic of China.* London, 1990.

Gordon, D. E. *Modern Art Exhibitions, 1900–1916. Selected Catalogue Documentation.* Munich, 1974.

Haftmann, W. *Skizzenbuch zur Kultur der Gegenwart, Reden and Aufsätze.* Munich, 1960.

Harrison, C., and Wood, P. (eds.) *Art in Theory 1900–1990. An Anthology of Changing Ideas.* Oxford, 1992.

Herbert, R. L., ed. *Modern Artists on Art.* Englewood Cliffs, N.J., 1964.

Hobhouse, J. *The Bride Stripped Bare. The Artist and the Nude in the Twentieth Century.* London, 1988.

Hughes, R. *The Shock of the New. Art and the Century of Change.* London, 1980.

Hunter, S., and Jacobus, J. M. *Modern Art from Post-Impressionism to the Present, Painting, Sculpture, Architecture.* New York, 1977.

Johnson, E. H. *Modern Art and the Object. A Century of Changing Attitudes.* London, 1976.

Lynton, N. *The Story of Modern Art.* Oxford, 1980.

Meier-Graefe, J. *Modern Art. Being a Contribution to a New System of Aesthetics.* 2 vols. London, 1908.

Micheli, M. de. *Le Avanguardie artistiche del novecento.* Milan, 1959.

Ozenfant, A. *Foundations of Modern Art.* New ed. New York, 1952.

Pevsner, N. *Pioneers of Modern Design from William Morris to Walter Gropius.* Rev. ed. Harmondsworth, 1964.

Poggi, C. *In Defiance of Painting: Cubism, Futurism and the Invention of Collage.* New Haven and London, 1992.

Ponente, N. *The Structures of the Modern World, 1850–1900.* Geneva, 1965.

Read, H. *Art and Alienation. The Role of the Artist in Society.* New York, 1967.

Read, H. *Art Now. An Introduction to the Theory of Modern Painting and Sculpture.* Rev. ed. New York, 1960.

Rubin, W. (ed.) *'Primitivism' in Twentieth-Century Art. Affinity of the Tribal and the Modern.* New York, 1984.

Russell, J. *The Meanings of Modern Art.* London, 1981.

Schapiro, M. *Modern Art. 19th and 20th Centuries.* New York, 1978.

Shapiro, T. *Painters and Politics. The European Avant-garde and Society.* New York, 1976.

Selz, P. *Art in Our Time. A Pictorial History 1890–1980.* New York, 1981.

Stangos, N. (ed.) *Concepts of Modern Art.* Revised ed. London, 1981.

Sylvester, D., *Modern Art, from Fauvism to Abstract Expressionism.* New York, 1966.

Tendenzen der Zwanziger Jahre. 2 vols. Berlin, 1977.

Varnedoe, K. *A Fine Disregard. What Makes Modern Art Modern.* London, 1990.
Varnedoe, K. and Gopnick, A. (eds.) *Modern Art and Popular Culture. Readings in High & Low.* New York, 1990.
Waldman, D. *Collage, Assemblage and the Found Object.* London, 1992.
Wescher, H. *Collage.* New York, 1968.
Zeitler, R. *Die Kunst des 19. Jahrhunderts* (Propyläen Kunstgeschichte, XI). Berlin, 1966.
Zervos, C. *Histoire de l'art contemporain.* Paris, 1938.

C. PAINTING
Dorival, B. *Les Peintres du vingtième siècle.* 2 vols. Paris, 1957.
Haftmann, W. *Painting in the Twentieth Century.* 2 vols. London, 1961. New ed., New York, 1965.
Hess, W. *Dokumente zum Verständnis der modernen Malerei.* Hamburg, 1956.
Lake, C., and Maillard, R., eds. *Dictionary of Modern Painting.* 3rd ed. London, 1964.
Ozenfant, A., and Jeanneret, C. E. (Le Corbusier). *La Peinture moderne.* Paris, 1927.
Raynal, M. *Modern Painting.* New rev. ed. New York, 1960.
Read, H. *A Concise History of Modern Painting.* Rev. and enl. ed. London, 1968.
Rosenblum, R. *Modern Painting and the Northern Romantic Tradition. Friedrich to Rothko.* London, 1975.
Shapiro, T. *Painters and Politics. The European Avant-garde and Society, 1900–1925.* New York, 1976.
Vallier, D. *Témoins et témoignages. Histoire de la peinture 1870–1940. Les Mouvements d'avant-garde.* Brussels-Paris, 1966.

D. SCULPTURE
Bowness, A. *Modern Sculpture.* London, 1965.
Elsen, A. E. *Origins of Modern Sculpture. Pioneers and Premises.* New York, 1974.
Elsen, A. E. *The Partial Figure in Modern Sculpture from Rodin to 1969.* Baltimore Museum of Art, 1969.
Giedion-Welcker, C. *Contemporary Sculpture. An Evolution in Volume and Space.* Rev. and enl. ed. New York, 1961.
Hammacher, A. M. *Evolution of Modern Sculpture. Tradition and Innovation.* New York, 1969.
Knaurs Lexikon der modernen Plastik. Munich, 1961.
Maillard, R., ed. *Nouveau Dictionnaire de la sculpture moderne.* 2nd ed. Paris, 1970.
Rowell, M. *The Planar Dimension, Europe, 1912–1932.* New York, Guggenheim Museum, 1979.

Selz, J. *Modern Sculpture, Origins and Evolution.* New York, 1963.
Trier, E. *Form and Space. The Sculpture of the Twentieth Century.* Rev. ed. London, 1968.
Tucker, W. *The Language of Sculpture.* London, 1974.

II. MOVEMENTS

A. ABSTRACT ART
Abstraction-Création 1931–1936. Münster, Landesmuseum, 1978.
Boudaille, G. *Art abstrait.* Paris, 1990.
Cheetham, M. A. *The rhetoric of purity: essentialist theory and the advent of abstract painting.* Cambridge, 1991.
Dabrowski, M. *Geometric Abstract Art 1910–1980.* New York, 1985.
Daval, J-L. *Histoire de la peinture abstraite.* Paris, 1988.
Henning, E. B., ed. *Paths of Abstract Art.* Cleveland, Museum of Art, 1960.
Kruskopf, E. *Shaping the Invisible. A Study of the Genesis of Non-representational Painting, 1908–1919.* Helsinki, 1976.
Poensgen, G., and Zahn, L. *Abstrakte Kunst, eine Weltsprache.* Baden-Baden, 1958.
Seuphor, M., and Ragon, M. *L'Art abstrait.* 4 vols. Paris, 1971–4.
Spate, V. *Orphism. The Evolution of Non-figurative Painting in Paris 1910–1914.* Oxford, 1979.
Towards a New Art. Essays on the Background to Abstract Art 1910–1920. London, Tate Gallery, 1980.

B. ART NOUVEAU AND JUGENDSTIL
Art Nouveau Belgique. Brussels, Palais des Beaux-Arts, 1980.
Art Nouveau in Britain. London, Arts Council, 1965.
Bangert, A., et al. *Jugendstil, Art Deco.* 4 vols. Munich, 1980–1.
Borisova, E., and Sternin, G. (eds.) *Russian Art Nouveau.* New York, 1988.
Bouillon, J. P. *Art Nouveau, 1870–1940.* New York, 1985.
Champigneulle, B. *Encyclopédie de l'Art Nouveau.* Paris, 1981.
Cirici Pellicer, A. *El Arte modernista catalán.* Barcelona, 1951.
Doede, W. *Die Berliner Secession . . .* Frankfurt am Main, 1977.
Hiesinger, K. B. *Art Nouveau in Munich.* Philadelphia, 1988.

Homage to Barcelona. The City and its Art 1888–1936. London, Arts Council, 1986.

Hughes, R. *Barcelona.* London, 1992.

Jullian, P. *The Triumph of Art Nouveau. Paris Exhibition 1900.* London, 1974.

Kempton, R. *Art Nouveau. An Annotated Bibliography.* Los Angeles, 1977.

Masini, L.-V. *Art Nouveau.* London, 1984.

Nebehay, C. M. *Vienna 1900: architecture and painting.* Vienna, 1984.

Schmutzler, R. *Art Nouveau.* New York, 1964.

Secession. Europäische Kunst um die Jahrhundertwende. Munich, Haus der Kunst, 1964.

Selz, P., and Constantine, M., eds. *Art Nouveau. Art and Design at the Turn of the Century.* Rev. ed. New York, Museum of Modern Art, 1975.

Varnedoe, K. *Vienna 1900: art, architecture and design.* New York, 1986.

Vergo, P. *Vienna 1900: Vienna, Scotland and the European avant-garde.* Edinburgh, 1983.

C. THE BAUHAUS

Bauhaus 1919–1939: le Bauhaus dans les collections de la Republique Démocratique Allemande. Brussels, Musées Royaux des Beaux-Arts, 1988.

Bauhaus Utopien: Arbeiten auf Papier. Cologne, Kunstverein, 1988.

Dearstyne, H. *Inside the Bauhaus.* London, 1986.

Fleischmann, G. *Bauhaus: Drucksachen, Typografie, Recklame.* Düsseldorf, 1984.

50 Jahre Bauhaus, Stuttgart, Württembergischer Kunstverein, 1968.

Naylor, G. *The Bauhaus Reassessed. Sources and Design Theory.* London, 1985.

Roters, E. *Painters of the Bauhaus.* New York, 1968.

Sammlungs-Katalog. Bauhaus Archiv. Berlin, 1981.

Scheidig, W. *Crafts of the Weimar Bauhaus 1919–24. An Early Experiment in Industrial Design.* London, 1967.

Utopias de la Bauhaus: obra sobre papel. Madrid, Centro de Arte Reina Sofia, 1988.

Herzogenrath, W. *Bauhausfotografie.* Stuttgart, 1983.

Whitford, F. *Bauhaus.* London, 1984.

Wingler, H. M., ed. *Graphic Work from the Bauhaus.* Greenwich, Conn., 1969.

Wingler, H. M. *The Bauhaus. Weimar, Dessau, Berlin, Chicago.* Cambridge, Mass., 1969.

D. DER BLAUE REITER (THE BLUE RIDER)

Der Blaue Reiter im Lenbachhaus München. Katalog der Sammlung. 2nd ed. Munich, 1982.

Der Blaue Reiter. München und die Kunst des 20. Jahrhunderts. Munich, Haus der Kunst, 1949.

The Blaue Reiter Almanac. New York, 1974. New documentary edition, edited with an introduction by K. Lankheit.

Buchheim, L. G. *Der Blaue Reiter und die 'Neue Künstlervereinigung München'.* Feldafing, 1959.

Kandinsky, W. and Marc, F. *Briefwechsel, mit Briefen von und an Gabriele Münter und Maria Marc.* ed. Klaus Lankheit. Munich, 1983.

Lottner, P. *et al. Der Blaue Reiter.* Hanover, 1989.

Marc, F., and Lasker-Schüler, E. *'Der Blaue Reiter präsentiert Eurer Hoheit sein Blaues Pferd'. Karten und Briefe.* Ed. P-K. Schuster. Munich, 1987.

Röthel, H. K. *The Blue Rider.* New York, 1971.

Vor 50 Jahren. Neue Künstlervereinigung. Der Blaue Reiter. Munich, Galerie Stangl, 1962.

Tavel, H. C. von. *Der Blaue Reiter.* Berne, 1987.

Vergo, P. *The Blue Rider.* Oxford, 1977.

Vogt, P. *Der Blaue Reiter.* Cologne, 1977.

Wingler, H. M. *Der Blaue Reiter. Zeichnungen und Graphik von Marc, Kandinsky, Klee, Macke, Jawlenksy, Campendonk, Kubin.* Feldafing, 1954.

E. DIE BRÜCKE (THE BRIDGE)

Ausstellung Künstlergruppe Brücke. Jahresmappen 1906–1912. Bern, Klipstein and Kornfeld, 1958.

Berlin, Brücke Museum, 1970.

——. *Künstler der Brücke, Gemälde der Dresdener Jahre 1905–1911.* Berlin, Brücke Museum, 1973.

——. *Künstlergruppe Brücke. Fragment eines Stammbuches.* Berlin, 1975.

Buchheim, L. G. *Die Künstlergruppe 'Brücke' und der deutsche Expressionismus.* 2 vols. Feldafing, 1973.

Curtis, P. *Out of the Wood. Die Brücke Woodcut Techniques.* London, Tate Gallery, 1990.

Die Künstlergruppe 'Brücke'. Hanover, Kunstmuseum, 1982.

Le Fauvisme français et les débuts de l'Expressionnisme allemand. Paris, Musée National d'Art Moderne, 1966.

Painters of the Brücke. London, The Tate Gallery, 1964. Exhibition catalogue with text by W. Grohmann.

Reidemeister, L. *Künstler der Brücke an den Moritzburger Seen 1909–1911.*

Roters, E. 'Beiträge zur Geschichte der Künstlergruppe "Brücke" in den Jahren 1905–07', *Jahrbuch der Berliner Museen II* (1960), 172–210.

Wentzel, H. *Bildnisse der Brücke-Künstler von einander,* Stuttgart, 1961.

F. CONSTRUCTIVISM

Biederman, C. *Art as the Evolution of Visual Knowledge.* Red Wing, Minn., 1948.

Kasimir Malevich, 1878–1935. Kleinere Werkgruppen von Pouguy, Lissitzky, und Mansourov aus den Jahren des Suprematismus. Bern, Kunsthalle, 1959 Exhibition catalogue.

Konkrete Kunst. 50 Fahre Entwicklung. Zürich, Kunstgesellschaft, 1960. Exhibition catalogue by M. Steber.

Konstruktive Kunst. Elemente und Prinzipien. 2 vols. Nuremberg, Kunsthalle und Institut für moderne Kunst, 1969.

Lewison, J. (ed.) *Circle: Constructive art in Britain 1934–40.* Cambridge, Kettle's Yard Gallery, 1982.

Lodder, C. *Russian Constructivism.* New Haven and London, 1983.

Martin, J. L., Nicholson, B., and Gabo, N., eds. *Circle. International Survey of Constructive Art.* London, 1937.

Rickey, G. *Constructivism. Origins and Evolution.* New York, 1967.

Rotzler, W. *Constructive Concepts. A History of Constructive Art from Cubism to the Present.* New York, 1977.

Rotzler, W. *Constructivism and the Geometric Tradition: Selections from the McCrory Corporation Collection.* Buffalo, Albright-Knox Art Gallery, 1979.

Rowell, M. *The Planar Dimension. Europe 1912–1932.* New York, 1979.

Sabroe, C. (ed.) *ICSAC. CAHIER 5.* Constructivism in Denmark, Finland and Sweden. Brussels, 1986.

G. CUBISM

Cooper, D. *The Cubist Epoch.* New York, 1971.

Cooper, D., and Tinterow, G. *The Essential Cubism.* London, Tate Gallery, 1983.

Le Cubisme (1907–1914). Paris, Musée National d'Art Moderne, 1953.

Douglas Cooper and the Masters of Cubism. London, Tate Gallery, 1987.

Faucherau, S. *La Revolution Cubiste.* Paris, 1982.

Fry, E. *Cubism.* New York, 1966.

Golding, J. *Cubism: A History and an Analysis, 1907–1914.* New and rev. ed. London, 1968.

Green, C. *Cubism and its Enemies.* New Haven and London, 1987.

Rosenblum, R. *Cubism and Twentieth-Century Art.* Rev. ed. New York, 1976.

Rubin, W. *Picasso and Braque. Pioneering Cubism.* New York, 1989.

West, R. V. *Painters of the Section d'Or, the Alternatives for Cubism.* Buffalo, Albright-Knox Art Gallery, 1967.

Wolfram, E. *History of Collage. An Anthology of Collage, Assemblages, and Event Structures.* London, 1975.

Zemina, J. *Cubist Art from Czechoslovakia.* London, Tate Gallery, 1967.

H. DADA

Ades, D., *et al. Dada and Surrealism Reviewed.* London, Arts Council, 1978.

Dachy, M. *The Dada Movement 1915–1923.* New York, 1990.

Dada. Ausstellung zum 50-jährigen Jubiläum . . . Exposition commemorative du cinquantenair. 2 vols. Zürich, Kunsthaus, 1966.

Foster, S. C. (ed.) *Dada Dimensions.* Michigan, 1985.

Foster, S. C. and Kuenzli, R. E. (eds.) *Dada Spectrum: TheDialectics of Revolt.* Iowa, 1979.

Mehring, W. *Berlin Dada. Eine Chronik mit Photos und Dokumenten.* Zürich, 1959.

Motherwell, R., ed. *The Dada Painters and Poets: an Anthology.* Rev. ed. New York, 1982.

Neff, T. A. R. (ed.) *In The Mind's Eye: Dada and Surrealism.* New York, 1984.

Poupard-Lieussou and Sanouillet, M. *Documents Dada.* Paris, 1974.

Prosene, M. *Die Dadaisten in Zürich.* Bonn, 1967.

Richter, H. *Dada. Art and Anti-Art.* New York, 1965.

Rubin, H. *Dada, Surrealism, and Their Heritage.* New York, Museum of Modern Art, 1968.

Sanouillet, M. *Dada à Paris.* Paris, 1965.

Schippers, K. *Holland Dada.* Amsterdam, 1974.

I. 'ENTARTETE' KUNST ('DEGENERATE' ART)

Barron, S. *'Entartete Kunst'. Das Schicksal der Avantgarde im Nazi-Deutschland.* Los Angeles and Munich, 1991.

Brenner, H. *Die Kunstpolitik des Nationalsozialismus.* Reinbek-bei-Hamburg, 1963.

Dresler, A., ed. *Deutsche Kunst und entartete 'Kunst'. Kunstwerk und Zerrbild als Spiegel der Weltanschauung.* Munich, 1938.

With illustrations from the exhibition of 1937.

Haftmann, W. *Banned and persecuted: dictatorship of art under Hitler.* Cologne, 1986.

Rave, P. O. *Kunstdiktatur im Dritten Reich.* Rev. ed. Hamburg, 1949.

Roh, F. *'Entartete' Kunst. Kunstbarbarei im Dritten Reich.* Hanover, 1962.

J. EXPRESSIONISM

Barron, S. *German Expressionist Sculpture.* Los Angeles, 1984.

——. (eds.) *German Expressionism 1915–1925. The Second Generation.* Los Angeles, 1988.

———., et al. German Expressionist Prints and Drawings. Vol. 1: Essays. Vol. 2: Catalogue of the Robert Gore Rifkind Collection. Los Angeles, 1989.

Behr, S. Women Expressionists. Oxford, 1988.

Dube, W-D. The Expressionists. London, 1972.

Dube, W-D. Expressionists and Expressionism. Geneva, 1983.

Expressionism. A German Intuition. 1905–1920. New York, Guggenheim Museum, 1980.

L'Expressionisme en Allemagne. Paris, Musée d'Art Moderne, 1993.

Le Fauvisme français et les débuts de l'expressionnisme allemand. Der französische Fauvismus und der deutsche Frühexpressionismus. Paris, Musée National de l'Art Moderne, and Munich, Haus der Kunst, 1966.

Gordon, D. E. Expressionism. Art and Idea. New Haven and London, 1987.

Lloyd, J. German Expressionism. Primitivism and Modernity. New Haven and London, 1991.

Myers, B. S. The German Expressionists. A Generation in Revolt. New York, 1957; concise ed., 1963.

Neuerburg, W. Der graphische Zyklus in deutschen Expressionismus und seine Typen, 1905–1925. 2 vols. Bonn, 1976.

Perkins, G. C. Expressionismus. Eine Bibliographie zeitgenössischer Dokumente, 1910–1925. Zürich, 1971.

Schulz, B. et al. Expressionisme à Berlin 1910–1920. Brussels, 1984.

Selz, P. German Expressionist Painting. Berkeley, Calif., 1957.

Spalek, J., et al., eds. German Expressionism in the Fine Arts, a Bibliography. Los Angeles, 1977.

Whitford, F. Expressionist Portraits. London, 1987.

K. FAUVISM

Crespelle, J. P. The Fauves. Greenwich, Conn., 1962.

Diehl, G. The Fauves. New York, 1975.

Elderfield, J. The 'Wild Beasts'. Fauvism and Its Affinities. New York, Museum of Modern Art, 1976.

Le Fauvisme français et les débuts de l'expressionnisme allemand. Der französische Fauvismus und der deutsche Frühexpressionismus. Paris, Musée National d'Art Moderne, and Munich, Haus der Kunst, 1966.

Freeman, J., et al. The Fauve Landscape. Los Angeles and New York, 1990.

Giry, M. Fauvism Origins and Development. New York, 1982.

Herbert, J. D. Fauve Painting. The Making of Cultural Politics. New Haven and London, 1992.

Laude, J. La Peinture française (1908–1914) et 'l'art nègre'. Contribution à l'étude des sources du fauvisme et du cubisme. 2 vols. Paris, 1968.

Leymarie, J. Fauvism. Biographical and Critical Study. New York, 1959.

Muller, J. E. Fauvism. New York, 1967.

L. FUTURISM

Andreoli-de Villers, J. P. Futurism and the Arts, a Bibliography, 1959–73. Toronto and Buffalo, 1975.

Apollonio, U., ed. Futurist Manifestoes. New York, 1973.

Drudi Gambillo, M., and Fiori, T., eds. Archiva del Futurismo. 2 vols. Rome, 1958–62.

Falqui, E. Bibliografia e iconografia del Futurismo. Florence, 1959.

Flint, R. W. (ed.) Marinetti. Selected Writings. London, 1972.

Futurism and the International Avant-garde. Philadelphia Museum of Art, 1980.

Hulten, P. (ed.) Futurismo & Futurismi. Milan, 1986.

Lista, G. Futurisme. Manifestoes, proclamations, documents. Lausanne, 1973.

Mantura, B., et al. Futurism in Flight. Rome, 1990.

Martin, M. W. Futurist Art and Theory 1909–1915. Oxford, 1968.

Marinetti, F. T. Teoria e invenzione futurista. Milan, 1968.

Taylor, J. C. Futurism. New York, 1961.

M. THE NABIS

Autour de la Revue Blanche. Paris, Galerie Maeght, 1966.

Bonnard, Vuillard, et les Nabis, 1888–1903. Paris, Musée National d'Art Moderne, 1955.

Frèches-Thory, C., and Terrasse, A. The Nabis. Paris, 1990.

Hermann, F. Die Revue Blanche, und die Nabis. 2 vols. Munich, 1959.

Die Nabis und ihre Freunde. Mannheim, Kunsthalle, 1963–4.

Perucchi-Petri, U. Die Nabis und Japan. Das Frühwerk von Bonnard, Vuillard und Denis. Munich, 1976.

Pont-Aven und die Nabis. Munich, Galleria del Levanto, 1966–7.

N. NAÏVE (POPULAR) ART

L'Art brut préféré aux arts culturels. Paris, Galerie René Drouin, 1949.

Bihalji-Merin, O. World Encyclopedia of Naïve Art. London, 1984.

Cardinal, R. Outsiders. An art without precedent or tradition. London, Arts Council, 1979.

Grochowiak, T. Deutsche naive Kunst. Recklinghausen, 1976.

In Another World. Outsider Art from Europe &
America. London, South Bank Centre, 1987.
Jakovsky, A. *Peintres Naïfs. Lexicon of the World's*
Naïve Painters . . . Paris, 1976.
Masters of Popular Painting. Modern Primitives of
Europe and America. New York, Museum of Modern
Art, 1938.
Le Monde des naïfs. Paris, Musée National d'Art
Moderne, 1964.
Das naïve Bild der Welt. Peinture naïve du monde.
Baden, Staatliche Kunsthalle, 1961.
Williams, S. *Britain's First International Exhibition of*
Naïve Art. London, Hamilton's Gallery, 1979.

O. NEO-IMPRESSIONISM
Benedetti, M. T. *Divisionismo Romano.* Rome, 1989.
Cachin, F., *et al. Exposition du Pointillisme.* Tokyo,
National Museum of Western Art, 1985.
Fénéon, F. *Œuvres.* Paris, 1948.
Herbert, R. L. *Neo-Impressionism.* New York, Gug-
genheim Museum, 1968.
Lee, E. W., *et al. Neo-Impressionisten: Seurat tot*
Struycken. Zwolle, 1988. *1893: Painters of Europe.*
Paris, Musée d'Orsay, 1993.
Rewald, J. *Post-Impressionism from Van Gogh to*
Gauguin. 2nd ed. New York, 1962.
Sutter, J., and others. *Les Néo-Impressionnistes.* Paris
and Neuchâtel, 1970.

P. DE STIJL
Blotkamp, C. *De Stijl: the formative years 1917–1922.*
Cambridge (Mass.) 1986.
Doesburg, T. van. *De nieuwe Beweging in de Schilder-*
kunst. Delft, 1917.
Jaffé, H. L. C. *De Stijl, 1917–1931. The Dutch*
Contribution to Modern Art. Amsterdam, 1956.
Jaffé, H. L. C., ed. *De Stijl. Extracts from the*
Magazine. London, 1970.
Lemoine, S. *Mondrian and De Stijl.* Paris, 1987.
Mondrian, De Stijl, and Their Impact. New York,
Marlborough-Gerson Gallery, 1964.
Overy, P. *De Stijl.* London, 1969.
Overy, P., *et al. The Reitveld Schröder House.* London,
1988.
Rietveld Furniture and the Schröder House. London,
South Bank Centre, 1990.
De Stijl. Amsterdam, Stedelijk Museum, 1951.
De Stijl. Delft, Leiden, and Meudon, 1917–32.
Complete reprint, 2 vols., Amsterdam, 1968.
De Stijl 1917–1931. Visions of Utopia. Minneapolis,
Walker Art Center, 1982.
Troy, N. J. *The De Stijl Environment.* Cambridge,
Mass., 1983.

Q. DER STURM
Brühl, G. *Herwarth Walden und 'Der Sturm'.* Col-
ogne, 1983.
Schweiger, W. J. *Oskar Kokoschka: Der Sturm die*
Berliner Jahre 1910–1916: eine Dokumentation.
Munich, 1986.
Der Sturm. Dokumente, Graphik, Bilder, Plastiken.
Zürich, Kunstgewerbemuseum, 1955.
Der Sturm. Herwarth Walden und die Europäische
Avantgarde. Berlin 1912–1932. Berlin, National-
galerie, 1961.
Walden, N. *Herwarth Walden. Ein Lebensbild.* Berlin,
1963.
Walden, N., and Schreyer, L. *Der Sturm. Ein*
Erinnerungsbuch an Herwarth Walden und die
Künstler aus dem Sturmkreis. Baden-Baden, 1954.

R. SURREALISM
Ades, D. *Dada and Surrealism Reviewed.* London,
Arts Council, 1978.
L'Amour Fou. Photography & Surrealism. London,
Arts Council, 1986.
Biro, A. *Dictionnaire général du Surréalisme et de ses*
environs. Fribourg, 1982.
Breton, A. *What is Surrealism? Selected Writings.* New
York, 1978.
Carrouges, M. *André Breton et les données fondamen-*
tales du surréalisme. 6th ed. Paris, 1950.
Chadwick, H. W. *Myth in Surrealist Painting.* Ann
Arbor, Mich., 1980.
Chadwick, W. *Women Artists and the Surrealist*
Movement. London, 1985.
Finkelstein, H. N. *Surrealism and the Crisis of the*
Object. Michigan, 1979.
Gershman, H. S. *A Bibliography of the Surrealist*
Revolution in France. Ann Arbor, 1969.
Jean, M. *The Autobiography of Surrealism.* New York,
1980.
Kellerer, C. *Objet trouvé und Surrealismus. Zur*
Psychologie der Modernen Kunst. Reinbek-bei-Ham-
burg, 1968.
Matthews, J. H. *The Imagery of Surrealism.* Syracuse,
N.Y., 1977.
——. *The Surrealist Mind.* London and Toronto,
1991.
Passeron, R. *Phaidon Encyclopedia of Surrealism.*
Oxford, 1978.
Ray, P. C. *The Surrealist Movement in England.* Ithaca
and London, 1971.
Robertson, A., *et al. Surrealism in Britain in the*
Thirties. Leeds, 1986.
Rosemont, F. *André Breton and the First Principles of*
Surrealism. London, 1978.

Rubin, W. S. *Dada and Surrealist Art*. London, 1969.
Vovelle, J. *Le Surréalisme en Belgique*. Brussels, 1972.

S. SYMBOLIST ART

Carluccio, L. *Du Symbole à l'expression. XIXe et XXe siècle, 1840–1920*. Geneva, 1974.
Damigella, A. M. *La Pittura simbolista in Italia, 1885–1900*. Turin, 1981.
Delevoy, R. L. *Symbolists and Symbolism*. New York, 1978.
French Symbolist Painters. Moreau, Puvis de Chavannes, Redon and Their Followers. London, Arts Council, 1972.
Gibson, M. *The Symbolists*. New York, 1984.
Goldwater, R. *Symbolism*. London, 1979.
Jullian, P. *The Symbolists*. London, 1973.
Kosinski, D. M. *Orpheus in nineteenth-century symbolism*. Ann Arbor, 1989.
Lucie-Smith, E. *Symbolist Art*. London, 1972.
Mellerio, A. *Le Mouvement idéaliste en peinture*. Paris, 1896.
Pierre, J., et al. *Simbolismo en Europa: Néstor en las Hespérides*. Las Palmas, 1990.
Rewald, J. *Post-Impressionism from Van Gogh to Gauguin*. 2nd ed. New York, 1962.
Rookmaaker, H. R. *Gauguin and 19th-Century Art Theory*. Amsterdam, 1972.
Le Symbolisme en Europe. Paris, Grand Palais, 1976.

T. VORTICISM

Cork, R. *Vorticism and Abstract Art in the First Machine Age*. 2 vols. London, 1976.
Vorticism and its Allies. London, Arts Council, 1974.

III. INDIVIDUAL COUNTRIES

A. AUSTRIA

Breicha, O., and Fritsch, G. *Finale und Auftakt. Wien 1898–1914. Literatur, bildende Kunst, Musik*. Salzburg, 1964.
Clair, J. *Vienne 1880–1938. L'Apocalypse Joyeuse*. Paris, 1986.
Entwicklung der österreichischen Kunst von 1897 bis 1938. Malerei, Plastik, Zeichnungen. Vienna, Akademie der bildenden Künste, 1948.
Hofmann, W. *Modern Painting in Austria*. Vienna, 1965.
Hofrat, H. A. *Biedermeier, Historismus, Secession 1830–1918*. Vienna, 1987.
Kallir, J. *Austria's Expressionism*. New York, Galerie St Etienne, 1981.
Sotriffer, K. *Modern Austrian Art*. New York, 1965.

Varnedoe, K. *Vienna 1900: Art, Architecture, and Design*. New York, 1986.
Vergo, P. *Art in Vienna 1898–1918. Klimt, Kokoschka, Schiele and their Contemporaries*. London, 1975.
Waissenberger, R. *Die Wiener Secession. Eine Dokumentation*. Vienna, 1971.
Waissenberger, R. *Wien, 1870–1930. Traum und Wirklichkeit*. Vienna, 1984.
Wien um 1900. Vienna, Kulturamt der Stadt Wien, 1964.

B BELGIUM

Autour de 1900: L'Art belge (1884–1918). London, Arts Council, 1965.
Belgian Art, 1880–1914. New York, Brooklyn Museum, 1980.
Belgische Malerei seit 1900. Vienna, Museum des 20. Jahrhunderts, 1962.
Colin, P. *La Peinture belge depuis 1830*. Brussels, 1930.
De Boeck, Joostens, Servranckx. *Pioneers of Abstract Painting in Belgium, 1915–30*. London, Annely Juda Fine Art, 1973.
Haesaerts, P. *Histoire de la peinture moderne en Flandre*. Brussels, 1959.
Haesaerts, P. *Laethem-St-Martin*. Brussels, 1965.
Langui, E. *L'Expressionnisme en Belgique*. Brussels, 1970.
Legrand, F.-C. *Le Symbolisme en Belgique*. Brussels, 1971.
Meewis, W., et al. *Obsessionen und Geschichte – Kunst aus Flandern*. Berlin, 1985.
Mössinger, I., et al. *Pastelle und Zeichnungen des Belgischen Symbolismus*. Frankfurt, 1988.
Oostens-Wittamer, Y. *La Belle Epoque. Belgian Posters, Watercolours and Drawings*. Washington, 1970.
Polden, S. *A clear view: the Belgian Luminist tradition*. London, 1987.
Quelques Artistes belges depuis Ensor. Brussels, Palais des Beaux-Arts, 1958.
Schoonbaert, L. M. A. *L'Identité Flamande dans la peinture moderne*. Lyon, Musée des Beaux-Arts, 1980.
Seuphor, M. *Abstract Painting in Flanders*. Brussels, 1963.
Vanbeselaere, W. *Ensor to Permeke. Nine Flemish Painters 1880–1950*. London, Royal Academy, 1971.
Vovelle, J. *Le Surréalisme en Belgique*. Brussels, 1972.
Werkijkheid en Verbeelding. Belgische Surrealisten. Arnhem, Gemeentemuseum, 1964.

C. FRANCE

Abadie, D., et al. *Paris-Paris. Création en France*. Paris, Centre Georges Pompidou, 1981.
Bouillon, J-P. *Art Deco 1903–1940*. Geneva, 1989.

Cousseau, H-C. *Colour since Matisse: French painting in the twentieth century*. Edinburgh, 1985.

Cowling, E., and Mundy, J. *On Classic Ground. Picasso, Léger, de Chirico and the New Classicism 1910–1930*. London, Tate Gallery, 1990.

Dorival, B. *Les Étapes de la peinture français contemporaine*, 3 vols. Paris, 1948.

Dorival, B. *Twentieth-Century Painters*. 2 vols. New York, 1958.

French Paintings Since 1900. London, Royal Academy, 1969.

German, M. I., comp. *Art of the October Revolution*. New York, 1979.

Hautecoeur, L. *Littérature et peinture en France du XVIIe au XXe siècle*, 2nd ed. Paris, 1963.

Jeffrey, I., *et al*. *La France. Images of Woman and Ideas of Nation 1789–1989*. London, South Bank Centre, 1989.

Johnson, D. *The Age of Illusion: art and politics in France 1918–1940*. London, 1987.

Kunstler, C. *La Sculpture contemporaine, La Sculpture français, 1900–1960*. Paris, 1961.

Lethéve, J. *De 1870 à 1914, des Impressionistes aux Cubistes*. Paris, 1967.

Marchiori, G. *Modern French Sculpture*. New York, 1963.

Martin, J-H., *et al*. *Paris – Moscou, 1900–1930*. Paris, Centre Pompidou, 1979.

Milner, J. *The Studios of Paris*. New Haven and London, 1988.

Paris – Berlin, 1900–1933. Paris, Centre Pompidou, 1978.

Restany, P., *et al*. *Paris – New York*. Paris, Centre Pompidou, 1977.

San Lazzaro, G. di. *Painting in France, 1895–1949*. New York, 1949.

Sérullaz, M. *Peintres maudits*. Paris, 1968.

Silver, K. *Esprit de Corps. The Art of the Parisian Avant-Garde and the First World War, 1914–1925*. London, 1989.

Warnod, J. *Les artistes de Montparnasse: La Ruche*. Paris, 1988.

D. GERMANY

Carey, F., and Griffiths, A. *The Print in Germany 1880–1933. The Age of Expressionism*. London, 1984.

Chapple, G., and Schulte, H. H. *The Turn of the Century. 1890–1915*. Bonn, 1981.

Eberle, M. *World War I and the Weimar Artists*. New Haven and London, 1985.

Grote, L. *Deutsche Kunst im zwanzigsten Jahrhundert*. 2nd enl. ed. Munich, 1954.

Grosshaus, H. *Hitler and the Artists*. New York, 1983.

Grzimek, W. *Deutsche Bildhauer des zwanzigsten Jahrhunderts. Leben, Schulen, Wirkungen*. Munich, 1969.

Hess, H., *et al*. *Art in Germany 1909–1936. From Expressionism to Resistance*. Munich, 1990.

Hinz, B. *Art in the Third Reich*. New York, 1979.

Ich und die Stadt. Mensch und Gross-stadt in der Deutschen Kunst des 20. Jahrhunderts. Berlin, Berlinische Galerie, 1987.

Joachimides, C. M., Rosenthal, N., and Schmied, W. (eds.) *German Art in the 20th Century*. London and Munich, 1985.

Kolb, E., *et al*. *Prints and Drawings of the Weimar Republic*. Stuttgart, 1987.

Makela, M. *The Munich Secession*. Princeton, 1990.

Neue Sachlichkeit and German Realism of the Twenties. London, Arts Council, 1978.

Paret, P. *The Berlin Secession. Modernism and its Enemies in Imperial Germany*. Cambridge, Mass., and London, 1980.

Roh, F. *German Art in the 20th Century*. Greenwich, Conn., 1968.

Schmidt, G. *Die Malerei des 20. Jahrhunderts in Deutschland, 1918–1955*. Königstein im Taunus, 1969.

Schrader, B., and Schebera, J. *The "Golden" Twenties. Art and Literature in the Weimar Republic*. New Haven and London, 1988.

Schrifttum zur deutschen Kunst des 20. Jahrhunderts. 2nd ed. Cologne, 1960. Bibliographies, in progress.

Wietek, G. *Deutsche Künstlerkolonien und Künstlerorten*. Munich, 1976.

Willett, J. *The New Society, 1917–1933. Art and Politics in the Weimar Period*. London, 1978.

Willett, J. *The Weimar Years. A Culture Cut Short*. London, 1984.

E. GREAT BRITAIN

Beattie, S. *The New Sculpture*. New Haven and London, 1983.

Bowness, A. *Contemporary British Painting*. London, 1968.

British Art. Decade 1890–1900. London, Arts Council, 1967.

British Art and the Modern Movement, 1930–40. Cardiff. National Museum of Wales, 1962.

British Contemporary Art 1910–1990. Eighty Years of Collecting by the Contemporary Art Society. London, 1991.

Carey, F., and Griffiths, A. *Avant-Garde British Printmaking 1914–1960.* London, British Museum, 1990.

Christian, J. (ed.) *The Last Romantics. The Romantic Tradition in British Art from Burne-Jones to Stanley Spencer.* London, 1989.

Collins, J. *The Omega Workshops.* London, 1983.

Cork, R. *Art Beyond the Gallery in Early 20th-Century England.* New Haven and London, 1985.

Cork, R. *Vorticism and Abstract Art in the First Machine Age.* 2 vols. London, 1976.

Farmar, F. *The Painters of Camden Town 1905–1920.* London, 1988.

Farr, D. *English Art 1870–1940.* Oxford, 1978.

Ford, B. (ed.) *The Cambridge Guide to the Arts in Britain. Vol. 8. The Edwardian Age and the Inter-War Years.* Cambridge, 1989.

Fox, C., and Greenacre, F. *Painting in Newlyn 1880–1930.* London, 1985.

Hammacher, A. M. *Modern English Sculpture.* New York, 1968.

Harrison, C. *English Art and Modernism, 1900–1939.* London and Bloomington, 1981.

Hartley, K. *Scottish Art since 1900.* London, 1989.

The Modern British Paintings, Drawings, and Sculpture. 2 vols. London, Tate Gallery, 1964–5.

Nairne, S., and Serota, N. (eds.) *British Sculpture in the 20th Century.* London, Whitechapel Art Gallery, 1981.

Rothenstein, J. *British Art since 1900. An Anthology.* London, 1962.

Spalding, F. *British Art Since 1900.* London, 1986.

Thirties. British art and design before the war. London, Arts Council, 1979.

Watney, S. *English Post-Impressionism.* London, 1980.

F. ITALY

Bairati, E., Bottaglia, R., and Rosci, M. *L'Italia Liberty. Arredamento e arti decorative.* Milan, 1973.

Ballo, G. *La Linea dell' arte italiana dal simbolismo alle opere moltiplicate.* 2 vols. Rome, 1964.

Ballo, G. *Modern Italian Painting from Futurism to the Present Day.* New York, 1958.

Braun, E. (ed.) *Italian Art in the Twentieth Century.* London and Munich, 1989.

Broude, N. *The Macchiaioli. Italian Painters of the Nineteenth Century* New Haven and London, 1987.

Bucarelli, P. *Scultori italiani contemporanei.* Milan, 1967.

Carrieri, R. *Avant-garde Painting and Sculpture (1890–1955) in Italy.* Milan, 1955.

Cento anni d'arte italiana moderna 1880–1980. Tokyo, Mainichi Shimbun, 1982.

Comanducci, A. M. *Dizionario illustrato dei pittori, disegnatori e incisori moderni e contemporanei . . .* 4th ed. 5 vols. Milan, 1970–4.

Fagioli dell' Arco, M. *Arte astratta italiana, dal Futurismo agli anni Trenta.* Rome, 1986.

Fiori, T., and Bellonzi, F. *Archivi del divisionismo.* 2 vols. Rome, 1968.

Hulten, P., and Celant, G. (eds.) *Italian Art 1900–1945.* Venice, 1989.

Marchiori, G. *Arte e artisti d'avanguardia in Italia (1910–1950).* Milan, 1960.

Mazzariol, G. *Pittura italiana contemporanea.* Bergamo, 1958.

La Poétique des peintres italiens à l'aube du XXe siécle. Brussels, Musée d'Ixelles, 1990.

Salvini, R. *Modern Italian Sculpture.* New York, 1962.

Schulz-Hofmann, C. *Mythos Italien, Wintermärchen Deutschland.* Munich, 1988.

Tallarico, L. *Avanguardia e tradizione da Boccioni a Burri.* Rome, 1981.

Weiermair, P., et al. *Italienische Kunst 1900–1985.* Frankfurt, Kunstverein, 1985.

G. THE NETHERLANDS

Blotkamp, C. *Symbolismus in den Niederlanden: van Toorop bis Mondrian.* Kassel, 1991.

Fierens, P. *L'Art hollandais contemporain.* Paris, 1933.

Gelder, H. E. van, and Duverger, J., eds. *Kunstgeschiedenis der Nederlanden.* 2 vols. Utrecht, 1954–5.

Hammacher, A. M. *Amsterdamsche Impressionisten en hun Kring.* Amsterdam, 1941.

Huebner, F. M. *Die neue Malerei in Holland.* Leipzig, 1921.

Loosjes-Terpstra, A. B. *Moderne Kunst in Nederland, 1900–1914.* Utrecht, 1959.

Pieters, D., et al. *Amsterdam art.* Paris, 1988.

Schippers, K. *Holland Dada.* Amsterdam, 1974.

Van Gogh bis Cobra: Holländische Malerei 1880–1950. Stuttgart, Kunstverein, 1981.

Welling, D. *The Expressionists. The Art of Prewar Expressionism in the Netherlands.* Amsterdam, 1968.

H. RUSSIA—U.S.S.R.

Art Into Production: Soviet Textiles, Fashion and Ceramics 1917–1938. Oxford, Museum of Modern Art, 1984.

Avantgarde Osteuropa 1910–1930. Berlin, Deutsche Gesellschaft für Bildende Kunst, 1967.

Bird, Alan. *A History of Russian Painting.* Oxford, 1987.

Bowlt, J. E., ed. and transl. *Russian Art of the Avant-Garde. Theory and Criticism. 1902–1934.* New York, 1976.

Elliott, D. *New Worlds. Russian Art and Society 1900–1937*. London, 1986.

Grabar, I. E., and others. *Istoriia russkogo iskusstva*. Vols. X–XI. Moscow.

Gray, C. *The Great Experiment: Russian Art 1863–1922*. London, 1962.

Kean, B. W. *All The Empty Palaces. The Merchant Patrons of Modern Art in Pre-Revolutionary Russia*. London, 1983.

Kunst in der Revolution . . . Frankfurt, Kunstverein, 1972.

100 Years of Russian Art 1889–1989. London, 1989.

Rudenstine, A. Z., ed. *Russian Avant-garde Art. The George Costakis Collection*. New York, 1981.

Russian and Soviet Paintings 1900–1930. Washington, Hirshhorn Museum, 1988.

Soviet Art 1920s–1930s. Harmondsworth, 1988.

Sternin, G. Yu. *Das Kunstleben Russlands an der Wende von neunzehnten zum zwanzigsten Jahrhundert*. Dresden, 1976.

Tatlin's Dream. Russian Suprematist and Constructivist Art 1910–1923. London, Fisher Fine Art, 1973.

The Twilight of the Tsars. Russian Art at the Turn of the Century. London, South Bank Centre, 1991.

Two Decades of Experiments in Russian Art, 1902–1922. London, Grosvenor Gallery, 1962.

Yablonskaya, M. N. *Women Artists of Russia's New Age 1900–1935*. London, 1990.

I. SCANDINAVIA

Askeland, J. *Norsk malerkunst*. Oslo, 1981.

Bodelsen, M., and Marcus, A. *Dansk kunsthistorisk Bibliografi*. Copenhagen, 1935.

Dreams of a Summer Night. Scandinavian Painting at the Turn of the Century. London, Arts Council, 1986.

Faucherau, S., *et al. Scandinavian Modernism. Painting in Denmark, Finland, Iceland, Norway and Sweden 1910–1920*. New York, 1989.

Katalog over norsk Malerkunst. Oslo, 1950. Norwegian paintings in the Nasjonalgalleriet, Oslo.

Lindblom, A. *Sveriges Konsthistoria från Forntid till Nutid*. 3 vols. Stockholm, 1944–6.

Lundqvist, M. *Svensk konsthistorisk Bibliografi*. Stockholm, 1967.

Nergaard, T., *et al. Per Krohg 1889–1965. Bilder 1910–1930*. Oslo, 1989.

Østby, L. *Modern Norwegian Painting*. Oslo, 1949.

Poulsen, V. *Danish Painting and Sculpture*. Copenhagen, 1955.

Poulsen, V., *et al. Dansk Kunsthistorie. Billedkunst og skulptur*, IV–V. Copenhagen, 1974–5.

Särnstedt, B., *et al. GAN. Gösta Adrian-Nilsson 1884–1965*. Stockholm, 1984.

Söderberg, R. *Introduction to Modern Swedish Art*. Stockholm, Moderna Museet, 1962.

Zahle, E., ed. *Danmarks Malerkunst fra middlelalder til nutid*. Copenhagen, 1937.

Zilbrandsten, J. *Moderne dansk Malerei*. 2nd rev. ed. Copenhagen, 1967.

J. SWITZERLAND

L'Art moderne suisse de Hodler à Klee. Paris, Musée National d'Art Moderne, 1960.

From Hodler to Klee. Swiss Art of the Twentieth Century. Paintings and Sculptures. London, Tate Gallery, 1959.

Joray, M. *La Sculpture moderne en Suisse*. 3 vols. Neuchâtel, 1955–67.

Neue Kunst in der Schweiz zu Beginn unseres Jahrhundert. Zürich, Kunsthaus, 1967.

Osten, G. von der. *Plastik des 20. Jahrhunderts in Deutschland, Österreich und der Schweiz*. Königstein im Taunus, 1962.

Reinle, A. *Kunstgeschichte der Schweiz*. 2nd ed. Frauenfeld, 1968.

IV. INDIVIDUAL ARTISTS

ALBERS

Albers, J. *Interaction of Color*. New Haven, Conn., 1975.

Alviani, G. (ed.) *Josef Albers*. Milan, 1988.

Benezra, N. D. *The murals and sculpture of Josef Albers*. London, 1985.

Bucher, F. *Josef Albers: Despite Straight Lines. An Analysis of His Graphic Constructions*. New Haven, 1961.

Gomringer, E., ed. *Josef Albers. His Works as Contribution to Visual Articulation in the 29th Century*. New York, 1968.

Weber, N. F. *The Drawings of Josef Albers*. New York, 1984.

AMIET

Bauer, A. *Cuno Amiet zur Vollendung seines fünfundsiebzigsten Lebensjahres*. Basel, 1943.

Cuno Amiet (1868–1961). Pont-Aven, Musée de Pont-Aven, 1982.

Cuno Amiet und die Maler der Brücke. Zürich, Kunsthaus, 1979.

ARCHIPENKO

Alexander Archipenko. A Memorial Exhibition. Los Angeles, University of California, 1967.

Archipenko, A. and others. *Archipenko. Fifty Creative Years, 1908–1958*. New York, 1960.

Karshan, D. H. *Archipenko. The Sculpture and Graphic Art, including a Print Catalogue.* Boulder, Colo., 1975.

Karshan, D. *Archipenko: the early works 1910–1921.* Tel Aviv: the Museum, 1981.

——. *Archipenko: sculpture, drawings and prints 1908–1963.* Danville, 1985.

Pontiggia, E. *Alexander Archipenko: l'arte e l'universo.* Montebelluna, 1988.

ARP

Arntz, W. F. *Hans (Jean) Arp. Das graphische Werk, 1912–1966.* The Hague, 1980.

Faucherau, S. *Arp.* London, 1989.

Giedion-Welcker, C. *Jean Arp.* New York, 1957.

Jean Arp, Sculpture. His Last Ten Years. New York, 1968.

Jean, M., ed. *Arp on Arp. Poems, Essays, Memories, by Jean Arp.* New York, 1972.

*Rau, B. *Jean Arp. The Reliefs. Catalogue of the Complete Works.* New York, 1981.

Read, H. *The Art of Jean Arp.* New York, 1968.

Trier, E. *Hans Arp.* Bonn, 1985.

BALLA

Baldacci, P. *Ricostruzione di casa Balla.* Milan, 1986.

Balla, E. *Con Balla.* Milan, 1984.

Balla. Paris, Musée d'Art Moderne de la Villa de Paris, 1972.

Crispolti, E. *Il Futurismo e la moda: Balla e gli altri.* Venice, 1986.

Fagiolo dell'Arco. M. *Compenetrazioni, iridescenti.* Rome, 1968.

Fagiolo, M. *Balla the Futurist.* Milan and Oxford, 1987.

Giacomo Balla (1871–1958). Rome, Galleria Nazionale d'Arte Moderna, 1971.

Lista, G. *Balla.* Modena, 1982.

Robinson, S. B. *Giacomo Balla. Divisionism and Futurism, 1871–1912.* Ann Arbor, 1981.

Rola, S. K. de. *Balla.* London, 1983.

BALTHUS

Balthus. London, Tate Gallery, 1968.

Balthus. New York, Metropolitan Museum of Art, 1984.

Balthus. Paris, Musée National d'Art Moderne, 1983.

Carandente, G. *Balthus: drawings and watercolours.* London, 1983.

Leymarie, J. *Balthus.* New York, 1979.

BARLACH

Barlach, E. *Ein selbsterzähltes Leben.* Munich, 1948.

Barlach, E. *Güstrower Tagebuch 1914–1917.* Munich, 1984.

Ernst Barlach. Plastik, Zeichnungen, Druckgraphik. Cologne, Kunsthalle, 1974.

Ernst Barlach. 2 Vols. Berlin, Altes Museum, 1981.

Franck, H. *Ernst Barlach. Leben und Werk.* Stuttgart, 1961.

Kräubig, J. *Ernst Barlach, Lithographien, Holzschnitte.* Stuttgart, 1989.

Jansen, E. *Ernst Barlach: Werke, Meinungen.* Vienna, 1984.

Piper, E. *Ernst Barlach und die nationalsozialistische Kunstpolitik. Eine Dokumentarische Darstellung zur 'Entartete Kunst'.* Munich, 1983.

*Schult, F. *Ernst Barlach.* 2 vols. Hamburg, 1958–60.

BAUCHANT

Gauthier, M. *André Bauchant.* Paris, 1943.

Uhde, W. *Five Primitive Masters.* New York, 1949.

BAUMEISTER

Grohmann, W. *Willi Baumeister. Life and Work.* New York, 1965.

Waldegg, J. H. von. *Willi Baumeister: Montaru III, 1953.* Mannheim, 1980.

Westecker, D. *Baumeister: Freunde und Schüler.* Düsseldorf, 1990.

Willi Baumeister 1945–1955. Stuttgart, Württembergischer Kunstverein, 1979.

BAYER

Dorner, A. *The Way beyond 'Art'. The Work of Herbert Bayer.* New York, 1947.

Herbert Bayer. Painter, Designer, Architect. London, 1967.

BEARDSLEY

Aubrey Beardsley. London, Victoria and Albert Museum, 1966.

Fletcher, I. *Aubrey Beardsley.* Boston, 1987.

Gillon, E. V. Jr. (ed.) *Beardsley's Illustrations for Le Morte Darthur.* New York, 1972.

Heyd, M. *Aubrey Beardsley: symbol, mask and self-irony.* New York, 1986.

Masas, H., Duncan, J. L., and Good, W. G. *The Letters of Aubrey Beardsley.* Rutherford, N.J., 1970.

Oresko, R. (ed.) *The Story of Venus and Tannhäuser or Under The Hill. A Romantic Novel by Aubrey Beardsley.* New York, 1974.

Reade, B. *Beardsley,* London, 1967.

Slessor, C. *The Art of Aubrey Beardsley.* London, 1989.

Weintraub, S. *Aubrey Beardsley, Imp of the Perverse.* University Park, London, 1976.

BECKMANN
Dückers, A. *Max Beckmann. Die Hölle.* Berlin, 1983.
Erpel, F. *Max Beckmann.* Berlin, 1985.
Frischer, F. W. *Max Beckmann. Symbol und Weltbild. Grundriss zu einer Deutung des Gesamtwerkes.* Munich, 1972.
*Göpel, E. and B. *Max Beckmann. Katalog der Gemälde.* 2 vols. Bern, 1976.
Hofmaier, J. *Max Beckmann: catalogue raisonné of his prints.* Berne, 1990.
Kessler, C. S. *Max Beckmann's Triptychs.* Cambridge, Mass., 1970.
Max Beckmann. Das druckgraphische Werk. Zürich, 1976.
Max Beckmann. Retrospective. St. Louis Museum of Art, 1984.
Max Beckmann. The Triptychs. London, Arts Council, 1980.
Schubert, D. *Max Beckmann. Auferstehung und Erscheinung der Toten.* Worms, 1985.
Selz, P. *Max Beckmann.* New York, Museum of Modern Art, 1964.
Twohig, S. O'B. *Beckmann's Carnival.* London, Tate Gallery, 1984.
Wiess, S. von. *Max Beckmanns zeichnerisches Werk, 1903–1925.* Düsseldorf, 1978.

BERGHE, VAN DEN
Hecke, P. G. van. *Frits van den Berghe.* Antwerp, 1948.
*Langui, E. *Frits van den Berghe. Der Mensch und sein Werk.* Antwerp, 1968.
Van den Berghe (et al.). Ghent, Museum voor Schone Kunsten, 1983.

BERMAN
Berman, E. *Imaginary Promenades in Italy.* New York, 1956.
Eugene Berman and the Theater of Melancholy. San Antonio, Marion Koogler McNay Art Museum, 1984.
Levy, J., ed. *Eugene Berman.* New York, 1947.
The Graphic Work of Eugene Berman. New York, 1971.

BERNARD
Dorra, H. 'Émile Bernard and Paul Gauguin', *Gazette des Beaux-Arts,* XLV (1955), 227–46.
Luthi, J. J. *Emile Bernard en Orient et chez Paul Cézanne (1893–1904).* Paris, 1979.
Luthi, J. J. *Emile Bernard. Catalogue raisonné de l'œuvre peint.* Paris, 1982.
Mornand, P. *Émile Bernard et ses amis.* Geneva, 1957.

BEVAN
Bevan, R. A. *Robert Bevan, a Memoir by His Son.* London, 1965.
*Dry, G. *Robert Bevan, 1865–1925. Catalogue raisonné of the Graphic Work.* London, 1968.

BILL
Anker, V. *Max Bill ou la recherche d'un art logique.* Lausanne, 1979.
Hüttinger, E. *Max Bill.* New York, 1978.
Max Bill. Geneva, Musée Rath, 1972.
Wood, J. N., comp. and ed. *Max Bill Catalogue.* Buffalo, Buffalo Fine Arts Academy, 1974.

BLEYL
Kruger, G. *Fritz Bleyl. Beiträge zum Werden und Zusammenschluss der Künstlergruppen 'Brücke'.* Berlin, 1968.
Wetzel, H. 'Fritz Bleyl, Gründungsmitglied der Brücke', *Kunst in Hessen und am Mittelrhein,* VIII (1968), 89–106.

BOCCIONI
Ballo, G. *Boccioni.* Milan, 1964.
*Bellini, P. *Catalogo completo dell'opera grafica di Umberto Boccioni.* Milan, 1972.
Birolli, Z. *Umberto Boccioni: racconto critico.* Turin, 1983.
Boccioni e il suo tempo. Milan, Palazzo Reale, 1973.
*Bruno, G. *L'Opera completa di Umberto Boccioni, 1882–1916.* Milan, 1969.
Calvesi, M. *Boccioni. L'Opera completa.* Milan, 1983.
Coen, E. *Umberto Boccioni.* New York, 1988.
Golding, J. *Boccioni's Unique Forms of Continuity in Space.* Newcastle upon Tyne, 1972.
Tallarico, L. *Boccioni: cento anni.* Rome, 1982.

BOMBERG
Cork, R. *David Bomberg.* New Haven and London, 1987.
———. *David Bomberg.* London, Tate Gallery, 1988.
———. *Poems and Drawings from the First World War by David Bomberg.* Ed. Neville Jason. London, Gillian Jason Gallery, 1992.
Cork, R. and Rachum, S. *David Bomberg in Palestine 1923–1927.* Jerusalem, Israel Museum, 1983.
David Bomberg. The Later Years, London, Whitechapel Art Gallery, 1979.
David Bomberg, 1890–1957. Painting and Drawings. London, Arts Council, 1967.
Lipke, W. *David Bomberg, a Critical Study of His Life and Works.* New York and South Brunswick, 1968.

BOMBOIS

Bing, B. H. *Camille Bombois*. Paris, n.d.

Uhde, W. *Five Primitive Masters*. New York, 1949.

BONNARD

Amoureux, G. *L'Univers de Bonnard*. Paris, 1985.

Bonnard. The Late Paintings. Washington, The Phillips Collection, 1984.

Bouvet, F. *Bonnard. The Complete Graphic Work*. London, 1981.

*Dauberville, J. and H. *Bonnard. Catalogue raisonné de l'œuvre peint*. Paris, 1965-. In progress.

Fermigier, A. *Pierre Bonnard*. London, 1987.

Mann, Sargy. *Drawings by Bonnard*. London, Arts Council, 1984.

Negri, R. *Bonnard e i Nabis*. Milan, 1970.

Pierre Bonnard. Munich, Haus der Kunst, 1967.

Pierre Bonnard. Centenaire de sa naissance. Paris, Orangerie des Tuileries, 1966–7.

Terrasse, A. *Bonnard*. Paris, 1988.

———. *Pierre Bonnard; illustrator: a catalogue raisonné*. London, 1988.

BOURDELLE

Basdevant, D. *Bourdelle et le Théâtre des Champs-Elysées*. Paris, 1982.

Bourdelle, E.-A. *Écrits sur l'art et sur la vie*. Paris, 1977.

Bourdelle, E.-A. *La Sculpture et Rodin*. Paris, 1937.

Cannon-Brookes, P. *Emile Antoine Bourdelle*. London, 1983.

Dufet, M. *Bourdelle et l'érotisme grec*. Paris, 1976.

Hall, D. *et al. Emile Antoine Bourdelle. Pioneer of the Future*. Yorkshire Sculpture Park, 1989.

Jianu, I. *Bourdelle*. New York, 1966.

L'Œuvre d'Antoine Bourdelle. 6 vols. Paris, 1925–32.

BRANCUSI

Bach, F. T. *Constantin Brancusi. Metamorphosen Plastischer Form*. Cologne, 1987.

Brezianu, B. *Brancusi in Romania*. Bucharest, 1976.

Constantin Brancusi, 1876–1957. A Retrospective Exhibition. New York, Guggenheim Museum, 1969.

Geist, S. *Brancusi. The Kiss*. New York, 1978.

Geist, S. *Brancusi, the Sculpture and Drawings*. New York, 1975.

Hulten, P. *Brancusi*. London, 1988.

Jianou, I. *Brancusi*. New York, 1963.

Shanes, E. *Constantin Brancusi*. New York, 1989.

Spear, A. T. *Brancusi's Birds*. New York, 1974.

Varia, R. *Brancusi*. New York, 1986.

BRAQUE

Braque lithographe. Monte Carlo, 1963.

Cooper, D. *Braque. The Great Years*. Chicago, 1972.

Fumet, S. *Sculptures de G. Braque*. Paris, 1951.

Golding, J., *et al. Braque Still Lifes and Interiors*. London, South Bank Centre, 1990.

Hoffmann, W. *Georges Braque. His Graphic Work*. New York, 1961.

Leymarie, J. *Georges Braque*. New York, 1988.

*Mangin, N. S., ed. *Catalogue de l'œuvre de Georges Braque*. Paris, 1959-. In progress.

Monod-Fontaine, I., and Carmean, E. A., Jr. *Braque. The Papiers Collés*. Washington, D.C., 1982.

Russell. J. *G. Braque*. London, 1959.

The Graphic Work of Georges Braque. London, Arts Council, 1978.

Wilkin, K. *Georges Braque*. London, 1991.

Zurcher, B. *Georges Braque: life and work*. New York, 1988.

BRAUNER

Bozo, D. *Victor Brauner*. Paris, Musée National d'Art Moderne, 1972.

Jouffroy, A. *Brauner*. Paris, 1959.

BURLIUK

Dreier, K. S. *Burliuk*. New York, 1944.

BURNE-JONES

Harrison, M., and Waters, B. *Burne-Jones*. Rev. ed. London, 1977.

Hartnoll, J. *Burne-Jones et l'influence des Pre-Raphaelites*. Paris, Galerie du Luxembourg, 1972.

Morgan, H. *Burne-Jones, the Pre-Raphaelites and their century*. London, 1989.

The Paintings, Graphic and Decorative Work of Sir Edward Burne-Jones. London, Arts Council, 1975.

CAMOIN

*Giraudy, D. *Camoin, sa vie, son œuvre*. Marseille, 1972.

CAMPENDONK

*Engels, M. T. *Campendonk. Holzschnitte*. Stuttgart, 1959.

Van Leckwyck, E. *Heinrich Campendonk*. Munich, Galerie Ketterer, 1976.

Wember, P. *Heinrich Campendonk*. Krefeld, 1960.

CAMPIGLI

Campigli, M., *et al. Omaggio a Campigli*. Rome, 1972.

Cassou, J. *Campigli*. Paris, 1957.

CARRÀ

Carrà, C. *La mia vita*. 2nd ed. Milan, 1945.

Carrà, C. *Pittura metafisica*. 2nd rev. ed. Milan, 1945.

Carrà, M. *Carrà. Tutta l'opera pittorica.* 3 vols. Milan, 1967–8.
Carrà, M. (ed.) *Carlo Carrà. Tutti gli scritti.* Milan, 1978.
Carrà, M. *Omaggio a Carlo Carrà: tutta l'opera grafica 1922 al 1964.* Bologna, 1985.
Riccio, L. *Carlo Carrà disegni 1918–1965.* Turin, 1987.

CASORATI
Carluccio, L. *Felice Casorati.* Milan, 1964.
Casorati. Ferrara, Palazzo dei Diamanti, 1981.

CASSATT
*Breeskin, A. D. *Mary Cassatt. A Catalogue Raisonné of the Graphic Work.* Washington, 1979.
*Breeskin, A. D. *Mary Cassatt. A Catalogue Raisonné of the Oils, Pastels, Watercolours, and Drawings.* Washington, 1970.
Mary Cassatt, Pastels and Color Prints. Washington, 1978.
Mathews, N. M. *Mary Cassatt.* New York, 1987.
Mauvieux, M. *Mary Cassatt.* Paris, Musée d'Orsay, 1988.
Witzling, M. R. *Mary Cassatt: a private world.* New York, 1991.

CÉZANNE
Andersen, W. V. *Cézanne's Portrait Drawings.* Cambridge, Mass., 1970.
Berthold, G. *Cézanne und die alten Meister. Die Bedeutung der Zeichnungen Cézannes nach Werken anderer Künstler.* Stuttgart, 1958.
*Chappuis, A. *The Drawings of Paul Cézanne. A Catalogue Raisonné.* 2 vols. London, 1972.
Coutagne, D., ed. *Cézanne ou la peinture en jeu.* Limoges. 1982.
 Proceedings of a colloquium held in Aix in 1982.
Doran, P. M. *Conversations avec Cézanne . . .* Paris, 1978.
Duchting, H. *Paul Cézanne: Bilder eines Berges.* Munich, 1990.
Gowing, L., *et al. Cézanne. The Early Years 1859–1972.* London, 1988.
Gowing, L. *Watercolour and Pencil Drawings by Cézanne.* London, Arts Council.
Krumrine, M. L. *Paul Cézanne. The Bathers.* London, 1990.
Lewis, M. T. *Cézanne's early imagery.* Berkeley, 1989.
Rewald, J. *Cézanne, a Biography.* New York, 1948.
Rewald, J., ed. *Paul Cézanne. Letters.* 4th ed., rev. and enl. New York, 1976.
Rewald, J. *Paul Cézanne. The Watercolors. A Catalogue Raisonné.* Boston, 1983.

Rewald, J. *Cézanne, the Steins and their circle.* London, 1986.
Rilke, R. M. *Letters on Cézanne.* London, 1988.
Rubin, W., ed. *Cézanne, the Late Work.* New York, Museum of Modern Art, 1977.
Schapiro, M. *Paul Cézanne.* 3rd ed. New York, 1965.
Shiff, R. A. *Cézanne and the End of Impressionism. A Study of the Theory, Technique, and Critical Evaluation of Modern Art.* Chicago, 1984.
*Venturi, L. *Cézanne. Son Art – son œuvre,* 2 vols. Paris, 1936.
Verdi, R. *Cézanne and Poussin. The Classical Vision of Landscape.* London, 1990.

CHAGALL
Alexander, S. *Marc Chagall. A Biography.* London, 1978.
Chagall. Philadelphia, Museum of Art, 1985.
*Chagall, M. *Lithographs.* 3 vols. New York, 1960–9.
Chagnall, M. *My Life.* Oxford, 1989.
Compton, S. *Chagall.* London, 1985.
Haftmann, W. *Marc Chagall.* New York, 1973.
Kamensky, A. *Chagall. The Russian Years 1907–1922.* London, 1989.
Kornfeld, E. W. *Verzeichnis der Kupferstiche, Radierungen und Holzschnitte von Marc Chagall.* Bern, 1970–. In progress.
Leymarie, J. *Marc Chagall. The Jerusalem Windows.* London, 1968.
Makarius, M. *Chagall.* London, 1988.
Marc Chagall. Paris, Musée des Arts Décoratifs, 1959.
Meyer, F. *Marc Chagall.* New York, 1964.
Walther, I. F. *Marc Chagall 1887–1985. Painting as Poetry.* Cologne, 1987.

CHIRICO, DE
*Bruni Sakraischik, C. *Catalogo generale de Chirico.* 7 vols. Milan, 1971–4.
Chirico, G. de. *The Memoirs of Giorgio de Chirico.* London, 1971.
Chirico, G. de. *Il Meccanismo del Pensiero: Critica, Polemica, Autobiografia 1911–1943.* Turin, 1985.
Fagiolo dell' Arco, M. *La Vita di Giorgio de Chirico.* Turin, 1988.
Fagiolo dell'Arco, M., and Baldacci, P. *Giorgio di Chirico. Parigi 1924–1929.* Milan, 1982.
Far, I. *De Chirico.* New York, 1969.
Lista, G. *De Chirico et l'avant-garde.* Lausanne, 1983.
Martin, R. (ed.) *Late de Chirico.* Bristol, Arnolfini Gallery, 1985.
Pincus-Witten, R. *Giorgio de Chirico. Post-Metaphysical & Baroque Paintings 1920–1970.* New York, Robert Miller, 1984.
Roche-Pézard, F. *De Chirico et Savinio.* Paris, 1986.

Rubin, W., ed. *De Chirico*. New York, Museum of Modern Art, 1982.
Schmied, W., *et al. De Chirico. Leben und Werk*. Munich, 1980.

ČIURLIONIS
*Di Milia, G. *Mikalojus Kostantinas Čiurlionis*. Paris, Cahiers du Musée National d'Art Moderne, 1980.
Vaitkunas, G. *Mikalojus Konstantinas Čiurlionis*. Dresden, 1975.
Worobiow, N. *M. K. Čiurlionis, der litauische Maler und Musiker*. Kaunas, 1938.

CORINTH
*Berend-Corinth, C., ed. *Die Gemälde von Lovis Corinth*. Munich, 1958.
Bussmann, G. *Lovis Corinth – Carmencita*. Frankfurt, 1985.
Corinth, L. *Gesammelte Schriften*. Berlin, 1920.
Corinth, L. *Selbstbiographie*. Leipzig, 1926.
Corinth, T. *Lovis Corinth, eine Dokumentation*. Tübingen, 1979.
Corinth, W. *"Ich habe einen Lovis Corinth Keinen Vater"*. Munich, 1990.
Horst, U. *Lovis Corinth*. Berkeley, Los Angeles and Oxford, 1990.
Netzer, R. *Lovis Corinth, Graphik*. Munich, 1958.
Osten, G. von der. *Lovis Corinth*. 2nd rev. ed. Munich, 1959.

CROSS
Compin, I. *H.-E. Cross*. Paris, 1964.
Rewald, J., ed. *Henri-Edmond Cross. Carnet de dessins*. Paris, 1959.

CROTTI
George, W. *Jean Crotti et la primauté du spirituel*. Geneva, 1959.

DALI
Ades, D. *Dali and Surrealism*. New York, 1982.
Dali, S. *The Secret Life of Salvador Dali*. New enl. ed. New York, 1961.
Dali, S. *The Unspeakable Confessions of Salvador Dali*. New York, 1976.
Dali, S. *Dialogues with Marcel Duchamp*. New York, 1971.
Descharnes, R. *Salvador Dali*. New York, 1976.
Gomez de la Serna, R. *Dali*. New York, 1979.
McGirk, T. *Wicked Lady: Salvador Dali's Muse*. London, 1989.
Rogerson, M. *The Dali Scandal: an investigation*. London, 1987.

Salvador Dali rétrospective 1920–1980. 2nd ed., rev. and enl. Paris, Musée National de l'Art Moderne, 1980.
Secrest, M. *Salvador Dali: the surrealist jester*. London, 1986.
Shanes, E. *Dali*. London, 1990.

DEGAS
Adhémar, J., and Cachin, F. *Degas, The Complete Etchings, Lithographs and Monotypes*. New York, 1975.
Adriani, G. *Degas Pastels, Oil Sketches, Drawings*. London, 1985.
Armstrong, C. *Odd man out: readings of the work and reputation of Degas*. Chicago, 1991.
Cooper, D. *Pastels by Edgar Degas*. New York, 1953.
Drawings by Degas. St Louis, City Art Museum, 1966.
Dunlop, I. *Degas*. London, 1979.
Gordon, R., and Forge, A. *Degas*. London, 1988.
Guérin, M., ed. *Degas. Letters*. Oxford, 1947.
Guillard, M., ed. *Degas. Form and Space*. Paris, Centre culturel du Marais, 1984.
*Janis, E. P. *Degas Monotypes, Essay, Catalogue and Checklist*. Greenwich, Conn., 1967.
Kendall, R. (ed.) *Degas by himself*. London, 1987.
Kendall, R., and Pollock, G. (eds.) *Dealing with Degas*. London, 1992.
*Lemoisne, P.-A. *Degas et son œuvre*. 5 vols. Paris, 1947–84.
McMullen, R. *Degas. His Life, Times, and Work*. Boston, 1984.
Millard, C. W. *The Sculpture of Edgar Degas*. Princeton, N.J., 1976.
Reed, S. W., and Shapiro, B. S. *Edgar Degas. The Painter as Printmaker*. Boston, Museum of Fine Arts, 1984.
Reff, T. *Degas. The Artist's Mind*. New York, 1976.
Reff, T. *The Notebooks of Edgar Degas*. 2 vols. Oxford, 1976.
Rewald, J. *Degas. Sculpture. The Complete Works*. New York, 1956.
Terrasse, A. *Degas et la photographie*. Paris, 1983.
Thomson, R. *The Private Degas*. London, 1987.
——. *Degas The Nudes*. London, 1988.

DELAUNAY
Buckberrough, S. A. *Robert Delaunay: the discovery of simultaneity*. Ann Arbor, 1982.
Cohen, A. A. *The New Art of Color. The Writings of Robert and Sonia Delaunay*. New York, 1978.
*Delaunay, R. *Du Cubisme à l'art abstrait, documents inédits*. Paris, 1957.

*Lipton, E. *Looking into Degas. Uneasy Images of Women and Modern Life*. Berkeley and Los Angeles, 1986.

Molinari, D. *Robert et Sonia Delaunay*. Paris, 1987.

Robert Delaunay (1885–1941). Paris, Musée de l'Orangerie, 1976.

Vriesen, G., and Imdahl, M. *Robert Delaunay. Light and Color*. New York, 1969.

DELAUNAY-TERK

Cohen, A. A. *Sonia Delaunay*. New York, 1975.

Damase, J. *Sonia Delaunay. Rhythms and Colours*. London, 1972.

Damase, J. *Sonia Delaunay: fashion and fabrics*. London, 1991.

Delaunay, S. T. *Nous irons jusqu'au soleil*. Paris, 1978.

Sonia Delaunay. A Retrospective. Buffalo, Albright-Knox Art Gallery, 1980.

Morano, E. *Sonia Delaunay: art into fashion*. New York, 1986.

DELVAUX

Bock, P.-A. de. *Paul Delvaux. L'Homme, le peintre, psychologie d'un art*. Brussels, 1967.

*Butor, M., *et al*. *Delvaux*. Lausanne-Paris, 1975.

Gaffé, R. *Paul Delvaux ou les rêves éveillés*. Brussels, 1945.

Jacob, M. *Paul Delvaux. Graphic Work*. New York, 1976.

Paquet, M. *Paul Delvaux et l'essence de la peinture*. 2 vols. Paris, 1982.

Rombaut, M. *Paul Delvaux*. Barcelona, 1990.

DENIS

Barazzetti-Demoulin, S. *Maurice Denis*. Paris, 1945.

*Cailler, P. *Catalogue raisonné de l'œuvre gravé et lithographic de Maurice Denis*. Geneva, 1968.

Denis, M. *Journal, 1884–1943*. 3 vols. Paris, 1957–9.

Maurice Denis. Gemälde, Handzeichnungen . . . Bremen, Kunsthalle, 1971.

Maurice Denis. Paris, Orangerie des Tuileries, 1970.

Maurice Denis: Maternité aux manchettes de dentelle. Rennes, Musée des Beaux-Arts Rennes, 1982.

DEPERO

Depero, F. *So I Think, So I Paint. Ideologies of an Italian Self-made Painter*. Rovereto, 1947.

DERAIN

André Derain. Paris, Grand Palais, 1977.

Derain, A. *Lettres à Vlaminck*. Paris, 1955.

Diehl, G. *Derain*. New York, 1964.

Exposition Derain, 1880–1954. Paris, Galerie Schmit, 1976.

Hilaire, G. *Derain*. Geneva, 1959.

Lee, J. *Derain*. Oxford, 1990.

Sutton, D. *André Derain*. London, 1959.

DESPIAU

Charles Despiau. Sculpture et dessins. Paris, Musée Rodin, 1974.

*Deshairs, L. *C. Despiau*. Paris, 1930.

DIX

Conzelmann, O. *Der andere Dix. Sein Bild vom Menschen und vom Krieg*. Stuttgart, 1983.

Conzelmann, O., ed. *Otto Dix. Handziechnungen*. Hanover, 1968.

Hartley, K., *et al*. *Otto Dix 1891–1969*. London, Tate Gallery, 1992.

Kicherer, M. *Otto Dix: Landschaften*. Friedrichshafen, 1984.

Kinkel, H. *Die Toten und die Nachten: Beitrage zu Dix*. Berlin, 1991.

Lehmann, H-U. *Otto Dix. Die Zeichnungen im Dresdner Kupferstich-Kabinett*. Dresden, 1991.

Löffler, F. *Otto Dix. Leben und Werk*. 2nd enl. ed. Dresden, 1967.

Löffler, P. *Otto Dix, 1891–1968. Œuvres der Gemälde*. Rechlinghausen, 1981.

McGreevy, L. F. *The Life and Works of Otto Dix*. Michigan, 1981.

Otto Dix. Peintures, aquarelles . . . du cycle de 'La Guerre'. Paris, Musée National de l'Art Moderne, 1972.

Otto Dix Inventory Catalogue. Preface by J-K. Schmidt. Stuttgart, 1989.

Schmidt, D. *Otto Dix im Selbstbildnis*. Berlin, 1978.

DOESBURG, VAN

Baljeu, J. *Theo van Doesburg*. London, 1974.

Doesburg, T. van. *Principles of Neo-Plastic Art*. New York, 1968.

English translation by J. Seligman of *Grandbegriffe der neuen gestalten den Kunst*, Munich, 1925.

Doesburg, T. van. *Scritti di arte e di architettura*. Rome, 1979.

Doig, A. *Theo van Doesburg: painting into architecture*. Cambridge, 1986.

Jaffé, H. L. C. *Theo van Doesburg*. Meulenhoff, 1983.

Straaten, E. van. *Theo van Doesburg, painter and architect*. The Hague, 1988.

DOMELA

*Clairet, A. *Catalogue raisonné de l'œuvre de César Domela-Nieuwenhuis*. Paris, 1978.

Zervos, C. *Domela*. Amsterdam, 1966.

DONGEN, VAN

Brodskaya, N. *Van Doesburg*. Leningrad, 1987.

Cornelis Theodorus Marie van Dongen, 1877–1968. Tucson, University of Arizona Museum of Art, 1971.

Kyriazi, J. M. *Van Dongen et le fauvisme*. Lausanne, 1971.

Van Dongen, 1877–1968. Geneva, Athenée, 1976.

DOTTORI

Gerardo Dottori. Mostra antologica. Todi, Palazzo del Popolo, 1971.

DUCHAMP

The Almost Complete Works of Marcel Duchamp. London, Arts Council, 1966.

Arman, Y. *Marcel Duchamp: plays and wins*. Paris, 1984.

Bailly, J-C. *Duchamp*. London, 1986.

Baruchello, G. *Why Duchamp: an essay on aesthetic impact*. New York, 1985.

Bonk, E. *Marcel Duchamp: the portable museum*. London, 1989.

Cabanne, P. *Dialogues with Marcel Duchamp*. New York, 1971.

Campfield, W. A. *Marcel Duchamp: Fountain*. Houston, 1989.

Clair, J. *Marcel Duchamp. Catalogue raisonné*. Paris, 1977.

Clair, J., ed. *Tradition de la rupture ou rupture de la tradition*. Paris, 1979.

Golding, J. *Marcel Duchamp: The Bride Stripped Bare by Her Bachelors, Even*. London, 1973.

d'Harnoncourt, A., and McShine, K., eds. *Marcel Duchamp*. Philadelphia Museum of Art, 1973.

Hopps, W., Linde, U., and Schwarz, A. *Marcel Duchamp: Ready-mades, etc. (1913–1964)*. Milan, 1964.

*Lebel, R. *Marcel Duchamp*. New York, 1959.

Linde, U. *Marcel Duchamp*. Stockholm, 1986.

Le Macchine celibi. The Bachelor Machines . . . Venice, New York, 1975.

L'Œuvre de Marcel Duchamp. 4 vols. Paris, Musée National d'Art Moderne, 1977.

Sanouillet, M. *Duchamp du signe. Ecrits*. Paris, 1976.

Sanouillet, M., and Peterson, E. *Salt Seller. The Writings of Marcel Duchamp (Marchand du Sel)*. New York, 1973.

Schwarz, A. *The Complete Works of Marcel Duchamp*. New York, 1969.

Schwarz, A. *Notes and Projects for the Large Glass*. New York, 1969.

DUCHAMP-VILLON

Cabanne, P. *The Brothers Duchamp . . .* Boston, 1976.

Cassou, J. *Le Cheval Majeur de Duchamp-Villon a la préfecture de Rouen*. Rouen, 1968.

*Hamilton, G. H., and Agee, W. C. *Raymond Duchamp-Villon, 1876–1918*. New York, 1967.

Jacques Villon, Raymond Duchamp-Villon, Marcel Duchamp. New York, Guggenheim Museum, 1957.

Pach, W. *Raymond Duchamp-Villon, sculpture (1876–1918)*. Paris, 1924.

DUFY

Cogniat, R. *Raoul Dufy*. New York, 1962.

Courthion, P. *Raoul Dufy. Documentation complète sur le peintre, sa vie, son œuvre*. Geneva, 1952.

Guillon-Laffaille, F. *Dufy. Catalogue raisonné des aquarelles, gouaches et pastels*. 2 vols. Paris, 1981–2.

*Laffaille, M. *Raoul Dufy, Catalogue raisonné de l'œuvre peint*. 5 vols. Geneva, 1972–85. *Supplément*. Paris, 1985.

Perez-Tibi, D. *Dufy*. London, 1989.

Raoul Dufy. Tokyo, Musée National d'Art Occidental, 1967.

Raoul Dufy. Paintings, Drawings, Illustrated Books . . . London, Hayward Gallery, 1983.

EGGELING

O'Konor, L. *Viking Eggeling 1880–1925. Artist and Film-Maker. Life and Work*. Stockholm, 1971.

Viking Eggeling, 1880–1925. Tecknare och filmkonstnär. Stockholm, Nationalmuseum, 1950.

ENSOR

Bonjour Monsieur Ensor. Ostend, L'Hareng Saur, 1985.

Ensor, J. *Les Ecrits de James Ensor*. Definitive ed. Brussels, 1944.

Haesaerts, P. *James Ensor*. New York, 1959.

James Ensor. Zürich, Kunsthaus, 1983.

Lesko, D. *James Ensor. The Creative Years*. Princeton, N.J., 1985.

Lesko, D. *James Ensor: the creative years*. Princeton, 1985.

McGough, S. C. *James Ensor's "The Entry of Christ into Brussels in 1889"*. New York, 1985.

Schneede, U. M., *et al. Ensor. Ein Maler aus dem späten 19. Jahrhundert*. Stuttgart, 1972.

*Taevernier, A. *James Ensor. Catalogue illustré de ses gravures . . .* Ghent, 1973.

Vanbeselaere, W. *L'Entreé du Christ à Bruxelles*. Brussels, 1957.

EPSTEIN

Buckle, R., ed. *Epstein Drawings*. London, 1962.

Buckle, R. *Jacob Epstein, Sculptor*. London, 1963.
Cork, R. *Jacob Epstein. The Rock Drill Period*. London, Anthony d'Offay Gallery, 1973.
Epstein, J. *Epstein, an Autobiography*. New York, 1955.
Friedman, T. *'The Hyde Park Atrocity'. Epstein's Rima: Creation and Controversy*. Leeds, 1988.
Friedman, T., and Silber, E. (eds.) *Jacob Epstein. Sculpture and Drawings*. Leeds and London, 1987.
Gardiner, S. *Epstein: artist against the establishment*. London, 1992.
Silber, E. *The Sculpture of Epstein*. Oxford, 1986.

ERNST
Bischoff, U. *Max Ernst 1891–1976: beyond painting*. Cologne, 1988.
Ernst, J. *A Not-so-still life*. New York, 1984.
Ernst, M. *Beyond Painting, and Other Writings by the Artist and His Friends*. New York, 1948.
Herzogenrath, W., ed. *Ernst in Köln*. Cologne, 1980.
Legge, E. M. *Max Ernst: the psychoanalytic sources*. Ann Arbor, 1989.
Max Ernst. Munich, Haus der Kunst, 1979.
Max Ernst. A Retrospective. New York, Guggenheim Museum, 1975.
Quinn, E. *Max Ernst*. New York, 1977.
Spies, W. *Max Ernst. Collagen, Inventar und Widerspruch*. 2nd ed. Cologne, 1975.
Spies, W. *Max Ernst. Frottages*. New York, 1968.
*Spies, W., ed. *Max Ernst, Œuvre-Katalog*. Houston and Cologne, 1975– . In progress.
Spies, W. (ed.) *Max Ernst*. Munich, 1991.
——. *Max Ernst Collages*. London, 1991.

FEININGER
*Hess, H. *Lyonel Feininger*. New York, 1961.
Lyonel Feininger, 1871–1956. Munich, Haus der Kunst, 1973.
Luckhardt, U. *Lyonel Feininger*. Munich, 1989.
Ness, J. L.,ed. *Lyonel Feininger*. New York, 1974.
*Prasse, L. E. *Lyonel Feininger. A Definitive Catalogue of His Graphic Work . . .* Cleveland, 1972.
Tobien, F. *Lyonel Feininger*. Thornbury, 1989.

FORAIN
Bory, J. F. *Forain*, Paris, 1979.
Browse, L. *Forain, the Painter, 1852–1931*. London, 1978.
Coutin, C. *Jean-Louis Forain, Chroniqueur-Illustrateur de Guerre (1914–1919)*. Paris, 1986.
Guerin, M. *Jean-Louis Forain; lithographs: catalogue raisonné*. Revised ed. San Francisco, 1980.
Jean-Louis Forain. Paris, Musée Marmottan, 1978.

FREUNDLICH
Hommage à Otto Freundlich . . . Jerusalem, Israel Museum, 1978.
Otto Freundlich, 1878–1943. Gemälde, Graphik, Skulpturen. Cologne, Wallraf-Richartz Museum, 1960.
Schriften. Ein Wegbereiter der gegendstandslosen Kunst. Otto Freundlich. Cologne, 1982.

FRIESZ
Gauthier, M. *Othon Friesz*. Geneva, 1957.

GABO
Gabo, Constructions, Sculpture, Paintings, Drawings, Engravings. Cambridge, Mass., 1957.
Gabo, N. *Of Divers Arts*. New York, 1962.
Hammer, M., and Lodder, C. *Naum Gabo. The Constructive Idea*. London, 1987.
Nash, G. A. *Naum Gabo*. New York, Solomon R. Guggenheim Museum, 1985.
An exhibition catalogue with a catalogue raisonné of sculpture and constructions.
Nash, S., and Merkert, J. (eds.) *Naum Gabo*. Munich, 1985.
Naum Gabo. Buffalo, Albright-Knox Art Gallery, 1968.
Naum Gabo: ein russischer Konstruktivist in Berlin 1922–1932. Berlin, Berlinische Galerie, 1989.
Newman, T. *Naum Gabo, The Constructive Process*. London, Tate Gallery, 1976.
Pevsner, A. *A Biographical Sketch of My Brothers, Naum Gabo and Antoine Pevsner*. Amsterdam, 1964.

GALLÉN-KALLELA
Gallén-Kallela, K. *Isani Akseli Gallén-Kallela*. 2 vols. Helsinki, 1965.
Okkonen, O. A. A. *Gallén-Kallela, elämä ja taide*. Helsinki, 1961.

GAUDIER-BRZESKA
Brodzky, H. *Henri Gaudier-Brzeska, 1891–1915*. London, 1933.
Cole, R. *Burning to Speak. The Sculpture of Gaudier-Brzeska*. Oxford, 1978.
Cork, R. *Henri Gaudier and Ezra Pound. A Friendship*. London, Anthony d'Offay Gallery, 1982.
Ede, H. S. *A Life of Gaudier-Brzeska*. London, 1930. American edition as *Savage Messiah*, New York, 1931.
Lewison, J. (ed.) *Henri Gaudier-Brzeska, Sculptor*. Cambridge, Kettle's Yard Gallery, 1983.
Secretan, R. *Un Sculpteur 'maudit'. Gaudier-Brzeska 1891–1915*. Paris, 1979.

GAUGUIN

Amishai-Maisels, Z. *Gauguin's religious themes*. New York, 1985.

Bodelsen, M. *Gauguin's Ceramics. A Study in the Development of His Art*. London, 1964.

Boyle-Turner, C. *Gauguin and the School of Pont-Aven*. London, 1986.

Brettell, R., Cachin, F., *et al. The Art of Paul Gauguin*. Washington, 1988.

Danielsson, B. *Gauguin in the South Seas*. London, 1965.

Field, R. S. *Paul Gauguin. Monotypes*. Philadelphia Museum of Art, 1973.

Gauguin, P. *Noa Noa. Gauguin's Tahiti*. Oxford, 1985.

Gray, C. *Sculpture and Ceramics of Paul Gauguin*. Baltimore, 1963.

Guérin, M., rev. ed. *L'Œuvre gravé de Gauguin*. San Francisco, 1980.

Hoog, M. *Paul Gauguin: life and work*. London, 1987.

Joworska, W. *Gauguin and the Pont-Aven School*. Greenwich, Conn., 1972.

Merlhes, V., ed. *Correspondance de Paul Gauguin. Vol. I. Documents, témoignages*. Paris, 1984.

Morgan, E. *Paul Gauguin: catalogue raisonné of his prints*. Bern, Galerie Kornnfeld, 1988.

Pickvance, R. *The Drawings of Gauguin*. London, 1970.

Rewald, J. *Post-Impressionism from Van Gogh to Gauguin*. 2nd ed. New York, 1962.

*Sugana, G. M. *L'Opera completa grafica di Paul Gauguin*. Milan, 1972.

*Wildenstein, G. *Gauguin. I. Catalogue*. Paris, 1964.

GIACOMETTI, ALBERTO

Alberto Giacometti, a Retrospective Exhibition. New York, Guggenheim Museum, 1974.

Bonnefoy, Y. *Alberto Giacometti*. Paris, 1991.

Genet, J., and Morris, F. *Alberto Giacometti. The Artist's Studio*. London, 1991.

Giacometti Sculptures, Paintings, Drawings. London, Arts Council, 1981.

Giacometti, A. *Paris sans fin*. Salzburg, 1985.

———. *Ecrits*. Paris, 1990.

Hohl, R. *Alberto Giacometti. Sculpture, Paintings, Drawing*. New York, 1972.

Imsand, M. *Alberto Giacometti sculptures*. Martigny, 1986.

Lord, J. *Giacometti. A Biography*. New York, 1985.

Malter, M. *Alberto Giacometti*. London, 1987.

Svendsen, L. A. *Alberto Giacometi. Sculptor and Draftsman*. New York, 1977.

Sylvester, D. *Alberto Giacometti*. New York, 1970.

GIACOMETTI, AUGUSTO

Augusto Giacometti. Ein Leben für die Farbe. Pionier der abstrakten Malerei. Chur, Bündner Kunstmuseum, 1981.

Poeschel, E. *Augusto Giacometti*. Zürich-Leipzig, 1928.

Zendralli, A. M. *Augusto Giacometti*. Zürich, 1936.

GLEIZES

Albert Gleizes, 1881–1953. A Retrospective Exhibition. New York, Guggenheim Museum, 1964.

Alibert, P. *Albert Gleizes. Naissance et avenir du Cubisme*. Paris, 1982.

Chevalier, J. *Albert Gleizes et le cubisme*. Basel, 1962.

Gleizes, A. *La Forme et l'histoire. Vers une conscience plastique*. Paris, 1932.

GOGH, T. VAN

Collectie Theo van Gogh. Amsterdam, Stedelijk Museum, 1960.

GOGH, V. VAN

The Age of Van Gogh. Dutch Painting 1880–1895. Zwolle, 1990.

Bailey, M. *Van Gogh in England*. London, Barbican Art Gallery, 1992.

Beeck, M. in der. *Merkmale epileptischer Bildnerei, mit Pathologie Van Gogh*. Bern, 1982.

Bernard, B. (ed.) *Vincent by himself*. London, 1985.

Hammacher, A. M. *Genius and Disaster. The Ten Creative Years of Vincent van Gogh*. New York, 1968.

Hammacher, A. M. and R. *Van Gogh*. London, 1982.

*Hulsker, J. *The Complete Van Gogh. Paintings, Drawings, Sketches*. Oxford, 1980.

*La Faille, J. B. *The Works of Vincent van Gogh*. Rev., augmented and annotated ed. Amsterdam, 1970.

Van Gogh-Bonger, J., and Van Gogh, V. W., eds. *The Complete Letters of Vincent van Gogh*. 3 vols. London and Greenwich, Conn., 1958.

Nordenfalk, C. A. J. *The Life and Work of Van Gogh*. London, 1953.

Pickvance, R. *English Influences on Vincent van Gogh*. University of Nottingham and Arts Council, 1974.

Pickvance, R. *Van Gogh in Saint-Rémy and Auvers*. New York, 1986.

The Rijksmuseum Vincent Van Gogh. Amsterdam, 1987.

Schapiro, M. *Vincent van Gogh*. New York, 1950, and later eds.

Stein, S. A. (ed.) *Van Gogh. A Retrospective*. New York, 1986.

Sweetman, D. *The love of many things: a life of Vincent van Gogh*. London, 1990.

Van Gogh in Arles. New York, Metropolitan Museum of Art, 1984.

Welsh-Ovcharov, B. *Vincent van Gogh. His Paris Period*. Utrecht-The Hague, 1976.

Wolk, J. van der. *The Seven Sketchbooks of Vincent Van Gogh*. London, 1987.

GONCHAROVA *see* LARIONOV

GONZALEZ

*Gilbert, J. *Julio Gonzalez. Catalogue raisonné*. 9 vols. Paris, 1975.

The Gonzalez Gift of the Tate Gallery . . . London, Tate Gallery, 1974.

Julio Gonzalez. A Retrospective. New York, Solomon R. Guggenheim Museum, 1983.

Julio Gonzalez. Scultpures & Drawings. London, Whitechapel Art Gallery, 1990.

Merkert, J. *Julio Gonzalez: catalogue raisonné des sculptures*. Milan, 1987.

Merkert, J. *Julio Gonzalez: catalogue raisonné des sculptures*. Milan, 1987.

Smith, D., *et al*. *Julio Gonzalez*. London, Tate Gallery, 1970.

Withers, J. *Julio Gonzalez. Sculpture in Iron*. New York, 1977.

GORE

Gore, F., and Shone, R. *Spencer Frederick Gore 1878–1914*. London, Anthony d'Offay Gallery, 1983.

GRIS

*Cooper, D., and Potter, M. *Juan Gris. Catalogue raisonné de l'œuvre peint* . . . 2 vols. Paris, 1977.

Gaya Nuño, J. A. *Juan Gris*. Barcelona, 1974.

Green, C., *et al*. *Juan Gris*. New Haven and London, 1992.

Gris, J. *Letters of Juan Gris (1913–1927)*. Transl. and ed. by D. Cooper. London, 1956.

Juan Gris. Baden-Baden, Kunsthalle, 1974.

Kahnweiler, D. H. *Juan Gris. His Life and Work*. Transl. by D. Cooper. New enl. ed. London, 1969.

Soby, J. T. *Juan Gris*. New York, Museum of Modern Art, 1958.

GROMAIRE

Briot, M-O. and Gromaire, F. *Peinture 1921–1939 de Marcel Gromaire*. Paris, 1980.

*Gromaire, F. *L'Œuvre gravé de Marcel Gromaire*. 2 vols. Paris, 1976.

Marcel Gromaire. Paris, Musée d'Art Moderne de la Ville de Paris, 1980.

Zahar, M. *Gromaire*. Geneva, 1961.

GROSZ

Dückers, A. *George Grosz. Das druckgraphischen Werk*. Berlin, 1979.

Flavell, M. K. *George Grosz. A Biography*. New Haven and London, 1988.

George Grosz, 1893–1959. Berlin, Akademie der Künste, 1962.

Grosz, an Autobiography. New York, 1983.

Grosz, G. *Ecce Homo*. New York, 1976.

——. *Love above all*. London, 1985.

Hess, H. *George Grosz*. New Haven and London, 1985.

Lewis, B. I. *George Grosz. Art and Politics in the Weimar Republic*. Madison, University of Wisconsin, 1971.

Schneede, U. M. *George Grosz. Der Künstler in seiner Gesellschaft*. Cologne, 1975.

HAUSMANN

Benson, T. O. *Raoul Hausmann and Berlin Dada*. Ann Arbor, 1987.

Bory, J.-F. *Prolégomènes à une monographie de Raoul Hausmann*. Paris, 1972.

Raoul Hausmann. Hanover, Kestner-Gesellschaft, 1981.

Raoul Hausmann. Stockholm, Moderna Museet, 1967.

HEARTFIELD

Herzfelde, W. *John Heartfield. Leben und Werk, dargestellt von seinem Bruder*. Dresden, 1962.

Kahn, D. *John Heartfield: art and mass media*. New York, 1985.

Pachnicke, P., and Honnef, K. (eds.) *John Heartfield*. New York, 1992.

Selz, P., *et al*. *Photomontages of the Nazi Period. John Heartfield*. London, 1977.

Siepmann, E. *Montage: John Hearfield*. West Berlin, 1977.

HECKEL

Ausstellung Erich Heckel. Werke der Brückezeit, 1901–1917. Stuttgart, Württembergischer Kunstverein, 1957.

Dube, A., and Dube, W.-D. *Erich Heckel. Das graphische Werk*. 3 vols. New York, 1964–74.

Erich Heckel. Zeichnungen, Aquarelle. Stuttgart and Zürich,1983.

Felix, Z. (ed.) *Erich Heckel 1883–1970*. Munich, 1983.

Henze, A. *Erich Heckel: Leben und Werk*. Stuttgart, 1983.

Vogt, P. *Erich Heckel*. Recklinghausen, 1965.

HEPWORTH

Barbara Hepworth. London, Tate Gallery, 1968.

Barbara Hepworth. Drawings from a Sculptor's Landscape. New York, 1967.
Gardiner, M. *Barbara Hepworth: a memoir.* Edinburgh, 1982.
Hammacher, A. M. *The Sculpture of Barbara Hepworth.* London, 1968.
Hepworth, B. *A Pictorial Autobiography.* London, 1969.
*Hodin, J. P. *Barbara Hepworth.* London, 1961.

HERBIN
Auguste Herbin. Düsseldorf, Kunstverein, 1967.
Herbin, A. *L'Art non-figuratif, non-objectif.* Paris, 1949.

HÖCH
Hannah Höch. Collages, Peintures... Berlin, Nationalgalerie, 1976.
Hannah Höch. Fotomontagen, Gemälde, Aquarelle. Tübingen, Kunsthalle, 1979.
Hannah Höch zum 90. Geburtstag. Berlin, Galerie Nierendorf, 1979.
Lavin, M. *Cut with the kitchen knife: the Weimar photomontages of Hannah Höch.* New Haven and London, 1993.
Ohff, H. *Hannah Höch.* Berlin, 1968.
Remmert, H., and Barth, P. *Hannah Höch: Werke und Worte.* Berlin, 1982.

HODLER
Brüschweiler, J. *Ferdinand Hodler. Selbstbildnisse als Selbstbiographie.* Bern, 1979.
Dietschi, P. *Der Parallelismus Ferdinand Hodlers. Ein Beitrag zur Stilpsychologie der neueren Kunst.* Basel, 1957.
Ferninand Hodler. Paris, Musée du Petit Palais, 1983.
Ferdinand Hodler. Landschaften der Reife und Spätzeit. Zürich, Kunsthaus, 1964.
Hirsh, S. L. *Ferninand Hodler.* London, 1982.
———. *Hodler's symbolist themes.* Ann Arbor, 1983.
*Loosli, C. A. *Ferdinand Hodler. Leben, Werk, und Nachlass.* 4 vols, Bern, 1921-4.
Mühlestein, H., and Schmidt, G. *Ferdinand Hodler. Sein Leben und sein Werk.* Zürich, 1983.
Selz, P. *Ferdinand Hodler.* Berkeley, University Art Museum, 1972.
Wagner, H. *Ferdinand Hodler 1853-1918.* London, Arts Council, 1971.

HOFER
Gedächtnis-Ausstellung für Karl Hofer. Berlin, Staatliche Hochschule für bildende Künste, 1956.
Feist, U. *Karl Hofer. Bilder im Schlossmuseum Ettlingen.* Berlin, 1983.

Hofer, C. *Über das Gesetzliche in der bildenden Kunst.* Berlin-Dahlem, 1956.
Hofer, K. *Aus Leben und Kunst.* Berlin, 1952.
Rathenau, E., ed. *Karl Hofer. Das graphische Werk.* New York, 1969.

HÖLZEL
Adolf Hölzel. Bilder, Pastelle, Zeichnungen, Collagen. Hanover, Kestner Gesellschaft, 1982.
Hildebrandt, H. *Adof Hölzel.* Stuttgart, 1962.
Hölzel und sein Kreis. Der Beitrag Stuttgarts zur Malerei des 20. Jahrhunderts. Stuttgart, Württembergischer Kunstverein, 1961.

ITTEN
Itten, J. *The Art of Colour. The Subjective Experience and Objective Rationale of Colour.* New York, 1961.
Itten, J. *Design and Form. The Basic Course at the Bauhaus.* London, 1964.
*Rotzler, W., ed. *Johannes Itten. Werke und Schriften.* Zürich, 1972. New ed. 1978.

JANCO
Janco, M. *Dada documents et témoignages. 1916-1958.* Tel Aviv, 1959.
Mendelson, M. *Marcel Janco.* Tel Aviv, 1962.
Seuphor, M. *Marcel Janco.* Amriswil, 1963.

JAWLENSKY
Alexej Jawlensky 1864-1941. Munich, Städtische Galerie im Lenbachhaus, 1983.
Hopps, S., and Coplans, J. *Jawlensky and the Serial Image.* Irvine, Calif., 1966.
Jawlensky. Frankfurt, Frankfurter Kunstverein, 1967.
Jawlensky, M., Pieroni-Jawlensky, L., and Jawlensky, A. *Alexej von Jawlensky: catalogue raisonné of the oil paintings. Vol.1: 1890-1914.* London, 1991.
Nagel, W. A. *Alexej Jawlensky: Meditationen.* Hanau, 1983.
Rosenbach, D. *Alexej von Jawlensky: Leben und druckgraphisches Werk.* Hanover, 1985.
Weiler, C. *Jawlensky. Hands, Faces, Meditations.* New York, 1971.

JEANNERET *see* LE CORBUSIER

JOHN
John, A. *Autobiography.* London, 1975.
Easton, M., and Holroyd, M. *The Art of Augustus John.* London, 1974.
Holroyd, M. *Augustus John, a Biography.* 2 vols. London, 1974.

KANDINSKY

Barnett, V. E. *Kandinsky at the Guggenheim*. New York, 1983.

——. *Kandinsky: watercolours. Catalogue raisonné. Vol.1: 1900–1921*. London, 1992.

Bellido, R. T. *Kandinsky*. London, 1987.

*Grohmann, W. *Wassily Kandinsky. Life and Work*. New York, 1959.

Kandinsky, N. *Kandinsky und Ich*. Munich, 1976.

Kandinsky, W. *Complete Writings on Art*. Boston, 1980.

Kandinsky in Paris, 1934–1944. New York, Solomon R. Guggenheim Museum, 1985.

Kandinsky. Oeuvres de Wassily Kandinsky 1866–1944. Paris, Centre Pompidou, 1984.

Overy, P. *Kandinsky. The Language of the Eye*. New York, 1969.

Röthel, H. K., and Benjamin, J. K. *Kandinsky. Catalogue raisonné of the Oil Paintings*. 2 vols. London, 1982–4.

Röthel, H. K. *Kandinsky. Das graphische Werk*. Cologne, 1970.

Vasily Kandinsky, 1866–1944. A Retrospective Exhibition. New York, Guggenheim Museum, 1962.

Washton-Long, R. C. *Kandinsky: The Development of an Abstract Style*. Oxford, 1980.

Weiss, P. *Kandinsky in Munich. The Formative Years*. Princeton, N.J., 1978.

Vergo, P. *Kandinsky Cossacks*. London, Tate Gallery, 1986.

KHNOPFF

Delevoy, R. L. *Fernand Khnopff. Catalogue raisonné*. Paris, 1987.

Dumont Wilden, L. *Fernand Khnopff*. Brussels, 1907.

Eemans, N. *Fernand Khnopff*. Antwerp, 1950.

Fernand Khnopff, 1858–1921. Paris, Musée des Arts Décoratifs, 1979.

Howe, J. W. *The Symbolist Art of Fernand Khnopff*. Ann Arbor, 1982.

KIRCHNER

Bollinger, H., and Reinhardt, G. *Ernst Ludwig Kirchner 1880–1938*. Munich, 1980.

Dube-Heynig, A., and Dube, W. D. *Ernst Ludwig Kirchner. Das graphische Werk*. 2 vols. Munich, 1967.

Ernst Ludwig Kirchner. Nachzeichnung seiner Lebens. Katalog der Sammlung von Werken . . . im Kirchner-Haus. Davos, 1979.

E. L. Kirchner. Dokumente. Aschaffenburg, 1980.

Ernst Ludwig Kirchner: Nachzeichnung seines Lebens. Basle, Kunstmuseum, 1980.

Gordon, D. E. *Ernst Ludwig Kirchner*. Cambridge, Mass., 1968.

Grisebach, L. *E. L. Kirchners Davöser Tagebuch. Eine Darstellung des Malers und eine Sammlung seiner Schriften*. Cologne, 1968.

KLEE

Geelhaar, C. *Paul Klee and the Bauhaus*. Bath, 1973.

Geelhaar, C. *Paul Klee. Schriften, Rezensionen und Aufsätze*. Cologne, 1976.

Glaesemer, J. *Paul Klee*. 3 vols. Bern, 1976.

*Grohmann, W. *Paul Klee*. New York, 1954.

Haftmann, W. *The Mind and Work of Paul Klee*. London, 1954.

Jordan, J. M. *Paul Klee and Cubism*. Princeton, N.J., 1984.

Klee, F., ed. *The Diaries of Paul Klee, 1898–1918*. Berkeley, Calif, 1964.

*Kornfeld, E. W. *Verzeichnis des graphischen Werkes von Paul Klee*. Bern, 1963.

Moesser, A. *Das Problem der Bewegung bei Paul Klee*. Heidelberg, 1976.

KLEIN

Geist, H. F. *César Klein und die gegenstandslose Malerei*. Hamburg, 1948.

Pfefferkorn, R. *César Klein*. Berlin, 1962.

KLIMT

Comini, A. *Gustav Klimt*. New York, 1975.

Fischer, W. G. *Gustav Klimt and Emilie Flöge. An Artist and His Muse*. London, 1992.

Frodl, G. *Der Beethovensfries von Gustav Klimt*. Salzburg, 1987.

Hofmann, W. *Gustav Klimt*. Greenwich, Conn., 1972.

Nebelhay, C. M., ed. *Gustav Klimt. Dokumentation*. Vienna, 1969.

*Novotny, F., and Dobai, J. *Gustav Klimt, with a Catalogue Raisonné of His Paintings*. New York, 1968.

Sarmany-Parsons. I. *Gustav Klimt*. Munich, 1989.

*Strobl, A. *Gustav Klimt. Die Zeichnungen*. 3 vols. Salzburg, 1980–1.

KOKOSCHKA

Calvocoressi, R. *Oskar Kokoschka 1886–1980*. London, Tate Gallery, 1986.

Kokoschka, O. *Das schriftliche Werk*. 4 vols. Hamburg, 1973–6.

Kokoschka, O. *My Life*. London, 1974.

Kokoschka, O., and Murnau, A. (eds.) *Oskar Kokoschka Letters 1905–1976*. London, 1992.

Rathenau, E., ed. *Kokoschka. Drawings, 1906–1965*. Miami, Florida, 1970.

Russell, J. *Oskar Kokoschka. Watercolours, Drawings, Writings.* New York, 1963.
Sabarsky, S. *Kokoschka: early drawings and watercolours.* London, 1985.
Schulz, K. *Oskar Kokoschka 1886–1980.* London, 1986.
Schweiger, W. J. *Der junger Kokoschka. Leben und Werk, 1904–1914.* Vienna and Munich, 1982.
Schweiger, W. J. *Oskar Kokoschka: Der Sturm die Berliner Jahre 1910–1916.* Munich, 1986.
Urbanek, W. *Oskar Kokoschka: Städtebilder und Landschaften.* Munich, 1990.
Whitford, F. *Oskar Kokoschka. A Life.* New York, 1986.
Wingler, H. M., and Welz, F. O. *Kokoschka. Das druckgraphische Werk.* Salzburg, 1975.
Wingler, H. M. *Oskar Kokoschka. Ein Lebensbild in zeitgenössischen Dokumenten.* Munich, 1956.

KOLBE
Binding, R. G. *Vom Leben der Plastik, Inhalt und Schönheit des Werkes von Georg Kolbe.* 2nd enl. ed. Berlin, 1933.
Kolbe, G. *Auf Wegen der Kunst. Schriften, Skizzen, Plastiken.* Berlin, 1949.
Pinder, W. *Georg Kolbe, Werke der letzten Jahre.* Berlin, 1937.
Tiesenhausen, M. F. von. *Georg Kolbe: Brief und Aufzeichnungen.* Tübingen, 1987.

KOLLWITZ
Fecht, T. *Käthe Kollwitz: works in colour.* New York, 1988.
Hartley, K., *et al. Käthe Kollwitz 1867–1945.* Cambridge, Kettle's Yard Gallery, 1981.
Hinz, R., ed. *Käthe Kollwitz. Graphics, Posters, Drawings.* New York, 1981.
Käthe Kollwitz: Druckgraphik, Handzeichnungen, Plastik. Stuttgart, 1990.
Prelinger, E. *Käthe Kollwitz.* New Haven and London, 1992.
*Klipstein, A. *The Graphic Work of Kaethe Kollwitz. Complete Illustrated Catalogue.* New York, 1955.
Kollwitz, H., ed. *Ich sah die Welt mit liebevollen Blicken. Ein leben in Selbstzeugnissen.* Hanover, 1968.
Kollwitz, H., ed. *Käthe Kollwitz. Diary and Letters.* Chicago, 1955.
Nagel, O. *Käthe Kollwitz. Die Handzeichnungen.* 2nd ed. Berlin, 1980.
Schneede, U. M. *Käthe Kollwitz: Das zeichnerische Werk.* Munich, 1981.

KUBIN
Alfred Kubin. Das Zeichnerische Frühwerk bis 1904. Baden-Baden, Staatliche Kunsthalle, 1977.

Kubin, A. *Mein Werk. Dämonen und Nachtgesichte ... mit einer Autobiographie fortgeführt bis 1931.* Dresden, 1931.
*Marks, A. *Der Illustrator Alfred Kubin. Gesamtkatalog seiner Illustrationen und buchkünstlerischen Arbeiten.* Munich, 1977.
Nigro, A. *Alfred Kubin: profeta del tramonto.* Rome, 1983.
Raabe, P., ed. *Alfred Kubin. Leben, Werk, Wirkung.* Hamburg, 1957.
*Schmied, W. *Alfred Kubin.* New York, 1969.
Seipel, W. *Alfred Kubin: Der Zeichner 1877–1959.* Munich, 1988.

KUPKA
Cassou, J., and Fédit, D. *Frank Kupka.* London, 1965.
Frank Kupka. Cologne, Galerie Gmurzynska, 1981.
František Kupka, 1871–1957. A Retrospective. New York, Guggenheim Museum, 1975.
Kupka. Gouaches and Pastels. New York, 1965.
Vachtová, L. *Frank Kupka.* New York, 1968.

LA FRESNAYE
*Cogniat, R., and George, W. *Œuvre complète de Roger de la Fresnaye.* Paris, 1950.
Seligman, G. *Roger de la Fresnaye.* New York, 1969.

LARIONOV
Chamot, M. *Gontcharova.* Paris, 1972.
Gontcharova. Larionov. Paris, Musée d'Art Moderne de la Ville de Paris, 1963.
Hoog, M., and Vigneral, S. *Larionov. Une avantgarde explosive.* Lausanne, 1978.
Loguine, T, ed. *Gontcharova et Larionov. Cinquante ans à Saint Germain-des-Prés.* Paris, 1971.
A Retrospective Exhibition of Paintings and Design for the Theatre. Larionov and Goncharova. London, Arts Council, 1961.

LAURENCIN
Day, G. *Marie Laurencin.* Paris, 1947.
Exposition Marie Laurencin. Paris, Musée d'Art Moderne, 1978.
Groult, F. *Marie Laurencin.* Paris, 1987.
Laurencin, M. *Le Carnet des nuits.* Geneva, 1956.
Marchesseau, D. *Marie Laurencin.* Paris, 1981.
Pierre, J. *Marie Laurencin.* Paris, 1988.

LAURENS
Henri Laurens. Rome, Academy of France, 1980.
Henri Laurens. Exposition de la Donation aux Musées Nationaux. Paris, Grand Palais, 1967.
Henri Laurens, 1895–1954. London, Arts Council, 1971.

Hofmann, W., and Kahnweiler, D. H. *The Sculpture of Henri Laurens*. New York, 1970.
Waldberg, P. *Henri Laurens ou La Femme placée en abîme*. Paris, 1980.

LE CORBUSIER
Curtis, W. J. R. *Le Corbusier: ideas and forms*. Oxford, 1986.
Hervé, L. *Le Corbusier, as Artist, as Writer*. Neuchâtel, 1970.
Le Corbusier. Œuvre plastique, peintures, et dessins, architecture. Paris, 1938.
Papadaki, S., ed. *Le Corbusier. Architect, Painter, Writer*. New York, 1948.

LE FAUCONNIER
Le Fauconnier. Amsterdam, Stedelijk Museum, 1959.
Le Fauconnier, 1881–1945. London, Crane Kalman Gallery, 1973.

LÉGER
Bauquier, G. *Fernand Léger: catalogue raisonné de l'oeuvre peint. Tome 1: 1903–1919. Tome 2: 1920–1924*. Montrouge, 1992.
——. *Fernand Léger. Vivre dans le vrai*. Paris, 1987.
Derouet, C. (ed.) *Fernand Léger. Une Correspondance de Guerre*. Paris, 1990.
Fernand Léger. Paris, Grand Palais, 1971.
Fernand Léger – the later years. London, Whitechapel Art Gallery, 1987.
Francia, P. de. *Fernand Léger*. New Haven and London, 1983.
Green, C. *Léger and the Avant-garde*. New Haven, 1976.
Léger et l'esprit moderne. Une Alternative d'avantgarde à l'art non-objectif (1918–1931). Paris, Musée d'Art Moderne de la Ville de Paris, 1982.
Léger F. *Functions of Painting*. New York, 1973.
Léger and Purist Paris. London, Tate Gallery, 1970.
Léger. Œuvres de Fernand Léger, 1881–1955. Paris, Musée National d'Art Moderne, 1981.
Saphire, L. *Fernand Léger. The Complete Graphic Work*. New York, 1978.
Schmalenbach, W. *Fernand Léger*. New York, 1976.

LEHMBRUCK
Heller, R. *The Art of Wilhelm Lehmbruck*. Washington, National Gallery of Art, 1972.
Hofmann, W. *Wilhelm Lehmbruck*. New York, 1959.
*Petermann, E. *Die Druckgraphik von Wilhelm Lehmbruck*. Stuttgart, 1964.
Salzmann, S. *Wilhelm Lehmbruck. Katalog der Sammlung des Wilhelm-Lehmbruck-Museums der Stadt Duisberg*. Recklinghausen, 1981.

Wilhelm-Lehmbruck-Sammlung. Plastik, Malerei. Duisburg, Wilhelm-Lehmbruck-Museum, 1964.
Wilhelm Lehmbruck: die Zeichnungen der Reifezeit. Stull, 1985.

LEWIS
Cianci, G. (ed.) *Wyndham Lewis Letteratura/Pittura*. Palermo, 1982.
Cork, R. *Wyndham Lewis: The Twenties*. London, Anthony d'Offay Gallery, 1984.
Dasenbrock, R. W. *The Literary Vorticism of Ezra Pound and Wyndham Lewis: towards the condition of painting*. Baltimore and London, 1985.
Edwards, P. *Wyndham Lewis: Art and War*. London, 1992.
Farrington, J. (ed.) *Wyndham Lewis*. London, 1980.
Lemaire, G.-G. *et al. Pour un Temps/Wyndham Lewis*. Paris, 1982.
Meyers, J. *The Enemy. A Biography of Wyndham Lewis*. London, 1980.
Michel, W. *Wyndham Lewis. Paintings and Drawings*. Berkeley and Los Angeles, 1971.
Normand, T. *Wyndham Lewis The Artist. Holding the mirror up to politics*. Cambridge, 1992.
Wyndham Lewis and Vorticism. London, Tate Gallery, 1956.
Wyndham Lewis on Art. Collected Writings 1913–1956. New York, 1969.

LHOTE
Exposition André Lhote. Albi, Musée Toulouse-Lautrec, 1962.
Jakovsky, A. *André Lhote*. Paris, 1947.
Lhote, A. *Écrits sur la peinture*. Paris, 1946.

LIEBERMANN
Brauner, L. *Max Liebermann*. Berlin, 1986.
Liebermann, M. *Gesammelte Schriften*. Berlin, 1922.
Max Liebermann in seiner Zeit. Berlin, Nationalgalerie, 1979.
Meissner, G. *Max Liebermann*. Vienna, 1974.
Meissner, G. *Max Liebermann*. Leipzig, 1986.
Schiefler, G. *Max Liebermann. Sein graphisches Werk*. 3rd ed. Berlin, 1923.

LIPCHITZ
Bermingham, P. *Jacques Lipchitz: sketches and models in the collection of the University of Arizona Museum of Art*. Tucson, 1982.
Hammacher, A. M. *Jacques Lipchitz*. New York, 1975.
Hope, H. R. *The Sculpture of Jacques Lipchitz*. New York, Museum of Modern Art, 1954.
Jacques Lipchitz. Skulpturen und Zeichnungen, 1911–1969. Baden-Baden, Kunsthalle, 1971.

Lipchitz, J., with Arnason, H. H. *My Life in Sculpture*. New York, 1972.
Stott, D. A. *Jacques Lipchitz and Cubism*. New York and London, 1978.

LISSITZKY
El Lissitzky. Cologne, Galerie Gmurzynska, 1976.
Lissitsky, E. *Russia: an architecture for world revolution*. Cambridge (Mass.) 1984.
Lissitzky-Küppers, S. *El Lissitzky. Life, Letters, Texts*. Greenwich, Conn., 1968.
Richter, H. *El Lissitzky. Sieg über die Sonne. Zur Kunst des Konstruktivismus*. Cologne, 1958.

LURÇAT
Lurçat, 10 ans après. Tapisseries, peintures, dessins. Paris, Musée d'Art Moderne de la Ville de Paris, 1976.
Roy, C. *Jean Lurçat*. 2nd rev. ed. Geneva, 1961.

MACKE
August Macke und die Rheinischen Expressionisten. Hanover, Kestner Gesellschaft, 1978.
Erdmann-Macke, E. *Erinnerung an August Macke*. Stuttgart, 1962.
Guse, E-G. *Die Tunisreise: Klee, Macke, Moilliet*. Stuttgart, 1982.
Heiderich, U. *August Macke die Skizzenbücher*. Stuttgart, 1987.
Holzhausen, W. *Auguste Macke*. Munich, 1956.
Macke, W., ed. *August Macke, Franz Marc. Briefwechsel*. Cologne, 1964.
Macke, A. *Briefe an Elisabeth und die Freunde*. Munich, 1987.
Stadler, W. *August Macke er gab der Farbe den hellsten Klang*. Freiburg, 1987.
Mesure, A. *August Macke 1887–1914*. Cologne, 1991.
*Vriesen, G. *August Macke*. 2nd rev. ed. Stuttgart, 1957.

MACKINTOSH
Charles Rennie Mackintosh (1868–1928). Architecture. Design and Painting. Edinburgh, Scottish Arts Council, 1968.
Cooper, J., ed. *Mackintosh. The Complete Buildings and Selected Projects*. New York, 1978.
Grigg, J. *Charles Rennie Mackintosh*. Glasgow, 1987.
Howarth, T. *Charles Rennie Mackintosh and the Modern Movement*. 2nd ed. New York, 1977.
Jones, A. *Charles Rennie Mackintosh*. London, 1990.
Macleod, R. *Charles Rennie Mackintosh. Architect and Artist*. New York, 1983.
Moffat, A. *Remembering Charles Rennie Mackintosh: an illustrated biography*. Lanark, 1989.

Nuttgens, P. (ed.) *Mackintosh and his contemporaries in Europe and America*. London, 1988.

MAGNELLI
Abadie, D. *Magnelli*. Paris, Centre Pompidou, 1989.
Alberto Magnelli. Florence, La Strozzina, 1963.
Fagiolo dell' Arco, M. *Magnelli in Toscana*. Fattoria Castello di Volpaia, 1983.
*Maissonier-Lochard, A. *Alberto Magnelli. L'Œuvre peinte. Catalogue raisonné*. Paris, 1975.

MAGRITTE
Gimferrer, P. *Magritte*. London, 1987.
Hammacher, A. M. *René Magritte*. New York, 1973.
Magritte, R. *Ecrits complets*. Paris, 1979.
Meuris, J. *Magritte*. London, 1988.
René Magritte. New York, Museum of Modern Art, 1965.
Rétrospective Magritte. Brussels, Palais des Beaux-Arts, 1978.
Sylvester, D. *Magritte*. London, 1992.
Sylvester, D., and Whitefield, S. (eds.) *René Magritte: catalogue raisonné. 1: oil paintings, 1916–1930. 2: oil paintings and objects, 1931–1948*. London, 1992.
Torczyner. H. *Magritte. Ideas and Images*. New York, 1977.
Waldberg, P. *René Magritte*. Brussels, 1965.
Whitfield, S. *Magritte*. London, South Bank Centre, 1992.

MAILLOL
Aristide Maillol: 1861–1944. New York, Guggenheim Museum, 1975.
George, W. *Aristide Maillol et l'âme de la sculpture*. Neuchâtel, 1977.
*Guérin, M. *Catalogue raisonné de l'œuvre gravé et lithographié de Aristide Maillol*. 2 vols. Geneva, 1965–7.
*Rewald, J. *The Woodcuts of Aristide Maillol . . .* New York, 1943.
Slatkin, W. *Aristide Maillol in the 1890s*. Ann Arbor, 1982.

MALEVICH
Andersen, T. *Malevich. Catalogue raisonné of the Berlin Exhibition, 1927 . . .* Amsterdam, Stedelijk Museum, 1970.
Beeren, W., et al. *Kazimir Malevich 1878–1935*. Leningrad, Moscow and Amsterdam, 1988.
Crone, R., and Moos, D. *Kazimir Malevich. The Climax of Disclosure*. London, 1991.
Douglas, C., et al. *Malevich: artist and theoretician*. London, 1991.

Gooding, M., and Rothenstein, J. (eds.) *Kazimir Malevich: a box*. London, 1990.
*Karshan, D. H. *Malevich, the Graphic Work, 1913–1930*. Jerusalem, Israel Museum, 1976.
Kasimir Malewitsch um 100 Geburtstag. Cologne, Galerie Gmurzynska, 1978.
Malevich, K. *Suprematismus – Die gegenstandslose Welt*. Cologne, 1962.
Malevich, K. S. *Essays on Art, 1915–1933*. 2 vols. Copenhagen, 1968.
Malevitch, 1878–1938. Actes du Colloque international tenu au Centre Pompidou . . . Lausanne, 1979.
Marcade, J-C. *Malevich*. Paris, 1990.
Petrova, E., *et al. Malevich. Artist and Theoretician*. Paris, 1990.
Simmons, W. S. *Kazimir Malevich's Black Square and the Genesis of Suprematism 1907–1915*. New York and London, 1981.
Zhadova, L. A. *Malevich. Suprematism and Revolution in Russian Art 1910–1930*. London, 1982.

MANGUIN
Cabanne, P., and others. *Henri Manguin*. Neuchâtel, 1964.
*Manguin, L. and C. *Henri Manguin. Catalogue raisonné de l'œuvre peint*. Neuchâtel, 1980.
Manguin parmi les Fauves. Martigny, Fondation Gianadda, 1983.

MAN RAY
Anselmo, L., and Bilat, B. M. *Man Ray. Opera Grafica*. Milan, 1984.
Baldwin, N. *Man Ray*. London, 1989.
Baum, T. *Man Ray's Paris Portraits: 1921–1939*. Washington, 1989.
Esten, J. *Man Ray: Bazaar Years*. New York, 1988.
Foresta, M. A. *Man Ray*. Paris, 1988.
Hartshorn, W., and Foresta, M. *Man Ray in Fashion*. New York, 1990.
Man Ray. *Self Portrait*. Boston, 1963.
Man Ray. Los Angeles County Museum of Art, 1966.
Man Ray. Photographies 1920–1934. Paris-Hartford, 1934.
Martin, J.-H. *Man Ray. Photographs*. New York, 1982.
Penrose, R. *Man Ray*. Boston, 1975.
Schwartz, A. *Man Ray. The Rigour of Imagination*. New York, 1977.

MARC
Franz Marc, 1880–1916. Munich, Städtische Galerie im Lenbachhaus, 1980.
*Lankheit, K. *Franz Marc. Katalog der Werke*. Cologne, 1970.

Lankheit, K. *Franz Marc, sein Leben und seine Kunst*. Cologne, 1976.
Lankheit, K., ed. *Schriften Franz Marc*. Cologne, 1978.
Levine, F. S. *The Apocalyptic Vision. The Art of Franz Marc as German Expressionism*. New York, 1979.
Marc, F. *Postcards to Prince Jussuf*. Munich, 1988.
März, R. *Franz Marc*. Berlin, 1987.
Partsch, S. *Franz Marc 1880–1916*. Cologne, 1991.
Pese, C. *Franz Marc: Leben und Werk*. Zurich, 1989.
Rosenthal, M. *Franz Marc*. Munich, 1989.
Tobien, F. *Franz Marc*. Kirchdorf, 1987.

MARCKS
Gerhard Marcks. Los Angeles, University of California, 1969.
Gerhardt Marcks. Werke der Köhner Jahre. Skulpturen, Holzschnitte, Zeichnungen. Cologne, Kunstverein, 1969.
Lammek, K. *Gerhard Marcks, das druckgraphische Werk*. Stuttgart, 1990.
*Rudloff, M. *Das plastische Werk Gerhard Marcks*. Berlin-Vienna, 1977.

MARCOUSSIS
Lanfranchis, J. *Marcoussis, Sa Vie, son œuvre. Catalogue complet des peintures, fixés sur verre, aquarelles, dessins, gravures*. Paris, 1961.
Millet, S. *Louis Marcoussis: Catalogue raisonné de l'oeuvre grave*. Copenhagen, 1992.

MARQUET
Albert Marquet, 1875–1947. Bordeaux, Galerie des Beaux-Arts, 1975.
Jourdain, F. *Marquet*. Paris, 1959.

MARTINI
Arturo Martini. Le Lettere, 1909–1947. Florence, 1967.
Bellongi, F. *Arturo Martini*. Rome, 1975.
Chinol, E. *Falsi nell'arte: il caso Martini*. Rome, 1986.
Clair, J., *et al. Arturo Martini 1889–1947. Sculptures*. Milan, 1991.
*Perocco, G. *Arturo Martini. Catalogo delle sculture e delle ceramiche*. Vicenza, 1966.
Vianello, G. *Arturo Martini: terrecotte e ceramiche*. Milan, 1985.

MASSON
André Masson: Line Unleashed. London, South Bank Centre, 1987.
Charbonnier, G. *Entretiens avec André Masson*. Ryôan-ji, 1985.
Davvetas, D. *Dialog = dialogue: André Masson*. Zurich, 1987.

Drot, J-M. *Masson: l'insurge du XXme siècle*. Rome, 1989.

Franzke, A. *André Masson: Skulp:uren*. Cologne, 1988.

Meredieu, F. de. *André Masson: les dessins automatique*. Paris, 1988.

Rubin, W., and Lanchner, C. *André Masson*. New York, Museum of Modern Art, 1976.

Will-Levaillant, F., ed. *André Masson. Le Rebelle du surréalisme. Écrits*. Paris, 1976.

MATARÉ

Flemming, H. T. *Ewald Mataré*. Munich, 1955.

Klapheck, A. *Ewald Mataré: aquarelle 1920–1956*. Munich, 1983.

*Peters, H. *Ewald Mataré. Das graphische Werk*. 2 vols. Cologne, 1957–8.

MATISSE

Barr, A. H., Jr. *Matisse. His Art and His Public*. New York, 1951.

Bois, Y-A., et al. *Henri Matisse 1904–1917*. Paris, Centre Pompidou, 1993.

Carlson, V. I. *Matisse as a Draughtsman*. Greenwich, Conn., 1971.

Cowart, J., et al. *Henri Matisse. Paper Cut-outs*. New York, 1977.

Cowart, J., et al. *Matisse in Morocco. The Paintings and Drawings, 1912–1913*. London, 1990.

The Drawings of Henri Matisse. New York, Museum of Modern Art, 1984.

Duthuit-Matisse, M., and Duthuit, C. *Catalogue raisonné de l'œuvre gravé . . .* 2 vols. Paris, 1983.

Elsen, A. E. *The Sculpture of Henri Matisse*. New York, 1978.

Elderfield, J. *Henri Matisse. A Retrospective*. London, 1992.

Flam, J. D., ed. *Matisse on Art*. London, 1973.

Flam, J. *Matisse: The Man And His Art*. London, 1986.

Gilot, F. *Matisse and Picasso: A Friendship in Art*. London, 1990.

Girard, X. *La Chapelle du Rosaire, 1948–1951*. Paris, 1992.

Guichard-Meili, J. *Matisse. Paper Cutouts*. New York, 1984.

Guillaud, J. and M. *Matisse: Le rythme et la ligne*. Paris, 1987.

Henri Matisse. Exposition du centenaire. Paris, Grand Palais, 1970.

Matisse, 1869–1954. London, Hayward Gallery, 1968.

Matisse. L'Œuvre gravé. 2nd ed., rev. Paris, Bibliothèque Nationale, 1970.

Monod-Fontaine, I. *The Sculpture of Henri Matisse*. London, Arts Council, 1984.

Reverdy, P., and Duthuit, G. *The Last Works of Matisse*. New York, 1958.

Schneider, P. *Matisse*. London, 1984.

Watkins, N. *Matisse*. Oxford, 1984.

MCWILLIAM

F. E. *McWilliam*. Belfast, Arts Council of Northern Ireland, 1981.

Gooding, M. *F. E. McWilliam Sculpture 1932–1989*. London, Tate Gallery, 1989.

MEIDNER

Eliel, C. S., and Roters, E. *The Apocalyptic Landscapes of Ludwig Meidner*. Los Angeles, 1989.

Grochowiak, T. *Ludwig Meidner*. Recklinghausen, 1966.

Kunz, L., ed. *Dichter, Maler, und Cafés*. Zürich, 1973.

Ludwig Meidner, an Expressionist Master. Ann Arbor, University of Michigan Museum of Art, 1978.

MEŠTROVIĆ

Gagro, B. *Ivan Meštrović*. Zagreb, 1987.

Schmeckebier, L. *Ivan Meštrović, Sculptor and Patriot*. Syracuse, N.Y., 1959.

The Sculpture of Ivan Meštrović. Syracuse, N.Y., 1948.

METZINGER

Metzinger. Pre-Cubist and Cubist Works. Chicago, International Galleries, 1964.

MILLES

Cornell, H. *Millesgården. Its Garden and Art Treasures*. Stockholm, 1960.

Liden, E. *Between water and heaven: Carl Milles search for American commissions*. Stock, 1986.

Rogers, M. R. *Carl Milles. An Interpretation of His Work*. New Haven, Conn., 1940.

Verneuil, M. P. *Carl Milles, sculpteur suédois*. 2 vols. Paris and Brussels, 1929.

MINNE

George Minne en de kunst rond 1900. Ghent, Museum voor Schone Kunsten, 1982.

Puyvelde, L. van. *Georges Minne*. Brussels, 1930.

Ridder, A. de. *Georges Minne*. Antwerp and Brussels, 1947.

MIRÓ

A Joan Miró: col. leccio permanent d'art contemporan. Barcelona, Fundació Joan Miró, 1986.

Català-Roca, F. *Miró: ninetey years*. London, 1984.
Char, R., *et al. Miró: oeuvre gravé*. Paris, 1990.
Cirici, A. *Miró et son temps*. Barcelona, 1985.
Dupin, J. *Joan Miró. Life and Work*. New York, 1962.
Joan Miró, Magnetic Fields. New York, Guggenheim Museum, 1972.
Joan Miró Paintings and Drawings 1929–41. London, Whitechapel Art Gallery, 1989.
Jeffett, W. *Joan Miró Sculpture*. London, South Bank Centre, 1990.
Jouffroy, A., and Teixidor, J. *Miró Sculpture*. New York-Paris, 1974.
Leiris, M. *Joan Miró Lithographes*. 3 vols. Paris, 1972–7.
Miró Bronzes. London, Arts Council, 1972.
Miró. L'Œuvre complet. 2 vols. Tokyo, 1967.
Rubin, W. S. *Miró in the Collection of the Museum of Modern Art*. New York, 1973.
Scheidegger, E., ed. *Joan Miró. Gesammelte Schriften, Fotos, Zeichnungen*. 2nd ed. Zürich, 1959.

MODERSOHN-BECKER
Busch, G. *Paula Modersohn-Becker. Malerin, Zeichnerin*. Frankfurt-am-Main, 1981.
Harke, P. J. *Stilleben von Paula Modersohn-Becker*. Bremen, 1985.
Modersohn-Becker, P. *The Letters and Journals . . .* Metuchen, N.J., and London, 1980.
Parry, G. *Paula Modersohn-Becker. Her Life and Art*. New York, 1979.
Pauli, G. *Paula Modersohn-Becker*. 2nd ed. Munich, 1922.
Uhde-Stahl, B. *Paula Modersohn-Becker*. Stull, 1989.

MODIGLIANI
Amedeo Modigliani, 1884–1920. Paris, Musée d'Art Moderne de la Ville de Paris, 1981.
Castieau-Barrielle, T. *La Vie et l'œuvre de Amedeo Modigliani*. Paris, 1987.
Ceroni, A. *Amedeo Modigliani, peintre*. Milan, 1958.
Ceroni, A. *Modigliani: les nus*. Paris, 1989.
Farneti, G. *Modigliani: storia di un falso d'arte e di una grande beffa*. Milan, 1988.
Fifield, W. *Modigliani*. New York, 1976.
*Lanthemann, J. *Modigliani, 1884–1920. Catalogue raisonné. Sa vie, son œuvre complet, son art*. Barcelona, 1970.
Rose, J. *Modigliani. The Pure Bohemian*. London, 1990.
Scheiwiller, G., ed. *Modigliani. Selbstzeugnisse, Photos, Zeichnungen, Bibliographie*. Zürich, 1958.
Shuster, B. *Modigliani: a study of his sculpture*. Jacksonville, 1986.

MOHOLY-NAGY
Caton, J. H. *The Utopian Vision of Moholy-Nagy*. Ann Arbor, 1984.
Kostelanetz, R. (ed.) *Moholy-Nagy*. London, 1971.
L. Moholy-Nagy. London, Institute of Contemporary Art, 1980.
Moholy-Nagy, L. *The New Vision, from Material to Architecture*. New York, 1932, and later eds.
Moholy-Nagy, L. *Vision in Motion*. Chicago, 1947.
Moholy-Nagy, S. *Moholy-Nagy. Experiment in Totality*. New York, 1950.
Passuth, K. *Moholy-Nagy*. London, 1985.

MONDRIAN
Bois, Y.-A., *et al. L'Atelier de Mondrian. Recherches et dessins*. Paris, 1982.
Carmean, E. A. *Mondrian. The Diamond Compositions*. Washington, National Gallery of Art, 1979.
Champa, K. S. *Mondrian Studies*. Chicago, 1985.
Henkels, H. *Piet Mondrian in het Haags Gemeentemuseum*. The Hague, 1985.
Jaffé, H. L. C. *Piet Mondrian*, Cologne, 1971.
Milner, J. *Mondrian*. London, 1992.
Mondrian, Drawings, New York Paintings. Baltimore, Museum of Art, 1981.
Mondrian, P. *Plastic Art and Pure Plastic Art, 1937, and Other Essays, 1941–43*. New York, 1945.
Mondrian, P. *The new art; the new life. The collected writings of Piet Mondrian*. London, 1987.
Piet Mondrian, 1872–1944. Centennial Exhibition. New York, Guggenheim Museum, 1971.
Ragghianti, C. L. *Mondrian e l'arte del XX secolo*. 2nd rev. ed. Milan, 1963.
Seuphor, M. *Piet Mondrian. Life and Work*. New York, 1957.
Shapiro, D. *Mondrian: flowers*. New York, 1991.
Threlfall, T. *Piet Mondrian: his life's work and evolution*. New York and London, 1988.

MONET
Arcangeli, F. *Monet*. Bologna, 1989.
Claude Monet au temps de Giverny. Paris, Centre Culturel du Marais, 1983.
Geffroy, G. *Claude Monet, sa vie, son œuvre. Edition critique*. Paris, 1980.
Hommage à Claude Monet. Paris, Grand Palais, 1980.
Hoog, M. *Les Nymphéas de Claude Monet*. Paris, 1985.
Hoog, M. *The Nymphéas of Claude Monet at the Musée de l'Orangerie*. Paris, 1990.
House, J. *Monet. Nature into Art*. New Haven, Conn., and London, 1986.
Isaacson, J. *Observation and Reflection. Claude Monet*. New York, 1978.
Kendall, R. (ed.) *Monet by himself*. London, 1989.

Monet's Years at Giverny. Beyond Impressionism. New York, Metropolitan Museum of Art, 1978.
Piguet, P. *Monet and Venice.* Paris, 1986.
Rewald, J., and Weitzenhoffer, F. *Aspects of Monet. A Symposium on the Artist's Life and Times.* New York, 1984.
Sagner-Düchting, K. *Claude Monet: Nymphéas.* New York, 1985.
Seitz, W. C. *Claude Monet.* New York, 1960.
Seitz, W. C. *Claude Monet. Seasons and Moments.* New York, Museum of Modern Art, 1960.
Spate, V. *The Colour of Time. Claude Monet.* London, 1992.
Stuckey, C. *Monet Water Lilies.* New York, 1988.
Tucker, P. H. *Monet at Argenteuil.* New Haven and London, 1982.
——. *Monet in the '90s. The Series Paintings.* Boston, New Haven and London, 1990.
*Wildenstein, D. *Claude Monet. Biographie et catalogue raisonné.* 4 vols. Lausanne and Paris, 1974–85.

MOORE
Bowness, A., ed. *Henry Moore, Sculpture and Drawings.* 5 vols. London, 1957–80.
Cramer, G., Grant, A., and Mitchinson, D. *Henry Moore. Catalogue of Graphic Work.* 2 vols. Geneva, 1973.
Henry Moore. London, Arts Council, 1968.
Henry Moore, Sculpture and Drawings. 3 vols. London, 1957–65.
Moore, H. *Henry Moore on Sculpture.* London, 1966.
Mostra di Henry Moore. Florence, Forte di Belvedere, 1972.
Wilkinson, A. G. *The Drawings of Henry Moore.* London, 1977.

MORANDI
Basile, F. *Morandi incisore.* Bologna, 1985.
Mundy, J. *Giorgio Morandi Etchings.* London, Tate Gallery, 1991.
Pasquali, M. *Morandi: acquerelli: catalogo generale.* Milan, 1991.
Vitali, L. *Giorgio Morandi. Catalogo generale.* 2 vols. Milan, 1977.
Vitali, L. *Giorgio Morandi, pittore.* Milan, 1965.
Vitali, L. *L'Opera grafica di Giorgio Morandi,* 2nd ed. Turin, 1964.

MOREAU
Bittler, P., and Mathieu, P.-L. *Catalogue des dessins de Gustave Moreau.* Paris, 1983.
French Symbolist Painters; Moreau, Puvis de Chavannes, Redon and their Followers. London, Hayward Gallery, 1972.

Gustave Moreau. Paris, Musée National du Louvre, 1961.
Gustave Moreau et le symbolisme. Geneva, Petit Palais, 1977.
Kaplan, J. *The Art of Gustave Moreau: theory, style and content.* Ann Arbor, 1982.
*Mathieu, P.-L. *Gustave Moreau. Complete Edition of the Finished Paintings, Watercolours and Drawings.* Oxford, 1977.
Mathieu, P-L. *Gustave Moreau aquarelles.* Fribourg, 1984.
——. *Le Musée Gustave Moreau.* Paris, 1986.
Paladilhe, J., and Pierre, J. *Gustave Moreau.* London, 1972.
Renan, A. *Gustave Moreau (1826–1898).* Paris, 1900.

MORISOT
Adler, K., and Garb, T. *Berthe Morisot.* Oxford, 1987.
*Bataille, M.-L., and Wildenstein, G. *Berthe Morisot. Catalogue des peintures, pastels, et aquarelles.* Paris, 1961.
Berthe Morisot. Drawings, Pastels, Watercolors, Paintings, New York, 1960.
Edelstein, T. J. (ed.) *Perspectives on Morisot.* New York, 1990.
Higonnet, A. *Berthe Morisot: a biography.* London, 1990.
Rouart, D., ed. *The Correspondence of Berthe Morisot with Her Family and Her Friends.* 2nd ed. London, 1959.

MUCHA
Mucha, 1860–1930. Peintures, illustrations, affiches, arts décoratifs. Paris, Grand Palais, 1980.
Mucha, J., et al. *Alphonse Mucha.* Rev. enl. ed. New York, 1974.
Mucha, J., ed. *The Graphic Work of Alphonse Mucha.* London, 1973.
Rennert, J. *Mucha: la collection Ivan Lendl.* Paris, 1989.

MUCHE
Georg Muche. Gemälde, Zeichnungen, Graphik. Munich, Städtische Galerie, 1965.
Muche, G. *Blickpunkt: Sturm, Dada, Bauhaus, Gegenwart.* Munich, 1961.

MUELLER
*Buchheim, L.-G. *Otto Mueller. Leben und Werk.* Feldafing, 1963.
Lüttichau, M-A. von. *Otto Mueller.* Cologne, 1993.
Otto Mueller zum hundertsten Geburtstag. Das graphisches Gesamtwerk. Berlin, Galerie Nierendorf, 1974.

MUNCH

Boe, A. *Edvard Munch*. Barcelona, 1989.

Carlsson, A. *Edvard Munch: Leben und Werk*. Stuttgart, 1984.

Edvard Munch. Symbols and Images. Washington, National Gallery of Art, 1978.

Eggum, A. *Edvard Munch: paintings, sketches and studies*. London, 1984.

——. *Munch and photography*. New Haven and London, 1989.

Heller, R. *Edvard Munch. The Scream*. London, 1973.

Heller, R. *Munch. His Life and Times*. Chicago, 1984.

Langaard, J. H., and Revold, R. *Edvard Munch. The University Murals, Graphic Art, and Paintings*. Oslo, 1960.

Messer, T. M. *Munch*. London, 1987.

Moen, A. *Edvard Munch. Graphic Art and Paintings*. 3 vols. Oslo, 1956–8.

Stang, R. T. *Edvard Munch. The Man and his Art*. New York, 1979.

Timm, W. *The Graphic Art of Edvard Munch*. New York, 1969.

Wood, M-H. (ed.) *Edvard Munch. The Frieze of Life*. London, National Gallery, 1992.

MÜNTER

Eichner, J. *Kandinsky und Gabriele Münter. Von Ursprüngen moderner Kunst*. Munich, 1957.

Gabriele Münter, 1877–1962. Munich, Städtische Galerie im Lenbachhaus, 1977.

Röthel, H. K. *Gabriele Münter*. Munich, 1957.

Windecker, S. *Gabriele Münter. Eine Künstlerin aus dem Kreis des Blauen Reiter*. Berlin, 1991.

NASH

Causey, A. *Paul Nash*. Oxford, 1980.

Colvin, C. *Paul Nash Places*. London, 1989.

Cork, R. '"A Bitter Truth": Paul Nash and the Great War'. *Essays in Honour of John White*, ed. Weston and Davies. London, University College, 1990.

Eates, M. *Paul Nash. The Master of the Image. 1889–1946*. London, 1973.

King, J. *Interior Landscapes. A Life of Paul Nash*. London, 1987.

Nash, P. *Outline. An Autobiography, and Other Writings*. London,1949.

Paul Nash. Through The Fire: Paintings, drawings and graphic work from the First World War. London, Imperial War Museum, 1988.

*Postan, A. *The Complete Graphic Work of Paul Nash*. London, 1973.

NEVINSON

Knowles, Elizabeth, *et al. C. R. W. Nevinson*. Cambridge, Kettle's Yard Gallery, 1983.

Nevinson, C. R. W. *Paint and Prejudice*. London, 1938.

Phillips, C. and P. *Nash and Nevinson in War and in Peace. The Graphic Work 1914–1920*. London, 1977.

Sitwell, O. *C.R.W. Nevinson*. London, 1925.

NICHOLSON

Alley, R. *Ben Nicholson*. London, 1962.

Ben Nicholson. Drawings, Paintings, Reliefs. 1911–1968. London, 1969.

Ben Nicholson. Fifty Years of his Art . . . Buffalo, Albright-Knox Art Gallery, 1979.

Lewison, J. *Ben Nicholson: the years of experiment 1919–39*. Cambridge, Kettle's Yard Gallery, 1983.

——. *Ben Nicholson*. Oxford, 1991.

Lynton, N. *Ben Nicholson: recent works*. London, Waddington Galleries, 1980.

Neve, C. *Ben Nicholson: new work*. London, Waddington Galleries, 1982.

Russell, J. *Ben Nicholson. Drawings, Paintings and Reliefs 1911–1968*. New York, 1969.

Sausmarez, M. de (ed.) *Ben Nicholson*. London, Studio International, 1969.

NOLDE

Emil Nolde: unpainted pictures. Seebüll, 1987.

Emil Nolde 1867–1956. Malmö, Konsthall, 1976.

Haftmann, W. *Emil Nolde*. New York, 1959.

Haftmann, W. *Emil Nolde. Unpainted Pictures*. New York, 1965.

Hesse-Frielinghaus, H. *Emil und Ada Nolde*. Bonn, 1985.

Hofmann, W., *et al. Emil Nolde und der Hamburger Hafen*. Hamburg, 1988.

Nolde, E. *Mein Leben . . .* Cologne, 1976.

Schiefler, G. *Emil Nolde. Das Graphische Werk*. Rev. ed. 2 vols. Cologne, 1966–7.

Selz, P. *Emil Nolde*. New York, Museum of Modern Art, 1963.

Urban, M. *Emil Nolde: catalogue raisonné of the oil paintings. Vol.1: 1895–1914*. London, 1987.

——. *Emil Nolde: catalogue raisonné of the oil paintings. Vol. 2: 1915–1951*. London, 1990.

OBRIST

Hermann Obrist, Wegbereiter der Moderne. Munich, 1968.

OZENFANT

Nierendorf, K. *Amédée Ozenfant*. Berlin, 1931.

Ozenfant, A. *Mémoires 1886–1962*. Paris, 1968.

PANNAGGI
Pannaggi, I. *Pannaggi*. Oslo, 1962.

PASCIN
Brodzky, H. *Pascin*. London, 1946.
Freudenheim, T. L. *Pascin*. Berkeley, University Art Museum, 1966.
Hemin, Y., *et al. Pascin: catalogue raisonné: peintures, aquarelles, pastels, dessins. Tome 1*. Paris, 1984.
Pascin: 100 oil paintings, watercolours and drawings from the Museum's Collection. Jerusalem, Bazalel National Museum, 1978.

PECHSTEIN
Fechter, P. *Das graphische Werk Max Pechsteins*. Berlin, 1921.
Krüger, G. *Das Druckgraphische Werk Max Pechsteins*. Hamburg, 1988.
Lemmer, K. *Max Pechstein und der Beginn des Expressionismus*. Berlin, 1949.
Max Pechstein. Kaiserslautern, Pfalz Galerie, 1982.
Pechstein, M. *Erinnerungen*. Wiesbaden, 1960.

PERMEKE
Constant Permeke. Retrospective Tentoonstelling. Antwerp, Musée Royal des Beaux-Arts, 1959.
Ridder, A. de. *Constant Permeke, 1887–1952*. Brussels, 1953.
Van den Bussche, W., and De Clerck, R. *Jabbeke. Provincial Museum Constant Permeke. Kataloog*. Bruges, 1972.

PEVSNER
Massat, R. *Antoine Pevsner et le Constructivisme*. Paris, 1956.
Naum Gabo. Antoine Pevsner. New York, Museum of Modern Art, 1948.
Peissi, P., and Giedion-Welcker, C. *Antoine Pevsner*. Neuchâtel, 1961.
Pevsner, A. *A Biographical Sketch of My Brothers, Naum Gabo and Antoine Pevsner*. Amsterdam, 1964.

PICABIA
Barras, M. L. *Picabia*. New York, 1985.
Camfield, W. A. *Francis Picabia. His Art Life and Times*. Princeton, N.J., 1979.
Francis Picabia. Paris, Musée National d'Art Moderne, 1976.
Le Bot, M. *Francis Picabia et la crise des valeurs figuratives (1900–1928)*. Paris, 1968.
Picabia, F. *Écrits. 1913–1920*. Paris, 1975.
Picabia, F. *Who knows: poems and aphorisms by Francis Picabia*. New York, 1986.
Picabia 1879–1953. Edinburgh and Frankfurt, 1988.
Sanouillet, M. *Francis Picabia et 391*. Paris, 1966.

PICASSO
Ashton, D., ed. *Picasso on Art. A Selection of Views*. New York, 1972.
*Bloch, G. *Pablo Picasso. Catalogue de l'œuvre gravé et lithographié . . .* 4 vols. Bern, 1968–79.
The Body on the Cross. Paris, Musée Picasso, 1992.
*Boeck, W., and Sabartés, J. *Picasso*. New York, 1955.
Chipp, H. B. *Picasso's Guernica*. London, 1989.
*Daix, P. *Le Cubisme de Picasso. Catalogue raisonné de l'œuvre peint 1907–1916*. Neuchâtel, 1979.
*Daix, P., and Boudaille, G. *Picasso. The Blue and Rose Periods. A Catalogue Raisonné of the Paintings 1900–1906*. Greenwich, Conn., 1967.
Glimcher, A. and M. (eds.) *Je Suis Le Cahier. The Sketchbooks of Picasso*. London, 1986.
Glozer, L. *Picasso und der Surealismus*. Cologne, 1974.
Kibbey, R. A. *Picasso, a Comprehensive Bibliography*. Chicago and London, 1980.
Late Picasso. London, Tate Gallery, 1988.
Leighten, P. *Re-ordering the Universe. Picasso and Anarchism 1897–1914*. Princeton, 1989.
McCully, M. *A Picasso Anthology. Documents, Criticism, Reminiscences*. London, 1981.
Penrose, R. *Picasso. His Life and Work*. Rev. ed. Harmondsworth, 1971.
The Picasso Museum, Paris, Catalogue of Paintings, Collages . . . New York, 1986.
Penrose, R., and Golding, J. (eds.) *Picasso in Retrospect*. London, 1981.
Picasso & les choses. Paris, Grand Palais, 1992.
Picasso's Picassos. London, Arts Council, 1981.
Richardson, J. *A Life of Picasso. Vol.1: 1881–1906*. London, 1991.
Russell, F. D. *Picasso's Guernica. The Labyrinth of Narrative and Vision*. London, 1980.
Rubin, W., ed. *Pablo Picasso. A Retrospective*. New York, Museum of Modern Art, 1980.
Sabartés, J. *Picasso lithographe*. 4 vols. Monte Carlo, 1949–64.
Schiff, G. *Picasso, the Last Years*. New York, 1983.
*Spies, W. *Picasso Sculpture, with a Complete Catalogue*. London, 1972.
Warncke, C-P. and Walther, I. F. (eds.) *Pablo Picasso 1881–1973*. 2 vols. Cologne, 1992.
Zervos, C. *Dessins de Pablo Picasso, 1892–1948*. Paris, 1949.
Zervos, C. *Pablo Picasso. Œuvres*. 21 vols. Paris, 1932–69.

PISSARRO, C.
Bailly-Herzberg, J. (ed.) *Correspondance de Camille Pissarro. Tome 1: 1865–1885*. Paris, 1980.
——. *Correspondance de Camille Pissarro. Tome 2: 1886–1890*. Paris, 1986.

——. *Correspondance de Camille Pissarro. Tome 3: 1891–1894*. Paris, 1988.

Brettell, R. R. *Pissarro and Pontoise: the painter in a landscape*. New Haven and London, 1990.

Brettell, R. R. and Pissarro, J. *The Impressionist and the City: Pissarro's Series*. New Haven and London, 1993.

Camille Pissarro, 1830–1903. London, Hayward Gallery, 1980.

Lloyd, C. *Camille Pissarro*. New York, 1981.

Lloyd, C. (ed.) *Studies on Camille Pissarro*. London, 1986.

Pissarro, C. *Letters to His Son Lucien*. 3rd ed., rev. and enl. Mamaroneck, N.Y., 1972.

Pissarro, L. R., and Venturi, L. *Camille Pissarro. Son art – son œuvre*. Paris, 1939.

Reed, N. *Camille Pissarro at the Crystal Palace*. London, 1987.

——. *Pissarro in Richmond*. London, 1989.

Shikes, R. E., and Harper, P. *Pissarro. His Life and Work*. New York, 1980.

Thomson, R. *Camille Pissarro*. London, South Bank Centre, 1990.

PISSARRO, L.

Meadmore, W. S. *Lucien Pissarro. Un cœur simple*. London, 1962.

Thorold, A. *A Catalogue of the Oil Paintings of Lucien Pissarro*. London, 1983.

PRAMPOLINI

Continuità dell' avanguardia in Italia. Enrico Prampolini. Modena, 1978.

Oliva, A. B. *Prampolini: opere dal 1913 al 1956*. Bologna, 1985.

Prampolini, E. *Arte polimaterica (verso un'arte collettiva?)*. Rome, 1944.

PURRMANN

Göpel, B., and Göpel, E. *Leben und Meinungen des Malers Hans Purrmann*. Wiesbaden, 1961.

Steigelmann, W. *Hans Purrmann und die Pfalz. Erlebte Kunstgeschichte in Briefen*. Edenkoben, 1975.

PUVIS DE CHAVANNES

Puvis de Chavannes, 1824–1898. Ottawa, National Gallery of Canada, 1977.

Wattenmaker, R. J. *Puvis de Chavannes and the Modern Tradition*. Toronto, Art Gallery of Ontario, 1975.

PUY

Puy, M. *Jean Puy*. Paris, 1920.

Rochas, C. *Jean Puy*. Geneva, 1977.

Valtat et ses amis: Albert André, Charles Camoin, Henri Manguin, Jean Puy. Besançon, Musée des Beaux-Arts, 1964.

REDON

Bacou, R. *Odilon Redon*. 2 vols. Geneva, 1956.

Bacou, R. *Musée du Louvre, la donation Ari et Suzanne Redon*. Paris, 1984.

——. *Odilon Redon pastels*. London, 1987.

Coustel, R. *L'Univers d'Odilon Redon*. Paris, 1984.

Eisenman, S. F. *The temptation of Saint Redon*. Chicago, 1992.

Gott, T. *The enchanted stone: the graphic worlds of Odilon Redon*. Melbourne, 1990.

Hobbs, R. *Odilon Redon*. London, 1977.

Mellerio, A. *Odilon Redon, peintre, dessinateur, et graveur*. Paris, 1923.

Odilon Redon. Winterthur, Kunstmuseum, 1983.

Odilon Redon, Gustave Moreau, Rodolphe Bresdin. New York, Museum of Modern Art, 1961.

Vialla, J. *La Vie et l'œuvre d'Odilon Redon*. Courbevoie, 1988.

RENOIR

Brodskaya, N. *Auguste Renoir*. Leningrad, 1986.

*Daulte, F. *Auguste Renoir. Catalogue raisonné de l'œuvre peint*, 1. Lausanne, 1971. In progress.

Drucker, M. *Renoir*. Paris, 1949.

Haesaerts, P. *Renoir, Sculptor*. New York, 1947.

Monneret, S. *Renoir*. London, 1990.

Renoir. London, Hayward Gallery, and Boston, Museum of Fine Arts, 1985.

Renoir, J. *Renoir, My Father*. Boston, 1962.

Renoir. London, Arts Council, 1985.

Rewald, J., ed. *Renoir, Drawings*. New York, 1958.

Rouart, D. *Renoir*. New York, 1985.

*Stella, J. G. *The Graphic Work of Renoir. Catalogue raisonné*. Bradford-London, 1975.

Wadley, N. (ed.) *Renoir: a retrospective*. New York, 1987.

White, B. E. *Renoir. His Life, Art, and Letters*. New York, 1984.

RIBEMONT-DESSAIGNES

Ribemont-Dessaignes, G. *Dada 2*. Paris, 1978.

Ribemont-Dessaignes, G. *Manifestes Dada . . .1915–1930*. Paris, 1974.

RICHTER

Gray, C., ed. *Hans Richter by Hans Richter*. New York, 1971.

Hans Richter. Ein leben für Bild und Film. Zürich, Kunstgewerbemuseum, 1959.

Richter, H. *Opera grafica dal 1902 al 1969*. Pollenza, 1976.

RIPPL-RÓNAI

Genthon, I. *Rippl-Rónai. The Hungarian 'Nabi'*. Budapest, 1958.
Keserü, K. *Jozsef Rippl-Rónai*. Berlin, 1983.

ROBERTS

Gibson, R. *William Roberts. An Artist and his Family*. London, National Portrait Gallery, 1984.
Roberts, W. *Abstract and Cubist Paintings and Drawings*. London, 1957.
Roberts, W. *Paintings, 1917–1958*. London, 1960.
Roberts, W. *Memories of the War to End War 1914–18*. London, n.d. (1974).
——. *Early Years*. London, 1982.

RODIN

Beausire, A. *Quand Rodin exposait*. Paris, 1988.
Champigneulle, B. *Rodin, His Sculpture, Drawings, and Watercolours*. New York, 1967.
Descharnes, R., and Chabrun, J.-F. *Auguste Rodin*. London, 1967.
Elsen, A., and Varnedoe, J. K. T. *The Drawings of Rodin*. New York, 1971.
Elsen, A. E., ed. *Rodin Rediscovered*. Washington, National Gallery of Art, 1981.
Elsen, A. E. *Rodin's 'Thinker' and the Dilemmas of Modern Public Sculpture*. New Haven, Conn., and London, 1985.
Elsen, A. E. *'The Gates of Hell' by Auguste Rodin*. Stamford, Calif., 1985.
Grunfeld, F. V. *Rodin: a biography*. London, 1987.
Güse, E-G. *Auguste Rodin: drawings and watercolours*. London, 1985.
Lampert, C. *Rodin Sculpture and Drawings*. London, Arts Council, 1986.
Pinet, H. *Les photographes de Rodin*. Paris, 1986.
Powis, R-M. *Camille: the life of Camille Claudel*. London, 1988.
Tancock, J. L. *The Sculpture of Auguste Rodin*. Boston, 1976.
*Thorson, V. *Rodin Graphics: A Catalogue Raisonné of Drypoints and Book Illustrations*. The Fine Arts Museums of San Francisco, 1975.

ROHLFS

Gädeke, T. *Christian Rohlfs: Bestands-Katalog seiner Werke im Schleswig-Holstein Landmuseum*. Schleswig-Holstein, 1990.
Scheidig, W. *Christian Rohlfs*. Dresden, 1965.
*Vogt, P. *Christian Rohlfs. Œuvre-katalog der Gemälde*. Recklinghausen, 1978.

Vogt, P. *Christian Rohlf's*. 2 vols. Recklinghausen, 1958–60.
Vogt, P. *Christian Rohlfs: Aquarelle, Wassertemperablatter, Zeichnungen*. Recklinghausen, 1988.

ROSSO

Barr, M. S. *Medardo Rosso*. New York, Museum of Modern Art, 1963.
Borghi, M. *Medardo Rosso*. Milan, 1950.
Caramel, L. *Medardo Rosso. Impressions in Wax and Bronze 1882–1906*. New York, 1988.
Medardo Rosso. Frankfurt-am-Main, Kunstmuseum, 1984.
Mostra di Medardo Rosso (1858–1928). Milan, Palazzo della Permanente, 1979.
Sanna, J. de. *Medardo Rosso o la creazione dello spazio moderno*. Milan, 1985.

ROUAULT

Benincasa, C. *Georges Rouault*. Turin, 1988.
*Chapon, F, and Rouault, I. *Rouault. Œuvre gravé*. 2 vols. Monte Carlo, 1978.
*Courthion, P. *Georges Rouault*. New York, 1962.
Dorival, B. *Cinq études sur Georges Rouault*. Paris, 1957.
Dorival, B., and Rouault, I. *Rouault: L'Œuvre peint*. Catalogue raisonné, 2 vols., Monte Carlo, 1988; Tokyo, 1990.
Georges Rouault. Exposition du Centenaire. Paris, Musée National d'Art Moderne, 1971.
Hergott, F. *Georges Rouault, Première période, 1903–1920*. Paris, Centre Pompidou, 1992.
——. and Whitefield, S. *Georges Rouault The Early Years 1903–1920*. London, Royal Academy, 1993.
Molinari, D. *Rouault*. Paris, Musée d'art moderne de la Ville de Paris, 1983.

ROUSSEAU

Alley, R. *Portrait of a Primitive. The Art of Henri Rousseau*. Oxford, 1978.
Bouret, J. *Henri Rousseau*. Greenwich, Conn., 1961.
*Certigny, H. *Le Douanier Rousseau en son Temps. Biographie et catalogue raisonné*. 2 vols. Tokyo, 1984.
Henri Rousseau. New York, The Museum of Modern Art, 1985.
Keay, C. *Henri Rousseau, le Douanier*. New York, 1976.
Stabenow, C. *Henri Rousseau 1844–1910*. Cologne, 1991.
Unagami, M. *Le Douanier Rousseau and Japan*. Tokyo, 1987.
Vallier, D. *Henri Rousseau*. New York, 1964.

ROUSSEL
*Alain (Chartier, E.). *Introduction à l'œuvre gravé de K.-X. Roussel.* 2 vols. Paris, 1968.
Édouard Vuillard. Xavier Roussel. Munich, Haus der Kunst, 1968.
Ker-Xavier Roussel, 1867–1944. Bremen, Kunsthalle, 1965.
Solomon, J. *K.-X. Roussel.* Paris, 1967.

RUSSOLO
Russolo, L. *The Art of Noise (Futurist Manifesto, 1913).* New York, 1967.
Russolo Zanovello, M., Nebbia, U., and Buzzi, P. *Russolo, l'uomo, l'artista.* Milan, 1958.

RYSSELBERGHE, VAN
Ermengem, F. van. *Théo van Rysselberghe.* Antwerp, 1948.
Pogu, G. *Théo van Rysselberghe. Sa Vie dans le cadre des recherches techniques et psychosociales des causes de l'art.* Paris, 1963.
Rétrospective Théo van Rysselberghe. Ghent, Musée des Beaux-Arts, 1962.

SCHIELE
Comini, A. *Egon Schiele.* New York, 1976.
Egon Schiele and His Contemporaries from the Leopold Collection, Vienna. Munich, 1989.
Gustav Klimt and Egon Schiele. New York, Guggenheim Museum, 1965.
*Kallir, O. *Egon Schiele.* New York, 1966.
*Kallir, O. *Egon Schiele. Œuvre-Katalog der Gemälde.* Vienna, 1966.
Kallir, J. *Egon Schiele. The Complete Works.* London, 1990.
Mitsch, E. *The Art of Egon Schiele.* London, 1975.
Nebehay, C. M. *Egon Schiele, 1890–1918. Leben, Briefe, Gedichte.* Salzburg, 1979.
Nebehay, C. M. *Egon Schiele: sketch books.* London, 1989.
Sabarsky, S. *Egon Schiele. 100 Dessins.* Paris, 1985.
Whitford, F. *Egon Schiele.* London, 1981.

SCHLEMMER
Bissier, J. *Julius Bissier/Oskar Schlemmer. Briefwechsel.* St Gallen, 1988.
Kuchling, H., ed. *Oskar Schlemmer. Man, Teaching Notes from the Bauhaus.* Cambridge, Mass., 1971.
*Maur, K. von. *Oskar Schlemmer.* 2 vols. Munich, 1979.
Oskar Schlemmer, der Mahler . . . Stuttgart, Wüttembergisher Kunstverein, 1977.
Oskar Schlemmer. Zeichnungen und Graphik. Stuttgart, 1965.

Schlemmer, T., ed. *The Letters and Diaries of Oskar Schlemmer.* Middletown, Conn., 1972.

SCHMIDT-ROTTLUFF
Brix, K. *Karl Schmidt-Rottluff.* Vienna, 1972.
Grohmann, W. *Karl Schmidt-Rottluff.* Stuttgart, 1956.
Schapire, R. *Karl Schmidt-Rottluff: Graphisches Werk bis 1923.* New York, 1987.
Thiem, G. *Schmidt-Rottluff. Aquarelle und Zeichnungen.* Munich, 1963.
Thiem, G. *Karl Schmidt–Rottluff: 1912 – Experiment Kubismus.* Munich, 1991.
Wietek, G. *Karl Schmidt-Rottluff im Hamburg und Schleswig-Holstein.* Neumünster, 1984.

SCHWITTERS
Bazzoli, F. *Kurt Schwitters.* Paris, 1991.
Elderfield, J. *Kurt Schwitters.* New York, 1985.
Elger, D. *Der Merzbau: eine Werkmonographie.* Cologne, 1984.
Kurt Schwitters. London, Tate Gallery, 1985.
Lach, F., ed. *Kurt Schwitters. Das literarische Werk.* 5 vols. Cologne, 1973–82.
Retrospective Kurt Schwitters. New York, Marlborough-Gerson Gallery, 1965.
Schmalenbach, W. *Kurth Schwitters. Leben und Werk.* Cologne, 1967.
Schwitters, K. *Anna Blume und andere: literatur und Grafik.* Cologne, 1986.
Themerson, S. *Kurt Schwitters in England.* London, 1958.

SEGONZAC
Kyriazi, J. M. *André Dunoyer de Segonzac. Sa vie, son œuvre.* Lausanne, 1976.
*Loiré, A., and Cailler, P. *Catalogue de l'œuvre gravé de Dunoyer de Segonzac.* 7 vols. Geneva, 1958–64.
Segonzac, A. D. de. *Dessins 1900–1970.* Geneva, 1970.

SÉRAPHINE
Foucher, J.P. *Séraphine de Senlis.* Paris, 1968.

SÉRUSIER
Boyle-Turner, C. *Paul Sérusier.* Ann Arbor, 1983.
Guicheteau, M. *Paul Sérusier.* Paris, 1976.
Sérusier, P. *ABC de la peinture, suivi d'une correspondance inédite recueillie par Mme P. Sérusier.* Paris, 1950.

SEURAT
*Dorra, H., and Rewald, J. *Seurat. L'Œuvre peint, biographie, et catalogue critique.* Paris, 1959.

Georges Seurat. Zeichnungen. 2nd enl. ed. Munich, 1984.
*Hauke, C. M. *Seurat et son œuvre.* 2 vols. Paris, 1961.
Homer, W. I. *Seurat and the Science of Painting.* Cambridge, Mass., 1964.
Khan, G. *Les Dessins de Georges Seurat. 1859–1891.* 2 vols. Paris, 1928.
Madeleine-Perdrillat, A. *Seurat.* New York, 1990.
Rewald, J. *Seurat. A Biography.* London, 1990.
Russell, J. *Seurat.* New York, 1965.
Seurat. Paintings and Drawings. Chicago Art Institute, 1958.
Seurat. Paris, Grand Palais, 1991.
Thomson, R. *Seurat.* Oxford, 1985.

SEVERINI
Fagiolo dell' Arco, M. *Gino Severini.* Rome, 1977.
Fonti, G. *Gino Severini: Catalogo Ragionata.* Milan, 1988.
Gino Severini. Florence, Palazzo Pitti, 1983.
Mascherpa, G. *Severini e il mosaico.* Ravenna, 1985.
Mostra antologica di Gino Severini. Rome, 1961.
Severini, G. *Dal cubismo al classicismo e altri saggi . . .* Florence, 1972.

SICKERT
Baron, W. *Sickert.* London, 1973.
Baron, W. and Shone, R. (eds.) *Sickert Paintings.* London, Royal Academy, 1992.
Browse, L. *Sickert.* London, 1960.
Emmons, R. *The Life and Opinions of Walter Richard Sickert.* London, 1941.
Late Sickert. Paintings 1927 to 1942. London, Arts Council, 1981.
Shone, R. *Walter Sickert.* Oxford, 1988.
Sickert, W. R. *A Free House! Or, the Artist as Craftsman.* London, 1947.
Sutton, D. *Walter Sickert, a Biography.* London, 1976.
Troyen, A. *Walter Sickert as Printmaker.* New Haven, Yale Center for British Art, 1979.

SIGNAC
Bosman, S. *Paul Signac (1863–1935). Watercolours and Drawings.* London, Marlborough Gallery, 1986.
Cachin, F. *Paul Signac.* Paris, 1971.
*Kornfeld, E. W., and Wick, P. A. *Catalogue raisonné de l'œuvre gravé et lithographié de Paul Signac.* Bern, 1974.
Signac. Paris, Musée National du Louvre, 1964.

SIRONI
Camesasca, E. (ed.) *Mario Sironi. Scritti editi e inediti.* Milan, 1980.

Ferrari, C. G. (ed.) *Mario Sironi 1885–1961.* Milan, Palazzo Reale, 1985.
Harten, J., and Poetter, J. (eds.) *Mario Sironi (1885–1961).* Cologne, 1988.
Mario Sironi. Ferrara, Galleria Civica d'Arte Moderna, 1972.

SLUYTERS
Juffermans, J. *Jan Sluijters: schilder.* Mijdrecht, 1981.
Knuttel, G. *Jan Sluyters.* The Hague, 1937.
Luns, H. *Jan Slijters,* 2nd printing. Amsterdam, 1941.

SMET, DE
Gustave de Smet. Antwerp, Musée Royal des Beaux-Arts, 1961.
Hecke, P. G. van. *Gustave de Smet. Sa Vie et son œuvre.* Brussels-Paris, 1945.

SMITH
Hendy, P. *Matthew Smith.* London, 1962.
Matthew Smith. Paintings from 1909 to 1952. London, Tate Gallery, 1953.
Matthew Smith. London, Barbican Art Gallery, 1983.
A Memorial Exhibition of Works by Sir Matthew Smith. London, Royal Academy of Arts, 1960.

SOFFICI
Carrà, M., and Fagone, V. (eds.) *Carlo Carrà, Ardengo Soffici lettere 1913–29.* Milan, 1983.
Cavallo, L. *Ardengo Soffici (1879–1964) giornate di pittura.* Bologna, 1987.
Pampaloni, G., et al. *Ardengo Soffici. L'Artista e lo scrittore nella cultura del 900.* Florence, 1976.

SOUTINE
Castaing, M., and Leymarie, J. *Soutine,* New York, 1964.
Chaim Soutine, 1894–1943. London, Arts Council, 1963.
*Courthion, P. *Soutine, peintre du déchirant.* Lausanne, 1972.
Lanthemann, J. *Soutine: catalogue raisonné de l'œuvre dessinée.* Monte Carlo, 1981.
Soutine, 1893–1943. London, Hayward Gallery, 1982.
Werner, A. *Chaim Soutine.* New York, 1977.

SPENCER
Alison, J., et al. *Stanley Spencer. The Apotheosis of Love.* London, Barbican Art Gallery, 1990.
Bell, K. *Stanley Spencer. A complete catalogue of the paintings.* London, 1992.
Carline, R. *Stanley Spencer at War.* London, 1978.
Collis, M. *Stanley Spencer. A Biography.* London, 1962.

Pople, K. *Stanley Spencer. A Biography*. London, 1991.
Robinson, D. *Stanley Spencer*. Oxford, 1990.
Rothenstein, J., ed. *Stanley Spencer. The Man: Correspondence and Reminiscences*. London, 1979.
Spencer, G. *Stanley Spencer*. London, 1961.
Stanley Spencer. London, Royal Academy, 1980.

STADLER
Haftmann, W. *Der Bildhauer Tony Stadler . . .* Munich, 1961.
Tony Stadler. Munich, Städtische Galerie im Lenbachhaus, 1978.

STEER
Ironside, R. *Wilson Steer*. London, 1943.
*Laughton, B. *Philip Wilson Steer, 1860–1942*. Oxford, 1971.
P. Wilson Steer 1860–1942. London, Arts Council, 1960.

STEINLEN
*Crauzat, E. de. *L'Œuvre gravét lithographié de Steinlen*. Paris, 1913.
Dessins de Steinlen 1859–1923. Paris, Musée du Louvre, 1968.
Jourdain, F. *Un Grand Imagier. Alexandre Steinlen*. Paris, 1954.

SURVAGE
Putnam, S. *The Glistening Bridge. Léopold Survage and the Spatial Problem in Painting*. New York, 1929.
Warnod, J. *Léopold Survage*. Brussels, 1983.

SUTHERLAND
Alley, R. *Graham Sutherland*. London, Tate Gallery, 1982.
Berthoud, R. *Graham Sutherland. A Biography*. London, 1982.
Hayes, J. *The Art of Graham Sutherland*. Oxford, 1980.
*Tassi, R. *Graham Sutherland. Complete Graphic Work*. New York, 1978.
Tassi, R. *Sutherland. The Wartime Drawings*. London, 1980.
Thuillier, R. *Graham Sutherland: Inspirations*. Guildford, 1982.

TAEUBER-ARP
Lanchner, C. *Sophie Taeuber-Arp*. New York, Museum of Modern Art, 1981.
Scheidegger, E., ed. *Zweiklang. Sophie Taeuber-Arp, Hans Arp*. Zürich, 1960.
Schmidt, G., ed. *Sophie Taeuber-Arp*. Basel, 1948.

TANGUY
Onslow-Ford, G. *Yves Tanguy and automatism*. Inverness (Calif.) 1983.
Tanguy, K. *Yves Tanguy. A Summary of His Works*. New York, 1963.
Waldberg, P. *Yves Tanguy*. Paris, 1977.
Yves Tanguy. Retrospective, 1923–1955. Paris, Musée National d'Art Moderne, 1982.

TATLIN
Milner, J. *Vladimir Tatlin and the Russian avant-garde*. New Haven and London, 1983.
Vladimir Tatlin. Stockholm, Moderna Museet, 1968.
Zhadova, L. *Tatlin*. London, 1988.

TCHELITCHEW
Kirstein, L., ed. *Tchelitchew. Drawings*. New York, 1947.
Soby, J. T. *Tchelitchew. Painting, Drawings*. New York, Museum of Modern Art, 1942.
Tyler, P. *The Divine Comedy of Pavel Tchelitchew*. New York, 1967.

THORN-PRIKKER
Hoff, A. *Johan Thorn-Prikker*. Recklinghausen, 1958.
*Polak, B. H. *Het 'Fin-de-sièclé' in de Nederlandse Schilderkunst. De symbolistische Beweging, 1890–1900*. The Hague, 1955.
Wember, P. *Johan Thorn-Prikker. Glasfenster, Wandbilder. Ornamente 1891–1932*. Kresfeld, Kaiser Wilhelm Museum, 1966.

TOOROP
Jan Toorop, 1858–1928. Impressionniste, Symboliste, Pointilliste. Paris, Institut Néerlandais, 1977.
Knipping, J. B. *Jan Toorop*. Amsterdam, 1947.
*Polak, B. H. *Het 'Fin-de-Sièle' in de Nederlandse Schilderkunst. De symbolistische Beweging, 1890–1900*. The Hague, 1955.

TORRES-GARCIA
Cáceres, A. *Joaquin Torres Garcia. Estudio psicológico y síntesis de critica*. Montevideo. 1941.
Joaquin Torres-Garcia. Providence, Museum of Art, Rhode Island School of Design, 1970.
Torres-Garcia, J. *Historia de mi vida, con illustraciones del autor*. Montevideo, 1939.

TOULOUSE-LAUTREC
*Adhémar, J. *Toulouse-Lautrec. His Complete Lithographs and Drypoints*. London, 1965.
Adriani, G. *Toulouse-Lautrec und das Paris um 1900*. Cologne, 1978.

Adriani, G. *Toulouse-Lautrec*. London, 1987.
——. *Toulouse-Lautrec: the complete graphic works*. London, 1988.
*Dortu, M. G. *Toulouse-Lautrec et son œuvre*. 6 vols. New York, 1971.
Feinblatt, E., and Davis, B. *Toulouse-Lautrec and his contemporaries*. New York, 1986.
Henri de Toulouse-Lautrec. Images of the 1890s. New York, Museum of Modern Art, 1985.
Huisman, P., and Dortu, M. G. *Lautrec by Lautrec*. New York, 1964.
Jourdain, F., and Adhémar, J. *T-Lautrec*. Paris, 1952. With biographical index of Lautrec's subjects.
Julien, E. *The Posters of Toulouse-Lautrec*. Monte Carlo, 1951.
Murray, G. B., and Schimmel, H. D. (eds.) *The Letters of Henri de Toulouse-Lautrec*. Oxford, 1991.
Toulouse-Lautrec. London, South Bank Centre, 1991.

UTRILLO
Courthion. P. *Utrillo e Montmartre*. Milan, 1969.
Fabris, J. *Utrillo: sa vie, son œuvre*. Paris, 1982.
*Pétridès, P., ed. *Maurice Utrillo. L'Œuvre complet*. 5 vols. Paris, 1959–74.

VALLOTTON
Busch, G., *et al*. *Félix Vallotton, son œuvre*. Paris, 1982
Busche, G., *et al*. *Vallotton*. Lausanne, 1985.
Guisan, G., and Jakubec, D. *Félix Vallotton. Documents pour une biographie et pour l'histoire d'une œuvre*. 3 vols. Lausanne-Paris, 1973–5.
Hahnloser, H. *Félix Vallotton, 1865–1925*. 2 vols. Zürich, 1927–8.
Hahnloser-Bühler, H. *Félix Vallotton et ses amis*. Paris, 1936.
 Includes Vallotton's catalogue of his works from 1885 to 1925.
Newman, S. M. *Félix Vallotton*. New York, 1992.
*Vallotton, M., and Goerg, C. *Félix Vallotton. Catalogue raisonné de l'œuvre gravé et lithographié* Geneva, 1972.

VALMIER
Bettex-Caillier, N. 'Georges Valmier', *Art Documents*, Geneva, no. 35 (1956).

VALTAT
Valtat, J. *Louis Valtat. Catalogue de l'œuvre peint 1869–1952*, I. Neuchâtel, 1977.

VANTONGERLOO
Georges Vantongerloo. Zürich, Kunsthaus, 1981.
Georges Vantongerloo. Bilder und Plastiken. Düsseldorf, Galerie Denise René Hans Mayer, 1971.

Vantongerloo, G. *Paintings, Sculptures, Reflections*. New York, 1948.

VELDE, VAN DE
Hammacher, A. M. *Le Monde de Henry van de Velde*. Paris, 1967.
Hüter, K. H. *Henry van de Velde. Sein Werk bis zum Ende seiner Tätigkeit in Deutschland*. Berlin, 1967.
Der junge Van de Velde und sein Kreis, 1883–1893. Hagen, Karl-Ernst-Osthaus Museum, 1959.
Osthaus, K. E. *Van de Velde*. Berlin, 1984.
Sembach, K-J., and Schulte, B. (eds.) *Henri van de Velde: ein europäischer Kunstler seiner Zeit*. Cologne, 1992.
Van de Velde, H. *Geschichte meines Lebens*. Munich, 1962.
Van de Velde, H. *Zum neuen Stil*. Munich, 1955.

VIGELAND
Brenna, A. *Guide to Gustav Vigeland's Sculpture Park in Oslo*. Oslo, 1960.
Lodrup, H. P. E. *Gustav Vigeland*. Oslo, 1945.
Stang, R. T. *Gustav Vigeland, 1869–1969*. Oslo, 1969.
The Vigeland Museum: catalogue of exhibited works. Oslo, 1986.

VILLON
*Ginestet, C. de. *Jacques Villon. Les Estampes et les illustrations. Catalogue raisonné*. Paris, 1979.
Jacques Villon. Master of Graphic Art (1875–1963). Boston Museum of Fine Arts, 1964.
Robbins, D., ed. *Jacques Villon*. Cambridge, Mass., 1976.
Vallier, D. *Jaques Villon. Œuvre de 1897 à 1956*. Paris, 1957.

VIVIN
Exposition des œuvres de Louis Vivin. Paris, Galerie Bing, 1948.
Uhde, W. *Five Primitive Masters*. New York, 1949.

VLAMINCK
Selz, J. *Vlaminck*. New York, 1963.
*Waterskirchen, K. von. *Maurice de Vlaminck. Catalogue de l'œuvre gravé . . .* Bern, 1974.

VORDEMBERGE-GILDEWART
Helms, D., *et al*. *Vordemberge-Gildewart: the complete works*. Munich, 1990.
Jaffé, H. L. C. *Vordemberge-Gildewart. Mensch und Werk*. Cologne, 1971.
Lohse, R.P., ed. *Vordemberge-Gildewart. Eine Bild-Biografie. Dokumente, Fotografien, Zeichnungen, und Bilder*. Ulm, 1959.

Vordemberge-Gildewart Remembered. London, Annely Juda Fine Arts, 1974.

VRUBEL
Gaiduk, A., *et al. Michail Vrubel.* Leningrad, 1985.
Guerman, M. *Mikhail Vrubel.* Leningrad, 1988.
Gusarove, A. *Vrubel.* Milan, 1966.
Iaremich, S.P. *Mikhail Aleksandrovich Vrubel. Zhizn i Tvorchestvo.* Moscow, 1911.
Isdebsky-Pritchard, A. *The Art of Mikhail Vrubel, 1856–1910.* Ann Arbor, Mich., 1982.
Kaplanova, S. *Vrubel.* Leningrad, 1975.

VUILLARD
Easton, E. W. *The Intimate Interiors of Edouard Vuillard.* London, 1989.
Édouard Vuillard, 1868–1940. Toronto, Art Gallery of Ontario, 1971.
Édouard Vuillard. Xavier Roussel. Munich, Haus der Kunst, 1968.
Makarius, M. *Vuillard.* Paris, 1989.
Ritchie, A. C. *Édouard Vuillard.* New York, Museum of Modern Art, 1954.
Roger-Marx, C. *L'Œuvre gravé de Vuillard.* Monte Carlo, 1948.
Russell, J. *Vuillard.* Greenwich, Conn., 1971.
Thomson, B. *Vuillard.* Oxford, 1988.
Vuillard. London, South Bank Centre, 1991.
Warnod, J. *Vuillard.* Paris, 1988.

WADSWORTH
Cork, R. *Edward Wadsworth Early Woodcuts.* London, Christopher Drake Ltd., 1973.
Drey, O. R. *Edward Wadsworth.* London, 1921.
Edward Wadsworth, 1889–1949. Paintings, Drawings and Prints. London, Colnaghi, 1974.
A Genius of Industrial England. Edward Wadsworth 1889–1949. London, Camden Arts Centre, 1990.
Glazebrook, M. *Edward Wadsworth 1889–1949. Paintings from the 1920s.* London, Mayor Gallery, 1982.
Wadsworth, B. *Edward Wadsworth. A Painter's Life.* Salisbury, 1989.

WEREFKIN
Hahl-Koch, J. *Marianne Werefkin und der russische Symbolismus.* Munich, 1967.
Werefkin, M. *Briefe an einen Unbekannten, 1901–1905.* Cologne, 1960.

WERKMAN
Dooijes, D. *Hendrik Werkman.* Amsterdam, 1970.
Hendrik Nicolaas Werkman, 1882–1945. 'Druksels' en gebruiksdrukwerk . . . Amsterdam, Stedelijk Museum, 1977.
Müller, F. *H. N. Werkman,* London, 1967.

WHISTLER
Cabanne, P. *Whistler.* Naefels, 1985.
Fleming, G. H. *James McNeill Whistler: A Life.* Moreton-in-Marsh, 1991.
From Realism to Symbolism. Whistler and His World. New York, 1971.
Getscher, R. H. *James McNeill Whistler: pastels.* London, 1991.
Honour, H. *The Venetian Hours of Henry James, Whistler and Sargent.* London, 1991.
James McNeill Whistler. Paintings, Pastels, Watercolors, Drawings, Etchings, Lithographs. Art Institute of Chicago, 1968.
*Levy, M. *Whistler Lithographs. An Illustrated Catalogue Raisonné . . .* London, 1975.
Lochnan, K. A. *Whistler's etchings and the sources of his etching style 1855–1880.* New York and London, 1988.
Pennell, E. R., and Pennell, J. *The Life of James McNeill Whistler.* 5th ed., rev. Philadelphia, 1911.
Spencer, R. (ed.) *Whistler: a retrospective.* New York, 1989.
Sutton, D. *Nocturne. The Art of James McNeill Whistler,* London, 1963.
Taylor, H. *James McNeill Whistler.* London, 1978.
Weintraub, S. *Whistler, a Biography.* New York, 1974.
*Young, A. McL., *et al. The Paintings of James McNeill Whistler.* 2 vols. New Haven, Conn., and London, 1980.

WOUTERS
*Avermaete, R. *Rik Wouters.* Brussels, 1962.
Delen, A. J. J. *Rik Wouters.* Antwerp, 1950.
Wouters, N. *La Vie de Rik Wouters à travers son œuvre.* Brussels, 1944.

ZADKINE
Hammacher, A. M. *Zadkine.* New York, 1959.
*Jianou, I. *Zadkine.* Paris, 1964.
Musée Zadkine: sculptures. Paris, Musées de la Ville de Paris, 1982.
L'Œuvre gravé et lithographié d'Ossip Zadkine. Paris, 1967.

LIST OF ILLUSTRATIONS

The location of a work of art is given in italic, the photographer's name in brackets. Where no photographer's name is quoted, the location is also the source of the photograph. The photographs are reproduced by courtesy of the institution or collector.

University Art Gallery (The Jules E. Mastbaum Collection of Rodin Drawings, Gift of his Daughter Mrs Jefferson Dickson)

29. Antoine Bourdelle: Beethoven, a Tragic Mask, 1901. Bronze. H. $30\frac{3}{4}$ in. *New York, Private Collection*

30. Medardo Rosso: Conversation in a Garden, 1893. Plaster. $12\frac{5}{8} \times 25\frac{1}{4}$ in. *Rome, Galleria Nazionale d'Arte Contemporanea*

31. Medardo Rosso: Madame X, 1896. H. 12 in. *Venice, Cà Pesaro, Museo d'Arte Moderna* (Photo Giacomelli)

32. Gustave Moreau: Hercules and the Hydra of Lerna, 1876. $69\frac{1}{2} \times 60$ in. *Art Institute of Chicago* (Gift of Mrs Morton Zurcher)

33. Pierre Puvis de Chavannes: The Shepherd's Song, 1891. $41\frac{1}{8} \times 43\frac{1}{4}$ in. *New York, Metropolitan Museum of Art* (Rogers Fund, 1906)

34. Odilon Redon: 'À l'horizon, l'ange des certitudes, et, dans le ciel sombre, un regard interrogateur', from *À Edgar Poe*, 1882. Lithograph. $10\frac{3}{4} \times 8\frac{1}{8}$ in. *Art Institute of Chicago* (The Stickney Collection)

35. Odilon Redon: Orpheus, after 1903. Pastel. $21\frac{1}{2} \times 22\frac{1}{4}$ in. *Cleveland Museum of Art* (Gift of J. H. Wade)

36. Paul Gauguin: The Vision after the Sermon – Jacob Wrestling with the Angel, 1888. $28\frac{3}{4} \times 36\frac{1}{4}$ in. *Edinburgh, National Gallery of Scotland* (Photo Annan)

37. Paul Gauguin: Be in Love and You Will Be Happy, 1889-90. Wood, painted. $38\frac{1}{4} \times 28\frac{3}{4}$ in. *Boston, Museum of Fine Arts*

38. Paul Gauguin: Aha oe Feii? – What! Are You Jealous?, 1891-2. 26×35 in. *Moscow, Pushkin Museum*

39. Paul Gauguin: Whence Come We? What Are We? Where Are We Going?, 1897. $55\frac{1}{2} \times 148\frac{1}{4}$ in. *Boston, Museum of Fine Arts*

40. Paul Gauguin: Be in Love and You Will Be Happy, c. 1893-5. Woodcut, printed in brown with another impression in black on tissue pasted over it. $6\frac{3}{8} \times 10\frac{7}{8}$ in. *Art Institute of Chicago* (Joseph Brooks Fair Collection)

41. Vincent van Gogh: Pollarded Birches with Shepherd and Peasant Woman, 1884. Pencil and pen. $15\frac{1}{2} \times 21\frac{1}{2}$ in. *Amsterdam, Rijksmuseum Vincent van Gogh*

42. Vincent van Gogh: The Potato Eaters, 1885. $32 \times 44\frac{3}{4}$ in. *Amsterdam, Rijksmuseum Vincent van Gogh*

43. Vincent van Gogh: The Night Café, 1888. 29×35 in. *New Haven, Conn., Yale University Art Gallery* (Bequest of Stephen C. Clark)

44. Vincent van Gogh: Dr Gachet, 1890. $26\frac{1}{4} \times 22\frac{1}{2}$ in. *Private Collection*

45. Vincent van Gogh: Sunflowers, 1889. $37\frac{3}{8} \times 28\frac{3}{4}$ in. *Amsterdam, Rijksmuseum Vincent van Gogh*

46. Vincent van Gogh: Woman rocking a Cradle (Mme Roulin), 1889. $35\frac{3}{8} \times 28$ in. *Otterlo, Rijksmuseum Kröller-Müller*

47. Émile Bernard: Peasant Girl keeping Ducks, and Paul Gauguin: The Gleaners. Drawings reproduced in *Le Moderniste*, 3 August 1889

48. Paul Sérusier: Landscape of the Bois d'Amour (The Talisman), 1888. Oil on wood. $10\frac{5}{8} \times 8\frac{5}{8}$ in. *Paris, Musée d'Orsay*

49. Maurice Denis: Mary with the Christ Child and St John, 1898. $23 \times 28\frac{3}{4}$ in. *Copenhagen, Ny Carlsberg Glyptotek*

50. Édouard Vuillard: Under the Trees, 1894. Distemper on canvas. $84\frac{1}{2} \times 38\frac{1}{2}$ in. *Cleveland Museum of Art* (Gift of the Hanna Fund)

51. Édouard Vuillard: Cipa Godebski and his Sister Missia Natanson, 1897. Oil on paper, laid down on panel. 25×22 in. *Karlsruhe, Kunsthalle*

52. Pierre Bonnard: Poster for *La Revue blanche*, 1894. Lithograph. $30\frac{3}{4} \times 23\frac{7}{8}$ in. *New Haven, Conn., Yale University Art Gallery*

53. Pierre Bonnard: Dining Room in the Country, 1913. 63×80 in. *Minneapolis Institute of Arts* (John R. Van Derlip Fund)

54. Henri de Toulouse-Lautrec: At the Moulin Rouge, 1892. $48\frac{3}{8} \times 55\frac{1}{4}$ in. *Art Institute of Chicago* (Helen Birch Bartlett Memorial Collection)

55. Henri de Toulouse-Lautrec: La Reine de joie, 1892. Lithograph. $59\frac{3}{4} \times 39\frac{1}{4}$ in. *New Haven, Conn., Yale University Art Gallery* (Collection of Mr and Mrs Carter H. Harrison)

56. James Ensor: The Entry of Christ into Brussels, 1888. $101\frac{1}{2} \times 169\frac{1}{2}$ in. *Malibu, Calif., J. Paul Getty Museum of Art*

57. James Ensor: Intrigue, 1890. $35\frac{1}{2} \times 59$ in. *Antwerp, Koninklijk Museum voor Schone Kunsten*

58. Edvard Munch: In Hell, 1904-5. $32\frac{1}{4} \times 26$ in. *Oslo, Kommunes Kunstsamlinger, Munch-Museet* (Photo O. Vaering)

59. Edvard Munch: The Scream, 1893. $33 \times 26\frac{1}{2}$ in. *Oslo, Kommunes Kunstsamlinger, Munch-Museet* (Photo Teigens)

60. Edvard Munch: Ashes, 1894. $47\frac{1}{2} \times 55\frac{1}{2}$ in. *Oslo, Nasjonalgalleriet* (Photo O. Vaering)

61. Edvard Munch: History and The Sun, 1910-15. Mural paintings. *University of Oslo*

62. Ferdinand Hodler: The Chosen One, 1893-4. $86\frac{1}{4} \times 116\frac{1}{2}$ in. *Bern, Kunstmuseum* (Foundation Gottfried Keller)

100. Käthe Kollwitz: Death greeted as a Friend, from *Death*, 1934-5. Lithograph. $12\frac{7}{16} \times 12\frac{5}{16}$ in. *Berlin, Deutsche Akademie der Künste*
101. Käthe Kollwitz: Mourning, 1938. Plaster. $11 \times 9\frac{7}{8}$ in. *Hamburg, Kunsthalle* (Photo A. Egger)
102. Paula Modersohn-Becker: The Old Woman by the Poorhouse Duckpond, *c.* 1906. $37\frac{3}{8} \times 30\frac{3}{4}$ in. *Bremen, Roseliushaus* (Photo Stickelmann)
103. Emil Nolde: Doubting Thomas, 1912. $39\frac{1}{2} \times 33\frac{3}{4}$ in. *Seebüll, Germany, Ada und Emil Nolde Stiftung*
104. Emil Nolde: Red and White Amaryllis. $9\frac{1}{4} \times 18$ in. *Hamburg, Kunsthalle*
105. Emil Nolde: Dancer, 1913. Colour lithograph. $21\frac{1}{8} \times 27\frac{1}{8}$ in. *Seebüll, Germany, Ada und Emil Nolde Stiftung*
106. Ernst Ludwig Kirchner: Adam and Eve, 1911. $44\frac{1}{4} \times 45$ in. *Private Collection* (Photo Marlborough Fine Art Ltd, London)
107. Ernst Ludwig Kirchner: Berlin Street Scene, 1913. $78\frac{3}{4} \times 59$ in. *Frankfurt, Städelsches Kunstinstitut, on loan from a private collection in Frankfurt* (Photo Witzel)
108. Erich Heckel: Convalescent Woman, 1913. Each panel $32 \times 27\frac{7}{8}$ in. *Cambridge, Mass., Busch-Reisinger Museum, Harvard University*
109. Erich Heckel: Sleeping Negress, 1908. Woodcut. $9\frac{3}{4} \times 13\frac{3}{4}$ in. *New Haven, Conn., Yale University Art Gallery* (Gift of Mr and Mrs Walter Bareiss)
110. Max Pechstein: The Red Turban, 1911. $47 \times 39\frac{1}{2}$ in. *Pittsburgh, Museum of Art, Carnegie Institute*
111. Karl Schmidt-Rottluff: Head of Christ, 1918. Woodcut. $19\frac{3}{4} \times 15\frac{1}{2}$ in. *New Haven, Conn., Yale University Art Gallery* (Collection of the Société Anonyme)
112. Christian Rohlfs: Church at Soest, 1918. $39\frac{3}{8} \times 24$ in. *Mannheim, Städtische Kunsthalle*
113. Ludwig Meidner: Self Portrait, 1912. $31\frac{3}{8} \times 23\frac{5}{8}$ in. *Darmstadt, Hessisches Landesmuseum* (Photo R. Dobrick)
114. Vasily Kandinsky: Night, 1906-7. Tempera. $11\frac{3}{4} \times 19\frac{1}{2}$ in. *Munich, Städtische Galerie im Lenbachhaus, Gabriele-Münter-Stiftung*
115. Vasily Kandinsky: Study for Improvisation 2 (Funeral March), 1909. Oil on cardboard. $19\frac{3}{4} \times 27\frac{1}{2}$ in. *Munich, Städtische Galerie im Lenbachhaus, Gabriele-Münter-Stiftung*
116. Vasily Kandinsky: Improvisation No. 30 (Cannons), 1913. $43\frac{5}{8} \times 43\frac{5}{8}$ in. *Art Institute of Chicago* (Arthur Jerome Eddy Memorial Collection)
117. Vasily Kandinsky: Black Lines No. 189, 1913. $51\frac{1}{4} \times 51\frac{1}{8}$ in. *New York, Guggenheim Museum*

118. Vasily Kandinsky: Composition VII, No. 186, 1913. $78\frac{3}{4} \times 118\frac{1}{8}$ in. *Moscow, Tretyakov Gallery*
119. Alexei von Jawlensky: Portrait of Alexander Sacharoff, 1913. Oil on paper. $21\frac{1}{4} \times 19\frac{1}{2}$ in. *Wiesbaden, Städtisches Museum*
120. Franz Marc: Deer in the Wood, No. I, 1913. $39\frac{1}{2} \times 41$ in. *Washington, Phillips Collection* (Photo John D. Schiff)
121. Franz Marc: Fighting Forms. 1914. $35\frac{3}{4} \times 51\frac{3}{4}$ in. *Munich, Bayerische Staatsgemäldesammlungen*
122. August Macke: Zoological Garden, I, 1912. $23\frac{1}{4} \times 38\frac{5}{8}$ in. *Munich, Städtische Galerie im Lenbachhaus, Bernhard Koehler-Stiftung* (Photo Munich Städtische Galerie)
123. Heinrich Campendonk: The Woodcarver, 1924. $27\frac{3}{4} \times 34\frac{3}{4}$ in. *New Haven, Conn., Yale University Art Gallery* (Collection of the Société Anonyme)
124. Alfred Kubin: A Lively Discussion, *c.* 1912. $11\frac{1}{4} \times 6\frac{2}{3}$ in. *Linz, Oberösterreichisches Landesmuseum* (late A. Samhaber Collection, Weinstein)
125. Henri Rousseau, le Douanier: Portrait of Pierre Loti, 1891-2 (later repainted). $24 \times 19\frac{3}{4}$ in. *Zürich, Kunsthaus*
126. Henri Rousseau, le Douanier: Merry Jesters, *c.* 1906. $57\frac{1}{2} \times 44\frac{1}{2}$ in. *Philadelphia Museum of Art* (Louise and Walter Arensberg Collection)
127. Louis Vivin: Basilica of the Sacred Heart, Montmartre, *c.* 1935. $28\frac{3}{4} \times 36\frac{3}{4}$ in. *Private Collection* (Photo Perls Galleries)
128. Charles Ginner: The Shell Filling Factory, 1918-19. 120×144 in. *Ottawa, National Gallery of Canada*
129. Harold Gilman: Canal Bridge, Flekkefjord, *c.* 1913. 18×24 in. *London, Tate Gallery*
130. Matthew Smith: Pale Pink Roses, 1929. $21 \times 25\frac{1}{2}$ in. *Private Collection* (Mary Keene)
131. Pablo Picasso: Les Demoiselles d'Avignon, 1907. 96×92 in. *New York, Museum of Modern Art* (acquired through the Lillie P. Bliss Bequest; photo Soichi Sunami)
132. Georges Braque: Harbour in Normandy, 1909. 32×32 in. *Art Institute of Chicago* (Purchased from the bequest of Samuel A. Marx)
133. Pablo Picasso: Still Life with Carafe and Candlestick, 1909. $20\frac{7}{8} \times 28$ in. *Private Collection*
134. Pablo Picasso: Woman's Head, *c.* 1909. Bronze. H. $16\frac{1}{4}$ in. *Buffalo, N.Y., Albright-Knox Art Gallery* (Edmund Hayes Fund)
135. Pablo Picasso: Female Nude, 1910. $38\frac{3}{4} \times 30\frac{3}{4}$ in. *Philadelphia Museum of Art* (The Louise and Walter Arensberg Collection)
136. Georges Braque: Violin and Palette, 1909-10. $36\frac{1}{4} \times 16\frac{7}{8}$ in. *New York, Guggenheim Museum*

137. Georges Braque: The Portuguese, 1911. $45\frac{7}{8} \times 32$ in. *Basel, Kunstmuseum* (Gift of Raoul La Roche)
138. Pablo Picasso: The Accordionist (Pierrot), 1911. $51\frac{1}{4} \times 35\frac{1}{4}$ in. *New York, Guggenheim Museum*
139. Pablo Picasso: Guitar and Wineglass, 1913. Pasted paper and charcoal. $18\frac{7}{8} \times 14\frac{3}{8}$ in. *San Antonio, Texas, McNay Art Institute*
140. Georges Braque: 'Le Courrier', 1913. Pasted paper and charcoal. $20 \times 22\frac{1}{2}$ in. *Philadelphia Museum of Art* (The A. E. Gallatin Collection)
141. Pablo Picasso: The Three Musicians, 1921. 80×74 in. *Philadelphia Museum of Art* (The A. E. Gallatin Collection)
142. Pablo Picasso: Wineglass and Die, 1914. Painted wood construction. $6\frac{1}{4} \times 6\frac{3}{4}$ in. *Paris, Musée Picasso* (Reproduced from C. Zervos, *Picasso*, II, part 2, figure 840)
143. Juan Gris: The Chessboard, 1915. $36\frac{1}{4} \times 28\frac{3}{4}$ in. *Art Institute of Chicago* (Gift of Mrs Leigh B. Block and the Ada Turnbull Hertle Fund)
144. Juan Gris: Guitar, Water Bottle, and Fruit Dish, 1922. $36\frac{1}{4} \times 28\frac{1}{4}$ in. *Private Collection, Spain*
145. Fernand Léger: The City, 1919. $91 \times 117\frac{1}{2}$ in. *Philadelphia Museum of Art* (The A. E. Gallatin Collection)
146. Fernand Léger: Discs, 1918. $94\frac{1}{2} \times 70\frac{7}{8}$ in. *Paris, Musée des Beaux-Arts de la Ville de Paris* (Photo Georges Allié)
147. Fernand Léger: The Great Parade, 1954. $117\frac{3}{4} \times 157\frac{1}{2}$ in. *New York, Guggenheim Museum*
148. Albert Gleizes: Man on a Balcony, 1912. $77 \times 45\frac{1}{4}$ in. *Philadelphia Museum of Art* (The Louise and Walter Arensberg Collection)
149. Jean Metzinger: Woman with a Compote, 1918. $31\frac{1}{2} \times 20\frac{7}{8}$ in. *Private Collection*
150. Roger de la Fresnaye: The Conquest of the Air, 1913. $92\frac{7}{8} \times 77$ in. *New York, Museum of Modern Art* (Mrs Simon Guggenheim Fund; photo Soichi Sunami)
151. Jacques Villon: Still Life, 1912-13. Oil on burlap. $35 \times 45\frac{3}{4}$ in. *New Haven, Conn., Yale University Art Gallery* (Collection of the Société Anonyme)
152. Jacques Villon: Colour Perspective, 1922. $23\frac{3}{4} \times 36\frac{1}{4}$ in. *New Haven, Conn., Yale University Art Gallery* (Collection of the Société Anonyme)
153. Marcel Duchamp: Nude descending a Staircase, No. 2, 1912. 58×35 in. *Philadelphia Museum of Art* (The Louise and Walter Arensberg Collection)
154. Robert Delaunay: The Eiffel Tower, 1910. $79\frac{1}{2} \times 54\frac{1}{2}$ in. *New York, Guggenheim Museum*
155. Robert Delaunay: Circular Forms, Sun and Moon, 1912-13. $39\frac{1}{2} \times 26\frac{3}{4}$ in. *Zürich, Kunsthaus*
156. Amédée Ozenfant: The Jug, 1926. $119\frac{3}{4} \times 58\frac{1}{2}$

in. *Providence, R.I., Museum of Art, Rhode Island School of Design*
157. Henri Laurens: Bottle and Glass, 1915. Painted wood and iron. H. $23\frac{5}{8}$ in. *Paris, Galerie Louise Leiris*
158. Alexander Archipenko: Walking, 1912. Bronze. H. 27 in. *Denver Art Museum* (Collection of the Charles Bayly Fund)
159. Alexander Archipenko: The Bather, 1915. Sculpto-painting: painted wood, paper, and metal. $20 \times 11\frac{1}{2}$ in. *Philadelphia Museum of Art* (The Louise and Walter Arensberg Collection)
160. Ossip Zadkine: The Destroyed City, 1947. Bronze. H. 20 ft. *Rotterdam, Plein 1940* (Photo L. W. Schmidt; City of Rotterdam)
161. Raymond Duchamp-Villon: The Horse, 1914. Bronze. H. 30 in. *New York, Museum of Modern Art* (Van Gogh Purchase Fund; photo Soichi Sunami)
162. Raymond Duchamp-Villon: Maggy, 1912. Bronze. H. $29\frac{1}{8}$ in. *New York, Guggenheim Museum*
163. Jacques Lipchitz: Bather, 1915. Bronze. H. $32\frac{1}{2}$ in. *Washington, D.C., Hirshhorn Museum*
164. Jacques Lipchitz: Mardi Gras, 1926. Gilded bronze. H. $10\frac{1}{2}$ in. *Private Collection* (Photo Adolph Studly)
165. Jacques Lipchitz: Figure, 1926-30. Bronze. H. $84\frac{1}{4}$ in. *Washington, The Hirshhorn Museum and Sculpture Garden*
166. Jacques Lipchitz: Sacrifice, 1948. Bronze. H. $48\frac{3}{4}$ in. *Buffalo, N.Y., Albright-Knox Art Gallery* (George Cary, Elisabeth H. Gates, and Edmund Hayes Fund)
167. Carlo Carrà: Funeral of the Anarchist Galli, 1910-11. $78\frac{1}{4} \times 102$ in. *New York, Museum of Modern Art* (Acquired through the Lillie P. Bliss Bequest; photo Soichi Sunami)
168. Luigi Russolo: The Revolt, 1911. $59 \times 90\frac{1}{2}$ in. *The Hague, Gemeentemuseum*
169. Umberto Boccioni: The Street enters the House, 1911. $39\frac{3}{8} \times 39\frac{5}{8}$ in. *Hanover, Niedersächsische Landesgalerie*
170. Umberto Boccioni: Development of a Bottle in Space, 1912. Bronze. H. 15 in. *New York, Museum of Modern Art* (Aristide Maillol Fund; photo Soichi Sunami)
171. Umberto Boccioni: Unique Forms of Continuity in Space, 1913. Bronze. H. $43\frac{1}{2}$ in. *New York, Museum of Modern Art* (Acquired through the Lillie P. Bliss bequest; photo Soichi Sunami)
172. Gino Severini: Dynamic Hieroglyphic of the Bal Tabarin, 1912. Oil on canvas with sequins. $63\frac{5}{8} \times 61\frac{1}{2}$ in. *New York, Museum of Modern Art* (Acquired through the Lillie P. Bliss Bequest)
173. Giacomo Balla: Study for the Materiality of Lights plus Speed, 1913. Gouache. $11\frac{3}{4} \times 15\frac{3}{4}$ in.

Private Collection (The Lydia and Harry Lewis Winston Collection) (Photo Gilchrist Studios)
174. Wyndham Lewis: Composition, 1913. Pencil, pen, and water colour. $13\frac{1}{2} \times 16\frac{1}{2}$ in. *London, Tate Gallery* (Mrs A. Wyndham Lewis)
175. Wyndham Lewis: Portrait of Ezra Pound, 1938. 30×40 in. *London, Tate Gallery* (Mrs A. Wyndham Lewis)
176. C. R. W. Nevinson: Returning to the Trenches, 1914. 20×30 in. *Ottawa, National Gallery of Canada* (The Massey Collection of English Painting)
177. David Bomberg: In the Hold, 1913–14. 78×101 in. *London, Tate Gallery*
178. Henri Gaudier-Brzeska: Red Stone Dancer, 1913. H. 17 in. Mansfield sandstone. *London, Tate Gallery*
179. Jacob Epstein: The Rock Drill, 1912–13. Bronze. H. 28 in. *New York, Museum of Modern Art* (Mrs Simon Guggenheim Fund; photo Soichi Sunami)
180. Jacob Epstein: Bust of Kramer, 1921. Bronze. H. 25 in. *London, Tate Gallery*
181. Mikhail Larionov: Autumn, 1912. $53\frac{1}{2} \times 45$ in. *Paris, Musée National d'Art Moderne*
182. David Burliuk: The Headless Barber, 1912. Oil and collage. 21×24 in. *Private Collection* (Photo Leonard Hutton Galleries)
183. Mikhail Larionov: Rayonist Construction, *c.* 1912. Dimensions and *present location unknown* (Reproduced from Eli Eganburi, *Nataliia Goncharova*)
184. Natalia Goncharova: Cats, *c.* 1911. $33\frac{1}{2} \times 33\frac{3}{4}$ in. *New York, Guggenheim Museum*
185. Kasimir Malevich: The Knife Grinder, 1912. $31\frac{3}{8} \times 31\frac{3}{8}$ in. *New Haven, Conn., Yale University Art Gallery* (Collection of the Société Anonyme)
186. Kasimir Malevich: Suprematist Composition, White on White, *c.* 1918. $31\frac{1}{4} \times 31\frac{1}{4}$ in. *New York, Museum of Modern Art* (Photo Soichi Sunami)
187. Kasimir Malevich: Suprematist Composition, Black Trapezium and Red Square, after 1915. $39\frac{3}{4} \times 24\frac{3}{8}$ in. *Amsterdam, Stedelijk Museum*
188. Vladimir Tatlin: Relief, 1914 (destroyed). Metal and wood. Dimensions unknown (Photo Camilla Gray)
189. El Lissitzky: Construction – Proun 2, 1920. Oil and coloured paper. $23\frac{1}{2} \times 15\frac{3}{4}$ in. *Philadelphia Museum of Art* (The A. E. Gallatin Collection)
190. Piet Mondrian: Composition in Line and Colour, 1913. $34\frac{3}{4} \times 45\frac{1}{4}$ in. *Otterlo, Rijksmuseum Kröller-Müller*
191. Bart van der Leck: Geometrical Composition II, 1917. $37 \times 39\frac{1}{4}$ in. *Otterlo, Rijksmuseum Kröller-Müller*

192. Theo van Doesburg: Composition (The Cow), 1916–17. $14\frac{3}{4} \times 25$ in. *New York, Museum of Modern Art*
193. Theo van Doesburg: Counter-composition in Dissonances XVI, 1925. $39\frac{3}{8} \times 70\frac{7}{8}$ in. *The Hague, Gemeentemuseum*
194. Georges Vantongerloo: Construction of Volume Relations, 1921. Mahogany. H. $16\frac{1}{8}$ in. *New York, Museum of Modern Art* (Gift of Miss Sylvia Pizitz; photo Soichi Sunami)
195. Piet Mondrian: Composition in Yellow and Blue, 1929. $20\frac{1}{2} \times 20\frac{1}{2}$ in. *Rotterdam, Museum Boymans-van Beuningen* (Photo A. Frequin)
196. Piet Mondrian: Fox Trot A, 1927. W. $43\frac{1}{4}$ in. *New Haven, Conn., Yale University Art Gallery* (Collection of the Société Anonyme)
197. Piet Mondrian: Victory Boogie-Woogie, 1943. Oil and scotch tape on canvas. 50×50 in. *Private Collection*
198. Lyonel Feininger: The Church at Gelmeroda XII, 1929. $39\frac{1}{2} \times 31\frac{5}{8}$ in. *Providence, R.I., Museum of Art, Rhode Island School of Design*
199. Oskar Schlemmer: Group of Fourteen Figures in Imaginary Architecture, 1930. Oil and tempera. $36 \times 47\frac{1}{2}$ in. *Cologne, Wallraf-Richartz Museum* (Photo Rheinisches Bildarchiv)
200. Oskar Schlemmer: Abstract Figure, 1921. Bronzed and matted nickel. H. $41\frac{1}{2}$ in. *The Baltimore Museum of Art* (Wurtzburger Collection, gift of the Janal Foundation, Inc.)
201. Vasily Kandinsky: Variegated Circle, 1921. $54\frac{1}{4} \times 70\frac{3}{4}$ in. *New Haven, Conn., Yale University Art Gallery* (Collection of the Société Anonyme)
202. Vasily Kandinsky: Balancing Act, No. 612, 1935. Oil with sand on canvas. $32 \times 39\frac{3}{8}$ in. *New York, Guggenheim Museum*
203. Laszlo Moholy-Nagy: Space Modulator, 1936. Plexiglass against wood. $34\frac{1}{2} \times 36\frac{1}{2}$ in. *Private Collection*
204. Laszlo Moholy-Nagy: Light-Space Modulator, 1922–30. A motor-driven mobile of steel, plastics, and wood to be operated in conjunction with banks of coloured lights. H. $59\frac{1}{2}$ in. *Cambridge, Mass., Busch-Reisinger Museum, Harvard University*
205. Josef Albers: Skyscrapers, 1927. Flashed glass, sandblasted. 13×13 in. *Private Collection*
206. Willi Baumeister: Siduri, 1942. $20\frac{7}{8} \times 25\frac{5}{8}$ in. *Private Collection* (Photo Johannes Schubert)
207. Viking Eggeling: Three drawings for the scroll painting Horizontal-Vertical Mass, 1919. Ink on paper. Each $8\frac{5}{8} \times 6\frac{1}{4}$ in. *New Haven, Conn., Yale University Art Gallery*

Headless Woman. Pasted paper, as reproduced in Ernst's *La Femme cent têtes* (Paris, 1929)
238. Max Ernst: Europe after the Rain, 1940-2, detail. Size of the original painting, $21\frac{1}{2} \times 58\frac{1}{2}$ in. *Hartford, Conn., Wadsworth Atheneum* (The Ella Gallup Sumner and Mary Catlin Sumner Fund)
239. Max Ernst: Lunar Asparagus, 1935. Plaster. H. $64\frac{1}{4}$ in. *New York, Museum of Modern Art* (Photo Soichi Sunami)
240. Yves Tanguy: Indefinite Divisibility, 1942. 40×35 in. *Buffalo, N.Y., Albright-Knox Art Gallery* (Room of Contemporary Art Collection)
241. Salvador Dali: Soft Construction with Boiled Beans - Premonition of Civil War, 1936. $39\frac{3}{8} \times 39$ in. *Philadelphia Museum of Art* (The Louise and Walter Arensberg Collection)
242. René Magritte: The Human Condition, 1934. $39\frac{1}{8} \times 31\frac{1}{2}$ in. *Pasadena, Calif., Norton Simon Museum*
243. Paul Delvaux: Procession, 1939. $43\frac{1}{2} \times 51$ in. *New Haven, Conn., Yale University Art Gallery*
244. André Masson: The Villagers, 1927. Oil and sand on canvas. $31\frac{7}{8} \times 25\frac{5}{8}$ in. *Paris, private collection* (Photo Galerie Louise Leiris)
245. André Masson: There is No Finished World, 1942. 53×68 in. *Baltimore Museum of Art* (Saidie A. May Collection)
246. Joan Miró: The Farmer's Wife, 1922-3. $31\frac{3}{4} \times 25\frac{1}{2}$ in. *Private Collection* (Photo Soichi Sunami)
247. Joan Miró: Painting, 1933. $51\frac{1}{4} \times 63\frac{1}{2}$ in. *Hartford, Conn., Wadsworth Atheneum* (The Ella Gallup Sumner and Mary Catlin Sumner Fund)
248. Joan Miró: Head of a Woman, 1938. $18\frac{1}{8} \times 21\frac{5}{8}$ in. *Minneapolis Institute of Arts* (Gift of Mr and Mrs Donald Winston)
249. Alberto Giacometti: The Invisible Object, 1934. Plaster. H. $61\frac{1}{2}$ in. *New Haven, Conn., Yale University Art Gallery* (Gift of Pierre Matisse)
250. Paul Nash: Monster Field, 1939. 30×40 in. *Durban Art Gallery, South Africa*
251. Ceri Richards: Two Females, 1937-8. Painted wooden construction. 63×46 in. *London, Tate Gallery* (Ceri Richards)
252. Amedeo Modigliani: Head, *c.* 1911-12. Stone. H. $24\frac{3}{4}$ in. *London, Tate Gallery*
253. Amedeo Modigliani: Jeanne Hébuterne, *c.* 1918. $39\frac{1}{4} \times 25\frac{3}{4}$ in. *Private Collection* (Photo Adolph Studly)
254. Chaim Soutine: Landscape at Céret, *c.* 1920-1. *Private Collection* (Photo Strickland Studios)
255. Chaim Soutine: The Old Actress, 1924. $36 \times 25\frac{1}{2}$ in. *Present location unknown* (Photo Marlborough Fine Art, London)

256. Jules Pascin: Young Girl Seated, *c.* 1929. $36\frac{1}{4} \times 28\frac{3}{4}$ in. *Paris, Musée d'Art Moderne de la Ville de Paris*
257. Maurice Utrillo: La Petite Communiante (Church at Deuil), *c.* 1912. Oil on cardboard. $20\frac{1}{2} \times 27\frac{1}{8}$ in. *Private Collection*
258. Marc Chagall: Double Portrait with Wineglass, 1917. $91\frac{7}{8} \times 53\frac{1}{2}$ in. *Paris, Musée National d'Art Moderne* (Photo Musées Nationaux)
259. Marc Chagall: White Crucifixion, 1938. 61×55 in. *Art Institute of Chicago* (Gift of Alfred S. Alschuler)
260. Pavel Tchelitchew: The Sleeping Zouave, 1931. $29\frac{3}{8} \times 40\frac{1}{2}$ in. *New Haven, Conn., Yale University Art Gallery* (Gift of James Thrall Soby)
261. Balthus: The Living Room, 1941-3. $44\frac{3}{4} \times 58$ in. *Minneapolis Institute of Arts*
262. Henri Matisse: White Plumes, 1919. $28\frac{3}{4} \times 23\frac{3}{4}$ in. *Minneapolis Institute of Arts* (Dunwoody Fund)
263. Henri Matisse: Still Life, 'Histoires Juives', 1924. $31\frac{7}{8} \times 39\frac{3}{8}$ in. *Philadelphia Museum of Art* (The Samuel S. White 3rd and Vera White Collection) (Photograph courtesy Philadelphia Museum of Art)
264. Henri Matisse: Seated Nude, 1922-5. Bronze. H. $31\frac{1}{2}$ in. *Baltimore Museum of Art* (The Cone Collection)
265. Henri Matisse: Pink Nude, 1935. $26 \times 36\frac{1}{2}$ in. *Baltimore Museum of Art* (The Cone Collection)
266. Georges Braque: Le Guéridon, 1929. 58×45 in. *Washington, Phillips Collection*
267. Georges Braque: Nude Woman with Basket (Canéphore), 1926. $63\frac{1}{2} \times 29\frac{1}{8}$ in. *Washington, National Gallery of Art* (The Chester Dale Collection)
268. Georges Braque: Atelier V, 1950. $56\frac{3}{4} \times 68\frac{7}{8}$ in. *Private Collection* (Photo Galerie Maeght, Paris)
269. Pablo Picasso: Mother and Child, 1921. $56\frac{1}{2} \times 64$ in. *Art Institute of Chicago* (Gift of Mary and Leigh Block Charitable Trust, Inc., Mr and Mrs Edwin E. Hokin, Maymar Corporation, Mr and Mrs Chauncey McCormick, Mrs Maurice L. Rothschild, and the Ada Turnbull Hertle Fund)
270. Pablo Picasso: Seated Woman, 1927. Oil on wood. $51\frac{1}{8} \times 38\frac{1}{4}$ in. *New York, Museum of Modern Art (bequest of James Thrall Soby)*
271. Pablo Picasso: Guernica, 1937. 138×308 in. *Madrid, Centro de Arte Reina Sofia*
272. Pablo Picasso: The Orator, 1939. Plaster. H. $14\frac{1}{4}$ in. *Paris, Musée Picasso* (Reproduced from D. H. Kahnweiler, *Les Sculptures de Picasso*, Paris, 1948, plate 170)
273. Constantin Brancusi: The New Born, 1915. Marble. H. 6 in. L. $8\frac{1}{2}$ in. *Philadelphia Museum of Art* (The Louise and Walter Arensberg Collection)

The following illustrations are © by SPADEM, Paris, 1967: 1–15, 19, 24–8, 34–40, 47–55, 62, 68–70, 77–81, 85–93, 123, 125–6, 131, 133–5, 138–9, 141–2, 145–7, 150, 156, 210, 221–2, 228, 236–9, 254–7, 262–5, 269–72, 291–6.

INDEX

Numbers in **bold** type indicate principal entries. References to the Notes are given to the page on which the note occurs followed by the number of the note; thus 538[1] indicates page 538, note 1. Only those notes are indexed which contain matter to which there is no obvious reference from the text. Individual pictures are indexed only when the subject is a portrait or a town.